33 REVOLUTIONS PER MINUTE

Dorian Lynskey is a music writer for the *Guardian*. He has free-lanced for a host of titles, including *Q*, *Word*, *Spin*, *Empire*, *Blender*, the *Observer* and the *New Statesman*. He is the author of *The Guardian Book of Playlists* (Aurum, 2008), a collection of his popular Readers Recommend columns for the *Guardian*.

Further praise for *33 Revolutions Per Minute*:

'[A] majestic new history . . . profoundly moving.' Patrick Sawer, *Sunday Telegraph*

'A thoughtful study of protest songs . . . lucidly and authorita-tively describing how they came to be written, the state of the artist's mind and career, and the political and musical context.' Dave Haslam, *Guardian*

'Dorian Lynskey's excellent overview of protest songs . . . mixes interviews new and old with diligent research . . . The book also doubles handily as a countercultural history of the West.' Book of the Week, *Time Out*

'Where a less ambitious and able writer might have contented himself with cranking out a potted biography of each song, Lynskey uses each track as starting marks for extensive, thought-ful, beautifully written and often wryly funny rambles around a theme . . . Anyone with any interest in rock 'n' roll or politics will find multitude *New Humanist*

DORIAN LYNSKEY

33 REVOLUTIONS PER MINUTE

A History of Protest Songs

faber and faber

First published in 2010
by Faber and Faber Limited
Bloomsbury House
74–77 Great Russell Street
London WC1B 3DA
This paperback edition first published in 2012

Typeset by Faber and Faber Limited
Printed in the UK by CPI Group (UK), Croydon, CR0 4YY

A CIP record for this book
is available from the British Library

ISBN 978-0-571-24135-4

2 4 6 8 10 9 7 5 3 1

For Dave Lynskey, 1946–2000

'There are two approaches to music. One is, "Man, I'm a musician and I got nuthin' to do with politics. Just let me do my own thing." And the other is that music's going to save the world . . . I think that music's somewhere in between.'

Joan Baez

'As bad as it may sound, I'd rather listen to a good song on the side of segregation than a bad song on the side of integration.'

Phil Ochs

'What Art gains from contemporary events is always a fascinating problem and a problem that is not easy to solve.'

Oscar Wilde

Contents

CONTENTS

PART FOUR: 1977–1987

PART FIVE: 1989–2008

Prologue

It is midnight in Chicago's Grant Park on 4 November 2008. Barack Obama has just been elected the first black president of the United States of America by a formidable majority. He stands on a platform in the cold night air and tells 100,000 cheering supporters: 'It's been a long time coming, but tonight, because of what we did on this day, in this election, at this defining moment, change has come to America.'

Some in the crowd, or watching at home, recognise the line as a paraphrase of words written by the soul singer Sam Cooke almost exactly forty-five years ago: 'It's been a long, a long time coming / But I know a change gonna come.' At this historic moment, one of the greatest orators of the day has borrowed the most memorable line of his acceptance speech from an old protest song.

Obama is, in a sense, the first protest-song president. He grew up on the politicised soul of Stevie Wonder and used Curtis Mayfield's civil rights anthem 'Move on Up' at his election rallies. During the campaign, a list of his ten favourite songs printed in *Blender* magazine included 'What's Going On' by Marvin Gaye, 'Gimme Shelter' by the Rolling Stones, 'Think' by Aretha Franklin, and will.i.am's 'Yes We Can', which was written around a recording of his own speech, thus making him the lyricist of his own protest song. At his inauguration concert, veteran protest singer Pete Seeger joined Bruce Springsteen to sing Woody Guthrie's 'This Land Is Your Land'; Stevie Wonder performed 'Higher Ground'; and Bettye LaVette and Jon Bon Jovi sang, inevitably, Cooke's 'A Change Is Gonna Come'.

Yet even as the music of the past spoke powerfully to the current moment, a giant question mark continued to hang over the future of the form. During the previous decade, newspaper articles had appeared with clockwork regularity asking where all the protest songs had gone – I wrote a couple myself. There were plenty of reasons to be fearful, angry, and occasionally hopeful during the 2000s, but songwriters seemed, for the most part, unable to translate any of them into compelling art. One purpose of this book is to explain why that might be.

The phrase 'protest song' is problematic. Many artists have seen it as a box in which they might find themselves trapped. Joan Baez, who sang for civil rights and against the war in Vietnam, once said, 'I hate protest songs, but some songs do make themselves clear.' Barry McGuire, who sang the genre-defining 1965 hit 'Eve of Destruction', protested, 'It's not exactly a protest song. It's merely a song about current events.' Bob Dylan told his audience, shortly before performing 'Blowin' in the Wind' for the first time, 'This here ain't a protest song.' No doubt some of the other songwriters included here will wince at the label, but I am using the term in its broadest sense, to describe a song which addresses a political issue in a way which aligns itself with the underdog. If it is a box, then it is a huge one, full of holes, and not something to be scared of.

But there are good reasons why the term is regarded with suspicion. Protest songs are rendered a disservice as much by undiscerning fans as by their harshest critics. While detractors dismiss all examples as didactic, crass or plain boring, enthusiasts are prone to acting as if virtuous intent suspends the usual standards of musical quality, when any music lover knows that people make bad records for the right reasons and good records for the wrong ones. The purpose of this book is to treat protest songs first and foremost as pop music. Not every song in the following pages is artistically brilliant but many are, because pop thrives on contradiction and tension. Electricity crackles across the gap between ambition and achievement, sound and meaning,

intention and reception. So the best protest songs are not dead artefacts, pinned to a particular place and time, but living conundrums. The essential, inevitable difficulty of contorting a serious message to meet the demands of entertainment is the grit that makes the pearl. In songs such as 'Strange Fruit', 'Ohio', 'A Change Is Gonna Come' or 'Ghost Town', the political content is not an obstacle to greatness, but the source of it. They open a door and the world outside rushes in.

This is also a book about dozens of individuals making certain choices at certain moments, for many different reasons and with a range of consequences. In the worst cases, singers have been censored, arrested, beaten or even killed for their messages. Less dramatically, there is the risk of looking shrill or annoying or egotistical. One popular canard about pop and politics is that people combine the two to attract publicity, but if there's one thing the history of protest songs demonstrates it's that there are far easier ways to shift a few extra records.

'It's always a double-edged sword,' says the former political songwriter Tom Robinson. 'If you mix politics and pop, one lot of criticism says you're exploiting people's political needs and ideas and sympathies in order to peddle your second-rate pop music [and another says] you're peddling second-rate political ideals on the back of your pop career. Either way they've got you.' Some of the anti-protest-singer criticisms that Phil Ochs drily catalogued in the sleevenotes to *All the News That's Fit to Sing* (1964) – 'I came to be entertained, not preached to'; 'That's nice but it really doesn't go far enough' – are still levelled today.

In many ways writing a protest song is asking for trouble, and it's this sense of jeopardy which gives the form its vitality. The songs in this book nearly all stem from concern, anger, doubt, and, in practically every case, sincere emotion. Some are spontaneous outpourings of feeling, others are carefully composed tracts; some are crystalline in their clarity, others enthralling in their ambiguity; some are answers, some just necessary questions; some were the product of outstanding courage, others the

beneficiaries of enormous luck. There are as many ways to write a protest song as a love song.

Of course, music has been used to make political or moral points for centuries (see Appendix 1), but I have chosen to start with the intersection of protest singing and twentieth-century popular music because that, I think, is where things get interesting. In the US before the 1930s there was the apolitical pop music of Tin Pin Alley on the one hand and the borrowed melodies of workers' songs on the other. Only when the pop song fully embraced politics with Billie Holiday's 'Strange Fruit', and folk music became radicalised by Woody Guthrie, did sparks begin to fly between the distinct poles of politics and entertainment. For reasons of space I have limited my focus to Western pop music except (as in the case of reggae or Afrobeat) where it made a significant impact on Western audiences. Of course, there exist myriad varieties of protest song elsewhere in the world, but that would be a whole other book.

For a while, in the dizzying rush of the 1960s, it was thought that pop music could change the world, and some people never recovered from the realisation that it could not. But the point of protest music, or indeed any art with a political dimension, is not to shift the world on its axis but to change opinions and perspectives, to say something about the times in which you live, and, sometimes, to find that what you've said speaks to another moment in history, which is how Barack Obama came to be standing in Grant Park paraphrasing the words of Sam Cooke. Most of these stories end in division, disillusionment, despair, even death. On one level, everything fails; on another, nothing does. It's all about what people leave behind: links in a chain of songs that extends across the decades.

In his colourful memoir *Bound for Glory*, Woody Guthrie expressed his ambitions for the songs he wrote:

Remember, it's just maybe, someday, sometime, somebody will pick you up and look at your picture and read your message, and carry you in his pocket, and lay you on his shelf, and burn you in his stove. But

he'll have your message in his head and he'll talk it and it'll get around. I'm blowing, and just as wild and whirling as you are, and lots of times I've been picked up, throwed down, and picked up; but my eyes has been my camera taking pictures of the world and my songs has been messages that I tried to scatter across the back sides and along the steps of the fire escapes and on the window sills and through the dark halls.

This book is about those scattered messages.

Abbreviations

AAA	Artists Against Apartheid
AFVN	American Forces Vietnam Network
ANC	African National Congress
ANL	Anti-Nazi League
ANP	Afrikaner National Party
BCM	Black Consciousness Movement
BM	British Movement
CIO	Congress of Industrial Organizations
CJB	Criminal Justice and Public Order Bill
CND	Campaign for Nuclear Disarmament
CORE	Congress of Racial Equality
CPUSA	Communist Party of the USA
DAR	Daughters of the American Revolution
ECLC	Emergency Civil Liberties Committee
FESTAC	Second World Festival of Black Arts and Culture
FMLN	Frente Farabundo Martí para la Liberación Nacional (Farabundo Martí National Liberation Front) [El Salvador]
FRELIMO	Frente de Libertação de Moçambique (Mozambican Liberation Front)
GAA	Gay Activists Alliance
GLC	Greater London Council
HUAC	House Un-American Activities Committee
IMF	International Monetary Fund
IRA	Irish Republican Army
IRBM	Intermediate Range Ballistic Missile
JDF	Jamaica Defence Force

JLP	Jamaican Labour Party
KKK	Ku Klux Klan
LPYS	Labour Party Young Socialists
MAD	Mutual Assured Destruction
MIR	Movimiento de Izquierda Revolucionaria (Revolutionary Left Movement) [Chile]
'Mobe'	National Mobilization Committee to End the War in Vietnam
MPLA	Movimento Popular de Libertação de Angola (Popular Movement for the Liberation of Angola)
MUSE	Musicians United for Safe Energy
NAACP	National Association for the Advancement of Colored People
NACODS	National Association of Colliery Overmen, Deputies and Shotfirers
NF	National Front [UK]
NME	*New Musical Express*
NUM	National Union of Miners
OAAU	Organization of Afro-American Unity
PAC	Pan-Africanist Congress of Azania
PIR	Philadelphia International Records
PMRC	Parents Music Resource Center
PNP	People's National Party [Jamaica]
RAR	Rock Against Racism
ROTC	Reserve Officer Training Corps
SCLC	Southern Christian Leadership Conference
SCUM	Society for Cutting Up Men
SDI	Strategic Defence Initiative
SDS	Students for a Democratic Society
SNCC	Student Nonviolent Coordinating Committee
SPG	Special Patrol Group
START	Strategic Arms Reduction Talks
SWAPO	South West Africa People's Organisation
SWP	Socialist Workers Party
UDA	Ulster Defence Association

USO	United Services Organizations
VDC	Vietnam Day Committee
VSC	Vietnam Solidarity Campaign
WTO	World Trade Organization
YIPPIE!	Youth International Party
YTS	Youth Training Scheme

PART ONE

1939–1964

1

'Black bodies swinging in the Southern breeze'

Billie Holiday, 'Strange Fruit', 1939

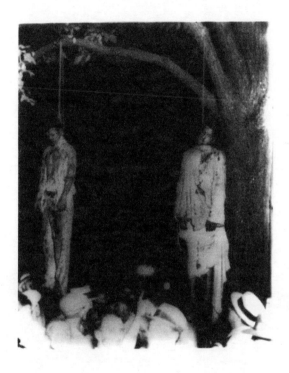

The birth of the popular protest song

The bodies of Thomas Shipp and Abram Smith, who were lynched in Marion, Indiana on 7 August, 1930. This picture inspired Abel Meeropol to write 'Strange Fruit'.

It is a clear, fresh New York night in the March of 1939. Over in Europe, the Spanish Civil War is about to end in victory for General Franco's Nationalists; by the end of the month British prime minister Neville Chamberlain will have officially abandoned his policy of appeasement towards Hitler's Germany. In the US, John Steinbeck's *The Grapes of Wrath*, an epic tale of sharecroppers during the Great Depression, is on its way to the printer's and will end up being the biggest-selling novel of the year. A movie of Margaret Mitchell's bestseller *Gone With the Wind* is due to reach cinemas in the summer. The black opera singer Marian Anderson has recently been denied permission by the Daughters of the American Revolution to sing for an integrated audience in Washington DC's Constitution Hall, prompting First Lady Eleanor Roosevelt to resign from the DAR in disgust and put her weight behind finding a new venue for Anderson's Easter recital.

You're on a date and you've decided to investigate a new club in a former speakeasy on West 4th Street: Café Society, which calls itself 'The Wrong Place for the Right People'. Even if you don't get the gag on the way in – the doormen wear tattered clothes – then the penny drops when you enter the L-shaped, 200-capacity basement and see the satirical murals spoofing Manhattan's high-society swells. Unusually for a New York nightclub, black patrons are not just welcomed but privileged with the best seats in the house.

You've heard the buzz about the resident singer, a twenty-three-year-old black woman called Billie Holiday who made her name up in Harlem with Count Basie's band. She has golden-brown, almost Polynesian skin, a ripe figure (*Time* magazine will soon condescendingly note, 'She does not care enough about her figure to watch her diet, but she loves to sing') and a single gardenia in her hair. She has a way of owning the room but she's

not flashy. Her voice is plump and pleasure-seeking, prodding and caressing a song until it yields more delights than its author had intended, bringing a spark of vivacity and a measure of cool to even the hokier material. There are many fine singers in New York in 1939, but it's the quicksilver spirit which lies behind Holiday's voice, beyond mere timbre and technique, that keeps you gripped.

And then it happens. The house lights go down, leaving Holiday illuminated by the hard, white beam of a single spotlight. Suddenly you can't get a drink because the waiters have withdrawn to the back of the room. She begins her final number. 'Southern trees bear a strange fruit.' This, you think, isn't your usual lovey-dovey stuff. 'Blood on the leaves and blood at the root.' What *is* this? 'Black bodies swinging in the Southern breeze.' Lynching? It's a song about *lynching*? The chatter from the tables dries up. Every eye in the room is on the singer, every ear on the song. After the last word – a long, abruptly severed cry of 'crop' – the whole room snaps to black. When the house lights go up, she's gone.

Now ask yourself this: Do you applaud, awed by the courage and intensity of the performance, stunned by the grisly poetry of the lyrics, sensing history moving through the room? Or do you shift awkwardly in your seat, shudder at the strange vibrations in the air, and think to yourself: *Call this entertainment?* This is the question which will throb at the heart of the vexed relationship between politics and pop for decades to come, and this is the first time it has demanded to be asked.

Written by a Jewish communist called Abel Meeropol, 'Strange Fruit' was not by any means the first protest song, but it was the first to shoulder an explicit political message into the arena of entertainment. Just prior to this, US protest songs had nothing to do with mainstream popular music. They were designed for specific audiences – picket lines, folk schools, party meetings – with an eye towards specific goals: join the union, fight the bosses, win the strike.

'Strange Fruit', however, did not belong to the many but to one troubled woman. It was not a song to be sung lustily with your comrades during a strike but something profoundly lonely and inhospitable. The music, stealthy, half in shadow, incarnated the horror described in the lyric. And instead of resolving itself into a cathartic call for unity, it hung suspended from that final word. It did not stir the blood; it chilled it. 'That is about the ugliest song I have ever heard,' Nina Simone would later marvel. 'Ugly in the sense that it is *violent* and tears at the *guts* of what white people have done to my people in this country.' For all these reasons, it was something entirely new. Up to this point, protest songs functioned as propaganda, but 'Strange Fruit' proved they could be art.

It is a song so good that dozens of singers have since tried to put their stamp on it, and a performance so strong that none of them have come close to outclassing Holiday – in 1999 *Time* magazine named her first studio version the 'song of the century'. It was, and remains, a song to be reckoned with, and the questions it raised in 1939 endure. Does a protest song enliven the politics and the music both, or merely cheapen them? Can its musical merits be separated from its social significance, or does the latter always obscure and distort the former? Does it really have the power to change minds, let alone policies? Does it convey a vital issue to a whole new audience or travesty it by reducing it to a few lines, setting it to a tune, and performing it to people who may or may not give a damn? Is it, fundamentally, a gripping and necessary art form or just bad art and lousy entertainment?

This is what 'Strange Fruit' first asked of its listeners in an L-shaped room in downtown Manhattan in the first few months of 1939 – the popular protest song's ground zero.

*

Before 'Strange Fruit', the only hit song to deal squarely with race in America was 'Black and Blue' (1929), written by Andy

Razaf and Fats Waller for the musical *Hot Chocolates*. Sung by Edith Wilson on the opening night, 'Black and Blue' wooed the audience with familiar minstrel imagery, then gut-punched them with the couplet: 'I'm white inside, it don't help my case / 'Cause I can't hide what is on my face.' When Wilson stopped singing there was a deathly hush, followed by a standing ovation. According to Razaf's biographer Barry Singer, that crucial couplet 'resolutely fractured the repressed traditions of black entertainment expression in this country forever'.

But 'Black and Blue' was too sui generis to set a trend for race-conscious show tunes.* To find black protest songs en masse, you had to tour the South, collecting the complaints of blues and folksingers who had never crossed the threshold of a recording studio. That was the mission of Lawrence Gellert, an outspoken left-winger who published some 200 examples in his 1936 volume *Negro Songs of Protest*. Having learned to be cautious in the Jim Crow South, the men who taught them to him did so only on condition of anonymity. The first blues singer to address race head on, and under his own name, was the Louisiana ex-convict Lead Belly, who composed 'Bourgeois Blues', about the discrimination he encountered on a trip to Washington DC in 1938.

But even if Abel Meeropol was aware of some or all of these examples when he sat down to compose 'Strange Fruit', there was not much they could have taught a white man from New York. Only a black man could have composed a song which explored day-to-day prejudice as keenly as 'Bourgeois Blues' or 'Black and Blue', but anybody could see that a bloodthirsty mob hanging someone from a tree was wrong. Although the practice was already on the decline by the time of 'Strange Fruit' – the grotesque photograph of a double hanging which moved

* Another ahead-of-its-time Broadway curio was Irving Berlin's 'Supper Time', from the 1933 topical revue *As Thousands Cheer*, in which a black man 'ain't coming home no more' because he has been lynched, although the lyric is scrupulously vague.

Meeropol to pick up his pen had been taken in Indiana in 1930 – lynching remained the most vivid symbol of American racism, a stand-in for all the more subtle forms of discrimination affecting the black population. Perhaps only the visceral horror that lynching inspired gave Meeropol the necessary conviction to write a song with no precedent, one which required a new songwriting vocabulary.

Meeropol published his poem under the title 'Bitter Fruit' in the union-run *New York Teacher* in 1937. The later name change was inspired. 'Bitter' is too baldly judgemental. 'Strange', however, evokes a haunting sense of something out of joint. It puts the listener in the shoes of a curious observer spying the hanging shapes from afar and moving closer towards a sickening realisation.

Meeropol was a Communist Party member who taught at a high school in the Bronx. In his spare time, under the gentile alias Lewis Allan, he churned out reams of songs, poems and plays with topical themes, only a handful of which found a wider audience. Meeropol worked out a tune and 'Strange Fruit' quickly became a fixture at left-wing gatherings during 1938, sung by his wife and various friends. It even made it to Madison Square Garden, via black singer Laura Duncan. In the crowd was one Robert Gordon, who had recently taken on a job at Café Society, directing the headlining show by Billie Holiday. The club was the brainchild of New Jersey shoe salesman Barney Josephson: a pithy antidote to the snooty, often racist elitism of other New York nightspots. Opening the night before New Year's Eve 1938, it owed much of its instant success to Holiday.

In her twenty-three years, Holiday had already seen plenty, although her notoriously unreliable autobiography *Lady Sings the Blues* obscures as much as it reveals. Born in Philadelphia, she spent some time running errands in a Baltimore whorehouse, 'just about the only place where black and white folks could meet in any natural way', where she first discovered jazz. After she accused a neighbour of attempting to rape her, the ten-year-old

9

Holiday, an incorrigible truant, was sent to a Catholic reform school until her mother secured her release. Moving with her mother to New York, she worked in another brothel, this time doing more than errands, and was jailed for solicitation. Upon her release she began singing in Harlem jazz clubs, where she caught the eye of producer John Hammond, who made her one of the Swing Era's hottest stars. 'When she was on stage in the spotlight she was absolutely regal,' jazz impresario Milt Gabler told Holiday's biographer John Chilton. 'It was something, the way she held her head up high, the way she phrased each word, and got to the heart of the story in a song, and to top it all, she knew where the beat was.'

Meeropol played Josephson his song and asked if he could bring it to Holiday. The singer later insisted she fell in love with it right away. 'Some guy's brought me a hell of a damn song that I'm going to do,' she claimed to have told bandleader Frankie Newton. Meeropol remembered it differently, believing that she performed it only as a favour to Josephson and Gordon: 'To be perfectly frank, I don't think she felt comfortable with the song.' Arthur Herzog, one of Holiday's regular songwriters, claimed that arranger Danny Mendelsohn rewrote Meeropol's tune, which he uncharitably dubbed 'something or other alleged to be music', which might have made the difference to Holiday.

Either way, Holiday road-tested the song at a party in Harlem and received what would become a familiar response: shocked silence followed by a roar of approval. Meeropol was there the night she debuted it at Café Society. 'She gave a startling, most dramatic, and effective interpretation which could jolt an audience out of its complacency anywhere,' he marvelled. 'This was exactly what I wanted the song to do and why I wrote it.'

Josephson, a natural showman, knew there was no point slipping 'Strange Fruit' into the body of the set and pretending it was just another song. He drew up some rules: first, Holiday would close all three of her nightly sets with it; second, the waiters would halt all service beforehand; third, the whole room would

be in darkness but for a sharp, bright spotlight on Holiday's face; fourth, there would be no encore. 'People had to remember "Strange Fruit", get their insides burned by it,' he explained.

It was not, by any stretch, a song for every occasion. It infected the air in the room, cut conversation stone dead, left drinks untouched, cigarettes unlit. Customers either clapped till their hands were sore, or walked out in disgust. Back then, before her life took a darker turn, Holiday was able to leave the song, and its politics, at the door on the way out. When Frankie Newton would hold forth on Marcus Garvey's black nationalism or Stalin's Five-Year Plan, she would snap, 'I don't want to fill my head with any of that shit.' John Chilton suggests that this was not because she wasn't interested but because she felt embarrassed by her lack of education. All that she knew and felt about being black in America, she poured into the song.

Holiday had an electric personality. She could be capricious, hot-tempered and hedonistic, but warm and generous company, too. Between performances she would take a hackney cab ride through Central Park, where she could smoke marijuana in peace because Josephson had banned it from the club. 'La Holiday is an artist with tears in her eyes as she sings "Strange Fruit",' wrote Dixon Gayer in *Down Beat*. 'Billie is carefree, temperamental, a domineering personality. They are both swell people.'

As the song's fame spread, Josephson pushed it as a reason to visit Café Society. 'HAVE YOU HEARD? "Strange Fruit growing on Southern trees" sung by Billie Holiday,' asked a press advertisement that March, casually mangling the song's title. It was begging to be recorded. Holiday's regular label, Columbia, blanched at the prospect, so she turned to Commodore Records, a small, left-wing operation based out of Milt Gabler's record shop on West 52nd Street. On 20 April 1939, just eleven days after Marian Anderson marked a watershed for black musicians with her rescheduled Easter concert on the steps of the Lincoln Memorial, Holiday entered Brunswick's World Broadcasting

Studios with Frankie Newton's eight-piece Café Society Band and recorded 'Strange Fruit' in one four-hour session. Worried that the song was too short, Gabler asked pianist Sonny White to improvise a suitably stealthy introduction.

On the single, Holiday doesn't open her mouth until seventy seconds in. Like Josephson with his spotlight, the musicians use that time to set the scene, drawing the listener in as if to a ghost story. Newton's muted trumpet line hovers in the air like marsh gas; White's minor piano chords walk the listener towards the fateful spot; then, at last, there's Holiday. Others might have overplayed the irony or punched home the moral judgement too forcefully, but she sings it as though her responsibility is simply to document the song's eerie tableau; to bear witness. Her voice moves softly through the dark, closing in on the swinging bodies like a camera lens coming into focus. In doing so, she perfects the song, narrowing the sarcasm of 'gallant South' to a fine point and cooling the temperature of the most overheated image: 'the stench of burning flesh'. She is charismatic but not ostentatious, curling the words just so. 'Swinging' becomes a savage pun on one of jazz's favourite verbs. 'Bulging' brings the title image to the point of obscene ripeness. 'Crop' is strung out and then cut short with neck-snapping force. Her gifts to the song are vulnerability, understatement and immediacy: the listener is right there, at the base of the tree. *Look*, she is saying. *Just look*.

Released three months later, with 'Fine and Mellow' as the incongruous flipside, it became not just a hit but a cause célèbre, at least in certain circles. Campaigners for an anti-lynching law mailed copies to congressmen. *The New York Post*'s Samuel Grafton called it 'a fantastically perfect work of art, one which reversed the usual relationship between a black entertainer and her white audience: "I have been entertaining you," she seems to say, "now you just listen to me.". . . If the anger of the exploited ever mounts high enough in the South, it now has its "Marseillaise".'

Not all of Holiday's fans shared Grafton's enthusiasm for this

anomalous offering. In his definitive book on the song, David Margolick collected opinions from a host of high-profile listeners. Jerry Wexler, the producer famed for his work with Ray Charles and Aretha Franklin, argued: 'It's got too much of an agenda. A lot of people who had tin ears and who wouldn't know a melody if it hit them in the head embraced the song only because of the politics . . . I absolutely approve of the sentiment. I think it's a great lyric. But it doesn't interest me as a song.' Black journalist Evelyn Cunningham admitted a more emotional reaction: 'There comes a time in a black person's life where you're up to your damned ears in lynching and discrimination, when sometimes you were just so sick of it, but it was heresy to express it.'

Wexler's objection is purely a matter of taste. One could argue that the song intrigues *because* of its melodic and harmonic simplicity, as if the lyric had stunned the singer into stillness. But Cunningham touches on an uncomfortable truth which would resonate down the decades all the way to hip-hop: that the same unflinching expressions of black tribulation which struck white liberals as bracing were simply depressing to many black listeners: *We know this already. Why spoil our Saturday night?* As jazz and blues historian Albert Murray put it to Margolick: 'You don't celebrate New Year's over chitlins and champagne to "Strange Fruit". You don't get next to someone playing "Strange Fruit". Who the hell wants to hear something that reminds them of a lynching?'

*

Holiday quit Café Society in August 1939, but she took 'Strange Fruit' with her and carried it like an unexploded bomb. In Washington DC a local newspaper wondered whether it might actually provoke a new wave of lynchings. At New York's Birdland the promoter confiscated customers' cigarettes, lest their firefly glow distract from the spotlight's intensity. When some promoters ordered her not to sing it, Holiday added a

clause to her contract guaranteeing her the option. Not that she always exercised that right. 'I only do it for people who might understand and appreciate it,' she told radio DJ Daddy-O Daylie. 'This is not a "June-Moon-Croon-Tune."'

Outside of Holiday's performances, 'Strange Fruit' travelled like a political refugee seeking safe haven. Liberals, black and white, valorised it. Radio stations banned or ignored it. Most Americans never even heard it. It's interesting how often eyewitnesses describe the song in physical terms, as if it were an assault. The actress Billie Allen Henderson told Margolick, 'all of a sudden something stabs me in the solar plexus and I was gasping for air'. The son of Jack Schiffman, owner of the Harlem Apollo, recalled: 'When she wrenched the final words from her lips, there was not a soul in that audience, black or white, who did not feel half strangled.' Then there's Josephson with his burning insides and Simone with her tearing guts. Burning, tearing, stabbing, strangling: no ordinary song, this.

Holiday took to claiming it had been written especially for her, and guarding it like a lioness. After the black folksinger Josh White joined Café Society in 1943 and added it to his repertoire, she paid him a visit. 'For a time, she wanted to cut my throat for using that song which was written for her,' remembered White. 'One night she called by the Café to bawl me out. We talked and finally came downstairs peaceably together, and to everyone's surprise had a nice little dancing session.' Evidently the nice little dancing session was forgotten by the time she wrote her memoir and uncharitably claimed: 'The audience shouted for him to leave the song alone.'

But Holiday was wrong about White, who understood the song better than most and did as much as she to popularise it. Growing up in South Carolina, he claimed to have witnessed two lynchings by the age of eight. In 1940 his band, the Carolinians, had released *Chain Gang*, an album of songs from Gellert's *Negro Songs of Protest*, and the following year's *Southern Exposure: An Album of Jim Crow Blues* made him one of President Roosevelt's

favourite singers.* He took his knocks for 'Strange Fruit', too. Taking a break between performances outside Café Society one night, he was set upon by seven white servicemen. During a show in Pennsylvania someone shouted, 'Yeah, that song was written by a nigger lover!' and tried, unsuccessfully, to physically ambush White afterwards. Notwithstanding these attacks, by the end of the war, the handsome, likeable White rivalled Burl Ives as the most popular folksinger in America, and success gave him a platform from which to deliver searching lyrics when he chose. 'Music is my weapon,' he would tell the *Daily Worker* in 1947. 'When I sing "Strange Fruit" . . . I feel as powerful as an M-4 tank.'

But the fact remained that White could pick it up and put it back down again – one song among many. Holiday could no more detach herself from it than if the lyrics had been tattooed on her skin. Any hit song, if it's powerful enough, can get away from the people who made it. It travels out into the world and lives a life all its own. But the people who made it can't always get away from the song. 'Strange Fruit' would haunt Holiday for the rest of her life. Some fans, including her former producer John Hammond, blamed it for robbing her of her lightness. Others pointed out that her burgeoning heroin habit did that job all by itself.

So did the persistent racism which poisoned her life just as it poisoned the life of every black American. In 1944 a naval officer called her a nigger and, her eyes hot with tears, she smashed a beer bottle against a table and lunged at him with the serrated glass. A little while later a friend spotted her wandering down 52nd Street and called out, 'How are you doing, Lady Day?' Her reply was viciously blunt: 'Well, you know, I'm still a nigger.' No wonder she clutched the song tightly to her breast, as a shield and a weapon, too. Jazz critic Rudi Blesh rubbished the song

* Until 1948 an 'album' comprised a package of 78 rpm discs rather than a 33⅓ rpm long-player.

at first and only realised its real meaning years later. 'Lynching, to Billie Holiday, meant *all* the cruelties, *all* the deaths, from the quick snap of the neck to the slow dying from *all* kinds of starvation.'

Holiday commenced her slow dying when she discovered heroin in the early 1940s, an addiction which eventually earned her a year-long prison term in 1947. Ten days after her release she performed a comeback show at New York's Carnegie Hall. According to *Lady Sings the Blues*, she accidentally pierced her scalp with a hatpin and sang with blood trickling down her face. There could be only one contender for the closing number. 'By the time I started on "Strange Fruit",' she wrote, 'between the sweat and blood, I was a mess.' *Time* called the performance 'throat-tightening'.

During the 1950s she performed it less often and, when she did, it could be agonising to watch. Her relationship with it became almost masochistic. The worse her mood, the more likely she was to add it to the set, yet it pained her every time, especially when it prompted walkouts by racist audience members. By the latter half of the decade her body was wasted, her voice weathered down to a hoarse rasp, and 'Strange Fruit' was the only song that seemed to dignify her suffering, wrapping her own decline in a wider American tragedy. Writing about her final years, David Margolick says 'she had grown oddly, sadly suited to capture the full grotesqueness of the song. Now, she not only sang of bulging eyes and twisted mouths. She embodied them.' It was as if the song, having lived inside her for so long, had finally warped its host.

Holiday died in a New York hospital on 17 July 1959, five months after recording 'Strange Fruit' for the fourth and last time during a performance in London. After her death, the song fell from favour for a while. Nothing could have been more guaranteed to kill the mood on a civil rights march than this grim, assaulting piece of work.* But unlike the freedom songs, it is not rooted to its place and time, and that's precisely because Holiday

was an artist rather than a campaigner. She was trouble, a misfit, and so was 'Strange Fruit'.

When Holiday first began singing it, her mother asked, 'Why are you sticking your neck out?'

'Because it might make things better,' Billie replied.

'But you'd be dead.'

'Yeah, but I'll feel it. I'll know it in my grave.'

* It wouldn't be recorded again until Lou Rawls included it, alongside Razaf's song, on his 1962 album *Black and Blue*. Nina Simone covered it in 1965.

2

'This land was made for you and me'

Woody Guthrie, 'This Land Is Your Land', 1944

Woody Guthrie's America

Woody Guthrie entertains customers in McSorley's Bar, New York, 1943.

'I ain't a writer, I want that understood,' fibbed Woody Guthrie in his 1940 radical songbook *Hard Hitting Songs for Hard-Hit People*, 'I'm just a little one-cylinder guitar-picker.' Guthrie was a natural storyteller, and the story he told best of all was his own. There was the man himself – thorny, contradictory, mischievous, erratic – and then there was the *idea* of Woody Guthrie: the archetypal American protest singer, a travelling truth-teller, raw-boned and tough-minded, forged in the parching clouds of the Dust Bowl, riding the rails and walking the hot roads, scourging hypocrisy and oppression from sea to shining sea. He was an extraordinary character who preferred to pass himself off as 'a guitar busker, a joint hopper, tip canary, kittybox man,' because aw-shucks self-effacement only made the myth stronger. He could best reach the common man by *being* the common man, by cloaking his intelligence, artistry and radicalism in hillbilly vernacular and plain commonsense.

Guthrie was a quintessentially American creation – a wanderer, a pioneer, an idealist, a democrat – and his value as an icon of the American left was incalculable. Communists and other progressive thinkers in the US during the 1930s and 1940s were often seen by the very workers that they sought to defend as elitist, internationalist, metropolitan – in short, not quite American. Guthrie was no simpleton, but his intellect was self-taught rather than schooled, and his roots were in the American heartland. 'He sings the songs of a people and I suspect that he is, in a way, that people,' testified John Steinbeck in his introduction to *Hard Hitting Songs*. 'Harsh-voiced and nasal, his guitar hanging like a tire iron on a rusty rim, there is nothing sweet about Woody, and there is nothing sweet about the songs he sings. But there is something more important for those who will listen. There is the will of a people to endure and fight against oppression. I think we call this the American Spirit.'

In Guthrie could be detected classic archetypes of American individualism: Thoreau, scribbling away in his beloved woods, or Huckleberry Finn, drifting down the Mississippi River. Most of all, there was Walt Whitman, with whom Guthrie shared so much: the lionisation of the common man, the mockery of those in power, the attempt to capture in vivid but simple language the vastness of the country, the desire to 'attract his own land body and soul to himself, and hang on its neck with incomparable love'. When you read the last line of Whitman's preface to his 1855 volume *Leaves of Grass* – 'The proof of a poet is that his country absorbs him as affectionately as he has absorbed it' – you also think of Guthrie, and especially of a song he wrote in a fleabag hotel in the winter of 1940, 'This Land Is Your Land'.

*

Woodrow Wilson Guthrie came into the world on 14 July 1912, in the tiny Oklahoma village of Okemah. His father, Charley, named him after the freshly anointed Democratic presidential candidate, an indication of his political ambitions. Charley stood for the state legislature and penned anti-socialist tracts warning of the creeping menace of free love and interracial marriage. Woody's mother, Nora, carried the mutated gene of Huntington's chorea, which would slowly dismantle both her and her son. She used to sing him old English and Irish folk songs, full of bad luck and violent ends.

The Guthries were plagued by fire: the one which destroyed their home three years before Woody's birth; the one which killed his fourteen-year-old sister Clara in 1919; and the one which scarred Charley in 1927. After Clara's death, destroyed by rumours that she had started the fire herself and, though she didn't know it, by Huntington's, Nora became panicky, anxious, violent, lost. Meanwhile, Charley's political and financial fortunes collapsed, and his once-strong body became wracked with arthritis. The 1927 blaze, started, perhaps intentionally, by Nora's kerosene lamp, sent Woody's father to the hospital and

his mother to the mental institution.

While his family crumbled, Woody haunted the town in bedraggled clothes, collecting junk and playing his harmonica. After Charley persuaded him to come and seek new opportunities in Pampa, Texas, Woody became a gluttonous autodidact, gobbling up books on psychology, ancient history and Eastern philosophy in the town library. He cut a shabby, solitary, incongruously bohemian figure, interested in nothing except strumming his guitar, cracking strange jokes, drawing cartoons and pursuing his esoteric private studies – his latest discoveries were yoga, spiritualism and Khalil Gibran's poetry. Even marrying his best friend's sister, Mary Jennings, and having a daughter, Gwendolyn Gail, didn't do much to root him. As the Depression bit hard, he barely seemed to notice.

That all changed on 14 April 1935, the day the Great Dust Storm rolled into Pampa, turning the air black and dry and cold. 'It was pitch black all the way to the ground,' remembered Woody's sister Mary Jo. 'They were saying, "It's the end of the world."' It hadn't rained in four years; the farms were suffering and the oil boom was over. A journalist memorably dubbed this area of Texas and Oklahoma 'the Dust Bowl', and someone else called the hundreds of migrants who fled its barren flats for the promise of work and freedom in California 'Okies'. Woody, who had already started writing songs, finally had something to sink his creative teeth into. These new songs were tough and astringent, befitting the times. His own father, by now scratching out his final years in an Oklahoma City flophouse, was one of the Great Depression's victims, too old to be saved by President Roosevelt's New Deal.

Woody upped sticks in 1936 and hopped on the boxcars with which he would always be associated, entertaining his travelling companions, with a grab-bag of folk ballads, country songs and hymns – songs with their roots in the same soil that his listeners were now fleeing, cracked with loss and regret, songs like 'The Boll Weevil Song' ('still looking for a home'), songs with the

power to bind and heal, if only for a little while. He had no trouble pulling a crowd. 'His singing voice was dry, flat and hard like the country,' writes his biographer Joe Klein. 'It wasn't a very good voice, but it commanded attention: listening to him sing was bitter but exhilarating, like biting into a lemon.'

Woody spent a year on the road, on and off, always coming home to Mary and his daughter before wanderlust gnawed at his heels again. It turned out he knew more about Khalil Gibran and Confucius than he did about the nature of American society. Shocked by the anti-Okie antipathy he encountered in California, where the police manned illegal roadblocks to deter undesirables, he turned to older souls on the boxcar circuit for political insight. And that was where he first heard the name Joe Hill.

*

Joe Hill was America's first star protest singer, even though his name and his tragic story have survived far longer than his music. He didn't write very good songs, but they commanded attention.

He was born Joel Hägglund in Sweden in 1879 and came to the US at the age of twenty-three, changing his name to Joe Hillstrom. In 1910, he joined the Industrial Workers of the World, commonly known as the Wobblies, then in their fifth year of shaking up the American working classes. Their brand of socialism was broad-shouldered, boisterous and uncompromising. Strikes and sabotage were their tools, the formation of One Big Union their goal. And – important, this – they had the songs, too. Fighting to make themselves heard above the righteous blare of a Salvation Army band in Spokane, Washington, in 1906, the Wobblies began crafting pungent parodies of Salvation Army hymns, which were compiled three years later into *Songs of the Workers*, popularly known as *The Little Red Song Book*. 'At times we would sing note by note with the Salvation Army at our street meetings, only their words were describing Heaven above, and ours Hell right here – to the same tune,' remembered Wobbly Richard Brazier.

The itinerant Hill made his name in 1911 with a parody he wrote to support strikers on the South Pacific Line: 'Casey Jones the Union Scab'. Witty, outrageous, suitably bloodthirsty and easy to sing, the lyrics were printed on coloured card and sold to aid the strike fund. His most famous songs, 'There Is Power in a Union' and the anti-Salvation Army satire 'The Preacher and the Slave' ('Work and pray, live on hay / You'll get pie in the sky when you die') made later editions of *The Little Red Song Book*. Hill gave as good a definition as any of the art of early-twentieth-century protest singing: 'If a person can put a few cold, common-sense facts into a song and dress them (the facts) up in a cloak of humour to take the dryness out of them, he will succeed in reaching a great number of workers who are too unintelligent or too indifferent to read a pamphlet or an editorial on economic science.'

Hill was in Utah, helping the Western Federation of Miners fight the copper industry, when two masked men shot dead John G. Morrison and his seventeen-year-old son Arling in their Salt Lake City grocery store on 10 January 1914. That same night Hill was treated for a gunshot wound; the doctor called the police. He was tried in June, amid press reports of his 'inflammatory' and 'sacrilegious' songs. Although the evidence was circumstantial, he was sentenced to death. There was international outcry; the Wobblies issued a 'Joe Hill edition' of *The Little Red Song Book*; Woodrow Wilson brought a temporary stay of execution. After Hill met a firing squad in November 1915, 30,000 mourners crowded the streets outside his funeral service in Chicago. 'What kind of man is this whose death is celebrated with songs of revolt and who has at his bier more mourners than any prince or potentate?' marvelled one reporter.

Whether or not Guthrie was conscious of it at the time, Hill's story contained some valuable lessons. There was Joe Hill the musician: vigorous but crude, not one for the ages. There was Joe Hill the man: definitely a rogue, possibly a murderer. And there was Joe Hill the myth: the biggest, boldest voice of working-class protest in the land, martyred by the system he opposed. What

echoed most loudly down the two decades following his death was the myth.

*

Guthrie's political awakening came in fits and starts. There was no lightning flash of understanding. But it began there, around the campfires, with the battered remnants of the Wobblies and the story of Joe Hill. 'I think Woody learned socialism on the highways of America,' his daughter Nora told a documentary crew. 'I don't think he learned it from a book.' He took to using more humour in his own Dust Bowl songs, borrowing the conversational rhythms of the talking blues, and worked up one of his classic songs, 'Talking Dust Bowl Blues', while riding the freight trains.

Returning to California in 1937, he stopped in on his cousin Jack, who called himself 'Oklahoma' and had aspirations to ride the coattails of the 'singing cowboy' craze, a thoroughly phony but enormously popular Hollywoodisation of country music. Jack landed the pair an audition on the KFVD station, run by the fiercely liberal J. Frank Burke, and *The Oklahoma and Woody Show* was an instant hit. When Jack got cold feet and returned to working in construction, his friend Maxine Crissman, whom Woody nicknamed 'Lefty Lou', took his place.

Guthrie knew that Burke hadn't hired him for his appreciation of Omar Khayyám and French Impressionism. There was an appetite in Los Angeles for a regular guy from the heartland. He didn't dumb down so much as funnel his wit into more expected forms: a hillbilly with a brain. Three times a day Woody and Lefty performed songs, read out requests, chatted about this and that, and dispensed what Woody called his 'Cornpone Philosophy'.

But nothing could hold Woody in one place for long, not even a comfortable wage and a remarkable one thousand fan letters a week. Sensing his restlessness, Burke gave him another channel for his energies, dispatching him to the migrant camps of the Farm Security Administration (FSA) to report on conditions

there. Woody encountered the same drawn, hollowed-out faces that would later fill James Agee and Walker Evans's ground-breaking book *Let Us Now Praise Famous Men*, and the same broken-backed hard-luck tales that would inspire *The Grapes of Wrath*. No place for Cornpone Philosophy, this. Disgust and rage gave him 'Dust Bowl Refugees', 'Dust Pneumonia Blues' and 'Dust Can't Kill Me'. He sang them as if the dust were rat-tling around his parched throat and scarring his lungs. In the face of such suffering and injustice, the old pulpit palliatives stuck in his craw. Hearing the Carter Family sing the Baptist hymn 'This World Is Not My Home', he followed the tradition of Wobbly parodies by twisting its all-things-must-pass fatalism into the wail of a rootless labourer who meets hardship and harassment at every turn: 'I Ain't Got No Home'. The man who romanti-cised the vagabond life while always having a wife and child to return home to suddenly faced what rootlessness really meant.

It was at this point that the Communist Party stepped into his life, in the form of Ed Robbin, a fellow KFVD presenter and columnist with the *People's World* newspaper who booked Guthrie to appear at a party meeting to celebrate the release of labour leader Tom Mooney after serving twenty-two years for alleged terrorism. The communists, not usually famed for their good-time joie de vivre, whooped and hollered. A bona fide Okie singing about Tom Mooney and the vicious LA establishment? He was almost too good to be true.

Formed after the Russian revolution, the Communist Party of the United States of America (CPUSA) had been promptly beaten into submission by a fearful government, but the Depression and the rise of Hitler had put the fire back in its belly. The commu-nists worked hard to become part of the US mainstream, joining the new union body the Congress of Industrial Organizations (CIO) and campaigning for FDR. Leader Earl Browder proudly declared: 'Communism is twentieth-century Americanism.'

While still on the air at KFVD (now *sans* Lefty Lou), Woody cultivated a different species of celebrity on the left-wing circuit,

playing as many as four shows a night under the guidance of his
new agent, Ed Robbin. At parties he was introduced, without
qualification, as 'the voice of his people'. In May 1939 he talked
his way into a column in *People's World*. 'Woody Sez' consisted
of a wry, punchy paragraph illustrated with one of his cartoons.
He relished playing the simpleton, sneaking in the blade of his
wit beneath the cover of bad grammar, misspellings and Okie
vernacular. One issue featured a vintage Woodyism which would
come in handy in darker times: 'I ain't a Communist necessarily,
but I been in the red all my life.'

Guthrie's relationship with communism is puzzling. He never
became a signed-up party member but, for a brief period, he
followed the Moscow line as hard as anyone. When the Nazis
and Soviets signed their infamous non-aggression pact in August
1939, Jews, anti-fascists and anyone else disinclined to perform
the ideological backflips necessary to justify this monstrous cyni-
cism fled the CPUSA. But as the war began, Woody stuck fast to
the new line that the Soviets had invaded eastern Poland only in
order to save it, portraying Stalin as some heroic saviour in the
shamefully naive 'More War News'. Frank Burke was horrified.
Their relationship, and Woody's radio show, was finished.

The party bookings dried up too, and Guthrie decided to join
Will Geer, a charismatic activist actor with whom he had played
several good-natured benefit shows, in New York. Geer put him
up on his couch and found him work on Manhattan's thriving
benefit circuit. On 3 March 1940 Geer put together a 'Grapes
of Wrath Evening', after which Guthrie met another performer,
an earnest, gangly young man named Pete Seeger. According to
folklorist Alan Lomax, who introduced the two men: 'You can
date the renaissance of American folk song from that night.'

*

Pete Seeger's father, Charles, was a well-born, Harvard-educated
professor of music at the University of California in Berkeley.
After a sobering trip to migrant labour camps in 1914, he

became a full-blooded radical, visiting the Wobbly headquarters in San Francisco and making enemies on campus by opposing US involvement in the First World War. He registered as a conscientious objector and was effectively fired from Berkeley, his mental and physical health in ruins from the strain. 'My father was a big influence on me,' Pete told the *New Yorker*'s Alec Wilkinson. 'He was overenthusiastic all his life. First about this, then about that.'

Pete was born in 1919, around the time that Charles Seeger, bored of composing, decided upon a Southern road trip 'to bring music to the poor people of America, who didn't have any music', a mission statement which revealed both a good heart and staggering ignorance of folk tradition. The Seegers played Chopin; the locals responded with fiddles and guitars.

In 1932 Charles married his second wife, fellow composer Ruth Porter Crawford, and joined the Pierre Degeyter Club, a left-wing klatsch named after the composer of the 'Internationale'. Alongside Aaron Copland (whose 1934 ballet *Hear Ye! Hear Ye!* satirically distorted 'The Star-Spangled Banner' thirty-five years before Jimi Hendrix), Earl Robinson (writer of the tribute 'Joe Hill') and Marc Blitzstein (composer of the 1937 pro-union musical *Cradle Will Rock*), he belonged to the club's Composers' Collective, which set out to write songs for demos and picket lines with the notion that radical messages necessitated radical forms. Their chief inspiration was Hanns Eisler, the German Marxist who replaced Kurt Weill as radical playwright Bertolt Brecht's songwriting partner, helmed the International Music Bureau of the Comintern, and scolded left-wing composers to make only 'useful' music, like his own avant-garde 'workers' choruses'. All of which doubtless sounded fabulous to a clique of Ivy League-educated composers trading ideas in Manhattan lofts, but failed to quicken the pulse of coal-miners in Kentucky.

But another leftist, the poet Carl Sandburg, saw radical promise in folk music. In 1927, with the help of Ruth Crawford, he published an influential collection of folk songs called *American*

Songbag, calling for these traditional American voices to be preserved in the go-faster era of the assembly-line and the aeroplane. The following year the Library of Congress inaugurated the Archive of American Folk Song, which came under the stewardship of long-time folklorist John Lomax in 1933. Lomax held a romantic, somewhat condescending vision of simple folk strumming away on their porches while urbanites rushed around raising skyscrapers, and it led him and his eighteen-year-old son Alan on a road trip through five Southern states, their cargo a disc recorder weighing over 300 pounds. Such trips used to be good business – on one legendary 1927 journey Victor Records' Ralph Peer discovered both Jimmie Rodgers and the Carter Family and thus launched country music – but by 1933, thanks to the Depression, the musical gold rush was over. The Lomaxes were interested in preservation, not profit.

Lomax Senior was no radical (he believed black people were happy with their segregated lot and had written in 1917, 'A nigger sings about two things – what he eats and his woman') but he knew talent when he heard it. At Angola Penitentiary, the Lomaxes found and recorded a barrel-chested black convict named Huddie Ledbetter, aka Lead Belly. Lomax the traditionalist dressed Lead Belly as if he had just stepped out of the prison yard or the cotton field; when the singer broke ties with his benefactor he promptly switched to double-breasted suits. He was interested in what he might become; Lomax was interested only in where he had come from. 'My grandfather was very patriarchal, domineering, complicated, sentimental,' remembered Lomax's grand-daughter Anna. 'No doubt he told Lead Belly what to do, but he told *everybody* what to do.'

Like John Lomax, the left were hung up on authenticity, but for different reasons. During a 1931 visit to the coal towns of Kentucky's Harlan County (aka 'Bloody Harlan'), a group of high-profile Northern leftists, including novelists John Dos Passos and Theodore Dreiser, was amazed by the stark storytelling of fifty-one-year-old Aunt Molly Jackson, herself a coal-miner's

wife. She was invited to New York, where she recorded 'Ragged Hungry Blues' (retitled 'Kentucky Miner's Wife' to assure listeners they were getting the real deal), played benefits and ended up settling. Another new hero of the left was Ella May Wiggins ('truly revolutionary words, bare of all ornament, full of earnestness and feeling', applauded poet Margaret Larkin), but she wasn't around to bask in the acclaim, having been shot dead during the Gastonia textile strike in 1929.

One day Aunt Molly Jackson attended a meeting of the Composers' Collective and blasted the scales from Charles Seeger's eyes. 'I went up to her and I said, "Mollie [sic], you're on the right track and we're on the wrong track," and I gave up the Collective,' he wrote. 'We were all on the wrong track – it was professionals trying to write music for the people and not in the people's idiom.' With a convert's zeal, he put folk at the centre of his work with the Works Progress Administration's Federal Music Project, part of the New Deal.

It constituted a kind of ideological land grab. The songs may have resided with the people, but the message belonged to whoever stuck a flag in it, and increasingly the flag was red. Like the Farm Security Administration photographers who encouraged their impoverished subjects to stand up straight and tighten their jaws, the better to represent the quiet dignity of hardship, leftist intellectuals were in love, most of all, with the idea of the common man. The real common man got up to all kinds of things. Sometimes he drank, he fought, he even shot his woman down. There was nothing ennobling about, say, the eerie, vengeful murmur of Lead Belly's 'In the Pines'. This was the type of folk music that the critic Greil Marcus memorably termed the sound of the 'old, weird America': the music of rumours, dreams, ghost stories and whispers in the night. If you encounter it now, perhaps via Harry Smith's definitive *Anthology of American Folk Music*, it will haunt and enthral you. But if you were a communist or progressive in the 1930s, you would have required a very different brand of folk.

Left-wing songbooks proliferated.* In these volumes, song-writers such as miner's wife Florence Reece ('Which Side Are You On?') and Aunt Molly's half-sister Sarah Ogan Gunning ('I Hate the Capitalist System') are beset by dangers on all sides. If the brutal bosses, scabs and Klansmen don't get them, then dust storms, mine explosions and tuberculosis will. The graphic misery is as old as folk music itself but the promise of salvation, invariably in the form of the unions, always illumines the gloom. As one gospel hymn, famously repurposed as a union anthem, vows, 'We Shall Not Be Moved'.

At the influential, labour-run Highlander Folk School in Tennessee, songleader Zilphia Horton collected over a thousand songs and set them to work as mechanisms for organising workers, while Earl Robinson founded the International Workers Order's People's Chorus. A canon of American protest songs was being slowly assembled, and no longer for the purposes of preservation but of action. What the movement needed now was a star.

*

Woody Guthrie arrived in New York in 1940 like an answered prayer. For some time, *Daily Worker* columnist Mike Gold had been arguing the need for 'a Communist Joe Hill' or, better yet, 'Shakespeare in overalls', someone to take protest folk beyond the rarefied air of academia and party meetings. And, all of a sudden, here he was, commanding the stage of the Forrest Theatre with the wit, the anger and the tunes to do the job. At a cocktail party afterwards, Alan Lomax, an instant fan, introduced Guthrie to Pete Seeger.

Seeger had grown into a long, lean, lonely young man, a passionately left-wing Harvard dropout who was searching for

* *The Red Song Book* (1932), which featured Jackson, Wiggins and Hill; the socialist *Rebel Song Book* (1934); Charles Seeger's *The New Workers' Song Book* (1934); the Composers' Collective's post-conversion *Songs of the People* (1935); and Lawrence Gellert's *Negro Songs of Protest* (1936).

somewhere to fit in. In 1939 Lomax invited him to the New York apartment of Aunt Molly Jackson; it was the first time he had ever heard a protest song performed in the flesh. Lomax got him a job at the Archive of American Folk Song, where he studied the old songs like sacred texts and added them to his own repertoire. The 'Grapes of Wrath Evening' benefit was his first public solo performance, sharing a bill with Lead Belly and Aunt Molly, no less.

Lomax asked Woody and Pete to help him with a project to collect some of the songs, mostly political, which conservative folklorists had tended to ignore, under the banner *Hard Hitting Songs for Hard-Hit People*: compiled by Lomax, transcribed and edited by Seeger, introduced by Steinbeck and characterfully annotated by Guthrie. Publishers deemed it 'too hot' and it was left to gather dust until 1967, but a friendship had been forged. The pair performed weekly parties in New York, to raise money for rent, which they called 'hootenannies'.*

Meanwhile, Woody's celebrity was growing. 'Sing it, Woody, sing it!' cheered Mike Quin in *People's World*. 'Karl Marx wrote it, and Lincoln said it, and Lenin did it. You sing it, Woody, and we'll all laugh together.' Lomax recorded long sessions with him at the Library of Congress, got him a guest spot on New York radio and, best of all, convinced Victor Records to put out a two-album set called *Dust Bowl Ballads*. Victor was hoping to cash in on the mania surrounding *The Grapes of Wrath* and asked Guthrie to write a new song about the novel's hero. One epic, wine-fuelled writing binge later he had seventeen verses of 'Tom Joad'. According to Will Geer, Steinbeck laughingly grouched, 'That fuckin' little bastard! In seventeen verses he got the entire story of a thing that took me two years to write!'

Dust Bowl Ballads was a major step forward from the songbooks. Here were protest songs you could *hear* rather than read, the fruit of Guthrie's journey so far: 'So Long, It's Been Good to

* This was a rural word for party which had been chosen as the offical term for the left-wing New Deal Club's musical fundraisers in the 1930s (coming in a close second in the vote was 'wingding').

Know You', his farewell to Pampa; 'Do Re Mi', which he had written about the police roadblocks outside Los Angeles; 'I Ain't Got No Home', his tart retort to Baptist fatalism; and a fistful of songs with 'Dust' in the title. Guthrie wrote in the *Daily Worker*: 'I'm sure Victor never did a more radical album.'

One recent composition, however, went unrecorded. Riding the freights up to New York, Guthrie had been plagued by Irving Berlin's ubiquitous hit 'God Bless America' and was moved to write an alternative. In the city, having been evicted from Will Geer's couch, he checked into Hanover House, a ratty hotel near Times Square, and dashed off six verses, set to a tune loosely modelled on the Carter Family's 'Little Darling, Pal of Mine', which had itself been based on the Southern gospel hymn 'Oh, My Loving Brother'. The new song transcended parody with the generous sweep of its Whitmanesque poetry. 'This land is your land, this land is my land,' it began. Guthrie titled it 'God Blessed America' and thought no more about it.*

While *Dust Bowl Ballads* was awaiting release, Guthrie decided to visit Mary and the kids (they had produced a second, Carolyn, in 1937) in Pampa and invited Seeger along for the ride. The trip was the making of Seeger: his introduction to the real America that until then had been a romantic ideal. They stopped off at the Highlander Folk School, played for striking oil workers in Oklahoma City and sang for their supper at every stop. Seeger had contracted the travel bug.

* There must have been a mood of left-wing patriotism in the air. Earl Robinson, who worked with Earl Browder's slogan pasted to his piano, composed 'Ballad for Americans', a voluminous history lesson which hymned the heterogeneous vitality of the country. Described by its author as a 'Whitman cantata', and originally named 'Song for Uncle Sam', it was radical enough for the left and patriotic enough for the Republican Party to use it at their national convention. When the black actor, singer and activist Paul Robeson sang it on CBS in November 1939, he received a twenty-minute standing ovation and hundreds of fan letters.

Back in New York, where *Dust Bowl Ballads* was warmly, if not widely, received, Guthrie reprised his Los Angeles experience: another high-profile radio show (*Back Where I Come From*, produced by Alan Lomax and Nicholas Ray, future director of *Rebel Without a Cause*), more squabbles with his benefactors, another rush of money and fame, and another stormy resignation. This time his unease with success was sharpened by guilt over toning down his politics, leaving nothing but a professional hayseed spinning inoffensive, down-home yarns to an audience 'all slicked up, and starched and imitation'. He fled to California, a journey he would vividly recount in his 1943 memoir *Bound for Glory*.

In May 1941 Stephen Kahn of the Bonneville Power Administration invited Guthrie to narrate, score and appear in a documentary on the building of the Grand Coulee Dam, promising a handsome $3,200 for a year's work. The dam, which would transform the lives of thousands of farmers, struck Woody as a noble cause. When Kahn, whose vetting procedure left much to be desired, belatedly discovered Guthrie's leftist sympathies, he reduced the contract to one month's soundtrack work, but it would nonetheless prove to be the most fecund month of Guthrie's career, producing twenty-six new songs rich in cascading, Whitman-style poetry, including 'Grand Coulee Dam' and 'Roll On, Columbia, Roll On'.

Back in New York, with his mentor AWOL, Seeger heard about someone else putting together a left-wing songbook and arranged a meeting. The compiler was a garrulous, thick-set preacher's son called Lee Hays and the pair had so much fun trading songs and ideas that they decided to form a band with Hays's clean-cut Jewish roommate, Millard Lampell: the Almanac Singers. They were an instant hit at Communist Party meetings. The *Daily Worker* proclaimed 'America Is in Their Songs' while Theodore Dreiser told them, 'If there were six more

* In a symbolic gesture, the communist and former Wobbly Elizabeth Gurley Flynn gave them Joe Hill's papers.

teams like you, we could save America.'*

Their repertoire was divided between union songs and peace songs, the latter an increasingly dicey proposition. Seeger hated fascism but he also hated war, and the Nazi–Soviet pact was enough to tip the balance; he followed the *Daily Worker* line. The anti-war movement made strange bedfellows: left-wingers such as Sinclair Lewis stood awkwardly alongside right-wing anti-Semites like Walt Disney and Charles Lindbergh. It made enemies, too. When a copy of the Almanacs' debut album, *Songs for John Doe*, which featured tracks such as 'Washington Breakdown', reached the White House, FDR flew into a rage and wondered aloud if it was grounds for arrest. The FBI, which had already decided that communal singing at labour meetings was a form of brainwashing, set out to track down the traitors.

So picture the anguish in June 1941, just a month after *Songs for John Doe*, when the Almanacs heard that Hitler had broken the pact and attacked the USSR. History had yanked the rug from beneath their feet. When Guthrie returned to New York and walked straight into the Almanacs line-up, he told Seeger, 'I guess we won't be singing any more peace songs, will we?' In December the situation changed again. The Japanese raid on Pearl Harbor, which brought America into the war, made the peace songs a painful, even dangerous embarrassment, while the new wartime anti-strike pledge put paid to the union songs that comprised their second album, *Talking Union & Other Songs*. What exactly were the Almanacs going to sing now?

The answer: *pro*-war songs. If the volte face seems grossly opportunistic now, then it was at least a sincere reaction to changing times. All the genuine disgust for Hitler that the Almanacs had suppressed during the pact came frothing out in the likes of 'Reuben James' and 'Round and Round Hitler's Grave' on the *Dear Mr President* album. Guthrie, in particular, took on Hitler with manic zeal, painting his guitar with the slogan 'This Machine Kills Fascists' and giving many of his old songs a wartime twist. One new song, 'Mister Lindbergh', laid

into the Almanacs' former America First allies. All compared favourably to the crass jingoism of songs like country singer Carson Robison's 'Have to Slap That Dirty Little Jap'.

Suddenly the Almanacs were big business, playing to thirty million listeners on a bellicose new radio show, *This Is War*, in February. But within months reporters, evidently better at their jobs than the FBI, had unearthed the now-deleted *Songs for John Doe* and made the connection. 'Singers on New Morale Show Also Warbled for Communists,' roared the *World Telegram*. The band's bookings dried up, and their morale hit rock-bottom. Seeger's draft notice in June 1942 was almost a blessing. A year later, Guthrie pre-empted his own draft by signing up for the Merchant Marine.

Seeger's thoughts as he donned his fatigues most likely echoed the sentiments of 'Dear Mr President', a candid blend of principle and pragmatism: 'We got to lick Mr Hitler, and until we do / Other things can wait.'

*

When Woody Guthrie returned to New York on shore leave in March 1944, the eternally well-connected Alan Lomax introduced him to a folk-loving Jewish entrepreneur named Moe Asch, president of Folkways Records, who arranged the most remarkable recording sessions of the singer's life. With a coterie of folk talent, including Lead Belly, Sonny Terry, Alan's sister Bess, and Woody's friend and fellow seaman Cisco Houston, Guthrie laid down hundreds of songs that April, some traditional and some his own. One composition was the long-dormant 'God Blessed America', now tweaked and retitled 'This Land Is Your Land'.

Guthrie left the boats for good in August and found a new berth on the 'Roosevelt Bandwagon', a travelling revue campaigning for a fourth FDR term in the coming election. It was organised by the Communist Political Association, the new, more liberal incarnation of the recently dissolved American Communist

Party, with Will Geer as master of ceremonies and Woody and Cisco leading the singing. Roosevelt won, and Guthrie secured a new weekly radio show on New York's WNEW. On his opening broadcast he performed 'This Land' and read out his mission statement: 'I am out to sing songs that will prove to you that this is your world . . . that make you take pride in yourself and your work. And the songs that I sing are made up for the most part by all sorts of folks just about like you.'

Pete Seeger came back from the Pacific in 1945 with something more ambitious in mind. While stationed on the island of Saipan he had hatched a scheme to 'get America singing'. 'I was hoping to have hundreds, thousands, tens of thousands of union choruses,' he said. 'Just as every church has a choir, why not every union?' The vehicle would be People's Songs, Inc., with the belligerently intelligent leader of the Communist Party musicians' club Irwin Silber as executive secretary. People's Songs soon had 2,000 members and, unbeknown to Seeger, an FBI file dedicated to it: both indicators of a certain degree of success.

The 'people', however, proved stubbornly resistant, preferring Tin Pan Alley pop, jazz and show tunes – the music that Woody regarded as 'panty waist crap' – to the spartan stridency of folk. The unions, shucking off their pre-war militancy, were cutting ties to the Communist Party, now re-established under its new hardline leader William Z. Foster. The onset of the Cold War meant that the working man feared the Reds more than he did the bosses. Thus Seeger was stuck with a small, if passionate, constituency of left-wing intellectuals.

The highlight of the organisation's New York hootenanny in April 1946, however, was a bona fide people's song: 'This Land Is Your Land', with Seeger orchestrating the thousand-strong crowd in four-part harmony. By now, the song had shed its 'God Blessed America' motif and acquired political bite, casting its eye over hungry queues at the relief office and foreboding signs reading 'private property'. 'I confessed it when I first heard the record . . . I wasn't that impressed by it,' Seeger told Radio 4. 'I

thought it was one of Woody's lesser efforts. The tune is not that exciting. However, he really hit the nail on the head, as they say, with that extraordinary last line.' Namely: 'This land was made for you and me.'

In his notes on *Hard Hitting Songs*, Guthrie predicted that the songs therein would outlive him, burrowing deep into the soil of American culture. He was, for the most part, wrong – who now can offer up a lusty chorus of 'The Preacher and the Slave' or 'I Hate the Capitalist System'? – but 'This Land', a song he moth-balled for four years, would fulfil his dreams.

As the song entered the veins of American life, however, it was diluted. The version which found its way into schoolbooks had room for neither relief queues nor selfish landowners. It was as if the romantic glow generated by its diamond deserts and ribbons of highway had grown so bright that it had erased the flickers of frustration and doubt. Guthrie inadvertently allowed this to happen by recording different versions himself. The song is stronger when the tougher verses remain, because they prod the listener into politically challenging territory before the chorus draws them back into its patriotic embrace. 'He keeps testing people,' said his daughter Nora. 'How much can they take? How much do they wanna hear? How much do they wanna know?'

More than all of his other songs put together, 'This Land' would be Guthrie's legacy to America. In 1946, however, he was struggling. He would stumble on stage, forgetting the words, fumbling chords, losing his temper if the audience response was not to his liking. At chi-chi fundraisers he was cranky, irascible and plain offensive. This was due partly to his heavy drinking, partly, he would later learn, to the first creeping symptoms of Huntington's chorea and partly to discomfort with his status. He felt both too successful and not successful enough: neither a slick mainstream folksinger like his old comrades Burl Ives and Josh White nor the workers' hero, but just another entertainer. 'People tried to explain this: "Was it Huntington's? Was it him?"' reflected Nora Guthrie. 'It all goes together. He was pissed, he

was angry, he was mean, he was nasty . . . he did a lot of terrible things. But hey, who wouldn't?'

Worse still, his songwriting was on the slide. His new topical ballads rambled on for verse after verse, his anger now so thick that it left no room for humour. His last great song came in 1948: 'Deportee (Plane Wreck at Los Gatos)', inspired by the death of a flightload of migrant workers being deported back to Mexico. It was like the last sparks thrown out by a dying firework as it falls.

In February 1947 fire ripped through Guthrie's life again when a radio lead shorted in his apartment on Mermaid Avenue, Brooklyn, and the ensuing blaze fatally burned his four-year-old daughter Cathy, his first child with his second wife Marjorie. He seemed cursed; it was Clara all over again.* In 1949 he pleaded guilty to sending obscene letters to Lefty Lou's sister Mary Ruth Crissman. He was sent first to a psychiatric hospital and then to jail, where he served ten days. The letters, like his unruly new lyrics, were the first signs that Huntington's was addling his judgement: the beginning of a long, sad decline.

Just as Guthrie's rise had paralleled the resurgent optimism of the American left, his personal and creative collapse coincided with political calamity, in the shape of Henry Wallace's presidential campaign.

Wallace had been Roosevelt's left-wing vice-president, dropped from the ticket in 1944 to appease conservative voters. This time, he was running for the White House himself at the helm of the freshly minted Progressive Party. The campaign began in jubilant spirits, with Seeger leading the singing at the party's national convention in Philadelphia; Alan Lomax, Paul Robeson and Harry Belafonte joined him on the bandwagon, and Laura Duncan performed 'Strange Fruit'. Irwin Silber boldly predicted that Wallace would win up to ten million votes, but

* Three children were then born in quick succession: Arlo, who would become a celebrated folksinger himself, Joady, after Tom Joad, and Nora.

President Truman went to town on Wallace over his main backers, the Communist Party, and the candidate's stump speeches were disrupted by hecklers from the Ku Klux Klan.

Come November, Wallace scraped together barely a million votes, coming fourth behind Truman, the Republican Thomas Dewey and the Dixiecrat segregationist Strom Thurmond. It was annihilation for the left. Seeger returned home from the campaign to find People's Songs' finances in ruins, along with its morale. 'The times which led the Almanacs to live and make good songs are no longer here,' Lee Hays wrote to Seeger.

The Wallace campaign was an early victim of the Red Scare, which would sweep the nation from the redwood forest to the Gulf Stream waters, taking with it reputations, careers and even lives, creating a paranoid, siege-minded vision of Americanism which brushed aside both Earl Browder's radical reading and Guthrie's generous, democratic ideal. Seeger had seen for himself which way the wind was blowing when he accompanied Wallace on a visit to Burlington, North Carolina. Whipped up by KKK agitators, the crowd hollered 'Go back to Russia!' and loosed volleys of eggs and tomatoes at the hapless politician. Aghast, Wallace grabbed one of his assailants and – like Seeger, like Guthrie – wondered aloud whose land it was now.

'Are you an American?' he cried above the hate-filled roar, egg yolk running down his shirt. 'Am I in America?'

3

'We are not afraid'

Zilphia Horton, Frank Hamilton, Guy Carawan and
Pete Seeger, 'We Shall Overcome', 1947–63

The power of the people's song

Folksingers Roger Johnson and Pete Seeger lead Freedom School students in singing 'We Shall Overcome' at Palmer's Crossing Community Center during Mississippi Freedom Summer, 4 August 1964.

By the time Pete Seeger first came across 'We Shall Overcome' on a visit to the left-wing Highlander Folk School in Tennessee in 1947, it had already travelled a long way.

The melody dated back to eighteenth-century Europe and, like so many others, crossed the Atlantic and seeped into the soil of the Southern plantations, where it became the hymn 'I'll Be All Right'. Passing through Baptist and Methodist churches, and taking its lyrical theme from Charles A. Tindley's gospel song 'I'll Overcome Someday', it mutated once more into 'I Will Overcome'. In October 1945 Lucille Simmons, who belonged to a local Baptist choir, made it the rallying cry of black strikers outside the American Tobacco plant in Charleston, South Carolina. 'I' became 'We'. 'The Lord' became 'the union'.

Simmons and another striker accepted an invitation to Highlander one day in 1947 and sang the song to songleader Zilphia Horton. Highlander, founded fifteen years earlier by Zilphia's husband Myles, was a pioneering force in civil rights, opening its doors to workers and activists of all races, and culture was integral to its educational programmes. Zilphia, who had a clear, strong, alto voice, believed that teaching was a two-way process, and was always eager to learn new songs from visitors to the school. 'Zilphia was a very warm and encouraging person and a wonderful singer,' says folksinger Guy Carawan. 'She was a good contrast to Myles, who pushed people to question their beliefs and actions. Zilphia helped people feel good about themselves, their music, their communities.'

Seeger was fascinated by the song. 'It's the genius of simplicity,' he once said. 'Any damn fool can get complicated. I like to compare it to the backboard in basketball. You bounce your life experiences off it and they come back with new meaning.' Before returning to New York, Seeger added two new verses, which began 'We'll walk hand in hand' and 'The whole wide

world around.' He also changed *will* to *shall*. '"We shall" opens the mouth wider; the *i* in *will* is not an easy vowel to sing well,' he explained.

In its new, though not its final, form, 'We Shall Overcome' was protest music boiled down to its quintessence: *we* – the power of community; *shall* – the promise of a brighter future; *overcome* – defiance and endurance. The piecemeal nature of its evolution intensified the 'we'. It traversed decades and states, groups and individuals, men and women, black and white: the antithesis of solitary genius. Seeger, who believed folk songs shone only when sung en masse, and saw himself as a propagator of songs rather than a star in his own right, was the perfect vehicle for it.

'We Shall Overcome' would not be copyrighted until 1963, the year that it became the most famous protest song in America. Seeger, sitting there in Highlander in 1947, hearing Zilphia Horton sing it for the first time, could have had no idea how much he would have to overcome personally in the intervening years.

*

The twin failure of People's Songs and the Henry Wallace campaign may have alerted Seeger to how unforgiving Cold War America could be to a left-wing musician, but the full force of the new situation didn't hit him until he tried to arrange an outdoor concert in Peekskill, a resort town in upstate New York, in August 1949.

A few months earlier Seeger and his wife Toshi had bought a seventeen-acre plot of land about fifteen miles up the Hudson River from Peekskill, and set about building a new life. The concert, also featuring Paul Robeson, was meant to be a convivial, picnicky affair, but it was a red rag to the war veterans of Westchester County, who made plans for a competing parade. There were rumours of Ku Klux Klan involvement, too; two effigies of Robeson were lynched on the eve of the show. Before Seeger could even get to the site the veterans had mobbed

concert-goers, screaming, 'Give us Robeson. We'll lynch the nigger up!' The crowd responded by linking arms in a chorus of the popular adapted spiritual 'We Shall Not Be Moved'. But moved they were – by ferocious veterans who marked their victory by erecting a burning cross. The local *Daily Mirror*'s headline was bluntly to the point: 'Robeson: He Asked For It.'

Nevertheless, the concert was rescheduled for the following weekend. Seeger sang his recent composition, 'If I Had a Hammer (The Hammer Song)', while Robeson, guarded by a ring of union men, essayed 'Go Down, Moses' and 'America the Beautiful'. They cut short their sets so that everyone could leave before nightfall, but despite this precaution, concert-goers drove straight into an ambush. Veterans, Klansmen and other 'concerned citizens' battered the convoy with stones. If the audience expected protection from the police, they were sorely disappointed: many state troopers joined in the attack, smashing windscreens and heads with their nightsticks. By the time the Seegers got home their hair and clothes glittered with shattered glass, the road was littered for miles with smashed and overturned vehicles and 150 attendees required medical attention. The aftermath was, if anything, even more shocking. A grand jury investigation exonerated the attackers and local representative Walton W. Gwinn absurdly branded the concert a 'Communist military raid'. Representative John Rankin (Mississippi) thundered, 'If that nigger [Rankin insisted he said *negra*] Robeson does not like this country, let him go to Russia and take that gang of alien Communists with him.'

Peekskill was just one sign of what Seeger was up against, as each month brought another fresh disaster for American communists: the test detonation of the first Soviet nuclear bomb; Mao Tse-tung's declaration of the People's Republic of China; the perjury conviction of State Department official and alleged Soviet spy Alger Hiss; and the arrest of a New York couple, Julius and Ethel Rosenberg, for passing nuclear secrets to Moscow. Who could be trusted to root out the Red menace?

Step forward Joseph McCarthy, the opportunistic junior senator from Wisconsin, the House Un-American Activities Committee (HUAC), and three ex-FBI agents who published the names of alleged communists in their newsletter, *Counterattack*.

At the end of June 1950, in the same week that North Korean troops crossed the 38th parallel into South Korea and seized the capital, Seoul, prompting President Truman to mount a defensive 'police action', the *Counterattack* team published *Red Channels: The Report of Communist Influence on Radio and Television*. Behind a cover showing a dastardly crimson hand reaching around a microphone was a list of 151 alleged show-business Reds, including Aaron Copland, Leonard Bernstein, Will Geer, Burl Ives, Langston Hughes, Dorothy Parker, Orson Welles, and . . . Pete Seeger.

The timing could not have been worse, because the publication of *Red Channels* coincided with Seeger's greatest success to date. It was the Almanacs story all over again: a brief, bright window of national celebrity snapped shut with savage force by politics. The Weavers, a quartet he had formed in the aftermath of Peekskill, had just released their debut single, a sanitised version of Lead Belly's 'Goodnight, Irene', and Americans were snapping up Weavers singles as quickly as Decca could press them. *Sing Out!*, a new folk periodical edited by Irwin Silber, had just been launched, taking its name from the chorus of 'If I Had a Hammer'.

The Weavers' golden streak continued with covers of Woody Guthrie's 'So Long, It's Been Good to Know You', Lead Belly's 'Rock Island Line' and Solomon Linda's 1939 hit 'Mbube' (retitled 'Wimoweh'). The fact that none of these hits had subversive messages did not deter the FBI from stepping up its harassment. Agents tracked them from state to state. TV and concert bookings mysteriously disappeared. A Senate subcommittee, somewhat carried away, looked into charging the band with 'seditious conspiracy'.

By that point, HUAC was on bullish form, having claimed

several scalps with the recent conviction for contempt of Congress of the writers and directors known as the 'Hollywood Ten', and the blacklisting of hundreds more. Leon Josephson, the lawyer brother of Café Society owner Barney, was also found guilty of contempt, and the press pounced on Barney's club, calling it a 'Moscow-line nightclub' and precipitating its collapse. In August 1950 the State Department revoked Paul Robeson's passport, declaring that his presence abroad would be 'contrary to the best interests of the United States'.

One musical victim of the new paranoia (and one which Seeger would later cover) was Vern Partlow's 'Old Man Atom'. Partlow, a journalist by trade, had written this satirical talking blues ('We hold these truths to be self-evident / All men may be cremated equal') after interviewing atomic scientists for the Los Angeles *Daily News* in 1945. In 1950, zoologist and part-time folksinger Sam Hinton released a hit version. But in August Victor Records withdrew its cash-in version by 'singing cowboy' group Sons of the Pioneers, fearing that its peacenik sentiments might be deemed unpatriotic, and a mooted recording by none other than Bing Crosby was quietly trashcanned. Partlow himself would soon be blacklisted.*

Another casualty of HUAC hysteria was friendship. Scared by the attacks on Café Society, Josh White severed ties with the club, and with People's Songs. In 1950 he buckled and testified to HUAC, attempting to walk an impossible tightrope. He was not asked to finger anybody as a communist, and defended his right to sing about social injustice, although he explained that he wouldn't sing 'Strange Fruit' abroad because 'it's our family

* Conversely, right-wing riffs on the subject of Cold War combat flourished. Country singers Charlie and Ira Louvin recorded 'Weapon of Prayer', urging Americans to support their 'boys' in Asia by getting on their knees. Hank Williams taunted Stalin in the bellicose 'No, No, Joe'. On 'Let's Keep the Communists Out', Ferlin Husky warned of a Red America in which there would be no Thanksgiving, Independence Day or Santa Claus.

affair, to be solved by Americans in the peaceful, democratic American way'. As another black folksinger, Jackie Washington, later argued, 'To most black folks, the important thing is being clever enough to get by, and Josh White found a way to maneuver through.'

Most people, however, were deaf to his subtle equivocations and he ended up shot by both sides: despised by the left for smearing his old friend Robeson, yet still blacklisted by the right. A dismayed Seeger sent White a letter featuring a sketch of a guitar broken in two; *The Daily Worker* branded him a 'toad'. Burl Ives, testifying in 1952, was less scrupulous about singling out others, thus earning himself a hot blast of contempt from Irwin Silber: 'We've never seen anyone sing while crawling on his belly before.'

The Weaver-baiters finally found their smoking gun not in the shape of White or Ives but of Harvey Matusow, a chubby, cheerful volunteer at People's Songs who was both a member of the Communist Party and, Seeger discovered too late, an FBI informant. In February 1952 Matusow testified that three of the Weavers were members of the Communist Party, and, like that, the sky fell in. The Weavers were on tour in Akron, Ohio, when they saw the morning headlines: 'Weavers Named Reds'.

Sheer stubbornness kept the band going for another year until Decca dropped them and deleted their back catalogue. As Seeger's biographer David King Dunaway drily observes, 'Seeger was now one of America's best-known, unemployable musicians'.*

*

In 1953, three major events drained some of the poison from the Red Scare. Stalin died in March (a passing marked by such

* Meanwhile, 'We Shall Overcome' made its first appearance on wax, under the name 'We Will Overcome', courtesy of labour organiser Joe Glazer and His Elm City Four (1950), and under its Seegerised title in a version by Laura Duncan (1952), the same unsung performer who had debuted 'Strange Fruit'.

crowing country tunes as Ray Anderson's 'Stalin Kicked the Bucket'), the Rosenbergs, convicted of espionage, went to the electric chair in June* and an armistice was signed in Korea in July. Meanwhile, McCarthy's star was waning as even feral anti-communists began to see him as a noisome liability. In June 1954 US Army attorney Joseph Welch delivered the fatal blow during the Senate Permanent Subcommittee on Investigations' army hearings, accusing the senator of 'cruelty [and] reckless-ness'. Before a live TV audience of twenty million Americans, Welch asked, 'Have you no sense of decency, sir, at long last?' By the end of the year, the senator's reputation was so tattered that, as President Eisenhower quipped, McCarthyism had become 'McCarthywasm'.

None of this, alas, helped Seeger, even if it allowed him a quick thrill of Schadenfreude. The old gang was in disarray. Josh White and Burl Ives were both persona non grata, of course. Alan Lomax was in self-imposed exile in England. Guthrie, now officially diagnosed with Huntington's, was in desperate shape, increasingly violent and erratic. People's Songs, it would later transpire, was riddled with FBI informants. And HUAC's zeal was as yet undiminished by McCarthy's fall.

In August 1955 Seeger was raising a barn on his land when a black car pulled up alongside him and a man handed him an envelope. He had been subpoenaed to appear before HUAC in two weeks' time. He was faced with three options: cooperate, like Ives and White; take the Fifth and stay silent; or challenge HUAC's right to question him, on First Amendment grounds, the same risky strategy which had landed the Hollywood Ten in jail seven years earlier.

During the hearings in New York, Seeger, stubborn as a mule, made himself an 'unfriendly' witness, giving one-line answers and needling his interrogators even further by threatening to

* One of their last requests was to hear the Weavers' 'Goodnight, Irene' for the last time. Their two sons were adopted by 'Strange Fruit' composer Abel Meeropol.

play his banjo, as if he could still their persecution with a song. He wanted to show them why 'Wasn't That a Time', which tied together America's past and present struggles for freedom, was his brand of patriotism – not, as they claimed, Soviet propaganda – but they were having none of it. He went home in no doubt as to what his principles would cost him. In the short term, his concert career was over. Further down the line: a trial for contempt of Congress, untold court costs, possible bankruptcy, probable imprisonment.

At least he had a friend in Folkways boss Moe Asch, who encouraged him to channel his creative energies into an epic recording binge, and paid him a weekly retainer. 'We, the people, suffer, by not having the songs we need,' Seeger wrote in summer 1955. 'We need thousands of new songs these days: humor, to poke fun at some of the damn foolishness going on in the world; songs of love and faith in mankind and the future; songs to needle our consciences and stir our indignation and anger.' He kept busy by performing at colleges, summer camps, private parties, anywhere that would have him, to audiences which included future stars Bob Dylan and Joan Baez. He also wrote one of his most famous songs, a lament for trampled idealism called 'Where Have All the Flowers Gone?'

In 1956 Seeger's manager, Harold Leventhal orchestrated a surprisingly successful Weavers reunion and rounded up the old People's Songs crew for a benefit concert to raise money for the now-hospitalised Woody Guthrie. Seeger later recounted that the finale 'almost proved too melodramatic'. The performers were taking their bows after a version of 'This Land Is Your Land' when the spotlight swung to the balcony, illuminating the shaky, spindly figure of Guthrie, allowed out by his doctors for the occasion. Earl Robinson leaned in towards Seeger's ear and whispered 'Sing the last chorus again.' As Seeger recalled, 'The whole crowd of over one thousand, mostly teenagers who had never seen Woody before, stood up and sang his song to him, as though to tell him they would carry his music across the land.

Tears were in the eyes of many old-timers as they listened to the strong young voices.'

But Seeger was fighting yesterday's battles. After Khrushchev's famous 1956 denunciation of Stalin, which made public the horrors of the purges and show trials, and the subsequent Soviet invasion of Hungary, all but the staunchest believers deserted the party in disappointment and disgust.* The Communist Party connections which had enabled protest singing to thrive during the 1930s now constituted a crippling millstone round its neck. Meanwhile, the left was turning its attention to a new conflict, one that it might actually win.

With its faith in the transforming powers of communism and the union movement shattered, the left regrouped under the banner of civil rights, and it did so in places like the Highlander Folk School. During the 1950s Highlander's patch of Tennessee became a kind of junction box of left-wing activism, running wires between black and white, urban and rural, labour and civil rights, folk and gospel. In the introduction to Zilphia Horton's 1939 songbook *Labor Songs*, union leader John L. Lewis had coined a phrase which would come to apply equally to the freedom songs of the South: 'a singing army is a winning army'.

One visitor to the school in July 1955 was a seamstress from Montgomery, Alabama, named Rosa Parks. A little over three months after Seeger took the stand in New York, Parks was arrested for refusing to give up her seat on a bus to a white man. Years later broadcaster Studs Terkel would ask her what part Highlander had played in her decision and she would answer simply, 'Everything.'

*

In 1955 the Jim Crow laws maintained an iron grip on the South. Restaurants, hotels, buses, lunch counters, gas station restrooms,

* Seeger later regretted his endorsement of Stalin, writing, 'I'll apologize for a number of things, such as thinking that Stalin was simply a "hard driver" and not a supremely cruel misleader.'

water fountains: all maintained boundaries between white and black customers. On 1 December Parks, who was secretary of the local branch of the National Association for the Advancement of Colored People (NAACP), had simply had enough. Montgomery black leader E. D. Nixon persuaded local ministers Dr Martin Luther King and Ralph Abernathy to help organise a one-day boycott of the bus network. The twenty-six-year-old King was an unknown quantity outside of his own congregation but his bravura speech on the night of the boycott was, in the words of local columnist Joe Azbell, 'the beginning of a flame that would go across America'.

After the speech, which established King's credo of non-violence, the meeting voted to extend the boycott indefinitely. King's trial and conviction on charges of organising an illegal boycott made him a national celebrity: the face of the newborn civil rights movement. In November 1956 the Supreme Court finally declared segregation on Montgomery's buses unconstitutional. After their victory, eight Southern ministers established a more activist alternative to the NAACP, the Southern Christian Leadership Conference (SCLC), with King at its helm.

Throughout the boycott, morale was boosted by singing repurposed hymns and spirituals.* During the slavery era, spirituals had been the protest songs that dared not speak their name. African slaves were forbidden to dance or play the drums but they brought their homeland's tradition of group singing into the plantation 'praise houses', where they were permitted to sing songs that weren't overtly critical of their masters. You have to wonder, though, how even the dimmest slave-drivers failed to notice their workers' fondness for particular Bible stories: Daniel delivered from the lion's den, Joshua bringing down the walls

* The year of the bus boycott, Alice Wine, who had attended a voter education school in South Carolina, rewrote the old gospel hymn 'Keep Your Hand on the Plow' (also known as 'Hold On' or 'Gospel Plow') as 'Keep Your Eyes on the Prize'. It was the first widely popular freedom song of the civil rights era.

of Jericho, Moses leading his people out of Pharaoh's bondage. Other spirituals encoded references to the escape route popularly known as the Underground Railroad: flight by river ('Wade in the Water'), road ('Swing Low Sweet Chariot') and rail ('Gospel Train').

After abolition, an event fervently anticipated in the song 'No More Auction Block for Me', spirituals were shunned by most African-Americans as shameful reminders of past indignities. Even when Paul Robeson revived the likes of 'Steal Away', 'Go Down, Moses' and 'Joshua Fit the Battle of Jericho' in the 1920s, they had only niche appeal: the writer Zora Neale Hurston pointed out that formal concerts were no place for songs born out of informal group singing in the praise houses and plantations. So when the boycotters of Montgomery began singing 'Steal Away' and 'Go Down, Moses' alongside hymns, they were reviving spirituals as a form of mass communication for the first time in almost a century, only now the secret was out and there was no need for codes. Right from the start, Martin Luther King wove song lyrics into his speeches; they were an integral part of his conversation with black history.

King and Parks visited Highlander on the occasion of its 25th anniversary in September 1957, the same month that President Eisenhower was forced to send paratroopers to enforce desegregation at a school in Little Rock, Arkansas. King was introduced to Seeger, who sang him 'We Shall Overcome'. It was the first time King had encountered the song, and on the drive to Louisville he found himself humming it. 'There's something about that song that haunts you,' he told fellow passengers.

*

'We Shall Overcome' also haunted two Californian folksingers, Frank Hamilton and Guy Carawan, who had first learned it on a visit to the school in 1953. Zilphia Horton died in 1956 aged forty-six. In 1959 Carawan replaced her as head of Highlander's music programme. Hamilton, who often played in black

churches in Los Angeles, developed a new chord structure for the song, which Carawan then expanded upon. It was sprouting new verses all the time. The old union references were long gone; in their place were fresh references to Jim Crow and living in peace. A police raid on Highlander that July inspired yet another verse when one member of a visiting youth choir, Mary Ethel Dozier, responded to the raiders' harassment with a cry of 'We are not afraid.' The other choristers, already defiantly singing 'We Shall Overcome', folded the new line into the song as if it had always belonged there, which perhaps it had. It is not a statement of fact: it is a promise.

'"We Shall Overcome" is definitely not my song,' says Carawan, now in his eighties. 'It is a [civil rights] movement song. My main role [was] being in the right place at the right time.' In February 1960 Highlander played host to some of the college students who had recently sparked a wave of anti-segregation lunch-counter sit-ins in Greensboro, North Carolina. At a musical workshop Carawan led them in a chorus of 'We Shall Overcome'. And it was that song, again led by Carawan, which crowned the three-day conference in Raleigh, North Carolina, which gave birth to the Student Nonviolent Coordinating Committee (SNCC) in April. Carawan and the SNCC loosened its limbs, adding rhythm, harmony and antiphony. 'We put more soul in, a sort of rocking quality, to stir one's inner feeling,' explained one SNCC member. 'When you got through singing it, you could walk over a bed of hot coals, and you wouldn't notice.'

Carawan disseminated the song on his travels through the South, which were 'both exciting and scary' and punctuated with regular arrests. 'As it passed through different campaigns it tended to take on the cultural flavour of each area,' he says. 'In Albany, Georgia, it took on a new beat and some additional decorations. In Birmingham it was given a gospel feeling. You ask about a "final version" and I don't actually think there is one.'

Civil rights leaders were impressed and energised. 'It is an oddity that the introduction of the Negro spiritual (with new

freedom lyrics) into the movement as a means of clear group expression of common goals . . . was through a young white folksinger,' reflected the SCLC's Wyatt Tee Walker. Among the songs Carawan brought with him were 'We Shall Not Be Moved' and the 1920s gospel song 'This Little Light of Mine'. Thus inspired, members of the SNCC quickly adapted old spirituals into songs such as 'Everybody Sing Freedom' and 'I'm on My Way to the Freedom Land'. Veteran activist Ella Baker, the so-called 'Godmother of SNCC', was one of the first to embrace the potential of freedom songs to make even the lowliest member of the civil rights movement feel empowered. 'The people were cold with fear,' remarked Georgia activist Vernon Jordan, 'until music did what prayers and speeches could not do in breaking the ice.'

In May 1961 some members of the fledgling SNCC joined the Congress of Racial Equality (CORE) on a mission to deseg-regrate waiting rooms and lunch counters on interstate bus routes, calling themselves the Freedom Riders. The good people of Alabama greeted the first bus by slashing its tyres, smashing its windows, attempting to burn the Riders alive and, when that failed, beating them to a pulp. The second bus sparked a full-blown riot; riders and reporters alike were set upon with bottles and lead pipes. CORE called off the ride but SNCC members in Nashville vowed to continue it. In Montgomery – hated, disgraced Montgomery – the violence was even worse: more animalistic beatings, more cries of 'Kill the niggers!' The next day the Freedom Riders were escorted to Jackson, Mississippi, where they were promptly jailed for breaking local segregation laws.

The prisons became hothouses for freedom songs. Sitting in Hinds County Jail, CORE's national director James Farmer put new words to Florence Reece's thirty-year-old union anthem 'Which Side Are You On?', and fellow Riders transformed Ray Charles's 'Hit the Road, Jack' into 'Get Your Rights, Jack'. Rock'n'roll songs, traditional ditties, labour anthems, blues numbers, hymns, spirituals – all were grist to the freedom-song

mill. 'In a sense the freedom songs are the soul of the movement,' wrote King. 'They are more than just incantations of clever phrases designed to invigorate a campaign; they are as old as the history of the Negro in America.' When *Sing Out!* transcribed some of the freedom songs that Carawan and his wife Candie had collected on their travels, the couple 'tried to explain these songs were evolving and changing, and the printed page was only a suggestion of what the songs could be'.

This is why even the four songwriters officially credited with 'We Shall Overcome' are only part of the story. It was a vagabond song, circulating through the South, known by many, owned by none, mutable in its particulars but constant in its melody and message. It held out the promise of victory – maybe not today but someday, someday.

After performing at a Highlander benefit at Carnegie Hall in February 1961, Carawan and the Montgomery Gospel Trio recorded the song for Moe Asch's Folkways label on an album called *We Shall Overcome: Songs of the Freedom Riders and the Sit-ins*. Soon enough, because it had to, the song circled back to the man who had first tinkered with it back in 1947, when everything was different.

*

In the years following his HUAC appearance, Pete Seeger had come to occupy a curious position in American life. To the swelling ranks of folk enthusiasts he was an heroic pioneer. In the autumn of 1958 the Kingston Trio's version of 'Tom Dooley' had sold a remarkable 2.6 million copies, sparking a boom in a form of music which had now outgrown *Counterattack*'s smears. Folk scenes blossomed simultaneously in several major cities and college towns. So what if the fresh-faced Kingston Trio niggled the purists? They had suddenly, unexpectedly, opened a door through which spikier talents could rush. And, as they were quick to acknowledge, they owed an enormous debt to Seeger.

In 1959 Seeger helped folksinger Theodore Bikel and formidable impresario Albert Grossman establish a folk festival in the high-toned Rhode Island resort town of Newport. An unknown eighteen-year-old named Joan Baez stood barefoot in the rain, singing 'We Are Crossing Jordan River', and a new folk star was born. The following year *Newsweek* and *Time* both reported on the boom, citing Seeger, Baez, Bikel and Alabaman singer Odetta Gordon (whom Dr King would crown 'the Queen of American folk music') among its stars. Not all commentators perceived the revival's radical roots – in 1961, *Time* cheerfully called the Limeliters 'as pleasant as an international blend of good coffees' – but to the left, it represented green shoots after the long, harsh conservative winter of the 1950s. New Left activist Todd Gitlin described 1950s folk music as 'the living prayer of a defunct movement . . . gingerly holding the place of a Left in American culture'.

In 1961 Seeger visited England, where his sister Peggy had married the Marxist folksinger Ewan MacColl. MacColl was a more fearsome character than Seeger but the two men had much in common. Born the son of a communist trade unionist in the depressed industrial region of Salford, which inspired his signature tune 'Dirty Old Town', he had started writing protest songs in the 1930s. After a long spell in experimental theatre he caught the folk bug from Alan Lomax in the early 1950s, when the American brought his song-collecting mission to Britain. Thus inspired, he spearheaded Britain's own folk revival in partnership with A. L. Lloyd, taking the hardline stance that English singers should only perform traditional English material. While his dogmatism alienated many, it fuelled a remarkable BBC radio series called *The Radio Ballads*, bringing the songs of fishermen, miners, railwaymen and more to a national audience. MacColl also adapted folk melodies and sea shanties into brand-new protest songs about the atom bomb ('That Bomb Has Got to Go!'), apartheid ('The Ballad of Sharpeville') and the glories of communism

('The Ballad of Ho Chi Minh').*

Seeger was so inspired by MacColl, and by Britain's centuries
-old tradition of broadside ballads, that upon his return to
America he helped former Almanac Agnes 'Sis' Cunningham and
her husband Gordon Friesen establish a journal of topical songs
called *Broadside*. The February 1962 launch issue was subtitled
'A Handful of Songs About Our Times'.†

But even as his celebrity and influence grew, Seeger lived under
a cloud. Every time he travelled to a show, which was pretty
much constantly, he had to notify the District Attorney by tel-
egram. Various local school boards and arts commissions moved
to prevent him performing on political grounds. And still his trial
for contempt of Congress moved through the system with ago-
nising slowness, consigning him to a purgatory of uncertainty.

Eventually, in March 1961, he stood trial in New York and was
found guilty of obstructing HUAC's work. Turning up for sentenc-
ing, he asked permission to sing 'Wasn't That a Time', just as he had
six years earlier. Again, he was denied. 'Do I have a right to sing
these songs?' he asked. 'Do I have the right to sing them anywhere?'
The judge sentenced him to a year and a day in prison. But before
he could serve it, in May 1962 the Court of Appeals overturned his
conviction on a technicality (albeit while still describing Seeger as
'unworthy of sympathy') and his seven-year ordeal was over. Purely
by chance, that very week the young folk trio Peter, Paul and Mary
hit the Top 40 with their version of Seeger's eulogy to pre-Red Scare
idealism, 'Where Have All the Flowers Gone?' The songwriter was
free, and he was famous, and he had work to do.

* Beginning in 1958, the newborn Campaign for Nuclear
Disarmament's annual marches between London and Aldermaston had
a catalytic effect on the writing of topical songs. 'Every 100 yards or
so you had a different kind of band: jazz, blues, skiffle, West Indian,'
Peggy Seeger told the *Observer*'s Colin Irwin. 'And of course people
made up their own songs. You didn't just shuffle along in misery.'
† Early issues showcased such emerging protest singers as Bob Dylan,
Phil Ochs, Tom Paxton and Woody Guthrie's son Arlo.

*

That October Seeger accepted an invitation to sing in Albany, Georgia, right in the fiery belly of the civil rights struggle. A long campaign backed by the SCLC and SNCC had ended in violent disappointment just two months earlier, with King on trial, crosses burning on Southern lawns and segregation as strong as ever. 'Albany remains a monument to white supremacy,' reported the *New Republic*.* As Seeger's car pulled up outside the church, a gang of white people jeered and brandished lead pipes, while Georgia police circled watchfully.

Seeger wanted to present a crash course in the history of the protest song, explaining how hymns gave birth to labour anthems and so on, but found himself out of step with the congregation. When he sang 'If I Had a Hammer' or 'Hold On', they had their own words, their own melodies. Only when he struck up 'We Shall Overcome' did he win the crowd over, and only then by shutting up and letting them sing the song the way they liked it sung, steeped in the call-and-response rituals of the church. He left the church chastened.

For Seeger, who prided himself on never meeting an audience that he couldn't unite in song, his failure in Albany smarted, but, bruised ego aside, wasn't this exactly what he wanted? A song for the people, sung by the people, in part even *written* by the people? In a short space of time the freedom singers had made the Northern folksingers seem staid. The *New York Times* folk critic Robert Shelton celebrated the freedom song movement as 'a different sort of folk music than one encounters among the pampered, groping, earnestly searching young people one meets in the Greenwich Villages of the North'.

* While incarcerated in Albany, Ralph Abernathy adapted the traditional 'Ain't Gonna Let Nobody Turn Me Round' into a classic freedom song, inserting the names of the town's police chief Laurie Pritchett and mayor Asa D. Kelley. Remarkably, Pritchett himself claimed to be a fan: 'These people got a lot of feeling and rhythm. I enjoy hearing them sing. The songs are catchy.'

Galvanised by what he had witnessed in Albany, Seeger advised the SNCC to establish its own touring group to raise funds and awareness. Sit-in veteran Cordell Reagon and nineteen-year-old Albany student Bernice Johnson (later his wife) formed the four-strong Freedom Singers two months later: Bernice called them 'a singing newspaper'. 'If your heart is downcast or blue, if you feel discouraged and it seems as though the future is all darkness and uncertainty, take up some of their songs,' Seeger advised readers of Sing Out! 'Songs have accompanied every liberation movement in history. These songs will reaffirm your faith in the future of mankind.'

'We Shall Overcome' was finally copyrighted under the joint authorship of Seeger, Horton, Hamilton and Carawan (royalties went to the civil rights movement) in 1963, the year that it became a kind of alternative national anthem. In April, Martin Luther King led demonstrations in Birmingham, the largest city in Alabama, whose new governor, George Wallace, had taken office with the promise of 'segregation now, segregation tomorrow, segregation forever'. After King was arrested, his SCLC colleague, the Reverend James Bevel, launched a new phase of the protest, preparing hundreds of children, some as young as six, to march on City Hall. Over the next few days images from Birmingham shocked the country: black men, women and children brutalised by police chief Eugene 'Bull' Connor's thugs, reeling from the explosive force of fire hoses, mauled by the fangs of police dogs, and still singing freedom songs, especially 'We Shall Overcome'. 'One cannot describe the vitality and emotion this one song evokes across the Southland,' wrote Wyatt Tee Walker. 'I have heard it sung in great mass meetings with a thousand voices singing as one; I've heard a half-dozen sing it softly behind the bars of the Hinds County prison in Mississippi; I've heard old women singing it on the way to work in Albany, Georgia; I've heard the students singing it as they were being dragged away to jail. It generates power that is indescribable.'

That summer, it also became the anthem of the movement's

white supporters in the North, sung by the new folk elite at both the Newport Folk Festival and the March on Washington. Summarised Seeger: 'To hundreds of thousands of freedom-loving Americans it was in 1963 no longer just "a" song but "the" song.'

*

'We Shall Overcome's time at the heart of the movement was, in fact, rather brief. Like many protest songs, it was overtaken by history. By the time King led his epochal march from Selma to Montgomery in 1965, freedom songs were on the wane. 'By 1965 people in the movement were becoming cynical and discouraged about overcoming any time soon,' remembers Carawan. 'Too many people had died, and people recognised how deeply racism was embedded in American society. No wonder people didn't find the same hope in "We Shall Overcome". I sometimes felt it was inappropriate to suggest it or lead it in civil rights situations.'

The 'glad thunder and gentle strength' that endeared 'We Shall Overcome' to Martin Luther King came to irritate more militant voices. Unlike the old Methodist hymns which promised relief in the 'sweet by and bye', 'We Shall Overcome' didn't postpone satisfaction until the afterlife but it postponed it nonetheless. 'What kind of namby-pamby, wishy-washy song is that?', the staunch Stalinist writer Lillian Hellman complained to Seeger. 'Mooning, always "Someday, so-o-me-day!" That's been said for two thousand years.'

Of course, King, who called his book about the struggle *Why We Can't Wait*, found nothing wishy-washy about the song – *someday* did not mean the twelfth of never – but younger, angrier leaders shared Hellman's reservations. 'I don't believe we're going to overcome [by] singing,' Malcolm X told a Harlem rally in 1964. 'If you're going to get yourself a .45 and start singing "We Shall Overcome", I'm with you.' Two years later, former *Sing Out!* employee Julius Lester, by now a preacher of Black Power, wrote an angry letter to the magazine in which he passed

a death sentence on the freedom song. 'Now it is over. The days of singing Freedom songs and the days of combating bullets and billy clubs with Love. "We Shall Overcome" (and we have overcome our blindness) sounds old, outdated.'

One of Lester's complaints was that the latest sheet-music edition of 'We Shall Overcome' featured not King but President Lyndon B. Johnson, a revealing sign that the song had been coopted by the establishment. When Johnson cited it in his speech urging Congress to pass the 1965 Voting Rights Act, he essentially killed it as an expression of black dissent. But then something strange happened to the song. Even as it lost traction with one audience it found several others, especially outside America, wherever there was strife and defiance. It flew to South Africa, where Robert F. Kennedy sang it alongside black Durbanites during his anti-apartheid tour in 1966, and the condemned anti-apartheid radical John Harris sang it at the gallows; to eastern Europe, where it endured as an anti-communist anthem right up until perestroika (somewhat ironically, given Seeger's communist affiliations); to Jamaica, Northern Ireland, Israel, India and Bangladesh.

By the end of the decade, even as it resonated overseas, it could only really be sung in its home country with a touch of nostalgia, because the history it represented – the history of Highlander and picket lines, of bus boycotts and sit-ins, of folk and freedom songs – had been rendered archaic by the heat and flash of the 1960s. But Pete Seeger kept faith with the song longer than civil rights did. He really did believe, deep in his heart, that he would overcome someday.

4

'How much do I know?'

Bob Dylan, 'Masters of War', 1963

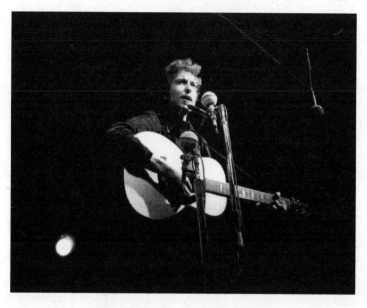

The abdication of Bob Dylan

Bob Dylan performing at the 1964 Newport Folk Festival in Rhode Island.

They tell me that every period, every time, has its heroes. Every need has a solution and an answer. Some people – the press, magazines – sometimes think that the heroes that young people choose lead the way. I tend to think that they happen because they grow out of a need. This is a young man who grew out of a need. He came here, he came to be as he is, because things needed saying and the young people were the ones who wanted to say them, and they wanted to say them in their own way. He somehow had an ear on his generation . . . I don't have to tell you – you know him, he's yours: Bob Dylan!

With those words, Ronnie Gilbert of the Weavers introduced twenty-two-year-old Bob Dylan to 40,000 folk fans in Freebody Park, Newport, Rhode Island, on 26 July 1963. Writing about that day, four decades later, in *Chronicles Volume One*, Dylan misremembered (perhaps deliberately) what Gilbert said, inserting an ominous command of his own invention: 'Take him, you know him, he's yours.' His addition speaks volumes about what Gilbert's words implied. America was convulsed by the bloody battle for civil rights and the palpable threat of nuclear war, and young Americans, losing faith in the wisdom of their elders, hungered for someone who could voice their inchoate discontent. As Gilbert, with the best of intentions, enshrined him as the man to do just that, this was the predatory whisper that only Dylan could hear: *Take him. Take him.* 'I wasn't a preacher performing miracles,' Dylan writes. 'It would have driven anybody mad.'

Newport 1963 saw the birth of a myth that will never be quashed: that of Dylan the protest-singing prophet. All of his most famous political songs were written in a relatively short period, between January 1962 and October 1963, but those are the songs which fixed him in the popular imagination. The singer's entire career since then can be seen as a flight from that myth and its attendant pressures. He was the first rock star to realise that, if you're not careful, then the people who claim to love

your music will kill it. Once you are famous, your fans create a version of you that is bigger and stronger than the real thing, and may bear only a passing resemblance to it. You can't dismantle this looming figment of the popular imagination, merely find a way to manoeuvre around it: move fast and nimbly and, like Orpheus in the underworld, don't look back.

In *Chronicles*, the prose shudders as he remembers the labels slapped upon him: 'Prophet, Messiah, Saviour'. As early as 1962 he was telling a friend, 'People are recognizing me, they're stopping me on the street and asking me what I meant in "Blowin' in the Wind", and what's the true meaning in my other songs. They're driving me flaky. Got to get out of here.' But soon there was nowhere to go. Wherever he fled, people pursued him looking for answers that weren't there: 'gate-crashers, spooks, trespassers, demagogues'. His descriptions of the madness at its height recall the reluctant messiah in *Monty Python's Life of Brian*. 'Fuck off!' he snaps. 'How shall we fuck off, O Lord?' reply the tenacious faithful.

Dylan's flight from the suffocations of fame would take several years but his estrangement from the folk scene, and the left in general, took place over just three summers: three Newport appearances. In 1963 he was a hero, in 1964 a conundrum, in 1965 a traitor. The most famous incident of that last festival occurred when Dylan's band began playing electric instruments and an aghast Pete Seeger said he wished he had an axe so he could cut the power cable.

History has been unkind to Seeger's Luddite outburst, but it is possible to sympathise both with Dylan's desire for artistic freedom and Seeger's horror at the death of the folk revival dream. When he talked of severing the cables, he was hoping to cut off not merely the electricity supply but the powerful cultural current which was threatening to make redundant all that Seeger and his allies had worked towards since the 1930s. That year, Dylan represented both modernity and the victory of the individual over the community. In the process he preserved his sanity and transformed rock music, but he also killed the folk revival as surely as if he had been wielding

Seeger's imagined axe. Protest music was one thing before Bob Dylan came upon it, and quite another afterwards.

*

Bob Dylan arrived in New York in January 1961, during the city's harshest cold snap in fifteen years. He trudged through the snow to Greenwich Village, talked his way into a slot at the Café Wha?, and introduced himself to the centre of the folk-music world with these words: 'I been travelin' around the country. Followin' in Woody Guthrie's footsteps. Goin' to the places he went to. All I got is my guitar and that little knapsack. That's all I need.'

For a short while, Dylan was the architect of his own myth, and that myth was pretty much Guthrie's. Back home in the small mining town of Hibbing, Minnesota, his heroes had been, in order of discovery, Hank Williams, Little Richard, James Dean and John Steinbeck: a promising palette of icons. When he moved to Minneapolis for a half-hearted dalliance with academia, he discovered another, more significant than all the rest put together. One new friend, Ellen Baker, came from a folk-collecting family and gave Dylan access to a treasure trove of Woody Guthrie 78s and bound copies of *Sing Out!* Dylan had already changed his name from Robert Zimmerman, and his Guthrie worship gave him a new persona to go with it. Assiduously he learned the songs while cultivating Okie mannerisms and an anti-intellectual image. 'To me Woody Guthrie was the be-all and end-all,' Dylan would later tell the *Los Angeles Times*. 'He was saying everything in his songs that I felt but didn't know how to.'

One of the first things Dylan did in New York was to forge a friendship with his ailing hero. The younger man possessed a compelling blend of charisma and vulnerability which made the people he met want to take him under their wing. And if some on the Village scene found something slippery and suspect about this shabby newcomer's flair for networking, then even they couldn't deny that he was a rare talent. Within three months of reaching New York he had secured a two-week residency at the city's

most influential folk club, Gerde's Folk City.* That September a hugely influential rave review by the *New York Times* folk critic Robert Shelton attracted the attentions of Columbia Records' John Hammond and heavyweight manager Albert Grossman.

In some ways, however, the most important person Dylan met during those first few months in the Village was not an industry figure, but a smart, beautiful seventeen-year-old named Suze Rotolo. They were introduced in July and fell in love almost immediately. At the apartment they shared on West 4th Street, Rotolo fed her boyfriend's gargantuan appetite for new stimuli with the likes of Arthur Rimbaud, Robert Graves and Bertolt Brecht: he devotes five pages in *Chronicles* to the 'outrageous power' of Brecht and Weill's 'Pirate Jenny' and its terrifying black freighter. Crucially, Rotolo also awoke his political conscience. She was working as a secretary for CORE and came home each night with stories about the civil rights struggle. One day towards the end of January 1962, with a CORE benefit show looming, Dylan composed 'The Ballad of Emmett Till', about a black fourteen-year-old who had been beaten and shot to death in Mississippi in 1955 for whistling at a white woman. Bob Dylan the protest singer was born.

*

Dylan denies he was ever a protest singer, but then he didn't think Woody Guthrie wrote protest songs either. He argued instead in terms of 'topical songs', like those written by his Village contemporaries Tom Paxton and Len Chandler. 'He didn't read or clip the papers and refer to it later,' Rotolo told Dylan's biographer, Anthony Scaduto. 'With Dylan it was not that conscious journalistic approach. It was more poetical. It was all intuitive, on an emotional level.' Dylan's new approach was just what Sis Cunningham and Gordon Friesen were looking for when they set up *Broadside* in February 1962. The first issue featured Dylan's wickedly satirical

* Only Irwin Silber was initially immune to his charms. When Dylan turned up unannounced at the *Sing Out!* offices with some songs for possible publication, he was shown the door.

take on the Red-baiting right, 'Talkin' John Birch Society Blues'; the third boasted 'I Will Not Go Down Under the Ground' (aka 'Let Me Die in My Footsteps'), a sardonic critique of bomb-shelter paranoia; the sixth introduced the world to 'Blowin' in the Wind'.

Dylan wrote the song that would transform his life in April after a long discussion about civil rights in a Village coffeehouse called Commons. He jotted down the line 'your silence betrays you' at the table and dashed home to write the rest of the lyric (in just ten minutes, he claimed), which he set to the melody of the old emancipation song 'No More Auction Block for Me'. The central image, he later explained, was that of 'a restless piece of paper' which nobody thinks to pick up and read, an idea uncannily close to Guthrie's comparison of himself to a 'blowing' scrap of paper. As soon as it appeared in *Broadside* in May, it was the talk of the town. Performing it at Gerde's before its publication, Dylan announced: 'This here ain't a protest song or anything like that, 'cause I don't write protest songs . . . I'm just writing it as something to be said, for somebody, by somebody.'

'Protest songs are difficult to write without making them come off as preachy and one-dimensional,' Dylan writes in *Chronicles*. 'You have to show people a side of themselves that they don't know is there.' To do this, at that time in American history, was to blow a hole in a dam and hope that you didn't drown in the torrent. 'Blowin' in the Wind' captured the gestalt by posing the questions that so many Americans were asking: 'How many times?' 'How many deaths?' 'How many years?' Dylan avoided specifics but, so soon after the Freedom Rides, few could have doubted the identity of the 'some people' who were not yet 'allowed to be free'. Unlike a topical song, with its clear narrative and cast of characters, 'Blowin' in the Wind' flattered the listener with its poetic vagueness: those in the know would understand. Not everyone was impressed. Tom Paxton dismissed it as 'a grocery list song where one line has absolutely no relevance to the next line', and Ewan MacColl later dismissed all Dylan's protest songs as 'puerile – too general to mean anything'. But its flaws were also its strengths.

Yes, it employed broad brush strokes – freedom, empathy: good; war, death, apathy, tears: bad – but only broad strokes could have painted it across the minds of a generation.

Dylan would later delight in rubbishing his own motives for writing such songs. It was just a way to get noticed, he told the *New Yorker*'s Nat Hentoff. But that was when he was sick of the hero worship; in 1962 he was still writing protest songs like he meant them. When James Meredith, a black student, was turned away from the University of Mississippi in September on racial grounds, sparking bloody riots and leading President Kennedy to send in troops to force desegregation, Dylan promptly composed the scathing and concise 'Oxford Town'. 'A Hard Rain's a-Gonna Fall' was written before the Cuban Missile Crisis, but became uncannily timely when listeners misinterpreted the hard rain as nuclear fallout.

Featuring only two original compositions, Dylan's eponymous debut album had been an inadequate advertisement for his talents and it sold accordingly. Starting in April 1962, he would spend a year, on and off, crafting the follow-up, applying much more rigorous selection procedures. 'The Ballad of Emmett Till', which Dylan now regarded as 'a bullshit song', was junked, as was 'Let Me Die in My Footsteps', while 'Talkin' John Birch Society Blues' was quashed by Columbia, but there would be room on *The Freewheelin' Bob Dylan* for his other recent protest songs and a scarifying new composition called 'Masters of War'.

*

In December 1962 Dylan flew to England, where he played a few shows, appeared in an ill-fated TV drama, and lapped up the country's folk music. He quickly managed to aggravate Ewan MacColl but befriended a younger, less severe English folksinger, Martin Carthy, who taught Dylan some folk melodies that he would later appropriate. Another traditional tune Dylan encountered was the bizarre and unsettling 'Nottamun Town', in an arrangement by American song-collector Jean Ritchie. He applied the melody to a lyric he had been working on about those who profited from war.

As he explained decades later, 'It's not an anti-war song. It's speaking against what Eisenhower was calling a military-industrial complex.'

It's an important distinction, because no pacifist could have written 'Masters of War'. As a boy, Dylan had been so fascinated with the army that he considered applying to West Point Military Academy. In New York, he imbibed the classic military theory of Sun Tzu and Carl von Clausewitz. In 1962 Dylan was pluck-ing extant melodies from all over, but 'Masters of War' has the quality of an M. R. James story, as if he had dug up this old tune and scraped off the mud and rust, but left some of the macabre violence of 'Nottamun Town' – its references to a stark-naked drummer and 'ten thousand drowned' – clinging to it. Ancient and malign, 'Masters of War' is the most evil-sounding protest song Dylan ever recorded. He used to refer to his 'finger-pointing songs', and 'Master of War' points the finger with the baleful power of a witch's curse. 'You' – *yew* – he sneers at the warmon-gers, bringing to bear all of his poisonous rage, 'you ain't worth the blood that runs in your veins.' In the final verse, Dylan tracks his quarry's coffin to its resting place and stands over it 'till I'm sure that you're dead'. You imagine that he might clamber down into the grave, crack open the casket and give the corpse a good kick just to be sure. He turns the topic of the military-industrial complex into an ancient horror story in which a wrongdoer is pursued by a vengeful spirit. It is also a form of generational warfare. In 'The Times They Are a-Changin'', Dylan would soon ask his elders to 'please heed the call', but there is no room for 'please' in 'Masters of War', only bitter sarcasm. He admits he is young, and that there's a lot he doesn't know, but he knows enough to damn his targets to hell.

'I've never really written anything like that before,' said Dylan in the liner notes to *The Freewheelin' Bob Dylan*. 'I don't sing songs which hope people will die, but I couldn't help it with this one. The song is a sort of striking out, a reaction to the last straw, a feeling of what can you do?'

The song's naked contempt sets it apart from folk's sweet reason,

as epitomised by the Guthrie-adapting slogan on Pete Seeger's banjo, 'This Machine Surrounds Hate and Forces It to Surrender', and prophesies the immoderate rage of Crass or N.W.A. It also keeps it alive decades later. Whereas 'Blowin' in the Wind' has been worn smooth by film-makers seeking cosy signifiers of 1960s rebellion, 'Masters of War' remains untameably over-the-top. As Greil Marcus notes: 'It's the elegance of the melody and the extremism of the words that attract people – the way the song does go too far, to the limits of free speech . . . [it] gives people permission to go that far.' It is a vehicle for all those dangerous, unpacifistic emotions that anti-war movements rarely allow themselves to express: that feeling of hating violence so much that all you want to do is match it with violence of your own.

It first appeared in *Broadside* in January 1963, accompanied by Suze's drawings, and then on *Freewheelin'* in May. In the year or so since 'Blowin' in the Wind', Dylan had been measured for his crown and robes as new King of the Folksingers. Newport would be both his coronation and the zenith of the folk revival.

*

Until the official start of US Beatlemania in February 1964, rock'n'roll was in a long slump and a folksinger was the thing to be. While the Village teemed with talent – Dylan, Baez, Paxton, Chandler, Dave Van Ronk, Carolyn Hester, Judy Collins, Buffy Sainte-Marie – folk scenes thrived across the country. So fashionable was it that in October 1962 the comedian Allan Sherman sold a million copies of an album of parodies called *My Son, the Folksinger*. The following month Baez became a *Time* magazine cover star, barefoot and strumming. 'Anything called a hootenanny ought to be shot on sight,' the profile began, 'but the whole country is having one.'

Baez was only six months older than Dylan. The precocious middle daughter of two highly cultured Quaker converts, she had come up through the Massachusetts folk scene. Her first three albums, featuring mostly traditional ballads, all went gold. Baez was a tough, savvy young woman, who had described

herself in a school essay thus: 'I am not a saint. I am a noise. I spend a good deal of my time making wise cracks, singing, dancing, acting, and in the long run, making a nuisance of myself.' But those peppery qualities were absent from her voice, which seemed to promise what it embodied: purity and clarity. Dylan calls it 'a voice that drove out bad spirits'.

Baez took Dylan (whom the same *Time* profile called 'a promising young hobo') under her wing in May 1963, when she invited him to perform 'With God on Our Side', his earnest attack on jingoism, with her at the Monterey festival. After the show he stayed with her for several days, even though he was still seeing Suze: the start of a rocky two-year relationship.

Less totemic than Baez, but more rampantly commercial, was the trio Peter, Paul and Mary, manufactured by Grossman as a hipper, more politicised alternative to the Kingston Trio: Peter Yarrow was the earnest folkie, Noel 'Paul' Stookey the joker and Mary Travers the boho beauty. Their eponymous 1962 debut album nested in the *Billboard* Top 100 for three years, introducing millions to Seeger's 'If I Had a Hammer (The Hammer Song)' and 'Where Have All the Flowers Gone?' After the somewhat less socially engaged 'Puff, the Magic Dragon', Grossman fed them material from his newest client; their version of 'Blowin' in the Wind' scaled the charts in the summer of 1963.

Phil Ochs was a much thornier prospect. Born in Texas in 1940, he had passed through Staunton Military Academy and Ohio State University, where he studied journalism, discovered the work of Guthrie and Seeger, and began writing protest songs of his own, calling his first band the Singing Socialists. When he arrived in Greenwich Village in 1962 he joked to *Broadside*'s Gordon Friesen that he got his lyrics from *Newsweek* and his melodies from Mozart, which was half right. In March 1963 he set out his stall in an eloquent *Broadside* essay called 'The Need for Topical Music'. 'Before the days of television and mass media,' he wrote, 'the folksinger was often a travelling newspaper spreading tales through music. It is somewhat ironic that in

this age of forced conformity and fear of controversy the folk-singer may be assuming the same role . . . One good song with a message can bring a point more deeply to more people than a thousand rallies . . . Every newspaper headline is a potential song.' Later he explained, 'A protest song is a song that's so specific that you cannot mistake it for bullshit.'

By this stage, folk meant dollar signs. In April the ABC network launched a Saturday night show called *Hootenanny*, although it was hobbled before it even began.* ABC's decision to continue blacklisting Seeger led many key players, including Dylan, Baez and Peter, Paul and Mary to boycott the show. Producers compounded their idiocy by forbidding guests to sing any 'subversive' songs. Soon afterwards, Dylan had his own run-in with timid television executives when CBS forbade him to perform 'Talkin' John Birch Society Blues' on *The Ed Sullivan Show*. Dylan, justifiably stubborn, chose not to appear at all. It was not as if he particularly needed the publicity. Two weeks later *The Freewheelin' Bob Dylan* became a sensation. The only complaints came from Jon Pankake and Paul Nelson at Minnesotan folk gazette *Little Sandy Review*, who, having earlier warned him to 'steer clear of the Protesty people' and attacked the 'sappy and idiotic simple-mindedness of *Broadside*'s output', called *Freewheelin'* 'melodramatic and maudlin'. Dylan would soon come around to their protestophobia, but not quite yet.

Returning after a two-year hiatus, the Newport Folk Festival in July was a joyous show of strength. Phil Ochs performed 'Too Many Martyrs' (about Medgar Evers, the NAACP field secretary recently murdered in Mississippi), 'Talking Birmingham Jam' (about the recent tumult in Alabama) and 'Power and the Glory' (a tribute to Woody Guthrie). But there was no doubt as

* There seemed no end to the commercial potential of the hootenanny concept in 1963: as historian Ronald D. Cohen records, folk fans could eat a Hootenanny candy bar, pop a dime into a Hootenanny pinball machine, attend a Miss Hootenanny contest and relax with a Hootenanny bath mitt.

to who was the main attraction. Peter, Paul and Mary sang four of Dylan's songs and introduced their version of 'Blowin' in the Wind' as 'written by the most important folk artist in America today', while Sunday-night headliner Baez brought him on stage for her final encore to duet on 'With God on Our Side'.

His own protest-heavy set was a sensation. 'Blowin' in the Wind' became an all-star performance, bolstered by Baez, Seeger and others. So stunned were they all by the roaring ovation that they encored with an impromptu rendition of 'We Shall Overcome'. A more potently symbolic tableau of unity could not have been imagined. Yet Dylan could already feel the jaws of a trap closing in on him. 'He was paranoid to start,' Dave Van Ronk told Anthony Scaduto. 'All of a sudden five million people were pulling at his coat and picking his brain, and he couldn't take it when just five people were doing that. His feeling, basically, was that the audience is a lynch mob. What he said was: "Look out, they'll kill you."'

Folk's ties with the civil rights movement were strong, so it was no surprise when many of the stars of Newport also appeared at the Lincoln Memorial the following month for the climax of the March on Washington for Jobs and Freedom, which brought together the five major civil rights leaders: Martin Luther King of the SCLC, James Farmer of CORE, John Lewis of the SNCC, Roy Wilkins of the NAACP and Whitney Young of the National Urban League.

By lunchtime on 28 August around a quarter of a million people, black and white, thronged the lawns around the Presidential Mall. In a pre-march morning concert Baez led the biggest ever mass rendition of 'We Shall Overcome'.* 'My knees were shaking,' she later told musician David Crosby. 'I'd never seen that many people before in my life.' She was followed by Odetta, Josh White, Peter, Paul and Mary, the SNCC Freedom Singers and Dylan, who sang two new songs, 'Only a Pawn in Their Game'

* Seeger, abroad at the time, sadly missed this defining moment.

(about Medgar Evers) and 'When the Ship Comes In'. The formal concert preceding King's speech later in the day featured opera star Marian Anderson and gospel icon Mahalia Jackson.* It is said that King only digressed from his script for his famous 'I have a dream' finale because Jackson leaned in and urged, 'Tell them about the dream, Martin!'

But even on the day Dylan doubted the march's effectiveness. 'Think they're listening?' he asked, looking towards Capitol Hill and Congress. 'No, they ain't listening at all.'

*

Suze Rotolo had moved out of the apartment on West 4th Street shortly before the march, and Dylan, by now jangling with paranoia, took the opportunity to flee to Albert Grossman's upstate rural getaway in Bearsville, near Woodstock. During the autumn he wrote his most self-conscious protest song: 'The Times They Are a-Changin''. It is both corny and visionary, its finger-pointing stridency complicated and enriched by its poetry. Most listeners would have heard it as a call for politicians, parents and squares in general to either listen to the new generation or get out of the way, but some of Dylan's vocabulary was in the same vein as earlier, unreleased songs 'I'd Hate to Be You on That Dreadful Day' and 'Train a-Travelin'': ancient, biblical, foreboding. Floodwaters rise, a battle rages, a curse is cast, things fall apart. Even when Dylan set out to write an anthem of hope, his language betrayed a shadow meaning: a tremor of fear that not all the change would be for the best. You can almost hear the foreboding foghorn of the black freighter.

So it cannot have helped Dylan's shaky psyche when on 22 November, not long after he finished recording the album of which 'Times' was the title track, President Kennedy was shot dead in Dallas. *You want change?*, the assassination seemed to

* Anderson, of course, had performed at the same Lincoln Memorial twenty-four years earlier, in the Easter concert which became another pivotal moment in African-American history.

say. *Well, here's your change.* The following night, Dylan played a show in upstate New York and opened, as he usually did, with 'Times'. 'Something had just gone haywire in the country and they were applauding the song,' Dylan told Scaduto. 'And I couldn't understand why they were clapping, or why I wrote the song. I couldn't understand anything. For me, it was just insane.'

Here was a man already queasy about organised politics, already chafing against the expectations hung round his neck, already looking over his shoulder. His next album, *The Times They Are a-Changin'*, was already the end of something. It featured three recently composed protest songs: the title track, the ominous, black-freighter-inspired 'When the Ship Comes In' and 'The Lonesome Death of Hattie Carroll', which turned a minor news story – the manslaughter of a black barmaid by a rich, young white man in Baltimore – into a microcosm of racial and class-based injustice in America, even as it wildly exaggerated the malice of the killer, William Zantzinger.* The other political numbers were a few months old. There would be no more explicit protest songs for a long time. Perhaps the submerged madness that surfaced in America with Kennedy's murder just confirmed what Dylan already felt – that things were happening too fast for certainty and sanctimony to do any good. So he said something about it.

A few weeks after the assassination, he agreed to accept the Tom Paine Award from the Emergency Civil Liberties Committee (ECLC) at a grand event in New York's Americana Hotel. Looking around at the wealthy *bien-pensants* resplendent in jewellery and furs, he got uptight, and then he got drunk. 'They were supposed to be on my side but I didn't feel any connection with

* Dylan scholar Clinton Heylin points out that 'The Death of Emmett Till', 'Only a Pawn in Their Game' and 'The Lonesome Death of Hattie Carroll' all play fast and loose with historical facts to make their point, suggesting that Dylan didn't much care about the details, perhaps unaware that countless listeners over the years would take his accounts as gospel.

them,' he later told Nat Hentoff of the *New Yorker*. Reluctantly, he stepped on stage to collect the award and rambled about the March on Washington, Cuba, and race. 'There's no black and white, left and right, to me anymore. There's only up and down, and down is very close to the ground. And I'm trying to go up without thinking about anything trivial, such as politics.' It got worse when he began talking about Lee Harvey Oswald. 'I saw some of myself in him,' he said hesitantly. Scattered boos ascended from the ballroom floor.

Dylan sent a long, confusing letter of qualified apology to the ECLC, the crux of which was that he was no longer interested in *we*, but *I*. His head was full of poetry (Byron, Ginsberg, especially Rimbaud) and drugs (pot, acid), and all that mattered to him was personal expression. Now when he talked in terms of those who were chained and those who were free, he didn't mean civil rights. In February 1964 he piled into a brand-new Ford station wagon with three friends and set off on a weird, stoned road trip, during which he worked on channelling his increasingly abstract, visionary sensibility into two new songs, 'Mr Tambourine Man' and 'Chimes of Freedom', which belonged in a new category far wilder and more tangled than protest.

It was a miraculous period for Dylan the artist; less so for Dylan the man. Consumed by his quest for personal freedom, he was less than splendid company, developing a taste for barbed and bullying mind games. One gets the impression that a conversation with Dylan often resembled a Kafkaesque job interview in which the reward was Dylan's friendship but the criteria painfully obscure. 'He started using bayonets on people,' Suze Rotolo's sister Carla told Scaduto. 'He'd find their vulnerable spots, and just demolish them.' One person who felt Dylan's poisonous tongue was Phil Ochs. 'The stuff you're writing is bullshit, because politics is bullshit,' he told Ochs. 'It's all unreal. The only thing that's real is inside you. Your feelings. Just look at the world you're writing about and you'll see you're wasting your time. The world is, well . . . it's just absurd.'

When the transformed Dylan returned to Newport in July 1964, the audience hung on his every note, but folk's old guard was horrified. It wasn't just that he put love songs and opaque imagery ahead of protest; it was the arrogant remoteness with which he conducted himself: a cardinal sin in the folk world, where no individual was more important than the community. In *Sing Out!* Irwin Silber accused him of having 'somehow lost contact with people'. Paul Wolfe, writing in *Broadside*, went further still, using Ochs as a stick with which to beat Newport's fallen idol: 'meaning vs innocuousness, sincerity vs utter disregard for the tastes of the audience, idealistic principle vs self-conscious egotism'. Ochs himself wrote a passionate defence of Dylan, pointing out that pandering to an audience's expectations might be considered the height of *in*sincerity. The *Little Sandy Review*'s Paul Nelson applauded Dylan for 'taking his first faltering steps in a long time in a productive direction for himself as an artist, and not himself as a hero'.

Newport '64 was the crest of the folk revival wave. Sales were booming, magazines were springing up everywhere, and folk was at the heart of the political action. In May Baez had joined stars such as Gregory Peck and Woody Allen at Madison Square Garden in the New York Democratic Party's salute to Lyndon Johnson, where she pointedly addressed 'The Times They Are a-Changin'' to the president. Seeger, back from almost a year of globetrotting, returned to the charts with a version of Malvina Reynolds's snarky anti-conformity broadside 'Little Boxes'.

Later in the year, readers of Nat Hentoff's Dylan profile in the *New Yorker* would discover what Dylan had told the interviewer back in June about giving up on 'finger-pointing songs': 'Me, I don't want to write for people anymore. You know – be a spokesman.' But anyone who listened closely to *Another Side of Bob Dylan*, which came out two weeks after Newport, already knew that. On 'My Back Pages', he consigned 'lies that life is black and white' to the past.

*

For a performer, the biggest problem with protest songs is that they engender smugness. Concert audiences are generally keen to appear on the singer's side, and a protest song intensifies the sycophancy: they know exactly when to laugh, when to cheer, when to boo. In the context of labour songs or freedom songs, that ritual of affirmation is rather the point, but it can be difficult for an artist to see a song that has been conceived with an element of danger and risk tamed and smothered by an audience's self-congratulatory approval: *We understand. We are not like* them. *We are all on the same side.*

So it was that by the time Dylan toured the UK in the spring of 1965, some of his most famous numbers were dead songs walking. He had lost ownership of them, and of their nuances. By the end of the tour, 'Subterranean Homesick Blues', a rollicking talking blues modelled on a Chuck Berry riff, would be released but, owing to the vagaries of international release schedules, the single riding high in the charts when he arrived in England was 'Times'. He found that audiences were expecting the wrong Bob Dylan. 'I was playing a lot of songs I didn't want to play,' he later told Hentoff. 'I was singing words I didn't really want to sing. I knew what was going to happen.'

This is the most charitable explanation for the unedifying figure that Dylan cuts in D. A. Pennebaker's aptly named tour documentary *Don't Look Back*. Another is that the only way he could protect himself from fame's predations was to make himself a moving target. Hence he is cagey and obnoxious, squandering his intellectual firepower on soft targets such as hopelessly square *Time* reporter Judson Manning, and surrounding himself with a coterie of snickering cronies. He is repellent towards Baez, in part because he was already fading her out of his life in favour of his new love, and future wife, Sara Lownds, but also, perhaps, because she represented so much that he was trying to leave behind: protest songs, community, the movement.

Released in 1967, when Dylan's new direction was abundantly clear, *Don't Look Back* made the viewer a knowing accomplice. Even more so at this remove, we too can pretend to be on Dylan's side, but in a different way from those 1965 audiences. Regarding their unthinking worship, we can flatter ourselves that we would have understood his emphasis on freedom and reinvention; we would not have killed those songs with too much love; we would have preferred the new material; we would not have been like *them*. But for most of us that is an illusion born of hindsight. Music and politics both offer people a chance to be part of something bigger than themselves, and the combination of the two can be intoxicating, so can we necessarily say that we wouldn't, with the best of intentions, have joined in cheering 'The Times They Are a-Changin'" to death?

If Dylan had never written a protest song, someone else might have fed the same cultural need, but no other artist was capable of producing the stuff he was coming up with by 1965. 'It's Alright, Ma (I'm Only Bleeding)' was a foaming torrent of striking imagery, jagged accusations and unforgettable slogans, a refusenik manifesto summed up in the line: 'Propaganda, all is phony' (like Salinger's Holden Caulfield, Dylan hated nothing more than a 'phony'). 'It's Alright, Ma' and 'Subterranean Homesick Blues' *were* protest songs of a sort, only what they were protesting was the entire status quo, with its bogus oppositions and schematic morality.

So when he sang 'Don't follow leaders' on 'Subterranean Homesick Blues', he didn't just mean Lyndon Johnson but people like Martin Luther King, Bobby Kennedy or even Dylan himself. It was the *I* protesting the *we*, which was the sort of message that appealed to young listeners who weren't especially interested in marches and meetings: a politics of the self. In doing so, Dylan was overturning the Lomax/Seeger, left-wing interpretation of folk that had prevailed for three decades, and unearthing instead the 'old, weird America'. 'The truth is, there are weird folk songs that have come down through the ages, based on nothing,

or based on legend,' he complained. 'Those old songs weren't simple at all. What's happened is the labour movement people, *they're* talking about keeping it simple . . . All they want is songs from the Thirties, union hall songs. "Which Side Are You On?" That's such a waste. I mean, which side *can* you be on?'

In interviews, his politics became more antic. The next year, in a *Playboy* interview with Hentoff, he would promise that a President Dylan would replace 'America the Beautiful' with his own 'Desolation Row' and challenge Mao Tse-tung to a fistfight. He also said that 'only college newspaper editors and single girls under 14 . . . could possibly have any time for' protest songs. He may have had one particular recent hit in mind when he said that.

*

One night in the middle of 1964, a nineteen-year-old aspiring songwriter called P. F. Sloan had worked until dawn on a song he called 'Eve of Destruction'. It was a somewhat gauche shopping list of reasons to be fearful: segregation, nuclear war, Vietnam, Red China, the JFK assassination, all conspiring to sweep humanity into an early grave. It had none of the Judgement-Day terror of Dylan's apocalyptic songs, and none of their agility (the third verse has no fewer than six rhymes for 'frustratin"), but a gripping momentum nonetheless. The hoarse-throated Barry McGuire, who had just left folk revivalists the New Christy Minstrels and was looking for solo material, consented to record it.

It came out as a B-side in July 1965, but the A-side was swiftly ignored by DJs, who put 'Eve' on heavy rotation. Reissued in its own right, it topped the charts two months later, selling six million copies to become by far the biggest protest song to date. 'The media frenzy over the song tore me up and tore the country apart,' wrote Sloan, with just a hint of hyperbole. Overwhelmed, he told reporters that it was 'a love song – a love song to and for humanity', but it made no difference. Radio and TV stations banned it, with one DJ asking, 'How do you think

the enemy will feel with a tune like that No. 1 in America?'
The Young Republicans and Citizens for Conservative Action
vilified it. Randy Sparks, McGuire's old colleague in the New
Christy Minstrels, called it 'communist fodder' and promised
to retaliate with his own 'A Song of Hope'. A group called
the Spokesmen recorded a rapid-response record, 'Dawn of
Correction'; some DJs, fearful of bias allegations, gave both
discs equal airplay.*

The left-wing folk establishment disliked 'Eve of Destruction'
for different reasons, horrified that this arriviste was plasticis-
ing protest. Dave Van Ronk called it 'an awful song'. Ochs was
a tad more sympathetic, saying that it had 'some very good
lines', but ultimately damned it as 'tenth-rate Dylan'. 'It will be
an introduction of protest songs to many people, but it's a bad
introduction,' he told *Broadside*. 'Better things have to happen.
Better songs have to get on the charts.'

In a piece called 'Message Time', *Time* found 'Eve' representa-
tive of a new wave of youthful frustration in folk-rock, linking it
to the Animals' 'We've Gotta Get Out of This Place' and Sonny
and Cher's trite 'Laugh at Me'. 'Suddenly the shaggy ones are
high on a soapbox,' it noted with typical condescension. 'The
rallying cry is no longer "I wanna hold your hand," but "I wan-
na change the world."'

'Half of 'em don't understand what they're trying to say,'
Dylan said when the *NME* asked him about 'Eve of Destruction'
and its ilk. 'I'm all for protest songs if they're sincere. But how
many of them are?'

*

'Eve of Destruction' was making its way up the charts when the
broken, hobbling romance between Dylan and the folk scene

* 'Dawn of Correction' is actually more Pollyannaish than right-wing,
accusing Sloan and McGuire of pessimism rather than communism.
'You missed all the good in your evaluation,' the Spokesmen chide.
'What about the things that deserve commendation?'

came to a shattering and public end at Newport in July 1965, with perhaps the most symbolic, exhaustively chronicled performance in the history of rock. One has to wonder exactly what the folk faithful expected. The heavily electric *Bringing It All Back Home* was already out, as was the explosively innovative 'Like a Rolling Stone', and Dylan arrived in Newport looking surly and secretive, cloaked in rumour. On Sunday night, introduced by Peter Yarrow, he appeared on stage backed by the Paul Butterfield Blues Band and kicked into a ragged, squalling 'Maggie's Farm'.

Joe Boyd, the festival's production manager, found Lomax, Seeger and Bikel in a furious knot backstage, shouting, 'It's too loud!' Seeger has since contended that his real objection was that the raging volume of the instruments drowned out the words, but this was when the metaphorical axe entered into folklore. When a livid Seeger marched up to the sound desk, Yarrow scowled, 'Pete, get away from here or I'll fucking kill ya.'

The precise cause of the boos which greeted the end of Dylan's three-song set can never be isolated – was it the poor sound quality, the apostasy of electricity, or simply the brevity of the show? – but Dylan heard them, and he was shaken. As some kind of atonement, he returned at Yarrow's urging for an acoustic encore of 'Mr Tambourine Man' and, tellingly, 'It's All Over Now, Baby Blue'. Unsettled and irate, he then went off and wrote the scornful 'Positively 4th Street' – in break-up terms, the equivalent of piling his ex-lover's belongings in a heap and setting fire to them. Within days, he had also recorded the revolutionary blues-rock thunder of *Highway 61 Revisited*.

But what of those he left behind? The mood backstage after Dylan's set was sombre and fractured. 'The old guard hung their heads in defeat while the young, far from being triumphant, were chastened,' Joe Boyd wrote in his memoir, *White Bicycles*. 'They realised that in their victory lay the death of something wonderful. The rebels were like children who had been looking for something to break and realised, as they looked at the pieces, what a beautiful thing it had been.'

Without Dylan in the vanguard, the folk revival faltered. Through the folk-rock door that he opened that summer charged the likes of the Byrds, the Fugs, Jefferson Airplane and Buffalo Springfield. By contrast, the parade of older folksingers who followed Dylan on Sunday evening at Newport suddenly appeared staid, washed-up, over, on the wrong side of history. Folk scene maven Izzy Young, one of Dylan's erstwhile mentors, penned a furious *j'accuse* called 'Bob Dylantaunt', in which he charged: 'His voice now tells the true story of Bob Dylan. He screams from the bottomless pit and it is truly heart-rending. But it is like sharing something dirty.' Paul Nelson, in his last piece as managing editor of *Sing Out!*, wrote: 'It was a sad parting of the ways for many, myself included. I choose Dylan. I choose art.'

Phil Ochs, who didn't believe that politics and art were mutually exclusive, could understand both sides of the row, even though he had good reason to lash out at Dylan. The previous month, after a Sing-In for Peace at Carnegie Hall, he had rowed with Dylan, who had ejected him from the limousine they were sharing and delivered the parting shot: 'You're not a folksinger. You're a journalist.' This was a redundant criticism directed at a trained journalist who called his debut album *All the News That's Fit to Sing*, but one can imagine the contempt with which Dylan sneered those three syllables. Like Baez, Ochs symbolised the skin that he was intent on shedding. And if Dylan became a model for every subsequent songwriter who chafed at the drawbacks of protest singing, then Ochs showed that it was possible to keep the faith despite them.

'I'm quite sure Dylan despises what I write,' he told *Broadside* afterwards. 'I get the impression he can't accept what I'm doing. Because in his mind it's political and therefore bullshit . . . In the song "My Back Pages" Dylan laughs at himself as an impotent musketeer fighting false battles. I often laugh at myself in the same way and many times consider my role ridiculous, but still I am forced to go on.'

When *Broadside* asked him if Dylan would like to 'see buried'

his protest songs, Ochs responded: 'I don't think he can succeed in burying them. They're too good. And they're out of his hands.'

5

'Lord have mercy on this land of mine'

Nina Simone, 'Mississippi Goddam', 1964

The struggle for civil rights

Shocked locals outside the ruins of the 16th Street Baptist Church in Birmingham, Alabama on 16 September 1963.

'I'm not beyond killing,' Nina Simone once said, remembering Sunday, 15 September 1963. 'Nobody is. But I wrote "Mississippi Goddam" instead.'

Simone was not exaggerating. When she heard the news from Alabama that day, her first instinct was murder. 'I went down to the garage and got a load of tools and junk together and took them up to my apartment,' she recounted in her autobiography, *I Put a Spell on You*. 'I was trying to make a zip gun, a home-made pistol. I had it in my mind to go out and kill someone I could identify as being in the way of my people getting some justice for the first time in three hundred years.'

The news was this: at 10.19 that morning over a dozen sticks of dynamite had detonated in the basement of the 16th Street Baptist Church in Birmingham, Alabama, during a Bible study class for black children. Four of the children – Denise McNair, eleven, Addie Mae Collins, Carole Robertson and Cynthia Wesley, all fourteen – were killed in the blast. 'As the bomb detonated and rafters buckled, the teacher shrieked, "Lie on the floor! Lie on the floor!"' Cynthia's father Claude would recall. 'Even as she screamed, the faces of Jesus in the church's prized stained-glass window shattered into fragments.' The culprit, it would later transpire, was one Robert Edward Chambliss, affectionately known to his fellow Klansmen as Dynamite Bob.

It was the latest, greatest outrage in a violent year. In May pictures of attack dogs and fire hoses on the streets of Birmingham had shocked the world. The following month Medgar Evers had been murdered in Mississippi. Shortly after that President Kennedy had been forced to intervene to stop Alabama's governor George Wallace blocking the integration of the state university. Simone, who had been drawn into the movement by the playwright Lorraine Hansberry, had been sickened by these events but retained her composure and her optimism – also,

some would say, her timidity. In April, after Martin Luther King's arrest in Birmingham, Hansberry had 'asked what I was doing for the movement while its leaders were stuck in jail'. The criticism stung.

Only when she heard about the four girls in Alabama, less than three weeks after the march which promised so much, did something inside her snap. 'All the truths that I had denied to myself for so long rose up and slapped my face . . . I suddenly realised what it was to be black in America in 1963, but it wasn't an intellectual connection of the type Lorraine had been repeating to me over and over – it came as a rush of fury, hatred and determination.'

So it was that Simone's husband and manager, Andrew Stroud, found her on the apartment floor, hysterical and ranting, trying to fit pieces of scrap metal into an ad hoc pistol. He stood there taking in the scene, calmly told his wife, 'Nina, you don't know anything about killing; the only thing you've got is music,' and walked out of the room. Simone cooled down enough to get up and move to her piano. An hour later she had her first protest song, 'Mississippi Goddam'. 'It erupted out of me quicker than I could write it down,' she remembered. One can picture her hammering the keys and crying out the opening lines while the four bodies in Birmingham were still warm: 'Alabama's got me so upset / Tennessee made me lose my rest / And everybody knows about Mississippi Goddam!'

'Mississippi Goddam' became one of the two defining black protest songs of 1964. The other, Sam Cooke's 'A Change Is Gonna Come', provides an instructive contrast. Behind the songs, Simone and Cooke were not so different. Both had grown up in religious households, traded church music for the secular variety, found themselves drawn into the movement and drummed up the courage to sing about it. But the songs represented the two divergent paths which were opening up in the campaign that year. Cooke's is midnight blue, slow and stately, full of hope and healing. Simone's flashes hot red: it is tart and frantic, ragged with impatient fury. In Cooke's you hear the graceful defiance of

Martin Luther King; in Simone's the flammable rage of Malcolm X and the SNCC's Stokely Carmichael. At the funeral of three of the murdered girls in Birmingham, 8,000 mourners sang 'We Shall Overcome', but that song already had one foot in the past. Between them, Cooke and Simone blazed a path beyond the freedom-song tradition.

*

Before the 16th Street Baptist Church was ripped apart, Nina Simone had no desire to write a political song. 'Nightclubs were dirty, making records was dirty, popular music was dirty and to mix all that with politics seemed senseless and demeaning,' she wrote.

Her puritanical streak came from her mother. With fifteen church ministers in her immediate family, it was only a matter of time before Mary Kate became one too. When she met John Divine Waymon, he was a white-suited entertainer who danced and blew harmonica in Pendleton, North Carolina. But by the time their second daughter, Eunice, was born in 1932, John was a Methodist deacon and Mary Kate one of the church elders, assisting the minister.

Music was part of the family's spiritual foundation. Everybody sang and played piano; when their house caught fire, the first thing they rescued was the pedal organ. But nobody sang and played like Eunice, who was picking out hymns on the organ before she was three years old. Mary Kate, by now a minister herself, soon had her playing gospel in church, and warned her daughter against playing 'real songs', tainted by such worldly concerns as love and dancing. But when she was out preaching, John would clandestinely teach Eunice the songs of his youth. Nevertheless, Eunice grew up snobbish about pop music: it was gaudy, cheap, ephemeral. She set her sights on becoming the first black concert pianist. After graduating high school in 1950, she took up a one-year scholarship at Juilliard in New York, where she was the only black student in her class, and studied towards

a place at the Curtis Institute in Philadelphia, but she was turned down. She heard it was because of her race and never forgot the snub.

She only started playing piano in bars and clubs to fund herself while she worked towards the concert halls. She held fast to her classical dreams throughout the 1950s: when she began working pop songs into her seven-hour sets at a bar in Atlantic City under her new stage name (*Nina* from an Hispanic endearment, *Simone* from the actress Simone Signoret); when she started getting bookings in Philadelphia and New York; even when Sid Nathan of Bethlehem Records convinced her to record an album, *Little Girl Blue*, which featured the reputation-making hits 'I Loves You Porgy' (from Gershwin's folk opera *Porgy and Bess*) and 'My Baby Just Cares for Me'. 'If someone had walked up to me in the street and given me $100,000 I would have given up popular music and enrolled at Juilliard and never played in a club again,' she wrote.

In 1959, however, the Colpix label released a live album, *Nina Simone at Town Hall*, which turned a sideline into a career. She was suddenly the new sensation in Greenwich Village, in a time and place teeming with new sensations. Up-and-coming comedians Bill Cosby, Dick Gregory, Woody Allen and Richard Pryor would open shows; John Coltrane and Art Pepper lit up the jazz scene; writers such as Lorraine Hansberry and Langston Hughes talked art and politics in coffeehouses and lofts; Len Chandler and Dave Van Ronk were coming up through the folk circuit. Simone was at the heart of it all and yet still an uncategorisable outsider.

Sam Cooke, meanwhile, spent much of 1959 preparing to take his career to the next level. Born a year earlier than Simone in Clarksdale, Mississippi, he had grown up the kind of boy who would have gladdened Mary Kate Waymon's heart. His father, the Reverend Charles Cook, was a Baptist minister who had his seven children join forces in a group called, somewhat unimaginatively, the Singing Children. At the age of nineteen, Cooke

became the new lead singer of gospel veterans the Soul Stirrers, a role he maintained for seven years. But the lure of secular music was too strong and in 1957 he went solo with the spectacularly successful 'You Send Me', which spent six weeks at number one. In 1959, he was on the cusp of a second wave of success.

Neither musician, however, was yet saying anything public about civil rights. That degree of vocal anger was thus far confined to the jazz world. During the voter registration clashes in Little Rock in 1957, the usually even-tempered Louis Armstrong had controversially cancelled a State Department-sponsored tour of the USSR in disgust. 'The way they are treating my people in the South, the government can go to hell,' he told one astonished reporter. 'The people over there ask me what's wrong with my country. What am I supposed to say?'

Post-colonial theorist Frantz Fanon saw the tough, intricate sound of bebop as symptomatic of an 'upward-springing trend' in black consciousness: 'Well before the political or fighting phase of the national movement an attentive spectator can thus feel and see the manifestation of new vigour and feel the approaching conflict.' Saxophonist Sonny Rollins was the first to make explicit his dissent with *Freedom Suite* (1958), which was quickly reissued as *Shadow Waltz* by his nervous record label. 'How ironic that the Negro, who more than any other people can claim America's culture as his own, is being persecuted and repressed,' he wrote in the sleevenotes. Bassist Charles Mingus passed oblique comment on Little Rock in 1959 with 'Fables of Faubus', named after Arkansas's segregationist governor Orval Faubus, but, due to record-label timidity, it came out as an instrumental. The following year he remedied this with 'Original Faubus Fables', on which he cacklingly branded the governor 'sick and ridiculous'.

Also in 1960, drummer Max Roach teamed up with lyricist Oscar Brown, Jr, for *We Insist! Max Roach's Freedom Now Suite*, an album originally planned to mark the centennial of the 1863 Emancipation Proclamation but brought forward, and made

angrier, by the North Carolina sit-ins. There was no mistaking its message. The sleeve was illustrated with a picture of a lunch counter sit-in and the assaultive central movement of 'Triptych: Prayer/Protest/Peace' consisted of nothing but Roach's pummelling drums and his wife Abbey Lincoln's hair-raising screams. 'All Africa' and 'Tears for Johannesburg', meanwhile, demonstrated the jazz movement's growing interest in Africa. As Nat Hentoff wrote in the sleevenotes, 'Some jazzmen began to know more about [Ghanaian president Kwame] Nkrumah than about their local Congressman.'* Simone and Cooke would prove a little slower to come around.

*

'Like anyone with half a brain,' Simone had been alerted to the civil rights struggle by the Montgomery bus boycott in 1955. In Greenwich Village, she had listened attentively to Hughes and Baldwin debating strategy, but it had only become personal after she met Lorraine Hansberry, the young playwright whose *Raisin in the Sun* had become the first play by a black writer to be staged on Broadway. During long conversations with Hansberry she began to see herself primarily not as a musician but as a black woman in a world dominated by white men. Her fascination with the new preachers of black identity cut both ways: members of the nascent SNCC told her that her albums were cherished artefacts within the organisation.

Cooke had more than half a brain, too. In August 1960 he publicly signed up to the cause in a guest column (ghostwritten by his clued-up white manager Jess Rand) for the *New York Journal-American*: 'I have always detested people, of any color, religion, or nationality, who have lacked courage to stand up

* In 1961 John Coltrane's *Africa/Brass* album featured a version of the coded spiritual 'Follow the Drinkin' Gourd', retitled 'Song of the Underground Railroad'. Coltrane later recorded his own response to the Birmingham church bombing, 'Alabama', patterned on the rhythms of Martin Luther King's oration at the girls' funeral.

and be counted.' Encouraged by the Drifters' outspoken Clyde McPhatter (another Baptist minister's son), he refused to play a blatantly segregated show in Memphis in May 1961, a decision which electrified the black press. Like Simone, he was becoming more aware of racial politics. On one tour he scolded his young guitarist Bobby Womack for processing his hair instead of wearing it naturally curly: 'You know, we'll never be those people. We black, and we'll stay black.'

After the horror and jubilation of the Freedom Rides, those Riders still eager to carry on the fight had two SNCC plans to choose from: join field secretary Bob Moses on a voter registration drive in Mississippi, or accompany executive secretary James Forman to desegregate Monroe, North Carolina, home to the controversial Robert F. Williams. In May 1959 Williams had made a national name for himself after a black man was convicted of raping a white woman, while a white man was simultaneously acquitted of doing the same to a black woman. An irate Williams stood on the courthouse steps and, in a shocking break with the movement's non-violent philosophy which earned him a six-month suspension from the NAACP, declared: 'We can get no justice under the present system . . . We must meet violence with violence.'*

When white mobs beat and shot at the Monroe contingent of the SNCC, the police promptly arrested the Riders for inciting a riot. During the melee, a white couple strayed into the black neighbourhood of Newtown, where Williams took them to his house – against their will and at gunpoint, alleged some reports; for their own protection, claimed others. Charged with kidnapping, Williams fled to Cuba, where he published the pioneering tract *Negroes With Guns*, in which he argued, 'Social change in something as fundamental as racist oppression involves violence.'

* Williams was not the only prophet of rage to hit the headlines in 1959. In July a New York TV channel aired a five-part series called *The Hate That Hate Made*, introducing viewers to the Nation of Islam and its fiercest young orator, Malcolm X.

Though shunned by the civil rights establishment, he was a fearsome herald of things to come.

While Forman's followers were sitting in a Monroe jail, Bob Moses's registration drive was faring even worse in Mississippi. Moses was beaten to the ground outside the Amite County courthouse. Herbert Lee, a black farmer attending Moses's voter registration school, was shot in the head by a white member of the state assembly. Nineteen student protesters were sentenced to jail in Pike County for breaching the peace and contributing to the delinquency of minors. 'Some of you are local residents, some of you are outsiders,' Judge Brumfield told them. 'Those of you who are local residents are like sheep being led to the slaughter. If you continue to follow the advice of outside agitators, you will be like sheep and be slaughtered.' Outrage upon outrage.

*

By the time the fire hoses were turned on in Birmingham two years later, every black performer had to decide which side they were on. Fats Domino faced a huge backlash from black fans when he said he would play segregated venues if the money was right. Nat 'King' Cole baulked at celebrity activism, calling it 'an idiotic idea' which some people exploited as a ploy for publicity (by no means the last time that accusation would be levelled) and claiming that if he sang protest songs 'no one would want to listen to me – not even my fellow Negroes'.

Louis Armstrong, Lena Horne and Sammy Davis, Jr, however, were squarely on the side of the protesters. Duke Ellington went so far as marking events in Birmingham with the composition, 'King Fit the Battle of Alabam'', a pungent rewrite of the spiritual 'Joshua Fit the Battle of Jericho'.* As Clyde McPhatter told one black weekly: 'There is hardly one major entertainer who

* When Dizzy Gillespie, only half-joking, ran for president in 1964, he promised to appoint Duke Ellington as secretary of state, Miles Davis as director of the CIA, Max Roach as minister of defence and Charlie Mingus as minister for peace.

hasn't at some time felt the sting of prejudice or the stick of jimcrow, and there is not one who wouldn't give his all to erase these things from the face of the globe.' In his gut, Cooke was midway between McPhatter and Fats; the picket line and the bottom line. He wanted to stand up and be counted, sure, but he also wanted to get paid.

The day the 16th Street Church was bombed, Cooke and his band were on tour in Nashville. Three weeks later Cooke arrived at a Holiday Inn at Shreveport, Louisiana. The desk clerk informed them that their reservation had mysteriously evaporated. Cooke hollered at him until his crew hustled him out of the door and they all drove off, shouting abuse and blaring their horns. When they got to the black guest house where Cooke's other travelling companions were staying, the police were waiting to arrest them for creating a public disturbance. That night the show was delayed by a bomb threat. The lesson was clear: Cooke may have been a superstar but he was still a *black* superstar. After the tour, he became increasingly close to Malcolm X through their mutual friend, the boxer and radical Cassius Clay.

Malcolm had come a long way in the four years since he became a public figure. He had met with Fidel Castro and several African leaders, and, while most eyes were on the South, had become a spokesperson for the frustrated black populations of Northern cities such as Detroit. He had also become increasingly estranged from Elijah Muhammad and the Nation of Islam hierarchy. When, on 1 December 1963, he argued that the assassination of President Kennedy was a case of 'chickens coming home to roost', the Nation found its excuse to expel him. A staunch black nationalist, albeit no longer a separatist, he declared in June 1964: 'We want freedom by any means necessary. We want justice by any means necessary. We want equality by any means necessary.'

His militancy was shared by charismatic young SNCC members such as Stokely Carmichael and James Forman. All across black America in the first half of 1964, patience was wearing

thin, as one small but insignificant episode during the March on Washington (which Malcolm X derided as 'the Farce on Washington') had recently demonstrated. At the end of King's legendary speech at the Lincoln Memorial, a furious voice had risen from the crowd.

'Fuck that dream, Martin! Now, Goddam it, now!'

*

'The name of this tune is "Mississippi Goddam",' said Nina Simone in her unmistakably regal tones, seated at her piano on the stage of Carnegie Hall. 'And I mean every word of it.'

'Mississippi Goddam' was never recorded in a studio, so the best-known version, recorded on 21 March 1964, allows you to hear the song punctuated by the (mostly white) audience's reaction. Simone strikes up a muscular vamp on the piano, somewhere between jauntiness and hysteria. She announces the title to gales of cosy laughter. She sings the first verse with lusty vigour, then says, 'This is a show tune but the show hasn't been written for it yet.' More laughter, but this time tense and muted. In the next verse, her performance becomes more threatening as she conjures up bad omens of black cats and hound dogs on her trail. You can sense the mirth freezing in the audience's throats as she climbs the rungs of her disquiet, from personal confusion to religious doubt to volcanic rage. 'Don't tell me, I'll tell you,' she snaps, and every white person in Carnegie Hall is implicated in that *you*. 'Me and my people are just about due.' Her band members chime in as the voice of the establishment – 'Do it slow' – as her impatience builds and builds, and the song snaps in two. 'I bet you thought I was kiddin', didn't you?' she says teasingly, and now there is no laughter at all because she is singing of picket lines and school boycotts and segregation and centuries of racist deceit, and her anger is magnificent and shocking: 'This whole country is full of lies / You're all gonna die and die like flies / I don't trust you anymore.' Even at a distance of over four decades you can almost taste the tension in the air, metallic like electricity

or blood. She smacks the piano keys, extrudes from her mouth a long, ragged *Goooodddaaaaamm*, and whoops a final 'That's it!' Of course that was it. How could she follow that?

Simone's song was 'Now, Goddam it now!' set to music: Cooke's was 'I have a dream'. Gospel preached patience and endurance: *keep on*. To a Forman or a Carmichael, that kind of faith in the face of lead pipes and fire hoses made you a sucker. To King and the believers, it represented a quiet strength which refused to be distorted by rage and hatred. Who was right didn't come into it – you either felt it or you didn't. Cooke felt it in his bones, despite the sickness in his stomach when he heard the latest reports from the South, and the hotness in his blood when he heard Malcolm X's revolutionary rhetoric, and now he was ready to put it into practice.

During the spring of 1963 Cooke's friend and business partner J. W. Alexander had given him a copy of *The Freewheelin' Bob Dylan* and the singer had become obsessed with 'Blowin' in the Wind'. 'Geez,' he told Alexander. 'A white boy writing a song like that?' When it was sung by a multiracial ensemble at the March on Washington, it got under Cooke's skin, reminding him of what he should be doing.

Shortly after Christmas he invited Alexander over to his house to hear a new song, one which united for the first time the pain and loneliness of blues with the redemptive promise of gospel. 'A Change Is Gonna Come' is a statement of faith under almost unendurable pressure. One verse obliquely referred to the Shreveport incident, another described being knocked down after asking his 'brother' for help, while a third adapted a line from the show tune 'Ol' Man River' with a daring agnostic twist: 'It's been too hard living but I'm afraid to die / 'Cause I don't know what's up there beyond the sky.' He sings the title four times during the song, his conviction increasing each time, like someone testing a rope to see how much weight it can bear. And so he is bruised and battered and brought to his knees but finally, in the last verse, he can sing, 'I think I'm able to carry on.' Cooke

renders the civil rights struggle as one man's vacillation between despair and hope, the two emotions doing battle most fiercely in just one word: the extended, wavering *long* in the final refrain of 'it's been a long, a long time coming'.

Cooke handed the song to arranger René Hall, who gave it a symphonic, cinematic feel just a whisker away from bombastic. Kettle drums beat out its steady defiance, brass salvoes punch home the more anguished lines and velvety strings and French horn affirm the song's final promise. The recording session, on 30 January 1964, went like a dream. As it moved between darkness and dawn, Cooke's vocal performance was a masterpiece of suffering and strength.

Cooke, however, was unsettled by the song. When he asked Womack for his opinion, the guitarist replied, 'It feels like death.' Then a qualification: 'No, I'm gonna take that back. It don't feel like death, but it feels eerie, like something's going to happen.' Sam agreed and said he was never going to sing it in public, but wiser heads prevailed and he debuted the song on *The Tonight Show* a week later. 'It almost scared the shit out of me,' he confessed to his drummer afterwards.

*

There were much scarier things afoot in 1964. In June a coalition of civil rights groups launched a voter registration drive known as Mississippi Freedom Summer, a nerve-racking journey through the dark heart of the South, bringing with it a wave of beatings, arrests and church bombings.* Hundreds of student volunteers, not to mention folksingers Pete Seeger, Phil Ochs and Judy Collins, returned tougher and wiser from their ordeal. Three never came back; missing for six weeks, their bodies were discovered beneath an earthen dam on farmland in Mississippi on 4 August.

There was drama of a different kind in Northern cities. In the

* Activists predictably took up 'Mississippi Goddam' as an anthem for the project.

space of just six weeks that summer, a string of race riots broke out in Harlem, Rochester, New Jersey, Jacksonville and Chicago, leading to hundreds of injuries and arrests. Events in Harlem introduced a new phrase to the vernacular of 1960s rebellion when black Maoist agitator Bill Epton was convicted of criminal anarchy for speeches including three pungent words: 'Burn, baby, burn!'

Preparations for the presidential election in November were also proving divisive. After the Republican National Convention nominated the profoundly conservative Barry Goldwater in July, black former baseball star Jackie Robinson wrote, 'I now believe I know how it felt to be a Jew in Hitler's Germany.' And in August, just weeks after Lyndon B. Johnson signed into law the Civil Rights Act, which outlawed racial segregation in employment and public places, delegates from the Mississippi Freedom Democratic Party, an SNCC-backed alternative to the state's white-only official delegation, were turned away from the Democratic National Convention. Once again, disillusionment begat militancy. 'This proves the liberal Democrats are just as racist as Goldwater,' railed Stokely Carmichael.

One of the big hits that troubled summer was 'Keep on Pushing', a gently stirring soul number by Chicago's Impressions. Despite the nothing-to-see-here tone of the record sleeve – the group grinning as they pretend to push a car down the street – there was no doubting the true nature of their 'higher goal', nor the 'great big stone wall' that stood in their way. Raised in Chicago's tough Cabrini Green housing projects, the Impressions' lead singer, the benign, bespectacled Curtis Mayfield, was the acme of gospel perseverance. Throughout his career he would pass social comment with a patience and generosity which never succumbed to anger: soul music's answer to Martin Luther King. 'Our purpose is to educate as well as to entertain,' he once explained. 'Painless preaching is as good a term as any for what we do.' The following year, his redemptive 'People Get Ready' would update the motif of the gospel standard 'This Train Is Bound for Glory'

by softening its stern, old-time righteousness: all but the most malign sinners were welcome aboard Mayfield's train.

Cooke, you feel, would have warmed to the song's compassionate embrace, had he been around to hear it. But on 11 December 1964, just days after editing 'A Change Is Gonna Come' for its imminent single release, he was shot dead by the female manager of a Los Angeles motel during a drunken struggle. His last, incredulous words: 'Lady, you shot me.'

*

When, in 1984, the NME's Gavin Martin asked Simone whether she was still involved in political causes she replied sadly, 'No, I am not. It got me into a lot of trouble. It hurt my career. Maybe it helped black people, but it hurt me.'

At first, however, she was reborn. Thus far, her success had been tainted by the hollowness she felt whenever she wasn't on stage and, beneath that, the vestigial guilt over betraying her mother with 'real songs'. Now, when the applause died down each night, she still had work to do: books to read, people to meet, a cause to champion. She developed friendships with Stokely Carmichael, the South African singer Miriam Makeba (who was Carmichael's new wife), Nation of Islam minister Louis Farrakhan and Malcolm X's wife Betty Shabazz.

Over the next few years, Simone would be sure to include one or two protest songs on each album. Some were her own compositions: 'Four Women' was a study of racial identity so frank that it was banned by some black radio stations, while 'To Be Young, Gifted and Black' paid homage to Lorraine Hansberry, who died from cancer in 1965. Some were classic political songs, pregnant with significance: 'Strange Fruit', 'The Times They Are a-Changin'', Pete Seeger's 'Turn! Turn! Turn!'. But, even more remarkably, she was able to colour unrelated songs with meaning, breathing the heat of the civil rights struggle into Brecht and Weill's 'Pirate Jenny' and Anthony Newley and Leslie Bricusse's show tune 'Feeling Good'. Most glorious of all was 'I Wish I

Knew How It Would Feel to Be Free', written by pianist Billy Taylor and lyricist Dick Dallas, with a vibrant arrangement which transmuted frustration into mighty joy. H. Rap Brown of the SNCC told her she was 'the singer of the black revolution because there is no other singer who sings real protest songs about the race situation'.

But Simone felt it all too deeply. Each fresh piece of bad news struck her like a bullet. She was rehearsing for a Carnegie Hall show in February 1965 when news arrived that Malcolm X had been shot dead by three Nation of Islam assassins at the Audubon Ballroom in Harlem. 'The moment you started feeling optimistic about the way things were going, as I did at the very start of 1965, you could be sure that something terrible – like Malcolm's death – would jump up and hit you in the face.'

Sometimes good news came out of bad. In March the killing of a black demonstrator by a state trooper in Alabama triggered a pivotal show of strength: an SCLC-organised march from Selma to the state capital, Montgomery, to demand an explanation from Governor Wallace. After two thwarted attempts, close to 8,000 people walked the fifty-four miles to the capital over five days. On arriving at a muddy church playground in St Jude, just outside Montgomery, they were greeted by an all-star rally featuring the likes of Harry Belafonte, Sammy Davis, Jr, Peter, Paul and Mary and Nina Simone. 'Instead of singing "Blowin' in the Wind" the way we did on the record, we sang it slowly, in the rhythm of their weariness, of that long march,' Peter Yarrow told David Crosby. By contrast, one can only imagine the cathartic force of hearing 'Mississippi Goddam' on such a day.*

Robert F. Williams, broadcasting from his Cuban exile, predicted that the coming summer would make 1965 'the Year of Fire'. On 6 August the Voting Rights Act signified the civil

* A sobering coda: after the Selma march, a white demonstrator, thirty-nine-year-old Viola Liuzzo, was shot dead by Klansmen for sharing a car with a black man. The song she was humming when they struck? 'We Shall Overcome'.

rights movement's victory over Southern segregation, but just as the Birmingham church bombings had seemed like a swift and crushing rebuke to the high hopes of the March on Washington, a new battleground opened up just days later.

On the evening of 11 August a California highway patrolman in the Los Angeles neighbourhood of Watts pulled over a motorist for driving erratically. The driver was arrested; his family protested; neighbours crowded around and clashed with police officers. The disturbance triggered a chain reaction throughout Watts as the long-fissile tension between the police and black residents finally went critical. Over the next five days, during which thousands of National Guardsmen poured into the city, thirty-four people were killed, around 1,000 injured, almost 4,000 arrested, and $46 million worth of damage wreaked on Watts by crowds whooping, 'Burn, baby, burn!' A news helicopter, the first of its kind, ensured that the whole thing was broadcast live to a horrified nation.

Sensing the looming white backlash, Dr King was heartbroken. On a visit to the smouldering neighbourhood, he met a group of young men who told him, 'We won.' 'How can you say you won?' asked King. 'We won because we made the whole world pay attention to us,' he was told baldly. Attorney General Ramsey Clark wailed, 'Everything seemed to collapse. The days of "We Shall Overcome" were over.' It was the boiling frustration of 'Mississippi Goddam', rather than the steady dignity of 'A Change Is Gonna Come', which had the tang of prophecy in the Year of Fire.

PART TWO

1965–1973

6

'Whoopee! We're all gonna die!'

Country Joe and the Fish,
'I-Feel-Like-I'm-Fixin'-to-Die Rag', 1965

Rock'n'roll goes to Vietnam

A US soldier in the 61st Infantry Division serving in Con Thien, South Vietnam, August 1967.

'What's almost unfathomable is the smallness of it,' says Country Joe McDonald, sitting in his living room in Berkeley, California. 'It was just another song. It wasn't much of anything.' He is talking about the September 1965 release of what would become his signature tune, 'I-Feel-Like-I'm-Fixin'-to-Die Rag'. When a few dozen copies of the record first appeared on the counter of a Berkeley bookshop, US troops had officially been in Vietnam for just six months. The death toll had not yet passed a thousand, three in five Americans polled supported the intervention, and President Johnson's approval rating was sky high. But by August 1969, when 'Fixin'-to-Die' became one of the seminal moments of the Woodstock festival and the most famous anti-war song in the country, over 40,000 US service personnel had died, public support for the war had halved, Johnson was gone, and America was a very different place.

It is an axiom of baby boomer mythology that rock artists were in the vanguard of the anti-war movement, but by the strictest measure, musical opposition to the war was feeble, tentative and diffuse: it's depressing to note that the biggest-selling Vietnam-themed hit of the era was Staff Sgt Barry Sadler's flag-waving 'The Ballad of the Green Berets'. 'There have always been a few hold-outs left over from the folk music period,' reflected *Rolling Stone*'s Jon Landau in January 1969, 'but despite the mass media's continually mistaken references to rock and roll as "protest music", rock musicians have done remarkably little protesting.'

But Vietnam was not just a war: it was the epicentre of the national conversation during the second half of the 1960s, an unparalleled magnet for dissent. To the ideologues of the New Left it epitomised the evils of imperialism, the failure of liberalism and the power of guerrilla resistance. To black radicals it was yet another manifestation of establishment racism. To less doctrinaire young Americans it embodied all the sins of their elders – the same

people who told you to cut your hair, or threatened to jail you for smoking a joint, also wanted to ship you off to the jungle to die. It stalled Johnson's Great Society, wrecked his presidency, radicalised campuses, caused uproar in the streets, and divided the country more than at any time since the Civil War.

Ed Sanders of avant-garde folk-rock group the Fugs compared making music during the Vietnam era to 'that Dada poetry reading that Tristan Tzara gave in 1922 in Paris, with an alarm clock constantly ringing during the reading. The war was THE alarm clock of the late '60s.'*

*

The first songwriter to sniff out inspiration in Indochina was Phil Ochs. As far back as October 1962, when the US had only 10,000 military advisers stationed in South Vietnam, he published 'Viet Nam' in *Broadside*. At that stage, Ochs was in a tiny minority of Americans who understood what their country was up to in Vietnam: propping up the corrupt and despotic South Vietnamese premier Ngo Dinh Diem and thwarting North Vietnamese dreams of reunification, for fear of other Asian countries falling like dominoes to the communists.

After the increasingly brutal Diem was ousted and murdered in a Washington-endorsed military coup in late 1963, *US News* still assured its readers that Vietnam was a 'local war . . . *Big war* is not threatened.' But Diem's replacement by even shabbier rulers meant that more direct action was called for. In August 1964 President Johnson used a wildly exaggerated naval skirmish in the Gulf of Tonkin as a phony pretext for a dramatic escalation that was already on the cards. Despite annihilating Barry Goldwater in the November election by painting his opponent as a dangerous hawk, Johnson himself took a hard line on Vietnam. Following Operation Rolling Thunder, a sustained bombing campaign over North Vietnam, the first US ground

* Tzara actually read from a newspaper, to the sound of bells, in 1920, but it's a good metaphor.

troops set foot on Vietnamese soil on 8 March 1965, and thus the police action became a war.

The anti-war movement coalesced with impressive speed. Just six weeks later, Students for a Democratic Society (SDS) organised the first national demonstration in Washington DC. Recalled SDS member Todd Gitlin: 'When we rolled into Washington I remember seeing great flocks of buses parked along the mall, scores of them . . . I thought, we're in business, we're rolling.' The marchers numbered 25,000: roughly equal to the number of troops stationed in Vietnam. Entertainment came from Joan Baez, Judy Collins, the Freedom Singers and Phil Ochs, who ruffled a few feathers with the waspishly satirical 'Love Me, I'm a Liberal'. His second album, *I Ain't Marching Anymore*, led with the pacifistic title track: 'Call it peace or call it treason . . . But I ain't marching anymore'. His efforts earned him a bulging file in the offices of the FBI. He was officially classified as a 'Security Matter' around the time he chose to decorate the sleeve of a live album with eight poems by Mao Tse-tung and the question, 'Is this the enemy?'

The likes of Ochs and Gitlin were very much ahead of the curve; most Americans backed the war, trusting in a speedy victory over the Red menace. In private, however, Johnson was far from confident of success. When someone at the Saigon embassy talked about 'light at the end of the tunnel', the president barked: 'Light at the end of the tunnel? Hell, we don't even have a tunnel. We don't even know where the tunnel is.'

*

When Joe McDonald arrived in Berkeley in the summer of 1965, it was the first time he had encountered like minds outside of his own home. Born in Washington DC, and raised mostly in El Monte, southern California, he was used to feeling isolated in his beliefs. His mother, the daughter of Russian Jewish immigrants, and his father, an Oklahoma farm boy, had both belonged to the Communist Party in the 1940s, an affiliation which had cost his father his job at the telephone company.

'I was twelve years old when my father lost his job. I grew up with communist literature in the household, Woody Guthrie music, the *People's World* newspaper,' says McDonald. He is a neat, serious man, a little remote at first, then increasingly animated. 'We didn't have many friends. Other progressive people didn't come by the house. Occasionally we went to a Pete Seeger concert.'

At school, there was a whole aspect of Joe's personality which he couldn't share with his classmates – the part that fretted about racism and labour rights and the Holocaust. So his only outlet for these ideas was music: Guthrie and Seeger, of course, but also, unexpectedly, Gilbert and Sullivan. 'They seem really lightweight these days but at the time they were feared by the establishment because they were satirical. They were political songwriters in a way.'

At the age of seventeen McDonald joined the US Navy for three years – so that 'girls would really like me', he explains with a shrugging smile. Returning home in 1962, he enrolled at college in Los Angeles, where he started writing songs, launched his own folk magazine, *Et Tu*, and joined some desegregation sit-ins. 'We had fun. Me and my friends used to go to Pershing Square and play Woody Guthrie songs for the winos and the bums.'

Attracted by the prospect of playing on local radio station KPFA, he moved to Berkeley in 1965. 'It was full of a lot of converted radicals and progressives. Most of them were solid, middle-class university people who discovered labour injustice, racial injustice, economic theory and became zealots. It was quite fun for me because I'd never encountered people like that before – a peer group who liked to say the word *imperialism* and stuff like that.'

The conflict in Vietnam was not yet dinner-table conversation across the fifty states, but if you were young in Berkeley in 1965, then the subject was hard to avoid. The University of California was already the most radical campus in the nation, the crucible of student activism. The previous December the Berkeley Free Speech

Movement, led by a twenty-year-old New Yorker and Mississippi Freedom Summer veteran called Mario Savio, had occupied the university's Sproul Hall to protest a ban on campus activism. The takeover ended with the arrest of around 800 students, the biggest such mass arrest in US history, and made a national star of Savio, who called for students to throw their bodies on the gears of 'the machine' until it was 'prevented from working at all'.*

The ban was lifted in January 1965, designating the steps of Sproul Hall a site for political discussion. In May 35,000 people attended an epic anti-war protest, during which a coalition of activists led by twenty-six-year-old Berkeley dropout Jerry Rubin founded the Vietnam Day Committee. The VDC included two other figures who would, like Rubin, become national celebrities: Abbie Hoffman, a twenty-eight-year-old Berkeley graduate and SNCC member, and Stew Albert, a twenty-five-year-old welfare worker from New York. The demonstration's musical director was Phil Ochs.

*

In September the writer and director Nina Serrano asked Joe McDonald to write some music for *Changeover*, a play about Vietnam. Joe spent three days crafting a poignant lament called 'Who Am I?' After finishing it, he kept strumming his guitar and the idea for 'Fixin'-to-Die' popped into his head. Half an hour later, the song was finished. 'I had to get it out,' he says. 'I put it together and thought, this is cute.'

No other Vietnam song captures the confusion and gallows humour of the average soldier's experience quite like this. Small wonder, as McDonald told historian Christian Appy, that many demonstrators saw it as 'facetious and sacrilegious'. It possesses a reckless, almost amoral fatalism quite apart from any other

* Joan Baez, who had recently begun withholding 60 per cent of her income taxes as a protest against Vietnam policy, sang 'We Shall Overcome' and 'The Times They Are a-Changin'' for the students. The police waited for her to leave before they moved in.

anti-war composition. 'It's almost a union labour song,' he says. 'The person singing the song is not apologising for anything, he's not saying anything about world peace, he's not saying he feels bad about killing people. It's *sarcastic* about killing people. And this was a time when people in the peace movement were blaming soldiers for the war.'*

Shortly after finishing 'Fixin'-to-Die', McDonald realised that he and his fellow editors of the small folk magazine *Rag Baby* were short of copy for the next issue and hit upon a solution: a 'Talking Issue', consisting of a seven-inch vinyl EP. With a fellow Berkeley folk musician, Barry Melton, he recorded the song in a jug-band style, along with another satirical new composition, 'Superbird': 'It's a bird, it's a plane, it's a man insane / It's my President LBJ.' But he didn't yet have a band name. *Rag Baby* colleague Ed Denson suggested Country Mao and the Fish, in reference to Mao's famous statement that 'revolutionaries move among the people like the fish through the sea'. McDonald thought that was stupid, but agreed to Denson's second suggestion: not everyone would realise that 'Country Joe' referred to Stalin.

As the Fish swapped acoustic instruments for electric ones and slowly mutated into a psychedelic folk-rock band, 'Fixin'-to-Die' was by no means the highlight of their live shows – the real acid heads preferred spacier numbers like 'Flying High' – but it became a fixture at local rallies and sit-ins. In October the student-run National Coordinating Committee to End the War in Vietnam galvanised 100,000 protesters in forty cities across the country. In Berkeley, when demonstrators marched past Country Joe's apartment, McDonald planted his speakers in the window and blasted the song into the street.

* The soldier was anathema to the early 60s folk movement. Ewan MacColl's 'The Dove' urged young men, 'Don't you join no army'. Buffy Sainte-Marie's controversial 'The Universal Soldier' (1964) drew a furious response from Jan Berry of surf duo Jan and Dean, in the shape of 'The Universal Coward'. Ochs was by turns sympathetic ('Talkin' Vietnam Blues') and scathing ('One More Parade').

But 'Fixin'-to-Die' would take a long time to permeate US culture. Meanwhile, the biggest combat-themed hit of the Vietnam era was just around the corner, and it came from the last place that anyone expected.

*

Time described twenty-five-year-old Staff Sgt Barry Sadler as 'probably the closest-cropped, ruggedest (black belt in judo), and most musically illiterate performer on the pop charts'. A former Special Forces Green Beret who had been wounded by a Viet Cong punji stake, he returned home and sent his song, inspired by Robin Moore's recent nonfiction bestseller *The Green Berets*, to a music publisher. Released in January 1966, 'The Ballad of the Green Berets', became RCA's fastest-selling single since Elvis's heyday, shifting two million copies in its first three months and ending up the biggest hit of the year. *Life* observed, 'The folk-rock of anti-Vietnam-war ballads has been drowned out by a best-selling patriotic blood-churner.' It even inspired its own answer record – 'Dawn of Correction' in reverse – in the form of the Beach Bums' 'The Ballad of the Yellow Beret', the hero of which was a draft dodger. Bizarrely, Sadler was booked to play Boston's Winterfest in March, on the same bill as Phil Ochs and Tom Paxton. One can only imagine the frosty response from the folk faithful.*

Sadler's success was no fluke. As 1965 bled into 1966, the country charts featured Johnny Wright's 'Hello, Vietnam' (about the need to 'save freedom now, at any cost') and 'Keep the Flag Flying', and Dave Dudley's 'What We're Fighting For', all written by Tom T. Hall to reassure scared and homesick soldiers that right was on their side. They were quickly followed by Loretta Lynn's 'Dear Uncle Sam', Stonewall Jackson's 'The Minute Men (Are Turning in Their Graves)', Pat Boone's venomously

* Previous attempts to coopt the protest song for conservativism tended to be jokey provocations, as advertised by the title of one Southern quartet's 1964 album: *The Goldwaters Sing Folk Songs to Bug the Liberals*.

sarcastic 'Wish You Were Here, Buddy', and Nashville DJ Allen Peltier's thick slice of patriotic ham, 'Day of Decision'. Only Kris Kristofferson, who was recently out of the army himself, transcended bellicose sentimentality with his song for Dave Dudley, 'Viet Nam Blues', a deft, soldier's-eye view of an encounter with a Ho Chi Minh-supporting protester: 'I don't like dyin' either but man I ain't gonna crawl.'*

Kristofferson represented the rational wing of pro-war sentiment: the belief, held by many soldiers, that it was a just conflict to save the South Vietnamese from communist oppression. The far more poisonous Red Scare tendency was epitomised by cartoonist Al Capp, creator of Lil' Abner. His new character, Joanie Phoanie, was a rich hypocrite who wrote folk songs to foment revolt. In one strip she sang: 'A Molotov cocktail or two / Will blow up the boys in blue.' Joan Baez demanded an apology. One was not forthcoming.

*

The nature of the anti-war movement changed dramatically in February 1966, when the Selective Service System extended conscription to the campuses, decreeing that students with poor grades could now be inducted. The backlash produced the era's first widespread student unrest and the birth of organised draft resistance, in the form of campus 'We Won't Go' groups. Throughout 1966 the anti-war cause expanded far beyond its original kernel of clued-up activists. Four middle-class housewives, dubbed the Napalm Ladies, were arrested for blocking trucks laden with napalm in California; a trio of soldiers, the Fort Hood Three, were jailed for refusing to take part in 'a war of extermination'.† Cassius Clay, now renamed Muhammad Ali,

* Later, Kristofferson turned against the war, saying, 'I think we killed for a lot of Americans the notion that America stands for liberty and justice for everybody.'
† Pete Seeger celebrated both groups with, respectively, 'The Housewife Terrorists' and 'Ballad of the Fort Hood Three'.

rejected his draft notice and was promptly cast into the sporting wilderness. These were not the usual suspects.

The dams broke in April 1967. At the beginning of the month Martin Luther King, diplomatically mute for so long, admitted that 'a time comes when silence is betrayal' and turned his rhetorical firepower on a government which was 'taking the black young men who had been crippled by our society and sending them eight thousand miles away to guarantee liberties in Southeast Asia which they had not found in southwest Georgia and East Harlem'. Less than two weeks later, the Sheep Meadow in New York's Central Park hosted a strikingly diverse demonstration in response to yet another expansion of the draft; it featured not just students, hippies and Black Power advocates but housewives, businessmen, nuns, priests, war veterans. Almost 200 young men took part in the country's first mass burning of draft cards. The rally, and a parallel event in San Francisco, both passed off peacefully, inspiring both the formation of Vietnam Veterans Against the War and plans for a 'Vietnam Summer' of grassroots protest. Wrote Ed Sanders of the Fugs: '1967! Yes. It saw a swelling of hope in America.'

Sanders was a fascinating character who had been arrested in 1961 for attempting to disrupt the launch of a Polaris nuclear submarine and founded a Greenwich Village journal called *Fuck You: A Magazine of the Arts*. The Fugs' 1965 debut album had been drolly titled *The Village Fugs: Ballads and Songs of Contemporary Protest, Points of View and General Dissatisfaction*. After being featured on the cover of *Life*, Sanders told Johnny Carson on *The Tonight Show* that he would agree to appear only if he could perform his blackly sarcastic 'Kill for Peace' (1966): 'The only gook an American can trust / Is a gook that's got his yellow head bust.' The invitation was swiftly withdrawn.

This period of burgeoning protest emboldened songwriters. 'The songs are sometimes satiric, sometimes sorrowful and sometimes indignant, but the tone is always negative,' reported the *New York*

Times in October 1967. 'Nobody "jabs" at the administration these days; it's more like a bomb for a bomb.' The songs came in many forms. Counter-culture humour coursed through Arlo Guthrie's 'Alice's Restaurant Massacree' (1967), an eighteen-minute quasi-autobiographical talking blues about being deemed unfit for the draft because of a conviction for littering, and Simon and Garfunkel's 'A Simple Desultory Philippic (or How I Was Robert McNamara'd Into Submission)' (1966), which included digs at the secretary of defence and Staff Sgt Barry Sadler. But Simon and Garfunkel concluded that album on a sombre note. '7 O'Clock News/Silent Night' overlaid the Christmas carol with recent headlines, creating an eerie power that transcended the easy irony of the conceit. Solemn to a fault was Joan Baez's 'Saigon Bride', with lyrics by Nina Duschek. Pete Seeger entered the fray with the compassionate 'Bring Them Home' and the satirical parable 'Waist Deep in the Big Muddy'. Seeger became obsessed with the war, attending marches, playing benefits, anguishing over the news. He was devastated when radio stations shunned 'Big Muddy'.

Some anti-war comments came from unexpected quarters. Sunshine-pop group the Association backed their biggest hit, 'Never My Love', with 'Requiem for the Masses', a plea for peace so florid that some of the lyrics were in Latin, while manufactured pop group the Monkees released 'Last Train to Clarksville', a veiled account of a draftee who wails, 'I don't know if I'm ever coming home'. 'We couldn't be too direct with the Monkees,' explained co-writer Bobby Hart. 'We couldn't really make a protest song out of it. We kind of snuck it in subtly.'

Stephen Stills of Buffalo Springfield wrote 'For What It's Worth' (1967), ostensibly about an event on his own doorstep: a battle between police and youths on Sunset Strip in West Hollywood after the imposition of a draconian curfew. But, he once explained, 'It was really four different things intertwined, including the war.' Musically, it's a stroke of genius. As protest, it's pretty weak sauce, but that very vagueness ('There's something happening here / What it is ain't exactly clear') allowed it

to resonate far and wide. In the late 1960s, few developments were 'exactly clear', least of all Vietnam.

*

The war's most tireless musical critic remained Phil Ochs. Shortly after moving to Los Angeles in May 1967, he heard about plans for a massive demonstration – 'A Human Be-In' – to take place in Cheviot Hills Park in the west of the city, and thence outside a fundraiser for President Johnson at the Century Plaza Hotel. He was intrigued both by Allen Ginsberg's goofy idea, expressed in the poem 'Wichita Vortex Sutra', that war was a semantic construct and could therefore be written out of existence, and the absurdist strategies favoured by the likes of Abbie Hoffman. Putting them together, he came up with the 'War Is Over' concept. He would declare the war over, celebrate this imagined armistice at Cheviot Hills Park and march to Century Plaza to congratulate the president on his achievement, holding up signs like 'Johnson in '68 – the Peace President'.

Ochs agreed that it was 'silly', but no sillier than the 'suicidal farce' of the war itself. He scribbled down a manifesto for the rally and wrote a song for the occasion, 'The War Is Over'. His hatred for military pageantry collided with compassion for 'one-legged veterans' in a song that was somehow both caustic and humane. He called on 'young Americans to face the responsibilities of an old America gone mad'.

Come 23 June and the Human Be-In was met with both a restraining order and 1,300 members of the LAPD. Ochs barely had time to sing 'The War Is Over' from a flatbed truck before the police moved in on the demonstrators, nightsticks swinging. Such brutality against the anti-war movement was unprecedented, and Ochs, who had woken up with high hopes for his playful street theatre, was horrified. 'Phil thought it was the beginning of something really big and really bad,' his friend Ron Cobb told Ochs' biographer Michael Schumacher. 'It was like a movie to him, a Fellini movie.'

Ochs, however, clung to his 'War Is Over' idea. Rallies were springing up across the country. In October the National Mobilization Committee to End the War in Vietnam, aka 'the Mobe', organised a nationwide Stop the Draft Week, bringing in the VDC's Jerry Rubin from Berkeley to help with the organisation. Rubin arrived at the first meeting fully hippified, with a plan (cooked up by Hoffman) to 'exorcise' the Pentagon. Hoffman applied to the Pentagon for permission to levitate the building 300 feet and pretended to have invented a new sprayable drug called Lace, which caused erotomania. This new prankish spirit was not to everyone's taste. 'Black people are not going to go anywhere to *levitate* the Pentagon, OK,' said the Mobe's Gwen Patton. 'We don't find that cute.'

On 15 October around 150,000 marchers descended on Washington DC and about a third of that number, including Ochs, crossed the Potomac River towards the Pentagon. Surrounded by people chanting mantras and banging drums, the Fugs stood on a flatbed truck and ordered 'the demons of the Pentagon to rid themselves of the cancerous tumours of the war generals'. Afterwards, Berkeley activist 'Super Joel' Tornabene was photographed sliding a flower into a soldier's gun barrel – an iconic image of the peace movement. The press, however, was more concerned with the violent clashes that went on late into the night. Compared to the triumphs of April, this new combination of mischief and violence did not sit well with many activists. But Ochs admired Hoffman and Rubin's talent for witty, eye-catching political showmanship. They shared Allen Ginsberg's belief that 'national politics was theatre on a vast scale, with scripts, timing, sound systems. Whose theatre would attract the most customers, whose was a theatre of ideas that could be gotten across?'*

* In December, Rubin again demonstrated his ludic approach to politics: in a debate with the Socialist Workers Party presidential candidate Fred Halstead, he refused to speak, instead playing the Beatles' 'I Am the Walrus' and Dylan's 'Ballad of a Thin Man' to a bemused audience.

Ochs promoted his new rally, held in New York's Washington Square Park on 25 November, as 'an attack of mental disobedience on an obediently insane society'. It was a joyous success. Ochs, resplendent in replica Civil War uniform, sang 'The War Is Over' and led around 2,000 people through downtown Manhattan in a protest that seemed more like a carnival. Rally members told passers-by, 'Did you hear? The war is over!' They hugged and kissed like it was VJ Day. All thoughts now turned to the Democratic National Convention in Chicago the following August.

*

In the intervening months, however, America, and the world, changed in ways that would once have seemed unimaginable. One seismic incident followed another with uncanny velocity. Hope see-sawed with despair. Nobody, from the president of the United States down, seemed able to control events. It was all they could do to keep up with them.

For the anti-war movement, the first major turning point came on 30 January 1968, when North Vietnamese troops and Viet Cong guerrillas marked the Vietnamese New Year, known as Tet, by launching a concerted attack on dozens of towns and cities in South Vietnam. One small cadre of guerrillas even managed to breach the US embassy compound in Saigon. By the time the attackers were repelled, they had killed just eight Americans but inflicted incalculable damage on the national psyche. Back in the States, TV viewers saw US troops ducking for cover, or lying dead on the ground, right at the heart of what should have been the safest haven in Vietnam.

It was the same story across the country. The Tet offensive failed to secure a single military objective, but scored a major propaganda coup. At the end of February venerable CBS anchorman Walter Cronkite editorialised live from Khe Sanh province and told nine million viewers that 'to say we are mired in stalemate seems the only realistic, though unsatisfactory conclusion'.

President Johnson was shaken. The man saying the war was unwinnable was no draft-card-burning hippie but a national institution.

The president's re-election campaign was already under threat from a grassroots Dump Johnson movement. On 12 March it hit a wall in the shape of Eugene McCarthy, the drily intellectual Minnesota senator who was standing on a pro-peace platform and whose many hippie supporters cut their hair and spruced up their outfits under the slogan 'Get clean for Gene'. In the bellwether Democratic primary in New Hampshire, Johnson beat his challenger by a mere 230 votes: a victory so narrow that it was tantamount to defeat for the incumbent. Four days later Bobby Kennedy ended months of speculation by agreeing to join the race. Johnson's press secretary George Reedy had a scheme to woo the youth vote – 'Organise one of those electric guitar "musical" groups to travel around to meetings' – but the president's approval rating was down to 35 per cent and no rock band could change that. On 30 March he announced to the nation that he was withdrawing from the race. He also declared a partial halt in bombing North Vietnam, and the appointment of a new peace negotiator, Averell Harriman.

To the anti-war movement, this seemed too good to be true. 'When Johnson read his withdrawal statement, I did a backward somersault from a sitting position,' remembered Tom Hayden. Hayden, a former SDS president and prominent activist, had been present in Lake Villa, Illinois, the previous weekend, at a meeting convened by the Mobe to discuss plans for Chicago. Among the 200 activists present had been Rubin, Hoffman and Mobe leader David Dellinger: practically a *Who's Who* of the New Left.

Negotiations were fraught. Moderate voices feared that the event would spoil the electoral chances of McCarthy and Kennedy, and were suspicious of Rubin and Hoffman's new Youth International Party (YIPPIE!), which planned a 'Festival of Life' to counteract the 'Convention of Death'. Upon hearing

Rubin claim, 'Radicalisation involves smoking dope in the park and fighting the pigs in the street', SDS member Greg Calvert muttered, 'You're crazy. You're absolutely insane.'

Hayden also found his authority challenged from the far left. Having come of age during the sit-ins and Freedom Rides, he was now twenty-nine, too old for the draft and suspect to a younger, angrier generation of campus radicals. Chief among them was Mark Rudd, a twenty-year-old SDS member from New Jersey who had recently returned to Columbia University from a trip to Cuba with dreams of becoming an American Che Guevara, and led a week-long occupation of campus buildings. Hayden found him 'committed to revolutionary destruction, sarcastic and smugly dogmatic', with 'an embryo of fanaticism'.

Hayden and Rudd's mutual antipathy was one emblem of division in the New Left coalition. Another was a public debate between Phil Ochs and Jerry Rubin. Ochs wanted his next album to be 'a comment on the spiritual decline of America', with end-of-an-empire songs such as 'The Harder They Fall' and 'When in Rome', but he still believed in the process, playing benefits for McCarthy and closely following Kennedy's fortunes. To Ochs, America was 'a beautiful shipwreck' which could still be salvaged. To Rubin, however, it was 'the Death Society', which needed to be dismantled. 'The battle in America is not between Johnson and Kennedy, or Democrats and Republicans,' he declared, 'but between children and the machine'.*

Country Joe McDonald was no fan of Rubin's rhetoric. He had been invited to a meeting at New York's Chelsea Hotel to discuss the musical programme for the Chicago convention – a more pragmatic alternative to Rubin's original dream line-up of the Beatles, the Rolling Stones and Bob Dylan – and had not been impressed. 'I didn't like [Hoffman and Rubin],' he says flatly. 'I thought they were dangerous. They didn't seem to have

* Rubin's 'Death Society' argument rang dark and true in the early hours of 5 June, when Kennedy was shot in Los Angeles; he died the following day.

an appreciation of the seriousness of what they were doing. I was thinking about the Haymarket riots in Chicago [in 1886] in which there was a union protest and the Chicago militia shot people dead in the streets. So I knew that the establishment in Chicago had the potential and the historical precedent of *killing* demonstrators. They wouldn't think twice.'

*

If the Democratic Party had chosen a different venue for its convention, then catastrophe might have been averted. But Chicago was under the thumb of Mayor Richard J. Daley, a squat, ornery, old-fashioned boss politician. Prior to the convention he refused a demonstration permit, thwarting plans to march the several miles from Grant Park to the convention's home at the International Amphitheatre, and blocked demonstrators from unfurling their sleeping bags in nearby Lincoln Park by imposing an 11 p.m. curfew. Thousands of would-be protesters, fearful of Daley's brutish reputation, decided to stay home. Even the fledgling *Rolling Stone* magazine urged readers not to let these 'left-over radical politicos . . . exploit the image and popularity of rock and roll'. Hoffman and Rubin predicted 100,000 people would turn up; only 5,000 did.

Even on a reduced scale, though, it was a gathering of the New Left tribes: SDS organisers, McCarthy volunteers, hippie peaceniks, Yippie pranksters, Black Panthers, and wild-card provocateurs like the East Village Motherfuckers. Celebrities, too: most, including Arthur Miller, Norman Mailer and William Burroughs, in a journalistic capacity. This was a story big enough to bring out the literary big guns: an almost mythic clash of generations and ideologies. With 12,000 policemen, and almost the same number of soldiers and National Guardsmen, standing by, violence was practically guaranteed.

The Mobe drew up a schedule involving non-violent picketing, rallies and a concert, while the Yippies advertised their own, more quixotic 'Festival of Life'. More alarmist media outlets took

some of the Yippies' jokes, and several unfounded rumours, seriously: they planned to dose the water supply with LSD, poison the Amphitheatre's air conditioning system, kidnap delegates. To Hoffman, whose whole raison d'être was manipulating the media, it might have been a lark, but it invited paranoid policing.

The omens were bad. On Wednesday 21 August, the TV news broadcast footage of Soviet tanks moving into Czechoslovakia, violently dashing the hopes of the Prague Spring; Hoffman, always ready with a soundbite, nicknamed Daley's city 'Czechago'. In the early hours of Thursday 22nd the police shot dead seventeen-year-old Dean Johnson in Lincoln Park, allegedly in self-defence.

Country Joe and the Fish, who had pulled out of the protest, arrived in Chicago at the weekend to perform two shows at the Electric Theatre, and got a taste of the trouble to come. They returned to their hotel after the second concert on Saturday night, with Joe carrying a human skull, a gift from a fan. 'I got into the elevator and this guy looked at me and said, "I fought in Vietnam for guys like you." And he hit me once in the face and broke my nose. I remember thinking, "Throw the skull at him!" And then I thought, "No, it will break and I really like it."'

McDonald left Chicago just in time. On Sunday afternoon the Festival of Life began in vastly reduced circumstances, with Detroit's MC5, the only band willing to play, performing a set Norman Mailer described as 'a holocaust of decibels . . . the electro-mechanical climax of the age'. MC5 guitarist Wayne Kramer experienced 'a gnawing, creepy feeling, like an inescapable cloak of dread. We felt it coming and there was absolutely nothing we could do about it.' At midnight, the police filled the park with tear gas, then proceeded to club demonstrators and journalists alike.

It was the beginning of a nightly ritual. Inside the Amphitheatre, meanwhile, anti-war delegates were fighting a losing battle. Not only was Johnson's vice-president, the so-called 'Happy Warrior' Hubert Humphrey, a shoo-in for the nomination, but he was conspiring with Southern Democrats to torpedo attempts to add

a peace plank to his election platform.*

Tuesday was the president's birthday, and the Mobe held an Unbirthday Party. Phil Ochs, who was in Chicago as a guest of the McCarthy campaign, sang to a crowd of bandaged, bruised and embittered protesters. During 'The War Is Over', someone lit a draft card and held it in the air. Someone else did likewise. Soon there were hundreds of flames flickering in the air. 'A candlelight chorus,' remembered Hayden, 'everyone singing, crying, standing, raising fists, reaching delirium at the words, "Even treason might be worth a try / The country is too young to die."' When Ochs left the stage he told his friend Paul Krassner: 'This is the highlight of my career.'

That night, the violence resumed, worse than before. The streets around Grant Park were a chaos of rocks, bottles and nightsticks. By 3 a.m. the park was surrounded by gasmasked National Guardsmen, some of them driving jeeps bristling with barbed wire, nicknamed 'Daley dozers'. Some protesters cried, 'Chicago Is Prague!'

Inside the Hilton, where most of the delegates were billeted, Peter Yarrow of Peter, Paul and Mary heard a protester shout through a microphone, 'Delegates, if you are with us, flash your lights!' He did so and heard a huge cheer. 'I realised that the wall of this hotel looked like a Christmas tree,' he remembered. He and Mary Travers left the hotel to see rows of police and guardsmen training their rifles on the crowd. Someone thrust microphones in their direction and they began singing 'If I Had a Hammer' and, somewhat bizarrely, 'Puff, the Magic Dragon'.†

* The Humphrey camp made its own misguided grab for the counterculture vote by asking San Francisco's Jefferson Airplane to write the VP's campaign anthem. The band's sarcastic offering, 'Crown of Creation', was not deemed suitable.

† Earlier that day, Yarrow had buttonholed a delegate to back the peace plank. 'From the look on his face, I knew my ability to use Peter, Paul and Mary's history of campaigning was going to be very minimal,' he wryly told GQ.

At midday on Wednesday the convention resumed to the sound of Mahalia Jackson singing 'The Star-Spangled Banner' and the spiritual 'Ain't Gonna Study War No More', a prelude to the peace-plank debate that afternoon. Across town, a rally began in the Grant Park bandshell, featuring another performance by Ochs. After yet another flurry of police violence, Hayden urged the crowd to leave the park and march towards the Hilton. 'Let us make sure that if our blood flows, it flows all over the city, and if we are gassed that they gas themselves. See you in the streets.'

As he left the park, Hayden heard the news from the Amphitheatre: the peace plank had been rejected by a 3:2 margin. Anti-war delegates began an impromptu protest right there on the convention floor. 'We started singing "We Shall Overcome" and swaying,' remembered McGovern staffer Marty Oberman. 'I think this went on for an hour . . . We just took over the floor and, in defeat, stood there and sang this protest song.'

Meanwhile, as dusk descended on the city, 5,000 protesters found their different ways out of the park and reconvened on Michigan Avenue, where they were joined, to their delight, by a mule train led by Martin Luther King's successor as head of the SCLC, Ralph Abernathy. They approached the Hilton, according to Hayden, 'like a peasants' army towards the castle of the emperors'. At the corner of Michigan Avenue and Balboa Drive they all sat down and began singing 'This Land Is Your Land' and the like. Bathed in the glare of flashbulbs and TV cameras, one bright spark coined a chant that spread across the crowd: 'The whole world is watching, the whole world is watching.'

This was to be the final showdown: 'Bloody Wednesday'. Amid clouds of tear gas, the police did not much care who they were beating and macing: reporters, medics and dazed hippies got the same treatment as rock-throwing Motherfuckers. Even the Hilton was no longer safe; McCarthy volunteers turned their headquarters into an ad hoc hospital, shredding bedsheets to use as bandages, until the police broke in there as well. Back at the convention, Humphrey's nomination finally took place at

midnight. Depressed McCarthy delegates marched the ten miles back to the Hilton, some wearing black crêpe armbands and holding candles, as if somebody had died.

Remarkably, nobody *did* die during convention week, but there were fatalities of another kind: faith in the Democratic Party, belief that the war would be over soon, the unity of the New Left coalition, and, for some, hope itself. Journalist John Schultz called Chicago 'the Atlantis of the left'. Ochs, who narrowly escaped a clubbing himself, sank into the deepest depression of his life. 'I've always tried to hang on to the idea of saving the country,' he told Izzy Young in *Broadside*, 'but at this point I could be persuaded to destroy it.' The cover of his next album, the harsh, despairing *Rehearsals for Retirement* (1969), pictured a gravestone, on which was written: 'PHIL OCHS (AMERICAN) / BORN: EL PASO, TEXAS 1940 / DIED: CHICAGO, ILLINOIS 1968.'

*

Country Joe may have only been a bit player in Chicago, but during 1968 something strange happened to 'I-Feel-Like-I'm-Fixin'-to-Die Rag', and it happened largely because of one four-letter word.

The Vanguard label blocked the song from appearing on Country Joe and the Fish's debut album, *Electric Music for the Mind and Body*, but allowed it to become the title track of their second. This new, fully electric version was preceded on the record by the 'Fish Cheer', a tongue-in-cheek chant of the kind favoured by high-school sports teams: 'Give me an F' and so on. In June the band played a festival in New York's Central Park sponsored by the beer brand Schaefer, and decided to replace 'F-I-S-H' with 'F-U-C-K'. News of the performance, which got them kicked out of the festival, travelled fast on the city's counter-culture grapevine. Simultaneously, a local radio station took to playing the 'Rag' every day, like a theme tune. Intertwined, the cheer and the 'Rag' became an underground anthem. 'It's an insane song,' McDonald reflected at the time. 'It's really insane.'

But despite the efforts of McDonald and Ochs, there were not yet any new songs to seize demonstrators' imaginations in the way that 'This Land Is Your Land' and 'We Shall Overcome' had done. 'One thing that's missing . . . is a song that could serve as a theme for the movement, a rallying cry,' noted the *New York Times*.* If the archetypal protest song required nothing more than a voice and an acoustic guitar, the better to sing along with, then the latest offerings were very much creatures of the studio. The Byrds' 'Draft Morning', the Animals 'Sky Pilot' and the Doors' 'Unknown Soldier' all used sound effects to evoke the eerie clamour of combat.

For every song that really was about Vietnam there were a handful that sounded as if they *might* be. British band the Zombies were flabbergasted when their US label chose as a single 'Butcher's Tale (Western Front 1914)', their most sombrely uncommercial song, because it was mistaken for a metaphor for Vietnam. California's Creedence Clearwater Revival, meanwhile, found that 'Have You Ever Seen the Rain?' (about tensions within the band), 'Run Through the Jungle' (about US gun crime) and 'Bad Moon Rising' (inspired by the 1941 movie *The Devil and Daniel Webster*) were taken as anti-war comments. But frontman John Fogerty, who had narrowly avoided the draft himself by serving in the Army Reserve, did write one explicit song about Vietnam, arguably the best of its era. 'Screaming inside' over privileged young men whose connections saved them from Vietnam – specifically David Eisenhower, grandson of Dwight and son-in-law of Richard Nixon – he wrote the blistering 'Fortunate Son' in one twenty-minute burst. At a time when the White House was attempting to contrast honest working-class soldiers with pampered middle-class protesters, this was an unprecedentedly powerful howl of blue-collar rage at the war effort. In August 1969 Creedence, along with Country Joe, Joan Baez and many more, were on their way to Woodstock.

* Dylan was no use to the cause. Contrary to the core, he had used a *Sing Out!* interview published a month before Chicago to defend a friend who supported the war. 'People have their views,' he said. 'Anyway, how do you know that I'm not, as you say, for the war?'

*

The festival, the high-water mark of the Age of Aquarius, was to take place just outside the town of Bethel, New York. The organisers promised Bethel authorities that no more than 50,000 people would attend; they privately anticipated 200,000; in the end, almost half a million turned up, most of them without tickets.

Country Joe and the Fish were booked for Sunday night but McDonald didn't want to miss a thing and turned up on Friday afternoon in time for the first act, Richie Havens. When Havens left the stage, the promoters persuaded McDonald to fill a gap in the schedule. He reluctantly played a few songs to a muted response, then ran out of material because he didn't want to pre-empt the Sunday performance by playing Fish songs. He asked his road manager, Bill Belmont, for advice. 'He said, "Nobody's paying any attention to you. What the hell difference does it make what you do?" And I thought, yeah, he's right, so I went back and yelled, "Give me an F!" And they stopped and shouted "*F!*". And I thought, wow, that's weird. And I just kept going. It was quite amazing because I wasn't aware that many people *knew* the song.'

Several other protest songs were performed over the weekend, but none captured the gestalt quite like 'Fixin'-to-Die'. Preserved and popularised by the following year's hit documentary, it was one of Woodstock's defining moments. Compared to the overcooked album version, with its circus-like feel and war-zone sound effects, this version's gutsy simplicity, backed by an impromptu choir of thousands, could make your neck hairs prickle. 'It would have been number one by 1970 if our country had been as free as it would like to be,' claimed Pete Seeger, who recorded his own, unreleased version. 'It was on the lips of every young person in the country.'*

* Despite the presence of McDonald, Baez and others, Woodstock was not an especially political event. In a revealing ruction between the activists and the rock elite, Abbie Hoffman interrupted the Who's set to make a political speech and was told, 'Fuck off my stage!' by an irate Pete Townshend.

Another key performance was Jimi Hendrix's rendition of 'The Star-Spangled Banner', without doubt the most eloquent instrumental protest song rock has ever produced. Hendrix didn't so much cover the national anthem as napalm it, but the wrenching eloquence of his playing made it into a sonic Rorschach blot, allowing each listener to decide what it represented. He was either putting to the torch the failed experiment of America or evoking the birth pangs of a new, less pernicious brand of patriotism: either the Death Society or the beautiful shipwreck.

Either way, Hendrix's pyrotechnics were a far cry from the earnest humanism of the folk revival. Two years earlier, Ed Badeaux of *Sing Out!* had painted the children of psychedelia as the barbarians at the gate: 'groups, electronically turned on LOUD to obscure the individual music, employing colored lights and film images to obscure the visual image. It is amplified. It is stoned. It is completely removed from life . . . And it is a truly accurate reflection of the America of this moment.'

Apart from the fact that he made this allegedly nightmarish vision sound incredibly exciting, Badeaux's mistake was to dismiss the need for music which absorbed and mirrored the madness of its times rather than stolidly denying it. 'Protest singers in the past were most often ideologues who set pallid verse to semi-musical melodies,' argued *Rolling Stone*'s Jon Landau, a little too harshly. 'The idea that it is the music that should convey the brunt of their meaning never occurred to them.' The war in Vietnam was noisy, mechanised, hallucinatory, chaotic – qualities which Hendrix understood and Seeger did not. Hendrix's 'Machine Gun' (1970) derives its anti-war power not from its often trite lyrics but from the glorious frenzy of the noise it makes. In Vietnam itself, setting an M-16 machine gun to automatic fire was known as putting it on 'rock and roll'.

*

The first time the war correspondent Michael Herr heard Hendrix, he was with several GIs, crouching in a rice paddy, sheltering from enemy fire, while a black corporal with a tape deck blasted out the song 'Fire'. 'In a war where people talk about Aretha's "Respect" the way others speak of Mahler's Fifth, it was more than just music,' he wrote. 'It was Credentials . . . That music meant a lot to them. I never once heard it played over the Armed Forces Radio Network.' In fact, the American Forces Vietnam Network playlist *did* play Hendrix, but protest songs were *verboten* and nobody relied on AFVN if they could help it.* One GI reported that 'the true American status symbol here is the tape recorder – it parallels the car thing in the States'.

The listening tastes of troops in Vietnam were thus as hetero-geneous as the men themselves. Black soldiers played a lot of soul music; white Southerners preferred country. 'We sometimes segregate ourselves from those white guys,' one black soldier joked to *Newsweek*. 'We don't like their hillbilly music.' There were songs about missing your lover (John Denver's 'Leaving on a Jet Plane'), songs of vague menace (the Rolling Stones' 'Paint It Black'), even out-and-out peacenik anthems – Herr observed a circle of GIs singing Seeger's 'Where Have All the Flowers Gone?' and heard others listening attentively to 'For What It's Worth'. But the quintessential Vietnam song was 'We've Gotta Get Out of This Place', written by New Yorkers Barry Mann and Cynthia Weil, transposed to industrial Newcastle by the Animals and remoulded once again in Vietnam. 'This was the Vietnam anthem,' noted war veteran Doug Bradley. 'Every bad band that ever played in an armed forces club had to play this song.'†

* A typical AFVN playlist, dated 16 November 1968, features Hendrix's 'All Along the Watchtower' alongside Donovan, the Beatles and the Supremes.
† Soldiers also wrote their own topical songs. Joseph Treaster of the *New York Times* observed a phenomenon which the freedom singers or the Wobblies would have recognised: 'The songs are laced with cynicism and political innuendoes . . . The tunes are usually old favorites.'

By 1969 troop morale was wilting. That year saw the first 'fraggings': murders of abusive officers by their own men using fragmentation grenades. Marijuana had always been part of the soldiers' wind-down arsenal, but now heroin and opium began to replace amphetamines and barbiturates. It was into this environment that the suddenly famous 'Fixin'-to-Die' emerged.

It would be several years before McDonald heard about the impact of his song in Vietnam. One ex-prisoner of war told him that Hanoi Hannah, the English-speaking North Vietnamese propagandist, used to play the song to residents of the prison nicknamed the Hanoi Hilton, in the belief that it would break their spirits. Instead, he said, 'the prisoners would smile and hum along'. McDonald owns a recording of a GI singing it in Vietnam, two months before he was killed in action. Another soldier explained to the singer how his friend had bled to death in his arms, singing, 'Whoopee, we're all gonna die.'

'Those things are just chilling,' McDonald says quietly. 'I never dreamed that would happen. But I like it. They said it provided them with a touchstone to keep them from going insane.'

7

'We'd rather die on our feet than be livin' on our knees'

James Brown, 'Say It Loud – I'm Black and
I'm Proud', 1968

Soul power meets Black Power

James Brown accompanies Vice President Hubert H. Humphrey as he addresses 500 youngsters in the Watts Labor Community Action Committee's summer program, 29 July 1968.

On the evening of 7 August 1968 James Brown was in his hotel room in Hollywood when he heard a knock at the door. When he opened it and peered out, the corridor was empty, but whoever had knocked had left behind a package demanding his attention. Squatting malignantly on the carpet was a deactivated hand grenade with the words 'James Brown' painted on it.

Or so he claimed in his memoirs. The timing of the threat, which he believed to be the work of the Black Panther Party, gives the sceptical reader pause for thought because that night Brown was due to go into the studio and record 'Say It Loud – I'm Black and I'm Proud', designed to silence the voices who had been crying, with increasing vehemence, that the Godfather of Soul was nothing more than an Uncle Tom, cosying up to the white establishment while his brothers plotted revolution. But whether the grenade was cold, metal reality or just a compact metaphor for all the hostility directed at him during that over-heated year, it makes its point.

Not long afterwards *Look* magazine would feature Brown on its cover above the headline 'Is This the Most Important Black Man in America?' The accompanying article argued: 'To millions of kids on ghetto street corners, he is living proof that a black man can make it big – and still come back to listen to their troubles.' And furthermore: 'His constituency dwarfs Stokely Carmichael's and the late Martin Luther King's.'

What the profile acknowledged only fleetingly was that there were some on those ghetto street corners who held a less glowing opinion of Brown. There were those, not least in Carmichael's constituency, who had winced at the patriotic boosterism of his pre-'Say It Loud' hit, 'America Is My Home' ('to sing lies about America is not beneficial to the Black Nation', scolded radical poet Amiri Baraka), his subsequent USO tour of Vietnam and his

blossoming friendship with Vice-president Hubert Humphrey. At a White House state dinner in May 1968, where the only other entertainer was establishment wisecracker Bob Hope, the *New York Post* columnist Earl Wilson had asked Brown, 'Won't they call you an Uncle Tom for doing this?' Brown shrugged off the question, but he must have known the accusation was out there, even as he seethed over the injustice of it. The SNCC's H. Rap Brown scornfully dubbed the singer 'the Roy Wilkins of the music world', comparing him to the famously cautious NAACP leader.

The phrase on black America's lips by 1968 was Black Power, an oppositional alternative to non-violence. Brown wanted to take those words and harness them to his own vision of black self-improvement. At show after show he would take time out from the music, his voice hoarse, his face glossy with sweat, and make his own pitch to the audience. 'I used to shine shoes in front of a radio station,' he would say. 'Now I own radio stations. You know what that is? That's Black Power.'

But it wasn't in James Brown's remit to remake Black Power in his own image. In cafés and universities and meeting rooms in cities across the US, the debate was carrying on without him. Only someone with Brown's supernatural self-confidence could believe that he could persuade black America to march to the beat of his drum, but even he realised that in order to get his point across he needed to remind people that he was nobody's Uncle Tom. 'Say It Loud' is constructed as a communal chant, a declaration by the many rather than one man, but when Brown entered the studio that day in August, the blackness he was most dedicated to reaffirming was his own.

*

To say that James Brown was there at the birth of Black Power might imply that he was a part of it. It's more accurate to say that he was in the vicinity. The catalyst was James Meredith, the political science graduate whose brave stand in 1962 had led to the integration of the University of Mississippi. In June 1966

Meredith announced that he would be leading a March Against Fear through the state. It was a quixotic endeavour, made all the more so by his decision not to invite any civil rights groups to join him. He set off with just four companions. The following day he was ambushed on the highway by a white hardware clerk who blasted him three times with a shotgun and left him covered in blood. Pictures of his plight prompted groups such as the SNCC to vow to complete his march.

Blooded by sit-ins, Freedom Rides and voter registration drives, the SNCC was now heading in a much more radical direction under its new leader, Stokely Carmichael. 'The paths of Negro–white unity that had been converging crossed at Selma, and like a giant X began to diverge,' wrote Martin Luther King. In January 1966 a college student and recent SNCC recruit called Sammy Younge, Jr, attempted to use the toilet at a white-run gas station and received a bullet in the head by way of reply. The killing was the last straw for Carmichael and his SNCC colleague, James Forman. 'For myself, Sammy's murder marked the final end of any patience with nonviolence,' wrote Forman. Carmichael's tough approach made him an enemy of the NAACP's Roy Wilkins, who was widely regarded by younger activists as an establishment bootlicker. The black activist Julius Lester mockingly wrote: 'If President Johnson had called up one night around midnight and said the sun was shining brightly, Roy would've had to look out the window to check.'

As the voices of militant dissent in the civil rights movement were growing louder and more numerous, a significant semantic change was also taking place. Malcolm X had argued for the word 'black', decreeing 'Negro' 'a label the white man placed on us to make his discrimination more convenient', and it was catching on via the likes of Carmichael. The phrase 'Black Power' had first been used in 1954 by writer Richard Wright, but it was only now about to become a sweeping slogan.

Even as the march began, the cracks in the movement were plain to see. Sporting sunglasses and an Afro, Carmichael linked

arms with the soberly suited Martin Luther King at the head of the march, a visual analogue for the two men's divergent policies.* When the marchers reached Greenwood, they staged a rally. SNCC organiser Willie Ricks took the microphone and asked, 'What do we want?'

The crowd gave the traditional response: 'Freedom now!'

'Uh uh,' scolded Ricks. He tried again.

'Freedom now!' they repeated.

Then he told them the new answer to the old question: 'Black power!' Again and again, he told them. Gradually, the new call rose up, smothering the old. At another rally that evening, Carmichael took up the cry and this time the crowds knew their lines. 'Ricks had everybody primed,' Carmichael later recalled. 'Ricks was there saying, "Hit them now, hit them now." I kept saying, "Give me time, give me time." When we finally got in, we dropped the Black Power, of course they had been primed and they responded immediately. But I myself, to be honest, I didn't expect that enthusiastic response.'

With all media eyes on Mississippi, the phrase spread like flu. King, aghast, called it 'an unfortunate choice of words'. 'Black Power can mean in the end only black death,' Wilkins dolefully warned. But there was no stopping it now. In the crowd at Greenwood, white veterans of the civil rights struggle felt the ground shifting beneath them and sensed the implication: this was no longer their fight.

Julius Lester would later gleefully record the moment in his tract *Look Out Whitey! Black Power's Gon' Get Your Mama*: 'What had been a dull march turned into a major news event. Everybody wanted to know what this Black Power was. If SNCC had said Negro Power or Colored Power, white folks would've continued sleeping easy every night. But BLACK POWER! Black! That word. BLACK! . . . My God, the niggers were gon'

* When King and his comrades began singing 'We Shall Overcome', other marchers omitted the verse about 'black and white together' and told him that they would rather be singing 'We Shall Overrun'.

start payin' white folks back.'

To paraphrase Buffalo Springfield, there was something happening here; what it was wasn't exactly clear. Having popularised Black Power, Carmichael was slow to define it. 'We're not ever to be caught up in the intellectual masturbation of the question of Black Power,' he told an audience in Berkeley in October 1966. It was less a solid political platform than a basket of different, even competing ideas: separatism, Afrocentrism, Islamism, revolutionary socialism. Although there was confusion over what Black Power stood *for*, what it was *against* was clear as day. At the end of his epic Berkeley speech, Carmichael warned white America: 'Move over, or we're going to move on over you.'

*

James Brown was uneasy about the changing mood. At thirty-three, a decade into an extraordinary career, he was political more by virtue of his unique position than of any deliberate intent. Born in a one-room shack in South Carolina, he had found fame with his group the Flames when their very first single, 'Please Please Please', sold over a million copies in 1956. Hard work and obstinacy kept the Flames touring solidly, even in the face of blatant racism in the segregated South.

Brown hit paydirt in spring 1963 with the bottled lightning of *Live at the Apollo*, which remains the greatest live album ever recorded. It was taped during a week-long residency at the Harlem Apollo the preceding October, two days into the Cuban Missile Crisis. Brown strutted and strained, shouted and shimmied, sweated and screamed. He fell to his knees. He hollered like a man possessed. He made America love him.

If *Live at the Apollo* was all about overload, then Brown's true stroke of genius depended on reining himself in. In February 1965 he had convened his band in Charlotte, North Carolina, to record 'Papa's Got a Brand New Bag', the ur-text of funk. Funk peeled away everything but rhythm, and then redefined what rhythm could do. Listeners had never danced to anything

like it, and single after single followed 'Papa's Got a Brand New Bag' into the charts, making Brown a superstar.

No black entertainer with such cultural reach could avoid becoming a spokesman. The previous month, Roy Wilkins had visited Brown backstage at the Apollo and recruited him to the NAACP. When Brown heard about Meredith's assault he flew down to Mississippi to visit him in hospital and perform for the marchers in Tupelo. Shortly afterwards, Brown flexed his political muscles on vinyl for the first time with the sternly self-improving single 'Don't Be a Drop Out'. Funk was the perfect vehicle for such a message, every whipcrack beat taut with the virtues of discipline and hard work. If this famously tough taskmaster could keep his band in line (he fined them $50 for drinking on the job or wearing a wrinkled suit), then why not the nation's black youth? He launched a Stay in School campaign, granting $500 scholarships to black students at every stop on his tour, and received a citation from Vice-president Humphrey.

Black radicals, however, had different ideas about how Soul Brother Number One should apply his enormous influence. As Brown proudly remembered, 'Stokely said I was the one person who was most dangerous to the movement at the time because people would listen to me.' And if Carmichael's Black Power speech in Greenwood had fractured the fragile multiracial unity of the civil rights movement, then the formation of the Black Panther Party for Self-Defense in October cracked it wide open.

*

It was the brainchild of Huey Newton and Bobby Seale, two community organisers in Oakland, California. They took their logo from the Lowndes County Freedom Organisation that Carmichael had established in Alabama and their revolutionary theory from Mao Tse-tung, Frantz Fanon and Robert F. Williams. Non-violence was no longer the tactic, integration no longer the goal. In their ten-point programme they combined reasonable demands for decent housing and education with

rather more dramatic ambitions: freedom for all black prisoners, all-black juries for black defendants, exemption of black men from military service and a UN-supervised plebiscite to decide on black self-rule.*

Newton and Seale were brilliant self-publicists. They gave the Panthers a uniform to match their platform – all-black – and a novel structure: Seale became chairman and Newton minister of defence. Eldridge Cleaver, whose radical prison writings had been collected under the title *Soul on Ice*, was appointed minister of information while on parole from Folsom Prison. No sooner had they launched the party than they began building an arsenal, raising funds by selling copies of Mao's *Little Red Book*. A new rumour began to sweep the ghetto, claiming that the government was preparing concentration camps to incarcerate black dissidents. The guns were key props in the Panthers' revolutionary theatre. A year earlier, a news helicopter had burned images from Watts on to the retinas of viewers nationwide: TV was the new battleground.

In May 1967 twenty armed Panthers drove from Oakland to Sacramento, home of California's new Republican governor, Ronald Reagan, to protest the proposed Mulford Act, which would prohibit the bearing of loaded guns in public places. By the time the Panthers entered the capitol building, uniformed in leather jackets, berets and guns, a forest of cameras was waiting to transmit the new face of black militancy across the nation. After being escorted from the debating chamber by police, Seale read his 'executive mandate' four times so that the journalists could take down every word. 'The time has come,' he declared, 'for black people to arm themselves against this terror before it is too late.' Once the media reported this 'invasion', the Panthers became white America's new bogeymen. To the surprise of nobody, the Mulford Act passed.

* The founding Panthers were obsessed with Dylan's 'Ballad of a Thin Man', which Newton interpreted, somewhat fancifully, as a parable about racism.

If the Panthers directed most of their scorn towards the white power structure (not white people per se, although the subtlety of the distinction was lost on many followers and foes alike), then they reserved some for the aspirant black middle class. At a rally in San Francisco the poet Amiri Baraka told the black bourgeoisie, 'We're going to try to burn you black, because if we don't burn you, nothing will but the actual fire, which we're trying to desperately bring about.'

And which performer better represented black bourgeois aspiration than James Brown?

*

In October 1966 Brown received a surprise visitor to the stage of the Apollo. The devoutly unfunky Nelson Rockefeller, who was running for re-election as governor of New York, surprised him with a handshake and a photo op. Brown smarted at the intrusion. 'OK, you got what you wanted, now go,' he told the governor before continuing the show.

Brown later boasted that he had never voted in his life ('I cast my vote with ideas and concepts'), but he was a prize catch for any politician courting the black vote. He counselled Hubert Humphrey about the gathering storm in the inner cities, although by that stage the vice-president hardly needed telling. 'I think I was providing the Democrats with one of the few non-white views they had of things from the street,' Brown later boasted. 'Dr King himself wasn't a street person. I was. I came from a ghetto and was close to the people in the ghettos all over America.'

Brown liked underdogs who thrived on their wits. 'My story is a Horatio Alger story,' he once said.* 'It's an American story, it's the kind that America can be proud of.' He believed passionately in equality of opportunity but always with the sobering addendum that black people needed to earn their place through hard work and self-discipline.

* Alger (1832–99) specialised in 'rags-to-riches' novels.

During the summer of 1967, as Brown's latest, greatest funk missive 'Cold Sweat' swept the country, the fire that Baraka was calling for finally engulfed inner-city America. In over sixty towns and cities, local confrontations with the police blossomed into full-blown riots, with the worst violence occurring in Newark and Detroit. H. Rap Brown, the twenty-three-year-old firebrand who had just replaced Carmichael as chairman of the SNCC, was practically licking his lips when he told an audience in Cambridge, Maryland, 'Detroit exploded, Newark exploded, Harlem exploded! It's time for Cambridge to explode, baby. Black folks built America. If America don't come around, we're going to burn America down, brother.' When, following his speech, a local elementary school was set on fire, H. Rap Brown was arrested and charged with inciting riot and arson. Released on bail, he called a press conference which was not notable for its repentant moderation. 'Violence is necessary,' he famously declared. 'It's as American as cherry pie.'

If Rap provided the post-riot rhetoric, then the Panthers provided the imagery. Cleaver staged an instantly iconic photograph of Huey Newton, posing in a wicker throne, tribal shields to either side and an animal pelt at his feet, with a spear in one hand and a shotgun in the other. His image was cemented by his arrest, in October, for shooting dead a rookie Oakland police officer called John Frey. Newton became an outlaw hero to black and white radicals alike and the cry, led by Cleaver, went up: 'Free Huey!'

So when the two Browns, H. Rap and James, sat down to talk at the Apollo in November 1967, there was a chasm between them: the extremist versus the diplomat, the enemy of the white system versus the vice-president's friend. Rap told James about his plans and the singer replied, 'Rap, I know what you're trying to do. I'm trying to do the same thing. But y'all got to find another way to do it. You got to put down the guns, you got to put away the violence.' No, Rap replied, 'you don't understand.' He wanted James to join the struggle, urge his fans to take up

arms. But the singer didn't want a revolution – even if one were to take place, he believed black people would never prevail. 'I agree with you, Rap, we got to get justice,' he tried one more time. 'But people shouldn't have to die. They shouldn't have to die.' A cordial impasse had been reached. The conversation was over.

But James Brown wasn't unsympathetic to his namesake's cause. During his next Apollo residency, he invited his accountant on stage to present a cheque to the H. Rap Brown Defense Fund and closed his tenure with a passionate and pointed speech. 'I know I am black, I always will be black, and you are my people,' he said. 'The way things are going in this country . . . I don't know . . . I may try to run for president.' And then he uttered the line that would eventually wind its way into 'Say It Loud': 'But no matter what, remember: Die on your feet, don't live on your knees.'

*

The Black Panthers entered 1968 by forging alliances. The Peace and Freedom Party, a new hardline white anti-war group, proposed a joint candidacy in the November presidential elections: Cleaver for president and Jerry Rubin for VP. In February, the same month the Kerner Commission, in its influential report on the previous year's civil disturbances, warned that 'our nation is moving towards two societies, one black, one white – separate and unequal', the Panthers also allied themselves with the SNCC, appointing Carmichael prime minister of the party, Rap Brown minister of justice and Forman minister of foreign affairs. On 17 February, Newton's birthday, they staged a Free Huey rally in Oakland, where Forman delivered a menacing warning: 'We must serve notice on our oppressors that we as a people are not going to be frightened by the attempted assassination of our leaders . . . If Huey Newton is not set free and dies, the sky's the limit.'

Brown, meanwhile, began the year with a different brand of empire-building, buying radio stations in Tennessee, Augusta and Baltimore. By 1969 he would be the proud owner of the

black-run Gold Platter restaurant chain, James Brown trading stamps and a fortune estimated at $3 million. At the end of March he made his first fleeting visit to Africa, playing in Abidjan, the capital of the Ivory Coast. But when he boarded the plane in Abidjan on Wednesday, 2 April, he had no idea he was flying back into the most challenging week of his life.

On the evening of 4 April Martin Luther King was shot dead by escaped convict James Earl Ray on the second-floor balcony of the Lorraine Motel in Memphis, while supporting striking black sanitation workers. The question was not whether anger would explode into violence but simply how soon, for how long and in how many places.

Brown was in New York when he heard the news, and appeared on TV urging black communities to 'cool it'. Meanwhile, in Boston, there was talk of cancelling Brown's show the following night. Black councilman Thomas Atkins told the city's youthful new mayor Kevin White, 'If the word gets out in the black community that the city would not let Brown come to town and perform in the wake of King's assassination, all hell will break loose.' On arriving at Logan Airport Brown was met by Atkins, who explained White's concerns on the limo ride into town. The National Guard, he said, was standing by in case of violence. 'It was rush hour, but the streets were deserted,' remembered Brown. 'Sort of like the calm before the storm.'

During the ride, Atkins and Brown discussed Dr King's philosophy of non-violence and the councilman explained his plan: the concert would go ahead with a simultaneous telecast. When Brown, whose admiration for King was outweighed only by his dedication to the bottom line, saw fans queuing for refunds at the Boston Garden so that they could stay home and watch for free, Atkins asked the reluctant mayor to guarantee his considerable fee. 'I never met anything like James Brown,' reflected White, who had never heard of the singer before. 'Man, he was a piece of work.'

At the very last minute, Brown got his money and Boston got

its concert. At the Garden, Brown (crassly introduced on TV as 'Negro singer Jimmy Brown and his group') opened proceedings by introducing White, somewhat generously, as a 'swinging cat'. Side by side, the two men then called for peace in the name of Dr King. Even their surnames combined to form a tableau of racial brotherhood: Brown and White together. It was an emotional show, during which Brown cried and made one of his impassioned pleas for *his* version of Black Power. Outside, on Boston's eerily quiet streets, no petrol bombs were thrown, no stores looted.

But beyond the protective force field that Brown seemed to have cast over Boston, fires raged in 110 other cities. The next day Brown flew to Washington DC, where rioters had come within two blocks of the White House, to survey the damage and dampen tensions. 'Don't terrorise; organise,' he said on television. 'Don't burn; give kids a chance to learn. Go home. Look at TV. Listen to the radio.' And then – why not? – 'Listen to some James Brown records.' His intervention would secure his invitation to the White House and cement his reputation among the country's politicians and opinion-formers as a black man they could do business with. But black radio DJs also played their part in quelling the mayhem. Faced with a choice between the depression of grief and the temporary catharsis of revolt, they gritted their teeth. 'If, in every major city, a black disc jockey had said, "Rise up," there would have been pandemonium,' New York DJ Del Shields told writer Nelson George. 'And that night was also the beginning of the end of black radio. It was never allowed to rise up again.'*

The militants, however, chose pandemonium. Smoothly setting aside the fact they had spent the past two years calling King a useless Uncle Tom, the firebrands of the Panthers and the

* The first musical reaction to King's death came quickly. On 7 April, at a festival in Long Island, Nina Simone's band performed a fifteen-minute version of a song they had just written, 'Why? (The King of Love Is Dead)'.

SNCC made a martyr of him and seized on his death as proof that there was no reasoning with white America any more. The chasm between the integrationists and the radicals had deepened into an ocean trench. On the night of the assassination, Carmichael sought to cool tempers but at a press conference the next day he was ablaze. 'White America has declared war on black people,' he thundered. 'There no longer needs to be intellectual discussion. Black people know they have to get guns . . . When America killed Dr King last night, she killed all reasonable hope.'

One journalist asked what the riots could possibly achieve. 'The black man can't do nothing in this country,' replied Carmichael. 'We're going to stand up on our feet and die like men. If that's our only act of manhood, then Goddammit, we're going to die. We're tired of living on our stomachs.'

Over in Oakland, on 6 April Eldridge Cleaver and a group of fellow Panthers clashed with the police in a thirty-minute gun battle which left Cleaver wounded and teenaged Panther Bobby Hutton dead. Coming on top of the Free Huey campaign, Hutton's death only enhanced the Panthers' martyr status. In a letter to the *San Francisco Chronicle*, such A-list sympathisers as James Baldwin, Norman Mailer and Susan Sontag claimed: 'We find little fundamental difference between the assassin's bullet which killed Dr King on 4 April, and the police barrage which killed Bobby James Hutton two days later . . . Both were attacks aimed at destroying this nation's black leadership.'*

In June Brown and his band flew into Saigon to play for US troops in heat so intense that they needed intravenous drips in order to rehydrate. At night, their bedrooms at the Continental Hotel would shake from gunfire; by day they travelled in a bus with anti-grenade screens over the windows. At a show for 40,000 members of the 9th Infantry Division, the funk was punctuated by the percussive rattle of distant Viet Cong gunfire.

* Country Joe and the Fish dedicated their 1968 album *Together* to 'Bobby Hutton: Black Revolutionary'.

As if that weren't enough to outrage black radicals (even King the ameliorator had fiercely opposed the war), Brown marked his return home with the bumptious patriotism of 'America Is My Home' ('I was talking about the land, the country, not the government,' he later insisted to *Look*. 'This is *home*; we can't leave') and joined Hubert Humphrey at an election rally in Watts. A supporter of Bobby Kennedy until his candidacy ended in assassination, Brown cajoled the floundering Humphrey into publicly promising greater opportunities for black businessmen.

Like Bob Dylan earlier in the decade, Brown found himself the repository of hopes and expectations that he could not fulfil; unlike Dylan, he lacked the agility to distance himself from them. Never a man handicapped by excessive humility, he believed he could be a friend to Hubert Humphrey *and* Rap Brown, the Panthers *and* the politicians, as if by the sheer force of his willpower – and, yes, his *rightness* – he could please all of the people all of the time. After all, who could object to a black man who clawed his way out of the Southern dirt to become a self-made superstar: a *black* superstar? This was not so much strategy as instinct. So when the Nation of Islam newspaper *Muhammad Speaks* asked, 'Has James Brown Rejected His Black Supporters for White Recognition?', he was baffled as much as angry. 'They called him Sold – S-O-L-D – Brother Number One,' recalled backing singer Marva Whitney. 'And that hurt him.' During his between-song raps at shows that summer, the strong, bright topnotes of his usual self-belief were undercut by an unfamiliar minor chord of gloom and confusion. 'It seems that some of our people think James Brown's a Tom,' he rumbled at an Oakland show. 'But Tom has been dead a long time.'

The Panthers were ratcheting up the pressure on Brown. Representatives visited him to complain about 'America Is My Home'. An anonymous telegram focussed on his employment of white bass player Tim Drummond: 'You have a white man working for you and a black man needs a job.' Death threats arrived at his record label; a bomb scare forced the band to evacuate a hotel in Atlanta.

And yet at the same time, Brown had never been more famous or more admired by the mainstream. Prime-time TV shows, newspapers and magazines courted him throughout the summer. 'Talk about your Black Power,' marvelled Albert Goldman in a *New York Times* profile. 'Take a look at James Brown, mister.'

*

Speaking to the *NME* in 1984, James Brown was testy on the subject of his most politically seismic hit. 'When we recorded "Say It Loud – I'm Black and I'm Proud" it was necessary to get people to come forward but to me it was a come down,' he told Gavin Martin. 'I didn't want to have to record that because it separates them. I had to separate them and give them an identity at one point and join them together later.' (Reading these words, you have to remind yourself that he is only talking about a pop song and not, say, the Treaty of Versailles.)

So you can picture Brown walking into Vox Studios on the evening of 7 August with a heavy heart. He may not have had a gun to his head but he had a grenade at his door and a steady rat-a-tat of criticism in his ears. The song had come together gradually. According to Brown's manager, Charles Bobbit: 'We were sitting there watching television and there was some black-on-black crime going on, and he said, "Mr Bobbit, I'm having trouble with the Black Panthers, they don't believe we're real, and look at this." He said, "Why don't black people love each other? Why can't black people respect each other? Why can't we have pride?"' The music, tough and agile, was written on the day by his bandleader, Alfred 'Pee Wee' Ellis. 'I think I might have been informed about the title, [so] I had that rhythm to go by,' says Ellis. 'He intended to make a statement, and a big one.'

Brown had a notion that the chorus should be sung by a jubilant crowd of children, so he invited the band and crew to bring their kids along to the studio ('I wanted it to sound as if there were a million people singing along with me'), the only catch being that he started work so late that most of the kids had been

packed off to bed by the time the tape was rolling. Undeterred, he dispatched Bobbit to round up some random children from neighbouring streets and restaurants, many of whom were, in fact, white or Asian. 'They were having fun,' remembers Ellis. 'They were in a room with *James Brown*.'

'Say It Loud' demonstrated funk's flexibility as a vehicle for protest. Urgent, commanding and repetitious, the sound was tailor-made for a good slogan. Brown performed it like a preacher, speaking the verses (though throwing in his usual wails and grunts) and leading the choruses. 'Say it loud!' he ordered. 'I'm black and I'm proud!' the kids shouted back. Let others name names or point fingers; Brown was bent on accentuating the positive.

'People call [the song] militant and angry,' he later wrote. 'Maybe because of the line about dying on your feet instead of living on your knees. But really, if you listen to it, it sounds like a children's song.' Once again, he wanted the best of both worlds. To his black critics, it was a song of empowerment. To his white fans – hey, don't worry! – it was just a bunch of kids singing along. Purely as a piece of music, that tension made it electric, the 'die on our feet' line seemingly bussed in from a far angrier song. Ellis remembers the first time they performed it live, at the Apollo: 'James Brown says, "Say it loud!" and the whole audience says, "I'm black and I'm proud!" Just that quick. It gave me chills. That's when it hit me we'd done something important that would last.'

But as a political statement, it became entangled in its own mixed messages. Some radio stations dropped him from their playlists, inspiring him to take out a newspaper advertisement which executed a brilliant semantic foxtrot around the racial vocabulary of the day. 'We know the Negro deejay won't play this record. We know the colored deejay won't play this record, but every BLACK deejay will play this record!' To underline his point, he cut his processed pompadour back to an Afro. 'It was like giving up something for Lent,' he said, lest anyone doubt the scale of his sacrifice. 'I wanted people to know that one of the

most prized things I let go of was my hair. It was a real attraction to my business. But I would cut it off for the movement.'

If 'Say It Loud' was not the sole catalyst for a new wave of racial consciousness in pop then it was certainly the flagship, selling 750,000 copies in its first two weeks. Before 1968, black-ness was encoded in such uplifting generalities as 'change' and 'respect', but following 'Say It Loud', black musicians embraced a new candour. Sly and the Family Stone recorded 'Don't Call Me Nigger, Whitey' ('Don't call me whitey, nigger,' responded Sly's backing singers equably), and Curtis Mayfield's Impressions released 'Mighty Mighty (Spade and Whitey)', followed by such melanin-conscious Mayfield solo songs as 'Miss Black America' and 'We the People Who Are Darker than Blue'.*

One person who chose not to capitalise on the impact of 'Say It Loud', however, was Brown himself. His next political song was rather less contentious: the Christmas single 'Santa Claus Go Straight to the Ghetto'. Come 1969 and he was back to preaching the gospel of capitalist self-sufficiency with 'I Don't Want Nobody to Give Me Nothing (Open Up the Door, I'll Get It Myself)'. No Santa Claus (or his state-funded alternatives) for him. Although he backed Humphrey through to election day, he didn't turn down an invitation to play at Richard Nixon's inau-gural ball in January. 'He had a lot of respect for Nixon,' says Ellis. 'He had a van that he used to ride me around in and tell me he had secret listening devices that Nixon had given him. I don't know if it was even true!'

The Panthers, meanwhile, were in bad shape. In September 1968 Huey Newton was sentenced to two to fifteen years for voluntary manslaughter and wounding. Eldridge Cleaver, fear-ing he would be killed by the police while awaiting trial, fled into exile in Cuba, and thence to Algiers. Bobby Seale was awaiting trial for his role in the recent unrest in Chicago. The alliance with the SNCC had fallen apart amid such bad blood that James

* Brown's song was directly quoted by both the Temptations
('Message From a Black Man') and Bob Marley ('Black Progress').

Forman had a nervous breakdown and checked into a psychiatric ward, while Stokely Carmichael was making plans to move to Ghana with his wife, Miriam Makeba. Throughout 1969 no fewer than 348 Panthers were arrested over clashes with police or allegations of conspiracy, while many others turned informant. Yet FBI director J. Edgar Hoover, whose COINTELPRO programme was busy infiltrating the Panther ranks, still deemed them 'the greatest threat to the internal security of the country'.

*

When Brown performed 'Say It Loud' in Dallas, just days after its release in August 1968, he set it up carefully, asking black fans to shout 'I'm black!' and everyone else to join in on 'I'm proud!', and galloped through it in under three minutes, as if it were something he needed to get out of the way. 'Thank you,' he said earnestly. 'The atmosphere seems so clean now. We can really get together now.'

But later, he would complain that it cost him a portion of his white audience that would never return. 'I paid the price for "Say It Loud",' he claimed. 'The white community took it entirely the wrong way, as a kind of aggressive statement meant to induce fear.' Naive enough to believe that he could control listeners' reactions to his songs, he was horrified that 'Say It Loud' had gotten away from him and found a new calling as a radical battle cry, but how could it not? When Olympic sprinters Tommie Smith and John Carlos stood on the podium and silently raised their gloved fists towards the Mexican sky in a Black Power salute on 16 October, many black viewers would have found themselves mouthing Brown's words. 'They thought I was saying kill the honky,' he complained. Meanwhile, those who really *were* saying 'kill the honky' maintained their belief that he was an establishment suck-up. He was like a man trying to lash down a tarpaulin in a gale: however hard he sweated, there was always one corner coming loose.

'He thought he was all-powerful and could do all that,' says

Ellis. 'And sometimes he pulled it off.' But, he adds gruffly: 'It was about James Brown first and foremost. He had so much opportunity and he could have done so much stuff to help people, when most of the stuff he did was a scam. It was about him being seen as the leader of our community. Luckily he landed on a good platform [with "Say It Loud"], and I'm glad he did.'

Brown blamed the drop-off in bookings the following year on white hostility to 'Say It Loud'; he was back, he sighed, 'preaching to the choir'. His friend and band member Bobby Byrd claimed that, on the contrary, it was Brown's new association with the hated Nixon that drove fans away. The truth, like 'the most important black man in America', was somewhere in the middle.

8

'This-ism, that-ism'

Plastic Ono Band, 'Give Peace a Chance', 1969

The puzzling politics of John Lennon

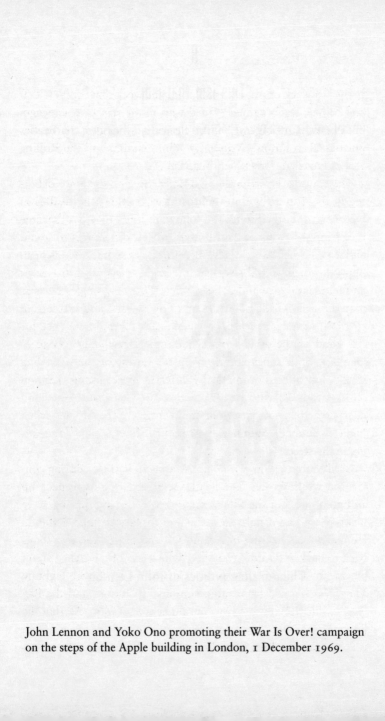

John Lennon and Yoko Ono promoting their War Is Over! campaign
on the steps of the Apple building in London, 1 December 1969.

In the last week of August 1968, the same week that the New Left and Mayor Daley's thugs waged war on the streets of Chicago, both of Britain's biggest bands released new singles: the Beatles put out 'Revolution', written by John Lennon, and the Rolling Stones unveiled 'Street Fighting Man'.

The contrast between the two was eerily perfect. Since debuting in the Top 40 within months of each other (the Beatles in October 1962, the Stones the following June) they had become the estranged twins of British music. Their differences in sound and temperament were easily caricatured as a series of Manichean oppositions: love and sex, day and night, clean and dirty, ego and id, reassurance and danger. What these new singles did was map those simplistic polarities on to the chaotic political terrain of 1968, turning, at least for a while, a listener's preference for one band or the other from a question of aesthetics to one of ideology. Both songs sprang from the unrest of the preceding spring, but offered dramatically different prescriptions. Lennon scolded radicals who carried pictures of Chairman Mao, and instructed them to 'free your mind instead'; the Stones' Mick Jagger whooped, 'Summer's here and the time is right for fighting in the street.'

Greil Marcus, who was demonstrating in Berkeley during convention week, wrote: 'The Beatles were ordering us to pack up and go home, but the Stones seemed to be saying that we were lucky if we had a fight to make and a place to take a stand.' He remembers hearing of a radio DJ who played the two songs back to back and said, 'You *know* which one of these they aren't playing in Chicago this week.' He was right: 'Street Fighting Man' was banned from radio stations in Chicago and the Bay Area, while 'Revolution' was put on heavy rotation. All that the Berkeley marchers knew of the Stones record, Marcus noted, was its title: the sheer *idea* of it possessed talismanic power.

The left's reaction to Lennon's anti-revolutionary stance was furious disappointment. The *New Left Review* damned it as 'a lamentable petty bourgeois cry of fear'. In Britain's radical newspaper *Black Dwarf*, John Hoyland penned 'An Open Letter to John Lennon': 'Love which does not pit itself against suffering, oppression and humiliation is sloppy and irrelevant.' The same issue reprinted, with Jagger's permission, the handwritten lyrics to 'Street Fighting Man', juxtaposing them with a quote from Engels. 'The rhythm of the Stones' music captured the spirit of '68 much more than did that of the Beatles,' *Black Dwarf* editor Tariq Ali later wrote.

But it was Lennon, not Jagger, who would become the face of the peace movement and then proceed to throw himself wholeheartedly into every left-wing cause he could find. And it was Lennon who would give the movement its abiding anthem, 'Give Peace a Chance'. 'Revolution' was merely the faltering start of an unprecedented journey into the heart of rock-star activism.

*

One reason that commentators seized upon these two singles with such zeal was their novelty value. While American songwriters had been dealing with politics since the folk revival, topical songwriting in Britain had withered on the vine. This was partly because the British folk scene had produced no Dylan-like figure who could bridge the gap between folk and rock – certainly not one who could compete with the white heat of the Beatles – and partly because, in comparison with the US, there simply wasn't as much to protest about. With the relatively benign Harold Wilson (arguably incompetent, but never belligerent) in Number 10 Downing Street, and none of the nationwide dramas which convulsed America, the concerns of the average young Briton were blessedly parochial. Not that the country was problem-free: the devaluation of the pound in 1967 was only the most blatant indicator of serious economic ill-health. But exchange rates do

not forge revolutionaries.* 'We were not pushed by any major issues,' remembered Sue Miles, whose husband Barry owned the counter-culture bookshop Indica. 'There was no draft, you could piss around in England quite a lot.'

So while Americans fretted about living on the eve of destruction, the defining British protest songs of 1965 – the Animals' 'We've Gotta Get Out of This Place' and the Who's 'My Generation' – were libertarian rather than reformist. Where Dylan had solemnly painted the generational divide as an almost biblical battle between idealistic youths and death-dealing methuselahs, the Who demanded nothing more than the right to have hassle-free fun: 'I'm not trying to cause a big sensation / I'm just talkin' 'bout my g-g-g-generation.'†

Until 1968, the Beatles's music was political by accident rather than design. In 1964, *Sing Out!* argued, 'Their enjoyment of life now is a strong protest and alternative to world preparation for war,' but this was not something the band themselves articulated. If some critics chose to contrast the wild joy of 'She Loves You' with escalation in Vietnam, well, that was up to them. In October 1965 Paul McCartney told the *NME*: 'We don't like protest songs of course, because we're not the preaching sort and in any case we leave it to others to deliver messages of that kind.' Asked if the group would be releasing a Christmas record, he joked, 'Definitely not our style, though come to think of it, I

* One of the few songwriters to reflect the political concerns of average Britons was the Kinks' Ray Davies, a Swinging Sixties refusenik who grumbled drolly about taxes, tower blocks, union power and declining national prestige, while dreaming of rural escape. If everyone who shared his views had bought his records, the Kinks would have been bigger than the Beatles.
† The earnest plaints and prophecies of American songwriters did not sit well with the English temperament. Reviewing P. F. Sloan's socially conscious 1965 single 'Sins of a Family', the *NME* chortled: 'It's the saga of a young girl who's a bit of a tramp, but don't blame her, folks, she's had a bad childhood!'

might suggest a Christmas protest song to John!' Six years later the joke would become a reality.

Lennon first ventured a political opinion in June 1966, when the Beatles' American label, Capitol, withdrew an edition of their *Yesterday . . . and Today* album amid uproar over its cover image of the Beatles in butchers' smocks, draped with raw meat and beheaded dolls. Lennon called the picture 'as relevant as Vietnam'. During their subsequent US tour he diligently followed the progress of the war. At a press conference in August the band chorused, 'We don't like war, war is wrong.' Lennon later emphasised their position: 'We think of it every day. We don't like it. We don't agree with it. We think it's wrong.' It was a bold and unambivalent statement but its impact was somewhat overshadowed by the ongoing controversy spawned by his earlier observation that the Beatles were 'more popular than Jesus'.

Upon returning to England, Lennon took time off to appear in *How I Won the War*, a peculiar Second World War black comedy directed by Richard Lester, who had previously established the Beatles' celluloid image in *A Hard Day's Night* and *Help!* At the premiere, in October 1967, Lennon declared: 'I hate war. If there is another war I won't fight and I'll try to tell all the youngsters not to fight either. I hate all that sham.'

Lennon's songwriting voice, however, did not lend itself to direct protest. Such anti-establishment sentiments as did creep into his songs were antic and oblique. While the Beatles' first political lyric was the unedifying 'Taxman' (1966), George Harrison's petulant moan about the Wilson government's sky-high top-rate tax, Lennon, awestruck by the mind-expanding power of LSD, was more interested in bending reality than quibbling with the details. The extraordinary 'A Day in the Life' turned 'newspaper writing' on its head, making recent headlines seem dreamlike, distanced, absurd. And the Lewis Carroll-inspired 'I Am the Walrus' was by no means as nonsensical as it initially appeared. It can be read, as Beatles scholar Ian MacDonald argues, as 'a damn-you-England tirade that blasts education, art, culture, law,

order, class, religion, and even sense itself . . . the most idiosyncratic protest song ever written'.

*

On 17 March 1968, 25,000 people gathered in Trafalgar Square for Britain's biggest anti-war demonstration yet. It was the work of the Vietnam Solidarity Campaign (VSC), founded the previous year by a group of left-wing activists including Tariq Ali, the charismatic young Pakistani editor of *Black Dwarf*. Although Harold Wilson's support for President Johnson's war was enough to trigger such a campaign, his refusal to make that support military ensured that the conflict remained distant from British life. As Ali's *Black Dwarf* colleague Robin Blackburn later remarked, 'The Vietnam War, however much one might demonstrate against it here, was theirs.'

Nonetheless, the VSC members were energetic campaigners. Their first march, scheduled to coincide with the US Stop the Draft Week, had taken place in October 1967. About 10,000 protesters had peacefully picketed the US embassy in Grosvenor Square, drawing letters of support from students, trade unionists, Labour MPs and celebrities such as actress Vanessa Redgrave. On the day of the March demonstration Viet Cong flags fluttered in Trafalgar Square as Redgrave addressed the crowd. The mood as they marched towards Oxford Street was ebullient. 'I am sure that the overwhelming majority wanted more than just a victory in Vietnam,' Ali recalled. 'We wanted a new world without wars, oppression and class exploitation, based on comradeship and internationalism.'

But when they reached Grosvenor Square, they met far fiercer resistance than before. Somebody cried, 'The Cossacks are coming,' as a troop of police horses charged the picket line. The demonstrators retaliated with chunks of brick and paving stones. After two hours of fighting, the demonstrators, some badly beaten, evacuated the square. The next day's tabloids, Ali noted, seemed most concerned with the welfare of the horses.

This so-called 'peace riot' was 1960s Britain's first experience of real street fighting, and the presence of one particular marcher added an extra frisson of rebel glamour to the whole affair, although Mick Jagger seemed more interested in checking out the scene than taking up arms himself.

Jagger's outlaw chic had already been enhanced by his own recent run-in with the law when he and Rolling Stones guitarist Keith Richards were given jail terms for drug possession. Although the judgement was overturned on appeal, there were whispers of an orchestrated establishment plot against these dangerous miscreants. Jagger then told the *Sunday Mirror* that 'war stems from power-mad politicians and patriots' and that 'there should be no such thing as private property'. For those optimists who believed that rock stars could be in the vanguard of the revolution, Jagger's presence in Grosvenor Square was too good to be true.

In fact, Jagger was rather ambivalent about the whole thing. 'Street Fighting Man', inspired by what he saw in Grosvenor Square and by the student uprising in Paris in May, is less a call to arms than a confession of disappointment with 'sleepy London town'. 'What can a poor boy do / Except to sing for a rock'n'roll band?', he shrugged, helplessly. When *Melody Maker* asked Jagger about politics, he lapsed into flip hipster gobbledegook: 'Oh, what? Own up! Just groove. Play another record and don't worry about a thing.' He told *NME*: 'It's stupid to think that you can start a revolution with a record. I wish you could!'

The Stones' cynicism was not unwarranted. The VSC's next demo, held at the end of October, was effectively its last gasp. University sit-ins, with a variety of agendas, took place during the same period before they too ran out of steam. 'In America, the rock'n'roll bands have gotten very political,' said Jagger. 'They express themselves very directly about the Vietnam War. But when I come home to England, everything is completely different, so quiet and peaceful. If one lives in such an atmosphere, one has a great detachment from politics and writes completely differently about them.'

Greil Marcus astutely described 'Street Fighting Man' as 'a challenging emotional jigsaw puzzle, not congratulations for being on the right side'. But, as is so often the case, Jagger's lyrical reservations were obliterated by the music's exultant menace. It *sounded* like revolution, and that was what mattered.

At the end of the year, the Stones released *Beggars Banquet*, which also featured the sardonic class dialogue 'Salt of the Earth' and the sulphurous 'Sympathy for the Devil', on which Jagger sounded both repelled and seduced by mankind's history of violence. *Rolling Stone*'s Jon Landau approvingly wrote: '*Beggars Banquet* is not a polemic or manifesto. It doesn't advocate anything . . . They make it perfectly clear that they are sickened by contemporary society. But it is not their role to tell people what to do. Instead, they use their musical abilities like a seismograph to record the intensity of feelings, the violence, that is so prevalent now.' In short, the Stones were political without having to say much at all.

*

Lennon, meanwhile, wasn't even in the country when the 'peace riot' happened. He was on an ashram in India with George Harrison, studying with the Maharishi Mahesh Yogi, and it was there that he came up with the line in 'Revolution', 'You know it's gonna be all right' – 'this, you know, "God will save us" feeling,' he later explained. From that peaceful remove, events in Grosvenor Square doubtless did seem ugly and futile. What's surprising is that he didn't qualify the song's message upon his return to the UK. His argument that violent protest provoked police aggression and tabloid backlash was true enough, but he phrased it in a lofty, condescending manner that was bound to raise hackles. Like the tabloids, he spent more time critiquing the form of political anger than its causes.

'Revolution' quickly became the most hotly discussed protest song in history – on the streets of Chicago and Berkeley, in the organs of the right and left, even in music. Nina Simone recorded a pugnacious answer record, also called 'Revolution',

which subverted Lennon's lyric virtually line by line (Lennon later called it 'very good'). The *New York Times* juxtaposed Lennon's face and words with those of New Left hero Herbert Marcuse. The right-wing *National Review Bulletin* crowed: 'The International Communist enterprise may at last have met its match: the Beatles. Radical sorts anxious to preempt the Beatles' creative and immensely popular music for the Left have found little or nothing in it to comfort them over the years.'

Greil Marcus hated the message but loved the vehicle – 'There is freedom and movement in the music, even as there is sterility and repression in the lyrics' – the irony being that this raucous recording was McCartney's idea; Lennon favoured the slower version, 'Revolution 1', which subsequently appeared on *The Beatles* (aka *The White Album*). In that incarnation (recorded first but released second) Lennon fudges the message, following 'count me out' with an awkwardly inserted 'in'. 'I put in both because I wasn't sure,' he later admitted. If he wasn't sure what he thought about such a flammable issue then, you might ask, why write the song? When *Rolling Stone*'s Jonathan Cott asked him how his 'free your mind' pablum would play with a frustrated Black Panther, Lennon offered a feeble 'I don't know.'

Lennon's muddled thinking also extended to the album's 'Revolution 9', a brave and divisive attempt to foist avant-garde collage on the record-buying public. Although he later claimed he was 'painting in sound a picture of revolution but . . . the mistake was that it was anti-revolution,' good luck to anyone finding any message, pro- or anti-, in its eight minutes of brilliantly dislocating clamour.* Towards the end of 1968, disenchanted Beatles fan John Hoyland concluded his damning 'An Open Letter to John Lennon' with an invitation: 'Look at the society we live in and ask yourself: why? And then – come and join us.'

* McCartney *did* actually write a protest song for the album, although it was so subtle that nobody noticed. In fact, discovering that 'Blackbird' was about a female civil rights activist, a (oh dear) 'black bird', does nothing to enhance one's enjoyment.

And then Lennon did something very unusual: he wrote back. The singer was in a state of unsettling flux. In 1967's 'Strawberry Fields Forever' he had sung: 'No one I think is in my tree, I mean it must be high or low,' meaning that he knew that he felt apart from everyone else, but not whether that meant he was, he later explained, 'crazy or a genius'. He was also feeling personally victimised over his new love affair with Yoko Ono. Facing such a hard-nosed assault on 'Revolution', he put in an aggrieved call to Tariq Ali, accusing him of 'publishing these attacks on me'. Ali suavely explained that they were just 'friendly criticisms' and invited Lennon to respond.

In a letter which appeared in the January 1969 issue of *Black Dwarf* Lennon snapped, 'I don't worry about what you, the left, the middle, the right or any fucking boys club think. I'm not that bourgeois. I'm not only up against the establishment but you too.' *No one I think is in my tree.* He argued that all revolutions failed because of 'sick heads'. He ended with a PS: 'You smash it – and I'll build around it.' Richard Neville of *OZ* magazine described it as 'a classic New Left / psychedelic left dialogue'.

Hoyland shot back with a Marxist analysis which blamed the system, rather than individual sick heads, for the world's ills: build a better society and you create better people. The call in 'Revolution' to 'free your minds instead' still rankled. 'You simply cannot be completely turned on and happy when you know that kids are being roasted to death in Vietnam . . . Why couldn't you have said – "as well" – which is what I would say?' It concluded, 'I just wish you were a bit more on our side. We could do with a few good songs.'

*

Lennon and Ono married in March 1969 and honeymooned at the Amsterdam Hilton, where they announced they would stay in bed for a week as 'our protest against all the suffering and violence in the world'. This 'bed-in' united John's whimsy, Yoko's love of performance art and the Yippies' ideas about 'fight[ing]

through the jungles of TV', and provided a playful alternative to the dryness of the peace movement. Inevitably, many in the mainstream media and counter-culture alike scoffed that it was the worst kind of rock-star narcissism, but, measured purely in terms of column inches and airtime, the stunt did its job.

Other light-hearted gimmicks followed: the happy couple sent symbolic 'acorns for peace' to world leaders, and invented 'bagism', which argued that if everyone was cloaked in a bag then they would be judged only on what they said, not on how they looked. What, the curious press corps wanted to know, did the couple hope to achieve? 'All we're saying is give peace a chance,' Lennon told journalists in Vienna. 'If the least we can do is give somebody a laugh, we're willing to be the world's clowns, because we think it's a bit serious at the moment.'

In May the couple attempted to repeat the bed-in in the US but a visa refusal left them stranded on the other side of the 49th parallel – in Room 1742 of the Fairmont Queen Elizabeth Hotel, Montreal. They lay in the king-size bed, dressed entirely in white, surrounded by flowers, while reporters and fans thronged the corridor outside. 'It was hilarious,' Lennon later told *Playboy*. 'In effect, we were doing a commercial for peace on the front page of the papers instead of a commercial for war.'

Meanwhile, events in one corner of Berkeley were reaching a head. Encouraged by Yippie leader Stew Albert, hundreds of local residents had transformed a vacant plot of university-owned land downtown into a picturesque spot known as People's Park. Governor Reagan, who saw the campus as 'a haven for communist sympathisers, protesters and sex deviants', sent in police officers to seize the park and erect a fence. On 16 May 6,000 demonstrators marched on the park, to be met by nightsticks, buckshot and tear gas. Reagan called in the National Guard; James Rector, blasted in the chest by a police shotgun, became the era's first student fatality. Speaking to Berkeley's KPFA radio during the battle for the park, Lennon urged non-violence of the flimsiest kind. 'The monster doesn't care – the blue meanie is

insane,' he said, somewhat undermining his point by comparing Berkeley police to the cartoon villains from the *Yellow Submarine* movie. Young critic Robert Christgau spoke for many on the left when he retorted: 'Lennon's call firmed up his newfound status as a pompous shit.'

During the dozens of interviews to which the couple submitted in Montreal, Lennon vacillated on the issue of activist tactics, neither endorsing nor condemning campus violence but suggesting the protesters think of 'something else'. As to what this 'something else' might be, he was unforthcoming. But on the final night of the bed-in, Lennon pulled a masterstroke, debuting a song he had just written, based on his slogan from the Vienna press conference: 'Give Peace a Chance'. In the room with John and Yoko were Timothy Leary and his wife Rosemary, Beatles confidant Derek Taylor and journalist Paul Williams, who was there to document Lennon's first meeting with Leary for *Playboy*. As Williams recalled: 'He gave the impression that he'd just been fooling around with this chorus phrase . . . and then the verses were spontaneously strung-together talk about anything that had recently caught his attention . . . He sang to us, charmingly, as though he were a poet just reading some recent notes from his journal.'

Late the next morning, Lennon recorded the song on a portable eight-track and video camera, with a roster of back-up singers and guitarists which reads like the set-up to an elaborate joke about people walking into a bar: Yoko, Taylor, Williams, the Learys, comedians Dick Gregory and Tommy Smothers, pop singer Petula Clark, a rabbi, a priest and the Canadian chapter of the Radha Krishna Temple. The beat was banged out on Hare Krishna drums and a mahogany dining table. The chorus lyrics were written on a sheet and hung on the wall.

'Give Peace a Chance' has to be the most ramshackle single ever released by a global superstar. The verses, which poke fun at politics, religion, the media and all manner of isms (*revolution* half-rhymes with *masturbation*, *rabbis* with *Popeyes*),

peter out before the halfway mark, leaving just the chorus, over and over, accompanied by the clumping tabletop rhythm. It is also the only protest song that is literally self-congratulatory, ending with the sound of Lennon and his ad hoc band clapping themselves. It is less an end in itself than a launch pad for something bigger.

*

During 1969 the anti-war coalition crumbled and rebuilt itself, in circumstances too Byzantine to describe here. The newborn Vietnam Moratorium Committee, founded to prove that students are 'not just "crazy radicals" but "your sons and daughters"', masterminded a National Moratorium Day on 15 October. Two million people across America wore black armbands, tolled church bells, flew flags at half-mast, read out the names of the dead, and otherwise expressed non-violent dissent. The New Mobe, which had replaced the fragmented old Mobe, followed with its own day of action on 15 November.

At the main demo in Washington DC, Pete Seeger began singing 'Give Peace a Chance' to a crowd half a million strong. Seeger had initially been unimpressed – 'I confess when I first heard it I didn't think much of it. I thought, "That's kind of a nothing of a song, it doesn't go anyplace"' – but then he hadn't thought much of 'This Land Is Your Land' either. He changed his mind when he heard a woman singing it on Moratorium Day and decided, on an impulse, to try it in DC. 'Are you listening, Nixon?' he cried. 'Are you listening, Agnew? Are you listening in the Pentagon?'

'For those present, it was one of the most moving days of their lives,' he remembered in *The Incompleat Folksinger*. 'The high point of the afternoon came, if I say so myself, when a short phrase from a record by Beatle John Lennon was started up by Brother Fred Kirkpatrick and me. Peter, Paul and Mary joined in, also song leader Mitch Miller, and soon hundreds of thousands were singing it over and over, swaying their bodies, flags,

and signs from right to left in massive choreography. It was not as militant or as forceful a song as will be needed, but it united that crowd as no speech or song had been able to all afternoon.'

Lennon was overjoyed. As he would later tell Tariq Ali: 'I was . . . pleased when the movement in America took up "Give Peace a Chance" because I had written it with that in mind really. I hoped that instead of singing "We Shall Overcome" from 1800 or something, they would have something contemporary. I felt an obligation even then to write a song that people would sing in the pub or on a demonstration.' The single and the chant were, in effect, separate entities. On the record, the chorus comes as both punchline and rejoinder to the verses' prolix overload. Divorced from them, it became the whole message, either joyous or solemn depending on the crowd's mood, and thus squarely in the venerable tradition of 'We Shall Overcome' and 'We Shall Not Be Moved'. No wonder Seeger grew to love it: it was a bona fide people's song. 'We might not have a leader, but now at least we have a song – and a mass movement doesn't go anywhere without a song,' one DC protester told *Newsweek*.

Meanwhile, Lennon embarked on a frenzy of political activity, publicising the plight of starving refugees in the breakaway Nigerian province of Biafra, giving money to gypsies and squatters, and joining the campaign to exonerate James Hanratty, hanged for the so-called A6 murders in 1962. In November he returned his MBE in protest against 'Britain's involvement in the Nigeria-Biafra thing, against our support of America in Vietnam, and against [new single] "Cold Turkey" slipping down the charts'. John and Yoko also announced plans for a peace festival in Toronto the following July and an unworkably ambitious International Peace Vote, neither of which came to fruition. Clearly, there were limits to even a Beatle's powers of persuasion.

In December the couple launched a new campaign which, perhaps unwittingly, used Phil Ochs's phrase: 'War Is Over'. But whereas Ochs had taken to the streets in aid of the concept, the

Lennons simply hired billboards in major international cities to carry the message: 'War Is Over – If You Want It – Happy Christmas, John and Yoko.' It was a somewhat aristocratic gesture.*

The same month, the Rolling Stones marked the end of the decade with *Let It Bleed*, a record Jagger described as an 'apocalypse'. 'Gimme Shelter' opened the album like a thunderclap. Inspired, said Jagger, by 'the Vietnam War, violence on the screens, pillage and burning', it truly sounded, unlike Barry McGuire's effort, like the eve of destruction. 'You Can't Always Get What You Want' saw out not just the album but the decade on a suitably ambivalent note, at once jubilant, defeated and pragmatic. Jagger's reference to attending 'the demonstration' sharpened the song's political implications – you can't always get what you want but sometimes you get what you need. It marked the end of the Stones' period as revolutionary pin-ups. As Keith Richards remarked, 'You don't shoulder any responsibilities when you pick up a guitar or sing a song, because it's not a position of responsibility.'

In his 1970 book *Revolt Into Style*, musician and critic George Melly reflected on the events of 1968 in London: 'This was surely the moment when you might have expected pop to provide the anthems, the marches, the songs for the barricade. In fact it did nothing of the sort . . . At all events the political upheaval of 1968 proved that pop music, in the revolutionary sense, was a non-starter, a fake revolt with no programme much beyond the legalisation of pot.'

Though Melly's analysis is hard to dispute, by the end of 1969 Lennon was, for good or ill, the public face of the peace movement. He issued a statement announcing that 1970 would be 'Year One. Because we believe the last decade was the end of the old machine crumblin' to pieces. And we think we can get it together, with your help . . . We have great hopes for the new year.' The BBC anointed

* Lennon and Ono would continue the theme on 'Happy Xmas (War Is Over)' (1971), which would remain a festive standard long after the idea that inspired it had been forgotten.

him 'Man of the Decade'. The *Daily Mirror*, however, crowned him 'Clown of the Year' in a mocking editorial: 'Mr Lennon's Cry is "Peace!" How about giving us some, chum?'

*

Unbeknown to the *Mirror*, or anyone else outside the Beatles' inner circle, Lennon had told his bandmates that September that he wanted to quit, agreeing to keep the news secret while various legal issues were resolved. The most potent song he brought to their final recording sessions, which would become the *Abbey Road* album, was 'Come Together', which stemmed from Timothy Leary's request, in that Montreal hotel room, for an anthem to soundtrack his implausible bid to replace Reagan as governor of California (campaign slogan: 'Come together, join the party'). The gobbledegook verses recalled 'I Am the Walrus', though the chorus, 'Come together, right now, over me', was rather more emphatic than 'goo goo goo joob'.

At the start of 1970, with the Beatles' demise still a secret, Lennon's activism continued apace. He threw his weight behind the anti-apartheid movement, CND and Michael X, a self-styled spokesperson for black Britons whose egotistical posturing and foggy rhetoric earned the suspicion of many on the left but succeeded in seducing the Lennons.

In March, Lennon came across the work of psychotherapist Arthur Janov, who believed in exorcising childhood demons through what he called primal scream therapy. Emerging from heroin addiction, Lennon signed up wholesale. While undergoing therapy in Los Angeles, he wrote most of the songs for his first post-Beatles album, *John Lennon / Plastic Ono Band*. Released at the end of the year, it was the most painfully personal statement ever made by a major rock star. While songs such as 'Mother', 'My Mummy's Dead' and 'Isolation' offered gruelling emotional catharsis, there were two significant engagements with the outside world. On 'God', Lennon discarded a series of icons, from Jesus and Buddha, through Kennedy and Hitler, to

Dylan and, most heretically of all, the Beatles. And then there was 'Working Class Hero'.

Lennon would later declare it 'a revolutionary song . . . I just think the concept is revolutionary and I hope it's for workers and not for tarts and fags.' Delivered with a snarl, it combined Marxist rhetoric ('Keep you doped with religion and sex and TV'), Janovian analysis ('The pain is so big you feel nothing at all') and autobiography. If some lines could apply to any worker, then others could only be about Lennon himself: the man who had climbed to the top to find that he was still a 'fucking peasant'. The last line is bitterly sarcastic: 'If you want to be a hero, well just follow me.' As a song about John Lennon, it is astonishing, but the 'worker' remains intangibly vague; Lennon always lacked McCartney's instinctive empathy for the common man or woman.

If these songs gave fans several clues as to Lennon's new state of mind, then he unveiled his full ideological makeover in two extensive interviews published in early 1971. Not content with killing the Beatles, he now seemed bent on burying them, and all that they represented. 'Nothing happened except that we all dressed up,' he told *Rolling Stone*'s Jann Wenner. 'The same bastards are in control, the same people are running everything, it's exactly the same . . . The dream is over.'* The furore over 'Revolution' still bothered him. 'I really thought that love would save us all. But now I'm wearing a Chairman Mao badge, that's where it's at . . . I'm just beginning to think he's doing a good job, he seems to be.'† He also grumbled about leftists who preferred 'Street Fighting Man': 'I resent the implication that the Stones are like revolutionaries and that the Beatles weren't.'

His dialogue with Tariq Ali and Robin Blackburn in new

* 'The dream is over' were also the last words he sang on *John Lennon / Plastic Ono Band*.

† The death toll of the Cultural Revolution, estimated at around two million, makes you wonder what Lennon would have considered 'a bad job'.

Marxist newspaper *Red Mole* was even more eye-opening. The interview, conducted over several hours at John and Yoko's Berkshire estate, Tittenhurst Park, was a work of wholesale revisionism, riddled with radical and psychiatric jargon. Somewhat melodramatically, he described his time in the world's biggest band as 'complete oppression' and 'humiliation after humiliation' (whether this variety was worse than that experienced by dissident artists during the Cultural Revolution, he did not say) and dismissed his drive to succeed as a product of emotional repression. The playful, idiosyncratic language for which he was famed was being subsumed by boilerplate dogma: 'If we took over Britain, then we'd have the job of cleaning up the bourgeoisie and keeping people in a revolutionary state of mind.' Ali's last question is perhaps unique in the annals of rock star interviews: 'How do you think we can destroy the capitalist system here in Britain, John?'

The day after the *Red Mole* interview, an enthusiastic Lennon phoned Ali. 'Look, I was so excited by the things we talked about that I've written this song for the movement, so you can sing it when you march.' He sang it down the telephone line and asked the stunned Ali: 'Well, what do you think?' Ali told him it was 'an ideal marching song'.

Adapting the Black Panther slogan 'All Power to the People', the song was called 'Power to the People' and it was an explicit repudiation of 'Revolution'. 'Say we want a revolution,' sang Lennon. 'We better get on right away.' And where 'Give Peace a Chance' had only requested the possibility of change, this new anthem demanded it. Released as a single in March 1971, it climbed higher in the US charts than either 'Revolution' or 'Give Peace a Chance', demonstrating Lennon's unrivalled ability to bring radical politics into the mainstream. '"Power to the People" isn't expected to make a revolution,' he clarified in *Melody Maker*. 'It's for the people to sing like the Christians sing hymns.'

But in later years, when his revolutionary fire had dimmed, Lennon would dismiss it as 'written in the state of being asleep

and wanting to be loved by Tariq and his ilk', a tacit admission that his much-touted political awakening was another kind of self-delusion. Having dispensed with God, heroin and the Beatles, Lennon needed something to plug the void. As Stew Albert told writer Jon Wiener: 'You wonder, when a person gets so rich and famous, where their motivation comes from. You're not hungry any more. Politics was a new hunger for John. It was a new world to learn.'

*

In November 1971 Paul McCartney was asked by *Melody Maker* about his old bandmate's new single, 'Imagine'. He ventured that it was 'what John is really like, but there was too much political stuff on the other albums'. Lennon dashed off a letter to the paper, telling McCartney that 'Imagine' was '"working class hero" with sugar on it for conservatives like yourself!! You obviously didn't dig the words. Imagine!'

But McCartney wasn't alone in perceiving only the sugar. Line by line, 'Imagine' is a radical song, repudiating both God and private property. It speaks both to the life's-what-you-make-it idealism of 'All You Need Is Love' and, as Jon Wiener argues, Marcuse's ideas about social change coming via the utopian imagination. But the song itself was so pretty and vague that it sowed the seeds of its own misreading, and something about the tone, as so often with Lennon, jarred. The smugness of 'I hope some day you'll join us' was cemented by the hideously misjudged video. If you're going to sing 'Imagine no possessions', it's a good idea not to do so while seated at a grand piano in your palatial country retreat. As with 'Revolution', Lennon seemed to expect every listener to understand his true intentions, oblivious to his own mixed messages.

It's striking how many of Lennon's latest lyrics took the same basic format as 'Give Peace a Chance' and 'God', i.e. lists of things he wanted nothing to do with: social constructs ('Imagine'), roles ('I Don't Wanna Be a Soldier Mama I Don't Wanna Die') and pernicious people ('Gimme Some Truth'). The latter was by far

the most combative, denouncing hypocrites, chauvinists, prima donnas and 'short-haired yellow-bellied son[s] of Tricky Dicky [Nixon]'. It functioned as the bilious twin of 'Imagine'.

By the time the album was in the shops, however, Lennon had left Britain for good, and he would be greatly missed. During the summer he had been wherever the left-wing action was. When the editors of the underground magazine *OZ* were successfully prosecuted for obscenity, Lennon released 'God Save Us' and 'Do the Oz' to raise money for legal fees. When the British government began interning without charge alleged paramilitaries in Northern Ireland, he joined a demonstration, marching down Oxford Street with a placard reading, 'For the IRA, against British imperialism'. When shipbuilders in Scotland's famously radical Clydeside staged a 'work-in' to protest the closure of the shipyards, Lennon sent them thousands of pounds. (One confused shipbuilder, on hearing the news, exclaimed, 'But Lenin's dead!')

So one can imagine the shock and disappointment when, just a few days later, Lennon told Tariq Ali that he was moving to America to help Yoko fight for custody of her daughter Kyoko from her second husband Anthony Cox. Ali later wondered what might have happened if Lennon had stuck around a few months and witnessed Britain's first national miners' strike since the 1920s. 'In New York, Lennon met the yippy leaders, Jerry Rubin and Abbie Hoffman, whose remoteness from the working class was celebrated,' he grumbled. 'The young miners who marched on Saltley Gates in Birmingham would have been far more satisfying to Lennon and, I am sure, he would have responded generously to their calls for solidarity.'

Well, perhaps. Even if he had stayed, the mercurial Lennon would doubtless have drifted away from the *Red Mole* gang soon enough. As his experiences in the US would prove, his activist fervour was destined to burn out quickly. Before it did, he would plunge into the chaotic diaspora that the New Left had become, discover the limits of celebrity, and produce some of the worst protest songs ever recorded.

9

'War! Good God, y'all! What is it good for?'

Edwin Starr, 'War', 1970

Norman Whitfield, Marvin Gaye and the radicalisation
of Motown

Edwin Starr, 'War' (Motown, 1970). This picture sleeve is from the German release.

Before Motown came around to reflecting the rage of black America, the rage of black America came to Motown.

It was the afternoon of 23 July 1967. At the Fox Theatre in Detroit, one of the label's hottest acts, Martha Reeves and the Vandellas, was headlining the Swinging Time Revue, a show promoted by a local TV station. Reeves had just finished their biggest hit, 'Dancing in the Street', and was about to introduce their latest, 'Jimmy Mack', when she was beckoned urgently to the side of the stage to be told the news: Detroit was burning.

'I was told that everybody had to get home and get the children home safely and walk out of the theatre in a timely fashion so that no one would get hurt in the stampede,' remembers Reeves. 'Everybody [was] in fear of being killed by one entity or another: either the rioters or the armed forces.'

The upheaval had begun in the middle of the night after a police raid on a popular after-hours drinking hole on 12th Street, but it had spiralled so fast that local law enforcement was overwhelmed. The following morning, Detroit's mayor Jerome Cavanagh and Michigan's governor George Romney called on President Johnson for federal help. Johnson, his liberal reputation already mortally wounded in the jungles of Vietnam, was loath to send in troops against his own people, but he had no choice. That night the boots of federal paratroopers hit the sidewalks of Detroit. And this was a city which prided itself on the dialogue between black and white leadership, attracting admiring profiles in the national press: a year earlier, *Look* magazine had named it All-America City. But simultaneously, the *Michigan Chronicle*, warning of the under-reported dangers of unemployment and aggressive policing, had asked 'Can It Happen in Detroit?' It could and it did.

Future Motown guitarist Dennis Coffey was recording at Golden World studios when the riot spread. 'They firebombed

the drugstore down the street so we had to put somebody out there to watch the flames so we could get the session done without catching on fire.' Otis Williams of the Temptations lay down on the floor of his apartment for hours, listening to the rattle of gunfire in the street. 'The next morning I went out for groceries,' he later wrote. 'On every corner stood soldiers with guns. They had orders to shoot looters, and the tension was so thick you could choke on it.' Tanks rolled past Motown's offices on West Grand Boulevard, only a few blocks from 12th Street.

Berry Gordy, the label's upwardly mobile founder, had no interest in message music, but after the last fires were extinguished and the last tanks off the streets, Motown could no longer ignore what was happening outside its walls. For better or worse, politics was in the air.

'It was *definitely* in the air,' agrees Otis Williams. 'When you're up in your apartment and you can hear a fifty-calibre machine gun going off in your neighbourhood, it's in the air *big time*.'

<p style="text-align:center">*</p>

When the Temptations signed to Motown's Miracle imprint in the early 1960s, musical director Maurice King gave them a lesson in Hitsville's politics of caution. 'He would tell us, "Do not get caught up in telling people about politics, religion, how to spend money or who to make love to, because you'll lose your fan base,"' Williams remembers. '"So don't let no interviewer get you talking about politics. Just tell them we ain't politicians; we just sing."'

The lesson came straight from Gordy. Born in 1929, he learned his business skills from his father – Berry, Sr – a self-made entrepreneur who named his grocery store after the forefather of black enterprise, Booker T. Washington. When his dreams of boxing glory faded, Berry, Jr, worked like a Trojan in his father's businesses, and then, like so many Detroit men, took a job at the Ford factory, known locally as 'the house of murder' because of the gruelling labour and long hours.

His escape route was songwriting. In 1957 he bagged an opportunity to write for up-and-coming singer Jackie Wilson and struck up a fortuitous friendship with another singer, seventeen-year-old William 'Smokey' Robinson. But despite the hits he wrote for Wilson, and for Robinson's band the Miracles, Gordy was still broke, his income eaten away by alimony and child support. During 1959 this aspiring hit-maker's bank balance averaged a mere $100. His frustration led him to write a song about a need more pressing than romance: 'Money (That's What I Want)'.

Gordy and Robinson hatched Motown on a car ride through the Michigan snow in the winter of 1959. Why be at the mercy of existing labels when they could start their own? Gordy devoted as much attention to the fledgling label's financial structure as to its crisp, unfussy pop-soul sound. The offices at 2648 West Grand Boulevard became a magnet for the city's black musical talent, including a tall, charismatic singer called Marvin Gay (later Gaye), who would become both Gordy's prize asset and his biggest headache.

Gordy learned a thing or two on Henry Ford's assembly line. Pop music, much though he loved it, was product like anything else and Motown developed into a spectacularly efficient machine. 'At the plant the cars started out as just a frame, pulled along on conveyor belts until they emerged at the end of the line – brand spanking new cars rolling off the line,' he wrote in his autobiography. 'I wanted the same concept for my company, only with artists and songs and records.'

Gordy believed in healthy competition. He installed rival songwriting teams in different rooms, commissioned hits from all of them, and picked the best. Results were everything, and egos were made for bruising. Up-and-comers had to prove themselves again and again before they could hope to join the elite troika of Holland–Dozier–Holland in the top rank. Motown's rigid hierarchy dictated even which brand of car you could drive. The bear pit of the whole operation was the Quality Control department,

at whose Friday meetings songs would be kicked around to see if they passed muster. The anointed ones were given Motown's sonic stamp at the mixing stage, ironing out any idiosyncrasies which didn't fit the label's brand. Sometimes producers wouldn't even hear what had been done to their song until the record was pressed. With each release choreographed down to the last drumbeat, what chance did anybody have of sneaking a controversial message past the gatekeepers of Quality Control?

*

In 1965 the First Annual Dignity Projection and Scholarship Awards honoured Motown 'for consistent presentation of Afro-American music, without apology, by Afro-American artists who project vibrant DIGNITY.' That phrase 'without apology' deserves a second look. Certainly, Gordy wasn't ashamed of his race, but neither did he make an issue of it. From the start he wanted Motown's infrastructure and its audience to be multi-racial. Gordy schooled his artists in etiquette and elocution and cultivated for them a cheerful, clean-cut image. As far as he was concerned, the language and fashions of the street could stay on the street. 'Motown's music was always geared for acceptance across the board,' says Otis Williams. 'I can understand him being very [cautious] because you wouldn't want to come out with something that was so overtly suggestive that the disc jockey wouldn't play it.'

Not that Motown artists were ignorant of the political situation. When the Motown Revue had hit the Southern states in late 1962, prejudice had been plain to see. They would arrive at hotels to find that their reservations had mysteriously disappeared, and turn up at restaurants where their business was not appreciated. 'It's an awful insult when you walk around and you got all kinds of money and you can't eat,' Martha Reeves told writer Gerri Hirshey. 'We got shot at in the bus down South. They thought we were Freedom Riders.'

But none of this made its way into the music, at least not

explicitly. Public Enemy's Chuck D calls the soul music of the mid-60s 'the brewing period'. Instead of overt protest songs there were circuits of hidden meaning, both implied and inferred. Black DJs would programme message songs such as 'A Change Is Gonna Come' or 'Keep on Pushing' next to soul standards like 'Stand By Me', politicising the latter by association. Key words resonated with certain listeners and passed others by unnoticed. So it was that when Otis Redding complained, in his Rolling Stones cover, that he couldn't get no satisfaction; or Aretha Franklin, covering Otis, urgently demanded respect; or Martha and the Vandellas called for the nation to start dancing in the streets, some people detected a dog-whistle of dissent.

Such was the popularity of Franklin's 'Respect' during the summer of 1967 that *Ebony* magazine declared it 'the summer of 'Retha, Rap and Revolt'. 'Aretha was the riot was the leader,' wrote black poet Nikki Giovanni. 'If she had said, "come, let's do it," it would have been done.' That Franklin never actually *did* say 'Come, let's do it' did nothing to diminish her popularity.

Aretha was the daughter of a hometown celebrity, the flamboyant C. L. Franklin, through whose doors passed the likes of Mahalia Jackson, Lou Rawls and Sam Cooke.* A gospel sensation by the age of fourteen, Franklin went on to an unspectacular jazz career before, with 1967's *I Never Loved a Man the Way I Love You*, harnessing the power of her remarkable, full-blooded voice and becoming, to many Americans, the very definition of soul.

Although the album featured a version of 'A Change Is Gonna Come' and the all-encompassing, all-pervading 'Respect' ('the song took on monumental significance', she wrote in her memoir), and her 1968 releases included Curtis Mayfield's 'People Get Ready' and the taut, reproving 'Think' ('Oooh, freedom!'), Aretha's significance lay less in the words she sang than in the

* C. L. Franklin was a prime mover behind Detroit's Great March to Freedom in 1963. Gordy released Dr King's speech at the march as Motown's first spoken-word album.

way she sang them. Steeped in the gospel tradition, electric with emotion, Franklin's voice traced the route from pain to redemption with a strength and vulnerability that every black listener could relate to. As comedian Dick Gregory once said, 'You'd hear Aretha three or four times an hour. You'd only hear [Martin Luther] King on the news.'

A *Time* reporter writing a story on the woman one radio DJ had dubbed 'the Queen of Soul' asked the black actor Godfrey Cambridge to define the genre. 'Soul is getting kicked in the ass until you don't know what it's for,' said Cambridge. 'It's being broke and down and out, and people telling you you're no good. It's the language of the subculture; but you can't learn it, because no one can give you black lessons.'

Such was the covert power of this subcultural language that whether those songs had a 'true' meaning one way or the other is moot. Isaac Hayes once told a documentary maker that 'Soul Man', the 1967 hit he wrote for Sam and Dave on Stax Records in Memphis, was inspired by the aftermath of the Detroit riots: 'All the black businesses, if they write "soul" on their businesses they're bypassed. And I thought about the night of Passover in the Bible.' But then the film cut to Sam Moore of Sam and Dave: '"I'm a black man"? Nah, it didn't mean that. It meant that whatever your hardship in your life you're able to get up and keep moving.' Among the masks and shadows of the brewing period, both men could be right.

Some, though, were horrified by the innuendo. At a British press conference after the Detroit riots, one journalist asked Reeves if 'Dancing in the Streets' was a coded call to arms.* 'I had a physical and mental breakdown when that was implied,' she says. 'It broke my heart because I would never have been a part of anything that would cause a nation to rise. I kept asking: "If I'm a gang leader where is my gang?"' She does, conversely,

* The Rolling Stones took Reeves's lyrics as the jumping-off point for 'Street Fighting Man': 'Summer's here and the time is right for fighting in the street, boy.'

contend that 'Jimmy Mack' was about Vietnam, even though the song contains nothing to imply that Mr Mack was anywhere more dangerous than another woman's bed. Masks and shadows.

Motown's first flat-out protest song arrived in June 1966, when sixteen-year-old wunderkind Stevie Wonder covered Bob Dylan's 'Blowin' in the Wind'. This was the kind of political comment that Gordy could handle: a familiar tune, a palatable message, and, crucially, no mention of race. Wonder followed it with an album, *Down to Earth*, which featured a ghetto tableau on the cover (Motown's first), and a song, 'A Place in the Sun', which was his own tentative response to Dylan's. One man, at least, was poking his head out of fortress Hitsville and wondering where the city was headed. *Can it happen in Detroit?*

Come the riots, and Gordy could no longer maintain Motown's policy of whistling past the graveyard. As the city's most admired black-owned business, the label felt pressure to acknowledge the struggle. In 1968 Motown threw its weight behind Detroit Is Happening, a summer-long official programme of job creation and educational initiatives designed to discourage future unrest ('I Care About Detroit,' sang Smokey Robinson and the Miracles), and staged a benefit concert in Atlanta for the SCLC-organised Poor People's Campaign, featuring such blue-chip stars as the Supremes, the Temptations and Stevie Wonder.

But the truth was that Gordy didn't have a radical bone in his body. By the time Motown moved from West Grand Boulevard to an ugly, functional slab on Woodward Avenue that autumn, its founder was spending most of his time in Los Angeles, seeking movie opportunities for his precious Diana Ross. When, the following year, new signings the Jackson 5 were asked about politics at a press conference, a Motown handler stepped in to say that the Jacksons didn't trouble themselves with such matters because they were 'commercial product'.

Motown's inchoate attempts to engage with the mood of the times were encapsulated in the short, strange career of Abdullah. Born Joseph MacLean in Brooklyn, he arrived in reception in

1968 touting a battered guitar case and a conviction that the stars had elected him to be Motown's latest superstar. Alas, the stars had not deigned to grant him the necessary talent – his voice was thin, his guitar-playing undisciplined – but had compensated by awarding him a spooky charisma which convinced Motown's usually level heads to give him a recording contract. While in prison, Abdullah had converted to Islam, which he combined with astrology, and he astonished staff by unrolling his prayer mat in the studio four times a day. Women were forbidden to approach the drums because, he explained, menstruation sapped the instruments' power.

Within a year, he would be on his way back to Brooklyn after lunging at high-ranking executive Ralph Seltzer, whom he deemed a 'blue-eyed devil', in a dispute over money. According to one account, his ever-present guitar case was found, on this occasion, to house a novel negotiating tool: a machete. But before his departure he released one single. 'I Comma Zimba Zio (Here I Stand the Mighty One)' was an Afrocentric tribute to 'the land of a Zulu', while the B-side, 'Why Them, Why Me' echoed Stokely Carmichael's argument that black men had no place in Vietnam when the real war was at home. If anyone had bought it, it would have brought Motown crashing into the political arena. Instead, that job fell to others.

*

In 1968, Motown was feeling the strain of Holland–Dozier–Holland's dispute with Gordy over unpaid royalties. The trio downed tools, opening the door for rival talent to fill the vacuum. Gordy assembled a crack five-person team, which he somewhat insensitively called 'the Clan', and billeted them in the Pontchartrain Hotel to write a hit for the Supremes. After four days they returned with 'Love Child', a vivid tale of unplanned pregnancy in the ghetto, albeit one with an uplifting moral. Released in September, it became the group's biggest hit yet (they symbolically swapped gowns for street clothes when they

performed it on *The Ed Sullivan Show*) and sent an encouraging signal to a hungry writer-producer named Norman Whitfield.

Harlem-born, Whitfield was an ambitious, watchful character who had used his winnings from pool tournaments to fund hours spent hanging around Hitsville, taking notes and plotting his rise. He joined Quality Control in 1962 and wrested creative stewardship of the Temptations from Smokey Robinson four years later. By 1968 he had a golden opportunity to redefine the Motown sound. Not only were Holland–Dozier–Holland AWOL, but the Temptations were looking for a new direction after the departure of lead singer David Ruffin and the arrival of Dennis Edwards. Whitfield had also won an important battle with Gordy over a song, 'I Heard It Through the Grapevine', he had written with new songwriting partner Barrett Strong.

Whitfield had recorded the ominous, paranoid 'Grapevine' with Marvin Gaye in 1967 but Quality Control deemed it a bad fit. Furious, Whitfield rearranged it for Gladys Knight and the Pips, who struck gold with it. (He was tenacious like that: if a song failed with one artist he would reheat it for another.) When Gordy *still* snubbed Marvin's version, Whitfield embarked on a war of attrition. 'He kept pushing and pushing,' Strong told writer Ben Edmonds, 'until Berry finally said, "Get out of my face. Mention that fucking record again and you're fired!"' Gordy allowed it on to Gaye's 1968 *In the Groove* album, where it grabbed so much airplay that it earned itself a single release. It didn't just blow the Pips' version out of the water: it outsold every Motown single to date. Whitfield learned an important lesson about dealing with Gordy: there was no arguing with success.

Otis Williams remembers standing outside Detroit's Casino Royale club one night in 1968 and suggesting to Whitfield that the Temptations take some cues from Sly and the Family Stone's raucous psychedelic soul. 'That ain't nothing but a little passing fancy,' the producer sniffed. 'That was Norman being Norman,' laughs Williams. 'If [an idea] didn't come from him he would

be that way. He was a wonderful person but he could be very aggressive and abrasive.'

Sly and the Family Stone were nearing the height of their powers, and these powers derived from optimism, wild and pure. Optimism is a treacherous commodity in pop. Handle it glibly, as if you'd never considered the alternatives, and you end up sounding banal. But Sly Stone didn't need anyone to tell him how tough life could be. He grew up in Oakland, home of one of America's most racist police forces, birthplace of the Black Panthers, and his response to a country beset by war and riot and mistrust was this fierce joy. The song titles were loud affirmations: 'Dance to the Music,' 'I Want to Take You Higher', 'Everybody Is a Star', 'Stand!'

What's more, no group ever sounded so intoxicated by its own *groupness*, so thrilled by the opportunity to come together to play and, by their very existence, to declare that unity was possible. Sly, guitarist Freddie Stone and bassist Larry Graham were black men; trumpeter Cynthia Robinson and vocalist Rose Stone black women; saxophonist Jerry Martini and drummer Greg Errico white men. Just the sight of them, in their freaky, rococo outfits, let alone their music, represented an unprecedented gathering of the Bay Area tribes: Haight-Ashbury hippies, Berkeley radicals and Oakland Panthers. Said Errico: 'To look at us and to hear us, it was kind of like, "What am I about to see? What am I about to hear? What's going on?"'

In 1968, after the failure of debut album *A Whole New Thing*, the Family Stone released *Dance to the Music*. It was politically cautious – 'Don't Burn Baby' and 'Color Me True' echoed the integrationist credo of James Brown – and musically revolutionary. The Chambers Brothers may have been the first to cry 'My soul's been psychedelicised!' in their 1966 acid-rock wig-out 'Time Has Come Today', but it was Sly Stone who defined the sound of psychedelic soul. The album's twelve-minute finale, 'Dance to the Medley', took the exultant title track, with its sturdy Motown backbeat and playful introducing-the-band

shtick, and pushed it down a rabbit hole of wild wah-wah and psychedelic phasing, breaking the band down to its constituent parts and building it back into a rampaging whole. In a year of riot and division, the Family Stone's rainbow vision appeared positively utopian. 'I want everybody to understand my songs,' explained Sly. 'I want even dummies to understand so they won't be dumb anymore . . . And those people that get bugged by being talked to loud, then you've got to talk soft.'

Whitfield was clearly more intrigued than he would like to admit. A few weeks after the Casino Royale conversation, he and Strong presented the Temptations with a new song, 'Cloud Nine', which broke with Motown tradition by highlighting each individual musical and vocal component, just like . . . Sly and the Family Stone. 'I said, "Uh-huh, so this is the guy who didn't want to do that,"' says Williams. 'And he said, "All right, you was right. Come on, let's do it."' Whitfield's brand of psychedelic soul was more tense and foreboding than Stone's. 'Cloud Nine' opens with snaking wah-wah and suspenseful rhythms, exploding skywards halfway through when the Temptations sing, à la 'Dance to the Medley', 'up, up and away'.

Although neither Whitfield nor Strong used drugs, the ever-cautious Gordy thought he detected a narcotic undercurrent. 'I know Berry thought that's what we were singing about but Norman said no, it's just a state of mind,' insists Williams. Reluctantly, Gordy bowed to majority opinion and let it be released in October. 'Cloud Nine' was a slow-burning phenomenon, eventually winning Motown's first ever Grammy. After the one-two punch of 'Grapevine' and 'Cloud Nine', there was no saying no to Whitfield.

Whitfield's productions had a simmering, roiling drama which made them far better vehicles for social comment than the celebratory Holland–Dozier–Holland model. Songs such as 'Ball of Confusion (That's What the World Is Today)' and 'You Make Your Own Heaven and Hell Right Here on Earth' (both 1970) are thick with fire-and-brimstone moralising: society is on the

verge of collapse, so you'd damn well better wake up and take responsibility for your actions. The Temptations sound not so much saddened by America's downward slide as *thrilled*, the thronging, brass-backed chorus of 'Ball of Confusion' betraying a kind of apocalyptic euphoria.

'Norman was a hands-on producer,' says guitarist Dennis Coffey, who made his Motown debut on 'Cloud Nine'. 'He'd be right in the room with us, counting off the songs. We'd all be sweating together. Norman would say, "Show me what you got. What tricks you got today?" And I'd open up my bag and pull out a distortion device or an Echoplex or a wah-wah pedal and he'd give me introductions and say, "Put something in there."' Motown musicians worked fast. 'Our job was to read the music, come up with some ideas and make it into a hit in an hour,' says Coffey. 'When Norman started expanding his songs into six or seven minutes, we'd get two songs in a three-hour session as opposed to three. At some point maybe he only got one song.'

Lyrically, Whitfield–Strong's output after 'Cloud Nine' suggested that they had a checklist of fashionable causes pinned to the studio wall. 'Message From a Black Man' (1969) tapped post-James Brown black consciousness, 'Psychedelic Shack' (1970) threw on a hippie kaftan, and 'Ungena Za Ulimwengu (Unite the World)' (1971) hitched a ride on the Afrocentric bandwagon. 'Ball of Confusion' alone packed in riots, war, drug addiction, unemployment and the final Beatles album. And yet those close to Whitfield and Strong don't recall them ever discussing these issues with any great passion. 'They didn't talk about politics,' says Williams. 'That's just what was happening in the world at the time. Norman and Barrett decided to capitalise on what was happening.' George Clinton of the Parliaments (later Parliament and Funkadelic) remembers Whitfield taping his band's shows for ideas. 'What bothers me about records like "Cloud Nine" and "Psychedelic Shack",' he told Ben Edmonds, 'was that he made them without any commitment to, or awareness of, what the kids were trying to say with that music.'

But Whitfield–Strong's explosive creativity overcame the bogusness. And other labels followed suit: in 1971, Brunswick's Chi-Lites would briefly take to the psychedelic soapbox with the brilliant '(For God's Sake) Give More Power to the People' and 'We Are Neighbours'. Even if Whitfield was just a cold-blooded hustler looking to grab the Black Power dollar, he gave Motown a counter-cultural voice too loud to ignore. And, in October 1970, he gave the label 'War'.

*

It wasn't until 1966, the year that Stokely Carmichael's SNCC officially condemned the war and Robert McNamara's Project 100000 relaxed aptitude standards to add 240,000 men to the draft (four in ten of whom were black) that soul began to turn its attention to Vietnam. Even then, songs such as William Bell's 'Marching Off to War' were only subtextually political. The narrators were invariably GIs, waving goodbye at the station or writing letters home. You'd have thought that the biggest threat to black soldiers' wellbeing wasn't the Viet Cong but whoever might be making moves on their wives and girlfriends while they were away. No singer questioned why they were there in the first place; rather, there was a sense of tenacious fatalism, of getting the job done and getting home. The exceptions came from outside soul: bluesman J. B. Lenoir's 1966 recording 'Vietnam Blues'; Nina Simone's 1967 arrangement of Langston Hughes's poem 'Backlash Blues' ('You raise my taxes, freeze my wages / And send my son to Vietnam'); and Les McCann's fierce jazz-soul hybrid (written by Eugene McDaniels) 'Compared to What': 'The President, he's got his war / Folks don't know just what it's for.'

It was Martha Reeves who broke the mould. In early 1970, songwriter Pam Sawyer (who also co-wrote 'Love Child') brought her 'I Should Be Proud', in which a woman receives a telegram saying that her lover has been killed in Vietnam. The message says that she 'should be proud: he was fighting for me'.

'But he wasn't fighting for me, my Johnny didn't have to fight for me,' Reeves sings. 'He was fighting for the evils of society.' 'I identified with it because I had a brother who had gotten hurt and damaged in Vietnam and came home and died,' says Reeves. Radio stations baulked at its contemptuous fury and the single, released in March, stiffed.

The same month, however, the Temptations included their own anti-Vietnam track, Whitfield–Strong's 'War', on their *Psychedelic Shack* album. Strong, at least, had a personal investment in the song. 'I had a cousin who was a paratrooper that got hurt pretty bad in Vietnam,' he told *LA Weekly*. 'I also knew a guy who used to sing with Lamont Dozier that got hit by shrapnel and was crippled for life. You talk about these things with your families when you're sitting at home, and it inspires you to say something about it.'

The Temptations' 'War' had a corny marching-song vibe: 'Hup-two-three-four, hup-two-three-four.' It sounded so gimmicky that Motown's refusal to endorse a single release, despite receiving a petition signed by 4,000 students, turned out to be a blessing. Rather than risk tying the lucrative Temptations to the anti-war movement, they let Whitfield pass it on to energetic soul shouter Edwin Starr. Walking down the hall at Motown, Starr heard Whitfield shout, 'Edwin, I got a song for you!'

'When [they] brought the lyrics and the initial track to me, it was very watered down, it was unimpressive,' Starr remembered. 'I said, "I can do this but I have to sing the vocals my way. I have to do what I feel." So . . . "Good God, y'all" and all those "Absolutely nothings" are my ad-libs. I did that record in one take.'

Divided among different Temptations, the song's impact dissipated. Funnelled into one almighty roar, it punched a hole in the radio. Brilliantly, it's an anti-war song that sounds like war, with Starr as a drill sergeant for pacifism and the horns streaking through the air and exploding like tracer bullets. And if no listener could hope to reproduce the intricate vocal cross-currents

of 'Ball of Confusion', then here was a song that any demon-strator or schoolkid could sing. 'War! Good god, y'all! What is it good for? Absolutely nothing! Say it again!' The symbio-sis of singer and band is all the more remarkable because, per Motown's assembly-line methods, they were never in the same room. 'We had no idea what the lyrics were,' says Coffey, who played the high fuzztone guitar line. 'The only thing we knew was the title.'

Starr, who, like Coffey, had served in the army before the war esca-lated, bizarrely downplayed the Vietnam connection. 'Actually, we were talking about a war of people – the war people wage against each other on a day-to-day basis,' he claimed unconvincingly. 'War' rocketed to the top of the *Billboard* charts and found an equally enthusiastic audience among disgruntled GIs. 'Certainly troops in Vietnam liked that song,' says Coffey.

Never one to let the moment pass, Whitfield had Starr record a more explicit follow-up, 'Stop the War Now', which laid on the message with a trowel: grieving mothers, callous politicians, and a John Lennon-inspired refrain of 'Give peace a chance'. Starr later dismissed it as 'totally redundant'; certainly it lacked the commanding simplicity of 'War'. Whitfield had already over-played his hand, and not because he lay awake at night agonising over the Mekong Delta. Asked on one occasion about the mes-sages in his songs he shot back, 'They got Western Union for that.'

But there were others in the Motown family for whom an anti-war stance was more than just good business.

*

When the Four Tops' tour bus arrived in Berkeley in May 1969, the Motown act must have experienced flashbacks to Detroit two years earlier. Witnessing the violent eviction of People's Park, the band's Renaldo 'Obie' Benson couldn't believe his eyes. 'I saw this and started wondering what the fuck was going on,' he told Ben Edmonds. 'What is happening here? One question

led to another. Why are they sending kids so far away from their families overseas? Why are they attacking their own children in the streets here?'

With lyricist Al Cleveland, Benson parlayed those questions (minus the 'fuck') into a plangent expression of pain and bewilderment that he called 'What's Going On'. The Four Tops, however, weren't about to join the Temptations on the soapbox. 'My partners told me it was a protest song,' said Benson. 'I said no, man, it's a love song, about love and understanding. I'm not protesting, I want to know what's going on.' For all their volcanic force, Whitfield–Strong compositions were not noted for their compassion or self-doubt. 'What's Going On', on the other hand, was tender and tentative, a cry from the heart rather than the head, and it found a sympathetic audience in Marvin Gaye.

At this point, Gaye was a soul in turmoil. Mourning the death of his lover and singing partner Tammi Terrell, chafing at his Gordy-defined role as a play-safe Romeo, sick of hitting the treadmill of live performance, he was all at sea. He was also haunted by long, tearful conversations with his brother Frankie, who had returned from a three-year tour of Vietnam in 1967 to a series of menial jobs in the ghetto, experiences which made Marvin's complaints seem like the bleatings of a pampered crybaby. Equally shaming, his cousin, also called Marvin, had died in Vietnam the same month 'I Heard It Through the Grapevine' went to number one. He felt shallow and useless. 'I know this sounds strange,' Frankie told his brother's biographer, David Ritz, 'but I think that Marvin was always envious of my war experience. He saw it as a manly act that he had avoided.'

Back in 1965 Marvin had first heard about the Watts riots when a radio announcer interrupted one of his early hits, 'Pretty Little Baby'. 'My stomach got real tight and my heart started beating like crazy,' he told Ritz. 'I wanted to throw the radio down and burn all the bullshit songs I'd been singing and get out there and kick ass with the rest of the brothers . . . I wondered to myself, "With the world exploding around me, how

am I supposed to keep singing love songs?"' By 1970, after even Elvis Presley, of all people, had embraced social comment via 'In the Ghetto', he told Ritz, 'I felt a strong urge to write music and write lyrics that would touch the souls of men.' And into his lap fell 'What's Going On'.

Excited, Gaye telephoned Gordy, who was on holiday in the Bahamas, and said he wanted to make a protest record. 'Protest about what?' asked Gordy. 'Vietnam, police brutality, social conditions, a lot of stuff,' replied Gaye. Gordy responded like a father whose favourite son had just rejected an Ivy League scholarship in order to become a Yippie. 'Marvin, don't be ridiculous. That's taking things too far.'

But Gaye wouldn't be deterred. According to Benson he tweaked and enriched the song, 'added some things that were more ghetto, more natural, which made it seem more like a story than a song . . . We measured him for the suit and he tailored the hell out of it.' Gaye wanted to produce it himself, mixing up Motown regulars with his own recruits. One of them, Eli Fontaine, supplied the warm breeze of alto sax which introduced the song. Fontaine had just finished loosening up when Gaye told him that he could go home. But, Fontaine protested, he was just goofing around. 'Well, you goof exquisitely,' said Gaye. 'Thank you.' It was indicative of the session's uncommonly relaxed atmosphere. Amid clouds of marijuana smoke, Gaye's friends provided the conversational hubbub which bubbled companionably around Fontaine's sax.

Gordy, predictably, declared it 'the worst thing I've ever heard in my life'. Gaye, who had never had more fun in the studio, responded by going on strike until his boss saw sense. Eventually, Motown, desperate for new Marvin Gaye product, released it without Gordy's knowledge while he was busy playing the movie mogul in Los Angeles. Its massive success allowed Gaye an opportunity for revenge. When a repentant Gordy demanded an album to follow the single, the singer dragged his heels. Swallowing his pride, Gordy took a limo ride to Gaye's

house and made him a deal: he could make whatever album he liked provided he could finish it by the end of March.

The *What's Going On* sessions challenged every tenet of the Motown playbook. Finish a track in an hour or three? Gaye's team worked twelve-hour days. Use the in-house experts? Gaye sought out underdogs such as Motown elevator man James Nyx (who added lyrics to 'Inner City Blues (Make Me Wanna Holler)', 'What's Happening Brother' and 'God Is Love') and local tenor saxophonist Wild Bill Moore (who improvised the urgent solo on 'Mercy Mercy Me'). Stay professional? Gaye kept joints and fine Scotch on hand for the coterie of friends that attended the sessions, and masturbated at length before vocal takes in order to drain himself of carnal distraction. Working as his own producer, and inspired by jazz, he loosed the bonds on his musicians to allow for a constant, mercurial swirl of creativity, out of which he and arranger David Van de Pitte crafted something unprecedented in Motown: a multivalent personal testament. 'A lot of people ask me . . . "Tell me this, how did you put that damn album together? A nut like you, I mean, really, explain that,"' Gaye told *Rolling Stone*. 'I say, "I don't know, it just happened." It really did. It happened through divinity; it was divine.'

As stories and rumours about the sessions filtered back to other Motown producers, Whitfield talked mockingly of Marvin's 'national anthems'. Perhaps it was a similar reaction to the one he had felt the first time he saw Sly and the Family Stone: a stab of jealousy because the game had changed and he hadn't been the one to change it. But while he could learn new tricks from Sly Stone and the Parliaments, this product of the assembly line and the Quality Control department was constitutionally unable to follow Gaye's new direction. Autobiography was anathema.

Gaye unveiled *What's Going On* on 21 May 1971. Anyone spying it in the racks would have instantly known that something new was afoot. Never before had so much care been lavished on a Motown sleeve: the portrait of Gaye, the collars

of his leather coat pulled up against the cold, with drops of rain glinting in his hair and beard; the gatefold sleeve containing, for the first time in the label's history, printed lyrics and musician credits. The music inside was meltingly fluid, a river of sound which coursed through America, carrying both bad news – war, unemployment, drug addiction, ecological blight – and solace. Its seductive admixture of confusion and hope spoke to its times. Among that year's bestselling books were such dire jeremiads as Paul Ehrlich's *The Population Bomb* and Hal Lindsey's *The Late Great Planet Earth*; the previous year, the first Earth Day had launched the US environmental movement. But *What's Going On* didn't sound alarmist or confrontational; here was a protest record that you could play in the bedroom with the candles burning.

One of Gaye's acknowledged inspirations was the tender ache of gospel, and *What's Going On* can be heard as a spiritual successor to Sam Cooke's 'A Change Is Gonna Come'. Both ended up speaking for a nation only by first speaking for themselves. Both saw light in the darkness. Neither merely passed comment on issues: they *felt* them. The big difference was that Cooke was feeling the stark injustice of the Jim Crow laws, and putting his faith in imminent reform, whereas Gaye was nervously anticipating the pervasive gloom and drift of the 1970s. 'God knows where we're heading,' he cried. A change *was* gonna come, but what kind?

10

'Tin soldiers and Nixon coming'

Crosby, Stills, Nash and Young, 'Ohio', 1970

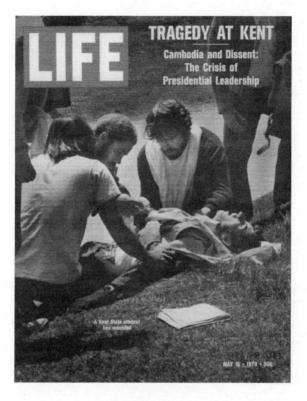

America at war

Kent State student John Cleary lies wounded after the National Guard opened fire, killing four other protesters. This was the issue of *Life* magazine which provoked Neil Young to write 'Ohio'.

One day in the middle of May 1970, Neil Young was hanging out at the house of his road manager Leo Makota in Pescadero, California, when David Crosby, his bandmate in Crosby, Stills, Nash and Young, handed him a copy of *Life* magazine. It contained a vivid account, and shocking photographs, of the killing of four students by the Ohio National Guard during an anti-war demonstration at Kent State University on 4 May. Sitting outside on Makota's sunlit porch, Young took a guitar proffered by Crosby and, in short order, wrote a song about the killings: 'Ohio'. 'I remember getting nuts at the end of the song, I was so moved,' Crosby told Young's biographer Jimmy McDonough. 'The hair was standing up on my arms – I was freaked out because I felt it so strongly, screaming, "Why? Why?"'

Crosby phoned Graham Nash, who was working on songs with Stephen Stills at the Record Plant in Los Angeles, and instructed him to book a studio session right away. He and Young flew down to LA and recorded the song live in just a few takes. At the end, according to Young, Crosby was in tears. Needing a B-side, the quartet sat down in four chairs, knee to knee, and sang an a cappella version of their regular set-closer about casualties in Vietnam, 'Find the Cost of Freedom'. They gave the tracks to Atlantic Records boss Ahmet Ertegun, who rushed the single into production and had it on the streets within days, wrapped in a sleeve which reprinted the section of the Bill of Rights that guarantees free assembly.

'Ohio' is perhaps the most powerful topical song ever recorded: moving, memorable and perfectly timed. But it turned out to signify the end of the era of protest songwriting which had begun with the folk revival, rather than a thrilling rebirth. There were several reasons for this, some artistic, others personal, but one major factor was the direction in which America was moving. The optimism and sense of unified purpose that had sustained

the music of the civil rights movement was dying. In its place: violence and factionalism on the left, backlash on the right. By May 1970 the country appeared to be breaking apart at a speed so terrifying that it left songwriters, among others, confounded.

Phil Ochs closed his ironically titled *Greatest Hits* album that year with the soulsick elegy 'No More Songs'. 'The drums are in the dawn,' he sang, 'And all the voices gone / And it seems that there are no more songs.'

*

In their '1969' single, the Stooges, an upstart group of avant-garde garage-rockers from Ann Arbor, Michigan, heralded the end of the 1960s with the line: 'Well it's 1969, OK! / War across the USA.' It was only a slight exaggeration. For many Americans, it did indeed seem as if the Union was becoming fatally divided.

Reading the cultural runes in the aftermath of Chicago a year earlier, syndicated columnist Joe Kraft had been the first to articulate a new concept in US politics: 'Middle America'. Pete Hamill wrote a similar piece for *New York* magazine headlined 'The Revolt of the White Lower Middle Class'. Reporters who had tasted police nightsticks for themselves in Chicago found to their dismay that many of their readers and viewers sided with Mayor Daley, disgusted at the sight of longhairs running wild in the streets and singing the praises of Ho Chi Minh. 'We were hated,' said key anti-war protester Todd Gitlin. 'We were seen, not inaccurately, as part of a radical ensemble that really wanted to turn a great deal upside down. Most of the country didn't want to have that much turned upside down.'

Nobody was keener to exploit Middle America's fears and frustrations than Richard Nixon. During the 1968 election campaign, Nixon sought to colonise the middle ground, promising both 'an honourable end to the war' and 'law and order' at home. In the event, he beat Hubert Humphrey by less than 1 per cent of the popular vote. Had the Democratic convention not been such a catastrophe, had disgruntled peace-plank supporters

not deserted Humphrey, had the renegade Democrat George Wallace not siphoned off millions of Southern votes, had the South Vietnamese president not sabotaged President Johnson's Paris peace talks, then Nixon might have lost again, as he had done to Kennedy eight years earlier. He was not about to risk such a close call a second time.

Wallace was the red-in-tooth-and-claw version of Middle America. He pitched himself as a radical conservative who cried, 'I want you for the Wallace rebellion!' and had the lyrics to 'The Battle Hymn of the Republic' rewritten as his campaign theme: 'He stands up for law and order, the policeman on the beat / He will make it safe to once again walk safely on the street.' He liked nothing better than a showdown with the hippies. At his final election rally in New York he announced, 'We ought to turn this country over to the police for two or three years and everything would be all right,' while outside anti-war demonstrators helped his case by burning Confederate flags and scuffling with officers.

Wallace's campaign collapsed after his running mate, Curtis LeMay, publicly admitted that he would be prepared to nuke Hanoi, but by then he had demonstrated the usefulness of the politics of polarisation. Nixon's team devoted a great deal of energy to wooing disgruntled Southerners away from Wallace. One strategist commissioned a country ballad ('Dick Nixon is a decent man / Who can bring our country back'), only to find that most of the big Nashville stars that he wanted to sing it were in the Wallace camp. Nixon's message to Middle America was Wallace lite. As Phil Ochs astutely observed: 'Nixon got across his image. "It's us against them. I mean, no matter what you think of me, I'm a regular, straight American guy, and if you're not going to have me, you're going to have some hairy freak, with dope in the streets and the destruction of the country. So take your choice." That's the game he played, and played very well.'

In the White House, Nixon played good cop to Vice-president Spiro Agnew's bad cop. Initially considered a joke figure because of his relative obscurity and inexperience, in October 1969 the

former governor of Maryland showed his teeth. At a party fund-raiser in New Orleans he tore into 'the hardcore dissidents and the professional anarchists within the so-called "peace movement"' and warned: 'A spirit of national masochism prevails, encouraged by an effete corps of impudent snobs who characterize themselves as intellectuals.'* Emboldened by the enthusiastic response, a week later he jettisoned any pretence of national unity with a call for 'positive polarisation': an all-out attack on America's enemy within. Scenting the new mood, Nixon himself appeared on TV to address the 'great, silent, majority of my fellow Americans' who wanted peace abroad *and* at home. But behind the reasonable tone, he was deliberately drawing up battle lines: the silent major-ity versus the noisy minority; Us versus Them.

*

Nixon and Agnew were not short of bogeymen. Just as Chicago had angered Middle America, it had further radicalised the New Left. At the University of Michigan in Ann Arbor, disillusioned SDS members formed a new hardline faction, the Jesse James Gang, which advocated 'aggressive confrontation politics'. Other radical new groups, inspired by the Black Panthers' exam-ple, sprang up, among them the May Day Tribe, the Crazies, the Alice's Restaurant Marxist-Leninist (named after Arlo Guthrie's hit) and the White Panthers.

The White Panthers were the brainchild of John Sinclair, the provocative manager of Detroit garage-rockers the MC5. Having moved to Detroit to find 'urban adventure', he was 'exhilarated' by the city's 1967 uprising. According to the MC5's Michael Davis, who attended the riots, 'We wanted to rewrite society. We wanted to build it from the ground up – y'know, tear everything down and start over, and do it right this time.'

* He doubtless had in mind the kind of people that New York mayoral candidate Mario Procaccino, in reference to supporters of his rival John Lindsay, had recently christened 'limousine liberals'. *Time* dubbed Procaccino's candidacy 'The Revolt of the Average Man'.

Sinclair founded the White Panthers in November 1968, with a ten-point programme containing the memorable prescription: 'Total assault on the culture by any means necessary, including rock'n'roll, dope, and fucking in the streets.' 'You can't approach the White Panther party without a sense of humour,' he said later. 'I mean, on the one hand we were serious political revolutionaries who wanted to overthrow the government. On the other hand, we were on acid.' Even a passing glance at the White Panther 'manifesto', which called for the freeing of all prisoners, the return of the barter system, and 'free food, clothes, housing, dope, music, bodies, medical care – everything free for everybody!', would have revealed that acid had the upper hand.

For a few months, especially after their Chicago performance, the MC5 seemed to fulfil the counter-culture's wildest dreams of rock stars as revolutionaries. 'I'm so useless, what will happen to me when the revolution comes?' wailed one awestruck spectator. But, despite recording the incendiary 'Kick Out the Jams' and a version of John Lee Hooker's song about the 1967 riots, 'The Motor City Is Burning', they fell well short of Sinclair's ambitions, and he turned to his other White Panther protégés, the Up. After he was jailed for pot possession, he wrote an anguished letter to MC5 guitarist Wayne Kramer: 'You guys wanted to be bigger than the Beatles and I wanted you to be bigger than Chairman Mao.'

Not all the new factions were too distracted by dope and fucking in the streets to cause real trouble. In June 1969 the SDS disintegrated in a melee of infighting, with different factions vying to prove their Maoist credentials. The most extreme were an offshoot of the Jesse James Gang who called themselves Weatherman, after a line from 'Subterranean Homesick Blues'. 'We felt like miners trapped in a poisonous shaft with no light to guide us out,' remembered Weatherman's Bo Burlingham. 'We resolved to destroy the tunnel even if we risked destroying ourselves in the process.'

The key theatre for Agnew's 'positive polarisation' during

1969 was the trial of eight activists – David Dellinger, Tom Hayden, Abbie Hoffman, Jerry Rubin, Rennie Davis, Lee Weiner, John Froines and Bobby Seale – for conspiracy to riot in Chicago.* The trial began on 24 September. Rubin and Hoffman hoped to put the system itself on trial and pump their message into millions of American homes. The prosecution planned to retrospectively tie disparate, even competing personalities into one big, sinister plot. Each camp was selling an illusion to the viewing public, exaggerating its opponents' villainy in a kind of media arms race.

Abbie Hoffman demonstrated his flair for phrasemaking, dubbing the courtroom a 'neon oven', insisting he was a citizen of 'the Woodstock Nation', and claiming, rather optimistically, that 'rock musicians are the real leaders of the revolution'. The defence called a string of counter-culture stars, including Allen Ginsberg, Timothy Leary, Norman Mailer, Arlo Guthrie, Phil Ochs and Country Joe McDonald, who began singing 'Fixin'-to-Die'. 'No, no, no, Mr Witness,' interrupted Judge Julius Hoffman. 'No singing.' McDonald recited the lyrics instead.† If the prevailing mood was one of puckish disrespect, then a darker note was sounded by self-styled revolutionary Linda Hager Morse. 'After Chicago I changed from being a pacifist to the realisation that we had to defend ourselves,' she said, speaking for many of her peers. 'A nonviolent revolution was impossible. I desperately wish it was possible.'

Weatherman staged its own media event, the Days of Rage. The intention was for a second battle of Chicago – 'Bring the War Home,' urged posters and leaflets. Although the hoped-for hordes of working-class revolutionaries never materialised, and

* The trial judge, Julius Hoffman, later decided that Seale's case should be heard separately, turning the Chicago Eight into the Chicago Seven.
† Phil Ochs and Judy Collins also tried, and failed, to perform protest songs in the courtroom: respectively, 'I Ain't Marching Anymore' and 'Where Have All the Flowers Gone?'

plans for a 'Wargasm' rock festival came to nothing, a few hundred demonstrators embarked on two days of street-fighting, during which city lawyer Richard Elrod, who had pushed forward the Chicago Eight indictments, tried to leap on a Weatherman, missed, crashed into a wall and was paralysed for life. That night Hayden was wracked by anxiety. 'Between Judge Hoffman's courtroom and the Weathermen,' he asked himself, 'where was the sanity?'

Most left-wing commentators regarded the Days of Rage as a feeble, irresponsible fiasco. Hendrik Hertzberg of anti-war magazine *Win* called it 'a huge unearned windfall for the forces of repression'. Chicago Black Panther Fred Hampton, whom Weatherman considered an ally, denounced the group as 'anarchistic, opportunistic, adventuristic and Custeristic'. At Weatherman's December 'War Council' in Flint, Michigan, they sang vicious parodies from the *Weatherman Songbook*, including 'White Christmas' ('I'm dreaming of a white riot / Just like the one on October 8') and Dylan's 'Lay Lady Lay' ('Stay Elrod stay / Stay in your iron lung'). Over subsequent months they went underground, cutting ties with their families and assuming fake names in preparation for further action.

The idea of armed revolution went mainstream in 1969. Short-lived Who affiliates Thunderclap Newman cried 'hand out the arms and ammo' on 'Something in the Air', while Jefferson Airplane whooped, 'Got a revolution, got to revolution' on 'Volunteers'. Columbia Records cynically branded their early 1969 rock releases 'Revolutionaries', with the slogan, 'The Man Can't Bust Our Music', and even hardware company Vaco jumped on the bandwagon, calling, 'Join the Tool Revolution!' As critic Robert Christgau shrewdly noted: 'It took about eighteen months – from early 1967 to late 1969 – for the idea of "revolution" to evolve from an illusion of humourless politniks to a hip password.'

In this roiling year, every major event seemed to invite two opposing perspectives. Take Woodstock. The national media, in

the same brief, Aquarian frenzy which led Hollywood to produce such calamitous LSD farces as *Candy* and *Skidoo*, went gaga for 'history's biggest happening'. A swooning *Time* report approvingly quoted Jimi Hendrix and Janis Joplin and declared: 'In its energy, its lyrics, its advocacy of frustrated joys, rock is one long symphony of protest. Although many adults generally find it hard to believe, the revolution it preaches, implicitly or explicitly, is basically moral.' Some of its readers were not so sure. 'Congratulations!' wrote Mrs A. Anderson Huber from Atlanta. 'Your article . . . does a superb job of furthering the moral decay of this nation.'

Those among the Silent Majority who saw Woodstock as a muddy Sodom and Gomorrah found their very own anthem the following month in Merle Haggard's country music hit 'Okie from Muskogee'. Although Haggard would later call it a 'satirical' look at a Middle America bemused by weed-smoking, free-loving hippies, and it *is* a pretty funny song, millions of listeners embraced it without irony. The 'Okie', once celebrated by Woody Guthrie as a proletarian hero for the left, was now a resentful patriot who waved Old Glory and believed in 'livin' right and bein' free'. A subsequent live version was punctuated by an entirely unsatirical cry of 'Tell it like it is!' from a crowd member, and the follow-up single left no room for humour. In 'The Fightin' Side of Me', Haggard delivered a surly warning to 'squirrelly', 'gripin'' peaceniks who are 'runnin' down my country'. Like 'Okie from Muskogee', it topped the country singles chart for weeks.*

In the final weeks of 1969 it was as if the worst fears of both sides had become flesh. Middle America came face to face with thirty-five-year-old Charles Manson, the nightmare hippie whose crazed followers, drawn from the human flotsam of

* Some 'Silent Majority' hits took the form of portentous narrations, including Victor Lundberg's 'An Open Letter to My Teenage Son' (1967) and Bill Anderson's 'Where Have All Our Heroes Gone' (1969), both of which have to be heard to be believed.

Haight-Ashbury, had hacked to death actress Sharon Tate and three of her friends in August. But Weatherman's Bernardine Dohrn called the killings 'wild!' The anti-war movement learned about Lt William Calley, a man with the bland good looks of a high-school jock, who had allegedly overseen the massacre of 109 civilians in the Vietnamese hamlet of My Lai following the Tet offensive. But in one poll following the publication of reporter Seymour Hersh's revelations, 49 per cent of Minnesotans refused to believe it had happened at all.* Two crimes, two emblematic villains, two Americas.

Nixon exploited this cultural rift for all it was worth. Imagine how things must have appeared to the average American watching the news in the first few days of December: Manson and his 'family' were indicted; eighteen-year-old Meredith Hunter was stabbed to death during the Rolling Stones' performance at the Altamont Festival in California; Black Panther Fred Hampton was shot dead by Chicago police, amid false allegations that the Panthers had fired first. So what if these events were unconnected? They all seemed like harbingers of collapse. No wonder the president's approval rating shot up to 81 per cent.

And so, in its first issue of 1970, *Time* proclaimed the Middle American its Man and Woman of the Year. According to the article, the Middle Americans 'answered MAKE LOVE NOT WAR with HONOR AMERICA and SPIRO IS MY HERO'; they learned 'baton twirling, not Herman Hesse'; they fretted about drugs and porn and student radicalism. Their heroes were Ronald Reagan, Spiro Agnew, astronaut Neil Armstrong, and John Wayne, star of 1968's big pro-war movie *The Green Berets*. Their villains were the Yippies, the Black Panthers and all the liberal intellectuals who endorsed their radical antics. But *Time* was careful to sound a note of caution about Nixon's manipulation

* Following Calley's conviction in March 1971, an Alabama DJ called Terry Nelson recited a spoken-word defence of the soldier over 'The Battle Hymn of the Republic'. 'The Battle Hymn of Lt Calley' sold its first million copies in just four days.

of Silent Majority resentment. The article quoted a report by the liberal-inclined National Committee for an Effective Congress: 'The Administration is working the hidden veins of fear, racism and resentment which lie deep in Middle America. Respect for the past, distrust of the future, the politics of "againstness."' *War across the USA.*

*

On 18 February the court found the Chicago Seven not guilty of conspiracy but sentenced five of them to jail for crossing state lines with intent to start a riot.* After sentencing, Rubin handed Judge Hoffman a copy of his new book, *DO IT!: Scenarios of the Revolution*, with the inscription, 'Julius, you radicalized more people than we ever could. You're the country's top Yippie.'

Out on bail pending appeal, Rubin immediately embarked on a speaking tour, which on 10 April reached the campus of Kent State University in Ohio. 'The first part of the Yippie program is to kill your parents,' he told students. 'And I mean that quite literally, because until you're prepared to kill your parents, you're not ready to change this country.'

Not long after Rubin's visit, Nixon's announcement of plans to expand military operations into Cambodia to knock out enemy sanctuaries precipitated a massive uptick in campus activism. At a May Day rally at Yale, Rubin and Hoffman led a crowd of thousands in a new version of John Lennon's hymn to peace: 'All we are saying is smash the state'.

At Kent State on 2 May radicals set fire to the headquarters of the university's Reserve Officers' Training Corps (ROTC) and threw rocks at the Ohio National Guard. Some of the Guardsmen were back from Vietnam; others had signed up precisely to avoid the war; none were sympathetic towards the grievances of privileged students. Their theme song, 'Billy Buckeye', emphasised their sense of defensive pride: 'We aren't no cheap tin soldiers.'

* The convictions were overturned in 1972.

On Sunday, with the campus under the Guardsmen's control, Ohio's governor James Rhodes flew in to brand the protesters worse than communists or Nazis. Nixon himself had recently described student protesters as 'bums'. One female Kent State student expressed her alienation to an interviewer: 'If the President thinks I'm a bum and the Governor thinks I'm a Nazi, what does it matter how I act?'

Monday. A rally had been scheduled for noon. This had been declared illegal by Governor Rhodes over the weekend, but most students and professors hadn't been properly informed. In fact, many had missed the weekend's activity entirely and only learned about it when they turned up for classes that morning to find Guardsmen on the lawn. As morning classes ended, the number of students on the campus commons topped a thousand, with at least twice as many curious spectators surrounding the area. To the hundred or so nervous Guardsmen, it must have looked like a mob; to the students, the gasmasked Guardsmen must have looked like stormtroopers.

On the dot of noon, three units of Guardsmen advanced on the commons, firing tear-gas canisters. They were met with rocks, chunks of wood studded with nails, and a storm of verbal abuse. They were 'toy soldiers', 'fascists', 'weekend warriors', and worse. The majority of the Guardsmen unwittingly walked into a dead end, hemmed in by a chain-link fence at the end of the university sports field. After fifteen minutes of rocks and ridicule, they retreated up the hill, trailed by cries of 'Pigs off campus!' Then, at around 12.24 p.m., one group of Guardsmen turned to face the students and opened fire. Thirteen seconds and sixty-one shots later, four students lay dead on the ground and nine were wounded.

If all the troops had fired directly into the crowd it would have been a massacre. Many of them, fearing just that, fired into the air instead. But four deaths were shocking enough: Nineteen-year-old ROTC member Bill Schroeder, who was not even a protester, was shot as he lay on the ground to avoid the gunfire.

Twenty-year-old Sandy Scheuer, just walking between classes, was caught in the neck. Nineteen-year-old Allison Krause was shot in the chest as she hid behind a car. Twenty-year-old Jeff Miller was hit in the mouth and lay dead in the roadway, missing most of his face.

Before Miller's body was removed a student photographer snapped a few pictures of fourteen-year-old runaway Mary Vecchio kneeling, open-mouthed, over the corpse, and it was these horrifying images that caught the eye of Neil Young.

*

'Neil surprised everyone,' David Crosby told one reporter after 'Ohio' came out. 'It wasn't like he set out as a project to write a protest song . . . I mean, we've all stopped even watching the TV news, but you read headlines on the papers going by on the streets.' Young's explanation, according to Crosby, was rather vague: 'I don't know. Never wrote anything like this before . . . but there it is . . .'

Indeed, Young was the only member of Crosby, Stills, Nash and Young who hadn't written a protest song before. 'It's quite strange that Neil should be seen as a political animal,' Nash told *Uncut* years later. 'It was always Crosby, Stills and Nash that were doing all that other stuff.'

Alumni, respectively, of the Byrds, Buffalo Springfield and Manchester's the Hollies, Crosby, Stills and Nash had teamed up in early 1969. At Stills's suggestion, his old Buffalo Springfield sparring partner Neil Young was invited into the fold to beef up the summer's live shows, including Woodstock. They represented what *Newsweek* saw as 'a move away from rock-as-cultural-offensive' towards 'contemplation, appreciation, celebration, a self-effacing harmony and poise seeking to refocus on a Utopian vision that had become fuzzy'. Jimi Hendrix neatly summed up their sound as 'western sky music – all delicate and ding-ding-ding'.

Inside the band, though, nothing was delicate and ding-ding-ding, as Stills, a born control freak, conducted a two-front war

against the irreverent Crosby and the domineering Young. Crosby was both the band's most politically concerned member and its most hedonistic, voicing his contempt for 'fucking parlor-pink revolutionary kids'. LA music historian Domenic Priore summed up the dichotomy: 'Do we change the world by going against the grain and shoving crap in The Man's face, or do we just drop out and become an alternate society?' This indecision produced woolly politicking: the post-apocalyptic whimsy of 'Wooden Ships', the obnoxious hippie posturing of 'Almost Cut My Hair' and the sappy sanctimony of Nash's 'Teach Your Children'. Only 'Long Time Gone' (written the night Robert Kennedy died) and 'Find the Cost of Freedom' had any kind of bite.

'Ohio', on the other hand, is a masterpiece. Young packs a lot into ten lines: the cold, accusatory refrain of 'Four dead in Ohio'; the gutsy, precise singling out of Nixon and the 'tin soldiers' of the National Guard; the sudden shift from the perspective of an outsider reading the news to that of a mourning friend crouched over a victim's body. When words no longer seem adequate, the wrenching guitar solo incarnates all the rage and grief of the subject at hand. The only problem with it is the first-person plural: *We're* finally on our own; soldiers are cutting *us* down. In the polarised vocabulary of the day it may have made sense, but there was a big difference between the Kent State students and a bunch of rock stars.

Gerald Casale was a Kent State SDS member who witnessed the deaths of Krause and Miller, both of whom were his friends. In later years he would form the art-punk band Devo, appear in Young's 1982 film *Human Highway*, and even cover 'Ohio'. But at the time, he told Jimmy McDonough, 'we just thought rich hippies were making money off of something horrible and political that they didn't get. I know there were big, screaming arguments in SDS meetings about Young being a tool of the military-industrial complex.'

'I always felt funny about making money off that,' Young told McDonough. 'It never has been resolved.'

Spiro Agnew called the Kent State killings 'predictable' and accused his old foes, the 'elitists', of fomenting a culture of 'traitors and thieves and perverts and irrational and illogical people'. In the following days, over a thousand campuses experienced some form of unrest. Strikes, sit-ins and rallies were commonplace; in some cases, ROTC buildings were burned and the National Guard called in. On 14 May, at Jackson State College in Mississippi, police opened fire, killing two black students and wounding twelve.

Meanwhile, Middle America made its feelings known. 'The score is four / And next time more' was one chant doing the rounds on the streets of Kent itself, while a national Gallup poll found that 58 per cent of respondents blamed the four students for causing their own deaths. Conservative attack dog Al Capp claimed that, 'the real Kent State martyrs were the kids in uniforms'. The Silent Majority, allegedly so stoic and decent, was taking up cudgels.

Four days after the Kent State killings, New York's Mayor Lindsay ordered the city's flags to be flown at half-mast as students marched down Wall Street in memory of the dead. To their amazement they were met by a counter-demonstration: two hundred construction workers waving banners with slogans such as: 'With Americans Like John Lindsay . . . Hanoi Can't Lose'. Joined by hundreds more workers on their lunch break, the hard-hatted patriots marched on City Hall, singing 'God Bless America' and 'The Star-Spangled Banner' as they battered their opponents. They then turned on Pace University, where they beat students with lead pipes wrapped in American flags, while the police, offering their tacit endorsement, showed no inclination to intervene. On 20 May 100,000 workers mounted a pro-war march in Manhattan. Among the placards this time: 'National Guard, 4 Kent, 0'. Country singer Harlan Howard, a former US Army paratrooper, later provided a potential soundtrack for

future blue-collar rampages with his *To the Silent Majority With Love* album, featuring such songs as 'Better Get Your Pride Back Boy' and 'Uncle Sam I'm a Patriot'.*

Nixon made a token effort to meet with Kent State students, inviting them to the Oval Office on 6 May. Two days later, as thousands of anti-war demonstrators gathered in Washington DC, he ventured down to the Lincoln Memorial in the wee hours to make awkward small talk with some of them, but he was on firmer ground later in the month when New York construction workers presented him with his own totem of working-class machismo: a hard hat stencilled with the words 'Commander in Chief'.

Nixon's Chief of Staff, H. R. Haldeman, later wrote: 'Kent State marked a turning point for Nixon, a beginning of his downhill slide toward Watergate.' It also marked the death, for many young people, of hippie idealism. 'That changed me,' Gerald Casale told writer Simon Reynolds. 'I was kind of a hippy until then. For me it was the turning point. I saw it all clearly from there on. All these kids with their idealism, it was very naive. Just shoot a few and it changed the whole world.'

Alexander Heard, Chancellor of Vanderbilt University, privately warned Nixon: 'The meaning of May [was] a big shove leftward . . . The self-identification by college students as a separate class in society is assuming extraordinary proportions.' This increased radicalism manifested itself on 21 May 1970, when Weatherman issued its 'Declaration of a State of War', promising: 'Within the next fourteen days we will attack a symbol or institution of Amerikan [sic] injustice. This is the way we celebrate the example of Eldridge Cleaver and H. Rap Brown and all black revolutionaries who first inspired us by their fight

* Johnny Cash, however, irritated Nixon by refusing to perform 'Okie From Muskogee' or Guy Drake's derisive 'Welfare Cadillac' during a White House concert in April 1970, choosing instead his own pro-youth 'What Is Truth?': 'The ones that you're calling wild / Are going to be the leaders in a little while.'

behind enemy lines for the liberation of their people.' They were a little late keeping their promise. It was nineteen days before they bombed their first target, the headquarters of the New York Police Department.*

The 2 November issue of *Time* bore the strapline 'The Urban Guerrillas', drawing together the disparate threads of home-grown terrorism, the Irish Republican Army, Quebecois separatists, Indian Naxalites and Uruguayan Tupamaro guerrillas. It quoted a sobering speech delivered to the United Nations by Britain's new prime minister, Edward Heath – 'It may be that in the decade ahead of us, civil war, not war between nations, will be the main danger we will face' – and noted that since the beginning of the year the US had experienced almost 3,000 bombings and over 50,000 bomb threats. Many cases were the work of right-wingers: the Not-So-Silent Majority. In Texas, two members of a racist cell called the Raiders were convicted of blowing up thirty-six school buses.

White bigots, however, were not whom the Republicans had in mind when they released TV adverts during the midterm elections, urging voters: 'Bring an end to the wave of violence in America.' Taking a move from George Wallace's playbook, the party positively welcomed disruptive demonstrators, especially when Agnew was speaking. 'If the Vice-president were slightly roughed up by those thugs nothing better could happen for our cause,' Nixon told his advisers. 'If anybody so much as brushes against Mrs Agnew, tell her to fall down.'

But the Republicans hadn't registered that there was something Middle America feared even more than student radicals: rising inflation. In the elections, they actually lost ground to the

* Despite their bogeyman status, the fugitive Weatherman membership numbered less than a hundred and soon renounced armed struggle in a self-searching December communiqué with the Dylan-inspired title 'New Morning – Changing Weather'. Although they continued to bomb property, they rejected assassinations, kidnappings and other attacks on individuals.

Democrats. A disgruntled Nixon drew up a list of new priorities, leaked to the press, among them: 'The image of the hermit leader, walled off from the people, antagonistic to the nation's youth, possessed by foreign affairs, must be changed,' and: 'The Vice-president . . . must be toned down.'

The hermit leader found at least one rock star who was sympathetic to his values. Shortly before Christmas he received an eager Elvis Presley at the White House. According to a memo written by White House aide Bud Krogh, Presley called the Beatles 'a real force for anti-American spirit', 'indicated to the President in a very emotional manner that he was "on your side"', and pledged to teach the youth clean-living and respect for the flag. Nixon was grateful but not entirely convinced. Three times, Krogh noted, the president expressed his 'concern for Presley's credibility'.

*

Shortly after Kent State, *NME*'s Ritchie Yorke wrote, 'You either do something about changing the bull-like rush of the Establishment, or you become part of the Establishment. No longer is there any middle ground.' He confidently predicted, 'There will almost certainly be a trend towards very politically-oriented pop acts in the very near future. Entertainment for the revolutionary troops, so to speak.' But quite the opposite proved to be the case. For Neil Young, 'Ohio's amalgam of fury, grief and topical precision was unrepeatable. As he told Jimmy McDonough, 'Events like that don't happen every day, so you gotta have an artist at a point in his or her life where the artist is vulnerable, open and feels completely what has happened so they can put it into words or some sort of expression. All those things gotta come together.'

His subsequent solo album, *After the Gold Rush*, spoke to turn-of-the-decade despond in more abstract terms: the burning castles and moaning sirens of 'Don't Let It Bring You Down', or the sci-fi eco-angst of the title track. His next outright protest songs, 'Southern Man' and 'Alabama' , were assaults on the

racist South which sounded bizarrely tardy in the early 1970s, with their references to burning crosses and cracking bullwhips. Although black singer Merry Clayton's hair-raising version of 'Southern Man' was a vast improvement, both songs were guilty of condescension – from a Canadian, no less – and were most memorable for inspiring Southern rockers Lynyrd Skynyrd to pen an indignant retort, 'Sweet Home Alabama' (1974). 'We thought Neil was shooting all the ducks in order to kill one or two,' explained frontman Ronnie Van Zant. A 1973 radio interview about 'Ohio' demonstrated that Young wasn't exactly a details guy, confusing *Life* with *Time*, and Mary Vecchio with 'Allison Whatsername'.

In 1971 Nash weighed in with the insipid 'Chicago' and 'Military Madness' while Crosby grumbled about White House warmongers on 'What Are Their Names', but such was the wasted, hippie-meltdown ambience of the album on which it appeared, *If I Could Only Remember My Name*, that listeners might justifiably have read the song's title as a literal expression of confusion. It's an impression confirmed by a scene in Young's unwatchably abstruse movie *Journey Through the Past*, in which Crosby solemnly explains cultural polarisation in terms of 'a gray-faced man who hates you' versus 'a girl runnin' through a field of flowers, half-naked and laughin' in the sunshine'.

Most songwriters seemed simply bewildered by the collapse of 1960s idealism. The Beach Boys' wretched 'Student Demonstration Time', taking in Kent State, Jackson State and People's Park, as good as claimed that anyone joining a demonstration was asking to be shot. 'I know we're all fed up with useless wars and racial strife,' wheedled Mike Love, 'But next time there's a riot, well, you'd best stay out of sight.' The Who repudiated political commitment with tremendous force on 'Won't Get Fooled Again': 'Meet the new boss / Same as the old boss.' Pete Townshend had been asked by British radical Mick Farren to write a song that would make the Who the 'tool of the British revolution' but responded instead with 'an anthem

for the apolitical'.* 'It's a terrible song,' he ruefully told writer
Robin Denselow years later. 'It's saying, "There's no point in
having anything to do with politics and revolution, 'cos it's all a
lot of nonsense."'

But nobody exemplified the widespread collapse in the quality
and efficacy of political songwriting after 1970 better than John
Lennon.

*

John and Yoko had decamped to New York in August 1971,
where they were immediately embraced by the Yippies. As Stew
Albert told Jon Wiener, 'Lennon always said he was more com-
fortable with us than with Tariq [Ali] and Robin [Blackburn]
because our style of politics was similar to showbusiness.' The
Lennons' new apartment on Bank Street became a magnet for
left-wing activists of every stripe, including Allen Ginsberg,
Bobby Seale and Huey Newton.

Lennon and Ono's first public appearance was at a rally in Ann
Arbor in aid of John Sinclair. The erstwhile White Panther was
two and a half years into a ten-year prison sentence, and had been
orchestrating a media campaign from his cell. On 10 December
Phil Ochs adapted 'Here's to the State of Mississippi' into 'Here's
to the State of Richard Nixon' and Stevie Wonder dedicated
'Heaven Help Us All' to Nixon and Agnew. Eventually, deep into
the wee hours, John Lennon made his return to the US stage after a
five-year absence and unveiled his latest efforts. 'John Sinclair' and
'Attica State', about September's bloody Attica Prison uprising,
were blunt to a fault, no more than hastily assembled sloganeer-
ing; Yoko's 'Sisters, O Sisters' was a misfiring feminist boogie. As
Ochs noted, the crowd's reaction was muted.

Two days later, amazingly, Sinclair was released. 'Somehow
the arrival of John and Yoko in New York has had a mystical

* Farren fronted both the Deviants, whom he called 'the killer-clowns
of the revolution', and the short-lived British arm of the White
Panther Party.

effect that is bringing people together again,' wrote Rubin, excitedly anticipating a 'political Woodstock' at the following year's Republican National Convention in San Diego. Lennon announced plans for a worldwide tour to raise money for political prisoners and campaign against Nixon in the coming election, in which, due to a change in the voting age, eighteen- to twenty-year-olds were suddenly a valuable constituency. During sessions with Bob Dylan the previous month, Ginsberg had recorded a song called 'Going to San Diego', and Lennon spoke to Dylan about playing his anti-Nixon tour. The excitement around the idea was palpable. 'We'd make musical history as well as political history,' Rubin told Jon Wiener. 'The whole thing was going to revive the sixties.'

In mid-February John and Yoko co-hosted *The Mike Douglas Show* every afternoon for a week, thus inviting the likes of Rubin and Seale into America's living rooms to rail against Kent State and Vietnam. To the champions of the Silent Majority, it all seemed like a surreal bad dream. The Justice Department moved ahead with plans to deport this increasingly bothersome ex-Beatle.

Meanwhile, Lennon was busy recording the next Plastic Ono Band album, *Some Time in New York City*. He was consumed by the idea of 'front-page songs', drawn directly and spontaneously from the latest headlines – Phil Ochs' 'newspaper writing' by another name. 'It was done in the tradition of minstrels – singing reporters,' he explained. 'Ohio', literally inspired by the front page of *Life*, had been a prime example of how to do it right. Practically everything on *Some Time in New York City* showed how to do it wrong. It was where the heyday of the 1960s protest song came to die.

The cover image was a mock-up of a *New York Times* front page, with the legend: 'Ono news that's fit to print.' The causes were up-to-the-minute: feminism, Bloody Sunday, the bloodbath at Attica. The songs were condescending, slapdash, gauche and inept. The excruciating nadir was the crass

doggerel of 'The Luck of the Irish' ('Let's walk over rainbows like leprechauns').* *Rolling Stone*'s reviewer called the album 'so embarrassingly puerile as to constitute an advertisement against itself'.†

When asked, a few years later, how his political passion had affected his music, Lennon would reply, 'It almost ruined it.'

*

In May 1972 Lennon publicly abandoned plans for his anti-Nixon tour. He was in the midst of a high-profile legal battle to avoid deportation and this was no time to take on the White House. It's debatable how much of a threat he posed anyway. An FBI informant had recently reported: 'Lennon appears to be radically oriented[;] however he does not give the impression he is a true revolutionist since he is constantly under the influence of narcotics.'

Consequently, musicians' efforts to remove Nixon in November took more conventional forms. The actor Warren Beatty organised benefit gigs for the Democratic candidate, so-called 'prairie populist' George McGovern, featuring the likes of Simon and Garfunkel (reunited for the occasion), Peter, Paul and Mary, Carole King and the Grateful Dead. McGovern himself awkwardly pandered to a benefit crowd at the Los Angeles Forum by quoting from the Beatles' 'Here Comes the Sun'. 'A great deal of the leadership of this generation comes from music and film people,' Beatty told the *New York Times*, 'whether people like that fact or not.'

* Not to be outdone, Paul McCartney's new band Wings rushed out their own terrible single, 'Give Ireland Back to the Irish'.
† It's a shame that Yoko's feminist songs weren't better, because the burgeoning women's movement was ill-served by protest music. Despite the efforts of the Chicago and New Haven Women's Liberation Rock Bands (respectively, 'Ain't Gonna Marry' and 'Abortion Song'), the movement's only anthem was Helen Reddy's Broadway-style 1972 hit 'I Am Woman'.

The benefit concert was the new, acceptable face of celebrity activism, one which rock stars found far more appealing and far less risky than writing protest songs or joining demonstrations. The fashion had been kick-started in August 1971 by George Harrison's all-star Concert for Bangladesh, which had raised a quarter of a million dollars to aid victims of war and natural disaster. It was the first step on the long road to Live Aid.

Unfortunately, the endorsement of the Grateful Dead et al. was probably the last thing McGovern needed. Democratic senator Thomas Eagleton, speaking anonymously, told columnist Robert Novak in April: 'The people don't know McGovern is for amnesty, abortion and legalization of pot. Once Middle America . . . finds this out, he's dead.' The quote – quickly abbreviated to 'amnesty, abortion and acid' – redoubled its destructive power during the Democratic National Convention in Miami Beach, where TV cameras recorded images that gave Middle America night sweats: hordes of hippies, no longer 'clean for Gene'; Allen Ginsberg, cross-legged and chanting; black leader Jesse Jackson in an African dashiki; Rubin and Hoffman, 'groovin' on democracy'; men in 'Gay Power' T-shirts kissing; victorious McGovernites singing 'We Shall Overcome' and whooping, 'The streets of '68 are the aisles of '72!' The other side of proceedings – the hundreds of old-fashioned, sensibly dressed delegates; the appearance by country music stars Tammy Wynette and George Jones – did not make for such colourful footage.

By contrast, the Republican convention, moved to Miami Beach from San Diego after a lobbyist scandal, radiated so much unity and strength that reporters were bored stiff. Inside, delegates loyally toasted Nixon and argued that the Democratic Party was now in the hands of 'radicals and extremists'. Outside, in Flamingo Park, different radical groups – the Yippies, their hardline stepchildren the Zippies, the militant SDS offshoot Attica Brigade, the not-so-militant Pot People's Party – vied

for attention. Rubin and Hoffman were dispirited. Having celebrated the power of spectacle in Chicago, they now found that spectacle, in its most clichéd and predictable form, had obscured the message behind it. A Gallup poll after the convention found that the president had a 34 per cent lead.

McGovern's campaign came off the rails when his running mate, none other than the loose-lipped Thomas Eagleton, withdrew amid revelations that he had received electroshock treatment for depression, and it never fully recovered. Nixon also benefited from the assassin's bullet which had struck, and paralysed, George Wallace in May.* With Wallace out of the race, Nixon had the Southern vote all sewn up.

On 7 November Nixon obliterated McGovern, taking every state except Massachusetts and the District of Columbia. By the time John and Yoko got to Rubin's house to watch the results that night, the scale of the defeat was already horribly clear. 'This is *it*?' Lennon screamed. 'I can't believe this is fuckin' *it*! I mean, here we are – this is the fuckin' revolution: Jerry Rubin, John and Yoko, and accessories. This is the fuckin' middle-class bunch that's gonna protect *us* from *them*!'

*

The aftermath of an election defeat is always difficult. Fragile alliances disintegrate. Priorities are reassessed. Wounds are licked. The tradition of rock protest, already faltering, had been given a late shot in the arm by Lennon's extraordinary if scatter-shot burst of activism. But shaken by failures both political and artistic, and hounded by the government, Lennon gave up on changing the world. He later attributed his radical phase to 'guilt for being rich, and guilt thinking that perhaps love and peace isn't enough and you have to go and get shot or something . . . to

* Continuing his obsession with the Alabama governor, Neil Young included a reference to the shooting in his pro-McGovern single with Graham Nash, 'War Song'.

prove I'm one of the people. I was doing it against my instincts.'*

For the rest of what Phil Ochs angrily described as the 'sodo-mized Seventies', rock stars would confine their politicking to single issues: Dylan's 'Hurricane' (1975), about wrongly con-victed ex-boxer Rubin 'Hurricane' Carter, or Randy Newman's droll satires on American bigotry and belligerence in songs such as 'Political Science' (1972) and 'Rednecks' (1974). Apartheid, nuclear power and the environment were also potential sub-jects, but no cause united people like the war had. After the last US helicopter left Saigon on 30 April 1975, Phil Ochs' brother Michael told David Crosby, 'It was like now that the dragon was slain, everybody was lost.'

Many others would eschew social comment completely. Even as soul music took up protest songs with a vengeance, rock turned inward. The touchstones were *Crosby, Stills and Nash*, Dylan's *Nashville Skyline*, Joni Mitchell's *Blue* and the back-to-the-land aesthetic of Dylan's former backing group, the Band. In a lofty defence of political apathy, Pete Townshend talked about creating 'a realistic and self-contained microcosm working effec-tively and humanely within a corrupt and apathetic democracy'. This withdrawal into apolitical introspection was intensified, in some cases, by vast wealth and heavy drug use. 'I cared mostly about my next fix,' Crosby candidly confessed in his memoir *Long Time Gone*. 'I didn't care too much about people starving in Afghanistan.'

The new disconnection from politics was encapsulated in one of 1972's breakthrough hits. The debut single from the Eagles, a new country-rock outfit from Los Angeles, was 'Take It Easy', a cheerfully pragmatic hymn to surrender which advised listeners:

'Lighten up while you still can / Don't even try to understand.'

* His 1973 album *Mind Games* (working title: *Make Love Not War*) did contain one political song, 'Bring on the Lucie (Freda People)', but critics either overlooked the message or, like *Creem*'s Lester Bangs, didn't rate it: 'This ain't Frantz Fanon, it's the same fat limey who sang "Twist and Shout".'

11

'You will not be able to plug in, turn on and cop out'

Gil Scott-Heron, 'The Revolution Will Not Be Televised', 1970

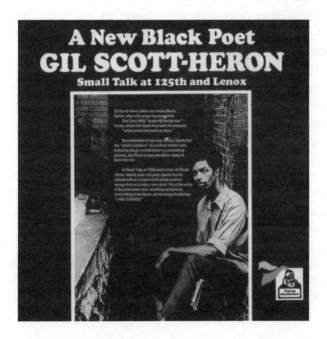

Poems that kill

Gil Scott-Heron, *Small Talk at 125th and Lenox* (Flying Dutchman LP, 1970). This album featured the first recording of 'The Revolution Will Not be Televised'.

In the days leading up to 19 May 1968, twenty-year-old Abiodun Oyewole was nervous. The young poet was booked to appear at a birthday tribute to the late Malcolm X in Mount Morris Park, Harlem, and he didn't have a clue what to perform. Although he had studied poetry at high school in Queens, and discovered performance poetry after seeing a theatrical recital of verses by the Harlem Renaissance poet Langston Hughes, his sole political poem to date, 'Wall Street Journal', was about the exploitation of Martin Luther King's death the previous month – not really appropriate for a Malcolm X tribute.

In need of inspiration, the budding poet took a walk around Harlem, soaking up the language of the street corner. '"What is your thing" is what everybody was saying,' he remembers in the book *On a Mission*. 'It meant What are you doing for the revolution? What are you doing for the movement? . . . Everybody had to have a thing.' Oyewole wrote a poem called 'What Is Your Thing?' His fellow performers also threw down the gauntlet to the black community: David Nelson asked, 'Are You Ready Black People?' while Gylan Kain observed, 'Niggers Are Untogether People.' That day, the three men became the Last Poets.

'I was the baby in the group,' Oyewole told *Perfect Sound Forever*. 'Kain was the greatest, most intense poet I'd ever heard in my life, especially dealing with the subject of "niggers" and how he made it clear how detrimental it was for us to follow that pattern.' The three men came on stage at Marcus Garvey Park performing a chant Oyewole had heard during coverage of a demonstration at Howard University. 'Are you ready, niggers?' they asked. 'You got to be ready.' Soon the whole crowd was chanting along. *Readiness* was one of the watchwords of the era. Readiness for what? Revolution, of course.

*

The Last Poets came together during an episode in the history of black America when it seemed that there was no ceiling on what changes might come. 'There wasn't any question about whether there was going to be one or not,' Oyewole writes. 'The revolution was inevitable.' Artists were expected to join the propaganda effort. 'All art must reflect the Black Revolution,' declared Ron Karenga of the black nationalist US Organization, 'and any art that does not discuss and contribute to the revolution is invalid.' Compared to the half-hearted revolutionary chic of white rock bands, this was serious business. The Last Poets named themselves after reading the poem 'Towards a Walk in the Sun', in which US-based South African poet K. William Kgositsile argues that the fight against the oppressor will at some point make art irrelevant: 'The only poem you will hear will be the spearpoint pivoted in the punctured marrow of the villain.' 'Therefore,' David Nelson extrapolated, 'we are the last poets of the world.'

The Last Poets, like the Watts Prophets and Gil Scott-Heron, operated at the nexus of black America's two most radical art forms: poetry and jazz. The most celebrated and controversial poet of Black Power was Amiri Baraka, formerly LeRoi Jones. After Malcolm X was killed, he abandoned his white family and beat-poet friends and moved to Harlem, where he founded the Black Arts Repertory Theatre. His 1965 poem 'Black Art' was a two-fisted manifesto for black poetry as intellectual warfare: 'We want "poems that kill." / Assassin poems'. Even now, it makes the reader flinch, due as much to its lurid misogyny and anti-Semitism as its stabbing verbal energy – anticipating the vexed power dynamic of militant hip-hop by twenty years, the oppressed becomes the oppressor.* Many young black poets responded to his call for a new species of warrior verse. 'He was taking strides outside the boundaries,' Oyewole told *Perfect Sound Forever*. 'He was a major influence and a true mentor of the Last Poets.'

* He repudiated these sentiments in 1980's 'Confessions of a Former Anti-Semite', later putting them down to 'trying to be super-militant'.

If the ideas behind 'Black Art' had a soundtrack in 1965, it was the avant-garde jazz of John Coltrane, Ornette Coleman, Archie Shepp and Albert Ayler – Baraka even recorded a jazz version of 'Black Art' with drummer Sunny Murray. Shepp, a fearsome saxophonist who commemorated Malcolm X on the eerie 'Malcolm, Malcolm – Semper Malcolm', told Nat Hentoff of the *New York Times*: 'Jazz is the product of the whites – the ofays – too often my enemy. It is the progeny of the blacks – my kinsmen. By this I mean, you own the music and we make it . . . I play about the death of me by you. I exult in the life of me in spite of you. That's what the avant-garde is about. We're not simply angry young men – we're enraged, and I think it's damn well time.'

Jazz and poetry went further and cut deeper than Motown ever could. While soul music's voices of protest were firmly entrenched in the mainstream music industry, circumscribed by concerns over airplay and how much rhetoric their existing fans would tolerate, even their most outspoken lyrics paled beside Eldridge Cleaver's battle cries. But just as Melvin Van Peebles' *Sweet Sweetback's Baadasssss Song* (1971) invented a DIY black cinema which operated outside of Hollywood, the new breed of black performance poets delivered messages undiluted by commercial considerations. Larry Neal, one of Baraka's allies in the Black Arts Movement, used to have heated discussions about the need for a truly radical black lyricist: 'Suppose James Brown read Fanon.' The new black wordsmiths offered a partial answer.*

*

During their first months together, the Last Poets swiftly aligned themselves with the revolutionary vanguard. They performed at Panther functions and invited the Panthers' own poets to appear at their East Wind poetry workshop on 125th Street. That summer, director Herbert Danska filmed three of the Last Poets

* The Panthers fielded their own revolutionary musicians, singer Elaine Brown and Temptations-style soul band the Lumpen, although their appeal proved rather limited.

– Nelson, Kain, and late arrival Felipe Luciano – rhyming on the streets and rooftops of Harlem. The movie, *Right On!*, would later be hailed by producer Woodie King, Jr, as 'the first totally black film', making 'no concession in language or symbolism to white audiences', but by the time it was released in 1970, things had become complicated. The film's three stars had broken away, calling themselves the Original Last Poets, leaving Oyewole with percussionist Nilija. 'We wanted to have a collective of men, different heads, with everybody not thinking the same but our ideologies similar enough for us to get on the stage,' said Oyewole. 'That proved to be, beyond everything else, the biggest test.' But one day the pair received an important visitor at East Wind, a hard-nosed young man from Ohio named Umar Bin Hassan.

Hassan had grown up in the tough Elizabeth Park housing projects of North Akron. As a teenager, he took part in the 1966 Hough race riots, battling the National Guard in the streets of Cleveland, and fell in with local black nationalist Ahmad Evans. When he saw the Panthers on TV, marching into Sacramento: 'That shit blew my mind . . . I fell in love with these brothers instantly.' His trigger to start writing poetry was a magazine picture of Amiri Baraka, arrested, bandaged and bleeding after the 1967 Newark riots, with the caption: 'Smash those jelly white faces.'

In February 1969 Hassan moved to New York and dropped in on the Last Poets, whom he had met the preceding year at an arts festival in Ohio. Oyewole found him a place to stay and invited him to make a guest appearance with him at a show. 'There's a brother here from Ohio,' Oyewole told the crowd. 'You decide if he's a Last Poet.' After Hassan performed two of his poems, the typically combative 'Nigger Town' and 'Muthafucka', the crowd shouted, 'Yeah, make him a Last Poet!' A few months later the Poets recruited another new member, a former paratrooper and Muslim convert called Jalal Mansur Nuriddin, and it was this line-up that recorded the 1970 album *The Last Poets*. 'Jalal almost didn't get into the group,' Oyewole told *Perfect Sound*

Forever. 'Nobody liked him. *Everything* he said was rhymes. All the damn time. He didn't talk to you unless it was a fucking rhyme. But I'm really tolerant.'

The first line you hear on *The Last Poets* is Oyewole's: 'I understand that time is running out.' Behind him, his bandmates strike up a sinister chant, 'Tick tock, tick tock.' The effect, which carries through the whole album, is both bracing and claustrophobic. While each track is credited to a single Last Poet, the others crowd around him, chanting, whooping, muttering, breathing, moaning, creating a mood of humid urgency: there is too much to say and not enough time in which to say it. America itself is in the crosshairs ('The Statue of Liberty is a prostitute') but so are slack, unrevolutionary black people: *niggers.* The word was only cautiously entering soul music by 1970, but here it is sprayed like bullets, each hard *g* a shock to the ear: 'Niggers Are Scared of Revolution', 'Wake Up, Niggers'.* The album is a series of demands that only the most revolutionary black man could hope to meet, an unforgiving ultimatum designed to shock listeners out of their perceived complacency. According to the black writer Darius James, the album 'dropped a bomb on black Amerikkka's turntables. Muthafuckas ran f'cover. Nobody was ready.'

There was, of course, not a hope of airplay, but 'Wake Up, Niggers' reached a hip audience when it was used in Nic Roeg's *Performance*, starring Mick Jagger. Signifying a cold blast of reality into the cloistered, dope-fogged atmosphere of a rock star's lair, it mirrored the real-life contrast between the decadent detachment of the rock aristocracy and the fierce hunger of black militants. The album broke into the national Top 30, through word-of-mouth: a remarkable feat. It also attracted the attention

* That year, the mild-mannered Curtis Mayfield shocked listeners with his introduction to '(Don't Worry) If There's a Hell Below We're All Gonna Go', an apocalyptic twist on multiracial unity: 'Niggers! Whiteys! Jews! Crackers!' The Temptations' satirical, Whitfield–Strong song about white flight, 'Run Charlie Run' featured the line 'The niggers are coming,' much to the band's consternation.

of COINTELPRO, the covert branch of the FBI which, since 1956, had been surveilling, infiltrating, harassing and sabotaging 'subversive' groups, with especial attention paid to the civil rights and anti-war movements.

No sooner had the album been released than the group was in flux once again. While Nuriddin wanted to be a star like his hero Miles Davis, Oyewole had had enough of poetry. 'I began to feel that being a poet was a pitiful example of being a revolutionary,' he remembered. First, he joined the Harlem Committee for Self-Defense, an offshoot of the Panthers. Then, at Shaw University in North Carolina, he fell in with student radicals. Oyewole and a friend stole some firearms and mounted an armed robbery on some local Klansmen, which led to a manhunt, arrest and almost four years in jail. Thus ended Oyewole's revolutionary adventure. 'Back then, I wanted to see everything burned and people hanged,' he told *Perfect Sound Forever*. 'I wanted to see riots. The one thing that stopped me in my tracks was this guy speaking at one of our forums: "You can't really be a revolutionary until you know the kind of world that you want your kid to live in." . . . These people were looking for another concept.'

Oyewole's most startling poem was 'When the Revolution Comes' (1970), in which he envisioned 'guns and rifles . . . taking the place of poems and essays' and 'black cultural centres' as 'forts supplying the revolutionaries with food and arms'. 'There I was, on the front lines of this great would-be revolution,' recalled Oyewole. 'I thought, how could I be a catalyst for this Armageddon? I wondered how can I say something that hasn't been said before?' But he was caustically sceptical about black people's readiness for such an uprising: 'Until then you know and I know niggers will party and bullshit.' And the first line would prove influential on another young black poet, Gil Scott-Heron: 'When the revolution comes, some of us will probably catch it on TV / With chicken hanging from our mouths.'

*

Gil Scott-Heron was born in Chicago in 1949 and spent his childhood with his grandmother in rural Tennessee, where he was playing piano by the age of four and writing detective stories by eleven. At thirteen he moved to the Bronx to live with his mother and earned a scholarship to the prestigious Fieldston School. He wrote a high-school paper on Langston Hughes, who encouraged him to apply to his own alma mater, Pennsylvania's Lincoln University. It was there he befriended a musically gifted younger student called Brian Jackson, with whom he formed a nine-piece band, Black and Blues, the start of a long and fertile creative alliance. 'We hit it off immediately,' Jackson told writer James Maycock. 'I thought, "What a way this man has with words!" . . . I figured if we can do the music right, we can draw enough people in to hear this.'

Scott-Heron took a year out from university to move back to New York and write his debut novel, a socially conscious urban thriller called *The Vulture*. He never returned to Lincoln to finish his degree; there were too many exciting opportunities coming his way. After writing a second novel, *The Nigger Factory*, set in a black university, and a volume of poetry, *Small Talk on 125th and Lenox*, he approached Bob Thiele, whose fledgling Flying Dutchman label was affiliated to Scott-Heron's publisher. Thiele didn't have the budget to finance a full musical recording but gave Scott-Heron the opportunity to perform his *Small Talk* poems as spoken word, backed by three percussionists (Jackson, still studying at Lincoln, was unavailable). The breathless liner notes which ran alongside the cover image of a skinny, intense young man slouched in a ghetto doorway promised, 'Gil Scott-Heron takes you Inside Black . . . His is the voice of the new black man, rebellious and proud, demanding to be heard, announcing his destiny: "I AM COMING!"'

From the start, Scott-Heron wanted to bring a new dimension to black music. 'There are 360° of the black experience,' he told *Rolling Stone*'s Sheila Weller, 'but the same *one* kept being sung about: sex-and-love, love-and-sex.' He was equally certain

of the style he wanted, inspired by Baraka and, further back, the West African tradition of the wandering bard, or *griot*. 'It seemed practical within a system where very few of our people can read with the type of interpretive perception that's necessary to deal with poetry,' he explained. He cited among his inspirations Langston Hughes, Huey Newton, John Coltrane and Nina Simone: 'She was black before it was fashionable to be black.'

Whereas the Last Poets had the theatrical vigour of actors or preachers, Scott-Heron was more of a raconteur. The live recording of *Small Talk on 125th and Lenox* is peppered with charming banter and appreciative audience laughter and he sings three tracks at the piano, displaying an aching tenor very different from his tough, sardonic speaking voice. He also puts the need for a stable home and a good education before revolutionary rhetoric, scolding street-corner radicals for damning other black men with Maoist hellfire ('Brother'), and telling 'a paleface SDS motherfucker' to 'go and find his own revolution' ('Comment #1'). 'Whitey on the Moon' has its eye firmly on the bottom line: 'I can't pay no doctor's bills / With Whitey on the moon.' The album's indisputable highlight, however, is the poem which would overshadow all the rest: 'The Revolution Will Not Be Televised'.

When *Small Talk* sold well enough to finance a second album, Scott-Heron decided to give its standout track another outing. Jackson had by now been ejected from Lincoln for protesting against the Eurocentric curriculum, and was free to bring his prodigious songwriting and arranging skills to bear. Consequently, *Pieces of a Man* (1971) was a completely different beast. Suddenly, the 'New Black Poet' was singing richly textured soul-jazz songs such as the addiction narrative 'Home Is Where the Hatred Is' and the celebratory 'Lady Day and John Coltrane', with a full band behind him.

The only poem on the disc was the revamped 'Revolution', now in possession of a muscular, prowling bass line and darting flute which made Scott-Heron's words both more commanding

and more seductive, and let his sly sense of humour breathe. His subject was a revolution of the mind, not the gun. 'That was satire,' he later told writer Rob Fitzpatrick. 'People would try to argue that it was this militant message, but just how militant can you really be when you're saying, "The revolution will not make you look five pounds thinner"?'

Scott-Heron unpacks the Last Poets' image of a revolution without commercials into a hallucinatory, channel-hopping tour of white popular culture, with cameos from, among others, Nixon, Agnew, Steve McQueen, Jackie Onassis and the Beverly Hillbillies. The language of advertising and TV news coverage is satirically *détourned* with immaculate precision; Scott-Heron is a pretty persuasive announcer himself. Double meanings abound: long-running soap opera *Search for Tomorrow* is contrasted with 'black people . . . looking for a brighter day'. 'The revolution will be no re-run, brothers,' he concludes. 'The revolution will be live.' Though not the first song to attack TV's mind-numbing power (Frank Zappa did so on 1966's Watts-inspired 'Trouble Every Day'), it was the first to use the medium's vocabulary against itself, twisting pre-chewed banalities, like papier-mâché, into new and subversive messages. The song would come to define him above all others, to his mild annoyance. 'The song that people decide to attach to you – the one they identify you with – is not often giving the other ones a look-in,' he told Fitzpatrick.

The spoken-word format attracted artists who wanted to go beyond sloganeering. 'You have to be able to perceive things with clarity, in depth as well as superficially,' Scott-Heron told the *NME*. 'If you're attempting to get people to think, which undoubtedly [James Brown] was, you have to get your information together otherwise it becomes terribly transparent that you haven't done your homework.' He called his albums 'survival kits on wax'. 'I sometimes thought he was a little too blunt, he kinda beat people over the head with it,' Jackson told James Maycock. 'But you know what? Sometimes that's good for you!'

It was a boom time for black spoken-word recordings, with and without musical backing. Motown's Black Forum imprint issued albums by King, Carmichael, Baraka and Black Panther Elaine Brown, among others. Nikki Giovanni presented the WNET TV show *Soul!* between 1970 and 1972, with guests including poets (Baraka, Gylan Kain), politicians (Louis Farrakhan, Jesse Jackson), and household names (Muhammad Ali, Bill Cosby, Sidney Poitier). Already a published poet, she recorded *Truth Is On Its Way* (1971), a hybrid of poetry and gospel, with the New York Community Choir.

The same year, the depleted Last Poets released their second album, *This Is Madness*, with a memorably stark advertisement. 'IF YOU'RE WHITE, THIS RECORD WILL SCARE THE SHIT OUT OF YOU,' it read in block capitals, white on black. 'IF YOU'RE BLACK, THIS RECORD WILL SCARE THE NIGGER OUT OF YOU.' And in South Central Los Angeles, an equally forceful coalition of militant poets made its debut.

*

The Watts Writers Workshop had been founded by Budd Schulberg, screenwriter of *On the Waterfront* and *A Face in the Crowd*, in the aftermath of the riots. During that period, young black people flocked to Watts to be part of the new creative scene as money flooded in from charities, government agencies and Hollywood liberals. In 1966 one newcomer was Texas-born Amde Hamilton, fresh out of prison after a four-year stint for drug possession. He only visited the workshop because he was out of work and needed something to eat. 'Watts people were the lowest on the totem pole, even in the black community,' he says. 'We were the poorest, we were the farthest out. The workshop was a place where people came to express themselves. There was singing, dancing, acting, writing.'

Hamilton got to know two other young poets: Richard Dedeaux, an aspiring actor from Louisiana, and Otis O'Solomon from the Deep South. Despite initial reservations about their

differing styles ('Anthony [Amde Hamilton] would go out there and talk about tearing up the world and we'd try to put it back together in some way,' explained Dedeaux), they teamed up for a talent show at the Inner City Cultural Centre. They were calling themselves Watts Fire until a female poet on the same bill rechristened them the Watts Prophets. They won second place, and began reading across the country – schools, prisons, parks, nightclubs, housing projects – but their militant message was not an easy sell. After one club performance, the owner told O'Solomon, 'You guys are going to make a lot of money, but not in this club.'

'What made the Watts Prophets so different was that we were so visual,' Hamilton told writer Brian Cross. 'Each poem was to us a complete play and each poet contributed to that. We didn't just stand on stage or walk back and forth . . . we would act it out.' If theatre was one pillar of their approach, then jazz was another. 'The cat in the front can be freestyling and blowing his solo and the cats in the back are supporting him, like a rhythm section,' Hamilton explains. 'It was like if Charlie Parker would walk in on Diz and Monk – they might not have anything written down but they all knew their parts.'

At first, the Prophets were oblivious to the similar work being done by the Last Poets. 'We didn't know them and they didn't know us,' says Hamilton. 'They were all the way east and we were all the way west. They talked mostly about whitey and revolution; we talked about ourselves. We weren't trying to be revolutionaries; we were trying to save our community.'

When Laugh Records, home of comedian Richard Pryor, heard about the Poets, it set up a subsidiary label, ALA Records, to release a compilation of poems from the Watts Writers Workshop. *The Black Voices: On the Streets of Watts* (1969) featured four poets, who were meant to record three poems apiece, but Hamilton was so fierce, so urgent, that he ended up dominating the record with nine. Indeed, he performed so energetically that he strained his back and had to rap his final contributions lying on the floor.

Beside the others' jazzier, more self-consciously poetical contributions, he sounds like some raging, unflinching prophet of doom: *poems that kill*. In just six seconds, 'The Meek Ain't Gonna' is a gangsta rap mission statement twenty years before the fact. 'The meek ain't gonna inherit shit,' Amde spits, 'cuz I'll take it!'

During 1970 the Prophets demonstrated their popularity by performing for eighteen weekends straight at Maverick's Flat, an influential club on Crenshaw Boulevard. Their skills honed by performing day and night, they cut their debut album, *Rappin' Black in a White World* (1971), in a single take, with musical accompaniment from former Motown songwriter Dee Dee McNeil. The poems, most of which are less than two minutes long, merge into one sustained piece. They can be thrillingly bellicose: 'AmeriKKKa' hijacks JFK to ask, shockingly, 'Ask not what you can do for your country but what in the fuck has it done for you?' But the best moments, especially the four-song, piano-led 'What Is a Man' suite, call on a more personal mode of storytelling. 'We were vomiting,' says Hamilton. 'We had a stomach full of pain. But it wasn't just rage. It had a lot to do with love and trying to understand what was happening to us.'

Audiences were, understandably, divided. 'White folks were afraid of us, black intellectuals was ashamed of us,' Richard Dedeaux recalled to writer Jeff Chang. 'And,' Amde Hamilton chipped in, 'the grassroots loved us!' By 1971, black audiences were ready for tough new voices.

*

The newest icon of the Black Power revolution wasn't even a real person. His name was Sweetback, and he was the star of America's first ever hit black movie, *Sweet Sweetback's Baadasssss Song*. Melvin Van Peebles, the thirty-seven-year-old who wrote, directed, edited, scored and starred in the movie, was following his own Guerrilla Cinema manifesto, the first part of which read: 'NO COP OUT. I wanted a victorious film. A film where niggers could walk out standing tall instead of avoiding each other's eyes.'

Van Peebles dedicated his movie, an X-rated paean to black manhood, to 'all the brothers and sisters who had enough of the Man'. Among its acts of cultural sacrilege was the use of famous freedom songs to soundtrack the barely pubescent Sweetback's seduction by a much older woman. On its release in April 1971 the Muslim paper *Muhammad Speaks* condemned it as a 'mangled, crippled, white supremacist, non-thinking, savage, inhuman version of Black people', but Black Panther Huey Newton was smitten with its uncompromising vision, urging his brothers to watch the 'first truly revolutionary Black film made'. Plenty did: it became the biggest-grossing independent movie of all time. Perhaps Newton envied Sweetback's ability to stick it to the Man and emerge triumphant. His own life was proving rather more complicated.

Newton's manslaughter conviction had been reversed on a technicality the previous year, and he emerged from prison, free on bail until his retrial, on 5 November 1970. A crowd of 10,000 supporters greeted their hero's release with untrammelled jubilation. Newton, however, was returning to a different party from the one he had left two years earlier. During his time in jail, Black Panther membership had declined amid rancorous infighting, fuelled by COINTELPRO's dirty tricks. Despite the revivifying jolt provided by Newton's release, healing the party's wounds was a tall order, and Newton, wracked by paranoia and impossibly high expectations, was not the man for the job.

Even before his release, he had made enemies in his own party over the case of George Jackson. Convicted for armed robbery when he was eighteen, Jackson had become a noted radical behind bars, founding the Marxist Black Guerrilla Family and joining the Panthers. While incarcerated in Soledad Prison, California, in January 1970, he was accused of murdering a white prison officer in revenge for the fatal shooting of three black prisoners. He and two other prisoners charged with the killing became known as the Soledad Brothers, and Jackson's writings while in solitary confinement made him an international celebrity.

While Jackson awaited trial, his seventeen-year-old brother

Jonathan hatched a quixotic plan to secure his freedom. From his exile in Algiers, Eldridge Cleaver promised armed support for Jonathan's plan to seize hostages to barter for his brother's release, then hijack a plane to fly him to safety in Cuba. Newton thought the plan ridiculous and withdrew Panther support. Undaunted, Jonathan Jackson pressed ahead, with guns owned by UCLA professor Angela Davis, single-handedly taking hostages at Marin County courthouse. The resultant shootout left Jackson, two escaping prisoners, and Judge Harold J. Haley dead, and three others wounded.

Some Panthers blamed Jonathan Jackson's death not on his own recklessness but on Newton's cowardice. Newton further alienated the rank-and-file by refusing to discipline the erratic and self-serving David Hilliard, who had run (and, some thought, run aground) the party in his absence. In fact, Newton seemed more interested in the spoils of celebrity than the challenges of leadership. Courted by Hollywood liberals, he acquired a taste for cognac, cocaine and groupies. *This* was the man whose iconic, warrior-like portrait still adorned so many walls? *This* was the man entrusted to lead the revolution? In February 1971, members of the Panther 21, a group of Panthers on trial for conspiracy to bomb buildings and assassinate police officers in New York, wrote an open letter praising Weatherman for its support and accusing the Panther leadership of 'tripping out, pseudo-masochism, arrogance, myrmidonism, dogmatism, regionalism, regimentation, and fear.' Newton responded by expelling the Panther 21.

Panthers disenchanted with Newton turned to Eldridge Cleaver. The FBI stoked tensions by sending Cleaver forged letters, allegedly from party members, urging him to take charge. In March Newton appeared on morning TV show *AM San Francisco* to discuss the Panthers' forthcoming Intercommunal Day of Solidarity at Oakland Auditorium, and the powder-keg exploded. On the phone from Algiers, Cleaver savaged Hilliard's leadership and demanded that Newton reinstate the Panther 21. Furious at this challenge to his authority, Newton promptly expelled Cleaver;

Cleaver, in turn, expelled Newton and the Oakland leadership. Broadly speaking, the east coast chapters backed Cleaver while the west coast stuck with Newton, triggering fratricidal civil war. Despite Newton's charm offensive – concentrating on free clinics and food programmes as well as political campaigning – members abandoned the party in droves. As for George Jackson, he was shot dead in San Quentin prison on 21 August. Prison authorities claimed that he had died during an escape attempt which also killed three guards and two white prisoners; Jackson's supporters claimed he was the victim of a political assassination.* Either way, yet another black revolutionary icon was gone. Elsewhere, the US Organization's Ron Karenga was jailed for torturing two female followers, the FBI shut down the Mississippi compound of the black separatist Republic of New Afrika, and the nadir of a traumatic year was yet to come.

On 9 September around a thousand inmates of Attica Correctional Facility in New York State rioted and took control of the prison, taking thirty-eight prison officers and civilian employees hostage. After four days of negotiations, state troopers retook Attica during a bloody assault which left twenty-six inmates and nine hostages dead. A subsequent state commission noted that this was the worst day of violence between Americans since the massacres of Native Americans in the late nineteenth century. The commission warned that, without speedy reform, there would be more confrontations to come: 'Attica is every prison, and every prison is Attica.'†

* Nina Simone's 'I Wish I Knew How It Would Feel to Be Free' was played at his funeral.
† In 1972 jazz saxophonist Archie Shepp marked the previous year's twin horrors with the fervid 'Attica Blues' and 'Blues for Brother George Jackson'. The Jackson case also inspired a brief spasm of what Tom Wolfe diagnosed as 'radical chic' among the rock aristocracy, with Bob Dylan's first topical song in eight years, 'George Jackson', and tributes to Angela Davis from the Rolling Stones (the crass, lecherous 'Sweet Black Angel') and John Lennon ('Angela').

Sweetback may have gotten away with fighting the system but in the real world, for George Jackson, the Attica rebels and the warring remnants of the Black Panthers, the revolution, televised or otherwise, would not be happening at all.

*

Although COINTELPRO was disbanded in April 1971, the government continued to monitor black artists in other guises throughout the decade. Unbeknown to the Watts Prophets, one black employee of the Watts Writers Workshop, Darthard Perry, was an FBI informant codenamed Othello; to his great regret, Amde Hamilton was the man who hired him. In a remarkable TV interview some years later, Perry revealed how much importance the bureau placed on art in the black community. 'You can take their culture and use it against them,' he said, emphasising that the FBI's archive of African-American books, magazines, videos and records exceeded that of a well-stocked Harlem library. His white FBI supervisor, he said, 'could name some jams of Miles Davis that I hadn't even heard of. He could name some books I hadn't even read pertaining to black culture.' In 1975 Perry crept into the Workshop with two cans of kerosene and a highway flare and burned it down. 'It got to me a great deal,' he admitted with an unreadable expression. 'I loved that theatre. I built the stage.'

After *Rappin' Black in a White World*, the Watts Prophets couldn't find a label to put out the follow-up, *Hey World*, and would not release another album together until 1997. 'Our goal was to open up an area of expression for people who had no area of expression, and we were totally successful at that,' says Hamilton. 'But we didn't make a dime.'

The Last Poets, now driven by Nuriddin, continued but by 1975 Hassan had gone. 'First, I started selling cocaine, then taking it, then [became] addicted to it,' he admitted. 'These were times when I didn't want to be a Last Poet, but I couldn't get away from it. I used to give poetry readings in crack houses.

People would say, "Ain't you . . . ?"'

Scott-Heron would lose several years to drugs himself in subsequent decades, but during the 1970s he enjoyed a creative blue streak. There are many reasons why he thrived where the Last Poets and the Watts Prophets did not: he had a consistently loyal musical partner, major-label backing and a far more flexible and mellifluous style. Moreover, while the other groups were inextricably linked with the Black Power era, Scott-Heron was ahead of the curve on issues from Watergate ('H2Ogate Blues') to apartheid ('Johannesburg') to nuclear safety ('We Almost Lost Detroit'). 'You have to make your voice heard,' he told Rob Fitzpatrick. 'There's a difference between being a piano player from Tennessee and an international crusader for some kind of right or wrong. This was not what I was trying to do.'

As the revolutionary flame dimmed, he was perfectly attuned to the ashy realities of inner-city life. In the words of his 1974 album, it was *Winter in America*.

12

'This place is cruel, nowhere could be much colder'

Stevie Wonder, 'Living for the City', 1973

Soul, *Super Fly* and Tricky Dick

Vacant lot with stripped car at Findlay Avenue and East 165th Street, South Bronx, New York, 4 January 1973.

When Sly Stone moved into an imposing gothic pile at 783 Bel Air Road, Coldwater Canyon, Los Angeles, some of his friends whispered that it was haunted. One later muttered that 'there was a cloud flying over that place'. During his troubled residency, there were long, messy parties, or rather the ghosts of parties, in which band members and hangers-on stayed up for days snorting cocaine, PCP and more besides. There was a steady stream of groupies traipsing in and out. There were guns, *lots* of guns. There were dogs everywhere, the floors mined with their excrement. The most feared was a vicious pitbull called Gun. '[Sly] had a baboon,' remembered saxophonist Jerry Martini. 'Gun killed the baboon, then fucked it.' The dog took to chasing his tail for hours on end. 'They cut the tail off,' said Kitsaun King, one of the house's residents. 'He came home, he just chased his butt.' So it's true that dogs come to resemble their owners.

The Sly Stone who emerged from 783 Bel Air Road in November 1971, bearing a sinister puzzle of a record that he called *There's a Riot Goin' On*, was a far cry from the ebullient pied piper who got Woodstock dancing at half past three in the morning and represented the rainbow idealism of the 1960s. 'It was over,' Sly's bodyguard Bubba Banks told writer Joel Selvin. 'He was through. He was doing shit you would expect to see in some kind of institution for mentally retarded people. He and Freddie [Stone's brother] walked around the house all day like zombies.'

The album, which came out of long, sleepless, drug-crazed recording sessions, was like a photonegative of what had gone before it: in place of movement, inertia; instead of community, dissipation. With members of the Family Stone largely cold-shouldered in favour of outsiders like Bobby Womack, and even a drum machine, the band sound neither quite broken up nor fully together. 'Family Affair', the album's big hit, is coldly fatalistic: 'You can't leave 'cause your heart is there / But you can't

stay, 'cause you been somewhere else.' Several songs convey a similar message: *run away, stay put, it doesn't matter, there's nothing you can do*. As Sly warns on the black-hole funk of 'Africa Talks to You (The Asphalt Jungle)': 'Watch out, 'cause the summer gets cold.'

The album's title led some listeners to read it as a retort to *What's Going On*, the soul sensation of the year – its smudgy, overdubbed production sounded like a malignant twist on Marvin Gaye's gorgeous blur – but nothing about the record was spelled out. *Riot*'s elusive, mumbled lyrics, like its music, are obscured from the listener as if by a thick pane of smeared glass. The critic Ian Penman cites *Riot* as an example of music 'in which any political inclination could only be registered as a trace of confusion or ambiguity'. It is not *about* disconnection and decay: it *is* disconnection and decay. The album's blackest joke is the title track, which clocks in at 00:00, and offers an even more chilling response to Gaye's question. What's going on? *Nothing's* going on.

In both its sound and the nature of its creation Sly Stone's dystopian masterpiece told the story of black America in 1971. It was no longer enough to be black and proud, because there were foes everywhere: not just in Washington, but on your own block, and even inside your own head. You didn't need to be blitzed on cocaine in a mansion full of guns and dogs to be paranoid. Many hit songs, such as 'Back Stabbers' and 'Smiling Faces (Sometimes)', told listeners to beware smooth-talkers everywhere; others, such as 'Slippin' Into Darkness' and 'Hell', prophesied chaos and collapse.

These were grim songs for grim times: recession, fuel shortages and Watergate on the national stage; ghettoisation, drug addiction and leadership crisis in the black community. Even as white artists retreated from politics, their black counterparts made the protest song their own, and with enormous success. If Sly Stone incarnated defeat, then nobody represented optimism and resolve better than the young Stevie Wonder, about to enjoy

an unparalleled run of creativity. His symbolic foes were two emblematic crooks: in the White House the paranoia-poisoned Richard Milhous Nixon, and on the streets a cocky hustler they called Youngblood Priest.

*

Curtis Mayfield agreed to write the soundtrack for *Super Fly* because he liked Phillip Fenty's screenplay, about a black cocaine dealer who plans one last big score before retiring from the drug game. Concerned that novice director Gordon Parks, Jr, was turning the story into 'a cocaine informercial', he decided to provide a potent counter-message, releasing the soundtrack three months ahead of the film so that many viewers would take their seats with Mayfield's alternative vision in their minds – the album sold two million copies and stayed in the charts for almost a year.

Super Fly was by no means politically ignorant – Priest's fellow dealer argues: 'I know it's a rotten game but it's the only one the Man left us to play' – but Mayfield was right about the dangerous allure of its gangster chic. Hard on the heels of *Sweet Sweetback* and hit black-cop movies *Shaft* and *Cotton Comes to Harlem*, it grossed $10 million, and canny merchandisers cashed in by selling crucifix cocaine spoons like the one used by Priest. The NAACP's Junius Griffin, who coined the derisive term 'blaxploitation', complained: 'The movie tells young people that if you can't beat the man in reality, you can beat him in fantasy. This is counter-revolutionary because our leaders have always emphasized the importance of dealing with reality.'*

Of *course* it was counter-revolutionary. Disenchanted by the failure of black leaders to overturn the system, many African-Americans were willing to downsize their objectives and focus on their own backyards. The Black Power advocates who angrily

* Blaxploitation's association with any film featuring a predominately black cast annoyed the makers of films such as *The Mack* and *Black Caesar*, which had a social conscience not found in, say, *Black Frankenstein*.

tell Priest, 'black folks been mighty good to you and you owe those people something, too', are dismissed as all rhetoric and no action. Priest may have represented the dark side of black capitalism, exploiting his brothers rather than helping them, but that made him no less of a hero to *Super Fly* fans.* Although the Panthers trashed *Super Fly* as 'part of a conspiracy', Huey Newton descended into coked-out mania while his old comrade Bobby Seale campaigned for mayor of Oakland in a pimp-style broad-brimmed fur hat.

Priest was a creature of his times. With the Panthers in self-immolating disarray and the dreams of liberalism crumbled, black America was facing a crisis of trust. Two big soul records, trembling with drama, were symptomatic. On 'Back Stabbers' (1972), the O'Jays are caught between shuddering piano chords and horns which jab like a knife between the shoulder blades. On the Undisputed Truth's 'Smiling Faces (Sometimes)' (1971), Norman Whitfield's orchestration sounds both grand and fenced in, unable to escape the gravitational pull of the ominous, stalking bass line. 'Beware of the pat on the back,' warns frontman Joe Harris. 'It might just hold you back.'

In the minefield of paranoid soul, you can trust neither your eyes nor your ears. Behind every 'smiling face' lurks a double-crosser, out to take your woman, your money or worse. On one level, this spoke to the fog of suspicion emanating from the White House. The 'credibility gap', defined by the *Baltimore Sun*'s Henry Trewhitt as 'the degree of refusal by the public to accept at face value what the government says and does', was a phrase coined during the Johnson administration, as Vietnam corroded public faith in their leaders' veracity. By the early 1970s, the gap had become a crevasse.

'Tricky Dick' was both a cultivator of paranoia, via

* The 1973 sequel *Super Fly T.N.T.*, written by Malcolm X biographer Alex Haley, attempted to rehabilitate Priest, packing him off to Africa to help guerrillas battle diamond-hungry imperialists. It bombed.

COINTELPRO infiltration, and a victim of it. In September 1971 his aide Chuck Colson began working on a 'master list' of anti-Nixon figures, which eventually ran to some 30,000 names, including politicians, activists, journalists, academics, businessmen and celebrities.* According to White House counsel John Dean, the enemies list was part of plans to 'use the available federal machinery to screw our political enemies', using weapons such as tax audits and damaging leaks. But Nixon's men did not stop at the available federal machinery. On the night of Saturday, 17 June 1972, a vigilant nightwatchman at the Watergate Hotel in Washington DC alerted the police to a break-in at the Democratic National Committee's headquarters and five intruders were arrested. Two reporters from the *Washington Post* sniffed out a link between the burglars and the Committee to Reelect the President, and the scandal that would bring down the president was set in motion.

Marvin Gaye looked to the White House on 'You're the Man' (1972), when he called for a candidate to challenge Nixon's 'lies': 'Don't give us no V sign / Turn around and rob the people blind.' But many paranoid soul records concentrated on treachery within the black community. The absentee father in the Temptations' 'Papa Was a Rolling Stone' (1972) isn't just a shiftless, hard-drinking womaniser: he's a phony storefront preacher. The song quotes the title of Paul Kelly's excoriating attack on religious hypocrisy, 'Stealing in the Name of the Lord' (1970). Black Power rhetoric was no more reliable. James Brown accused people of 'talkin' black during the week and livin' like a negro on

* It even included eccentric soul singer Jerry 'Swamp Dogg' Williams, who had been involved in Jane Fonda's controversial 1971 Free the Army campaign (alongside Nina Simone and Country Joe McDonald) and released the majestically dolorous single 'God Bless America For What?' 'I wasn't trying to help overthrow the government,' said Williams. 'I was just trying to enlighten people . . . I guess after a while they said, "This son of a bitch ain't about too much of nothing. He's silly."'

weekends' on 'Talkin' Loud and Sayin' Nothing' (1972), while the O'Jays snapped at a smooth-talking creep 'skinnin' and grinnin'' and raising his fist in 'the power sign' on 'Don't Call Me Brother' (1973). On another Temptations single, 'Law of the Land' (1973), Norman Whitfield warned listeners to create their own moral leadership: 'A teacher man can't be found / Until you find yourself.'

<p style="text-align:center">*</p>

The O'Jays' paranoid soul songs appeared on a rising label whose name advertised both local pride and grand aspirations: Kenny Gamble and Leon Huff's Philadelphia International Records (PIR). Raised by a deeply religious single mother, Gamble was a staunch black capitalist with a stern moral streak. He slowly clawed his way up through the music industry and forged a songwriting and producing partnership with gruff New Jerseyite Huff. After making hits for the likes of Jerry Butler and Wilson Pickett, they convinced Columbia Records to back their new venture, PIR, in 1971. This was the year of *What's Going On*, *Sweet Sweetback* and the new nationally syndicated black music show *Soul Train*. The black market was big business – by 1978 PIR would be the fifth-biggest black-owned company in the country.

Gamble, like Whitfield, scented the commercial potential of message music, but unlike the Motown producer he built upon a foundation of sincere political convictions. He considered following his mother's lead in becoming a Jehovah's Witness, before becoming drawn towards the Nation of Islam; PIR star Teddy Pendergrass observed that Gamble 'never seemed to care about material possessions. He never even wore a wristwatch.' Most of all, he believed that black people needed to take responsibility for themselves: get an education, get a job, benefit the community.

'Back Stabbers' was written by two newcomers, Gene McFadden and John Whitehead, but it chimed perfectly with Gamble's

contempt for black people who undermined their hard-working brothers, and he ran with the theme on his own composition, 'Shiftless, Shady, Jealous Kind of People'. The single resonated with both black and white audiences – the *Back Stabbers* album became PIR's first gold record – but it's likely that more bought it for Thom Bell's extraordinarily seductive arrangement than for its message. The luxuriant, aspirational 'symphonic soul' of the Philadelphia sound allowed Gamble to channel all kinds of socio-political messages into millions of homes.

As if to take this strategy to its limits, the O'Jays' next album, *Ship Ahoy* (1973) opened with its ten-minute title track, a brooding, cinematic retelling of the passage of slave ships across the Atlantic, complete with creaking timbers and cracking whips. The album also included 'For the Love of Money', a stern and spooky rejection of *Super Fly*'s self-justifying avarice. Strong medicine, and yet it stayed on the charts for forty-eight weeks. Sometimes, PIR's artists weren't so sure about Gamble's outspoken approach. Thirty-seven-year-old Billy Paul was enjoying his first number one hit with the sumptuous adultery drama 'Me and Mrs Jones' when Gamble chose to follow it with the stridently funky 'Am I Black Enough For You?' (1972). Paul begged him not to release the single, fearing it would 'turn off a lot of people', but, he recalled, 'Kenny Gamble *insisted*.' Just as Paul feared, the single stalled at number seventy-nine, in a stroke turning the singer from potential crossover star to one-hit wonder. 'It damaged me, and I was bitter about it for a long time,' confessed Paul.*

The kind of message a mainstream audience wanted to hear was less confrontational, more inclusive. Just as the Impressions' 'People Get Ready' had updated 'This Train' for the civil rights era, the O'Jays' rampagingly optimistic 'Love Train' (1972) made the concept global, stopping off in Europe, Russia, China, Africa and Israel. Stevie Wonder praised Gamble and Huff for

* Nevertheless, Paul continued to record such terrific protest songs as 'War of the Gods' (1973) and 'Black Wonders of the World' (1975).

mixing 'the joy of love with the pain of oppression. They let it marinate and it was sweet.'

*

As 13 May 1971 approached, Wonder had more reason than most young men to anticipate his twenty-first birthday. Under US law, any contracts signed before that age become null and void, which meant that Motown's publishing arm, Jobete, would no longer be entitled to 100 per cent of his songwriting royalties. He had been mentally stockpiling new songs for three years, loath to record them under the old contract. 'He had not played them to anyone,' said Malcolm Cecil, one of his musical collaborators. 'They were bursting out of him.' On his birthday, Wonder told Berry Gordy that he would only stick with Motown if he were guaranteed complete creative control. Gordy had misgivings – Motown's success to date had been built on *not* giving artists creative control – but he had no choice. Emboldened by Marvin Gaye's success in making *What's Going On* the way he wanted, Wonder wasn't budging.

The singer had already made steps to establish a new identity distinct from 'Little' Stevie Wonder. 'Heaven Help Us All' (1969), composed by producer Ron Miller, was a gospel cry for deliverance from racism and war, and the transitional *Where I'm Coming From* (1971), his first self-produced effort, saw out his existing contract on a socially conscious note. 'I hope for a better tomorrow,' he told one interviewer. 'I believe that the only thing I can do to help is to express my ideals. This is why my new album is dealing from a political standpoint, so people will know where I am, where I stand.'

While his hard-nosed new attorney Johanan Vigoda slowly hammered out a new contract with Motown, Wonder embarked on a binge of writing and recording. Malcolm Cecil and his fellow studio engineer Robert Margouleff had recently released a pioneering record, *Zero Time*, under the name Tonto's Expanding Head Band. TONTO – The Original Neo-Timbral

Orchestra – described the customised Moog synthesiser, measuring twenty-two feet across, that they had put together at their midtown Manhattan studio. One day in May, Wonder turned up with a copy of *Zero Time* under his arm, eager to hear this novel contraption in action.

The three men started work at the beginning of the Memorial Day weekend and emerged on Monday morning with seventeen songs. Relocating to Jimi Hendrix's Electric Ladyland studios in Greenwich Village, they came up with even more. Wonder became known for working through the night, sometimes going forty-eight hours without sleep or dozing next to his equipment so that he could record immediately if he woke up with a new idea. 'I had all the instruments set up in the studio in a circle – the piano, the clavinet, the Rhodes, the Moog, everything,' explained Margouleff. 'Stevie would go, just like Braille, from one instrument to the next. They were all plugged in all the time.'

The first fruits of their collaboration appeared on *Music of My Mind* (1972), which bore the proud boast: 'This album is virtually the work of one man.' Wrongfooting many fans, the album sold modestly, so Wonder set about wooing a white rock crowd. Having befriended a Beatle when he appeared alongside John Lennon at the Free John Sinclair rally, Wonder, and his interracial backing band Wonderlove landed the job of supporting the Rolling Stones during their summer 1972 US tour. His relationship with the Stones, who were at the peak of their debauchery, was not always harmonious but it did the job.

He cemented his crossover appeal with a juggernaut of a new single, 'Superstition'. Most of the Tonto material thus far had dealt with love and heartbreak, but 'Superstition' tapped into the national paranoia. Odd though it seemed for an astrology enthusiast like Wonder to be criticising superstition, the song's hulking power was unarguable. Accompanying it on *Talking Book* (1972) was another song about watching what, and who, you put your faith in. 'Big Brother' savaged lying politicians who 'just come to visit me 'round election time', kill black leaders and

spy on their citizens. One line, despite its bald simplicity, spoke volumes in the vocabulary of the day: 'I live in the ghetto'.

*

The ghetto was the main arena for black songwriters' psycho-social angst for much of the 1970s. Until the 1960s, middle-income suburban housing developments had been blatantly segregated. Real estate boards did their damnedest to stop black families moving into white neighbourhoods, and those who did manage to do so were often driven away by cross-burnings, beatings and death threats. Meanwhile, minorities flooded into the increasingly dilapidated inner cities, looking for manufacturing jobs that were fast disappearing. Overcrowding begat unemployment, which begat alcoholism, drug addiction, prostitution and street crime. Even when overtly racist housing policies were overturned, segregation continued by other means. Once an area had seen a notable influx of minorities, banks withheld mortgages, landlords began to cut corners, and predatory brokers known as 'blockbusters' scared the remaining white residents into selling up at a reduced price. Some real estate owners, faced with plummeting assets, simply cut their losses and left their property to rot; the worst burned the buildings for the insurance money. Ghetto residents, many on low wages or welfare, therefore had little incentive to neighbourhood pride. Neglect bred bad habits, from littering all the way up to arson. Black and Latino gangs, originally formed in self-defence against turf-protecting groups of white youths, soon expanded into powerful criminal cartels as the Panthers' influence waned; 1971 saw a months-long gang war in the South Bronx.

The pace of ghettoisation could be precipitous. In 1960, 85 per cent of residents in the Brooklyn district of East New York were white, most of them working-class Jews. Just seven years later it was 80 per cent black and Puerto Rican, but the numbers didn't balance – many of the vacated houses were left empty. In 1971 a journalist from the *New York Times* magazine described

the scene: 'The vacant houses in East New York . . . are now burned out, vandalized, shattered, filled with old shoes, smashed furniture, forgotten dogs and a sour effluvium of neglect and despair . . . The sidewalks and streets are littered with garbage, wind-whipped newspapers and rotting mattresses . . . Broken glass is always being crunched underfoot.' Dr Harold Wise of the South Bronx's Martin Luther King, Jr, Health Centre used even more dramatic language, declaring his own area 'a necropolis – a city of death'.

Ghettoisation was rampant long before songwriters latched on to its emblematic power. When Mac Davis, a white man from Texas, was writing 'In the Ghetto' (1969) for Elvis Presley, he called it 'The Vicious Circle': *Ghetto* was a late addition, a new buzzword. The same year, Chicago-based jazz singer Marlena Shaw recorded the astonishing 'Woman of the Ghetto', which used echoes of slavery ('chained, tied together') and civil rights rhetoric ('I'm free at last / I've seen the children dying') to attack the political class, while also slamming limo-driving drug-dealers and irresponsible fathers ('Remember me, I'm the one who had your babies'). Although it was not a hit, this vivid, erudite, indignant record contained elements of all the ghetto songs to come.*

So popular was the ghetto motif in the early 1970s that by the time the Temptations released Whitfield's 'Masterpiece' (1973), its tropes were well-worn: the roaches, the rats, the dopeheads, the muggers, the saintly mother trying to hold her family together, etc. Bobby Womack looked a little deeper in 'Across 110th

* A selection of songs which used the word in its title between 1970 and 1974: Donny Hathaway's 'The Ghetto' and 'Little Ghetto Boy', Stanley Winston's 'No More Ghettos in America', S.O.U.L.'s 'Down in the Ghetto', Gil Scott-Heron's 'The Get Out of the Ghetto Blues', Bobby Patterson's 'This Whole Funky World Is a Ghetto', War's 'The World Is a Ghetto', The Spinners' 'Ghetto Child', Willie Hutch's 'Life's No Fun Living in the Ghetto', and Leroy Hutson's 'The Ghetto 1974'. Bizarrely, the first use of the word by a major black artist was James Brown's 1968 Christmas record 'Santa Claus Go Straight to the Ghetto'.

Street' (1972). Recorded for the blaxploitation movie of the same name, the title referred to the border between Manhattan's Upper West Side and Harlem, which symbolically demarcated New York's white middle-class from its impoverished African-Americans. 'The family on the other side of town / Would catch hell without a ghetto around,' Womack noted.

Of course, many cities had ghettos but New York became most synonymous with urban decay. Mayor John Lindsay, a liberal Republican who crossed the floor to the Democrats in 1971, was a patrician idealist. This kept him from stooping to the dissensus politics practised by Nixon, but his lack of the common touch proved fatal. For example, his plan to reduce ghettoisation by building 'scatter-site' housing – low-income projects peppered across middle-income areas – ran into fierce opposition from residents who had only recently fled their old neighbourhoods and associated minorities with irreversible decline.

During Lindsay's tenure (1966–1973), New York's tribulations could be expressed via arithmetic: the murder rate rose by 137 per cent, the city haemorrhaged over a quarter of a million jobs, and three in twenty New Yorkers – an unprecedented 1.25 million citizens – claimed some form of welfare. When the rest of the country moved out of recession in 1971, the average wage in New York actually fell. But just as significant was the crisis in morale. As Times Square became a hub of vice, graffiti spread like moss on every wall and subway train, and crime stories filled the front pages, New York seemed to some to have become a dysfunctional city, represented on screen by the likes of *Midnight Cowboy* and *The Panic in Needle Park*. It was, therefore, the perfect setting for Stevie Wonder's most vivid protest song yet.

*

Wonder's first two albums with Cecil and Margouleff had been only sporadically political, but, depressed by Nixon's 1972 re-election and the shooting of ten-year-old Clifford Glover by a

plainclothes white cop in April 1973, Wonder began waxing apocalyptic about a record he intended to call *The Last Days of Easter*. 'It's the last days of life, of beauty,' he said. 'All the horrors and hypocrisy in the world today. People neglecting other people's problems. It's what needs doing, socially, spiritually and domestically. I can only do it through song, and I try to be positive about it.'

The album, eventually titled *Innervisions*, was a panoramic portrait of a country blighted by drug addiction ('Too High'), phony religiosity ('Jesus Children of America') and deceit ('He's Misstra Know-It-All'), while Wonder oscillated between faith ('Higher Ground') and doubt ('Visions'). In the latter song, like 'Woman of the Ghetto', Dr King's cry of 'free at last' is reprised with poignant irony.

The centrepiece of the album is 'Living for the City'. It was 'the deepest I really got into how I feel about the way things are', Wonder explained. 'I was able to show the hurt and the anger.' In the song, a black family moves from rural Mississippi to a typical New York ghetto. The parents work hard in menial jobs, the older brother looks in vain for work, the sister goes to school in threadbare clothes, and the younger brother, the main character, pounds the polluted sidewalks in despair. In the final verse, Wonder addresses the listener directly, calling for 'a better tomorrow'. New York, he explains, 'is cruel – nowhere could be much colder'. One wonders what Lindsay, fighting in vain for re-election, made of this damning assessment.

The middle of the track is an audio portrait of urban life, designed to show the listener how a blind man perceives the city. Its mosaic of dialogue, traffic noise and sirens looks back to the chatter of *What's Going On* and forward to hip-hop's tradition of street-corner skits. In truth, the narrative's a little strained – within forty-five seconds of getting off the bus in New York, a spectacularly unfortunate young innocent, voiced by Wonder's brother Calvin Hardaway, has had a run-in with a drug dealer, been arrested, wrongfully convicted and jailed – but

it successfully ups the song's stakes. When Wonder reappears for the final verse, he has never sounded angrier, his voice an unfamiliar clotted growl. To emphasise the soundscape concept, Wonder arranged for journalists to be blindfolded, driven through the city, and, still sightless, played the album for the first time. 'It was one hell of a way to experience "Living for the City" for the first time,' recalled *Rolling Stone*'s Dave Marsh.

Innervisions was a creative and commercial triumph, eventually winning a Grammy award for Album of the Year, while 'Living for the City' was named Best R&B Song. The radio DJ Gary Byrd, later, one of Wonder's co-writers, recalled Wonder's ability to 'reach people who otherwise might not want to listen to that kind of message, but through his musical genius would not only listen but would digest and understand it'.

But the album had been in the shops for just three days when, on 6 August 1973, a car driven by Wonder's cousin John Harris smashed into a logging truck in North Carolina. A log crashed through the windscreen and hit the singer, who had been asleep in the front passenger seat. He was rushed, unconscious and bleeding, to hospital, where he was diagnosed with a broken skull and severe brain contusion, putting him into a coma. Many radio DJs followed reports of his condition with 'Higher Ground'. He would wake up several days later a changed man.

*

Talking about his work with Wonder, Malcolm Cecil summed up its cultural significance: 'His product does more than sell millions of records. It reaches people and breaks down ethnic barriers. All of a sudden there's money going from the white people to the black people, even if it's only for their bloody music.'

Black people had never been more visible in US culture, not just for their bloody music but for their bloody movies as well. After years when the only black face movie-goers saw belonged to Sidney Poitier, blaxploitation at last gave black people a cinema of their own. 'You've got to understand this,' said *Super*

Fly's Ron O'Neal. 'You could not see black people on the screen! They were nonexistent before these films.'

Blaxploitation also proved a boon for musicians. Among those who enjoyed hit soundtrack albums were Isaac Hayes (*Shaft*, *Truck Turner*), Marvin Gaye (*Trouble Man*) and Willie Hutch (*The Mack*). When the producers of *Hell Up in Harlem* vetoed director Larry Cohen's plan to use James Brown for the soundtrack, Brown channelled the rejected music into his own album, *The Payback*, and ended up with a gold record.* Albums like *The Payback*, *There It Is* and *Hell* had a tough, cinematic feel – a righteous swagger.† The cover of *Hell* was a dense collage of contemporary ills, including a bandaged GI, a reel of Watergate tape, an empty fuel pump and, lest anyone accuse Brown of understatement, a Native American, wrapped in an American flag, glumly reading a newspaper. It illustrated, albeit heavy-handedly, a pervasive mood of crisis that made it hard for any soul singer *not* to protest. Motown, not so long ago allergic to political content, released Eddie Kendricks's mantric, African-influenced 'My People – Hold On' and Smokey Robinson's enormously affecting 'Just My Soul Responding'. The plight of black veterans returning from Vietnam to the urban jungle was poignantly articulated by Curtis Mayfield in 'Back to the World' and Bill Withers in 'I Can't Write Left-Handed'.

But if songs and movies about the ghetto made struggling blacks feel that they were no longer invisible, then they did nothing to materially improve their situation. Hence the unprecedented event known as Wattstax, stemming from a suggestion by the Watts Prophets' Richard Dedeaux. On 20 August 1972,

* Similarly, the O'Jays' 'Ship Ahoy' was originally written for the soundtrack to *Shaft in Africa*. Its rejection proved a blessing in disguise.

† Despite his unhappiness with the state of the country, Brown decided to endorse Nixon for re-election in 1972, thus earning the Godfather of Soul a new, less dignified nickname: 'James Brown, Nixon's clown'.

the last day of the Watts Summer Festival, thousands of Watts residents paid just a dollar a head to watch an all-star line-up at the LA Coliseum. It was a remarkable day. On a bill headlined by big, bald Isaac Hayes, aka 'Black Moses', the Rance Allen Group told a story of American deceit, going all the way back to Columbus, in 'Lying on the Truth'; family group the Staple Singers held their heads high on 'Respect Yourself' and 'I'll Take You There'; the Soul Children complained, 'I Don't Know What This World Is Coming To'; and Kim Weston sang James Weldon Johnson's 'Lift Ev'ry Voice and Sing' and Pete Seeger's 'If I Had a Hammer'. Movie stars such as *Shaft*'s Richard Roundtree and *Sweet Sweetback*'s Melvin Van Peebles introduced the acts. The charismatic black activist Jesse Jackson, resplendent in Afro and dashiki, roused the crowd with an empowering chant of 'I am somebody' and ended the show, fist raised, beside Stax boss Al Bell.

Wattstax wore its political agenda proudly. The concert movie ('100,000 brothers and sisters turning on to being black . . . telling it like it is!') interspersed live footage with glimpses of ghetto life, and profits went to bodies such as the Martin Luther King Hospital and Jesse Jackson's Operation PUSH. But sceptical voices wondered whether anybody benefited from the event quite as much as Bell. 'Whose cause was it – Wattstax's or Al Bell's?' asked Duck Dunn of Stax act Booker T and the MGs. 'Were they doing it for the people of LA, or were they doing it to promote Al Bell in LA? And what did they ever do for Memphis? Not a goddam thing.'

Despite the triumph of Wattstax, Stax struggled to reassert itself, declaring bankruptcy in 1975. Over at PIR, Kenny Gamble was also under pressure. A hands-on workaholic, he'd oversee up to five albums at once while also struggling with paperwork, his disintegrating marriage and the demands of his Muslim faith. One day in 1975, he called twelve of his employees into his office one by one to tell them, 'You are one of my disciples.' He then locked the door and subjected the chosen ones to an eight-hour

rant. After four days of increasingly erratic behaviour, he was hospitalised with a nervous breakdown and PIR went into suspended animation for several months. On his return, Gamble became increasingly outspoken, coining the label's new slogan 'The Message Is in the Music', and penning long, sermonising sleevenotes. On the O'Jays' *Family Reunion* he warned of an 'evil plan' to break up the black family. On Billy Paul's *When Love Is New* he inveighed against abortion, imploring record-buyers, 'Let's keep on making babies so we can have a great, beautiful, wise, righteous, meek, but strong nation.' His lyrics, meanwhile, became more baldly prosaic. 'There's only sixteen families that control the whole world,' sang the O'Jays on 'Rich Get Richer', 'I read that in a book y'all.' It was all a long way from 'Love Train'.

*

Stevie Wonder emerged from his coma with his mind on spiritual matters, too, but he remained the friendly face of protest. His fame was greater than ever: when he played a London show in January 1974, the audience included Paul McCartney, Pete Townshend and David Bowie. Two months later he took home five Grammy awards and climaxed a Madison Square Garden concert by singing 'Superstition' hand in hand with Sly Stone, Roberta Flack and Eddie Kendricks. But some in his circle found him increasingly distant as he erected around himself a force field of advisers and hangers-on. 'Stevie became more black-oriented in terms of the people around him,' said Malcolm Cecil. 'He didn't want anybody who didn't absolutely have to be there who wasn't black.' Tonto's fourth and last album with Wonder was *Fulfillingness' First Finale* (1974), which ended with the most damning protest song Wonder ever recorded: 'You Haven't Done Nothin''.

By 1974 Nixon's skulduggery had spread like a toxic cloud across the whole country. Gil Scott-Heron, always a fast mover, had written his response to the scandal, 'H2Ogate Blues', in

March 1973, even before the hearings got under way. As the affair revealed ever lower, dirtier depths to the president's mal-feasance, other musicians weighed in: funk outfit the Honey Drippers demanded 'Impeach the President'; erstwhile Nina Simone bandleader Weldon Irvine led his band in a series of topi-cal jokes on 'Watergate'; James Brown's backing band the JBs opted for droll pragmatism on 'You Can Have Watergate Just Gimme Some Bucks And I'll Be Straight'; and former Motown songwriter Lamont Dozier's 'Fish Ain't Bitin'' implored, 'Tricky Dick please quit.'

But none of these artists had half the profile of Stevie Wonder. 'You Haven't Done Nothin'' was a mercilessly funky political obituary which looked beyond Watergate to rubbish Nixon's entire time in office. 'We are sick and tired of hearing your song,' declared Wonder, backed by the Jackson 5. In a press statement accompanying the single release, Wonder wrote: 'Everybody promises you everything but in the end, nothing comes of it . . . And they feed you with hopes for years and years. I'm sick and tired of listening to all their lies.' *Fulfillingness' First Finale* came out on 22 July 1974. Eighteen days later, Nixon bowed to the inevitable and resigned.

The new president, Gerald Ford, was a decent, honest man with the singular misfortune of following two crooks in quick succession. He had only ascended to the vice-presidency in October 1973 after Spiro Agnew resigned in a bribery scandal; now, less than a year later, he was expected to clean up Nixon's mess. Upon taking the oath of office he promised Americans that 'our long national nightmare is over', but a month later he pardoned the cause of that nightmare, causing the biggest single fall in a president's approval rating in the history of the Gallup poll.* Another poll brought even more wretched news.

* Scott-Heron shot back with the spoken-word 'Pardon Our Analysis (We Beg Your Pardon)': 'We beg your pardon because the pardon you gave this time was not yours to give.' He dubbed Ford 'oatmeal man' – tepid.

In 1964, 76 per cent of respondents had said they trusted their government; the figure was now just 36 per cent. Democratic congressman William Hungate wailed: 'Politics has gone from an age of Camelot when all things were possible to the age of Watergate when all things are suspect.'

Hence the title of Gil Scott-Heron and Brian Jackson's 1974 album, *Winter in America*. 'We approach winter, the most depressing period in the history of this industrial empire, with threats of oil shortages and energy crises,' the sleevenotes groaned. America was still suffering the effects of the 1973 oil shock when OPEC nations proclaimed an oil embargo to protest US support for Israel during the Yom Kippur war. This crisis, which led to petrol rationing, completed an already dire economic picture: rising prices and unemployment, a falling dollar and a worldwide stock-market crash. Major problems, and no faith in the government to fix them.

The recession reversed many of the advances of the black middle class. As the inner cities lost ground, and tax revenue, to the suburbs, they became more reliant on state and federal funds, and just at the time that black politicians had finally worked their way into positions of power. Coleman Young became Detroit's first black mayor in November 1973, when the city was on its knees. 'I was taking over the administration of Detroit because the white people didn't want the damn thing anymore,' wrote Young. 'They were getting the hell out, more than happy to turn over their troubles to some black sucker like me.'

Wonder chose his causes carefully. He was an enthusiastic supporter of Coleman Young but turned down an invitation from Ford to attend a UNESCO benefit because, apart from African diplomats, his would have been the only black face there. Wonder was becoming increasingly interested in Africa, wearing a dashiki and visiting the continent for the first time in 1975. He even claimed that he planned to retire and work with handicapped children in Africa, although this was probably just a tactic in his latest contract negotiations with Motown.

The popular idea that socially conscious soul was swept away by bubbleheaded disco escapism does a disservice to both genres. It was more the case that by 1976, artists were running out of new ways to comment on America's ills, and audiences were getting bored of hearing them. After *Masterpiece* and *1990*, the Temptations had lost patience with both Norman Whitfield's message songs and his increasingly autocratic ways. 'I read a review of *Masterpiece* and it said "the Norman Whitfield singers" and when I saw that I said, "OK, now we're losing our identity,"' says the Temptations' Otis Williams. 'It was the writing on the wall.' Even Kenny Gamble dropped his proselytising after the O'Jays' *Message in the Music*. Stevie Wonder scattered some topical songs through his elephantine *Songs in the Key of Life*, only to follow it with a puzzling concept album about vegetation, *Journey Through the Secret Life of Plants*. Only Curtis Mayfield maintained his political commitment: *There's No Place Like America Today* was as sombre as he ever got.

The prevailing mood of the Ford years was a kind of cranky depression, a nationwide headache that wouldn't go away. During 1975, the Isley Brothers were sick and tired of 'red tape' and 'the big runaround' on 'Fight the Power', breaking a pop taboo by snapping the word *bullshit*, as if all the courteous alternatives had been exhausted; Billy Paul bemoaned corruption and stagflation on 'Let the Dollar Circulate'; and the Alexander Review sharpened Sam Cooke's fervent hope into an impatient demand on 'A Change Had Better Come'. 'Time's getting short,' grumbled James Brown on 'Funky President (People It's Bad)' (1974), which treated the new man in the Oval Office as a minor irrelevance. Even the album titles seemed tired and glum: *Survival* (the O'Jays) and *Reality* (Brown). 'What ever happened to the protest and the rage?' asked Gil Scott-Heron on 'South Carolina (Barnwell)'.

While earlier protest songs had sought to educate and alert listeners, Brown and the Isleys now assumed that everybody knew the problems and were as fed up as they were. Howard

Beale, 'the Mad Prophet of the airwaves' in Paddy Chayefsky's despondent 1976 satire *Network*, knew the score: 'I don't have to tell you things are bad. Everybody knows things are bad.' Beale wanted his viewers to get 'mad as hell'. In the real world, though, a lot of Americans just wanted to forget it all and have some fun at last.

Just as the baton of protest music had passed from rock to soul in the early 1970s, it was now moving overseas: to South America, Africa, Jamaica and Britain.

PART ONE

PART THREE

1973–1977

(CHILE, NIGERIA, JAMAICA)

13

'A man who will die singing'

Victor Jara, 'Manifiesto', 1973

The killing of a protest singer

Undated picture of Chilean folksinger and activist Victor Jara.

It was in the summer of 1971 that Phil Ochs decided he needed to visit Chile. The years since the disaster of Chicago and Nixon's election had been tough for him. He was drinking heavily and gobbling Valium, depressed and unable to write. He vowed to visit every country in the world before he died, which, he was convinced, would be prematurely.

When he started reading about events in Chile, his interest was piqued. The previous November Dr Salvador Allende had become the world's first democratically elected Marxist head of state, an inspiration to leftists everywhere. Ochs suggested a visit to his regular travelling companion Jerry Rubin, who in turn invited Stew Albert along.* The trio touched down in Santiago in August and embarked on a long fact-finding mission, visiting 'jungles, mines, caves, factories, basketball games, film and TV studios, newspaper offices, the desert . . .' On the morning of 31 August they were wandering through Santiago when they spotted a handsome, curly-haired man holding a guitar and chatting to a woman. Rubin approached them and discovered that they were the folksinger Victor Jara and his English wife Joan.†

Jara was practically unknown in the US, but in Chile he was a folklorist, activist and star, the charismatic champion of Chile's poor and a key player in Allende's election campaign. That day, he was booked to perform a half-time concert during a basketball match between a local college side and a team of copper miners, and he invited Ochs along to sing a couple of songs and talk with the workers. Over the next few weeks Ochs came to

* Ochs had been beaten to it by Country Joe McDonald, who had visited Chile with a documentary crew in the build-up to the election.
† This account comes from Michael Schumacher's *There But for Fortune: The Life of Phil Ochs*. Joan Jara writes that the meeting took place under rather different circumstances in May 1973, but Ochs was in the US during that period.

love both Chile and his new host, with whom he performed on national TV. 'I just met the real thing,' he later told his brother Michael. 'Pete Seeger and I are nothing compared to this. I mean here's a man who really is what he's saying.' As he moved on to Argentina and Uruguay with his new companion, the Jewish radical David Ifshin, he looked forward to seeing Jara again some day.

Two years later, Ochs had just returned from a trip to Africa with Ifshin when he heard the news about his friend. On 11 September 1973 a CIA-backed military junta had overthrown Allende's government, killing the president and hundreds of his supporters. Among them, Ochs learned, was Jara, who had been executed while detained in the Estadio Chile.

This was something horrifically new. American protest singers had been hounded, like Paul Robeson, or prosecuted, like Pete Seeger, but nobody expected one to be murdered.* Jara was doubtless too polite to say so to Ochs, but he regarded his American counterparts as a pampered, trivial lot, manipulated to sinister ends. He believed that the US authorities had 'taken certain measures: first, the commercialisation of so-called "protest music"; second, the creation of "idols" of protest music who obey the same rules and suffer from the same constraints as the other idols of the consumer music industry – they last a little while and then disappear. Meanwhile they are useful in neutralising the innate spirit of rebellion of young people. The term "protest song" is no longer valid because it is ambiguous and has been misused. I prefer the term "revolutionary song".' The business of US protest singers was, at root, entertainment. In Chile, Jara knew, the stakes were always higher.

*

* Jara was not the first protest singer to be executed – Congolese bandleader Franklin Boukaka had been killed during a failed coup the previous year – but Jara's case was the first to garner international coverage.

The country into which Jara had been born, in 1935 in the rural village of Lonquen, was, by South American standards, blessed with stability. While much of the rest of the continent was wracked by coups and civil wars, Chileans prided themselves on their traditions of democracy and compromise, calling themselves 'the English of Latin America'. The electorate was split fairly evenly between three main parties, which meant that governments had to proceed by coalition and consensus. After a rocky period in the 1920s, which included a couple of short-lived coups, liberal-led coalitions governed steadily for the next two decades.

Jara's father Manuel was an illiterate farmer, but his mother Amanda was a well-read folksinger who wanted more for her children and moved the family to Santiago when Victor was a boy. In the city, though, there was no demand for her musical services and her guitar gathered dust. The family struggled and in 1950 Amanda suffered a fatal stroke. A distraught Victor then spent two unhappy years in a Catholic seminary and one year in the army, fulfilling his compulsory military service. He was studying to be an accountant when he finally found himself compelled to explore his mother's musical heritage, and travelled into the countryside to study folk songs. He also joined a mime troupe and, in 1956, successfully applied to the theatre school at the University of Chile.

For the next few years music was his hobby and theatre his vocation. At a bohemian café in Santiago he befriended the folklorist Violeta Parra, a sort of Chilean Alan Lomax, who sang in the peasant tradition and travelled abroad, recording folk songs for the likes of the BBC. Victor joined a folk group called Cuncumén, whose indigenous name was an index of their earnest intent. He closely studied the way traditional song and dance styles varied according to region and occupation, much as Ewan MacColl and A. L. Lloyd were doing in Britain during the same period. In 1961 he spent several months touring with Cuncumén in eastern Europe and the Soviet Union, and his

parallel reputation as one of Chile's most talented young writers and directors offered him yet more eye-opening opportunities for foreign travel. Touring a play in Cuba shortly after Castro's 1959 revolution, he was granted an audience with Che Guevara. And it was while attending a theatre festival in Uruguay in 1964 that he first met the leader of the Chilean Socialist Party, Salvador Allende.

Born in 1908, Allende was a former physician who had fought two unsuccessful election campaigns as the Popular Action Front candidate in 1952 and 1958. He was a gripping orator with a populist touch and his 1964 campaign had a strong musical dimension. Since the early years of the century, the labour movement had used songs to get across its message to illiterate workers. Now, while mainstream radio stations, owned by corporations or conservative landowners, favoured US pop, folk music became the soundtrack of the left, and Jara was one of several folksingers who performed at PAF rallies. But the Cuban revolution had panicked the Chilean right, which made the strategic decision to back the centrist Christian Democrat Eduardo Frei, thus blocking Allende for a third time. But Frei took charge of a splintering nation, and his 'third way' between capitalism and Marxism proved unable to glue it back together. While his progressive social programmes enraged wealthy conservatives, his working-class supporters came to see him as an establishment crony serving the interests of the wealthy.

During Frei's six-year term Jara became an icon of the left-wing opposition and of the folk revival known as Nueva Canción, or 'New Song', which began in Chile (the phrase was first coined in Santiago in 1968), Uruguay and Argentina and gradually advanced northwards up the continent. The nexus of Nueva Canción Chilena was an artistic co-operative established at the Peña de los Parra in central Santiago by Violeta Parra's children Angel and Isabel. This shabby house became a way station for musicians, writers, students, politicians and

intellectuals who would listen to folk music in its boisterous, informal ambience. Three times a week, Jara would finish his work at the theatre and come to the Peña to play songs into the small hours, while the well-travelled Parra siblings introduced visitors to songs they had collected from across Latin America. Three of the bearded young men who frequented Peña de los Parra formed the Nueva Canción group Quilapayún (Jara became their artistic director) and another penã, at the Technical University, spawned the scene's other major band, Inti-Illimani.

The Peña de los Parra's reputation spread beyond Chile's borders and it became a magnet for musicians fleeing persecution elsewhere in the continent. In 1968, four years into Brazil's military rule, the new, irreverent, avant-garde sound of *tropicália* represented a challenge to the junta, despite avoiding obvious protest lyrics. *Tropicália* pioneers Gilberto Gil and Caetano Veloso were arrested the following year and went into exile upon their release, while other musicians were tortured or forced into mental institutions. Argentina, whose Nueva Canción stars included Mercedes Sosa, experienced an army takeover in 1966.* Uruguay declared a state of emergency in 1968, and became progressively more oppressive; folksinger Daniel Viglietti was arrested and imprisoned four years later, and Los Olimareños's Braulio Lopez was arrested and tortured in Argentina in 1976.

During the watershed year of 1968, Jara visited the US and UK on a theatre tour, but he found the experience overwhelming for all the wrong reasons. 'It seems that nobody dares to be themselves,' he complained in a letter home to his British wife

* Argentina returned to civilian rule in 1973 but was seized by another, much more brutal junta after just three years. During the following 'Dirty War' by the government against internal dissidents, tens of thousands of people were 'disappeared' by the regime. At a concert in 1979 Mercedes Sosa was arrested on stage, along with her entire audience.

Joan. 'They are afraid of solitude and because of that, everyone is alone in a mass of lonely people . . . Apart from being in the hands of the United States and other defects, Chile is at least a place where bread is bread and earth is earth.'*

His songwriting, meanwhile, became more overtly political. In 1967 he dedicated 'El aparecido' to Che Guevara, who was at that point fomenting revolution in Bolivia and only months away from being shot dead. 'El soldado', a song he wrote for Quilapayún, targeted the military, which was increasingly pre-occupied with crushing internal dissent rather than national self-defence. In the name of anti-communism, the US was funnelling guns and riot gear to Chile's feared special police squad, the Grupo Movil. When the Grupo Movil broke up student demonstrations for university reform with water cannons and tear gas, he and Quilapayún wrote 'Movil Oil Special', a pun on US oil company Mobil, and peppered the recording with the sound of chanting demonstrators and exploding tear-gas grenades. At the invitation of labour organisers and activists, his music travelled out of the peñas and into the hills, oilfields and mining towns. 'An artist must be an authentic creator and therefore in very essence a revolutionary,' said Jara. 'A man as dangerous as a guerrilla because of his great power of communication.'

On the morning of 9 March 1969, on instructions from the Minister of the Interior, Edmundo Pérez Zukovic, armed police descended on a patch of land just outside the city of Puerto Montt. The ground was being occupied by dozens of peasant families as a protest against rural living conditions. Zukovic, a wealthy right-winger who oversaw the Grupo Movil, was determined to evict them suddenly and, if necessary, savagely. Police encircled the encampment, set the temporary huts ablaze and opened fire on the scattering peasants with machine guns, killing eight. Four

* Allende was equally dismissive of the libertine drop-outs to the north, announcing: 'Escapism, decadence, superficiality and the use of drugs are the last resort of young people who live in countries which are notoriously opulent but devoid of any moral strength.'

days after the massacre, Jara mounted the stage during a massive protest in Santiago and debuted his angriest song yet: 'Preguntas por Puerto Montt' (Questions about Puerto Montt).

The song cemented Jara's position as the fearless folksinging champion of the common man, and he was asked to sing it everywhere he went. To others in the increasingly febrile political climate it confirmed him as a dangerous radical. He was respectively lauded and attacked in different sectors of the press. While performing at a school in June, he was pelted with stones and almost mobbed by anti-communist students before escaping via the back door. But opposition only inflamed his radical zeal. The First Festival of Chilean Song that year became a showcase for Nueva Canción, featuring Jara, Quilapayún, Inti-Illimani and the Parra siblings (Violeta had committed suicide in 1967). The song prize was awarded to Jara for his new peasants' anthem, 'Plegaria a un labrador' (Worker's Prayer).

As the 1970 presidential election loomed, Chile's long-cherished political civility was in shreds, with both left and right stepping up their activities on the streets. In October 1969 right-wingers in the army, enraged by Frei's cuts in military spending, attempted an unsuccessful coup, which failed only because the army hierarchy still believed in respecting the constitution. The new commander-in-chief, General René Schneider pledged to respect the result of the election, but some of his colleagues had other ideas. When the Popular Unity alliance chose as its candidate Salvador Allende, certain right-wing forces decided that the good doctor needed to be stopped.

*

In the months before the election, consternation about Allende's prospects of taking the presidency at his fourth attempt wasn't confined to the country's elite. In Washington, Henry Kissinger fumed, 'I don't see why we need to stand idly by and watch a country go communist due to the irresponsibility of its own people.' In March, Kissinger's Congressional 'Committee of 40'

authorised the first payments to Allende's political opponents, on the understanding that if the US could not prevent Allende's election then it would destabilise him once he took office.

The election was closely, and bitterly, contested. Rival street campaigners, or *brigadas*, covered Santiago's walls with competing slogans in favour of Allende, the Christian Democrat Radomiro Tomic and the right-wing National Party candidate Jorge Alessandri. Popular Unity supporters fought with the police and fascist paramilitaries. When one demonstrator, eighteen-year-old Miguel-Angel Aguilera, was killed, Jara commemorated him in 'El alma llena de banderas' (Our Hearts Are Full of Banners). He also wrote new lyrics to Allende's campaign theme, 'Venceremos' (We Shall Triumph). On election day, 4 September, almost a million Popular Unity supporters sang it on the streets of Santiago.*

As the votes were counted, it became evident that the right had made a fatal strategic error. By abandoning the Christian Democrats out of disgust with Frei, they had split the anti-Allende vote and handed the Socialist leader the narrowest of victories. According to Chilean law, however, a winning candidate who lacked an overall majority had to be confirmed by Congress. There were rumours that the Christian Democrats would overrule the popular vote and back Alessandri, or even that the army would step in to thwart Allende. The CIA station office in Santiago received a cable from headquarters in Langley, Virginia: 'It is firm and continuing policy that Allende be overthrown by a coup.'

In Chile, the right did its part. To stoke fears of shortages and economic collapse under Allende, businessmen shuttered their factories, withdrew their savings and drove down share prices. Popular Unity voters responded with massive pro-Allende demonstrations. The whole country seemed to be holding its breath.

* The music was composed by Nueva Canción star Sergio Ortega. An earlier version of 'Venceremos', with lyrics by Claudio Iturra, was released by Inti-Illimani.

On 22 October, just two days before the congressional vote, General Schneider was shot during an attempted kidnapping by coup plotters. His murder cast a sinister pall over Congress's decision: the Christian Democrats had decided to obey the will of the voters, and Allende moved into Santiago's Moneda Palace on 3 November. During one victory speech, he stood in front of a banner reading: 'You can't have a revolution without songs.'

From that first day, however, it was a fragile victory, under siege from hostile forces at home and abroad. Allende was not the Marxist monster his more hysterical opponents had made him out to be, but he pressed ahead with unapologetically left-wing policies, dissolving the Grupo Movil, opening links with Cuba and China, nationalising mines and banks and docking millions of dollars in 'excess profits' from foreign copper companies. The US hit back by slashing aid and flooding the international copper market so as to hurt Chilean exports. The right-wing press, secretly funded by the Committee of 40, maintained a steady campaign of scare stories.

Schneider's successor as commander-in-chief, General Carlos Prats, reaffirmed the army's commitment to back the legitimately elected government, but for how long? Across the continent, workers regarded the Popular Unity government as a beacon of progress, while businessmen saw it as a dangerous cancer to be excised from the body politic before it metastasised. Allende was a test case – the likelihood of other countries following suit rested on whether his government stood or fell.

For Jara and his friends Allende's time in office was a period of celebration veined with anxiety. 'People believed paradise was around the corner,' recalled former Allende supporter Marco Antonio de la Parra. 'There was an explosion of passion, a drunken binge of ideas . . . But there was also a sense of violence, a feeling that it would all come crashing down. We suffered the calamitous impact of a utopian time.'

Jara wrote several songs welcoming the new era and lionising the poor (1972's *La Población* was a concept album about

peasant life), but did not flinch from goading the right. 'Las casitas del barrio alto', his version of Malvina Reynolds's 'Little Boxes' turned a cutesy satire into a wounding assault on the wealthy elites who approved of Schneider's murder. Countless groups emerged (Quilapayún even multiplied, hydra-like, into sub-groups called Quila I, Quila II, etc.), and every fresh political development sparked a new topical song, though not always a good one. 'Some were funny, some were explanatory and therefore, perhaps, useful, some were satirical, but many were just plain boring and musically unoriginal,' wrote Joan Jara. The opposition commissioned its own anti-Allende compositions.

It was the ferocity of the opposition forces that enabled Jara to maintain his radical edge even while closely allied with the president. It's hard to imagine a US protest singer writing the theme music for the national TV station, as Jara did for Channel 7, but the Popular Unity government somehow felt like rebels even while in office. Meanwhile, the right-wing opposition had the money (including $8 million from the Nixon administration) and the media outlets. They began organising demonstrations to spread fear of food shortages, with middle-class women symbolically banging saucepans in 1971's 'March of the Empty Pots'. The opposition's slogan was 'Accumulate rage' and its shock troops were a notoriously violent fascist militia, Patria y Libertad (Fatherland and Liberty).

Unfortunately for Allende, the Marxist guerrillas of the Movimiento de Izquierda Revolucionaria (MIR) responded to Patria y Libertad's efforts with violence of their own. In July 1971 a radical left-wing splinter group, the Vanguardia Organizada del Pueblo, assassinated former Minister of the Interior Zukovic, a murder which some tried to blame on the man who wrote 'Preguntas por Puerto Montt'. Popular Unity became sandwiched between extremists on both sides, and pushed further left by party militants. Eager to raise living standards fast, the government fixed prices too low and wages too high, stagnating the economy.

Eventually, food shortages became more than a nasty rumour thanks to a lorry-drivers' strike, ordered by industrialists rather than unionists, which cut off supplies of essential goods in October 1972, leading to food queues and rationing. The crisis was brought to a close only by the appointment of General Prats as Minister of the Interior, a guarantee of relative calm until the parliamentary elections the following March. But Chilean poet Pablo Neruda spoke for many of his countrymen when he celebrated his recent Nobel Prize at the National Stadium in December and expressed his fears that civil war was coming.

On Christmas Eve, Victor was sitting outside his house with Joan when he said to her, 'This coming year is a crucial one, Mamita. I wonder where we shall all be next Christmas?'

*

The parliamentary election campaign was soundtracked by topical songs on both sides. The opposition even brazenly commandeered the melody of Jara's 'El hombre es un creador' for a TV commercial based on the slogan, 'Allende = Chaos'. Jara campaigned tirelessly for Popular Unity, making stump speeches as well as singing. The party took more than 40 per cent of the vote, thwarting opposition attempts to remove Allende by democratic means and hastening plans for the alternative.

A sense of crisis hung over Chile like a thunderhead. After the elections, Patria y Libertad launched a new campaign of street violence advertised on walls by the initials SACO: 'System of Organised Civic Action'. More than once Jara narrowly escaped being pummelled by fascist gangs, and a simple journey to work each day involved running a gauntlet of rioters and policemen. 'We worked to a background of shouting in the street, the noise of breaking glass, the crunch of tear-gas grenades exploding,' wrote Joan. Victor recorded an anti-fascist song with Inti-Illimani, 'Vientos del pueblo', in which he scolded 'Those who talk of liberty / But whose hands are marked with guilt.'

The impatience of the armed forces was stoked by a

widespread conviction (hugely exaggerated, as it turned out) that leftist militias were stockpiling guns in preparation for a Marxist revolution. There was feverish talk of a conspiracy by Allende to assassinate troublesome officers – the so-called Plan Z – but there is no evidence that such a plot ever existed. In June a mutinous tank regiment turned its guns on Moneda Palace in an attempted coup. Once again General Prats was the hero of the hour, confronting the tanks in person to order the plotters to surrender, but he was only postponing a takeover, not preventing one. The Christian Democrats snubbed Allende's last-ditch attempt to win their vital support, while coup enthusiasts within the armed forces plotted to get rid of Prats and his law-abiding fellow constitutionalists, one of whom, the navy's Commander Arturo Araya, was assassinated in July. Another boss-led strike, much more concerted than the one in October, paralysed the economy, coinciding with a new wave of paramilitary sabotage. 'The task is great,' Prats wrote in his diary. 'The truckers' strike continues, as does that of the owners' and professional guilds; terrorism is spreading . . . the dialogue between the government and the Christian Democratic party has, for the moment, failed. The country is tired.'

On 22 August the penultimate domino fell when the Chamber of Deputies called on the military to remove Allende; Prats, realising he no longer had the confidence of his fellow officers, resigned from both the army and the government. His replacement was a textbook military man – austere, punctual, disciplined, tireless – assumed to be loyal to the constitution but who in fact nursed a deep hatred for communism: General Augusto Pinochet.

On 3 September, Allende's fearful supporters marked the third anniversary of his election with a massive demonstration: the last gesture of love for a dying government. The Jaras were told they should make plans to flee when the worst happened, but Victor decided that he would stay and fight. His final album was, unexpectedly, his least political yet, a collection of risqué peasant songs called *Canto por travesura*. 'We Chileans are naturally a

very cheerful people with a great sense of humour,' he explained. 'We need to be reminded of it.' It was scheduled for release in September, but it never made it out of the pressing plant. He also recorded some songs for his next album, which was compiled posthumously. In the title track, 'Manifiesto', Jara explains why he sings, positing himself, like Pete Seeger, not as a star but as a vessel for a message: 'A song has meaning / When it beats in the veins / Of a man who will die singing.' The performance is glitteringly sad: it sounds almost like a goodbye.

*

On the morning of 11 September, Joan Jara woke to news reports of unusual troop movements in Santiago. She and Victor listened to Allende make his farewell broadcast, thanking his listeners for their support. 'History belongs to us,' he promised, 'because it is made by the people.' Then the signal went dead as all the pro-Popular Unity radio stations were cut off by the military, and the only sound coming out of the set was martial music. Later, a voice interrupted the music to announce that Allende had been given until midday to resign his post. As pro-opposition neighbours hurled gloating insults at him, Victor diligently went off to work at the Technical University, promising his wife, 'I'll be back as soon as I can.'

Eight minutes before midday, Joan heard two Hawker Hunter fighter jets fly low over her house and then, seconds later, a huge explosion as the first rockets hit Moneda Palace. After them came the helicopters, spraying the palace with machine-gun fire. They were acting under the orders of Pinochet, a late recruit to the coup who took to his new role with savage gusto. Before calling in the air strike from his base in the Santiago suburbs he ranted to aides about 'that whole pile of pigs in there . . . all that filth that was going to ruin the country'.

Allende's bodyguards fired back for a while before emerging from the blazing palace waving a white flag of surrender. Upon entering La Moneda, a group of soldiers discovered the president

slumped on a red velvet couch with most of his head destroyed and his hands dusted with gunpowder. Propped against him was an automatic rifle engraved with the words: 'To Salvador from your companion in arms. Fidel Castro.'

Even before the palace fell soldiers were sweeping through Popular Unity strongholds, arresting Allende supporters. Pockets of students and workers, armed by the MIR, fought back but lacked both the resources and the planning for wide-scale resistance. A curfew was imposed. At about 4.30 p.m. Victor phoned Joan to tell her he could not get home from the university but would see her in the morning. 'Mamita, I love you,' he said before he hung up.

Joan lay in bed all night listening to bursts of gunfire puncture the dark. When she went out to buy bread the next morning the streets were full of soldiers and fascist militiamen. There was no sign of Victor. She spent most of the day watching the news, which is how she learned that tanks had seized the university. A friend told her that anyone captured there had been taken to the Estadio Chile, once the site of the Song Festival, now a giant political prison. On Friday, three days after the coup, Joan drove to the stadium but there was no way in. On Sunday she received a visit from a young communist who apologetically informed her that a body in the morgue, one of hundreds of corpses taken from the Estadio, was Victor's. When she got to the morgue, she walked down a long row of bodies before finding her husband. There was an open wound in his abdomen; his chest was a colander of bullet holes; his hands dangled from smashed wrists. At least, Joan thought, he had been identified and could be given a funeral instead of being shovelled, with all the anonymous dead, into a mass grave.

What had happened, Joan later discovered, was this. Victor had spent the night of the 11th at the university, attempting to comfort a few hundred students and teachers with his songs. After soldiers seized the campus the next morning, he was recognised before they even reached the Estadio. 'You're that fucking

singer, aren't you?' barked one soldier, knocking him to the ground and kicking him. He was taken to a special section of the Estadio reserved for prominent prisoners. On Thursday morning one officer approached him and gloatingly mimed playing a guitar, then drew his finger across his throat. Throughout the day, he was beaten so badly he could hardly walk.

The Estadio's 5,000 prisoners were denied food and water, disoriented by glaring spotlights, bombarded with threats and, from time to time, machine-gunned to death, all of which Jara silently recorded in his last, unfinished song, scribbled on borrowed paper. When he was hauled off by soldiers, he passed the song to another prisoner, who hid it in his shoe. Other detainees memorised individual verses so that the song would survive even if the paper was discovered. It begins as a documentarian account of conditions in the Estadio, mutates into a plea to God for justice and ends, prematurely, with a wrenching twist on the why-I-sing theme of 'Manifiesto'. 'How hard it is to sing when I must sing of horror,' runs one line. 'Silence and screams are the end of my song,' goes another.

In one of the same dressing rooms where he had prepared to perform at the Song Festival, he was tortured for hours, then taken into the main body of the stadium for a final public humiliation. 'Sing now, if you can, you bastard!' ordered the officer who had mocked him earlier. Through bloodied lips, Jara managed a ragged verse of 'Venceremos' before being knocked to the ground and dragged away. Some time afterwards, he was shot dead.*

* In June 2009, Jara's body was exhumed for a proper autopsy, which found more than thirty bullet wounds and several broken bones. A former army conscript, José Adolfo Paredes Márquez, was charged with murder but claimed an officer known as 'El Loco' had killed the singer during a game of Russian roulette, instructing his men to machine-gun the body along with fourteen witnesses. Jara's body was reburied, surrounded by hundreds of mourners, in December, over thirty-six years after his death.

By December around 1,500 civilians had been murdered as a result of the coup, but Jara was the only prominent musician. Inti-Illimani and the original Quilapayún were fortunate enough to have been abroad on tour, where they proceeded to make an international resistance anthem out of Sergio Ortega's Popular Unity song 'El pueblo unido jamás será vencido' (The People United Will Never Be Defeated). Angel Parra was held in the Estadio Chile but eventually released. When a heartbroken Pablo Neruda died on 25 September after a long illness, his public funeral became an unofficial farewell to Jara, Allende and all the other victims of the coup: a mournful last hurrah for the Popular Unity era. Jara's records, and those of the entire Nueva Canción movement, were promptly thrown on bonfires alongside politically suspect literature. Joan was forced to immolate the family's own collection but took the master tape of his final recordings with her when, never more grateful for her British passport, she fled to London.

*

Joan Jara left behind a country in the grip of state terror. The four-man junta dissolved Congress, banned political parties, introduced rampant censorship and incarcerated tens of thousands of political opponents, who endured months of humiliation and abuse. Many law-abiding conservative Chileans who had welcomed the end of what official propaganda summarised as 'chaos, ambulances, violence', realised with unease that the junta had no intention of handing back power to the politicians until the task of 'moral cleansing' had been completed, whenever that might be, but it was the left who suffered the brunt. The anti-communist fear and paranoia generated by the plotters over the past three years licensed all manner of vengeful atrocities and 'disappearances'. 'It could only have happened in a country that was already sick,' said former Allende supporter Marco Antonio de la Parra. 'The crimes were committed by one side, but the passions of the other side took away all their scruples and made anything possible.'

Historians Pamela Constable and Arturo Valenzuela describe the contrast with what had come before: 'The Allende era had been an intensely public experience, with an endless stream of political activity and cafés bustling until dawn. The coup brought down a swift steel curtain on this frenzied drama. Bookstalls closed, nightlife vanished, and radio stations replaced Andean protest bands with Mexican mariachis and American pop songs. Santiago became a tense, subdued city where commuters rode buses in silence and restaurant conversations were held in murmurs.'

Phil Ochs was devastated. 'When that happened I said, "All right, that's the end of Phil Ochs,"' he later explained. But he managed to turn his grief into energy, organising a massive awareness-raising benefit concert: An Evening with Salvador Allende. Deni Frand, a former McGovern volunteer who helped with the organisation, remembered: 'Phil used to say to me, "Unless you're prepared to die for something, it's not worth doing." . . . He believed. He *truly* believed.' Ticket sales were sluggish until he bumped into Bob Dylan in Greenwich Village one evening and bombarded him with facts about the Chilean situation, including a passionate recital of Allende's inaugural address. The day before the show, Dylan finally agreed to perform; a few hours later, every ticket had been sold.

An Evening with Salvador Allende was Och's most forcefully political benefit concert yet. The audience, which included Joan Jara and Allende's widow Isabelle, was greeted with intense speeches, short documentaries and appearances from the likes of Arlo Guthrie, who sang the freshly composed 'Victor Jara', and Pete Seeger, who later recorded an English translation of Jara's last, unfinished song, 'Estadio Chile'.* Although Ochs's voice had been severely damaged during a mugging in Africa, he

* In subsequent years, the events of September 1973 would figure in several more songs, including the Clash's 'Washington Bullets' (1980), Working Week's 'Venceremos (We Will Win)' (1984), U2's 'One Tree Hill' (1987) and Drugstore's 'El President' (1998), which was performed during Pinochet's controversial visit to London that year.

joyfully joined Dylan, his old friend, rival and critic, for a ragged, boozy finale of 'Blowin' in the Wind'. It was the singer's last major achievement.

Ochs had wildly ambitious ideas but no longer enough faith or focus to see them through. His drinking got worse, as did his depressions and mood swings. The final 'War Is Over' rally which marked the fall of Saigon to the North Vietnamese in 1975 gave him one final burst of energy, followed by a catastrophic decline. He announced that he was now John Butler Train, a surly, filthy, paranoid Mr Hyde who boasted, 'I killed Phil Ochs.' With cruel déjà vu, his last grand scheme, a massive all-star benefit concert in Peru, was quashed in its final planning stages by a right-wing coup. The erstwhile protest singer was broke and unstable, relying on the charity of friends and telling anyone who would listen that the FBI was out to assassinate him. His symbolic 'murder' by Train was a rehearsal for the real thing. On 9 April 1976 Ochs hanged himself with his belt in his sister's bathroom.

Both Ochs and Jara died because they *truly* believed in the importance of protest singing. Of course their stories were different: Jara was still singing and writing just hours before his murder, whereas Ochs lost his creative voice, and his optimism, long before he took his own life. But both were ultimately victims of the politics of that most brutal and disillusioning decade. So how remarkable it is that their paths briefly intertwined when, full of energy and idealism, they met by chance one morning on the streets of Santiago.

14

'Go and kill, go and die'

Fela Kuti and Afrika 70, 'Zombie', 1976

The Afrobeat revolution

Fela Kuti and Afrika 70, *Zombie*, (Coconut Records LP, 1976).

'You cannot see two of Fela,' says Tony Allen, peering with bloodshot eyes over his cup of tea. 'He was who he was and there's no point anyone challenging him.' Allen is seventy, self-contained and somewhat terse over a Dictaphone, yet still impossibly tentacular at the drum kit. It is three decades since he last worked with Fela Anikulapo Kuti, and four since the pair of them invented Afrobeat. Allen, as he says more than once, cares about 'only the music'. Fela wanted to do *everything*. He was Africa's James Brown, its Bob Marley, its John Lennon: band-leader, icon, hedonist, moralist, would-be politician and full-time troublemaker. And when the Nigerian authorities decided he had defied them enough, they came down on him so hard that a lesser man would have cracked in two.

Fela was born in 1938 with dissent in his veins. He was a member of the influential Ransome-Kuti dynasty, who belonged to the ethnic Yoruba and lived in Ogun state in southwestern Nigeria. His father, the Reverend Israel Oludotun Ransome-Kuti, co-founded Nigeria's teacher and student unions. His mother, Funmilayo, was a campaigner for women's rights. One of his cousins was the Nobel Prize-winning writer Wole Soyinka. A 1946 editorial in the *Daily Service* described the Ransome-Kutis' hometown, Abeokuta, as 'by far and away the most explosive in Nigeria . . . The temperature is almost always at boiling point.'

Fela grew up in a relatively prosperous and learned environment; all four of his siblings proceeded to work in medicine. His parents did not tolerate disobedience under their own roof, regularly dishing out punitive beatings to the stubborn and mischievous Fela, but outside the home they battled authority. 'What I liked about my father is that he kicked *everybody's* ass,' remembered Fela. In the late 1940s, Funmilayo led local women in massive protests against Abeokuta's discriminatory tax policies, driving the town's corrupt leader into exile with the lyrics of

abusive songs ringing in his ears: 'Ademola Ojibosho / Big Man
with a big ulcer / Your behaviour is deplorable.' The Yoruba
had an ancient tradition of praise singing – topical songs which
hymned the glories of various rulers – and these spontaneous
protest songs showed just how powerful the form could be when
praise was replaced with scorn. Flushed with success, Funmilayo
became a celebrated campaigner: leader of the movement for
women's suffrage, close friend to Ghana's first president Kwame
Nkrumah and pen pal to Paul Robeson.

The adolescent Fela, however, was more interested in the
Lagos nightlife. 'Highlife', a musical genre which had evolved
over decades into a vibrant and colossally popular amalgamation
of sounds from West Africa, Europe, Cuba and the Caribbean,
was good-time music for the affluent elite, and Fela began sing-
ing with Victor Olaiya's Cool Cats. In 1958 he went to London
to study the trumpet at the Trinity College of Music, where he
formed his own highlife band, Koola Lobitos, to entertain other
black students, and immersed himself in the jazz scene. It was an
exhilarating historical moment for a young, ambitious African.
Nkrumah triggered sub-Saharan Africa's post-colonial landslide
in 1957; Guinea followed suit the following year; in 1960, the
year that British prime minister Harold Macmillan spoke of a
'wind of change . . . blowing through this continent,' seventeen
countries, including Nigeria, declared independence.* But even
as liberation politics swirled all around him, Fela paid little
attention. 'Man, I was so fucking ignorant about world politics
then, I didn't know shit,' he told interviewer Carlos Moore. 'And
I really didn't give a fuck either!'

Fela married a black British woman, had three children in
quick succession, graduated from Trinity and returned to Nigeria
in 1963. His new band, also called Koola Lobitos, merged jazz

* Nkrumah's historic achievement inspired two of the most
transcendentally joyous political songs you will ever hear: 'Ghana',
by Zimbabwean singer Dorothy Masuka, and 'Birth of Ghana' by
London-based calypso artist Lord Kitchener.

and highlife and pivoted on the breathtaking, multivalent drumming of Tony Allen. However, highlife was about to experience a drastic evolution for reasons that extended far beyond music.

*

Nigeria was a shotgun marriage of hundreds of ethnic groups, forced into coalition by the British Empire at the start of the century. Three were dominant: the Yoruba in the southwest, the Islamic, semi-feudal Hausa-Fulani in the north, and the mostly Christian, democratic Igbo in the southeast. In January 1966 a group of mostly Igbo officers staged a military coup, which was soon toppled in a counter-coup by Hausa-Fulani leaders, who appointed thirty-two-year-old Yakubu Gowon as head of state. Tens of thousands of Igbos living in the north were massacred in a string of retributive pogroms. Over a million fled eastwards to shelter in their homeland, among them most of the biggest highlife stars. As the musicians were chased out of Lagos so, it seemed, was the carefree optimism which had animated highlife.

In May 1967 Igbo leader Chukwuemeka Odumegwu Ojukwu declared that his region would secede from Nigeria and become the Republic of Biafra, thus precipitating civil war. The government wanted to secure the oil reserves that lay below the rebel territory, and to deter other regions from seceding. A year later, Nigerian forces seized Biafra's major supply route, Port Harcourt, and blockaded the country, thus forcing hundreds of thousands of Biafrans to starve to death.

After the war Fela would profess his support for the Biafrans, but at the time he was just another working musician. As American soul music swept West African clubs, Fela traded highlife for a new sound which he christened Afrobeat. In June 1969 he accepted an invitation to tour the United States with Koola Lobitos and met a Black Panther named Sandra Smith, who introduced him to new worlds: Nina Simone and the Last Poets, Martin Luther King and Stokely Carmichael, Nikki Giovanni and Angela Davis. He fell particularly hard for *The*

Autobiography of Malcolm X. 'I said, "This is a man!"' he told Moore. 'I wanted to be like Malcolm X. Fuck it! Shit! I wanted to *be* Malcolm X . . . Everything about Africa started coming back to me.' Fela's band, now called Nigeria 70, thrived and evolved in Los Angeles; funkier and pared down, Afrobeat was no longer just a name but a radical new sound. 'I had been using jazz to play African music, when really I should be using African music to play jazz,' he explained to writer John Collins.

'Everything changed after America,' says Tony Allen. 'The music changed, the ideology changed, everything changed.'*

*

The beleaguered Biafran forces surrendered in January 1970, two months before Fela's return to Nigeria, and Gowon began the task of rebuilding the country. He was cannily magnanimous in victory, granting amnesty to secessionist troops and reintegrating them into Nigerian society. The feared genocide of the Igbo did not materialise, and the country's wounds were further salved by prosperity. By the end of the year it was the world's tenth-largest exporter of oil, bringing in millions of dollars a day, and it swelled further still during the 1973 oil shock. By then Nigeria boasted the most affluent economy and the largest army in black Africa.

With more money for leisure, it was a boom time for the music industry. EMI and Decca both headquartered their West African operations in Lagos and signed a new generation of artists, including King Sunny Ade and Sonny Okosuns. As more young, middle-class Nigerians travelled and studied abroad, they brought back a taste for Western rock and funk. EMI's in-house

* Before meeting Smith, however, Fela wrote a patriotic song to curry favour with the government back home: the buoyant 'Viva Nigeria' ('One nation indivisible / Long live Nigeria'). 'It was just bullshit,' he told Moore. 'I feel so bad about that record now; I was on Biafra's side.' To make matters worse, back in Nigeria Wole Soyinka was one of those imprisoned for opposing the war.

producer, Odion Iruoje, had been dispatched to London to observe the recording of the Beatles' *Abbey Road* album, and he scouted for talent across Nigeria, recruiting crack session musicians to sharpen the recordings. Bands such as the Hygrades and the Funkees played with the uncorked vigour of US garage-rock groups, seizing a moment that might never come again. Iruoje worked with Fela, too, but not for long. 'He was talking about government, politics,' he complains. 'I didn't like it. Music is his gift. You cannot decide to drop music and go into activism. He allowed the political side to override the music side.'

On his return to Nigeria, Fela first needed to adapt his new black consciousness to African ears. At his comeback show in Lagos, he raised his fist in a Black Power salute only to find that the nonplussed audience had no idea what it signified. So on 'Black Man's Cry' and 'Why Black Man Dey Suffer' he advocated an African version of racial nationalism. In 1972 he introduced a six-strong female chorus to lend his songs a call-and-response dynamic, and began singing in the pidgin English of Nigeria's working class, a decision both political (it aligned this elite scion with the street) and musical (it freed him up to weave around the rhythm). His songs became longer and longer, but there was nothing baggy about them. 'There are no jam sessions in Fela's music,' says Allen. 'Never. It's written music. Everything there. You can't add anything except me. I'm the only one.' Fela dismissed other genres, from highlife to Afro-rock, as manifestations of an unhealthy colonial mindset. Afrobeat, by contrast, was the music of independence.

His base of operations, just across the street from his house at 14A Agege Motor Road, was an insalubrious hotel courtyard which he named the Afrika Shrine. Several times a week the twenty or so members of the band now known as Afrika 70 played six-hour night-time shows to hundreds of revellers beneath a corrugated tin roof. The courtyard was bordered by flags of all the independent African nations, while above the T-shaped stage glowed a neon map of the continent. The

air was constantly perfumed with marijuana smoke. Later, Fela constructed an altar containing pictures of political icons such as Nkrumah and Malcolm X, to whom he would give thanks before performances. It became a site of quasi-mystical pilgrimage, somewhere between a nightclub and a church, with Fela the wildly charismatic priest-cum-master of ceremonies – indeed, his peppery newspaper column was called 'Chief Priest Say'.

But Fela didn't sing like a chief priest: rather a sly, sexy and quick-witted ringleader, translating the humming energy of the Lagos street into vivid imagery and serpentine grooves. Friday night was Yabis night, *yabis* being a satirical mode, literally meaning to make fun of someone. From time to time the diverse clientele of students, workers and dissidents would include an international star such as Paul McCartney, in town to record *Band on the Run*, or South African exile Hugh Masekela. 'Many things happening there,' says Allen enigmatically. 'You have to be sure of yourself to come there. Anything can happen.'

Over time, Fela converted his home into a compound for family, friends, band members, his ever-expanding entourage, and numerous girlfriends (monogamy, he explained, was another unwelcome colonial innovation). Typically, he would go to bed at dawn and rise mid-afternoon, summoning lackeys to bring him food, drink and marijuana, before heading out into the compound wearing nothing but a pair of briefs, flanked by girlfriends. Before each night's show he would mount a donkey and lead Afrika 70 across the road to the Shrine, surrounded by chanting and cheering fans.

Fela's brand of celebrity had an electricity all its own: political, musical, tribal, sexual. He spoke like Huey Newton, lived like Hugh Hefner and ruled his private kingdom like an autocratic village chief. What began as a band and expanded into an entourage steadily became its own subversive subculture. He and his followers travelled in a fleet of cars and buses decorated with the Afrika 70 logo, paid for by revenues from stadium tours and an unceasing flow of new albums. Yet despite this ostentation he

remained a folk hero to beggars, prostitutes and the underclass – even criminal gangs let him pass unmolested – and a magnet for political malcontents. 'Everywhere he goes,' noted writer John Collins, 'people stop what they're doing, shout his name, and give the Black Power salute. Once, at the Surulere football stadium in Lagos, he received an overwhelming ovation, greater even than the Head of State had received.' To the authorities, he represented a twin-pronged affront, flouting their laws with his deviant lifestyle and fostering unrest with his radical politics.

At that point Fela was not interested in naming names or making enemies, though his colourful commentaries on urban life illustrated some of the downsides of Nigeria's boom time. Root-and-branch corruption hampered the construction of vital infrastructure and ensured that wealth flowed to the elite: while fortified mansions sprang up in some parts of Lagos, shanty towns sprawled in others. Incompetence plunged airports and docks into gridlock and congestion was no better on the streets. 'Go Slow' (1972) humorously described being stuck in a traffic jam in a country with the worst road-safety record in the world. Tourists were advised to keep their arms inside their vehicles during go-slows, lest roving gangsters sever them with machetes to take rings and watches. 'Things started going haywire and you started to see armed robbers,' says Allen. 'That made the whole country become scary. People who went out in the night before can't go out any more because they're scared of not coming back home.'

In 1974 the government finally decided it was time to move against Fela. '1974!' Fela told Carlos Moore. 'That was the year when all the horrors started. The arrests . . . The clubbings . . . The imprisonments . . . Everything!'

*

You wonder if Fela would have become such a thorn in the government's side had it left him unmolested. Inside his ad hoc kingdom he lived a blessed life, amply furnished with money, sex

and adulation. He was a rebel, yes, but not a revolutionary, and he neither relished nor expected head-on confrontation with the state. At the beginning of 1974, he told Moore, 'I had nothing to fear. I wasn't even thinking they could have something against me.'

On 30 April fifty armed riot policemen raided the Afrika 70 house, claiming to be investigating reports of drug dealing and underage sex. Fela and sixty other inhabitants were arrested and taken to Alagbon Close prison. Freed after eight days, they were promptly subjected to a second raid, during which police attempted to plant a large joint on the premises. The raid took a farcical turn when Fela snatched the hemp, swallowed it and washed it down with whiskey, causing the police to return him to Alagbon Close and wait for his bowels to yield the incriminating evidence. Sympathetic cellmates helped him to use the communal toilet so that the sample he eventually produced for his captors was 'clean like a baby's shit'. After his release he channelled his indignation into 'Alagbon Close' and his cackling humour into 'Expensive Shit'. 'Me, I be Fela, I be Black Power man,' he brags, 'I go bend my yansch [behind], I go shit.' The police arrested a troublemaker and released a full-blown radical. 'You know how people are brought up thinking that jail is just for criminals, man,' he told Moore. 'For people who've "gone against society" . . . But after they put me in that cell with the people they call "criminals", I started thinking: "Who the fuck is Society? Who jails Society when it does horrors to people?"' As he explained to John Collins: 'Our music should not be about love, it should be about reality and what we are up to now.'

November brought another incursion, this time on charges of abducting an underage girl. Spraying tear gas, riot police smashed into the compound and gave Fela such a severe beating that he was hospitalised for seventeen days. He returned to Afrika 70 like a king from exile, with thousands of supporters parading behind him, and played a show at the Shrine that night.

The more the police tormented him, the more heroic he became. In 1975 he followed in Malcolm X's footsteps by swapping his 'slave name', Ransome, for Anikulapo, a name meaning 'He who carries death in his pouch'.* He also anointed 14A Agege Motor Road the Kalakuta Republic, after the nickname of the police cell at Lagos police HQ, proclaiming it an autonomous state and ringing it with barbed wire. *Kalakuta*, he explained, was Swahili for 'rascal'. Ever since his childhood he had been described as a rascal. Very well, then: he would become the biggest and most fearsome rascal of them all.

Just as he was fortifying himself, physically and psychically, for future confrontations, the political situation unexpectedly swung in his favour. Knee-deep in corruption and ineptitude, the once-popular President Gowon finally exhausted Nigeria's patience when he fudged his promise to return the country to civilian rule. After months of unrest he was ousted in a bloodless coup by General Murtala Mohammed, who conducted a top-to-bottom purge of crooks and cronies throughout Nigerian society. He especially endeared himself to pan-Africans like Fela by funding Communist MPLA forces in Angola and attacking the US over its support for South Africa's apartheid regime. These were good times for Fela. He signed with Decca, headlined Lagos Stadium and began filming a documentary, grandly titled *Black President*. He was even friendly with Mohammed's police chief, Muhammadu Dikko Yusufu. 'I'm very cool with this government,' an apparently relieved Fela told John Collins. 'We feel that we are going to progress now.'

But no such luck. After just seven months in office, Mohammed was shot dead through his car window while immobilised in a Lagos go-slow. The assassination had allegedly been ordered by the exiled Gowon, possibly with the support of Western governments. He was succeeded by one of his ministers, General

* His full name now translated, rather splendidly, as 'He who emanates greatness, who has control over death and who cannot be killed by man.'

Olusegun Obasanjo, who, it so happened, had been born in the same town as Fela and was a year or so his senior. Amid the anguish following the murder, Obasanjo pressed ahead with a project that would reaffirm Nigeria's place in the vanguard of African nationalism: the Second World Festival of Black Arts and Culture, or FESTAC.*

The government spent around $140 million on this month-long showcase for African culture, with presentations from every corner of the arts and performers from fifty-five nations. Fela had been recruited to the planning committee by Mohammed but his relationship with Obasanjo quickly soured and, amid mud-slinging on both sides, he withdrew from FESTAC in October 1976, three months before its launch. He and other critics accused the organisers of being corrupt, inept, vainglorious and elitist, more interested in the opinion of the outside world than that of the average Nigerian. Determined to disentangle Lagos's go-slow traffic flow before the foreign tourists arrived, Obasanjo announced 'Operation Ease the Traffic', which licensed police to horsewhip disobedient motorists. 'FESTAC!' exclaimed Fela later. 'One big hustle, man! A rip-off!'

Fela, self-appointed 'Black President' of his own country-within-a-country, decided to stage his own 'counter-FESTAC' at the Africa Shrine. Foreign delegates and performers, including Stevie Wonder and Archie Shepp, ignored government advice and flocked to the Shrine to see the country's biggest star in action. The more that foreigners raved about counter-FESTAC and disparaged the official event, the more embarrassed and enraged Obasanjo became. To salt the wound, Fela set up a group called Young African Pioneers, who flooded Lagos with thousands of leaflets decrying the administration. Furthermore, Fela announced plans to run in the country's first post-coup civilian election three years later. As if all this were not provocation enough, in the months leading up to FESTAC he released 'Zombie'.

* The first had been held in Dakar, Senegal, in 1966.

'Zombie', Fela explained to journalist Vivien Goldman, was 'against the kind of mind that takes orders without thinking'. During the mid-1970s, the Nigerian army had an appalling reputation, dogged by scandals involving beatings and ransackings. To nettle them in a song was either extraordinarily brave or extraordinarily stupid. Although the prolific Fela issued a stream of songs attacking religion, government, the police and the colonial mentality, none had the seditious punch of 'Zombie'. Instead of earnestly denouncing soldiers, Fela dances around them, poking fun, each blurting trumpet line or darting chant representing another knock to their macho pride. 'Zombie no go think,' Fela sings, 'unless you tell am to think.' He picks up speed, spoofing the staccato ritual of the parade-ground drill: 'Fall in! Fall out! Fall down!' And then he laughs. The song's sheer reckless jubilance is jawdropping. Mischievous boys would sing it to taunt nearby soldiers, marching sarcastically with sticks under their arms instead of rifles.

'We had to get permission from the government to release that album,' Allen says solemnly, 'but it still caused a problem at the end of the day.'

*

Not far from the Kalakuta Republic stood the Abalti barracks, and on 12 February 1977, shortly after FESTAC's closing ceremony, a group of Kalakuta residents clashed with Abalti soldiers in the street. Six days later a young member of Fela's entourage was beaten up over a traffic offence and his battered body was carried back to the compound. A group of soldiers came to the door and demanded the boy. Fela refused. 'You can come with bazookas, rifles and bombs if you want,' he said defiantly. And so they did.

A little while later Fela looked out from his balcony and saw around a thousand troops surrounding Kalakuta, holding up signs urging local residents to evacuate, at which point events moved with horrifying speed. The soldiers set fire to Fela's fleet

of cars and the generator which powered the Republic's electrified fence, then tore through the barbed-wire and rampaged through the compound.

Many of the women were raped, some with gun barrels and bottlenecks, and dragged, naked, off to the barracks. Some of the men had their testicles smashed. Fela's brother Beko, who ran the Republic's free medical clinic, was beaten so fiercely that he was confined to a wheelchair for months afterwards. His mother, the seventy-eight-year-old Funmilayo, was tossed off a balcony, breaking her hip. Fela himself was cornered and assaulted. 'Oh man, I could *hear* my own bones being broken by the blows!' After two hours of violence, the soldiers set fire to the compound, destroying not just the house but the clinic and recording studio, and with it the tapes to the *Black President* soundtrack. When firefighters and newspapermen rushed to the blaze, the soldiers attacked them too, and proceeded to loot and brutalise the surrounding neighbourhood. All of Kalakuta's sixty residents at the time ended up in either jail or hospital. Tony Allen, who was due to visit the Republic that day, arrived to witness the aftermath. 'I saw a disaster,' he says. 'Everybody had been arrested and taken away already and the police said it was a no-go zone. Fire brigade come and axed down the ceiling so there was no more ceiling. It was burnt from down to top. All of his vehicles. The generator. Everything. And that was it. You can't replace it again. It's done.'

Although there is no firm evidence that the government ordered the sack of Kalakuta, it was quick to whitewash the affair. In April an official inquiry pinned all the blame on an 'exasperated and unknown soldier' (hence Fela's caustically titled 1979 song 'Unknown Soldier') while criticising Fela's declaration of independence and briefly banning Afrika 70 from public performance. Even when the ban was overturned, where could they play? The Shrine had been shut down and other Lagos venues were too intimidated to book the group. In the autumn, Fela led his impoverished, demoralised band into exile in Ghana.

This was not, however, the proud, progressive Ghana of old. Kwame Nkrumah, the Ransome-Kutis' family friend, had been ousted by a CIA-backed military coup in 1966. By the time of Fela's journey to Ghana, the country had experienced four more heads of state and yet another coup. Just as in Nigeria, students, dissidents and the working classes treated Fela as a hero, directing 'Zombie' at their own corrupt military leader, General Ignatius Acheampong. Just as in Nigeria, state forces looked for an excuse to get rid of him. One Afrika 70 member quarrelled with a local merchant; others were busted for possessing marijuana. That would prove to be enough.

Fela returned to Nigeria several times to prepare a multi-million-dollar lawsuit against the government. With typical flamboyance, he marked the first anniversary of the Kalakuta attack by marrying twenty-seven female members of his entourage in a Lagos hotel, with a promise to acquire yet more wives in future. 'I've rarely been happy in my life,' he told Moore. 'But marrying my 27 women made me feel happy. The few times I've felt happiness, it's always been followed by something terrible. This time was no exception.'

When Afrika 70 flew back to Ghana, they were turned back at the airport. Upon his return to Lagos, another insult: Fela's lawsuit had been dismissed. Two months later Funmilayo died, having never recovered from the shock of the Kalakuta raid. When she was buried in Abeokuta, 50,000 mourners paraded through the blazing heat to pay their respects. The 1974 drug bust had radicalised Fela; the demolition of his Republic had shaken him; now the death of his mother made him reckless. 'Seeing my mother die has made death very unimportant to me now,' he told the *Sunday Punch*. 'I swore on the day I first saw her dying that I would put my struggles into top gear.'

Fela's post-Kalakuta material became increasingly venomous. Some songs were so controversial that Decca refused to release them and the government confiscated the master tapes. Only after a seven-week occupation of Decca's offices by Afrika

70, and a court case, did Fela get his songs back. The songs he clawed back, 'Sorrow, Tears and Blood' (1977) and 'Shuffering and Shmiling' (1978), were bleak, angry works. 'We know every time when the lyrics come we should be expecting trouble but we don't tell him don't do it,' says Allen. 'Why should anybody try to? He is a writer and nobody should tell him what to write. And nobody would have the guts!'

Although the soldiers who brutalised and burned the Kalakuta Republic didn't break Fela's spirit they succeeded in extinguishing a vital spark of humour and optimism, qualities which had helped to hold Afrika 70 together. In October 1978 the band headlined the Berlin Jazz Festival, a show which turned out to be their last. For years Fela's musicians had enjoyed more kudos than financial reward and his decision to use the proceeds from the Berlin date to fund his political ambitions rather than pay his band was the last straw. 'I managed to be inside everything – all of the shit of the government – up to this moment,' says Allen. 'Am I supposed to be repeating what he's saying again? No. He has done enough, he has said enough. If that was going to change anything, things would have been changed.'

Allen resigned from Afrika 70 and most of the band followed suit; weary of harassment, many of Fela's wives left him over the coming months. The society Fela had constructed around himself in his pomp was not built to weather such hard times. While Afrika 70 was falling apart in Berlin, back in Lagos government bulldozers symbolically levelled the remains of Kalakuta. Hundreds of fans stood and watched in the heavy rain, chanting, 'Ka-la-ku-ta, Going! Going! Gone!'

*

Around the time of 'Zombie', it had seemed that Fela was capable of anything. Now he discovered his limitations, starting with his presidential ambitions. Of the fifty upstart political parties that applied to contest the 1979 election only five were officially approved; Fela's Movement of the People was not among them.

The country was nauseous with corruption scandals, massacres and the suppression of political dissidents. On 30 September, the day before Obasanjo handed over power to the civilian government, Fela made the most powerful statement he could, depositing a life-size replica of his mother's coffin outside the general's official residence, an incident later documented in 'Coffin for Head of State'.

So Fela did not become president. Nor did he become a Third World superstar like Bob Marley, who began espousing pan-Africanism himself on 1979's 'Zimbabwe' and 'Africa Unite'.* While Marley tailored his sound for cross-border appeal, Fela's compositions became longer, more didactic and more densely enmeshed in Nigerian politics, and the mercurial line-up of his new band, Egypt 80, never boasted a musician on a par with Allen. Despite some initial success in Europe, he was eclipsed as Nigeria's first breakthrough star by King Sunny Ade.

Back home, Fela lacked the funds to release many records himself and did a spectacular job of alienating the big two labels. His ongoing feud with Decca boss Chief Abiola, whom he savaged in 1979's 'I.T.T. (International Thief Thief)', reached a nadir when his men delivered several buckets of human excrement to Abiola's mansion and smeared the contents over the walls.† At any rate, the Nigerian music industry was brought to its knees by the collapse of oil prices, and therefore the economy. Spiralling street crime left most people too scared to attend his new Shrine and he was seriously beaten by the police in 1981, displaying his

* 'Zimbabwe' celebrated the liberation struggle in the nation then still known as Rhodesia. The country's own Thomas Mapfumo was imprisoned in 1978 for singing *chimurenga* (meaning 'second war of liberation') songs in support of Robert Mugabe's Zimbabwe African National Union, and released on the condition he played a rally for establishment candidate Bishop Abel Muzorewa, a compromise which almost destroyed his reputation.
† I.T.T. (International Telephone & Telegraph), the corporation which employed Abiola, had also been involved in funding anti-Allende plotters in Chile.

injuries on the sleeve of that year's *Original Sufferhead* album.

He became increasingly drawn to mysticism, often accompanied by a Ghanaian magician called Doctor Hindu, and prone to bizarre pronouncements. In Carlos Moore's 1982 book of interviews, *Fela, Fela: This Bitch of a Life*, Fela explained how 'technology, industrialisation will cause the downfall of white nations' and how homosexuality was a psychological illness brought about by environmental pollution and artificial food additives. He claimed to have been visited by his mother's spirit and talked about joining her: 'I say to myself: "How can I cancel my existence?" Cause I don't want to be any more. You understand? I think about that one a lot.'*

Fela was in the same situation that Phil Ochs had faced. Constitutionally incapable of putting politics to one side, he raged like a wounded bull as the country rotted around him: scandals, riots, strikes, debt, inflation and unemployment, until after four years of civilian rule the army mounted another coup. How could he not be angry? But how could his listeners not grow tired of hearing his anger? One disenchanted fan, Niyi Odutola, wrote to the *Punch* newspaper in 1982: 'He says his music is not for pleasure but [no] one wants a political or ideological lecture for the price of a long-playing record . . . Confrontation is no music.' Perhaps, but confrontation was the only music Fela now knew. 'With my music I create a change,' he told Carlos Moore, even as the only change in Nigeria was for the worse. 'I see it. So really I am using music as a weapon. I play music as a weapon.'

* He would eventually die from AIDS-related Kaposi's sarcoma in 1997.

15

'Babylon burning, red hot, red hot'

Max Romeo and the Upsetters, 'War Ina Babylon', 1976

Reggae's state of emergency

Max Romeo and the Upsetters, *War Ina Babylon* (Island LP, 1976).

In 1972 Jamaica experienced its first reggae election. In the ten years since independence, the ruling right-wing Jamaica Labour Party (JLP) had alienated a huge swathe of radicals, students, Rastafarians and the poor, all of whom were thirsty for change. Michael Manley, the former trade unionist who led the left-leaning People's National Party (PNP), recognised the importance of reggae in voicing this vital constituency's hopes and frustrations. Six months before polling day he launched his Musical Bandwagon, a flatbed truck which toured the country hosting performances by such rising stars as Bob Marley, Alton Ellis and Dennis Brown. His righteous image was bolstered by his Rod of Correction, a staff gifted to him by Ethiopia's emperor, Haile Selassie, the man from whose coronation the whole Rastafarian religion flowed.

Many saw the election in biblical terms. Manley compared himself to Moses's successor Joshua, who brought down the walls of Jericho and conquered Canaan for the Israelites. Prime Minister Hugh Shearer was characterised, in two songs by devout Rasta Junior Byles, as 'King of Babylon' and 'Pharaoh Hiding'. Manley's election slogans combined Rasta prophecy ('Better Must Come', the name of a 1971 Delroy Wilson hit), Black Power zeal ('Power to the People') and even quasi-hippie uplift ('It's Time for a Government of Love'). Clancy Eccles blatantly hitched his wagon to Manley's with his songs 'Power to the People' and 'Rod of Correction', and would be rewarded with a post as government adviser on music-industry issues. The PNP also approached rising star Max Romeo for permission to use his song 'Let the Power Fall': 'How long will the wicked reign?' 'It wasn't intended to be a slogan song,' says Romeo, 'but Michael Manley heard it and thought it would be a good slogan for the party and I said yeah, go ahead. He was a good man. There was a lot of suffering in Jamaica and he was aware of it.'

But when Manley went to the voters again four years later, there was no Rod of Correction, no Bandwagon, no lofty comparisons with Joshua. The rancorous struggle between the PNP and JLP spilled over into street battles between armed gangs, with scores of casualties, and Romeo was now reporting 'War Ina Babylon'. By the 1980 election, which Manley lost, Jamaica was a basket case.

The fortunes of roots reggae mirrored those of Manley's government: a burst of optimism, a phase of fiery drama, then a grim, exhausted battle for survival. At its high-stakes peak, however, reggae wasn't just the most creatively and commercially vital form of protest music in the world; it fully introduced the paranoid style to political songwriting. There was already an eschatological strand in protest songs ('Eve of Destruction', 'Ball of Confusion') but it took reggae, grounded in the arcane cosmology of Rastafari, gravid with symbols and portents, to establish a richly persuasive vocabulary of apocalypse, both thrilling and terrifying, which would go on to inform the catastrophists of punk and hip-hop.

The prophets of doom weren't strictly paranoid – things really *were* pretty terrible – but their rhetoric fits the mindset described by US academic Richard Hofstadter in his 1964 essay, 'The Paranoid Style in American Politics': 'The paranoid spokesman sees the fate of conspiracy in apocalyptic terms . . . He is always manning the barricades of civilization. He constantly lives at a turning point: it is now or never in organizing resistance to conspiracy. Time is forever running out.'

*

The reggae singer Jimmy Cliff once described Caribbean music as 'the ghetto's newspaper'. Both Jamaican mento and Trinidadian calypso were built for telling topical stories of island life. So when Jamaica, under the leadership of Alexander Bustamente, declared independence in 1962, the burgeoning record industry was quick to provide the soundtrack with singles such as Al T.

Joe's 'Rise Jamaica (Independence Time Is Here)' and Kentrick Patrick's 'Independent Jamaica'. Edward Seaga, Bustamente's minister of development and welfare, and a record producer himself, encouraged the growth of ska, a new genre which combined mento rhythms with American R&B, as part of his programme of cultural nationalism; he called it Jamaica's finest export 'since rum and bananas'. What Seaga and the rest of the ruling elite did not want to see, however, was the growing prominence of Rastafarianism.

Rastafarianism was born in 1930, when Ethiopia's thirty-eight-year-old regent, Ras (prince) Tafari Makonnen, was crowned emperor Haile Selassie I, King of Kings, Conquering Lion of Judah and the Elect of God. The coronation was an international sensation, making the cover of *Time*, but had particular resonance in Jamaica, where it seemed like a prophecy fulfilled. For the previous decade or so Jamaican-born, Harlem-based Marcus Garvey had preached black nationalism and the virtues of wide-scale repatriation to Africa, establishing his own short-lived Black Star Line for that purpose. After serving two years in jail for mail fraud, Garvey was deported to Jamaica in 1927, where he told his followers: 'Look to Africa when a black king shall be crowned, for the day of deliverance is near.'

Rastafarianism was not a conventional religion – no churches, no official hierarchy, no rulebook – but its central narrative was powerfully appealing to people chafing at the bonds of colonial rule. In Rasta cosmology, believers are the children of Israel, captive in Babylon (Western society), waiting for Jah (the living god Selassie) to lead them home to Zion (Ethiopia). Rasta was a rebel creed, racially militant, dismissive of authority, spiritually allied to African independence movements and therefore deeply worrying to Jamaica's British rulers, who harassed and persecuted its leaders: in 1954 the rural Rasta commune of Pinnacle was trashed by government forces, causing many Rastas to relocate to Kingston.

Rasta customs developed over time. In the 1950s some Rastas

began growing warrior-like dreadlocks, deeming scissors and combs Babylonian. Because the body was itself regarded as a church, diet was meant to be natural, or *ital*, which meant no alcohol, caffeine, salt, pork or artificial additives. Birth control was considered a sinister plot against nature. Believers discussed theology and day-to-day issues in weekly reasoning sessions, helped along by the sacramental smoking of marijuana, and African-influenced chanting and drumming. Language, too, was bent to suit Rasta beliefs. *I* became the crucial letter, a sign of the interconnectedness of all Rastas, hence the all-inclusive first-person pronoun 'I-and-I'. Based more on intuition than etymology, syllables were replaced for being unlucky ('dedicate' became 'liv-i-cate') or misleading ('oppression' became 'down-pression'). Terrible puns were rife: believers disdained the 'politricks' of the 'shitstem'. Rastafari's linguistic plasticity and vivid theology would prove a gift to reggae, a form at once musically accessible and lyrically esoteric. While early Jamaican rebel songs, like Clancy Eccles's pre-independence 'River Jordan' and 'Freedom', were rooted in the Pentecostal church, Rastas marked independence with Winston and Roy's chant 'Babylon Gone', backed by celebrated Rasta drummer Count Ossie.

Jamaicans soon learned, however, that Babylon was very much still in place. The independent nation's three biggest industries – tourism, factory-farming and the mining of bauxite, an ore used in the manufacture of aluminium – were largely owned by US companies, ensuring that most of the money flowing into the country flowed right back out again. Soon one in four Jamaicans was out of work, putting huge strain on the welfare budget. The US, keen not to see Jamaica go the way of Cuba, channelled guns to the JLP and the street gangs that they employed as political militias, leading the PNP to arm its own gunmen. And one unfortunate by-product of foreign tourism was soaring demand for marijuana, making the drug trade one of the island's few boom industries. Small wonder that many jobless young men decided the only way to claw back some pride was to get some

firearms themselves. As the brisk ebullience of ska gave way to the slow swagger of rocksteady, the rude boy era was afoot. At first the surly rude boys posed as Robin Hood figures, defending the dispossessed urban poor, hence celebratory records like the Pioneers' 'Rudies Are the Greatest', but it quickly became a dog-eat-dog situation in which the poor suffered most of all: in fact, they were known as *sufferahs*.

The Valentines' 'Blam Blam Fever' (1967) wailed: 'Every time you read the *Gleaner* or *Star* [Jamaica's two national dailies] / It's man shot dead or rude boy at war.' On the satirical 'Judge Dread' (1967), Nation of Islam convert Prince Buster played a no-nonsense magistrate handing down 400-year sentences to out-of-control rudies. 'Because the sound man has a big standing in the community, if they come out in public against the rude boys it give the decent people something to hold on to,' Buster told reggae historian Lloyd Bradley. What brought the rude boy era to a close, however, was the growth of Rastafari as an alternative movement for angry young Jamaicans.

Haile Selassie's first and only state visit to Jamaica, in April 1966, gave the religion an incalculable boost. At the same time the ideas of Malcolm X and Black Power found an enthusiastic audience, despite an official ban on most of the key texts. Even as the JLP attempted to pander to black nationalism – in 1964, it brought Marcus Garvey's body home to Jamaica for burial – it cracked down hard on the dissident variety. A young university lecturer called Walter Rodney undergirded Rasta mysticism with class-conscious black nationalism so persuasively that the minister for home affairs blocked him from returning to Jamaica after a lecture tour in 1968, triggering fierce protests from the campuses to the ghettos.

The official response to Jamaica's post-independence tribulations was silence: unemployment and class resentment were getting so bad that the PNP and JLP agreed not to exploit these issues in the 1968 election for fear of exacerbating popular unrest. Meanwhile, Jamaica's famously fickle record-buyers

were in the mood for another stylistic change. Just as ska had succumbed to the slower, smoother sound of rocksteady, rocksteady was giving way to reggae, and a crop of tiny independent studios provided ample outlets for voices that were too challenging and unorthodox for the big operations. The time was ripe for bona fide *sufferah* music.

<p style="text-align:center">*</p>

In the tradition of the 'ghetto's newspaper', reggae concerned itself with what was already happening, but it also emphasised what was *about* to happen. No other form of protest music spent so much time anticipating disaster. 'One day the bottom must drop out,' predicted the Ethiopians on 'Everything Crash' (1968). 'When it drops, oh you gonna feel it,' warned Toots and the Maytals on the same year's 'Pressure Drop'.

Neither band could have been accused of undue pessimism. Jamaica's post-independence economy was built on sand. Heavy reliance on foreign imports made the country vulnerable to inflation the minute exchange rates went south. Unemployment ballooned, putting intolerable pressure on the welfare system. What money there was coming in went to the elite, while the *sufferahs* got poorer, angrier and increasingly susceptible to Rasta's rebel gospel. This gospel would be conveyed in the most riveting way imaginable by the two titans of 1970s reggae: Bob Marley and Lee 'Scratch' Perry.

Although Lee Perry has, on occasion, claimed to hail from Jupiter, he was in fact born in the rural Jamaican town of Kendal some time in the mid-1930s. He moved to Kingston in around 1960 and served his musical apprenticeship at Coxsone Dodd's Studio One, where he first met Bob Marley and the Wailers, before going his own way in 1966, later assuming the Upsetter alias.* His breakthrough single, 'People Funny Boy' (1968), was a complaint about being underpaid by Joe Gibbs, his studio boss

* One job at the studio was with Prince Buster: Perry voiced one of the defendants on 'Judge Dread'.

at the time, illustrated with an urgent, African-influenced beat and the kind of production flourish that would define his work: a crying baby from a sound-effects record.* Some call it the first reggae record.

Like Perry, Bob Marley was a country boy, from the village of Nine Miles. With his friends Peter Tosh and Bunny Wailer, he had formed the Wailers and signed up with Coxsone Dodd. Their first hit, 'Simmer Down' (1963), was a tough riposte to the rude boys who loitered around Studio One, although police harassment pushed them into recording pro-rudie songs like 'Rude Boy' (1965). 'Them shouldn't have said "rude boy", them should have said "Rasta",' he said years later. 'You dig me? But in them times, me didn't know Rasta.'

Marley then spent a frustrating year or so working menial jobs in the US. Upon his return to Jamaica and the music industry, he became interested in Rastafari via his wife Rita and pioneering Rasta philosopher Mortimo Planno, and in black nationalism via his new manager Danny Sims, an American who had been a booking agent for Malcolm X, Curtis Mayfield and Sam Cooke. For his James Brown-quoting 'Black Progress' (1970), he wanted to use Lee Perry's house band, the Upsetters and thus reconnected with the producer.

When Marley came calling, Perry was quite happy making lucrative instrumentals such as the Upsetters' spaghetti western-inspired hit 'Return of Django', and had no burning desire to work with another singer, but he saw that Marley needed direction. They started working on new material that Perry described as 'revolutionary soul', and the producer encouraged Marley to bring back his old Wailers bandmates. Marley would never again sound as fresh and raw as he did on Upsetter recordings such as 'Duppy Conqueror' and '400 Years'. '*This* is how reggae should sound!' Perry exclaimed during the sessions. Marley's self-produced 'Trenchtown Rock' was Jamaica's number one

* The B-side, a cover of 'Blowin' in the Wind', was similarly enlivened by a somewhat literal windstorm.

321

single for a spectacular five months in 1971, but Perry and the Wailers soon fell out for uncertain reasons, most likely money-related. After the Wailers' acrimonious exodus, the producer scouted for other politically outspoken singers, one of whom was Max Romeo.

I meet Romeo backstage after one of his occasional London shows where, like so many once-radical black artists, he had attracted an audience consisting overwhelmingly of white middle-class liberals. Beneath a fountain of greying dreads, his face is benevolent and quick to smile. He describes how he was raised in a repressive evangelical Christian household and ran away from home at the age of fourteen. In the 1960s he sang with the Emotions and then the Hippy Boys, who became the Upsetters. Romeo enjoyed a massive hit with the lubricious 'Wet Dream' (1970), but quickly disavowed sexual lyrics when he became a father and converted to Rastafarianism. With Perry he recorded two direct attacks on the JLP regime: 'Ginalship' (i.e. 'crooked-ness') and 'Labor Wrong'. When Manley heard 'Let the Power Fall', Romeo became one of the stars of the Bandwagon.

Another committed Rasta to join Perry's camp was Junior Byles. He found enormous success with 'Beat Down Babylon' (1971), a passionate Rasta screed punctuated by a cracking whip. 'A Place Called Africa' (1972) was a keening hymn to the motherland in the form of a dialogue with his mother, who explains to her son the history of slavery. The Abyssinians' inde-pendently released 'Satta Massagana' (1971) also pined for 'a land far, far away' and went one better with lyrics partly sung in Amharic, a Semitic language spoken in Ethiopia.

'Satta Massagana' had in fact been recorded at Studio One two years earlier but canned for being uncommercial. During reggae's first few years the artists were invariably more radical then the big studio bosses. 'A lot of people were surprised when, with the voice I have, I wanted to start singing the protest songs,' angelic-sounding Horace Andy told Lloyd Bradley. 'They used to say "What a waste of a voice."' Hits such as Desmond Dekker's

'Israelites' (1968) lamented poverty in personal rather than political terms, and many protest songs were cover versions of US records: David Isaacs did Stevie Wonder's 'A Place in the Sun' (1968); Prince Buster and Toots and the Maytals both sang 'Give Peace a Chance' (1970). But Niney the Observer portended the apocalyptic style to come with 'Blood and Fire' (1970): 'Let it burn, burn, burn.'

Just as Jamaica was preparing for political change, reggae took a giant step into the international arena with the release of the crime movie *The Harder They Come* and its fast-selling soundtrack, which included its lead actor Jimmy Cliff ('Many Rivers to Cross'), the Melodians ('Rivers of Babylon') and the Maytals ('Pressure Drop'). As if to yoke himself to the movie's success, Michael Manley married one of its actresses, Beverly Anderson, the same year. The JLP regime banned overt Rasta songs from the radio, but could not stop them reaching the people via Kingston's countless street-corner sound systems. With the new reggae generation on his side, Manley's populist platform appealed to a coalition of Rastas, communists, Garveyites, urban youth and *sufferahs*, who swept him to a landslide victory. Now it was time for Joshua to live up to his own hype.

*

It only took a few months for Manley's reggae constituency to express its frustration with the slow pace of change. With the PNP's own election slogan in mind, Junior Byles asked, 'When Will Better Come', while Max Romeo cried, 'No Joshua No'. 'The people started questioning me in the street because I was very instrumental in the Bandwagon show,' says Romeo. 'So people started asking me what happened: "Hey, you say you wanted us to vote PNP. Now we've voted PNP and there's nothing happening." So I did the song "No Joshua No". He summoned me to Jamaica House and said he had a cut of that song three times on one cassette playing in his car and that's what inspired him to do all the social programmes that he brought in.'

Romeo may be overstating his role a touch but it's true that Manley was struggling to fulfil impossibly high expectations. Manley increased spending on public services, housing, literacy programmes and basic infrastructure, but there simply wasn't enough in the coffers to sustain this level of investment. His attempts to raise funds by hitting the rich backfired horribly. Tax rises, a much-needed minimum wage and the renationalisation of several industries alienated entrepreneurs, many of whom emigrated. A levy on bauxite mining made the mineral so expensive that foreign aluminium companies simply looked for alternative sources. Meanwhile, his enthusiastic courtship of Castro's Cuba and Angola's MPLA angered the US, who cut back on aid and investment and encouraged tourists to avoid the island. All of this would have been bad enough even without the 1973 oil shock and consequent worldwide recession. By March 1976, Jamaica's national debt was so vast that international commercial banks had stopped lending to the country altogether. Leo Graham's 'News Flash' (1973) updated 'Everything Crash' from prophecy to statement of fact: 'Everything crash, don't you hear the news flash?'*

Lee Perry's new base was a backyard studio called the Black Ark. His productions ventured further into the ghostly canyons of dub reggae, which translated Rasta mysticism into equally cryptic instrumental remixes, shrouded in echo and distortion, riddled with strange, unplaceable sounds. 'When the people hear what I-man do, them hear a different beat, a slower beat, a waxy beat – like you stepping in glue,' Perry once explained. 'They

* Perry adapted 'News Flash' into 'Station Underground News', into which he dropped a sample of the Chi-Lites' '(For God's Sake) Give More Power to the People', a song he liked so much that he proceeded to cover it under the title 'Justice to the People'. The message of Black Power-era soul songs had obvious currency in Jamaica, and there were persuasive versions of 'Message From a Black Man' (the Heptones) and 'Am I Black Enough For You?' (the Chosen Few).

hear a different bass, a rebel bass, coming at you like sticking a gun.' 'He was a guy who makes sound out of anything,' says Romeo. 'He'll fill three glasses of water – one quarter, one half and one full. And then he'll hit it with a spoon, you get a different sound. He'll find a stone with a particular sound and hit it with a fork and that's percussion.'

At the Black Ark and studios all over Kingston, roots reggae voiced increasingly militant sentiments. On *Revelation Time*, Max Romeo deplored police brutality and prison conditions and, somewhat bloodcurdlingly, warned the elite that 'heads a go roll down Sandy Gully one of these days'. Tappa Zukie's 'M.P.L.A.' and Pablo Moses's 'We Should Be in Angola' urged Rastas to join Cuban troops in southern Africa. Fred Locks prepared for repatriation, Garvey-style, on 'Black Star Liner'. Burning Spear, who took his stage name from Kenyan president Jomo Kenyatta, conceived his roots masterpiece *Marcus Garvey* with an explicitly educational agenda. 'Marcus Garvey is from the town where I-man is from,' he told reggae historian David Katz. 'There were elderly people who knew a lot about Marcus Garvey, but not so much of the young people.'

Marcus Garvey did well abroad, but nobody could match the international profile of Bob Marley, who to many foreign listeners simply *was* reggae. Island Records founder Chris Blackwell cannily remixed (you might say sanitised) the Wailers' *Catch a Fire* (1973) for non-Jamaican ears and encased initial copies in an eye-catching and expensive sleeve based on a Zippo lighter. The reggae cognoscenti were unimpressed. 'There is really no dread in Marley's music,' complained Linton Kwesi Johnson, the London-based Jamaican poet and critic. 'The dread has been replaced by the howling rock guitar and the funky rhythm.'

But mainstream critics sensed crossover potential. Robert Christgau later described the sound as 'a rough spiritual analogue to the Rolling Stones, with social realism their welcome replacement for arty cynicism'. It was quickly followed by *Burnin'* (1973) (after which Tosh and Wailer, annoyed by the

emphasis on Marley, left the band), *Natty Dread* (1974), and *Rastaman Vibration* (1976). Re-recorded Perry collaborations such as 'Duppy Conqueror' were outshone by powerful new rebel songs: 'Get Up, Stand Up', 'I Shot the Sheriff', 'Burnin' and Lootin''. His version of Rasta revolt fell easily on Western ears, and journalists lapped up his gnomic pronouncements. He seemed to be privy to some great truth, even if what that truth might be remained shrouded. In the close-knit world of the Kingston reggae industry, however, his music had negligible influence and his sudden elevation to superstardom was met with some ambivalence. 'He was on the other side of the fence,' Romeo says dismissively. 'No communication. He was a big pop star now so he wasn't as accessible as he used to be. He was on a different vibe to the rest of us.'

Marley's self-confidence was indomitable. When Haile Selassie died on 27 August 1975, some Rastas were thrown into spiritual turmoil. If Selassie was a living god, how could he die? Junior Byles was so distraught that he attempted suicide and spent several years in Bellevue mental hospital. Marley, however, headed straight into the studio with Perry to record the defiant 'Jah Live'. When a reporter asked him about the song, which was an instant hit, Marley replied solemnly, 'Yuh cyan't kill God.'

*

During Michael Manley's first election campaign, Jamaicans had dared to hope for a better future. By the time of his second, they simply prayed things wouldn't get any worse. Max Romeo's 'War Ina Babylon' described the horrendous violence that convulsed the island throughout 1976: 'I-man satta at the mountain top / Watching Babylon burning red hot, red hot.'

For the past few years Kingston street gangs had aligned themselves with the rival parties. Now, with an election looming, all-out political warfare broke out. Party logos became gang colours, their symbolism even extending to brands of beer: JLP supporters drank Red Stripe while PNP partisans favoured

green-bottled Heineken. Polarisation was mirrored on an official level, with the police generally backing Edward Seaga's JLP, and the Jamaican Defence Force loyal to Manley. Predictably, ordinary non-aligned Jamaicans were caught in the crossfire as gangsters and lawmen ran rampant. In June the government declared a state of emergency. By the end of the year, over two hundred people had died in political violence.

Some reggae singers responded to this horror on a socio-political level. The title of John Holt's 'Up Park Camp', for example, referred to the Jamaican Defence Force's notorious barracks. On 'Heavy Manners', self-styled 'Voice of Thunder' Prince Far-I sounded like he was reporting from the front line, with Dopplering sirens among the ominous, dub-style sound effects. On the mellifluous 'Mr Cop', Gregory Isaacs simply asked the police not to bust him for smoking weed, reasoning, 'It's better than in the streets busting gun.' Junior Murvin, who consciously echoed Curtis Mayfield's melancholy falsetto, complained that 'all the peacemakers turn war officers' on the irresistible Lee Perry production 'Police and Thieves'.

But others looked to their Bibles and saw the bedlam in a distinctly millenarian light. Joseph Hill of the trio Culture claimed to have had a vision of 1977 as a year of judgement, as predicted by Marcus Garvey, and wrote the dread, in every sense of the word, 'Two Sevens Clash': 'When the two sevens clash, it bitter, bitter, bitter.' 'When they see their back is going up against the wall, that was the time we reminded them to remember what Marcus Garvey say,' explained Hill. 'That was the time they start getting awake.'

The magic formulation 'Marcus Garvey prophesy . . .' was one key trope in reggae that year. Another was the increasingly fateful word *time*. The Heptones warned, 'Time is slipping away' on 'Sufferer's Time'. The Meditations compared the country to earth before the biblical deluge in 'Running from Jamaica', urging listeners to 'pick your place for now before it's too late'. The Maytals declared 'today is judgment day' on the *sufferah* anthem

'Time Tough'. The Mighty Diamonds urged Rastas to stand firm during the conflagration on 'Right Time'. The Professionals called their 1976 album *State of Emergency*.

Pulling all these threads together – the socio-political, the Garveyite and the apocalyptic – was Max Romeo's 'War Ina Babylon'. There is some uncertainty about its origins, with Perry once claiming that he wrote it for Marley, but Romeo describes it this way: 'I always remember it. I was at the studio and Lee did this rhythm. So I start writing the lyrics, "War ina Babylon, it's wicked out there." And Lee Perry says, "No don't say wicked, say 'sipple' out there." "Sipple" means "slippery". And we put it together there and then.'

The singer Clinton Fearon told David Katz that he was the source of Perry's brainwave. He had been on the bus on his way to the studio, slipping and sliding off the uncomfortable seats while a squabble took place further down the vehicle, when the woman next to him tutted, 'Everything sipple this morning.' Whatever the inspiration, sipple was an ingenious substitution. Instead of judging the situation as 'wicked', Romeo was stating a truth nobody could deny: things were getting slippery (the song was originally released as 'Sipple Out Deh'). And the music itself seemed slithery rather than wicked. Whereas punk rock decided that violent subject matter demanded violent modes of expression, 'War Ina Babylon', like most crisis reggae, is uncannily mellifluous, glazed with the honeyed harmonies of Heptones Barry Llewellyn and Earl Morgan.

The *War Ina Babylon* album was a masterpiece. 'Uptown Babies Don't Cry' was a poignant take on the wealth gap, the infectious 'Chase the Devil' promised to fire Satan into outer space 'to find another race', and 'One Step Forward' scolded Manley for straying from the righteous path. 'I said, "Wait we're taking one step forward and two steps backward because you don't know whether to suit Uncle Sam or to suit the people,"' Romeo told Katz. Although most of the album's profits went to Perry – after his initial $2,500 fee, Romeo never received

a cent in royalties – the singer no longer bears a grudge. 'He was a genius,' he says, laughing. 'You go into the studio with a bunch of lyrics and he look at it and say, "Change that word. Use that word instead." And overnight he do the rhythm. I love Lee Perry.' *War Ina Babylon* was a considerable hit, capturing the mood of the nation. 'We were calling people's awareness to the ills and thrills of the time,' says Romeo. And on the night of 3 December Jamaica's election-year bloodshed almost claimed a celebrity scalp.

In October the Ministry of Culture had approached the Wailers to play a benefit show, called Smile Jamaica. It was scheduled for 5 December, but the government put Marley in an invidious position by announcing the election for ten days later, thus turning the benefit into a de facto rally and enraging the JLP. The Wailers' base at 56 Hope Road began receiving anonymous threats.

On the evening of the third, Chris Blackwell was en route to Hope Road when he stopped off at the Black Ark to watch Perry at work on some new tracks, including a demo for Marley about police harassment of Rastas, 'Dreadlocks in Moonlight'. After a few hours Blackwell left and Perry began work on a Junior Murvin track with Earl Morgan and Barry Llewellyn. They were midway through when a friend burst in with news from Hope Road: 'Them just shot Bob Marley.' Morgan told Katz: 'Me and Lee Perry and Barry drive up to UC [University College Hospital], look 'pon the man and say "Wha'ppen?" and him say, "Jah live." It was an experience.'

At the hospital they found out what had happened. Around nine o'clock, seven gunmen had broken into Hope Road and rampaged through the house, firing into room after room. One bullet hit Marley in the arm; another grazed his chest. It was rumoured that the gunmen had been sent by the JLP, perhaps to kill Marley, perhaps just to warn him; at any rate, over the coming months the assailants all turned up dead. Michael Manley himself visited the hospital and put the singer under armed

guard. Two days later Marley made a defiant appearance at Smile Jamaica, then fled the country, not to return for another year. His next album bore the apt title *Exodus*.

*

The problem with apocalyptic lyrics is that their prophecies are destined to go unfulfilled. The two sevens clashed – on 7 July, the day that *four* sevens clashed, streets, schools and offices were practically deserted and the Jamaica Defence Force (JDF) was on high alert – and judgement day did not come. Jamaica's problems continued to be depressingly prosaic. Manley was re-elected because he was the better of two evils, not because he seemed to have the answers. Despite his proud declaration that 'we are not for sale', his Emergency Production Plan to shore up the collapsing economy was deemed unworkable and he was forced to seek a loan from the International Monetary Fund. When Jamaica then failed its first test, the IMF imposed punitive measures, forcing massive cuts in public spending and wages. Unemployment continued to rise and food shortages became commonplace.

Meanwhile, political violence continued long past election day, as Leroy Smart's mournful 'Ballistic Affair' testified. Amid the mayhem, Lee Perry produced a trio of classic albums at the Black Ark that year: *Party Time* by the Heptones, *Police and Thieves* by Junior Murvin and *Heart of the Congos* by the Congos.* On the latter, Perry's production was as beautifully numinous as the Congos' scripture-heavy songs. But some artists seemed to have gone past the point of calling for calm. On 'Equal Rights', ex-Wailer Peter Tosh snapped, 'I don't want no peace / I need equal rights and justice,' and declared solidarity

* Murvin, who modelled his delivery on Curtis Mayfield, recorded Mayfield's classic 'People Get Ready' as 'Rasta Get Ready', and Bob Marley wove elements of the same song into 'One Love'. Mayfield's benign spirituality and distinctive falsetto made him Jamaica's favourite soul star; he had even co-produced a 1964 compilation, *The Real Jamaica Ska*.

with liberation armies in Angola and Rhodesia. On the cover to *Stand Up to Your Judgment*, the Mighty Diamonds were drawn wearing green fatigues and bandoliers and holding assault rifles.

Even Jamaicans accustomed to brutality, however, were shocked in January 1978 when a dozen gunmen from JLP strongholds were lured to the Green Bay firing range and ambushed by snipers from a covert wing of the JDF, leaving five dead. While these vicious thugs did not invite enormous sympathy, such a cold-blooded execution outraged the population, inspiring Tappa Zukie's 'Green Bay Murder'. Rumours of a military coup, or even civil war, began to sweep the island. Something had to be done. Rival gang leaders Bucky Marshall (PNP) and Claudie Massop (JLP) broke bread and announced a truce. Jacob Miller's 'The Peace Treaty Special' and Frankie Jones's 'The War Is Over' trumpeted the news on the sound systems, but there was only one performer who could sell the truce to the people of Jamaica.

Marshall and Massop separately visited Bob Marley abroad to persuade him to come home and headline another benefit show, One Love, which would raise money for the *sufferahs* of West Kingston and help heal the country's sectarian wounds. Marley touched down at Kingston airport on 26 February to the biggest welcoming party since Haile Selassie's visit twelve years earlier. One Love took place without incident on 22 April and Marley lived up to his statesmanlike stature when, during 'Jamming', he beckoned Manley and Seaga to the stage and convinced these bitter rivals to join hands in front of 30,000 astounded spectators. Marley, and reggae, would never again seem as powerful as they did in that one miraculous moment. After that, everything crashed.

Claudie Massop was executed by the police in 1979; Bucky Marshall was shot dead the following year. Violence during the 1980 election season was worse than ever, with firefights, raids and executions claiming almost 900 lives, over four times more than in 1976. Some attributed the increased ruthlessness to the gunmen's new appetite for cocaine, which was tearing through the ghettos like a firestorm.

Meanwhile, Lee Perry suffered an apparent meltdown. Drinking and smoking heavily, he covered the walls of the Black Ark in indecipherable script and built junk sculptures in his backyard. Old friends were alienated and new visitors turned away. His wife left him for another musician. Perry soured on Rastafari after falling out with the Congos and, according to Max Romeo, resorted to drastic measures to keep the dreads from his door, fastening rotting pork to the antenna of his car and a sign reading 'I am a batty man [homosexual]' on the back.

Perry has always denied this, and has since suggested that most of his strange behaviour was an elaborate ruse to stop people pestering him. If so, it was remarkably convincing. When Henry Targowski, who ran the Black Star Liner distribution company, visited Perry to discuss business in April 1979, he found a 'mad professor' babbling apparent nonsense in a decaying studio, while his cherished tape archive lay in ribbons on the floor, soaking in puddles of rainwater. 'I sensed a method in Scratch's madness,' Targowski later wrote. 'Somehow, Scratch created a feeling of conspiracy. He was weaving spells and forming a vast cosmology – and all of it was directed towards the accomplishment of some clandestine goal.'

Jamaica voted on 30 October 1980. With the PNP no longer able to guarantee law and order or food supplies, its support collapsed and Edward Seaga, who had campaigned under the slogan 'Deliverance is Near', won a crushing victory. Having risen with Manley, roots reggae went down with him too, partly because record-buyers demanded fresh sounds and partly because all those years of prophecy, complaint and calls to Jah had, it seemed, changed nothing. Day-to-day life was harder than it had ever been. Like fans of US soul five years earlier, reggae fans had grown weary of bad news and wanted a little musical escapism. Indeed, Marley's 1979 album had the same grimly stoical title as the O'Jays' 1975 release: *Survival*.

The roots reggae era came to a decisive close on 11 May 1981 when Bob Marley succumbed to cancer. In death, as in

life, he seemed to float above the rest of the reggae world, and even Jamaican politics. On 21 May, following a national day of mourning, a state funeral ceremony was held at the National Arena, with speeches from both Manley and Seaga. Afterwards, accompanied by an unofficial escort of thousands, his body was ferried to a hilltop mausoleum for burial.* One houseful of mourners at the bottom of the hill blasted Marley's music into the night: the final track on his final album, 'Redemption Song'. Significantly, it wasn't even reggae at all, but an old-fashioned folk protest song with a Rastafarian twist, and it would travel further than anything that came out of the Black Ark, because it was not constrained by style or context, and because it spoke of hope rather than apocalypse, and hope is always an easier sell in the long run. Marley's voice carried through the darkening air, bearing neither blood nor fire: 'Won't you help me sing these songs of freedom? / 'Cause all I ever have: redemption songs.'

* One of the priests at the funeral was Watts Prophet Amde Hamilton, by now a member of the Ethiopian Orthodox church, who performed his poem 'Wisdom and Knowledge' over Marley's coffin.

PART FOUR

1977–1987

PART FOUR

16

'Are you taking over or are you taking orders?'

The Clash, 'White Riot', 1977

The chaos of punk

Mick Jones, Joe Strummer and Paul Simonon of the Clash, backstage at the Rainbow Theatre in North London, reading a newspaper article about punk rock, 9 June 1977.

In August 1975 David Bowie conducted an infamous telephone interview with the *NME*. 'Over here,' he said from his current base in Los Angeles, 'it's bright young Americans, you know, the lilting phrase before the crashing crescendo. In England it's a dirge – the days are all grey over there.' As the singer rambled on about 'Philistine' culture and moral decline, interviewer Anthony O'Grady asked what the next step was. 'Dictatorship,' Bowie replied firmly. 'You probably hope I'm not right. But I am. My predictions are very accurate.'

Even allowing for the fact that Bowie was so icebound by cocaine that he would later be unable to remember much about the period at all, how must his home country have looked from a distance of eight time zones? The US and UK both suffered from declinism but the narratives were different. Shaken by Watergate, disillusioned Americans perceived their government as wily and treacherous, capable of complex Machiavellian plots to deceive the nation. By contrast, Britain's rulers seemed too feeble and incompetent to plan any such thing.

After thirty years, post-war consensus politics was under terminal strain. Conservative prime minister Edward Heath had been brought low during the oil crisis by the imposition of petrol rationing and a three-day working week, followed by a national miners' strike. Labour's Harold Wilson, returning to Number 10, was faced with a plunging pound and a quagmired economy, governing to a soundtrack of angry picket lines and IRA bombs. In April 1975 the *Wall Street Journal* concluded a gloatingly gloomy editorial with the words: 'Goodbye, Great Britain, it was nice knowing you.'

Fiction told a similar story. In J. G. Ballard's *High Rise* a modernist tower block became an exaggerated metaphor for Britain as power cuts led to class war, atavistic brutality and the emergence of rival demagogues. Street gangs ran riot in the brutalist dystopia

of Stanley Kubrick's film of Anthony Burgess's *A Clockwork Orange*. The new sci-fi comic 2000 AD was about to intro-duce the fascistic, post-apocalyptic lawman Judge Dredd. Doris Lessing's *The Summer Before the Dark* and Margaret Drabble's *The Ice Age* depicted a paralysed nation on the brink of some sinister metamorphosis. Bowie's drug-addled *führer* fantasies, unbeknown to him, echoed conversations in the drawing rooms of the elite, where excitable industrialists, newspaper columnists and military men spoke approvingly of Pinochet's example and talked of a coup to save Britain from the Marxist menace.

'People [forget] what genuine flux the society was in,' says the former punk-era musician Tom Robinson. 'We were thinking so short-term. It really felt like, "The end of the world is nigh – who knows what's going to happen?" All the old certainties were being shaken.'

*

When I interviewed a dozen or so punk veterans to mark the thirtieth anniversary of 1977, the scene's turbulent breakthrough year, I asked them what punk was opposed to. Some offered 'long hair' and 'guitar solos', but nobody mentioned police har-assment or unemployment. Whereas 1960s musicians tend retro-spectively to overstate their rebellious intent, punks are more inclined to play it down, as if politics were some pretentious dis-traction from the real business of music. Indeed, the Clash's Joe Strummer, who died in 2002, was the only member of punk's first wave who was happy to call his compositions 'protest songs'.

Age played a part. The oldest member of the band, Strummer had been fifteen when anti-Vietnam War demonstrators clashed with police outside the American embassy in Grosvenor Square in 1968: old enough to thrill to the revolutionary spectacle unfolding on the TV in his suburban living room but too young to go along and throw some bricks himself. 'I always felt like I was coming on the field of a great battle twelve hours after the battle was over,' he later reflected, 'so the casualties were all lying

on the field but the battle was gone.' Although his father's thoroughly establishment occupation as a Foreign Office civil servant would often be held against him, Strummer was a keen student of the counter-culture. At art school in London, the young man born John Mellor took the name Woody (after Guthrie) and began learning the guitar. Soon dropping out of college, he styled himself as a hippie hobo, living in squats and busking his way round Europe.

Older still was Bernie Rhodes, who was thirty when, in May 1976, he introduced Strummer to guitarist Mick Jones and bassist Paul Simonon, and thus became both midwife and manager to the Clash. Rhodes was charismatic, mercurial, egotistical, inspirational. 'The Clash was a bit like the Communist Party, with Bernie as Stalin,' Simonon once quipped. He was the intellectual whetstone on which Strummer could sharpen his mind. 'Joe was his own man and didn't need any goading to be political,' says the DJ and film-maker Don Letts, a close friend of the Clash. 'But Bernard recognised the tradition that Joe was in and maybe helped focus his aim. He understood the history of the counter-culture and joined the dots way back.' Rhodes urged Strummer, 'Write about what's important,' and the singer eagerly rose to the challenge. In September 1976 he told new punk fanzine *Sniffin' Glue* that the Clash were there to educate listeners about what was happening in Britain. 'The situation is far too serious for enjoyment, man,' he said sternly.

Before the Clash, Rhodes's intellectual sparring partner had been Malcolm McLaren, a brash but insecure art-school dropout with a mania for big ideas. Chief among them was situationism, with its love of pranks and slogans and its enduring associations with the student uprisings of Paris 1968; he claimed he had been at that year's Grosvenor Square protest. The two had become friends in the 1960s and came together again in 1974 at McLaren and Vivienne Westwood's provocative King's Road boutique Let It Rock (later renamed Sex). What McLaren dreamed of was a band to go with it.

McLaren's first thought had been to front the group himself – he even took singing lessons before deciding that he was too old for the job. He wrote to a friend: 'I have the idea of the singer looking like Hitler, those gestures, arm shapes etc. and talking about his mum in incestuous phrases.' What came his way was the Strand, a ramshackle outfit comprising working-class Londoners Steve Jones, Paul Cook, Glen Matlock and Warwick Nightingale. But Jones wasn't much of a frontman and McLaren needed a singer who could fulfil his multiple ambitions for the band: to become Britain's answer to the thrillingly volatile New York Dolls, translate his scattergun ideas into songs and, more prosaically, promote the King's Road shop.

One regular visitor to Sex was a skinny, hunched, green-haired teenager called John Lydon. At the age of eight he had been bedridden for a year with meningitis, which left him with bad eyesight and intense unease with his own treacherously fragile body. When his Irish parents settled on the Six Acres council estate in London's Finsbury Park, he attended a Catholic school. 'I learnt hate and resentment there,' he told writer Jon Savage. 'And I learned to despise tradition and this sham we call culture.' Furthermore, he felt a burning sense of social rejection. 'It's the repressive class system that destroys any hopes of people like me,' he says. 'We didn't have the money, we didn't have the education and we were looked down on even when we did educate ourselves. It was a hopeless situation.' By the time he first walked into Sex, all of this had left him with a profound sense of unbelonging. 'Which is oddly enough the warmest feeling,' he says with a brittle, cawing laugh. 'You can wear it like a coat – it wraps around you.'

So when Lydon auditioned for McLaren in August 1975 he was on a completely different page from his bandmates and manager. 'I suppose Malcolm's idea of the Sex Pistols was a Labour Party version of the Bay City Rollers,' he later sneered to writer Robin Denselow. Jones, Cook and Matlock (Nightingale was gone by now) wanted to play hard, fast garage-rock like the

Stooges and the MC5; Lydon loved reggae, Captain Beefheart and saturnine prog-rock misfit Peter Hammill. They appeared to hate each other on sight. Right from the start, the Sex Pistols were an unstable compound, destined to explode.

*

It is entirely apt that they were formed in 1975, a year in which it seemed everywhere that time was running out and some violent transformation was imminent. You could hear it in reggae's dire prophecies, in Bowie's fascist daydreams and in the last-chance mania of New York bands such as the Ramones, who appeared in the first issue of a significantly titled new fanzine at the end of the year: *Punk*. 'There was nihilism in the atmosphere, a longing to die,' New York writer Mary Harron told Jon Savage. 'Part of the feeling of New York at that time was this longing for oblivion, that you were about to disintegrate, go the way of this bankrupt, crumbling city. Yet that was something almost mystically wonderful.' But in New York that death-drive had a sly, knowing quality, and Harron was both shocked and thrilled by what she saw when she visited London the following autumn. 'I felt that what we had done as a joke in New York had been taken for real in England by a younger and more violent audience.'

New bands sprang up, warrior-like, from the dragon's teeth sown by the Pistols in 1976 – the Damned, the Buzzcocks, the Adverts – while some existing ones were reborn. Joe Strummer was fronting the fast-rising 101ers when the Pistols supported them in April 1976; within weeks he had quit and formed the Clash. 'The Pistols had to come in and blow everything away,' he said later. 'They were the stun grenade into the room before the door could go.' Meanwhile, a clique of extravagantly dressed suburban teenagers known as the Bromley contingent, some of whom would later form Siouxsie and the Banshees, gravitated towards the Sex Pistols via Vivienne Westwood, their style an amalgam of Weimar Germany, S&M, gay fashion and *A Clockwork Orange*, their preferred drug amphetamine sulphate, their politics imponderable.

Everything happened very fast. 'What had begun as an excuse to annoy people,' writes Savage, 'quickly took on an almost messianic flavour as the inner circle surfed through the city on a diet of sun, sex, sulphate and swastikas.'

The swastika was emblematic of punk's addled politics. Although some punk offshoots would later overlap uneasily with neo-Nazi groups, in 1976 the symbol connoted nothing more sinister than a desire to outrage hippies, liberals and the older generation which still took vocal pride in defeating Hitler. In the US, where the Stooges' Ron Asheton had flaunted the swastika as far back as 1969, the Ramones and the editors of *Punk* dabbled in Nazi imagery and espoused a trashy, grooveless, inauthentic, distinctly *white* aesthetic, without ever tipping into outright racism. 'I don't think anyone wanted to read too much depth into it: it was more emotional,' said *Punk* co-founder Legs McNeil. The critic Lester Bangs attributed this vogue to 'a reaction against the hippie counterculture and what a lot of us regarded as its pious pussyfooting around questions of racial and sexual identity, questions we were quite prepared to drive over with bulldozers.'

During that summer in London the scene was so far under the radar that punks were able to throw all these wild, half-understood ideas into the air and let them fall where they may, not fearing the consequences. Nothing was fixed; anything was possible – at least for a short while. Ironically, one victim of punk's flirtation with fascist iconography was the most passionately anti-racist of all the bands. When the Clash played Lanchester Polytechnic in November, the student union, misunderstanding one particular lyric, refused to pay them. The offending song was called 'White Riot'.

*

Britain is not a country accustomed to heatwaves, and the summer of 1976 took everyone by surprise. Average temperatures were their highest since at least the seventeenth century, while month after rainless month produced crop failures, yellowed

lawns, emergency water rationing and a bizarre plague of lady-birds. The last weekend of Britain's scorched summer was a seismic one for punk. On Sunday, 29 August, McLaren hosted a remarkable triple bill at the Screen on the Green in Islington, north London. The Sex Pistols were supported by the Buzzcocks and, playing only the third gig of their short life, the Clash. With several A&R men in the crowd, it was an underground movement's first step towards the mainstream.

At the same time, a few miles to the west, the annual Notting Hill carnival was taking place. It had been founded as a gesture of defiance after the race riots of 1958, when white mobs attacked West Indian homes, and had quickly become a red-letter day for London's black population. As second-generation immigrants came of age, the nostalgic island sounds of soca and calypso were steadily eclipsed by the militant thunder of reggae. 'The whole idea of being black and British had no meaning then, so we were looking to Jamaica, looking to America,' says Don Letts. 'What were we, man?' he asks himself, pacing the floor, spliff in hand. 'I don't know what the fuck we were. We were black and *deadly*.'

By 1976, against a backdrop of racist policing, the carnival was coiled with tension. The police stationed 1,600 officers at the event, octupling the previous year's manpower. 'You went there thinking, "Great, a day of freedom,"' recalls Letts. 'When you approached the carnival, that illusion was immediately shattered. Trust me, when you walk past a bunch of cops sniggering at you, it doesn't set the day up right from the get-go.' While punk's standard-bearers played in Islington, West Indians ominously chanted, 'Coming down, coming down' on the streets of Notting Hill and Ladbroke Grove.

On Monday, the carnival's second and final day, Strummer, Simonon and Rhodes paid the Grove a visit. The reggae-loving Simonon had grown up in Notting Hill and, prior to that, Brixton, another hub of Caribbean life in the capital, so black culture held no mystique for him. But Strummer felt like an

outsider, plugged into a different tradition of dissent. On arriving at the carnival, the trio began dancing to the reggae sound systems. Around 5 p.m., however, police attempted to arrest a young black man for alleged pickpocketing and were met with a hail of bricks and bottles. 'We were there at the very first throw of the brick,' Strummer remembered. 'All hell broke loose.'

Strummer was caught in the surging crowd, losing sight of his friends. The next time he saw Simonon, a few minutes later, the bassist was throwing a plastic traffic cone at a police motorcyclist. The pair tried to set fire to a car but, comically, couldn't keep a match lit long enough in the breeze. A return visit to the carnival that evening, with curious Sex Pistols associate Sid Vicious in tow, was aborted in the face of hundreds of hardcore rioters. 'That was when I realised I had to write a song called "White Riot",' Strummer told Jon Savage, 'because it wasn't our fight.'*

'If you lived in the streets of London you could have foretold it,' says Letts. 'It wasn't a black and white thing: it was a wrong and right thing. We'd all had enough, it's just the black people who were brave enough to pick up a brick.' All of the Clash had witnessed prejudice and police harassment in various forms, but they weren't themselves regularly stopped and searched by the police, or threatened by racist thugs. Just as white American folk fans had been entranced by the 'authentic' grit of Delta bluesmen, and 1960s white radicals had mooned over the Black Panthers, Strummer was intoxicated by the justified wrath of the carnival rioters, as opposed to the docile apathy of white youth, only he had enough self-knowledge to accept his own apartness. He was *in* the riot but not *of* the riot.

Not insignificantly, the West Indians also had the night music. By the mid-1970s, white Britons still had no vital form of musical

* The song, perhaps unintentionally, echoed both Weatherman's parody of 'White Christmas' ('I'm dreaming of a white riot') and the MC5's salute to the Detroit rioters, 'Motor City's Burning' ('I may be a white boy, but I can be bad, too'), but Strummer was more self-aware than either.

protest to call their own. Despite fitful, late-1960s gestures such as 'Street Fighting Man', British rock's dominant modes in the following decade were distinctly artistic and escapist, from the elaborate fantasias of progressive rock, through the bucolic day-dreams of folk-rock to the arch, sci-fi androgyny of glam. But reggae had everything: fascinating characters, sonic derring-do, social comment and end-of-days drama. It was irresistible. 'We did feel like we were on the frontline of Babylon,' journalist Vivien Goldman told writer Simon Reynolds.

Recorded in February 1977, 'White Riot' is on high alert from the opening police siren to the final burglar alarm. It takes roots reggae's sense of emergency and translates it into sheer velocity. On the other side of the single, the Clash offered their response to Culture's 'Two Sevens Clash'. 'In 1977,' glowered Strummer, 'Knives in West 11 . . . Sten guns in Knightsbridge.'

*

The Sex Pistols marked their signing to EMI in the autumn of 1976 with a debut single even more formidable than 'White Riot': 'Anarchy in the UK'. Lydon had been introduced to the titular concept by McLaren's friend Jamie Reid, who designed all of the band's record sleeves, but he was not particularly interested in Bakunin and Kropotkin. His concern, he told Jon Savage, was not 'political anarchy, because I still to this day believe that anarchy is just a mind-game for the middle classes, but personal anarchy, which is quite different'. McLaren and Reid attempted to flood Lydon's mind with such cherished ideas as situationism, but they could not dictate what he did with them, nor, more importantly, how he delivered them. One cannot detach the words from the voice, and the voice seemed to scream up from the void.

'Anarchy in the UK' was a thunderclap, a declaration of war, a sick joke. Johnny Rotten introduced himself to the world with the words 'Right! Now!', a stage laugh, and an assault on the language itself, rolling his *r*s with satanic relish and forcing

'anarchist' at gunpoint to rhyme with 'antichrist'. His bandmates' love of rock'n'roll, beefed up by Chris Thomas's production, gave it an irresistibly thrilling muscularity, a wild, liberating glee. It is at once absurd and genuinely disturbing: comic-strip villainy warping into real, slash-and-burn rage. *Who*, or *what*, you might have asked in 1976, *is this creature? And what does he want?*

Lydon/Rotten sounded literally *unhinged*, snapped off from mainstream thinking, whirling off into new and chaotic territory with no indication of where he might dock. Protest singers have an ideal outcome in mind, but Lydon here resembles a terrorist whose demands are obscure and, one suspects, impossible to satisfy. 'They didn't know which direction we were coming from,' Jamie Reid told Savage. 'In the same week we could be accused, quite seriously, of being National Front, and in the next breath you were mad communists and anarchists.'

Towards the end of 'Anarchy in the UK', Rotten spits out paramilitary acronyms – the MPLA and the opposing Irish guerrillas, the UDA and the IRA – in a way which renders them laughable and meaningless. These days, he says, he doesn't believe in extreme politics. 'When you go to one extreme or another you're negating one part of your personality and I think that's a dangerous move.' Which is very sensible, but *dangerous* is exactly how he sounds on 'Anarchy'. This does not sound like someone carefully weighing their options and finding a middle path. It sounds like someone dancing amid the flames and rubble: 'Get pissed, destroy!'

On the night that changed Lydon's life for ever, however, he did not seem particularly terrifying. It was 1 December, and their new EMI labelmates, Queen, had dropped out of an appearance on Thames Television's *Today* show, so the Sex Pistols were airlifted in at the last minute, with unforeseeable consequences. When you watch this footage now, it seems far more bathetic than outrageous. The host, Bill Grundy, comes across as a pompous, drunken fool, in the process of needling himself out of a career. The band and four members of the Bromley contingent (including Banshees Siouxsie and Steve Severin) look shockingly young

and green. The infamous swearing – 'tough shit', 'you fucking rotter!' – whiffs of schoolboy mischief rather than sedition.

But a country, like an individual, is more likely to take offence if it is feeling insecure, and by the end of 1976 Britain's crisis of confidence was crippling. In November the chancellor of the exchequer, Denis Healey, had been forced to cut a humiliating deal with the IMF to save the pound, necessitating substantial cuts in public spending. Unemployment had passed the symbolic one million mark. An ongoing industrial dispute at the Grunwick film-processing plant in north London was prompting sympathetic strike action with no resolution in sight. The Notting Hill riots, and attendant fears of racial violence, were still fresh in the memory. The country appeared to be drifting slowly through the night towards an iceberg. And now here were these ghastly apparitions, spouting filth on national television at teatime! As Margaret Drabble wrote in *The Ice Age*: 'All over the country, people blamed other people for all the things that were going wrong . . . Nobody knew whose fault it really was, but most people managed to complain fairly forcefully about somebody.'

Many people were happy to blame the Sex Pistols. The *Daily Mirror* coined the classic headline, 'The Filth and the Fury!' while the *Daily Mail* asked, 'Who Are These Punks?' And the public reaction was real and visceral. The *Mirror* reported that one middle-aged lorry-driver was so enraged that he kicked in his TV screen. Dee Generate, the fourteen-year-old drummer of schoolboy punks Eater, received a brick through the window of his family home. Even McLaren, whose whole modus operandi was *épater la bourgeoisie*, was thrown into panic by the backlash, which turned the Pistols' Anarchy tour (supported by the Clash) into an anticlimactic farce of cancelled bookings, fistfights and sour tempers. 'From that day on, it was different,' Steve Jones told Savage. 'Before then, it was just music; the next day, it was the media.'

*

During the Anarchy tour, it was obvious that the Pistols and the Clash had drastically divergent agendas. 'I've always thought the Clash read books and just copped headlines,' says Lydon. 'A much more juvenile approach. And they didn't actually live a lifestyle according to the stance they were taking – a little bit of an act on their part.'

There was certainly a theatrical aspect to the Clash. Inspired by reggae albums such as the Professionals' *State of Emergency* and Prince Far-I's *Under Heavy Manners*, they stencilled lyrics on to boiler suits for the cover photograph of 'White Riot'/'1977'. Strummer was fascinated by the activities of Germany's Baader-Meinhof Gang and Italy's Red Brigades, far-left groups who had delivered the kind of revolutionary violence that Weatherman had only promised, while at the same time he insisted: 'we're anti-fascist, we're anti-violence, we're anti-racist and we're pro-creative'. Strummer was torn between the desire for truthfulness and the allure of street fighting radical chic: a pacifist in uniform. The discrepancy made the Clash electric, neither too earnest nor too nihilistically irresponsible, but it also exposed them to accusations of naivety and hypocrisy. While Lydon could use his toxic sarcasm as both shield and sword, Strummer was armed with nothing more than confused sincerity. The difference between the two frontmen was written in their faces: Lydon a snarling gargoyle palpably estranged from his own flesh; Strummer a handsome biker from a 1950s B-movie.

Strummer's advantage was that he threw listeners a lifeline. The impact of the Sex Pistols was a sudden shock to the system, like resuscitation paddles applied to a struggling heart, but they offered no guidance as to how the patient might then recuperate. Lydon was such an extreme and complex personality that the listener could not follow him – his was a riot of the mind. The Clash, for all their freshness, were more conventional protest rockers, documenting the world around them. To people who inhabited the dole queues, underpasses and tower blocks of the inner cities, the Clash's reportage was excitingly familiar; to those who didn't,

it was grippingly exotic. When they released *The Clash* in April 1977, three weeks after 'White Riot'/'1977', *NME*'s punk apostle Tony Parsons purred: 'They chronicle our lives and what it's like to be young in the Stinking Seventies better than any other band, and they do it with style, flash and excitement.'

As a last-minute addition to their debut, the Clash took the bold step of covering a reggae song, Junior Murvin's election-year lament 'Police and Thieves', which had been on heavy rotation at Notting Hill carnival prior to the riot.* They were initially hesitant – would they be honouring reggae or travestying it? – but they succeeded by foregrounding the cultural differences: Murvin's keening falsetto gave way to Strummer's chewy London vowels, Lee Perry's spacious lilt to a terse rock beat. Much though the Clash admired reggae and black resistance, they knew they were fundamentally apart from it. *This wasn't our fight.*

This sense of awkward remove inspired one of the Clash's greatest songs. In June, after a triumphant White Riot tour in the spring, Strummer accompanied Letts to a reggae all-nighter at Hammersmith Palais, where he experienced a disappointment which can be traced all the way back to Pete Seeger's politicised folk mission and forward to liberal qualms with gangsta rap. 'It was a lot more glitzy than he expected,' says Letts. 'He expected, I don't know, a backdrop of corrugated iron and barbed wire keeping the crowd back. He didn't realise that the ghetto is something you get out of, not something you want to get into. He realised that was his misconception. Joe would always be questioning the situation and his part in it.' On the reggae-inflected '(White Man) in Hammersmith Palais' (1978), Strummer chased his faulty assumptions down an echoey rabbit warren of ideas about the limits of revolutionary rhetoric, of punk, and of the Clash themselves. Few protest songs have ever constituted such a long and unflinching look in the mirror, or come so close to admitting defeat.

* In the days following the riot, sound-system DJs began playing a revocalled unofficial version which featured 'police and youths in the Grove'.

Indeed, one of the Clash's most endearing qualities was their readiness to acknowledge the pitfalls of their street fighting stance. On an autumn visit to Belfast, they misguidedly used the Troubles as an authentically ravaged backdrop to a photo shoot. 'The soldiers crouching in cubby holes thought we were dicks,' Mick Jones admitted to *Melody Maker*. 'The kids thought we were dicks.' An equally naive jaunt to Jamaica in November (during which, confessed Jones, they cowered in their hotel, 'scared shitless') inspired 'Safe European Home': 'Sitting here in my safe European home, I don't wanna go back there again.' They could at least take comfort from the approval of Lee 'Scratch' Perry, who, while staying in London, produced a session for the band and the exiled Bob Marley's own tribute to punk, 'Punky Reggae Party'. On balance, 1977 was a triumphant year for the Clash, but it proved a fatal one for the Sex Pistols.

*

While the Clash were preparing to release their debut album, McLaren had big plans for the Pistols. The second issue of his magazine, *Anarchy in the UK*, ended with a shopping list of rebel icons: 'Che, Durruti, the Watts Riots, the Weathermen, the Angry Brigade, the '72 Miners' strike, the Levellers et al., Black Power, the Women's Movement, Gene Vincent.' It went without saying that the Pistols belonged in such illustrious company.

Hastily dropped by EMI, the band, with Lydon's somewhat unstable friend Sid Vicious replacing Glen Matlock on bass, had found new patrons at A&M and McLaren wanted their first single for the label to make a splash. He chose a song Lydon had written in the kitchen of his Hampstead squat the previous autumn: 'No Future'. They recorded it in March under a new title, 'God Save the Queen', chosen by McLaren because Elizabeth II's Silver Jubilee was imminent, and because 'No Future' 'sounds like an ad for a bank'. Jamie Reid put a safety pin through the monarch's lip in a *détourned* version of Cecil Beaton's official portrait. Everything was in place for a media sensation until Sid

Vicious threatened Bob Harris, host of stalwart TV pop show *The Old Grey Whistle Test*, at a London nightclub and A&M decided they were too hot to handle. Just a week after signing a contract A&M jettisoned the Pistols and destroyed almost all of the 25,000 copies that it had pressed of 'God Save the Queen'. The Clash had 'White Riot' and an album ready to go. The Buzzcocks had their *Spiral Scratch* EP. The Damned and the Stranglers both had debut albums in the shops. New bands like X-Ray Spex, the Slits and Wire were springing up on a weekly basis. Yet the Pistols didn't even have a record deal.

McLaren, frantic to get the single out before the Jubilee in June, went knocking on doors and finally struck lucky with the risk-taking independent label Virgin, just in time to release 'God Save the Queen' on 27 May. Promoting it became a guerrilla campaign. The BBC refused to play it, TV and radio stations shunned the adverts and several high-street stores wouldn't even stock it. Yet there it was at number two in the charts come the Jubilee, a rallying cry for all those who rejected this flimsy fig-leaf of patriotism, believing that the Queen was not a remedy for the national malaise but a vessel for the disease.

The song's rhetoric is deliberately overheated. Of course, the British establishment in 1977 was far from being a 'fascist regime' – to the far right, chance would be a fine thing. Lydon's sarcasm is nuclear, portending a scorched earth. There is optimism submerged in the broiling destruction – 'We're the flowers in the dustbin' – but of a frightening kind. Lydon knew his reggae, and here is Rasta eschatology shorn of religion, a purifying blaze with an uncertain promise. Despite what the tabloids said, Lydon was a deeply moral character, but his morality was scourging in its extremity and opaque in its expression, and if you were not yourself a flower in the dustbin 'God Save the Queen' must have sounded like the end of the world. And this was an era when disparaging the monarch could still be seen as cultural treason. By the end of Jubilee week, Jamie Reid had had his leg and nose broken and Lydon had been slashed with a

machete by a mob shouting, 'We love our Queen, you bastard!' How could any band be expected to survive being hospitalised over a pop song?

Overfamiliarity and social change may have drawn the sting from 'Anarchy in the UK' and 'God Save the Queen', but the two most recent songs on *Never Mind the Bollocks, Here's the Sex Pistols*, both recorded in a state of frazzled post-assault siege, continue to disturb. On 'Holidays in the Sun' Lydon uses an old situationist slogan ('Club Med: a cheap holiday in other people's misery') as the launch pad for a demented pilgrimage to the Berlin Wall, where his fevered brain ricochets between the past sins of a united Germany and the caged paranoia of a divided one, and he babbles the kind of desperate confession that conventional protest singers cannot allow themselves to voice: 'I don't understand this bit at all!'

'Bodies' is an even more frightening window into Lydon's singular psyche: the story of an abortion in which the narrative viewpoint skids wildly from third-person observer ('She was a no one who killed her baby') to reluctant would-be father ('Fuck the fucking brat') to the foetus itself ('I'm not a throbbing squirm') with horrifying speed. Lydon delivers the profanities like he's throwing punches, and the final scream of 'Mummy!' like someone jerked awake by a nightmare. To say, as some conservative critics have, that it is a pro-life statement is to ignore the writhing confusion that puts it way beyond politics. You try to get to the bottom of these songs but you can't find the bottom. Lydon is throwing stones into a well so deep that nobody can hear the splashes.

Having lived most of their short life in public, it was fitting that the fractious and exhausted Sex Pistols terminated it on stage before a paying audience, at San Francisco's Winterland on 14 January 1978. 'It took us about three years to realise that we weren't going to change the world,' reflected the *NME*'s Neil Spencer, who had come of age in the late 1960s. 'It took the punks about 18 months.'

*

The Clash received the news of the Pistols' demise while rehearsing in London and they were shaken. They had been two sides of the same coin: rivals more than friends, perhaps, but punk's two contrasting visionaries. Now the Clash were alone at the top and the responsibility weighed heavy on their shoulders.

There was, however, a pack of bands snapping at their heels. Sham 69, from Hersham in Surrey, were an instant success that year with a brash, street-kid populism epitomised by 'If The Kids Are United', and motormouth frontman Jimmy Pursey became a music-press regular, spouting opinions noted more for their forthright energy than for their sophistication or coherence. Sham 69 tapped into the Clash's blokey, tower-block-rock side, while ignoring their musical curiosity and searching ambivalence. Another Surrey band, the Jam, also trafficked in punchy urban realism for 'the kids'. Frontman Paul Weller barked, 'We gonna tell ya about the young idea' on 'In the City' and called for a 'youth explosion' on 'All Around the World'. Like their obvious influences, the Who and the Kinks, the Jam's protest songs suggested a chippy, libertarian antipathy towards anyone in power rather than a left-wing agenda. In fact, Weller notoriously declared that he would be voting Conservative in the next election, though he soon dismissed it as just 'a silly comment' designed to irritate the Clash. During the 1980s Weller would become one of the most vocal left-wingers in rock.

In 1978 that role was briefly filled by twenty-seven-year-old Tom Robinson. The Cambridge-born singer had been treading water in acoustic trio Café Society when he first saw the Sex Pistols in October 1976. 'I was kind of ready for a road-to-Damascus moment,' he says when we meet for lunch. 'I left after fifteen minutes: "This is horrible!" But I couldn't forget it.' This coincided with his immersion in gay-rights activism. 'I tried to kill myself at sixteen because I fell in love with another boy at school, so when I finally hit London aged twenty-three, I was going to the opposite extreme and I took to gay liberation like religion.' He watched aghast as the police cracked down on

the gay scene in Earls Court during the long, hot summer, and offered to write songs for the fledgling Gay Pride parade, including the furiously sarcastic 'Glad to Be Gay'. 'In the safe, elegant clubs these "Glad to Be Gay" badges had started to appear, but people would take them off when they left the club,' he says. 'And that, coming with what was going on at the dirtier end of the scene, made me want to write a very bitter, cynical song about all the reasons why you *wouldn't* sing if you're glad to be gay. It was only intended to be sung once that day to that select audience.'

But EMI's A&R man, Nick Mobbs, was still smarting from being forced to drop the Sex Pistols and was looking for a new political band. The Tom Robinson Band (TRB), used the cheerfully catchy hit '2-4-6-8 Motorway' as a Trojan horse through which to smuggle more challenging songs into the Top 40. On the TRB's debut album, *Power in the Darkness* (1978), 'Winter of '79' depicted a fascistic near-future in which the National Front ran rampant, gays were jailed, the police behaved like stormtroopers and violence was endemic. 'I wrote it in '76 and it didn't seem at all certain that everything would still be here in '79,' says Robinson. 'Perhaps I was naive but to me it did seem like a lot of that stuff in "Winter of '79" could have happened.'

Other songs underlined the sense of imminent disaster: 'Up Against the Wall', 'You Gotta Survive', 'Better Decide Which Side You're On'. 'It's make-your-mind-up time,' he told *Melody Maker*. 'The Tom Robinson Band is unequivocal. Things are moving fast, you can't afford to fuck about.' The TRB played every benefit gig going and lent their support to young bands such as Ulster's Stiff Little Fingers, whose singles 'Suspect Device' and 'Alternative Ulster' introduced a courageous new political voice from a province already embroiled in civil war. But Robinson's new, press-trumpeted role of rock's conscience troubled him.

'I was a driven, unhappy person,' he says. 'It wasn't like, "How can I change the world? I'll form a band." It was, "I want to be famous and I want people to know me and validate me as

a person." And the pressures of overnight fame were such that I was a rabbit frozen in the headlights. If enough people tell you you're marvellous for long enough, you start fucking believing it. People would ask me, "What's the solution to the situation in Northern Ireland?" and I'd actually try to tell them! The hubris was just enormous.' After recording a miserable, muddled second album, the TRB split and Robinson left the country for several years. Reflecting on his brief spell as Britain's most prominent protest singer, he sighs: 'It could have been done better, it could have been subtler, it could have done without the phony cockney accent, but given my circumstances, it was all right.'

*

The Clash, meanwhile, were able to take their contradictions, chiefly the way that they supported worthy causes while culti-vating a macho, us-against-the-world image, and make them compelling. On their second album, *Give 'Em Enough Rope*, Strummer sounded both horrified and enthralled by violence of every stripe, from Westway street fighting to Kingston gunplay to Palestinian terrorism. The world map on the sleeve, showing such hotspots as Ulster and Cambodia, hinted at the interna-tionalist perspective they would bring to *Sandinista!* (1980) and *Combat Rock* (1982). 'The lyrics of Joe Strummer were like an atlas,' U2's Bono once said. 'They opened up the world to me.'

What is striking, revisiting the febrile debates of the time, is how unfashionable the Clash had become, and how sud-denly. 'It's hard when you define a period so accurately,' wrote Jon Savage in *Melody Maker*. 'The Pistols broke up and neatly avoided the issue. Here, the Clash seem locked in time . . . from being radicals, they become conservatives.' *NME*'s Nick Kent, though more enthusiastic about the music, derided 'Strummer's totally facile concept of shock-politics'.

So the Clash's angry, humane masterpiece *London Calling* (1979) came out of a siege mentality. To the street-punk con-tingent they had lost touch with the high-rises and underpasses

which had nurtured them, while to a new breed of more militant and avant-garde post-punks their stance was posturing, self-regarding and musically reactionary. While the Clash talked of getting their message across to high-school Kiss fans in America, the likes of Gang of Four and the Pop Group maintained that rock'n'roll was part of the problem, not the solution. 'We're going for a new direction,' Gang of Four's Hugo Burnham sarcastically told the *NME*. 'We're gonna sing about cars and girls and surfing and high school and drugs, just like the Clash do.'

Other groups poked fun in song. The Mekons' brittle, self-deprecating 'Never Been in a Riot' was the antithesis of last-gang-in-town heroics, while Scritti Politti's 'Skank Bloc Bologna' sneered at 'rockers in the town'. Many of these post-punk intellectuals had soaked up Gramsci and Althusser at university. By their often forbidding standards, wearing a Red Brigades T-shirt and singing about tommy guns just didn't cut it.

In one sense, the critics were right. The Clash *were* retrograde. Despite their embrace of reggae and, later, elements of hip-hop, they did not share post-punk's contempt for rock'n'roll. And they *could* be gauche and clumsy in their politics. But their flaws were entwined with their strengths: both stemmed from a pell-mell, do-or-die ambition to connect with their audience and live with their contradictions. This is why they had a catalytic influence on such politicised artists as U2, Billy Bragg, Public Enemy and the Manic Street Preachers, and left a more potent legacy than any of those who found them ideologically wanting. They were the only band of the punk era who possessed a kind of heroism, a quality as old-fashioned and potentially ridiculous as it is inspiring.

'We didn't have any solutions to the world's problems,' Strummer reflected a few years before his death. 'We were like groping in the dark . . . [But] we did try to think and talk with each other about what we were doing, or what songs meant, or what we should do, or what we shouldn't do. We never let it lie.'

17

'Now I won't judge you – don't you judge me'

Carl Bean, 'I Was Born This Way', 1977

Gay pride and the hidden politics of disco

City supervisor Harvey Milk attends San Francisco's seventh annual gay freedom parade, 26 June, 1978.

If you had asked a New York punk in 1976 about the politics of disco, he would most likely have barked a derisive laugh. In the launch issue of *Punk*, editor John Holmstrom decreed: 'The epitome of all that's wrong with western civilization is disco.' With equal ferocity, Jesse Jackson, the hero of Wattstax, branded it 'garbage and pollution which is corrupting the minds and morals of our youth'.

But while Holmstrom and Jackson hated disco for being glossy and narcissistic, a trashcan of opprobrium was dumped on disco by people who loathed the entire culture it represented: black, gay and metropolitan. Although most disco had no particular intellectual axe to grind, favouring escape over confrontation, it was, at least initially, political by its very existence: an exuberant response to hard times, spearheaded by marginalised cultural groups. For the early practitioners and fans of disco, the party *was* the protest: both a message of resistance and a vision of a better society – one where race and sexuality were no longer obstacles but reasons to celebrate. The fact that the fantasy became commercialised, corrupted and, finally, was brought crashing to the ground does not make it any less potent.

*

Because disco meant so many things to so many people – rich and poor, straight and gay, black, white and Latino – it had no one point of origin. It took many streams to make a river. But if you trace one of those streams back to its source, it will lead you to 53 Christopher Street in Manhattan's West Village, and a grimy bar called the Stonewall Inn on a warm night in 1969.

A grimy dive bar owned by mafiosi who privately reviled 'faggot scumbags', the Stonewall nevertheless attracted a loyal clientele. At 1.20 a.m. on Saturday, 28 June, eight police detectives raided the Stonewall Inn, arresting several revellers. As

police loaded prisoners into vans, a tense crowd gathered and somehow a small riot broke out. Drag queens tussled with officers, while onlookers chanted, 'Gay power!' and riot police arrived, clubs swinging. Further clashes took place outside the bar for the next five nights. Allen Ginsberg came down to check out the scene and said approvingly, 'It's about time we did something to assert ourselves.'

Compared to, say, the Watts uprising, Stonewall was small beer, but it had a catalytic effect. In the era of Black Power and the anti-war movement, the riot was the trigger for a new brand of gay activism, which took shape with the formation of the Gay Activists Alliance, with its slogan 'Out of the closet and into the streets,' and the more militant Gay Liberation Front. These two bodies organised the country's inaugural Gay Pride march to mark the first anniversary of the raid, and, the following year, successfully campaigned to overturn the city's laws restricting homosexual admission to nightclubs. It wasn't until December 1973 that the American Psychiatric Association removed homosexuality from its list of mental disorders.

The GAA's Firehouse community centre in Manhattan's SoHo district hosted intense political meetings during the day and parties at night, where the dancefloor heaved to the sound of dark, hypnotic funk records. Understandably, the parties proved more attractive than the meetings, and functioned as a form of protest in which hedonism was not the vacuous antithesis of gay politics but a manifestation of it. While the likes of the Weatherman were practising dour self-denial, gay clubbers made pleasure their battleground. Homosexuals were persecuted and discriminated against on the basis of their desires, so to celebrate love, lust and companionship was the purest form of dissent. 'I was on the streets and in the party,' David Mancuso, host of pioneering gay club the Loft, told writer Tim Lawrence. 'Dancing and politics were on the same wavelength.' It was an idea whose time had come. In 1973, a printer of T-shirts created an inspired paraphrase of a line from the late anarchist Emma Goldman,

and popularised a slogan which spoke directly to the counter-cultural aspects of disco: 'If I can't dance I don't want to be in your revolution.'*

During the early 1970s, gay discos sprang up in the hedon-ists' haven of Fire Island, a beach resort just off the coast of Long Island, and in the city itself, at clubs such as the Sanctuary, the Flamingo, the Tenth Floor and Tamburlaine. Clubs like the Planetarium, Shaft and Better Days, catering specifically to gay African-Americans, became something of a safe haven for those excluded from the unashamedly elitist, and profoundly Caucasian, Tenth Floor. As New York clubgoer Michael Gomes wrote, black gay men 'couldn't tune in and drop out because they had nothing to drop out from', so they 'created their own world, their own lit-tle artificial paradise, in which the clubs became these sanctuaries'.

Unease around black clubgoers seems especially pernicious con-sidering that most of the records they were dancing to at the Tenth Floor and elsewhere were by black artists. Until Giorgio Moroder introduced a mechanised, Europeanised pulse to disco with Donna Summer's sublime 'I Feel Love' (1977), the music was firmly root-ed in the increasingly luxuriant productions coming out of soul labels. It coalesced out of a swirl of innovations: the urgent 4/4 thump of Eddie Kendricks's 'Girl You Need a Change of Mind' (1972), the shagpile lushness of the Love Unlimited Orchestra's 'Love's Theme' (1973) and the high-rise escapism of MFSB's 'Love Is the Message' (1974). MFSB were Philadelphia International's house band before defecting to landmark disco label Salsoul, so many of those early 1970s partygoers were dancing to the

* As Peter Shapiro writes in his history of disco, *Turn the Beat Around*, there was a long tradition of dancing as covert resistance, going back to the glamorous, jazz-loving 'Swing Kids' of Hitler's Germany and their counterparts in occupied France, 'Les Zazous', some of whom ended up in labour camps. The Pet Shop Boys' electro-pop song 'In the Night' (1985) is a poised homage to the Zazous, in which the night is the setting for both rebellious after-hours hedonism and the dread 'knock on the door'.

righteous message music of Gamble and Huff acts like the O'Jays. What nobody had yet come up with was a record that spoke to black and gay disco fans at the same time. Surprisingly, that job fell to a straight, black, Christian woman.

In the 1960s, Bunny Jones had run a string of beauty salons in Harlem and become outraged by the bigotry suffered by her mostly gay employees. 'I began to feel that gays are more suppressed than blacks, Chicanos and other minorities,' she told *The Advocate*. 'You hear of great designers or famous hairdressers, and that's about as far as society will let gays go.' Jones wrote the lyrics to 'I Was Born This Way' in 1971, but it took her three years to find a collaborator, one Chris Spierer, to write the music; his stirring melody was let down only by its rinky-dink rhythm. Although the song examines the nature of homosexuality ('Ain't no fault, it's a fact') and critiques homophobia ('I won't judge you, don't you judge me'), the most important line was a bald, two-word statement: 'I'm gay.' It was as joyously direct as James Brown's 'Say It Loud – I'm Black and I'm Proud'.

Jones set up her own label, Gaiee Records, to release the single. 'I particularly named the label Gaiee because I wanted to give gay people a label they can call home,' she explained. To perform it, she recruited Charles 'Valentino' Harris, a twenty-two-year-old neophyte straight off a revival of the hippie musical *Hair*. After selling 150,000 copies herself, she was offered a distribution deal by Motown. Remarkably, Berry Gordy himself kissed Jones on both cheeks and told her, 'You've got a hit record.' 'No major company has ever had to deal with a gay protest record before,' said Jones. 'No one ever stood up and said, "I'm gay." . . . I'm sure that when Motown can readjust themselves to this type of record, they will make it a hit.'*

* Homosexuality was apparently de rigueur at Motown that year. The Miracles, now *sans* Smokey Robinson, surprised fans with an album track called 'Ain't Nobody Straight in LA'. In this thoroughly bizarre song, the band debate going to a gay bar, reasoning, 'Gay people are nice people too, man.' Indeed.

Unfortunately not. Motown's promotion was minimal and, although it made waves on the gay scene, 'I Was Born This Way' evaporated on contact with the mainstream in January 1975. Harris, whose solo career was stillborn, noticed the effect the record had on straight dancers. 'When the song came on, immediately people would begin dancing, and then when people got to that one word – they would stop dancing. It's really strange how one word can upset so many people.'

'I'm gay' was still a bold statement when 'I Was Born This Way' got a second bite of the cherry two years later. In 1977 an ordinance was passed in Dade Country, Florida prohibiting discrimination on the basis of sexuality. This enraged thirty-seven-year-old Anita Bryant, a former Oklahoma beauty queen and pop singer who was now the face of the Florida Citrus Commission and a staunch Christian conservative. She promised to 'lead such a crusade to stop it as this country has not seen before'. By June her campaign had led to a repeal of the ordinance, sparking a wave of anti-gay legislation across the US and a simultaneous increase in homophobic violence.

Bryant quickly became the gay community's bête noire. Supported by such celebrities as Barbra Streisand and Bette Midler, gay bars boycotted the Florida Citrus Commission, introducing a new cocktail called the 'Anita Bryant': vodka with apple juice instead of orange. The night the ordinance was repealed, 3,000 gay residents of San Francisco's Castro district marched through the city, led by charismatic aspiring politician Harvey Milk. 'Anita's going to create a national gay force,' promised Milk.

It was in this heated climate that Motown tried again with 'I Was Born This Way', but with a different vocalist. Bunny Jones suggested a gospel singer from Baltimore called Carl Bean. At the time, she didn't know much about him, but he turned out to be remarkably well equipped to sing her song. He had been raised by Baptist foster parents who took him to their minister for counselling about his sexuality when he was just twelve.

'The preacher didn't have an answer,' Bean told the *Los Angeles Times* many years later. 'I can remember more than anything leaving his office with nothing. There was only a greater void in my life. I went up to the bathroom and took everything in the medicine cabinet – pills, aspirin, whatever medications my parents had. I meant to go out of here. I had locked the door, and my father forced it open and rushed me to the hospital.'

Bean left his foster family and rejoined his birth mother, who was more understanding. At sixteen he left home, touring with the Alex Bradford Gospel Troupe and then his own gospel group, Universal Love, and appearing on Broadway. In the mid-1970s he moved to Los Angeles, at which point he came to Bunny Jones's attention. 'She is the opposite of Anita Bryant,' he told *The Advocate*. 'She is a Christian woman, a mother and a person who understands how gay people feel.'

Bean's recording of the song was an improvement in every way. The lyrics were tweaked to address bigoted listeners more directly, and the third verse, which ends 'From a little bitty bitty boy / I was born this way', seems to speak directly to that day in the preacher's office.* Former MFSB members Norman Harris and Ron Kersey overhauled Spierer's arrangement, giving it a lustrous, surging, reassuringly expensive Philadelphia feel, while Tom Moulton, one of disco's greatest talents, provided the remix. Bean, meanwhile, brought a vivid gospel intensity to the song. 'The entire studio was filled with joy, praise and freedom,' he later recalled. 'The spirit in that studio turned the session into a revival meeting . . . God indeed was the executive producer!'

Unfortunately, God was not in charge of radio playlists. 'The name of the game in the recording industry is money,' Bean told *The Advocate*. 'If this single is successful, I expect a lot of the other labels to pick up some of the action. They'll be looking for gay artists everywhere.' But straight promoters told Motown

* Interestingly, in a 1978 interview with *The Advocate*, Bean claimed never to have experienced homophobia in his upbringing, perhaps wary of tainting the song's uplifting message.

that the record had no place in their clubs, radio stations gave it the cold shoulder, and the single once again hit a glass ceiling. Still, Bean had made his statement. 'I am using my voice to tell gay people that they can still feel good about being gay even if there are people like Anita Bryant around,' he said.

The mainstream failure of 'I Was Born This Way' demonstrated that disco was not the most suitable vehicle for overt messages. Another debut single released that year, Chic's 'Dance, Dance, Dance (Yowsah, Yowsah, Yowsah)', smuggled social comment on to the dancefloor in a much more subtle manner.

<div align="center">*</div>

The year 1977 was not just a banner one for disco and gay politics. It was also one of the most eventful twelve-month periods in the history of New York: a heatwave, a blackout, the Son of Sam killings, and a mayoral election that would decide the future of a beleaguered city.

Abe Beame, Mayor Lindsay's sixty-seven-year-old former comptroller, had defeated his boss in the 1973 election and spent most of his term trying to save the city from bankruptcy. He had inherited a fiscal timebomb from Lindsay, who, fearful of exacerbating racial unrest, had chosen to borrow heavily rather than make cuts in services. Beame laid off city employees, only to then rehire most of them under union pressure. In 1975 New York's credit rating became so bad that it could no longer raise funds by selling bonds, so Beame resorted to mass layoffs and swingeing cuts. Sanitation workers went on strike, leaving 58,000 tons of garbage to fester in the heat. In October, Beame was forced to travel to Washington to beg President Ford for assistance, only to receive a lecture on bookkeeping. William Brink, managing editor of New York's *Daily News*, came up with one of the most famous headlines in US tabloid history: 'Ford To City: Drop Dead'. Already despised by much of middle America for its liberalism and perceived decadence, New York's pariah status was confirmed.

By 1977 things were slightly less desperate thanks to a new

financing package and the arrival in the White House of Jimmy Carter, who had promised during his campaign to 'never tell the people of the greatest city on earth to drop dead'.* But crime was still out of control. In 1976, the same year Martin Scorsese's *Taxi Driver* portrayed Gotham as a hellish cesspit, police reported a record seventy-five felonies an hour. This demoralised, divided city seemed ready to explode. All it needed was a trigger.

On the hot, sticky evening of Wednesday, 13 July 1977, a series of lightning strikes, malfunctions and human errors led to a complete loss of electricity to all of the five boroughs. Within minutes the first looters had taken to the darkened streets and the police were overwhelmed, their station house cells quickly filled to capacity. The ghettos of the South Bronx and Brooklyn's Bushwick section got the worst of it. Some looters, through a mixture of boredom and nihilistic rage, set fire to ransacked stores. When the sun rose fierce and bright the next morning, a pall of black smoke hung over Bushwick and broken glass littered the ground. The night had brought over 1,000 fires and 3,776 arrests, the biggest mass apprehension in the city's history. Mayor Beame called it 'a night of terror', and commentators bemoaned the contrast with the peaceful stoicism which had greeted New York's last blackout in 1965. If the despair of ghetto life was no excuse for such rampant destruction, then it was certainly the primary reason. A Catholic priest from Brooklyn told *Time*: 'When the lights went out, people just said, "Here's our chance to get back at the mothers who have been ripping us off."' But *Time*'s article concluded by noting that the ghettos suffered the worst damage: 'No amount of booty can compensate the looters for what they have lost.'

* Carter's nomination at the Democratic National Convention in New York was celebrated with a chorus of that old warhorse, 'We Shall Overcome'. 'Everyone in the room wept,' remembered Hendrik Hertzberg, Carter's speech-writer. 'Everyone – even in the press section – linked arms and swayed and sang. The moment carried tremendous emotional power.'

Just three months prior to New York's darkest night, a new nightclub had opened its doors on West 54th Street, promising the acme of high-life sophistication. Studio 54 was the vaultingly ambitious brainchild of two Brooklyn restaurateurs, Steve Rubell and Ian Schrager, who turned an old theatre into a fantasia of sex and money. It was an instant gossip-column sensation, with elite regulars (described by writer Anthony Haden-Guest as 'a Praetorian Guard, a social commando unit') such as Andy Warhol, Truman Capote, Liza Minnelli and Bianca Jagger. If the blackout was how New York saw itself in its worst nightmares, then Studio 54's aspirational glitz represented the city in its finest dreams: indefatigable, questing, always moving onwards and upwards. Chic were a band smart and subtle enough to combine both: an appreciation of escapism and a keen understanding of exactly what was being escaped.*

Guitarist Nile Rodgers came to disco with a unique perspective. He had taken acid in his teens, which turned him on to first psychedelic rock and then radical politics. He was tear-gassed on anti-war protests, joined the Black Panthers while still in high school and busked protest songs in Central Park. Despite a rocky first encounter, this off-the-wall black hippie forged an abiding friendship with the more strait-laced Bernard Edwards, a prodigiously gifted bassist also working the New York circuit. In 1977, inspired by the arch glamour of Roxy Music, they formed Chic.

Given his background, it was inevitable that Rodgers would view disco's pleasure-seeking ethos through a socio-political lens. 'When the Vietnam War stopped, it made us feel empowered,' he told writer Peter Shapiro, 'The protesters joined forces: It was the Black Power movement with the gay power movement with the women power movement. We were all out there protesting

* Odyssey's 'Native New Yorker' (1977) is an underrated example of this kind of ambivalence: pure desperation ('There you are, lost in the shadows, searching for someone / To set you free from New York City') cloaked in a candy-sweet melody.

together. And when that ended, it masqueraded as liberation for everybody . . . So what happens? You celebrate. And that's all that happened. In the middle 70s, we started celebrating the victories.'

But at the same time, Rodgers was keenly aware of the enduring problems in the local and national economy – the battles not yet won. This ambivalence fed directly into Chic's debut single, 'Dance, Dance, Dance (Yowsah, Yowsah, Yowsah'). While many revellers took the song as a simple call to party, some may have recognised the archaic word 'yowsah' from Sydney Pollack's 1969 movie *They Shoot Horses Don't They?* The film told the story of dance marathons during the Great Depression, in which couples danced till they dropped in order to win much-needed prize money. In that light, the song's demand to 'keep on dancing' seemed crazed with desperation.

Fortunately for Chic's career prospects, all most listeners heard was the slickly addictive groove generated by Rodgers, Edwards and drummer Tony Thompson. Similarly, the millions who made Chic's third single, 'Le Freak', one of the biggest-selling singles of all time were oblivious to its origins in a pissed-off jam session after Rodgers and Edwards were turned away from Studio 54 on New Year's Eve 1977. Fuelled by anger at the elitism of 'fucking Studio 54 and those assholes', it was originally titled 'Fuck Off'.

Chic's enjoyment of double meanings, which harked back to soul's mid-1960s 'brewing period', was only partly an artistic strategy. It also reflected the differences between Rodgers and Edwards. 'That was the bargain between Bernard and I,' Rodgers told Chic's biographer, Daryl Easlea. 'Mr Black Panther was never going to be politicising our music. That meant that the lyric writing had to be clever as hell . . . It pains me that people don't understand the intellectual content of our lyrics after how hard we worked on a song.' He told *Blender* magazine that Chic songs have 'DHM – Deep Hidden Meaning'.

But sometimes the meaning was hidden so deep it could not be excavated. 'At Last I Am Free', a ghostly, enervated break-up

song, had been written by Rodgers as a rock track back in the early 1970s, following a disrupted Black Panther demonstration in Central Park at which, bruised and acid-dazed, he stumbled through the police tear gas to the borders of the park, hence the line, 'I can hardly see in front of me'. Once Edwards had developed the lyrics in a more romantic direction – the female singer is blinded by tears rather than tear gas – nobody could have guessed the song's origins.

Sincere though Rodgers's political reading of disco was, it was very much a minority view. A few weeks before his run-in with the Studio 54 door staff, disco went global with the release of John Badham's colossally successful movie *Saturday Night Fever*, the story of Italian-American dancer Tony Manero (John Travolta), who sees disco as his ticket out of working-class Brooklyn. Rodgers sees it as a 'genius' study of racism and class identity, and calls the 2.5-million-selling soundtrack 'as relevant and as valid as when the Sex Pistols are delivering a message', but this seems somewhat excessive for a film which sold a conspicuously white and straight version of the disco dream to Middle America off the back of the Bee Gees' falsettos and Travolta's moves.

If *Saturday Night Fever* whitewashed the multiracial, pansexual melting pot which produced disco, then the Village People fatally caricatured it. The quintet, assembled by French producers Henri Belolo and Jacques Morali, dressed up as a policeman, biker, construction worker, cowboy and Red Indian (Native American is not really the apt term here) and pitched a cartoonishly camp version of gay culture, striking big with 'YMCA', 'In the Navy' and 'Go West'. Even if one could generously read 'Go West' as a paean to the new gay mecca of San Francisco ('I am sincerely trying to produce songs to make the gay people more acceptable,' Morali told *Newsweek*), then there was no denying that most listeners took the Village People as a colourful joke.

By February 1979 disco was a $4 billion industry, worth more than Hollywood, with 20,000 discotheques in operation

across the US. For a solid nine months that year, every single to top the US charts was disco. Inevitably, the sublime warred with the ridiculous. Among the more dispiriting passengers on the disco bandwagon were Rod Stewart, Ethel Merman and Mickey Mouse.* Even Nile Rodgers cannot offer a socio-political defence for them. While the best disco records were still lavished with care, it was now too easily reduced to a formula: syrupy Philly strings + vapid lyrics + a galloping 4/4 beat. 'Too many products, too many people, too many record companies jumping on this kind of music,' Giorgio Moroder told Anthony Haden-Guest. 'I guess it was overkill.' For most Americans, writes Peter Shapiro, disco 'was hearing "YMCA" six times in one night at the Rainbow Room of the Holiday Inn in Cedar Rapids, Iowa, while doing line dances with a bunch of traveling salesmen.'

*

But even as disco became a victim of its own success, savvy talents continued to produce brilliant records of substance. Machine's startling 'There But for the Grace of God Go I' (1979) was the work of one August Darnell, a mixed-race drama-school graduate who had been a member, with his brother, of Dr Buzzard's Original Savannah Band, a witty and eccentric outfit pitched halfway between the penthouse and the ghetto. Hooked up with the otherwise unremarkable Machine, he crafted an unsettlingly catchy parable of middle-class flight gone wrong, in which an Hispanic couple flee the Bronx to raise their daughter in a place with 'no blacks, no Jews and no gays' (a line sung with disconcerting vivacity), only for her to go wild and leave home at sixteen with an older man. The moral: 'Too much love is worse than none at all.'

* As early as December 1975, *Record World*'s disco columnist Vince Aletti had been complaining of muzak versions of disco hits, and the first big novelty hit, Rick Dees' mocking 'Disco Duck', had appeared in 1976.

'There But for the Grace of God Go I', however, stands alone: there is simply nothing else like it in disco, and it was not a major hit. Kenny Gamble's own attempt at message disco, 'Let's Clean Up the Ghetto', recorded with an all-star line-up to raise funds to regenerate inner-city Philadelphia, also flopped, and understandably so – its lyrics about garbage strikes, cockroaches and 'all kind of diseases' would have put a damper on anyone's Saturday night.*

By contrast, some of the most resonant disco records were politicised after the fact by audiences who read generalised sentiments through their own prisms, often to the surprise of songwriters – just as soul fans had reinterpreted the likes of 'Dancing in the Street' a decade earlier. Gene McFadden and John Whitehead, the backroom team who wrote the O'Jays' 'Back Stabbers', were simply celebrating their emergence as name artists after years of feeling unappreciated when they wrote the exuberant 'Ain't No Stoppin' Us Now', but it became a politically loaded anthem among the black community anyway. Equally, Gloria Gaynor's colossal 'I Will Survive', despite being widely embraced as a feminist battle cry, had its roots in more personal concerns: after damaging her spine during an onstage fall, Gaynor had briefly feared her career was over, and recorded the song while wearing a back brace.

Then there was Sylvester James, an out-and-proud gay man who had spent three years in San Francisco's cross-dressing counter-culture troupe the Cockettes before becoming a convert to disco. His 1978 hit 'You Make Me Feel (Mighty Real)' fused his euphoric gospel-trained vocals with producer Patrick Cowley's cantering synthesisers to make a landmark record in the gay disco style known as Hi-NRG, equating 'realness' with

* Featuring the O'Jays, Billy Paul, Teddy Pendergrass, Archie Bell, Lou Rawls and Dee Dee Sharp Gamble, 'Let's Clean Up the Ghetto' was the first single to rally A-list names to a single cause, pre-dating 'Do They Know It's Christmas' and 'We Are the World' by several years.

sexual honesty. Unprepared for success, however, Sylvester resented media focus on his flamboyant sexuality. 'I've never been an advocate of gay rights,' he later told the *NME*. 'There's too much bullshit going on in the community anyway, with discrimination against groups within groups. So how can you go out and ask the world and society to accept your lifestyle when you're not even willing to accept the same lifestyle?'

Perhaps the most famous example is Sister Sledge's Chic-penned 'We Are Family', a reference to the tight bond between the group's four sisters which resonated with black, gay and feminist listeners.* In each case there is a sense of trials having been overcome: depression, heartache, being 'held down'. But Chic's last giant hit added a new and bitter realisation that those trials had not gone away, and the wolf was still at the nightclub's door. Naturally, they called this record 'Good Times'.

*

By 1979 an ongoing strike by Iranian oil workers, followed by the toppling of the Shah by Ayatollah Khomeini's Islamic revolution, had brought about another worldwide energy crisis. In the US, rocketing oil prices pushed inflation even further out of control and the Federal Reserve's drastic measures to lasso it, chiefly stringent interest rates, were about to sink the country into a long recession. The dollar, weak for most of the decade, was now in free fall. On 15 July, President Carter addressed the nation, diagnosing the US with a sense of 'paralysis and stagnation and drift' which amounted to 'a crisis of confidence'. His sobering warning: 'The erosion of our confidence in the future is threatening to destroy the social and the political fabric of America.'

'Good Times' has absolutely no confidence in the future. Even more so than 'Dance, Dance, Dance', it describes the nightlife as a merry-go-round that the singers are too scared to exit. 'I remember the journalists criticising us,' Rodgers told *Blender*.

* Rodgers even claimed that Nelson Mandela told him he became a fan of the song when he heard his prison guards whistling it.

'How could our music be so celebratory and hedonistic when the times were so bad? But we were aware of the historical context.' Indeed, it is laced with knowing references to upbeat Depression-era songs: 'Happy Days Are Here Again' (FDR's 1932 campaign theme) and Al Jolson's 'About a Quarter to Nine'. 'If Dylan was standing in front of a tank singing "happy days are here again", people would say, "Oh, check Bob,"' Rodgers complained to Easlea. 'It would make all the sense in the world.'

'Good Times' is at once a celebration and an elegy. While Bernard Edwards's innovative, prodding bass line kept the song dancefloor friendly, the vocalists Fonzi Thornton, Michelle Cobbs, Alfa Anderson and Luci Martin parroted faintly ludicrous high-life aspirations ('clams on the half-shell and roller-skates, roller-skates') and warned, 'A rumour has it that it's getting late / Time marches on, just can't wait.'

'Good Times' epitomised the melancholy self-awareness at the heart of the best disco: a sense that fun, far from being vapid, is a serious business, hard-earned and easily lost. It went to number one six weeks after an event which became known as 'the day disco died'. *Time marches on.*

<p style="text-align:center">*</p>

In July 1979 Michael Veeck was the promotions manager for the Chicago White Sox baseball team. They had been having a wretched season, and attendance had dropped accordingly, when Veeck hit upon a wheeze. Between games of an upcoming doubleheader there would be a Disco Demolition Derby, and anyone arriving with a disco record to be destroyed could get in for a bargain ninety-eight cents. His partner in crime was radio DJ Steve Dahl, who had been running a campaign against 'the dreaded musical disease known as DISCO' on his show for months.

While there were doubtless sound aesthetic reasons to object to the trashier symptoms of disco fever, Dahl represented an uglier strand in the burgeoning anti-disco backlash. Record-smashing

events had been organised by various shock jocks since 1978, around the same time disgruntled, denim-clad rock fans had begun sporting 'Death to Disco' T-shirts. They were spiritual descendants of the hard-hat vigilantes who had marched through downtown Manhattan in 1970, only this time it wasn't the flag that was seen to be under threat but American manhood itself. In a study of the backlash, one media consultant concluded, 'Obviously, some people dislike disco for being black and gay.' Even those who were not blatantly bigoted, he noted, felt that it lacked 'balls'. This was Nixon and Agnew's politics of resentment in action. Tellingly, the summer of 1979 also saw the birth of Jerry Falwell's deeply homophobic, conservative Christian lobby group, The Moral Majority.

On the night of 12 July Comiskey Park was beyond rammed: 90,000 people crammed into a stadium meant for 52,000. Impatient fans hurled records at players during the first game, along with beer cans and firecrackers. When this game ended Dahl, dressed in combat gear, appeared in a jeep to detonate a box of disco vinyl while leading a chant of 'Disco sucks!' This, to his horror, became the cue for fans to storm the field, wrecking the ground and starting fires. After pleas for calm failed, the riot was eventually broken up by mounted police. The ruckus made national headlines. 'It felt to us like Nazi book-burning,' Nile Rodgers told Easlea. 'This is America, the home of jazz and rock, and people were now even afraid to say the word *disco*. I had never seen anything like that.'

But there is a danger of oversimplifying opposition to disco. Dahl, who denies homophobia, has claimed with justification that disco was merely a lightning rod for Middle America's broader frustrations with the tanking economy and plunging national morale: 'Disco was probably a catalyst because it was a common thing to rally against.' And assaults did not come from white America alone. Chasing affluent new markets, most major black artists sanded down their rough edges to infiltrate either the dancefloor (disco) or the bedroom (soft-focus soul),

and when disco crashed, it hurt black music in general. Jesse Jackson organised boycotts via Operation PUSH, and George Clinton diagnosed disco as 'the Placebo Syndrome' and advocated blasting it with funk on Parliament's 'Bop Gun (Endangered Species)' (1977). 'They're spoiling the fun / We shall overcome,' he snapped, deploying civil rights rhetoric against a new cultural enemy. While the 'Disco Sucks' crew considered disco too black, Clinton deemed it too *white*. The racial politics of disco were, to put it mildly, complicated. 'Every time a person of colour denigrated the work, it became that much easier for the larger society to attack it,' Chic's Alfa Anderson complained to Easlea.

Left-wing punks, meanwhile, disliked disco's perceived mindlessness and apathy, the theme of the Dead Kennedys' 'Saturday Night Holocaust' (1978). New Jersey rock critic Jim Testa, who wrote the lyrics to the Slickee Boys' anti-disco rant 'Put a Bullet Thru the Jukebox' (1978), argued that 'there were a lot of legitimate, artistic reasons to hate disco, reasons that didn't have anything to do with not liking black or gay people'.

The demise of disco has also been exaggerated. The version that died at Comiskey Park was the one espoused by Tony Manero, the Village People and Holiday Inn. Meanwhile, the hardcore devotees kept dancing and the music mutated, as all genres do. Chic went on to produce Diana Ross and Debbie Harry, while Rodgers alone had enormous success with David Bowie (*Let's Dance*) and Madonna (*Like a Virgin*). Disco's counter-culture streak manifested itself in the arch and arty output of ZE Records, where August Darnell reinvented himself as Kid Creole and Detroit's Was (Not Was) marked the advent of the Reagan administration with the funky paranoia of 'Tell Me That I'm Dreaming' (1981). Gay clubs continued to embrace the hyperactive gallop of Hi-NRG, but that carefree era was about to be brought to an end by something far more destructive than the rednecks at Comiskey Park.

On 5 June 1981 the US Centers for Disease Control recorded five gay men in Los Angeles suffering from an as-yet-unnamed

deficiency of the immune system. The following year the disease was officially defined and named: AIDS. Patrick Cowley, the producer who shaped the sound of Sylvester's 'You Make Me Feel Mighty Real', was one of the first fatalities, passing away in November 1982. Sylvester himself died of AIDS-related complications six years later. Carl Bean, who had left music to train as a minister shortly after the failure of 'I Was Born This Way', founded the Unity Fellowship of Christ Church in Los Angeles, and went on to perform pioneering work with black people living with HIV/AIDS. Having sung the lyrics of 'I Was Born This Way', he spent the subsequent decades acting on them.

18

'Dem charge mi fi murdah'

Linton Kwesi Johnson, 'Sonny's Lettah
(Anti-Sus Poem)', 1979

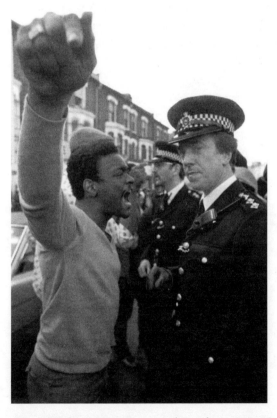

Linton Kwesi Johnson, 2 Tone and Rock Against Racism

A black youth confronts a police officer during civil unrest in Brixton, south London, 11 April 1981.

'Do we have any foreigners in the audience tonight?' Eric Clapton began ominously. The venue was the Birmingham Odeon, the date 5 August 1976. The artist who had done as much as anyone to popularise blues in Britain, and had even covered Bob Marley, was on the brink of earning himself an ignominious place in the history of British race relations.

Clapton, clearly drunk, proceeded to share with his audience his views on immigration, and the need to stop Britain 'being a colony within 10 years'. To this end, he pledged his support to Enoch Powell, the maverick MP whose notorious 1968 jeremiad against immigration, teeming with lurid anecdotes, racist canards and a classical allusion to 'the river Tiber foaming with much blood' had made him persona non grata in mainstream politics but a hero to many Britons. Exiled to the Westminster fringes by Conservative leader Edward Heath, Powell had switched to the Ulster Unionists and in 1976, only months before Clapton's comments, he was at it again, warning that if immigration were not restricted then Britain would see a race war that would make Belfast's tribulations 'enviable'. Shortly afterwards, Sikh teenager Gurdip Singh Chaggar was stabbed to death in Southall, west London, by a white gang. 'One down – a million to go,' responded John Kingsley Read, leader of the far-right National Front (NF).

Formed a year before Powell's 'rivers of blood' speech, the NF was well placed to sweep up anti-immigration voters estranged from the major parties. By the mid-1970s, it was polling surprisingly strongly in by-elections and had a peak membership of around 17,000. 'For the first time, four manifestos were dropping through your letterbox instead of three,' remembers Tom Robinson. 'Knowing what we knew about how Hitler had come to power posing as [the leader of] a legitimate party, there was a strong sense that the far-right parties only needed a foot in the door.' At the same time, the rank-and-file acquired a reputation

for brutality. In June 1974 an NF march clashed with a left-wing counter-demonstration in London's Red Lion Square and student Kevin Gately became the first fatality at a British demonstration since 1919.

This was the sharp edge of British racism, but black Britons also had to contend with a more pervasive cultural variety. The sitcoms *Till Death Us Do Part* and *Love Thy Neighbour* were both intended as satires on blue-collar bigotry but attracted many viewers to whom the terms 'wog' and 'nig-nog' were intrinsically hilarious. The racist stand-up comedy of Jim Davidson and Bernard Manning was also considered uproarious family fare. 'It is very difficult to explain to a white person what it means to be at the receiving end of racial oppression,' the Jamaican poet Linton Kwesi Johnson says with solemn, somewhat intimidating authority, like a schoolmaster faced with an eager but dense pupil. 'Race was everywhere you turned – at school, on the streets, everywhere you went you were subjected to racial abuse . . . That was the order of the day.'

In the last week of August 1976, by chance the same week as the Notting Hill carnival riot, a furious missive appeared in all the major national music papers, signed by several people calling themselves Rock Against Racism. 'We want to organise a rank and file movement against the racist poison in music,' it concluded, adding a tart PS – 'Who shot the sheriff, Eric? It sure as hell wasn't you!' – and a PO box address to which interested readers could write for more information. It was the creation of photographer Red Saunders, a veteran campaigner and agitprop theatre performer who had been infuriated by Clapton's outburst. 'When 400 letters arrived I thought, shit, this is serious,' recalls Saunders.*

Although RAR coincided with punk, it was far bigger than

* Clapton was remarkably unrepentant. Even by 1978 he was telling *Melody Maker* that Powell was 'the only bloke who was telling the truth, for the good of the country'. But David Bowie, whose flirtation with fascist imagery had been another spur to RAR, was quick to recant.

that, and when we talk about punk politics we really mean the pan-generic alliance that formed under the RAR umbrella: the activist end of punk, the multiracial sound of 2 Tone, the leading lights of British reggae, and standalone artists such as Tom Robinson. This cause was Britain's belated equivalent to civil rights and Vietnam. Over the next few months and years, RAR would mobilise bands and their fans on an unprecedented scale, and help to inspire British pop's first real topical song boom. 'There was a window of opportunity,' says Saunders. 'The train came into the platform and milling around were all these extraordinary people: Rastas, punks, lefties, all disenchanted odd people with no particular home, and the doors opened and they all stepped on board and off we went.'

*

Linton Kwesi Johnson was born in rural Jamaica in 1952, and raised by his grandmother in a village with no running water, streetlights or television. His introduction to poetry was the Bible; he could recite Old Testament verses by heart. In 1963 he joined his mother in south London, where he was shocked by the casual prevalence of racism. Even some of his teachers, he discovered, 'couldn't hide their contempt'. He remembers the aftermath of Powell's speech: the assaults and arson attacks on immigrant families. One day his sixth-form debating society had as its guest speaker 'a remarkable woman' called Althea Jones, a key figure in the British Black Panther movement, a body sympathetic, though not formally connected, to the US organisation. He began attending Youth League meetings and selling copies of the *Black People's News*, before becoming a full member. Via the Black Panthers, and the Trinidadian publisher and activist John La Rose, Johnson was introduced to Caribbean poets such as Derek Walcott and Kamau Brathwaite, as well as hipster favourites like Sartre, Neruda and Hesse, and learned more about black liberation movements in the US and Africa. 'It was a period of rising consciousness among young black people.'

After the Black Panthers dissolved in 1972, Johnson attended Goldsmiths College and went through a period of cultural nationalism. 'I was attracted to Rastafari because of its obvious anti-colonial sentiments and its Garveyite roots,' he says. 'But I never became a Rasta. I couldn't reconcile myself to the idea of Haile Selassie being God. Neither could I reconcile myself to the wholesale repatriation of black people back to Africa. It would be like turning back the clock of history.'

His first poems, published by John La Rose's Race Today Collective, explored violence in the clubs and on the streets. 'For me, writing verse was a political act and poems were cultural weapons in the black liberation struggle,' he says. 'I tried to make the music as entertaining as possible without distracting from the seriousness of the lyrical content.' One influence was the Last Poets: 'They were doing jazz poetry, and I wanted to do reggae poetry.' He began writing alongside a trio of Rasta drummers, Rasta Love, that he knew from school. 'I would improvise words to go with the rhythms and chants. I kept on hearing music within the language.'

By the time Johnson came to record his first album, *Dread Beat an' Blood*, with pioneering British reggae musician Dennis Bovell over one weekend in 1978, he had a considerable back catalogue of poems – in fact, most of the tracks had first appeared in a 1975 volume of verse of the same name. He still describes himself as a 'cultural activist' rather than an artist, and he set about his task with a journalist's attention to detail. 'It Dread Inna Inglan (For George Lindo)' honoured a black Bradford factory worker who was wrongly jailed for robbery and later freed thanks to the efforts of Race Today. 'Man Free (for Darcus Howe)' celebrated the release of the *Race Today* magazine editor after three months in prison for allegedly assaulting a police officer. On *Forces of Victory* (1979), he homed in on an issue which even the most politically disengaged black man could not ignore: the hated Sus law.

The law, which allowed police to detain anyone suspected of

having 'intent to commit an arrestable offence', dated back to the 1824 Vagrancy Act but had lain dormant for several decades until police resurrected it in earnest in the 1970s, aiming it disproportionately at black youths. Its most feared practitioners were the Special Patrol Groups, or SPGs, and its application was habit-forming. Young black men were stopped with such vindictive regularity that an us-and-them mentality was inevitable. 'We used to make jokes about how black men never jogged because if a black man was seen running down the road everyone would immediately assume he was a criminal,' says Don Letts. 'I used to leave to go to the cinema half an hour early because I knew I'd probably get pulled over and miss the beginning of the film. It was almost funny. But then you'd read headlines about people actually getting killed.'

Like most young black Britons, Johnson had been stopped and searched countless times. In 1972 he had even been wrongly charged with assault after writing down the identification numbers of police officers who were beating up some black youths. Johnson's own experiences, and those of his friends, coalesced into the story of Sonny. 'Sonny's Lettah (Anti-Sus Poem)' is an epistolary poem written by a young immigrant to his mother back home in Jamaica. Like many of Johnson's poems, it was written long before it was recorded, some time in the mid-1970s. Johnson doesn't need to summon his fearsome indignation or explain why Sus is unjust: he just tells one man's story.

The letter starts with the sender's address: Brixton prison. Sonny is hesitant, apologetic: 'I don't know how fi tell yu dis . . . I really did try mi bes.' He has promised to look after his little brother Jim so when three policemen stop Jim at a bus stop and start beating him, Sonny intervenes. He punches one policeman, who hits his head on a dustbin and dies. The music, lithe and suspenseful, stops dead too. Sonny explains that Jim has been arrested under Sus, and he, Sonny, has been charged with murder. But he does not fulminate against the police, nor bemoan his own plight: his only thought is to reassure his mother that

somehow things will be OK, even though the listener knows they will not. To examine an issue through an individual's suffering is an emotive enough strategy; to do so in a conversational, first-person narrative voice is more potent than a dozen slogans. But slogans, during that fractious period, had their place too.

*

After its initial letter appeared in the music papers, RAR snowballed with prodigious speed. Although it occupied premises owned by the Socialist Workers Party (SWP), it did not entangle itself in theory or factionalism, but cleaved tightly to a simple message (anti-racism) and means of delivery (music). 'It was a raggedy-arsed united front,' says Red Saunders. 'People understood this was an emergency and we had to put aside our differences.' RAR's first event was held in a London pub in November 1976, the idea being that people would come for the music and be converted to the cause.

While black youths were radicalised by police harassment, their white contemporaries were inflamed by more blatant forms of racism, in the shape of both the NF and the smaller, more thuggish British Movement (BM), which appealed to skinheads and football hooligans who preferred street battles to the ballot box. In August 1977 a National Front 'anti-mugging' march through Lewisham, south London, turned into a pitched street battle with the SWP, inspiring the formation of the broader based Anti-Nazi League (ANL). 'As the police prepared to charge,' recorded RAR's Dave Widgery, 'an Afro-Caribbean woman who had been watching from the top floor of her home hoisted her hi-fi speaker on to her windowsill. It was playing Bob Marley, "Get Up Stand Up".'

Widgery was a vigorous intellectual and prose stylist, connecting RAR to everything from free jazz to Russian constructivism. Describing the movement as 'garage politics', as in garage rock, he saw RAR and the ANL as 'an opportunity . . . to take the revolutionary cultural spirit of the May events in 1968 and translate

them into the British racial crisis of the late seventies'. In the first issue of RAR's magazine, *Temporary Hoarding*, he sounded a musical call to arms: 'We want Rebel music, street music, music that breaks down people's fear of one another. Crisis music. Now music. Music that knows who the real enemy is.' The ANL and RAR began collaborating on their first major musical event: a huge open-air concert in Victoria Park, east London, on 30 April 1978.

The concert was timed to drum up anti-racist turnout for the local elections in May (the NF was strongest in the East End) but for the RAR founders, who had been politicised by the upheavals of spring 1968, it was also a significant decennial. The concert began at 1.30 p.m. and, midway through a set by punk band X-Ray Spex, 10,000 marchers arrived from their rally in Trafalgar Square. Throughout the afternoon coaches kept arriving from around the country, bearing a colourful medley of punks, hippies, trade unionists and local activists; by the end of the day, the crowd was 80,000 strong. The line-up established the breadth of the RAR coalition: the Clash, X-Ray Spex and Sham 69's Jimmy Pursey representing punk, Steel Pulse from the reggae scene, and committed supporters the Tom Robinson Band, who printed RAR's logo and Widgery's 'Rebel music' manifesto on the sleeve of *Power in the Darkness*. In a stroke the carnival cleansed punk of its careless swastika-sporting political ambiguity. 'This was their Woodstock and their Grosvenor Square,' declared Widgery.

By the end of the year RAR had staged 300 concerts and five carnivals, with as broad a musical base as possible. Following the lead of Dennis Bovell's group Matumbi, the mid-1970s saw a wave of British roots reggae bands, chiefly Steel Pulse from Birmingham and Aswad, Black Slate and Misty in Roots from London, who performed vivid urban narratives with considerable flair. They chose to tour with punk bands and Steel Pulse recorded the custom-made RAR anthem 'Jah Pickney – R.A.R.' The reggae–punk alliance also produced RAR regulars the Ruts, who

allied themselves with Misty in Roots' People Unite! Collective. Though obviously indebted to 'White Riot', The Ruts's 'Babylon's Burning' was even more potent an assimilation of reggae's sense of dire emergency, and 'S.U.S.' was co-written by a black associate of the band who had experienced the Sus laws first-hand. Linton Kwesi Johnson criticised RAR early on for being just 'entertainment', but gradually came round. 'Initially I was a bit cynical,' he admits, 'but later on I began to appreciate they were doing an important job. It brought a lot of people who wouldn't necessarily come together under the same banner.'

Dennis Bovell also applied his production skills to female trio the Slits (*Cut*, 1978) and forbidding post-punks the Pop Group (*Y*, 1979). Having absorbed reggae as teenagers at parties in Bristol's largely Caribbean St Paul's district, the Pop Group threw funk, free jazz, beat poetry, situationism and radical politics into the frothing mix. They toured with Johnson, played Scrap the Sus benefits and sang scolding condemnations of Western society (sparing neither the band nor their listeners) which were heavy weather even given the politicised tenor of the times: 'We Are All Prostitutes', 'Forces of Oppression', 'There Are No Spectators'. 'I don't see the point in entertaining just now,' the Pop Group's Gareth Sager frowned to the *NME*. 'It's pure escapism. People have this ridiculous conception that rock'n'roll is teen rebellion. It's pathetic.'

But the most vivid illustration of RAR's 'Black and white, unite and fight' ethos was a new band from Coventry called the Specials. 'In '76, there were very few black and white musicians playing together on stage,' says Red Saunders. 'Suddenly there were the Specials. When I saw them I thought, fuck me, this is job done.'

*

By the time punk broke in 1976, Jerry Dammers was already twenty-four, with a string of failed bands behind him. The son of a radical clergyman, he was a talented organist who had

marched against apartheid, but it took him several years to find the right formula of music and politics. In 1977 he recruited some local Coventry musicians into a band he called the Automatics, later renamed the Special AKA the Automatics, then the Special AKA, and, finally, the Specials: five white members and two black. Their initial attempts to merge punk and reggae, as the Clash had recently done, were disjointed and unconvincing. A tour with the Clash and a brief spell under the wing of Bernie Rhodes in summer 1978 proved equally disappointing, but Dammers had learned some important lessons. From Rhodes he absorbed the importance of a striking image, while a violent incident on the Clash tour, in which support band Suicide were pummelled by skinheads, gave him the idea for a thoroughly integrated music.

During his teens he had seen skinheads dancing to ska, and he realised that the genre dovetailed perfectly with punk's pogoing energy. To illustrate this new approach, he designed a character he christened Walt Jabasco: a stylish, pop-art hybrid of Jamaican rude boy and British skinhead who would become the figurehead of Dammers's significantly titled new label, 2 Tone. Name, logo and line-up all spelled out the same message of black and white in harmonic juxtaposition. In May 1979 the Specials released their commanding debut single, 'Gangsters', on the heels of which came further 2 Tone releases by fellow newcomers Madness, the Selecter and the Beat. Another multiracial Midlands band arrived, the reggae group UB40, addressing issues such as African famine ('Food for Thought'), apartheid ('Burden of Shame') and unemployment ('One in Ten') with impressive grit and acuity.

'It *was* about starting the revolution,' Dammers told *Mojo*'s Lois Wilson. 'I felt we had to become part of [the skinhead] scene and change it so it didn't become affiliated with the far right.' *The Specials* (1979) advertised a multiracial crew finding strength through solidarity in a city where love is a letdown and violence lurks around every corner. In 'Concrete Jungle' (named

after a Bob Marley song) Roddy Byers reassures himself, 'Glad I got my mates with me,' the band's own unity juxtaposed with the thuggish camaraderie of a football hooligan's chant. The only problem being that the unity was so very fragile. 'There were seven people in that band,' Specials frontman Terry Hall told me in 2003. 'Are you going to tell me we all had exactly the same political beliefs? Well we didn't. Absolutely not. But we were walking on stage each night and saying, "This is what we all believe." I think it's tricky.'

As the general election loomed, RAR sent forty bands whizzing up and down Britain's motorways on the get-out-the-vote Militant Entertainment Tour, using slideshows of slogans and radical imagery to obviate the need for long speeches from the stage. The Labour party even co-opted the group's name for a music-press advert: 'Don't just rock against racism, vote against it.' The NF, meanwhile, staged a final show of strength in Southall, home to one of the country's largest Asian populations, on 23 April, St George's Day. This time, though, the ANL ended up fighting the police, who were protecting the NF march, rather than the fascists; there was almost one officer for every demonstrator. At the end of a day of brutal confrontation, thirty-three-year-old New Zealander Blair Peach, a school teacher and ANL activist, was dead, apparently beaten to death by SPG officers, although nobody was ever prosecuted. Another victim of the SPG was Clarence Baker, manager of Misty in Roots, who was left with a fractured skull and a blood clot in his brain. Peach's funeral, as the Pop Group's Mark Stewart told Simon Reynolds, was a tense affair: 'Everyone had their fists up in the air as the police helicopters circled overhead while they were putting this poor bloke into the grave. It was a fiery time.'

Almost uniquely in British pop, it is possible to reconstruct the key events of the period from the topical songs they inspired. Peach was memorialised in Linton Kwesi Johnson's 'Reggae fi Peach', while Baker ('no troublemaker') was mentioned by his friends the Ruts in 'Jah War', a fiery account of Southall which

was refused airplay lest it prejudice the trial of some of the demonstrators. Another celebrated martyr was Liddle Towers, a thirty-nine-year-old amateur boxer whose death in police custody in 1976 inspired the Angelic Upstarts' 'The Murder of Liddle Towers' and the Tom Robinson Band's 'Blue Murder'. The 'newspaper writing' that John Lennon had dramatically failed to master had finally arrived in Britain, and not a moment too soon.

*

'I haven't got much to say,' said Terry Hall on stage at Hampstead's Moonlight Club on the night of 2 May. 'It's the eve of the election and it's up to you.' If, with hindsight, Hall's attitude to a pivotal event in post-war British history seems rather lacksadaisical, then it was not uncommon at the time. The embittered alienation out of which punk had flowered had come about under a Labour administration and those who had not been scrutinising Margaret Thatcher's policy statements believed things could hardly get worse.

Had Callaghan declared an election earlier, he might have clung to power, but he gambled on economic recovery and lost. Between November and March, the so-called Winter of Discontent, the country seemed to unravel in the face of epidemic industrial action. Industry after industry was paralysed by an unprecedented wave of strikes, and Britons were bombarded by media images of the more dramatic consequences, from empty supermarket shelves to mounds of uncollected rubbish. On 28 March the Conservatives forced a no-confidence motion, which the government lost by a single vote, and thus was forced to call an election, the result of which was a foregone conclusion. 'It was like being on a liner in mid-ocean when all the engines have stopped,' Downing Street policy adviser Bernard Donoughue told writer Andy Beckett. 'Just drifting silently.'

To many, party politics seemed an irrelevance when the whole system was rotten, but some sounded warning bells about the

incoming prime minister. Joe Strummer wanted to feature a collage of Thatcher's face and a swastika on the cover of the Clash's election-day release, *The Cost of Living* EP (Mick Jones vetoed the idea) and Linton Kwesi Johnson had scented trouble the previous January when the Tory leader had told an interviewer: 'People are really rather afraid that this country might be swamped by people with a different culture.' Compared to Powell's foaming Tiber, this was mild stuff but it sent out a powerful message. 'They've created a lot of mischief, a lot of uncertainty among both black and white people,' Johnson told the *NME* in April. His opinions were controversial enough for the BBC to postpone a documentary on him, *Dread Beat an' Blood*, until after the election. In the film, Johnson recited the lyrics to 'It Dread Inna Inglan': 'Maggi Tatcha on di go wid a racist show . . .'

When the ballots were tallied, the Tories had a majority of forty-three seats and the National Front's vote had collapsed to less than 200,000. Certainly, the activities of the ANL and RAR had blunted their advance. 'We didn't stop racism,' says Saunders. 'What we stopped was the emergency. We plugged the hole and stopped us being drowned and they all went back down their sewers.' But Johnson emphasises another, more sinister factor: 'They lost ground because the Tories were able to win over a significant section of their constituency with their own racist policies.'

Their hopes of electoral respectability in shreds, the NF and BM turned their attention to the streets and, disturbingly, punk shows. While the NF's own musical endeavours, Punk Front and Rock Against Communism, featuring white-power bands such as the Dentists, proved short-lived, racist bootboys successfully latched on to certain existing acts. Most notoriously, they hijacked the boisterous, working-class punk scene known as Oi!, much to the disgust of many of the bands. Sham 69 gigs, meanwhile, became, in the words of the *NME*'s Nick Kent, 'frightening near-massacres', with mobs of skinheads routinely rushing the

stage despite Jimmy Pursey's pleas for calm. The singer's incoherent politics didn't help. In one breath he would call for racial harmony or complain about the 'system's oppression', while in the next he would glorify working-class patriotism. 'Pursey was so brave,' counters Saunders. 'He was on stage saying "I'm for Rock Against Racism," when half his fans – half his *road crew* – were NF. I don't know how the poor bloke functioned.'

Bizarrely, they also flocked to the multiracial 2 Tone crew. When Madness played London in October their support band were driven off the stage by howls of *sieg heil*. The group's response left much to be desired. 'We don't care if people are in the NF or the BM or whatever, so long as they're behaving themselves, having a good time and not fighting,' new member Chas Smash told the *NME*. Singer Suggs was more circumspect: 'I'm all for these sociological lyrics, I just can't be bothered to write 'em.' But the Specials, who, unlike Madness, had black members, weren't prepared to ignore the skinheads in the hope they would go away. When a contingent started *sieg heil*-ing at Brunel University, some Specials jumped off the stage, evicted them and returned, triumphantly, to play the anti-racist 'Doesn't Make It Alright'.

If only the Specials' internal tensions could have been dealt with so swiftly. During their fractious, exhausting US tour in early 1980, some members chafed at Dammers's principled asceticism: while he, on their behalf, shunned limousines and fancy hotels, singer Neville Staple protested, 'Fuck that, I'm from the streets – I want to live a bit.' When Dammers proposed cancelling the band's summer tour of UK seaside resorts in order to get back in the studio, he was outvoted seven to one, underlining his isolation.

More Specials (1980) was queasy, tense, despairing. 'Every day someone left,' singer Lynval Golding said of the recording. 'It was horrible.' But it was not the worst thing to happen to Golding that summer: he was savagely attacked by racists in north London for walking down the street with two white girls,

an incident he vividly described on 'Why?'. The Specials' autumn tour was also plagued by violence. With so many distractions, they weren't quite as politically active as they might have been. 'We found it hard to address all the world's problems,' Roddy Byers told writer Dave Thompson. 'Our own problems were challenging enough.'

During that benighted tour, however, Dammers was inspired to write the Specials' last, and greatest, single. Driving through Britain's inner cities in the tour bus, he witnessed the consequences of the worst recession since the war. By the end of the year unemployment would hit 2.8 million, with young and black people especially affected. 'In Liverpool all the shops were shuttered up, everything was closing down,' he told the *Guardian*'s Alexis Petridis. 'You could see that frustration and anger in the audience . . . It was clear that something was very, very wrong.'

Dammers had heard a song called 'Ghost Town' by the Nips and liked the title. The urban blight he had witnessed on tour merged with his own depression over the imminent demise of the band. '"Ghost Town" was about my state of mind and the break-up of the Specials,' he says. 'But I didn't just want to write about me so I tried to relate it to the country as a whole.' In this light, the line, 'Bands won't play no more / Too much fighting on the dancefloor' seems to describe more than just external violence. 'Everybody was stood in different parts of this huge room with their equipment, no one talking,' bassist Horace Panter told Petridis. 'Jerry stormed out a couple of times virtually in tears . . . It was hell to be around.' Guitarist Roddy Byers, who was drinking heavily, tried to kick a hole in the wall, almost triggering their eviction from the studio. 'No! No!' Dammers beseeched the studio engineer. 'This is the greatest record that's ever been made in the history of anything! You can't stop now!'

If 'Ghost Town' is not quite the greatest record in the history of anything, then it is certainly up there. The music perfectly dramatises the lyric, crawling out of a spectral fog – is that wail a cold wind or a distant siren? – with an organ riff redolent of

a deserted fairground. The aural landscape is so vast that each member sounds disconnected from the next: Hall's chirpy memories of the 'good old days', Golding's dread murmur ('People getting angry'), Staple's righteous fire, Rico Rodriguez's long elegiac trombone solo, and that ghastly chorus of taunting wraiths. The record does not so much end as lose the will to go on, sinking back into the fog. It is the negative image of a song like 'Babylon's Burning': hollowed out rather than crammed with incident, smouldering instead of blazing. Like all great records about social collapse, it seems to both fear and relish calamity. The ghost town is theirs to haunt.

The Specials' death throes coincided with dangerous spasms in the body politic. By the time 'Ghost Town' reached number one in July, dozens of British cities would be aflame. 'You didn't have to be a prophet to realise that there was going to be some kind of reaction,' says Linton Kwesi Johnson. 'To me it was obvious that sooner or later there was going to be some kind of explosion.'

*

During Thatcher's first two years in office, relations between black Britons and the police went from bad to worse. In April 1980 residents of the St Paul's district of Bristol rioted against the hated SPG. The following January the Metropolitan Police was accused of callous insensitivity in the investigation of a fire which killed thirteen black revellers at a birthday party in New Cross, south London.* Johnson was among the members of the New Cross Massacre Action Committee, which helped to organise a Black People's Day of Action, a 20,000 strong march to Hyde Park on 2 March.

With black Britons now convinced that the police were at best

* A 2004 inquest reached an open verdict but strongly suggested that the fire had indeed been accidental rather than arson. However, the police and media's apparent indifference to the case had been an affront in itself. UB40 included a reference to the case on 'Don't Let It Pass You By' (1981).

uncaring and at worst actively hostile, in April 1981 the Met launched Operation Swamp 81, a massive campaign of stop-and-search in Brixton, tactlessly named after Margaret Thatcher's speech about being 'swamped' by immigrants. After almost a thousand people were questioned, violence and looting broke out on the evening of Saturday the 11th. Overturned police vans were used as barricades, a double-decker bus was hijacked and driven at riot police, and a local pub, loathed for its racist door policy, was burned down. The rioters' behaviour was clearly disproportionate but one had to be remarkably obtuse to ignore the cumulative impact of years of harassment and soaring unemployment. Unfortunately, Margaret Thatcher *was* remarkably obtuse. Even as Home Secretary Willie Whitelaw announced a public inquiry, chaired by Lord Scarman, Thatcher declared, 'Nothing, but nothing, justifies what happened,' and praised the 'marvellous' police.

Another figure that failed to enter Thatcher's moral calculus was the thirty-one racist killings that police had recorded since 1975, not to mention the many injuries, countless unreported assaults, and left-wing bookshops and black community centres set ablaze. During the spring the Specials marked some of the deaths with anti-racist benefit gigs and, by some sinister fluke of timing, 'Ghost Town' was on its way up the charts as inner-city Britain finally exploded.

On 3 July, while the Specials were playing RAR's swansong carnival in Leeds, furious Asians besieged a pub gig by three Oi! bands in Southall, battling skinheads and policemen alike, even though at least one of the bands, the Business, was avowedly anti-racist. Simultaneously, the arrest of a black man in Toxteth, Liverpool, sparked four days of intense rioting, with fierce street battles, rampant arson and the first ever deployment of CS gas in mainland Britain. Disturbances also erupted in Manchester and London that week. Then, on 10 July, rioting became epidemic: Brixton in London, Handsworth in Birmingham, Chapeltown in Leeds, Sheffield, Newcastle, Blackburn, Leicester, Nottingham,

Portsmouth, Edinburgh, on and on and on. While some out-breaks were prompted by specific scuffles or arrests, others seemed to be merely the visceral manifestation of a national mood, fuelled by cathartic exhilaration rather than focussed fury. That old alarmist Enoch Powell predicted 'civil war'. And this was the precise point at which 'Ghost Town' finally reached the top of the charts. 'It was frightening,' Hall told *Mojo*. 'We were breaking the news as it happened.'

Of course, 'Ghost Town' was not *about* the riots, but its three-week chart reign felt like a premonition fulfilled, a song waiting spectrally in the wings until people were ready to enact what it seemed to prophesy. It was while the Specials were at *Top of the Pops* to perform the song that Hall, Golding and Staple informed Dammers they were going to leave. Dammers, John Bradbury and Horace Panter pressed on as the Special AKA, while the departing trio reappeared as Fun Boy Three in November, releasing the ominous 'The Lunatics Have Taken Over the Asylum' three weeks before Lord Scarman published his report on the first Brixton riot.

Scarman concluded that 'complex political, social and economic factors' had created 'a disposition towards violent protest', blaming racial disadvantage, inner-city deprivation and appalling relations between the police and the local community.* Thatcher, who stubbornly refused to accept any connection with unemployment, implemented only a few of Scarman's recommendations and concentrated instead on building an arsenal of state-of-the-art anti-riot gear.

Throughout that year Linton Kwesi Johnson was unexpectedly silent. As soon as the disturbances had begun, his phone began to ring, but he refused all interview requests. 'There was a rather nasty little journalist who tried to say that I, Linton Kwesi Johnson, was personally responsible for a generation of semi-literate young blacks who were hellbent on violence, which is of

* The Sus law had already been repealed in August, in a bill passing through parliament even as the riots broke out.

course a nonsense,' he says. 'So you have to know when to speak out and when to keep your mouth shut.'

His response came in his own time, in the form of 1983's *Making History*, on which he talked of New Cross, Brixton, Toxteth, and the events of that landmark year. 'What I was trying to do with my verse was to chronicle the contemporary history of blacks as it was being made,' he explains. 'Unlike African-Americans, who had a history going back hundreds of years, we were just making ours now. When history is written it's often written from the point of view of the dominant class. It was important that our side of the story was told.'

19

'Bragging that you know how the niggers feel cold'

The Dead Kennedys, 'Holiday in Cambodia', 1980

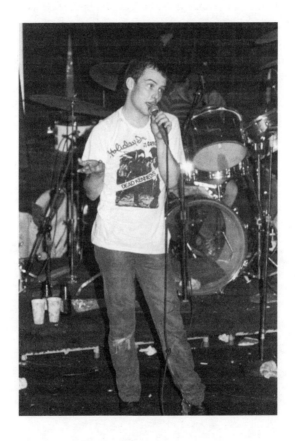

Punk and the hippie legacy

Jello Biafra wearing a 'Holiday in Cambodia' T-shirt during the Dead Kennedys' show at the Whisky a Go Go in Los Angeles, June 1980.

One night in the middle of 1979, Jello Biafra and Bruce 'Ted' Slesinger, respectively singer and drummer of Bay Area punk band the Dead Kennedys, were on their way to a concert by Pere Ubu. The band was only a year old but already notorious for its name, which, Biafra said, referred to the events which 'torpedoed the American dream'. Their debut single, 'California Uber Alles', was only just on the shelves.

Biafra was sounding off about politics, as was his wont, and Ted said, 'Yeah, Biafra, you got such a big mouth, you should run for president. No, no! Run for mayor!'

So when he got to the Pere Ubu show, Biafra told everyone he met that he was running for mayor. 'What's your platform?' they asked. He wasn't sure, so he grabbed a felt-pen and a wet napkin and started blurrily jotting down whatever policies came into his head. True to his songwriting style, his ad hoc manifesto was a combination of serious, radical ideas (legalised squatting; a ban on cars within the city limits) and Yippiesque provocations (an official Board of Bribery; compulsory clown costumes for businessmen). Biafra secured a place on the ballot, campaigned in a cheap suit and borrowed shoes, and issued ludic slogans such as 'There's Always Room for Jello' and 'Apocalypse Now – Vote Biafra'. A local TV reporter concluded that he 'would be a joke except he's too smart'.

Even before Biafra announced his maverick candidacy, it was an unusual election. The acting incumbent, Dianne Feinstein, had taken office the previous December after Mayor George Moscone and Supervisor Harvey Milk were shot dead by former supervisor, Dan White. The murders inflamed the gay community, to whom Milk had been a heroic, crusading figure. Furthermore, the killings came just days after the mass suicide in Guyana of 909 followers of the San Francisco-based People's Temple: the so-called 'Jonestown massacre'. Following these twin tragedies,

an editorial in the *San Francisco Examiner* described 'a city with more sadness and despair in its heart than any city should have to bear'.

White's trial highlighted tensions between the city's police and gay community; some policemen sported 'Free Dan White' T-shirts. On 21 May, Milk supporters reacted with howls and moans to the news that a sympathetic jury had acquitted White of murder and opted instead for involuntary manslaughter. In what would be dubbed the White Night riots, an outraged mob besieged City Hall and battled riot police for several hours. Biafra's election platform included a plan to erect statues of White around the city for citizens to pelt with eggs and tomatoes, but he reserved his real contempt for Feinstein who, as president of the Board of Supervisors, had stepped into Moscone's shoes. Despite being a Democrat, she had tended to vote with the board's centrist bloc, often siding with White and against Moscone. 'She was a mean, hateful witch who didn't even bother to hide her contempt for the disadvantaged,' Biafra told punk historians Jack Boulware and Silke Tudor.

Come election day, Biafra polled 6,591 votes – 4 per cent of the ballot – and placed fourth behind Feinstein, chief rival Quentin Kopp and a drag queen named Sister Boom-Boom. Between them, Biafra and Boom-Boom peeled off enough protest votes to force the two main contenders into a run-off election, which Feinstein won.

What the ambitious, charismatic Biafra did not expect is that during the quarrelsome evolution of US punk rock, he would experience the same type of backlash that the Clash had endured in England. 'I never voted for Jello to be mayor,' punk scenester James Angus Black told Boulware and Tudor. 'I didn't vote for Jello to be king punk rocker . . . Most of the kids involved in that scene had enough of people telling them what to do. They just wanted someplace to hang out and get high and listen to music, and have fun and forget about all the bullshit for awhile. And here came Jello, "*Wha wha wha*, you shouldn't be doing that, you should be more political." He was just another authority figure.'

The Dead Kennedys, 'Holiday in Cambodia'

*

The best thing about punk rock was that it could be anything you wanted it to be. The trickiest thing about punk rock was that it could be anything you wanted it to be. In the US, as in the UK, the key figures attempted to impose their own agendas on this shifting mass, and then cursed their rivals when it shifted in the 'wrong' direction, which it always did sooner or later. One difference was that the Sex Pistols and the Clash injected politics into British punk's bloodstream from the start; whether other bands chose to embrace or reject it, it was part of the mix. American punk, however, was initially defined by the Ramones and the staff of *Punk* magazine, and they couldn't have cared less about making big statements. 'It had no political agenda,' writes *Punk* founder Legs McNeil. 'It was about real freedom, personal freedom. It was also about doing anything that's gonna offend a grown-up. Just being as offensive as possible.' This was McNeil's ideal; it was not Tim Yohannan's.

Yohannan, who died in 1998, was, depending on your perspective, US punk's hero or villain *ne plus ultra*. Famously difficult and doctrinaire, he wrested the tiller from the likes of McNeil and steered punk from its trashy, reckless childhood into its tough and angry adolescence, and though he didn't do it alone, he became political punk's propagandist-in-chief.

In 1977 Yohannan was already in his thirties, born within a few months of Malcolm McLaren and Bernie Rhodes and equally shaped by the ructions of the 1960s. He was working in a warehouse at the University of California in Berkeley when he befriended student Al Ennis and the pair started up a radio show, *Maximum Rocknroll*, to play all the new punk records they were obsessively collecting. Over time, Yohannan's personal politics came to the fore. He set up the East Bay branch of Rock Against Racism and invited political activists on to the show as well as musicians. Sternly opposed to drink, drugs, sexism and bigotry of any kind, he was Legs McNeil's worst nightmare. Another

opponent was Bill Graham, the promoter who dominated the Bay Area's concert scene and who represented, to the punks, the worst aspects of hippie capitalism. 'The rebels in the sixties fought the establishment but in San Francisco a lot of them *became* the establishment,' says Biafra. 'If they had any reaction to punk at all it was very negative.'

'Both Tim and I wanted to create a vibrant new counterculture that would replace the hippies and maybe even ultimately transform culture and society in big ways,' Yohannan's colleague Jeff Bale told Boulware and Tudor. 'Tim wanted to revolutionise the kids. That was his plan. Even though we were much more cynical than we had been in the sixties, we felt like, why couldn't we generate a whole new youth movement?'

'We were very close friends,' says Biafra. 'He told me why he was a socialist and not an anarchist: "Anarchy's all very well as a concept but you need some kind of government to transfer the wealth from people who have too much to people who have too little." And I agree with that.'

Biafra was born Eric Boucher in Boulder, Colorado. In 1969, when he was a precociously intelligent schoolkid of eleven, his music teacher brought her boyfriend to visit the class and said, 'Hey, kids, this is a real Air Force pilot.' Eric piped up with a question about how it felt to bomb children in Vietnamese villages. After a chilly silence the teacher said, 'Oh, well, Eric reads a lot of newspapers. Next question.'

At home, his parents, a librarian and a social worker turned poet, encouraged Eric not just to watch the news avidly but to discuss it. 'There were one or two cartoon shows when I was home from school, and then on came the six o'clock news, and I watched both with equal fascination,' says Biafra. 'Images of everything from Vietnam to the race riots to the Biafra war were seared into my mind, never to leave.'

In the 1960s, says Biafra, Boulder was a hotbed of activism. That was 'back when hippies were dangerous and fun, but by the time I came of age a lot of the old hippies who had money were

The Dead Kennedys, 'Holiday in Cambodia'

putting in little boutiques. We were sick of these hanging-plant pot people telling us that the way we expressed ourselves was too harsh and we should mellow out. To me, mellowing out was a one-way ticket to apathy and fascism.'

Biafra studied at the University of California in Santa Cruz, but could stomach only a few weeks in the company of 'pathetic deadheads with rich parents', and left before the end of his first semester. In his short time there, however, he discovered the Sex Pistols. He used to think he'd been born too late – 'until punk broke out and then I began to realise I was born at exactly the right time. It was a great revelation that probably saved my life.' He fetched up in San Francisco in 1978, where he auditioned for a new band formed by Berkeley graduate Ray Pepperell, aka East Bay Ray. His adopted stage name bluntly juxtaposed the tackiness of US culture with the horrors taking place in the Third World.

The Dead Kennedys were by no means the Bay Area's first punk band: a San Franciscan in 1978 might have predicted big things for groups such as the Avengers, the Nuns, Crime, Negative Trend and the Dils, who made their politics abundantly clear with their singles 'I Hate the Rich' and 'Class War'. But none of them progressed beyond a couple of EPs. The Dead Kennedys had better songs, better organisation, better luck. 'There was a fanzine called *Search and Destroy* which brought together people from the beat generation like Allen Ginsberg and William Burroughs, mixing with teenage punks like me,' remembers Biafra. 'The peer pressure was to come off as interesting and intelligent as possible if you were interviewed by *Search and Destroy*. That was the stew I was thrown into. If I'd moved to Los Angeles instead, it might have been a completely different thing.'

In 1979, the year of Biafra's quixotic mayoral campaign, the Dead Kennedys founded their own record label, Alternative Tentacles, and released their debut single, 'California Uber Alles', which drew a bead on Governor Jerry Brown. On the face of it, Brown was a textbook progressive. He had opposed the Vietnam

405

War, championed environmental issues in the face of oil indus-
try resistance, criticised the death penalty and appointed liberal
judges. As if that weren't enough to endear him to progressive
baby boomers, he also had an on-off relationship with LA rock
queen Linda Ronstadt, and numbered among his supporters
David Geffen, the Eagles and Jane Fonda.

But some people found him sinisterly messianic, including his
former aide J. D. Lorenz, who published a tell-all memoir in
which he remembered something Brown had told him in 1974:
'People will tear each other apart if given half a chance. Politics
is a jungle, and it's getting worse. People want a dictator these
days, a man on a white horse . . . to ride in and tell them what
to do.' Lorenz wrote: 'When I heard Jerry talk about the Man on
the White Horse in the fall of 1974, I assumed he was opposed
to him and would do whatever was necessary to block his entry
into the political arena, but now . . . I realized that Jerry had
wanted to become the Man on the White Horse all along.'

This was the fear which informed 'California Uber Alles', in
which Brown became a 'zen fascist' and 'Big Bro' on a white
horse', issuing his hippie ultimatum: 'Mellow out or you will
pay!' The song's Orwellian imagery didn't seem to square with
the reality of this smiling progressive, but to Biafra he was a
potent symbol of establishment hippiedom. 'I thought, "Oh my
God, after all this rebellion I expected more out of the seven-
ties than people wandering in the mental darkness looking for
someone with all the answers to tell them what to do." And one
powerful politician alone seemed to be able to tap into that.'*

To the punks, *hippie* implied someone affluent, complacent,
fuzzily liberal – in short, a sell-out. At the same time Biafra,
along with members of punk bands like Minor Threat, Black
Flag and the Minutemen, nursed a powerful longing for the hey-

* Biafra soon came to realise that he had overstated Brown's
perniciousness. Many years later, the two men met at a political
function. 'I have no idea what shade of red my face turned!' Biafra
told writer Alex Ogg. 'He seemed more or less understanding.'

day of the 1960s counter-culture, a period they experienced only from a distance as young teenagers. Far from rejecting the previous generation wholesale, they sought to revive the electrifying radicalism of the SDS and the Yippies. 'The 1970s turned out to be so stale, and so boring, and so backward compared to what had come just before,' Biafra complained. 'We were too young to have fully experienced the sixties and the fervour of the anti-war movement.'

Right from the start the Dead Kennedys set out to provoke and annoy. At the Bammy Awards, hosted by the free magazine *Bay Area Music*, they aggravated an audience including hippie icons Jerry Garcia and Carlos Santana with an anti-music-industry satire called 'Pull My Strings'. They appeared wearing shirts emblazoned with the letter S, then flipped down their ties to form dollar signs. They were not invited back. 'Anybody who doesn't use art as a weapon is not an artist,' Biafra reasoned.

*

Their next, and best, single, 'Holiday in Cambodia', had its origins in Boulder; like 'California Uber Alles' it was co-written with Biafra's friend John Greenway. During Biafra's youth, the University of Colorado developed a reputation as a 'party school', a magnet for beer-chugging frat boys and sorority girls. 'It broke my heart,' says Biafra. After he left high school, he got a job delivering pizzas, which necessitated repeat visits to college dormitories. 'I just shook my head as I left some of those places. The door would open and people would be carefully stacking beer cans all the way up the walls as a status symbol. "Holiday in Cambodia" was [about] drunk jocks and the idiot women who pursue them. I guess I just juxtaposed that with the reports coming out of Cambodia.'

These reports were horrific beyond belief. In 1975 Pol Pot's communist Khmer Rouge had seized power in Cambodia with the goal of 'restarting civilisation' in 'Year Zero'. Currency was abolished, private property and religions outlawed, schools and

hospitals shut down, books burned, families dismantled. His iron-fisted agricultural reforms led to catastrophic famines, while political opponents, professionals, intellectuals and ethnic minorities were tortured and executed en masse. The savagery was on a mind-boggling scale: between one and two million Cambodians either starved to death or were murdered by the Khmer Rouge before Vietnamese forces removed Pol Pot in January 1979. He then spent several years directing an insurgency.

It took a singularly black sense of humour to imagine dispatching fatuous frat boys to the Cambodian killing fields, and to do so with such corrosive vim. 'I had done quite a lot of stage acting before moving to San Francisco,' says Biafra, 'and a lot of the teachers I had were Method acting directors. I didn't realise until years later how deeply that influenced not only how I write lyrics but how I approach writing the music and mixing the albums. It's almost more like directing a film than recording a song.'

Biafra's original music – 'more of a Ramones-style chainsaw punk song' – was rejected by his bandmates, so they collaborated on something new: sinister, serpentine, sick with menace. The single's producer, Geza X, also encouraged Biafra to make the lyrics more barbed, hence the still-troubling line, 'Bragging that you know how the niggers feel cold / And the slums got so much soul.' 'He thought it would probe deeper into the mindset of the bourgeois, comfortable, spoilt white kid that the song focusses on,' says Biafra. 'When D. H. Peligro [who is black] joined the band I vaguely remember asking him about the line and I believe I changed it back to "blacks", which I've used ever since.'

To intensify the impact, Biafra chose for the single sleeve an image of a right-wing mob beating the corpse of a student during a 1976 massacre of protesters in Thailand. Biafra had a good eye for a politically loaded image: the sleeve of their debut album, *Fresh Fruit for Rotting Vegetables*, portrayed a police car set alight during San Francisco's White Night riots. *Fresh Fruit* featured macabre songs about poison gas, child murder and roller-coaster disasters, and an even more extreme example

of Method-inspired satire. 'Kill the Poor', which proposed the neutron bomb as a novel means of tackling poverty, shared its extreme black comedy with both the Fugs' 'Kill for Peace' and Jonathan Swift's 'A Modest Proposal'. 'Unsightly slums gone up in flashing light,' leered Biafra in stage-villain mode. 'Jobless millions whisked away!' Not everyone got the joke: after a gig in Brooklyn one girl rushed up to him and exclaimed enthusiastically, 'Awright! Kill the poor!' 'East Bay Ray [says] that he regretted that the band didn't censor my lyrics because he thought they were too far over people's heads,' says Biafra. 'One thing I always liked about good art was when part of it doesn't make sense so you go and figure out what the person is talking about.'

The following year the Dead Kennedys released the eight-track EP, 'In God We Trust, Inc.', the highlight of which was a lounge-jazz reworking of 'California Uber Alles', no longer aimed at Jerry Brown but at a far more successful 'man on a white horse', the new occupant of the Oval Office. As if admitting that he'd chosen the wrong target two years earlier, Biafra called it 'We've Got a Bigger Problem Now'.

<p style="text-align:center">*</p>

On 22 January 1981, two days after Ronald Reagan's presidential inauguration, the *Washington Post* reported on a new subset of punk: hardcore. Based in the DC neighbourhood of Georgetown, and overwhelmingly young, the hardcore punks celebrated discipline in both their music (fast, hard, tight) and their lifestyles (no drink or drugs). Their concerns were as parochial as those of the Who on 'My Generation'. 'We don't say "fuck the world",' explained Ian MacKaye, nineteen-year-old frontman of Minor Threat. 'We just say "fuck the people around us".'

In US punk, the survival of the fittest was not just a figure of speech. In all the major punk centres – New York, San Francisco, DC, LA – the gleefully sloppy and hedonistic class of '77 fizzled out. Unless, like Blondie, they had the pop smarts to qualify as

new wave, they couldn't rely on radio to spread the word across this vast and diffuse continent. Most bands atomised after a handful of singles, heroes in their hometown scenes yet nobodies everywhere else. The future belonged to tougher, leaner, more self-regimented bands with the stamina to criss-cross the country night after night, week after week, month after month.

Hardcore's Stakhanovs were Black Flag. They formed in Hermosa Beach, a few miles south of Los Angeles, in 1977, and acquired a fan base of thick-necked suburban jocks and skaters, fuelled by rage and machismo. Forced out of LA by their reputation for violence, they, like the Dead Kennedys, hit the road with a vengeance, playing anywhere that would have them. Black Flag had a life-changing effect on two of the intense young outsiders interviewed by the *Washington Post*: Ian MacKaye and his friend Henry Garfield. At one Black Flag show in DC, Garfield jumped on stage to sing, or rather scream, a song with them, and with implausible speed became their new frontman, now rechristened Henry Rollins. Their first album, a dense ball of ire and alienation called *Damaged* (1981), was the quintessential hardcore statement. 'Police Story' is a protest song driven mad by its own impotence: 'understand we're fighting a war we can't win'. 'TV Party' is a viciously ironical portrait of apathy: 'Don't talk about anything else / We don't wanna know!' Powerfully libertarian, hardcore sought not to reform a corrupt society but to deny it – to 'Rise Above', in the words of *Damaged*'s besieged anthem. Black Flag's label, S.S.T., practised vigorous self-reliance and group living which had the flavour of a survivalist compound rather than a hippie commune.

Back in DC, Ian MacKaye was also endeavouring to rise above. His antidote to forms of social control was fanatical *self*-control. He was inspired by the rigour of Bad Brains, an African-American band who had switched, unexpectedly, from jazz fusion to hardcore and proceeded to become militant Rastas who lived on a communal farm, discussing scripture and writing urgent, millenarian screeds such as 'Big Takeover' and

'Destroy Babylon'. They had an unusual reason to fear Reagan's arrival in the White House, noting that there were six letters in each word of 'Ronald Wilson Reagan': 6-6-6, the number of the Beast. 'It was like a vision,' explained Bad Brains frontman H.R. (for 'Human Rights'; he was born Paul D. Hudson). 'It just dawned on me that things were going to get bad – really bad – for America.'

MacKaye absorbed Bad Brains' searing righteousness, though not their Rastafarianism. Having attended anti-war demonstrations with his parents as a child (his father covered politics and religion for the *Post*), he blamed drugs for sapping the radical energy of the 1960s. 'I came from the Sixties, I grew up in the Sixties,' he told music journalist Michael Azerrad, 'and I felt like there were higher goals . . . I never understood what happened to these people who were starting their own farm, these people who were fighting the government. What happened? Everyone was just getting high.'

MacKaye's subject matter was the aimless decadence of his con-temporaries. He wrote many of his songs while collecting tickets at the Georgetown Theatre, watching with disgust as the drunken college kids and proto-yuppies staggered past: 'a parade of fuck-ing idiots'. Velocity and venom were Minor Threat's guiding lights. In songs like 'Straight Edge' and 'In My Eyes', released on his own independent Dischord label in 1981, MacKaye berated smokers, drinkers, drug-takers and sleeparounds like some mad-eyed sect leader dispensing rough justice from the pulpit. The man who derided fundamentalist religion on 'Filler' effectively formed one of his own: straight-edgers endure to this day. At this early stage, his bandmate Paul Nelson reflected, MacKaye could be 'a preaching motherfucker'. 'It's less music as religion than religion as music,' wrote Tom Carson in the *Village Voice*. 'Like his West Coast counterpart, Jello Biafra, [MacKaye is] not just the front-man for his band but the organizer and main spokesperson for a whole community and he's committed to his flock above all.'

Minor Threat and Black Flag's puritanical machismo attracted a crowd to match. At first, hardcore's energy was exhilarating. When

the Dead Kennedys played DC, Biafra told the crowd: 'Now all you've gotta do is take this kind of attitude and storm the White House and the Capitol Building.' But by 1983, belligerent idiocy had taken much of the fun out of it; tired of being a punchbag for some Black Flag fans, Rollins responded by working out like a prison weightlifter, transforming his body into a wall of muscle. MacKaye was equally tired of the straight-edge orthodoxy he had inadvertently fathered, expressing his disenchantment in songs such as 'Salad Days', 'Think Again' and 'Betray': 'Normal expectations, they were on the run / But now it's over, it's finished, it's done.'

*

The Dead Kennedys also suffered from punk's knucklehead invasion and Biafra set aside his usual satirical role-playing for the blunt address, 'Nazi Punks Fuck Off' (1981). His primary target was not political Nazis, though he spotted the occasional White Power T-shirt in the audience, but the thugs who came to concerts spoiling for a fight. US punk never had one single transformational Bill Grundy moment but it certainly lost its underground innocence in 1982, when the heroes of primetime TV cop dramas *CHiPs* and *Quincy* confronted the menace of ne'er-do-well punk rockers. Despite Biafra's admonitions ('You fight each other, the police state wins'), to many newcomers punk signified nothing deeper than an excuse for a ruck. 'I never knew what was going to happen next,' Biafra told Boulware and Tudor. 'I got stabbed at [a show]. Somebody set off dynamite in front of my house and I didn't know who did it for the longest time . . . I was constantly on the verge of a nervous breakdown.'

On *Plastic Surgery Disasters* (1982), the macabre humour was beginning to drain out of Biafra's songwriting, replaced by viciously direct attacks on conformity ('Terminal Preppie'), US foreign policy ('Bleed for Me'), environmental pollution ('Moon Over Marin'), and the pharmaceutical industry ('Trust Your Mechanic'). There was even less to laugh at on *Frankenchrist* (1985): 'Stars and Stripes of Corruption' balled up all of Biafra's concerns into a dense and

savage *j'accuse* against Reagan's America, then unfurled them into an old-fashioned call to action worthy of Woody Guthrie: 'Our land, I love it too / I think I love it more than you / I care enough to fight.'

Biafra was depressed by the news headlines but he was also dismayed by what was happening on his own doorstep: the factionalisation of punk. The slam-dancing straight-edgers were just annoying. So, too, were the arriviste poseurs whom he derided in 'Anarchy for Sale' (1986): 'Be sure to rebel in proper style.' Much more terrifying were the skinheads. A couple of years after he wrote 'Nazi Punks Fuck Off', the skinhead scene became infiltrated by bona fide fascists from the White Aryan Resistance. What had happened in the UK in 1979 – the violence, the *sieg heil*ing – was being repeated in California. Skinheads began turning up to Dead Kennedys shows pointedly brandishing the Stars and Stripes.

At the other end of the political spectrum was Tim Yohannan. Published in 1982, the inaugural cover of his *Maximum Rocknroll* magazine trumpeted the issue's contents: a list of bands (including Minor Threat) 'and, God forbid, politics'. *Maximum Rocknroll*'s importance as a pre-internet bush telegraph for the international punk scene was unarguable, but he was an idealist, and idealists often aren't easy to be around. *Maximum Rocknroll* was run like a punk-rock *Pravda*, with Yohannan as punk's gatekeeper and legislator, on a mission to channel the scene's anger and energy into the 'right' causes. The magazine would have no room for racism, sexism, homophobia or, equally offensive, major labels. His ideal band was M.D.C. (aka Millions of Dead Cops), a Texan band who wrote hectoring, mirthless songs with titles like 'Corporate Deathburger' (1982) and 'Multi-Death Corporations' (1983).* 'We did find out that

* In 1983, M.D.C. toured with Bad Brains but were horrified when H.R. called the gay singer of another band, the Big Boys, a 'Babylon bloodclot faggot'. M.D.C. recorded 'Pay to Come Along', which attacked Bad Brains' 'Jah fascist doctrine'. Biafra professed to 'heartbreak' over the affair, which permanently blotted Bad Brains' reputation and proved once again that not all politicised punks were on the same side.

even though there's humour in some of [M.D.C.'s] songs, there wasn't a lot of humour within the band *about* the band, or the scene in general, which made for some rather volatile disagreements,' says Biafra, smiling. After a trip to San Francisco, Ian MacKaye contrasted his more personal, localised politics with M.D.C.'s approach: 'While I may be ignoring what's happening in Latin America, it's sort of vice versa for M.D.C. I like to see it as the two of us kind of being a full novel, filling the whole picture.'*

'In retrospect,' Yohannan's former colleague and housemate Jeff Bale told Boulware and Tudor, '*Maximum Rocknroll* reflected all too perfectly the sectarian, intolerant left-wing milieu of the Bay Area.' Biafra found himself defending the magazine to interviewers who asked him if it was a communist cult, only to end up being branded a sell-out himself. 'Tim became more hardline as he got older and his mind and sense corroded,' he says ruefully.

Yohannan conducted regular, quasi-Maoist 'attitude adjustment tribunals' in which members of the community would pick apart their behaviour in the hope of achieving ideological purity. In 1986, he set up a club at 924 Gilman Street, Berkeley, which became a magnet for left-wing misfits, from middle-aged hippies to teenagers with Mohawks and anarchy tattoos. Inevitably, with Yohannan involved, there were rules: no backstage area, no paid staff, no hierarchy, no drugs, no alcohol, no bigotry and absolutely no major-label bands. 'It was like its own mini-country,' says Billie Joe Armstrong, a Gilman Street regular who found fame with Green Day. 'Going into Gilman and seeing that for the first time, I felt like I was reborn. My education started

* Two other significant political punk bands were LA's Fear, whose debut album included the Biafraesque 'Let's Have a War' ('We could all use the money!') and a version of the Animals' Vietnam standard 'We've Gotta Get Out of This Place', and Berkeley-based Crucifix, whose frontman, Sothira Pheng, had fled Cambodia with his family after the Khmer Rouge seized power.

officially.' The political orthodoxy could, he concedes with fond bemusement, be sometimes comical. 'There were a lot of bands at Gilman who would say, "This song is about how much I hate the government. It's called 'I Hate the Government'!"'

The high-water mark of punk-as-rebellion in the Bay Area was the Democratic National Convention in San Francisco in July 1984. The Dead Kennedys and M.D.C. had appeared together the previous year at a Rock Against Reagan show organised by veteran Yippies, performing beneath circling helicopters and probing searchlights on the Washington Mall. When they again shared a bill in front of thousands of protesters outside San Francisco's Moscone Center, the Dead Kennedys wore Ku Klux Klan hoods which they removed to reveal Reagan masks. Mayor Feinstein, who had vice-presidential ambitions, was keen to present the city as vibrant and diverse but, above all, safe. Creative protesters, however, plotted an ambitious programme of leafleting, teach-ins, street theatre and direct action under the name 'War Chest Tours'.

After the police arrested eighty-four 'peace punks' in a War Chest Tour rally outside the Bank of America, the crowd marched to the Hall of Justice to demand their release. Some protesters proudly noted that it was the biggest mass arrest in the Bay Area since the Vietnam War. The War Chest Tours were the first flowering of 'positive punk', a new form of imaginative grassroots activism. Over the next few months, branches of a new activist group, Positive Force, opened in Nevada, Chicago and Washington DC. Many DC punks moved away from 'personal politics' and talked about 'putting the protest back into punk', carving out a new scene distinct from the macho 'Rambo-punks'. At the heart of this was Ian MacKaye, whose post-Minor Threat bands, Embrace and Fugazi, were more humane and outward-looking. 'We wanted to do something we felt good about,' MacKaye told writer Ben Myers. 'We weren't interested in trying to take back the punk scene – they could have it – when we could just start another one.'

Meanwhile, Jello Biafra's energies were diverted by a long court case over distributing 'harmful matter' in the form of an H. R. Giger print which was included inside the Dead Kennedys' 1985 album *Frankenchrist*. The charges were eventually dropped but the Dead Kennedys disbanded during the trial and Biafra threw himself into a new career as a spoken-word artist, label owner, anti-censorship activist and Green Party campaigner. The band's swansong, *Bedtime for Democracy* (1986), featured 'Chickenshit Conformist', a damning verdict on what punk rock had become and perhaps the saddest lyric Biafra ever wrote. He called punk 'a close-minded, self-centred social club' and a 'meaningless fad'.

'Any form of underground culture that's good is gonna get co-opted eventually,' he reflects. 'When hardcore hit, the demographic was younger, which we all thought was cool until we realised there was the same macho jock mentality and gossipy, backbiting hang-ups that we thought we'd left behind.' Heartbreakingly, he decided, punk had repeated the 'same old mistakes' of the hippies: 'Chickenshit conformist / Just like your parents.'

20

'It's like a jungle, sometimes it makes me wonder how I keep from going under'

Grandmaster Flash and the Furious Five feat. Melle Mel and Duke Bootee, 'The Message', 1982

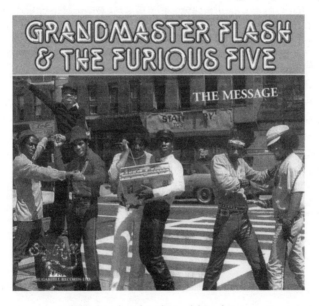

The birth of political hip-hop

Grandmaster Flash and the Furious Five, *The Message* (Sugar Hill Records, 1982).

The summer of 1982 was a tough one for New York City. In July US unemployment hit 9.8 per cent, its highest level since 1941. In New York, it vaulted to 10.7 per cent: one in three New Yorkers aged between sixteen and nineteen was without work. Things were worst in the South Bronx, an amorphous area whose borders were defined more by perception than by geography; if a part of the borough was plagued by poverty and crime, then it counted as the South Bronx. During the 1970s it became a byword for urban blight. Although the area had improved somewhat since the dark days of 1977, its reputation remained dire. To many Americans it was not just *a* ghetto – it was *the* ghetto. In 1981 its notoriety was cemented by the Paul Newman thriller *Fort Apache, the Bronx*, which portrayed it as an urban Wild West. The tagline on the poster – '15 minutes from Manhattan there's a place where even the cops fear to tread' – was sensationalist but not entirely inaccurate.

Yet it was also an exciting summer for South Bronx residents, at least those who followed hip-hop. That June the Roxy on West 18th Street became the epicentre of New York's clubland, shipping the sound of the South Bronx to the hip environs of Chelsea, at the same time as the art galleries of the East Village were legitimising the work of outlaw graffiti artists. To the sound of pioneering DJs such as Afrika Bambaataa, Bronx kids rubbed shoulders with artists (Warhol, Basquiat), savvy post-punks (Talking Heads, the B-52s) and rock royalty (David Bowie). The anthem for downtown Manhattan's first truly mixed club during this electric summer was Afrika Bambaataa and the Soulsonic Force's 'Planet Rock', a melting-pot manifesto for the hip-hop nation: 'No work or play, our world is free / Be what you be!'

But if you listened to the radio for any length of time, you'd hear a different sound: a halting, wounded rhythm which seemed to frown upon dancing, a shivery synthesiser riff, a slow and

steady litany of grievances, and, again and again, a tight-lipped refrain: 'Don't push me 'cause I'm close to the edge / I'm trying not to lose my head.'

This was 'The Message', the new single from Bronx heroes Grandmaster Flash and the Furious Five. It was hip-hop for the basements and the back alleys rather than the downtown dance-floors, and it ran counter to all of the hip world-party promises of 'Planet Rock': local instead of global, introspective instead of extrovert, paranoid instead of celebratory.

'At that time anybody could have said that,' the Furious Five's Melle Mel later recalled. 'Half the people in America probably wanted to say that.'

*

With hindsight, 'The Message' was inevitable. It was the record that critics, especially white ones, had been waiting for, placing hip-hop in the socially conscious bloodline of Stevie Wonder, Curtis Mayfield and Gil Scott-Heron. This offspring of the Bronx slums wasn't just the most exciting party music in the world; it finally had something to say. The highfalutin *Paris Review* even printed the lyrics, an honour it had not afforded, say, Kurtis Blow's 'Christmas Rappin''.

But almost nobody saw it coming, not even the group whose name was printed at the centre of the record. With the exception of Melle Mel, the Furious Five couldn't stand it; they thought it was a crazy idea. Hip-hop was *dance* music. Who wanted to hear about broken glass and roaches on a Saturday night? If they wanted reality, they could look out the window. They were *drowning* in reality. They didn't need to hear it pumping from the radio.

Sylvia Robinson thought differently. That was her gift. She was a music industry veteran who had scored her first hit in 1957 as half of R&B duo Mickey and Sylvia. In the 1960s she founded with her husband Joe a studio and label called All Platinum. A decade later it spawned Sugar Hill Records, based in Englewood,

New Jersey. But in 1979 hip-hop was a local scene, dominated by DJs rather than rappers, and content to remain so. When Robinson tried to sign Flash, the city's most celebrated DJ, he rebuffed her. Release hip-hop *records*? What was the point?

OK, then, thought the forty-three-year-old Robinson. If she couldn't sign a hot rap group, then she'd make her own. One afternoon that summer Joe heard a would-be rap impresario called Hank 'Big Bank Hank' Jackson rapping along to a tape during his day job at a local pizza parlour, and invited him to audition for Sugar Hill. With the addition of two buddies, Guy 'Master Gee' O'Brien and Michael 'Wonder Mike' Wright, the Sugarhill Gang was born, a group as manufactured as any boy band. The Robinsons shoved them into the studio with three session musicians and the bass line from Chic's 'Good Times'. They emerged with a record which would go on to sell eight million copies.

Insanely long, repetitive and gleefully nonsensical, 'Rapper's Delight' was about as unlikely a hit record as could be imagined. The impression was of men making it up as they went along. Over the course of fifteen minutes, the trio meander through dancefloor chants, randy boasts, daft similes, outlandish fantasies of wealth, an extended analogy about a chicken dinner, and an amorous encounter with Lois Lane. The listener gets the distinct impression that the record only stopped because they ran out of tape. The key word was *delight*. It didn't matter what they said: they were hooked on the sheer pleasure of rhyming.

'Rapper's Delight', this novelty record by an artificial alliance of untried amateurs, raised hip-hop's game for ever. Even as some observers dubbed it a dancefloor fad, it became a magnet for downtown hipsters who had never set foot in the Bronx. Blondie, Malcolm McLaren and the Clash were among those flocking to the clubs, and the man they all wanted to meet was the one deified by Debbie Harry on Blondie's 1981 hit 'Rapture': 'Flash is fast, Flash is cool'.

*

For Grandmaster Flash, being cool was a mixed blessing. He was not a born star but a quietly focussed geek called Joseph Saddler. He was born in Bridgetown, Barbados, in 1958, before his parents emigrated to the South Bronx. He is earnest and gently spoken, expressing himself most fluently with great swooping hand gestures. He exudes the quiet discipline of a martial artist, hence the Grandmaster half of his alias, in tribute to Bruce Lee. (Flash was the superfast DC Comics character whose chances of outrunning Superman were the subject of feverish playground debate.)

As a kid he used to take apart radios and household appliances in order to understand how they worked. Sometimes he couldn't put them back together again and got a beating. He thinks he might have been an engineer, as his mother had hoped, if he hadn't gone along to a block party at Park 63 on 168th Street one day in 1973 and witnessed Kool DJ Herc, the eighteen-year-old Jamaican credited with inventing hip-hop DJing. 'I just stood and watched this guy in awe,' he says. 'I was like, I wanna *be* there.'

Perfecting a better way of DJing developed into his new obsession. 'It became a science,' he says. 'I guess in my early teen years I didn't have girlfriends, didn't go to the park and play basketball or go to many parties. It was like school, work, back to my room. Just looking for something. Just in search of . . .'

After practising for two years, he decided to debut his skills at Park 63. 'I said to myself, I'm going to play sixteen records in two minutes. My theory was that if I played the most exciting parts of these records one behind another, seamlessly, to the beat, then I should have the crowd in a total frenzy. It turned out to be a seminar. They were just standing and staring. I think I cried for a week after that.'

Flash realised he needed MCs to hype up the crowd. The first one he found was Keith 'Cowboy' Wiggins, a former gang member he describes as his town crier. In 1978 came brothers Melvin 'Melle Mel' Glover and Nathaniel 'Kidd Creole' Glover,

creating Grandmaster Flash and the 3 MCs. With the addition of Guy Todd Williams (Rahiem) and Eddie Morris (Scorpio), they became the Furious Five. At that point, the DJ was the undisputed star and the MCs only existed to spread the word.

The first time Sylvia Robinson came calling, Flash turned her away. The second time, he knew better. 'I was like, "Nobody's going to want to buy a record they already know with people talking on it,"' says Flash. 'So when I heard "Rapper's Delight" it was just so haunting. It was like, "Oh shit. I could have been the first."'

The Five signed first to the Enjoy label run by Bobby Robinson (no relation), where they released 'Superrappin'', and then to Sugar Hill. In 1981 they supported the Clash during their residency at Bonds in Times Square. That same year they put out 'The Adventures of Grandmaster Flash on the Wheels of Steel', a turntable tour de force combining Chic, Queen, Blondie, the Sugarhill Gang and Harlem rapper Spoonie Gee. Here, the DJ was the star once more, but it was to be the last time.

*

'The Message' was the brainchild of Sugar Hill's house percussionist, Edwin 'Duke Bootee' Fletcher. Raised on jazz, he was a recent convert to hip-hop. 'I didn't respect it at first from an artistry point of view,' he told rap historian JayQuan. 'It wasn't until I saw Flash and them. I didn't understand exactly what it was, but I knew that whatever it was they worked hard on it, and they did it well.'

One night Fletcher was at the Sugar Hill studio in Englewood, absent-mindedly beating out a rhythm on a plastic water bottle. The other musicians joined in, creating a kind of African rhythm. Robinson liked it, but it languished for over a year. 'When we first came to this company we heard it and we used to joke about it,' Mel told *High Times*.

When James 'Jiggs' Chase, Sugar Hill's chief arranger and Robinson's right-hand man, later asked Fletcher to write some

lyrics, out came the line: 'It's like a jungle, sometimes it makes me wonder how I keep from going under.' Smoking some weed, he wrote the whole thing one night in his mother's basement. 'Every so often a nigga might ride by and you'd hear a bottle get broken. So I said "broken glass everywhere". [Chase] told me to keep goin' and I did.'

Inspired by the synth-heavy sound of Zapp and the Tom Tom Club, Fletcher junked the original percussion and wrote a more commercial backing track, incorporating elements of dub, electro and R&B. Robinson loved it and decided it would be the Furious Five's next single. The Furious Five, however, did not. Hedging his bets, Fletcher had produced another, more straightforward dance track. The titles say it all: Robinson wanted 'The Message' while the Five wanted 'Dumb Love'. 'Nobody actually liked the song,' says Melle Mel. 'It was something totally different from what everybody was doing at the time so nobody thought much of it.'

'There was nothing in rap like that before except for maybe the Last Poets, and they were more philosophers,' Kidd Creole told *Melody Maker*. 'And they were too anti-social for a lot of people,' added Cowboy. As Flash told *High Times*: 'Like you listening to music, let's say throughout the week you're nine-to-five, you had a hard week's work, you're tired, you want to go out and party. Why would a person want to hear this? . . . The risk factor was so high, either it was going to be a big thing or it was gonna miss.' Fletcher remembers the Furious Five getting so annoyed with the track that they stormed out of the studio and called a car to pick them up.

Mel, though, came back. He was canny enough to know that he should show willing. Taking a page from Berry Gordy's playbook, Robinson kept Sugar Hill's engine running by stoking the fires of rivalry, and she didn't much care who appeared on a record, provided it was a hit. 'A track might be cut already and different groups tried to put their rhymes to it,' said Duke Bootee, 'and she would let whoever she was hot on have the

track. Sometimes the rappers would bring a track in and lose it because somebody else put a better rhyme to it.'

'She owned the company,' Mel says flatly. 'If that was the song that was going to come out I wanted to be on that song. It wasn't like she had to convince me. It was just logical.'

Where Flash was quiet and circumspect, Mel, three years his junior, was loud and bullish, with a physique to match. These days, his biceps are big as cantaloupes, his voice a drill-sergeant bark. Moving fast, he recycled a verse that he had written for the Five's first single, 'Superrappin", three years earlier, about a friend who hanged himself in his prison cell. It had barely been heard outside of the Bronx. Robinson tried out Rahiem on Fletcher's verses but it didn't work. Because the music was all crafted by Fletcher and Chase, with no need for Flash's turntable skills, a single purportedly by Grandmaster Flash and the Furious Five ended up featuring only one member of the group.

Between Robinson's divide-and-rule diplomacy and the strong subject matter, Flash had a bad feeling about this song. '"The Message" wasn't one of my favourites,' he says. 'What she wanted out of us was totally opposite of what we were. We were into DJing, talking about women, the party thing. Sylvia had this feeling that America was ready to hear social commentary lyrics and we were the only ones in the company that could pull it off. We dodged it for a year or two and then she cornered us.'

Politics wasn't entirely new to hip-hop. In 1980, Kurtis Blow had released the recession-themed 'Hard Times', and a maths teacher called Daryl Aamaa Nubyahn had recorded a didactic single in the alarm-call spirit of the Last Poets' 'When the Revolution Comes'. Put out under the name of Brother D and the Collective Effort, it bore the title 'How We Gonna Make the Black Nation Rise?' and told the infant hip-hop nation to get its priorities straight. The group seemed to be quarrelling with their own cheerful backing track, Cheryl Lynn's 1978 disco hit 'Got to Be Real', delivering a harsh warning to block party revellers: 'The party may end one day soon / When they're rounding

up niggers in the afternoon.' But the party didn't end in 1980, and Brother D's dire premonitions of gun-wielding Klansmen descending on the Bronx were drowned out by the sound of celebration. Brother D was right when he rapped, 'You might be tired of my lecturing.' So-called 'message rap' didn't sell.

Instead, hip-hop, which owed so much to the rhythmic pulse of 'Good Times', shared some of the song's implicit politics: what Nile Rodgers called its 'DHM – Deep Hidden Meaning'. The same year that Flash first witnessed Kool Herc in action, legendary city planner Robert Moses deemed the Bronx 'beyond rebuilding, tinkering and restoring. [It] must be levelled to the ground.' While he was perfecting his turntable skills in 1975, the city of New York was ready to declare bankruptcy. Around the time he made Cowboy his town crier, the July 1977 blackout brought the city's agonies bubbling into the streets.* At that point, only the violence and deprivation was visible to the watching world, but a growing clique of South Bronx residents was building something new, a form of music which would capture the ears of the world. That was hip-hop's DHM: *We're still here. You gave us nothing and we made something.*

But there was nothing hidden about 'The Message', which annexed the terrain vacated since the mid-1970s by Stevie Wonder and the other erstwhile ghetto chroniclers. In a few stark, eloquent verses, Edwin Fletcher sketched out the city that the hip-hop kids came home to when the clubs and the block parties were over. The music's tense, enervated strut evokes a walk through the Bronx in the sickly, hungover dawn. Here are roach-infested tenements and failing schools, predatory junkies and pitiful bag ladies, hookers and killers, inflation, unemployment and strikes: things falling apart.

* The blackout proved an unexpected boost to hip-hop. Looting of hi-fi stores enabled some impoverished ghetto residents to acquire their first turntables. 'It was like Christmas for black people,' recalled Bronx rapper Grandmaster Caz. 'The next day there were a thousand new DJs.'

The narrator is one you don't hear very often in hip-hop: neither a gangster nor a player, but an ordinary blue-collar guy reaching the end of his tether. On the early verses he's compassionate and conversational. He has a job but not one that pays enough to ward off the debt collectors; his neighbourhood is decaying; his son wants to drop out of school. By the fourth verse, he has reached breaking point: hunted, paranoid, packing a gun.

Mel takes the first two verses, leaving the third and fourth to the man who wrote them. They express two sides of the protagonist's outlook: Fletcher sombre and reflective, Mel indignant and irate. It ends with Mel's 'Superrappin'' verse, chronicling the life and death of a kid who sees that the only people making decent money on his block are 'the number book takers, thugs, pimps, pushers'. So he drops out of school, 'turns stick-up kid', gets sent to jail and ends up swinging from a noose in his cell. 'It was based on a cross between me and someone that really got the bad end of it,' Mel told *High Times*. 'Like, I've been to jail, but I was only in jail for five days. I robbed a decoy cop, dressed like a bum.'

Even the rest of the Furious Five get sucked in when they finally make an appearance on the closing skit. They're preparing for a night at Disco Fever, the South Bronx hotspot which had given Flash his first DJing residency five years earlier, when the police pull them over: 'The Furious Five? What is that? A gang?'

'The Message' is protest phrased as an ultimatum, poised on the borderline between the anguished humanism of 1970s soul and the howling nihilism of gangsta rap. It's the internal monologue of a good man who's trying to stay on the right path when it's just so damn hard. Even the most conscientious soul stars sang as outsiders observing the ghetto from a distance – passionately engaged for sure, but nobody was going to repossess *their* cars. The narrator of 'The Message' lives it every day, so he spits every syllable through gritted teeth. *Don't. Push. Me. 'Cause. I'm. Close. To. The Edge. I'm. Try. Ing. Not. To. Lose. My. Head.*

'The Message' is hip-hop's first truly inward-looking record, pointing the way to such introspective, anti-social narratives as the Geto Boys' shivery, haunted masterpiece 'Mind Playing Tricks On Me' (1991) and the cornered belligerence of 2Pac's *Me Against The World* (1995). Even as it describes the urban landscape, it delineates the narrator's internal geography: the stinking alleys and smouldering husks of the mind. Its priority is not how to make the black nation rise but how to save one man from falling.

<p style="text-align:center">*</p>

You can see why Flash was worried. To a DJ, this sounded like commercial poison. He could picture people fleeing from the dancefloor, asking what went wrong with the great Grandmaster Flash. 'I remember one person scared the daylights out of me,' he admitted a year later. 'He said, "Flash, I've always been your devoted fan, I love you, but I don't like that record." I just stayed in the house, but Mrs Robinson said, "Flash, this is gonna be a big thing." You gotta respect the woman for her intuition. All of a sudden, she made one dub, boom, that was it: It blew up. "Like a jungle, like a jungle" on every station.'

Flash and Cowboy took an initial test pressing to Frankie Crocker, a DJ at WBLS. The next day, every other radio station in New York received a copy. 'We could turn the dial from WBLS to WKTU to KISS and hear it right behind each other in succession,' Flash marvelled. 'It played all day, every day.'

Another litmus test was the crowd at Disco Fever. 'When they played a record like that to a party crowd and people still partied off it, we knew it was a hit record,' says Melle Mel. Asked about Flash's objections, he hollers his disapproval: 'If anybody's got a problem with it, I mean they made just as much money as me. And if they wanted to come up with something better they should have. You can't knock somebody for putting out one of the biggest records you ever made in your life. Only an idiot would even *think* that.'

From Disco Fever to the offices of the *Paris Review*, 'The Message' got through. Message rap was suddenly a going concern. The Furious Five, though, were ill-placed to capitalise on its success. Sylvia Robinson's machinations had created a fault line through the middle of the group. The following year, Flash's decision to sue Sugar Hill for $5 million in unpaid royalties ruptured it completely, with Melle Mel, Scorpio and Cowboy in Sugar Hill's corner and Kidd Creole and Rahiem sticking with the DJ. Flash was right, too. Sugar Hill's demise in 1985 was largely down to its appalling business reputation discouraging any new artists from signing.

In their death throes, the Mel-led Furious Five released two more notable message raps: 'Message II (Survival)', ghostwritten by Spoonie Gee, and 'White Lines (Don't Don't Do It)', an ambivalent song about cocaine recorded by people *on* cocaine. 'After the discovery that business was in disarray and could not be repaired, I think I probably went through a drug binge for a minute to escape reality,' admits Flash, who was now exiled from the group he had founded. Some binges lasted a lot longer: Cowboy died in 1989 from the effects of crack cocaine addiction. 'Everybody was high and coked out,' Mel testifies. 'If you don't have money you're looking around for reasons why you ain't got money and one of the reasons might have been because we was with a record company that didn't do business right but another reason was that we was all fucking high.'

After the Furious Five disintegrated, Mel kept going with 'Jesse', in support of Jesse Jackson's 1984 White House bid, and the suitably apocalyptic 'World War III', which climaxes in a ghastly vision of America reduced to a blasted wasteland. Message rap caught on in other quarters, too, but they tended to be far more didactic than 'The Message', with titles like 'Problems of the World (Today)' (the Fearless Four), 'It's Life (You Gotta Think Twice)' (Rock Master Scott and the Dynamic 3), and 'Hard Times' (Run-D.M.C.).

In the struggle between Flash and Sylvia Robinson, history

has proven the Sugar Hill boss right: America was hungry for a record like this, and for a new direction in hip-hop. But Flash wasn't exactly wrong to resist it. In the minds of some critics, the success of 'The Message' created a moral hierarchy in hip-hop, elevating the politicised rappers to a higher plane than the thugs and the hedonists – in 2002 it became the only rap record in the inaugural intake of the Library of Congress's National Recording Registry, dedicated to recordings that are 'culturally, historically, or aesthetically important, and/or inform or reflect life in the United States'. But that doesn't make it a truer representation of hip-hop's soul. The instinct to forget one's troubles may not be as noble as the urge to transcend them, but it is just as valid, just as potent, just as fundamental. 'The Message' was not the end of the debate: it was the beginning.

21

'How does it feel to be the mother of one thousand dead?'

Crass, 'How Does It Feel?', 1982

The Thatcher problem

Margaret Thatcher celebrates her landslide re-election on 6 June, 1983.

In the outhouse-cum-office of his home in the Essex country-side, Penny Rimbaud walks over to his stereo and inserts a twenty-seven-year-old cassette. It is a partial recording of Prime Minister's Question Time some time in 1982 and the questioner is Ray Powell, Labour MP for Ogmore in Wales. He opens with a pointed inquiry about Margaret Thatcher's relationship with the unions but then takes an unexpected detour into punk rock. 'Will she take time off today,' he asks in his thick Welsh accent, 'to listen to the new record of "How Does It Feel to Be the Mother of the Death of One Thousand Lives"?'

Unfortunately he makes rather a hash of it. The real title, by Rimbaud's group Crass, is the somewhat snappier 'How Does It Feel?', from which the lyric continues, 'to be the mother of one thousand dead?' – a reference to the approximate death toll of the recently concluded Falklands War – and Powell's convoluted query is anyway too easily deflected. 'Mr Speaker, sir,' replies Thatcher with condescending amusement, 'I think there were rather a lot of questions there.' She proceeds to address the union issue, but her thoughts on the work of Crass go unrecorded.

Rimbaud allows a wintry smile and winds to a different portion of the cassette. It is a radio debate from the same year, in which Conservative MP Tim Eggar plummily describes 'How Does It Feel?' as 'the most vicious, scurrilous and obscene record that has ever been produced' and calls for prosecution under the Obscene Publications Act. So many years later, the idea that a protest song might have been the subject of such discussion, inside and outside parliament, seems impossibly distant.

Rimbaud walks outside to a garden table, where he sits in the spring sunshine, chain-smoking roll-up cigarettes. With his long, grey-blond hair, loose-fitting clothes and skin tanned and toughened from working in the garden, he might be mistaken for a hippie, but his voice is flinty and brutally direct. 'I'm an absolute

elitist,' he admits. 'Nietzschean in that way. Basically, there is no authority but yourself.' He moved to this place, Dial House, then a semi-derelict red-brick farmhouse, in 1965 and threw open the doors to all-comers three years later. 'I remember removing all the locks and imagining what might happen. My dream, and it's one of the biggest disappointments of my life, was that by now there would be fifty or sixty similar places across the country. And there isn't one place that has been inspired to operate in this way. And I know why, because it's fucking difficult.'

Difficulty and disappointment were two of the enduring themes of Crass's tenure as the most radical band of their era. Between 1977 and 1984 its nine members would crowd around Dial House's small kitchen table, talking late into the night about music and politics, fuelled by tea, toast and roll-ups. 'I've got one friend who won't sit there any more because he's banged his fist down in anger so many times,' says Rimbaud. It was here that they conceived the fiercest, most uncompromising series of records ever released by a British band, and here that they entertained a motley parade of visitors, from teenage dropouts to fugitive terrorists. Dial House was conceived as an ideal, and like all ideals it was slowly eaten away by reality. 'We couldn't get off the band,' says Rimbaud. 'The band was the track. So all sorts of internal conflicts were not handled or even looked at and when the band no longer existed then the whole thing blew up like a fucking volcano.'

A few weeks earlier I talked to Crass's former vocalist Steve Ignorant and asked him if, in some sense, Margaret Thatcher killed the band by extinguishing the political optimism necessary for the band to pursue its exhaustingly principled path. 'In many ways yeah,' he said. 'It was one thing after another with that bloody government. It was like, Where the fuck does it stop?' In the period after 'How Does It Feel?', he says, Crass felt increasingly like a duty; it certainly wasn't fun. 'By that time I think we just couldn't turn it around. We couldn't not be serious. We'd gone too far.'

'*Fun?*' says Rimbaud when I mention this. 'I don't think it was ever *fun*, to be honest. What is fun? It's usually a waste of time, isn't it? . . . Fun is not wanting to know.'

*

One of Penny Rimbaud's earliest memories is of waving a sparkler, at the age of two, at the VE Day celebrations. His father, who was among the first to enter the Nazi concentration camps during the Liberation, was still serving in Europe. 'I didn't meet my dad till I was about three and I thoroughly disliked him, and I continued to do so for the rest of my life,' he says flatly. 'I just wasn't interested in him; I thought he was idiotic.' He thinks that his political education began then and there. 'I never had any respect for government, and that's not because I read anarchism – it's because I never had any respect for my parents, who are the first form of government, and I never had any respect for my school or the church, which are the second and third forms of government.'

Rimbaud, whose real name is Jeremy Ratter, remembers a series of revelations about the horrors of the world: the first time he saw photographs of Auschwitz and Hiroshima in a history book; the incident when his church group said he couldn't bring his Irish Catholic friend along because he 'didn't belong'; the day a fellow pupil, future holocaust denier David Irving, asked him if he realised his friend Henry was a Jew. 'I didn't know what the fuck he was talking about. What a weird fucking question! So that's how you learn – not through books or theory.'

Rimbaud was expelled from two different public schools and left art school (*sans* degree) after four years. After a spell as an art teacher he devoted his time to transforming Dial House into a commune, refurbishing the building and tending to his vegetable patch as house guests came and went: painters, film-makers, writers, musicians. No TV, radio or newspapers invaded his orbit. 'For the best part of five years . . . the world outside might not have existed,' he later wrote.

In 1973, however, he and some of the Dial House residents formed an 'art happenings group', Exit, and toured universities and arts venues, combining discordant music with performance art: one member slowly wrapped her naked body in Sellotape; another hacked open polythene bags filled with offal, this being the sort of thing one did at art happenings in 1973. Exit's successors, Ceres Confusion, made freaked-out jazz-rock which keyboardist Bernhardt Rebours described as 'like World War Three in music'. Their sole public performance took place at the Stonehenge People's Free Festival, a crucial event in the evolution of Crass.

The festival was the vision of Phil Russell, aka Wally Hope, a charismatic, tireless, occasionally annoying New Age visionary who began visiting Dial House in 1972. His followers, called the Wallies, would sit around campfires, tripping on LSD and discussing pyramids, ley lines, aliens and other issues of cosmic import. The following year, however, Hope was arrested for drug possession and sectioned to a psychiatric hospital, from which he emerged a fragile shell. Rimbaud became convinced that Hope's subsequent suicide was in fact murder. 'For me, Phil's death marked the end of an era and destroyed the last grain of trust that I had in the society in which I lived,' he wrote.

The received wisdom goes that the hippies begat prog-rock self-indulgence, which was then blown away by the shock troops of punk. But during the early 1970s many hippies, preferring the term *freaks*, took a more hardline stance, clustered around the squats of west London and rural free parties. Their ranks included Hawkwind (who recorded 1973's controversial 'Urban Guerrilla'), the Pink Fairies (ex-members of 1960s radicals the Deviants) and Third World War, working-class rockers who rejected 'that love and peace shit' and whose songs 'Urban Rock' and 'Hammersmith Guerrilla' (1972) formed a seldom acknowledged bridge between the MC5 and the Clash. While Wally Hope represented hippiedom at its most utopian, Hawkwind roared: 'Don't talk to me about love and flowers / And things that don't

explode.' Wally's death pushed Rimbaud firmly in the latter direction. Another Dial House regular, Steve Ignorant, would be his entry point to the new world of punk.

*

Ignorant, who was born Steve Williams, began attending Dial House as a Bowie-loving Dagenham teenager. 'When I first went there, I thought they were all fucking nuts,' he told Crass biographer George Berger. 'All long hair, didn't eat meat, and no telly. I thought, what the fuck's happening here?' But they treated him 'as if I was an equal' so he kept going back for a while. In 1976 he witnessed the Clash in action and was transformed: 'I remember getting a lump in my throat, thinking, "This is it – this is my time now – I've *got* to be a part of it."'

He returned to Dial House after a long hiatus with the intention of forming a band, and found Rimbaud alone and depressed. Rimbaud's ex-girlfriend Gee Vaucher had moved to New York (where she saw first-hand the flowering of US punk), the flow of new guests had dried up and he was pouring all of his angst over Wally's death into a furious anti-religious pamphlet called *Christ's Reality Asylum*. The band began as a duo: Rimbaud on drums, Ignorant on machine-gun vocals: a kind of prototype white rap. 'We used each other,' says Rimbaud. 'He couldn't have done it without me and I couldn't have done it without him. Steve should have got the same sort of stuff as Joe Strummer. Joe Strummer had a certain amount of political integrity, he was a good rock'n'roller and he made a good living out of it. That's what Steve deserved, and he got involved with the wrong person.'

They started out with the regrettable name of Stormtrooper, but as new members drifted in – Andy Palmer and Phil Free on guitar, Pete Wright on bass, Joy de Vivre on occasional vocals – they became Crass, inspired by the word's usage in Bowie's 'Ziggy Stardust'. They adopted the logo that had been designed for *Christ's Reality Asylum*: an intricate quasi-mystic symbol in which one might glimpse a crucifix, a swastika or a Union flag.

Their early shows, including a one-off for Rock Against Racism, were invigorating mayhem.

Despite the initial impact of the Clash, they liked the idea of punk more than the reality; Rimbaud's tastes skewed more towards jazz. 'I got style from the Clash, I liked their gear, but beyond that it was rock'n'roll from the start,' he says with disdain. 'When we were doing our first gigs in the White Lion in Putney in '77, while the whole King's Road coterie was highly active ten minutes' walk away, it was like we were on a different planet.' After a messy show at punk epicentre the Roxy, Crass scrawled graffiti on the outside wall: 'Punk is dead. Long live punk.'

Nothing about Crass was predictable. They resembled a militia, dressed head-to-toe in black and occasionally mistaken for fascists, yet they lived like the most idealistic hippies.* They refused to spotlight individual members, either literally on stage or figuratively in print, preferring to speak with one voice. Their image was their logo, which they disseminated via a groundbreaking campaign of stencil graffiti, so this most anti-capitalist of bands had an unrivalled sense of brand identity. On tour, they moved their own equipment instead of hiring roadies, and slept on fans' floors rather than hotel beds. Such parsimony was both a point of principle and a by-product of their stringent pricing policy: they sold their records at half the standard price, printing the amount on the sleeve with the legend 'Pay no more than'.

Their music was as deliberately stark and ugly as their subject matter. While songs such as 'Do They Owe Us a Living?' and 'So What' on their 1978 debut album *The Feeding of the 5000*, were hard little bullets of *fuck*-spattered punk rock, other tracks bore the influence of avant-garde composer John Cage, and the live shows practised Brechtian alienation techniques. 'We didn't

* There was one heated debate about whether Dial House's cats should be vegetarians; after a few weeks subsisting on a mush of oats, carrots and Marmite, and going bald as a result, they were allowed to break the house's no-meat rule.

want to seduce anybody,' says Rimbaud. 'We wanted to give people the information and then they could make their minds up, to consciously make it difficult: if you want it, you'll have to work for it.'

It seems amazing now that such fiercely uncommercial music found such a large audience. But in the fertile chaos of 1978's post-Pistols diaspora, Crass's uncompromising stance and aggressive mystique was intoxicating. Although most critics were repelled – *Sounds*' Garry Bushell decided they were 'full of shit'; *NME*'s Tony Parsons branded the album 'a nasty, worthless little record' – Crass records sold impressively: at their peak, each single shifted around 100,000 copies. Nobody was more surprised than Crass themselves. 'The sight of crowds of earnest young men dressed entirely in black, and ready at the flick of a drumstick to storm the Bastille, made me wonder whether we'd created an audience or an army,' Rimbaud writes in his memoir, *Shibboleth*. 'What the hell had I got myself into now?'

So what exactly did they represent to their tribe of disaffected disciples? Certainly not the traditional left. Though they despised capitalism and religion, they scorned 'submissive' socialism and the dignity of labour. 'The Left, in the guise of middle-class liberals, wanted us to support the workers, whereas the workers, mostly in the guise of skinheads, wanted us to support the Right,' Rimbaud writes. They found a third way by appropriating the encircled *A* of anarchism and, to distance themselves from revolutionary violence, threw in the CND symbol. Because Crass's members could not agree on a unanimous programme, they maintained a careful ambiguity. 'People would ask, "What do you want at the end of punk rock?"' says Ignorant. 'And I'd say, "Peace and love," basically. I didn't know if I was socialist or communist or situationist or what. "What are you?" Well, I'm an anarchist.'

During the 1979 election campaign party politics seemed to them an irrelevance. 'I didn't think it mattered one way or another,'

admits Ignorant. 'It was a real wake-up call when Thatcher got in because she started decimating everything.' Rimbaud, typically, has no regrets. 'I think Thatcher was an absolute fairy godmother. Christ, you're an anarchist band trying to complain about the workings of capitalist society and you get someone like Thatcher. What a joy! I do think we create these realities ourselves to a large extent. Thatcher was what we created.'

*

Prior to Thatcher, post-war prime ministers were disliked by their opponents but not really hated. During the era of consensus politics, governments broadly sought to unite the country rather than to practise the 'positive polarisation' of Nixon and Agnew. But Thatcher seemed actively to despise significant sectors of the population: trade unionists, socialists, liberals, doleites and peaceniks. 'To fuel the aggression that drove her career,' writes her biographer John Campbell, 'she had to find new antagonists all the time to be successively demonised, confronted and defeated . . . She viewed the world through Manichaean spectacles as a battleground of opposed forces – good and evil, freedom and tyranny, "us' against "them".'

With her imperious tones – a schoolmarm with pretensions to royalty – her shrill condemnations and her patronising, mirthless laugh, she was powerfully easy to dislike. Her perceived attitude was summed up by a T-shirt design by the Pop Group: a customised portrait of the prime minister flicking a V-sign. 'If there's one thing that Thatcher taught me, it's how to hate,' says Ignorant. 'I hate that woman with a fucking vengeance.'

But it took a while for this hatred to foment. The first anti-Thatcher protest songs – the Beat's 'Stand Down Margaret' and the Specials' adaptation of Dylan's 'Maggie's Farm' – broadcast annoyance rather than outright contempt. Rimbaud's own opinion did not harden until the death of Bobby Sands and nine other Irish Republican hunger strikers during the spring and summer of 1981. 'That was what suggested to me that Thatcher was

different from Callaghan,' he says. 'Allowing ten people to die in that way when at any point she could have called a halt without making any great concessions, that was when one realised one was dealing with cruelty.'

The hunger strike coincided with the inner-city riots and the peak of the recession, and by the end of the year Thatcher's personal approval rating was 25 per cent, the lowest for a British prime minister since polling began. She was also still battling centrists, the so-called 'wets', within her own cabinet; that autumn there were rumours of a leadership challenge. Perhaps this explains the moderation of the musical attacks on her. She was unpopular but vulnerable: a figure who seemed unlikely to dominate the rest of the decade. She sorely needed an enemy that she could revile, and defeat, with impunity, and within months she would be fortunate enough to find a tinpot adversary in the South Atlantic.

Meanwhile, the cult of Crass was swelling with each release. With the Clash turning their attentions to America, there was a vacuum waiting to be filled by a band who spoke to the concerns of disenfranchised British youth. The highlights of Crass's second album, *Stations of the Cross* (1979) contained a savage critique of Strummer's gang, alongside fascists, socialists, liberals and politics in general. 'White Punks on Hope' claims, 'They won't change nothing with their fashionable talk / All their RAR badges and their protest walk,' and hijacks a line from 'White Riot' ('Black man's got his problems') to very different ends: 'Don't fool yourself you're helping with your white liberal shit.' The following year's 'Bloody Revolutions', which quoted the Beatles' 'Revolution', clarified their philosophy: 'I don't want your revolution, I want anarchy and peace.'

At the same time, a bona fide subculture was forming around them. Crass spawned a wave of anarcho-punk bands, of varying worth, and released singles through their own label, Crass Records. Among their artists were Iceland's Kukl (featuring

future superstar Björk), Belfast solo artist the Hit Parade (who privately printed anarchist propaganda in the heat of the Troubles) and Crass's Essex neighbours the Poison Girls.* Only once did they encounter a band even more extreme than they were. The Rondos were Maoist punks from Holland with a record of fighting street battles over squat evictions. 'They never smiled,' says Ignorant. 'I thought, blimey, they've out-Crassed Crass in that department. I heard through the grapevine that a couple of them had gone right over the line and done armed robberies.'

Operating out of Dial House, Crass was literally a cottage industry. Although the band refused to sell merchandise, less scrupulous entrepreneurs did a brisk trade in T-shirts, while legions of fans stencilled the band's logo on to their jackets. Because they were mostly disliked by the music press, they turned to fanzines, for whom a Crass cover story was a sure-fire sales-booster. One of very few mainstream journalists to get the nod was *NME*'s Paul Du Noyer, who visited Dial House in early 1981. 'They're popular but they're not "personalities",' he wrote. 'They're acclaimed but not by virtue of their music, which is far from remarkable. Crass represent an ideal, a cause, a crusade.'

By that summer, however, there was a backlash afoot. Crass were increasingly seen as a force for joylessness, a charge some members were hard-pressed to deny. 'I don't think there's a day when we don't confront ourselves with what's happening in the world,' they told *The Face*. 'We have been made aware of being

* There were dozens of so-called 'Crass bands' who put politics front and centre, including long-running Leeds collective Chumbawamba; squat-scene regulars Zounds, who updated Frank Zappa on 'More Trouble Coming Every Day'; the terribly earnest Flux of Pink Indians, who entitled their debut album *Strive to Survive Causing Least Suffering Possible*; and the Subhumans, who called their debut *The Day the Country Died*. Their influence crossed the Atlantic: both M.D.C. and Minor Threat's Ian MacKaye paid visits to Dial House.

humourless and having no compassion, but that's the way we feel it. We lay ourselves open.' Many fans mistranslated Crass's lifestyle choices into censorious, holier-than-thou Puritanism, similar to the straight-edgers who worshipped Minor Threat. Ignorant lamented the fact that while other singers could get drunk and meet girls after shows, he was obliged to sit down and discuss anarchism with earnest young men. Although he admired animal-rights militants Conflict, with whom he would later perform, most of the anarcho-punk bands bored him. 'You'd end up with forty bands doing songs about Cruise missiles, all dressed in black,' Ignorant told *NME*'s Steven Wells in 1987. 'I got to the stage where I thought, if I hear one more bastard song about Cruise bastard missiles . . .'

That's not to say they were without a sense of humour. Under a different name, they persuaded the popular teen magazine *Loving* to give away a free flexi-disc of 'Our Wedding', an apparently sugary romantic ditty which became bitterly sarcastic as soon as its origin was revealed. When the truth came out, *Loving*'s embarrassed editor called it a 'sick joke' and the *News of the World* warned its readers about this 'BAND OF HATE'. But it was not merely a prank – more of a companion piece to the overtly feminist *Penis Envy* (1981), which brought Joy de Vivre and more recent recruit Eve Libertine to the fore, reciting songs about rape, body image and the cynicism of the bridal industry. Joe Strummer had recently told Paul Du Noyer that Crass's stubborn integrity was 'self-defeating' because 'no-one gets to hear about it'. 'Our Wedding', however, was a brilliant media smash-and-grab, giving them instant notoriety.

Christ: The Album (1982) was a summation of everything Crass had tried to say and do thus far: a confident, ambitious double disc with an accompanying booklet of essays titled (after a line from a disparaging *Melody Maker* review) *A Series of Shock Slogans and Mindless Toxic Tantrums*, the pick of which was Rimbaud's intense memoir-cum-manifesto, 'Last of the Hippies'.

'Artistically, that's where I would have liked to have bowed out,' Rimbaud told Berger. 'If it hadn't been for the Falklands, we wouldn't have known what to do, because we'd said it all.'

*

The Falkland Islands had long been an anomalous leftover from the days of imperial adventurism: an inhospitable, strategically irrelevant archipelago in the South Atlantic. Ever since British rule was established in 1833, Argentina had claimed sovereignty over the islands it called the Malvinas, and in recent decades successive British governments had tried to broker a deal which would appease Argentina while guaranteeing the 1,800 inhabitants independence; the latest proposal had been torpedoed by the islanders in 1980. In December 1981 General Leopoldo Galtieri took charge of Argentina's unpopular military junta and decided to distract attention from the catastrophic economy with a short, sharp expedition to retake the Malvinas before the symbolic 150th anniversary of British rule. Recent British plans to slash the navy budget led Galtieri to believe that the UK would be unwilling, and unable, to mount a defence of a territory 8,000 miles away.

Argentina planned to strike in the summer of 1982 but its hand was forced when a minor diplomatic incident in neighbouring South Georgia on 19 March prompted the Royal Navy to send the ice-patrol vessel HMS *Endurance* to investigate. Fearing that the UK was preparing a full-scale defence of the islands, the Argentinians invaded the Falklands in the early hours of 2 April, to the Foreign Office's great shock. As historian Lawrence Freedman writes, 'Britain underestimated the military intentions of Argentina while Argentina overestimated those of Britain.' Britain dispatched a naval task force to the South Atlantic and began its assault on 1 May.

The war was concluded by 20 June. Most of the musical responses appeared after it was over: Robert Wyatt's 'Shipbuilding' in late 1982; Pink Floyd's 'The Fletcher Memorial Home' in 1983; Billy Bragg's 'Island of No Return' and New Model Army's

444

'Spirit of the Falklands' in 1984.* But Crass were lean and agile enough to move faster. While the task force was still en route, Rimbaud scribbled a last-minute anti-war addendum to *Last of the Hippies* in time for *Christ: The Album*'s release, and penned 'Sheep Farming in the Falklands', a grisly collage of news broadcasts, skits and vicious, mocking lyrics which imagined British soldiers 'fucking sheep'.

It was a guerrilla release: their independent distributors Rough Trade slipped copies of the flexi-disc into random albums in their warehouse. Ignorant quickly regretted it. 'I never got the joke,' he says. 'I still don't see where it's funny. The minute we heard that people had been killed I thought, Oh God, it's awful.' Rimbaud remembers the joke palling after the Royal Navy submarine HMS *Conqueror* controversially sank the Argentinian warship *General Belgrano* with the loss of 323 lives, but is unrepentant about the lyrics: 'They're fucking killing machines. You have to accept that people are responsible for their actions, quite regardless of how and why they came to be making them. "What about our boys?" You hear too fucking much of that.'†

During the war, Crass felt completely isolated in their opposition. 'The silence was just unbelievable,' says Rimbaud. He determined to record another single about the conflict: 'How Does It Feel?' Though impossibly hostile by most bands' standards, it was more conventional than 'Sheep Farming' and all

* 'Shipbuilding' was as poignant as 'How Does It Feel?' was blunt. Producer Clive Langer had conceived a gorgeous melody for Robert Wyatt and asked Elvis Costello to write the lyrics. Inspired by Wyatt's recent run of protest songs (including a version of 'Strange Fruit'), Costello wrote about a labourer in an ailing shipyard who gets lucrative new work thanks to the same war in which his son will be fighting. Sung with wounding tenderness by Wyatt, it radiates a compassion which, for all their strengths, was beyond Crass's ambit.
† The sinking of the *Belgrano* inspired Joe Strummer to write the unreleased 'Falklands Rock' ('Exocet! Exocet! Two elections to win!') and change the name of the new Clash album from *Rat Patrol from Fort Bragg* to *Combat Rock*.

the better for it: scattershot satire yields to breathtaking moral fury. 'It personalised what these bastards get away with,' says Rimbaud, who claims he was trying to produce music as ugly and violent as the war itself. After a spoken-word introduction derived from Rimbaud's prose rant 'Rocky Eyed', Ignorant delivers Rimbaud's condemnation of Thatcher in an unbroken torrent of spittle-flecked, vein-popping rage, a street-corner prosecutor brandishing an interminable charge sheet. 'Pen puts twelve words in a sentence where you should only have four,' says Ignorant, laughing. 'I had to really struggle with the syllables.'

The Falklands changed everything for Crass. Ray Powell and other Labour MPs sent the band messages of support. Dial House was receiving over 200 letters a week from fans requesting information. A woman from the tattered remnants of the Baader-Meinhof gang arrived seeking sanctuary after committing a series of bank robberies in mainland Europe. A sailor who had served on HMS *Coventry* contacted the band to share his theory that HMS *Sheffield*, sunk on 4 May, had been deliberately sacrificed to draw fire away from the *Coventry*, whose crew included Prince Andrew. As a novel way of leaking the information, Pete Wright spliced together recordings of Thatcher and Reagan into a fake telephone conversation to make it seem as if the prime minister was admitting to the *Sheffield* conspiracy. The US State Department speculated that the hoax was the work of the KGB, which was a compliment of sorts, and it later emerged that Crass were being monitored by MI5. 'I suppose it was empowering,' says Rimbaud. 'The danger of that was: power towards what?'

The sense that they were entering shadowy territory far removed from the business of making music was magnified when they were approached, via an acquaintance, by a call girl touting compromising pictures of Thatcher's husband Denis. 'I was certain they existed because the person who informed us about them was absolutely reliable,' says Rimbaud. 'There was about a month of debate [but] we didn't want to get into the imbecilic sex scandal mentality of the tabloids.' Ignorant, meanwhile,

worried that Crass might attract more dangerous attention from aggrieved squaddies. 'It scared the shit out of me,' he admits. 'It wouldn't have surprised me if some blokes had thrown petrol bombs through the window. That's when I started sleeping with a baseball bat under my bed.' The already sombre mood within Crass became an oppressive, leaden pall.

Before the war, Thatcher had seemed to be on the ropes, but now she was transformed, as John Campbell writes, 'from a bossy nanny into the breast-plated embodiment of Britannia'. Having vanquished Galtieri, inflation and the Tory wets, she seemed suddenly invulnerable as she sailed towards the general election in June 1983. Under Callaghan's benign but ineffectual successor Michael Foot, Labour had unpopular policies to sell and no flair for selling them: Shadow Environment Secretary Gerald Kaufman described their hard-left election manifesto, which called for widespread renationalisation and unilateral nuclear disarmament, as 'the longest suicide note in history'. Thatcher was returned to Number 10 with a crushing 144-seat majority.

Before the election, Rimbaud had sent a furious missive to *Sounds* calling for a mass mobilisation of bands in the face of war, nuclear escalation and public service cuts. 'Rock'n'roll appears to have increasingly concentrated on shallow fun and cretinous escapism,' he thundered. There were, in fact, a number of artists speaking out at the time, but Crass felt no less alone. Thatcher seemed to loom over everything they did: loathsome, invincible.

The band marked election day with 'Whodunnit?', a lavatorial music-hall record which asked, 'Who put the shit in number 10?' 'Even that, which was supposed to be a laugh, was serious,' says Ignorant glumly. 'We couldn't *not* be serious. How could you inflect comedy into a Crass gig anyway? Whoopee cushions?'

Crass's fifth album, *Yes Sir, I Will* (1983) was gangrenous with gloom: essentially one, long, despairing, cacophonous mono-logue. On tour, they played it in its entirety; Rimbaud smiles

as he remembers audience members pouring out the door after twenty minutes of atonal improvisation. *Yes Sir, I Will* was similarly unsparing of listeners at home, merging all the separate issues of the day into one engulfing black hole of misery. It was a record with no exit routes. Their next, and last, single, 'You're Already Dead' (1984), came in a sleeve showing Thatcher with her eyes gouged out. 'Everything we did post-Falklands was uncompromisingly straight in your fucking face,' says Rimbaud, 'and, frankly, not a useful political tool any more because not many people could take it.'

Ignorant remembers the late-night discussions around the kitchen table getting darker and more intense. 'One was: "What can we do to actually bring it home to people? Do we have to throw a corpse into the audience? Is that how far it's got to go?"' Subject to growing police harassment and an obscenity trial over the lyrics of *Penis Envy*, Crass felt besieged. Rimbaud had come to the conclusion that pacifism was 'unrealistic and naive' and, *contra* 'Bloody Revolutions', that 'nothing short of all-out global revolution could change our planet into a safe home.'

By 1984 Rimbaud felt that Crass had become 'a parody of ourselves, an empty vessel on an empty sea'. He claims he always intended to dissolve the band that year, because of the Orwellian significance and because 'if you can't say what you need to say in seven years you're never going to say it'. His 1977 booklet *Christ's Reality Asylum* had been numbered 721984 (i.e., seven years to 1984) and Crass's catalogue numbers had been counting down ever since. What he could not have anticipated was the miners' strike.

*

Thatcher had been anticipating a showdown with the miners since before she took office, steadily making preparations to safeguard energy supplies by building up coal stocks, switching some power stations to oil and toughening up the police. She intended to break the back of the union movement by triumphing over its most powerful body, the National Union of Miners (NUM).

There was an economic case for shutting down unprofitable pits but Thatcher was also driven by an atavistic desire for revenge for the miners' role in bringing down Edward Heath's government in 1974. Arthur Scargill, the NUM's firebrand leader, was also spoiling for a fight. Like Thatcher he was a prickly ideologue who thrived on conflict, and he hated capitalism as fiercely as she loved it, but every time he called for a national strike NUM delegates voted him down.

On 6 March, Ian MacGregor, chairman of the Coal Board, announced the closure of twenty pits with the loss of 20,000 jobs. The issue at stake for miners was not pay or conditions but the survival of a way of life, so Scargill responded six days later with a string of regional strikes, bussing in flying pickets to key areas such as Yorkshire. By circumventing a national vote, thus breaking NUM rules, and stubbornly refusing to accept the need for any closures at all, he made himself exactly the kind of pantomime villain that Thatcher needed: implicitly comparing him to Galtieri, 'the enemy without', she famously called the miners 'the enemy within'. 'Mrs Thatcher was fortunate in her enemies,' reflected Labour leader Neil Kinnock. 'If a Tory prime minister has got to find an enemy, Arthur Scargill would come straight from central casting.' Even though Scargill was a hard man to love, the ferocity of the government's response fostered enormous sympathy for the average striker and his family. At the so-called Battle of Orgreave in June, a coking plant became the site of an almost medieval confrontation between miners and police. The miners were braver and nobler than their leader, and they had more to lose.

Crass reached the end of the road in Aberdare, a pit village in Wales's Rhondda Valley, where they planned a benefit gig for striking miners in July. 'It was one of the saddest things I've ever been a part of,' recalls Rimbaud. 'A fantastic gig but the sense of wet, dark despair was so redolent. It's not being romantic to say the miners were there with tear-filled eyes. It wasn't the pits – it was their communities that were being

destroyed. That was the viciousness of Thatcher. It wasn't that she thought coal was a bad idea – she thought *working-class culture* was a bad idea.'

After the gig they packed up the van and Andy Palmer announced he wanted to leave. 'There was a general hubbub,' Ignorant remembers. '"Are you joking? Are you sure?" About an hour into it me and a couple of others said, "Actually I've been thinking of packing it in too." I think everybody in the band was relieved even if they say they wanted to go on. We really were burnt out by it – scarred by it.'

Crass released one more album, *Acts of Love*, and an EP, *Ten Notes on a Summer's Day*, which were virtually Rimbaud solo records: poems set to free jazz-influenced music. Although other anarcho-punk bands plugged the gap, Crass's influence was not primarily musical. Their uncompromising self-reliance broke new ground for subsequent independent labels, while the Greenpeace-organised Stop the City demonstrations in which they played a key role anticipated the DIY activism of Reclaim the Streets in the 1990s. Theirs is perhaps the saddest and noblest failure in this book. They lived the ideals that they expressed in their songs, and never gave an inch, and still they fell apart with an overwhelming sense of depression and defeat, incapable of knowing what vital seeds they had sown.

22

'When two tribes go to war'

Frankie Goes to Hollywood, 'Two Tribes', 1984

Living with the Bomb

Protect and Survive booklet, published by the British government
in 1980.

During the first week of 1984 *Time* featured on the cover of its annual Man of the Year issue an illustration of President Ronald Reagan and Soviet premier Yuri Andropov, studiously ignoring each other. Far from being honoured for their statecraft, the two leaders were accused of flirting with Armageddon. 'The deterioration of US–Soviet relations to [a] frozen impasse overshadowed all other events of 1983,' *Time* anguished, deciding that the two men 'share the power to decide whether there will be any future at all'.

The magazine was not given to hyperbole. In March 1983 Reagan had fired a verbal missile in Andropov's direction, branding the Soviet Union 'an evil empire', while announcing the launch of a new Strategic Defence Initiative (SDI), which would come to be nicknamed Star Wars. Andropov, in turn, described Reagan's negotiating style as 'obscenities alternating with hysterical preaching'. Soviet negotiator Yuli Kvitsinsky stormed out of talks with his opposite number, Paul H. Nitze, with the words, 'Everything is finished!' In response to the diplomatic breakdown, the editors of the *Bulletin of the Atomic Scientists* moved the long hand of their symbolic Doomsday Clock to three minutes to midnight, its direst position since the invention of the hydrogen bomb in 1953. 'Never in my thirty-five years of public service,' said the seventy-nine-year-old Cold War theorist George Kennan, 'have I ever been more afraid of nuclear war.'

Even those who did not closely follow the progress of arms reduction talks could feel the temperature dropping. During 1983 the scientists and bestselling authors Carl Sagan and Paul R. Ehrlich published a study introducing the world to the devastating concept of 'nuclear winter', in which nuclear war would generate enough smoke and soot to block the sun's rays for months on end. In October 100 million Americans tuned in to ABC's post-apocalyptic drama *The Day After*, a programme so

troubling that Secretary of State George Shultz felt compelled to appear immediately after the end credits to assure viewers that the Reagan administration was doing all it could to avert doomsday.

So this was the climate in which a pop group from Liverpool released a berserk dance record about nuclear annihilation. 'Two Tribes' translated the era's pervasive fear into crazed celebration, thus becoming not just the most successful, and bizarre, anti-war record ever made, but the UK's fourth biggest-selling single of the 1980s. It did so thanks to an improbable alliance between a stoned art-punk maverick, a punishingly perfectionist producer and a journalist obsessed with Italian futurism. 'I was just writing songs in Liverpool on the dole,' says the band's Holly Johnson. 'I had no vision of it being a hit. It crossed over in a way that was unforeseeable and quite amazing.'

*

Songs about nuclear war have always flourished in periods of tension. The post-war boom produced novelty songs (Doris Day's 'Tic, Tic, Tic'), sermons (Lowell Blanchard's 'Jesus Hits Like an Atom Bomb') and the occasional batsqueak of protest (Vern Partlow's 'Old Man Atom'). The era of the Aldermaston marches and the Cuban Missile Crisis prompted jeremiadic visions from Bob Dylan and Ewan MacColl. Following Kennedy and Khrushchev's brush with disaster, however, the hand of the Doomsday Clock retreated – by 1972 it was a record twelve minutes from midnight – and during the Carter administration American musicians seemed more concerned with the threat posed by unsafe power stations.*

In Britain, however, there was a curious outbreak of nuclear

* Following a partial core meltdown at Pennsylvania's Three Mile Island in March 1979, a coalition led by Jackson Browne and Graham Nash formed Musicians United for Safe Energy (MUSE), organising a series of No Nukes concerts and a 200,000-strong rally in New York.

paranoia, coinciding with the publication of a Home Office booklet called *Protect and Survive*. Towards the end of 1979, several readers of the London *Times* wrote to the paper asking about the government's civil defence plans in the event of nuclear war. *The Times* took up the cause, demanding that the government disseminate a 1976 booklet that it had intended to publish widely only if an international crisis arose. Taken aback by the mounting attention, the Home Office published *Protect and Survive* in May 1980. For just 50p Britons could now learn how to construct a fallout shelter from propped-up doors and boxes, and how to label the bodies of dead relatives. Further advice, the booklet promised, would arrive via the airwaves after a nuclear attack. 'REMEMBER', it read, 'to listen to your radio.' Designed to reassure, it proceeded to scare the daylights out of anyone who read it.

Pop fans who did listen to their radios soon heard the impact of *Protect and Survive*, and its attendant pre-publicity, on the national psyche. Instead of scolding the masters of war, artists conveyed a visceral amalgam of terror, nausea and confusion. 'Final Day' by Cardiff indie band Young Marble Giants was an eerie doomsday lullaby, suggesting a mind stunned into childlike regression. On the Specials' 'Man at C&A', Terry Hall portrayed a doleful Everyman, contemplating events beyond his comprehension or control, while Neville Staple cried, 'Warning, warning! Nuclear attack!'. On the swelling panic of 'Breathing', Kate Bush inhaled particles of fallout inside a *Protect and Survive*-style refuge, while an official-sounding voice coolly explained the process of a nuclear blast. UB40's 'The Earth Dies Screaming' was a dubwise tour of empty houses and abandoned roads. Only the Clash, on 'Stop the World', stepped back to rail at 'the wealthy and the noble of birth', sheltering underground while London becomes 'a flat, burning junkheap'.

Margaret Thatcher was a fervent believer in the merits of Mutual Assured Destruction (MAD), the doctrine which argued that neither the US nor the USSR would dare launch a nuclear

strike for fear of being wiped out in return. She even claimed that supporters of a strong nuclear deterrent were 'the true peace movement'. Reagan, however, thought MAD 'the craziest thing I ever heard of' and compared it, in the kind of Hollywood analogy he was so fond of, to 'two westerners standing in a saloon aiming their guns at each other's head – permanently'. His defence policy was strongly influenced by his fascination with biblical prophecies. 'We may be the generation that sees Armageddon,' he told an interviewer in 1980. Equal to his fear was his conviction that he could do something to avert disaster, but his grasp of the mechanics lagged some distance behind, leaving him susceptible to more hawkish advisers. His biographer Lou Cannon writes: 'Reagan was guided both by extraordinary vision and by remarkable ignorance.'

Not herself haunted by the juicier passages of the Book of Revelation, Thatcher focussed on brass tacks. Within months of taking office she had decided to replace Britain's obsolete Polaris system with submarine-based Trident missiles and agreed to station US cruise missiles in Britain as part of NATO's response to the Soviets' new Intermediate Range Ballistic Missile (IRBM), the SS-20. But many Europeans felt that cruise, far from protecting them, would make them sure-fire targets in the event of a US–USSR showdown. CND, which had been reduced to a stub during the 1960s and 70s, was suddenly reborn, bigger than ever. On 26 October 1980, 70,000 people joined a rally in Trafalgar Square against cruise and Trident. A year later the marchers' ranks swelled to 250,000. At the same time, female protesters began to gather outside the RAF base at Greenham Common in Berkshire, where ninety-six of the cruise missiles would be deployed, inspiring further peace camps to flower up and down the country.*

* Protesters were arrested for blocking fuel pipes, cutting holes in the fence, painting peace symbols on a US spy plane, and even dancing on the missile silos. Rebecca Johnson, one of those detained, recalls singing Bob Dylan's 'Masters of War' to keep morale up.

Having been schooled in high-profile activism by Rock Against Racism, musicians were quick to embrace CND. The Clash, the Specials and the Jam all donated songs to a 1982 benefit album, *Life in the European Theatre*. Somerset farmer Michael Eavis revived his dormant Glastonbury festival in 1981, quickly becoming CND's biggest single fundraiser; MUSE linchpin Jackson Browne even offered to play for free so that his fee could go straight to CND. By the middle of 1982, with the Falklands hardening Thatcher's reputation as a warmonger, nuclear disarmament had replaced anti-racism as music's unifying issue.

*

At this point, twenty-two-year-old Holly Johnson was, by his own admission, 'just an impoverished songwriter in Liverpool who was almost about to give up and go to art college'. He had enjoyed minor success with Liverpool punk band Big in Japan, but they broke up in 1979, and a couple of solo singles made no impact. Johnson watched as contemporaries such as Echo and the Bunnymen and The Teardrop Explodes found the mainstream popularity that had eluded him. Trying again, he joined a new band, whom he renamed Sons of Egypt and then, after a line-up change, Frankie Goes to Hollywood.

In early 1982 they were just a trio: Johnson, bassist Mark O'Toole and drummer Peter Gill. O'Toole had a Russian-sounding instrumental he liked to warm up with during rehearsals. 'He said it was like the story of a Russian peasant going to work,' Johnson recalls. 'I said I could turn that into a song. And he laughed and said that was funny.' Johnson decided it needed a counterpoint, so he introduced an overtly American funk bass line and the trio worked on the basic structure that would remain intact all the way to the final version. Johnson then consulted his lyric book to see if there was anything that would suit this Russo-American hybrid, and came up with a strange combination of blockbuster hyperbole and real-world angst. 'I was a bit of a stoner,' he says by way of explanation, 'and I was influenced by that William

Burroughs / David Bowie cut-up thing where I'd pluck lines from bizarre sources and collect them in the lyric book.'

Although Johnson confesses that 'CND hadn't particularly infringed upon my mental landscape at this point,' he was unusually agitated by the Falklands War. 'I'd be in the local wine bar and there'd be a woman in tears because she hadn't heard from her son.' It says a great deal about his mental state at the time that he became paranoid that he would be drafted into the army, somehow believing not only that such a localised conflict would necessitate full-scale conscription but that a gay, unemployed musician with a penchant for marijuana would be near the top of the draft board's list. At the same time, one of the year's big box-office hits was the Australian post-apocalyptic action movie *Mad Max* 2. One line in the opening voiceover, which describes how a Third World War has made oil a dangerously rare commodity, stuck with him: 'For reasons long forgotten, two mighty warrior tribes went to war and touched off a blaze which engulfed them all.'

Johnson also remembers being influenced by Timmy Thomas's 1972 protest song 'Why Can't We Live Together', a popular floor-filler at London gay club Heaven; childhood exposure to Barry McGuire's 'Eve of Destruction' and Zager and Evans's dystopian novelty hit 'In the Year 2525'; and a black-and-white film (its title long-since forgotten) in which a character asks: 'Are we living in a land where sex and horror are the new gods?' Furthermore, he was fascinated by Ronald Reagan – 'Cowboy number one' – and a trivial episode in his Hollywood career when the future president became a spokesman for the shirt manufacturer Van Heusen. All of these random fragments ended up in his lyric book and were inserted, mosaic-like, into 'Two Tribes'. 'It sounds quite obtuse unless you know the facts,' he admits. 'I was a fan of ridiculous, absurd humour.'

Frankie used to bookend their live sets with 'Two Tribes' and recorded a version during their first Radio 1 John Peel session in October. They soon attracted the attention of producer

Trevor Horn and *NME* journalist Paul Morley, who had recently established their own record label, ZTT. The initials stood for Zang Tumb Tuum, a reference to Italian futurist poet Filippo Marinetti's 1912 piece evoking the sound of the Battle of Adrianople. Such an obscure and highfalutin reference was a powerful clue that this was not your average pop label. ZTT's first release was *Into Battle with the Art of Noise* (1983) by Art of Noise, a deliberately faceless anti-pop group named after the work of another futurist, Luigi Russolo. 'What I wanted to do was reconstruct that time in the 1910s and the 1920s of surrealism and Dadaism and futurism that just seemed to be completely lost – the war just destroyed it,' Morley told *Melody Maker*. 'To me, there was a great sense of play going on there, and also provocation, and I felt that rock in its known types of provocation had died a death.'

According to ZTT's business brain, and Horn's wife Jill Sinclair, Morley didn't want to sign Frankie, but Horn talked him round and got to work turning one of their tracks, 'Relax', into a pop colossus. 'Relax' became a cultural phenomenon when Radio 1 DJ Mike Read, in a notorious fit of pomposity and pique, wrenched the single from his turntable live on air and declared it 'obscene'. The lyrics weren't particularly shocking on the page, but Johnson delivered them with pornographic relish, the ringmaster of his very own S&M circus. The BBC promptly pulled it from its playlists and banned the video from its TV stations; just as quickly, it went to number one and stayed there for five weeks, making it the most notorious hit since 'God Save the Queen', and Frankie a kind of horny, Hi-NRG Sex Pistols. True to Morley's futurist intent, Frankie provided both play and provocation, on a scale as enormous as Horn's grandiose production.

Johnson was adamant that the follow-up should be 'Two Tribes', though Horn was reluctant. 'He was saying, "Oh, I think ['Two Tribes'] is going to take too much work." Because he'd just spent three months on "Relax" and he thought it was going to take another three months.' Although the recording

wasn't quite as Sisyphean as 'Relax', Horn's production team spent weeks learning to use their new, state-of-the-art Synclavier sampler and perfecting the bass line on which the whole record hinged. Eventually, Johnson got the call to come in and record his vocal at 11 p.m. one night – the same evening that he met the man who would become his life partner. 'I met Wolfgang in a bar and said, "Sorry I have to go to a recording studio," and he didn't believe me because it was such a bizarre thing to do. Hours worked were very peculiar.'

The release of the single was a multimedia war on all fronts. 'This was Horn and Morley's big chance as much as it was mine,' says Johnson. 'The pressure was on because it could so easily have been a one-hit-wonder situation.' Hence Art of Noise's Anne Dudley was tasked with arranging and conducting a sixty-piece orchestra to perform the Russian-influenced opening theme, and the packaging took on a life of its own. Morley wanted to make 'Two Tribes' 'part of public language' and to compete for people's attention with movies and TV. The record sleeve was a work of art, featuring a shot of Moscow's Lenin mural and scads of terrifying Cold War statistics that Morley had procured from CND. After their first idea, based on *Death Race 2000*, threatened to eat up even the handsome profits of 'Relax', video directors Kevin Godley and Lol Crème conceived a symbolic wrestling match with actors playing Reagan and new Soviet premier Konstantin Chernenko in the ring, an audience modelled on the United Nations, and the band playing a TV news crew. The video ended, with the same calm restraint that marked the whole project, with the earth exploding.

As if that weren't enough, ZTT scattered several remixes across various formats, with impressionist Chris Barrie hired to lend his (slightly ropey) Reagan impersonation to the Annihilation Mix. When ZTT approached CND for statistics, the organisation showed them an illegally obtained copy of a *Protect and Survive* film clip, featuring a voiceover by the actor Patrick Allen. ZTT hired Allen to reprise his role on the 'Two

Tribes' remixes, and the actor kept remembering scripted lines that had been too bleak for the final film: 'If your grandmother or any other member of the family should die whilst in the shelter, put them outside but remember to tag them first for identification purposes.'

'I was behind the mixing desk, thinking, "Wow this is fantastic,"' Horn told Simon Reynolds. 'I knew I was going to use that bit over and over again, because I thought it was the most chilling thing. And Morley had written a bit for him that went, "Mine is the last voice you will ever hear." And if you listen on the session tapes Patrick Allen's going, "Oh dear, that's a bit depressing, isn't it? I certainly hope not!"'

Inspired by Katharine Hamnett's sloganeering designs, Morley came up with a series of polemical printed T-shirts – 'FRANKIE SAY ARM THE UNEMPLOYED', 'FRANKIE SAY WAR, HIDE YOURSELF' – which sold a quarter of a million and turned fans into walking billboards. ZTT's bombastic press release proclaimed the single 'the first genuine protest song for eight years, picking holes in the Official Secrets Act, and firing at the two great world powers more than a pop record ever has'.

'Two Tribes' went on to sell an extraordinary 1.5 million copies and top the charts for nine weeks. By this time, the scenario it described seemed closer than ever. 'There was paranoia in the air,' says Johnson. 'There was that uncomfortable feeling that it could happen at any time.'

*

In the two years since Johnson had first written the song, nuclear diplomacy had reached a new nadir. Reagan was convinced that the Soviets were developing first-strike capability, thus wrecking the apocalyptic logic of MAD, though Premier Brezhnev fiercely denied it. Strategic Arms Reduction Talks (START) stuttered for months, and collapsed completely after Reagan announced his Star Wars initiative. Diplomacy was not made any easier by the parlous health of successive Soviet leaders: the

seventy-five-year-old Brezhnev died in November 1982; his sixty-eight-year-old successor, Andropov, lasted just fifteen months; seventy-two-year-old Politburo hardliner Chernenko took the reins in February 1984 despite being so ill that he could barely read the eulogy at Andropov's funeral. It was farce on the cusp of tragedy.

But though many of Reagan's critics seemed to believe him a real-life version of Slim Pickens in *Dr Strangelove*, waving his Stetson as he rides a bomb to oblivion, the president was as terrified of nuclear war as anyone and was severely shaken by three incidents during autumn 1983. For one thing, an advance screening of *The Day After* left him 'greatly depressed': the film's focus on a small group of ordinary Kansans struck a folksy, Hollywood chord with the president. This fell between two misunderstandings which raised the horrific spectre of an accidental war, the theme of the recent hit movie *War Games*. On 1 September the USSR mistakenly shot down a South Korean airliner. Two months later a NATO training exercise was taken for the real thing by some Soviet intelligence analysts, causing them to prepare their own missiles for retaliation: it was the closest the world had come to cataclysm since the Cuban Missile Crisis.

Public concern reached a head that year. Reagan was shocked by huge popular support for a 'freeze' of America's nuclear arsenal and wary of being portrayed as a sabre-rattler by his Democratic opponent in the forthcoming presidential election.* In Britain, meanwhile, Labour adopted its noble, albeit electorally suicidal, disarmament pledge, and CND attracted

* He did, however, make a queasy joke during a radio soundcheck in August 1984. Anyone hearing the president say, 'My fellow Americans, I'm pleased to tell you today that I've signed legislation that will outlaw Russia forever. We begin bombing in five minutes,' might well have assumed it was Chris Barrie preparing yet another 'Two Tribes' remix. It was, in fact, then sampled on a satirical dance track, 'Five Minutes', by Talking Heads guitarist Jerry Harrison and P-Funk bassist Bootsy Collins.

250,000 marchers to its October rally in London. The campaign organised its own Festival for Peace in London in May, where Paul Weller's new, post-Jam outfit the Style Council performed 'Money Go Round', a didactic white funk record with a topical nod to cruise. A Christmas show in London saw the debut of two new bomb-related protest songs – Elvis Costello's elegant 'Peace in Our Time' and Ian Dury's mocking 'Ban the Bomb' – while headliners U2 performed the fretful, quasi-martial 'Seconds'.

But while 'Seconds', like Depeche Mode's 'Two Minute Warning' and the Police's 'Walking in Your Footsteps', adopted a conventionally grim tone, two global hits brought some gaudy gallows humour to the topic. In her disconcertingly jaunty '99 Red Balloons', the German singer Nena imagined a cloud of toy balloons being mistaken by a malfunctioning defence computer for a first strike, thus triggering a nuclear showdown.* Prince's '1999' was a party anthem for the end of days. In a world where one could conceivably be extinguished in a blinding flash, the singer reasoned, 'I'll dance my life away.'† In 2000 *AD*'s Judge Dredd strip that year, some of the war-crazed citizens of Mega City One, who have escaped nuclear bombardment by the dastardly Sov-Bloc, take comfort in dancing to a song called 'Apocalypso'.

This macabre twist on *carpe diem* seemed to inform the sound of 'Two Tribes'. The record is so insanely, exhilaratingly *de trop* that it turns a battlefield into a dancefloor, and vice versa. Even more so than Edwin Starr's 'War', which Frankie covered on the

* The original German version ('99 Luftballons') squarely blames the machines, reducing humans to hapless bystanders, whereas the subsequent English version compensates for its awkwardly accented delivery with a more vicious, *Dr Strangelove*-style depiction of loopy bellicosity: 'This is it, boys! This is war!' In the US, ABC gave the song a boost by broadcasting the video following *The Day After*.
† Prince had already toyed with politics on his *Controversy* album (1981), jerking back and forth between lubricious funk and scattered thoughts on race relations, gun control, literacy, revolution and war. 'Ronnie, Talk to Russia's frantic plea for Cold War diplomacy is by far the oddest of the lot.

B-side, it asks the question: should an anti-war record really be this physically exciting? Johnson's lyrics are obtuse and fragmented enough to allow the music to flood in and fill the gaps. His daft, funk-style ad libs – 'We got the bomb, yeah', 'Sock it to me biscuit' – were intended to spoof American gung-hoism but sounded sincerely exuberant. In its mad, magnificent overload, 'Two Tribes' conflates war, sex and dancing to the extent that you are unsure which of these activities is right and which wrong. 'Are we living in a land where sex and horror are the new gods?' Undoubtedly, you feel, but is that necessarily a bad thing? It is as if 'Apocalypso' has escaped into the real world, and everyone with a radio is suddenly implicated in 2000 AD's absurdist satire.

The apparent ambiguity of 'Two Tribes' was enough to annoy more staunchly political musicians. 'I don't know exactly what it says other than the fact that there are Americans and there are Russians,' Dave Wakeling of the Beat grumbled to NME. 'The picture of Lenin on the sleeve probably meant more to me than the actual record.' In his book The Bomb: A Life, historian Gerard DeGroot curtly dismisses the video as 'a rather pathetic attempt at a sophisticated political message', which is a harsh misreading: it never claimed to be sophisticated. Oddly, the most vocal critic of the song's efficacy as a protest record was Morley himself. 'I've always been a bit pissed off with people like Weller and the Clash and Killing Joke, these people who say there can be some kind of polemic within pop,' he told his former employers at NME. 'Well, "Two Tribes" was trying to prove to people that it's impossible. I mean, we get to number one for nine weeks with an explicit, extravagant anti-war thing . . . and the next week it's George Michael taking over at number one, and that's the end. Nine weeks, and nothing's happened. I like that in a way. Because . . . what can happen?'

But how could 'Two Tribes' have succeeded by Morley's standards? By being number one for ever? By forcing a humbled Reagan and Chernenko to join hands and destroy their nuclear

arsenals? When you set the bar for political pop music that high, it will always fail. The impact of 'Two Tribes' was both more significant and more complex. For thousands of young listeners it was an unforgettable introduction to the whole concept of nuclear war. It was hard to shake the memory of Patrick Allen advising on how to dispose of your dead grandmother. And the song's ambiguity is precisely what makes it so rich and rewarding as pop rather than mere polemic.

What was not apparent at the time was that the worst, in terms of US–Soviet relations, was in fact over. Arms reduction talks resumed in June 1984, just as 'Two Tribes' was beginning its chart reign, and the Soviet side of the equation clicked into place when Chernenko died in March 1985 and was replaced by the moderate Mikhail Gorbachev. Concerned by the ailing Soviet economy, Gorbachev saw arms reduction as the quickest route to cutting the budget and wooing vital Western investors, and was willing to make at least some of the concessions that his predecessors had rejected. Step by cautious step, the two sides moved towards an agreement. Reagan and Gorbachev signed the historic Intermediate-Range Nuclear Forces Treaty on 8 December 1987, and the hands of the Doomsday Clock retreated to six minutes to midnight. By then, incapable of living up to the amok ambition of those early singles, or, indeed, of getting on with ZTT or even each other, Frankie Goes to Hollywood were finished.*

*

Washington DC, 6 November 1984: election night. Frankie Goes to Hollywood have just played the first show on American soil. Their set begins with projections of politicians, mushroom clouds and napalmed Vietnamese children. Afterwards, a reporter from TV's *Entertainment Tonight* asks one fan why he has come.

* One of the wilder Morley ideas that the band rejected was a movie, to be written by Martin Amis and directed by Nic Roeg, in which war would break out while Frankie were en route to LA, meaning that they landed in a post-apocalyptic wasteland.

'Because they are making an important political message with their song "Two Tribes",' he replies.

'What is that point?' asks the reporter.

'Oh, I don't know.'

23

'In the name of love'

U2, 'Pride (In the Name of Love)', 1984

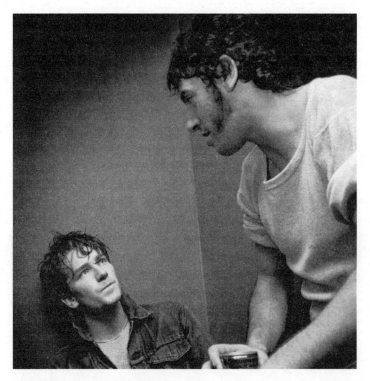

U2, Bruce Springsteen, Live Aid and the difficult art of
stadium protest

Bruce Springsteen talks to Bono backstage after U2's show at London's Hammersmith Palais, 9 June 1981.

Bono explains U2's approach to protest music and activism by way of a story. It's a story he heard from Harry Belafonte, and it takes place in early 1961, just after Bobby Kennedy's appointment as US Attorney General.

Martin Luther King convened a meeting of civil rights leaders to discuss how to win over the hard-nosed new appointee, not yet the hero of the left, to their cause. After some time listening to his colleagues hurl abuse at Kennedy, King banged the table and closed the meeting, saying, 'Right, we will reopen this discussion when somebody can find one redeeming thing to say about Bobby Kennedy because that, friends, is the door through which our movement will pass.' 'And Belafonte was telling me this,' says Bono, 'by way of encouragement for the work that I do – find that one redeeming thing and try to go through that door.'

Belafonte told Bono this story in the late 1990s, so it did not transform his ideas; rather it confirmed what he already believed, namely that you catch more flies with honey than with vinegar, and that the path to political progress is paved with diplomacy and compromise. The story could not have found a more receptive audience because it involved Martin Luther King and the benefits of tact, both of which had informed the writing of U2's breakthrough international hit, 'Pride (In the Name of Love)', over a dozen years earlier.

In November 1983 U2 were playing a show in Honolulu, Hawaii, having spent almost a year on a world tour. They were billeted in the Kahala Hilton, a hotel so luxurious that, had they arrived a little earlier, they might have spotted President Reagan by the poolside. During a soundcheck before the show, they began working on a luminescent melody and chord sequence, full of light and space. 'I was looking for a balance to this operatic chorus and I wanted to write some dark verses,' says Bono. 'It was

originally meant as the sort of pride that won't back down, that wants to build nuclear arsenals,' he told *NME*'s Gavin Martin. 'But that wasn't working. I remembered a wise old man who said to me, don't try and fight darkness with light, just make the lights shine brighter. I was giving Reagan too much importance. Then I thought Martin Luther King, there's a man. We build the positive rather than fighting with the finger.' A journalist had recently given Bono a copy of Stephen Oates's bestselling biography of King, *Let the Trumpet Sound*. 'In the end this slain preacher from Atlanta, that dark note, was the way I found the balance,' he says. 'So I was able to keep that song in an ecstatic place.'*

'Pride' epitomises the politics of the stadium: stirring and inclusive, yet vulnerable to being misread or diluted. Bruce Springsteen's 'Born in the USA', which came out the same year, showed just how easily that process could occur, and how hard it is to project a nuanced message to people sitting in row ZZ of a Brobdingnagian sports venue. Both artists became part of Live Aid, its associated singles and the birth of rock-as-philanthropy, in which only the biggest, broadest gestures count, and there is precious little room for rebellion or subversion. Both nonetheless took measures to retain those qualities and answer the burning question: Can you be part of the establishment without being neutered by it?

*

U2 were never much good at being punks. Not enough vinegar. Coming together at school in Dublin in September 1976, they were, and remain, an alliance of divergent, though mutually sympathetic personalities. Bono has the silver tongue of a raconteur, the taut, jabbing body language of a retired boxer

* Bono subsequently called the lyric 'just a load of vowel sounds ganging up on a great man'. It contains one embarrassing error: Bono sings 'early morning April 4' when King was actually shot at 6:01 p.m.

and the focussed charisma of a politician, fervently convinced of the power of words to change minds. Guitarist The Edge is as still and softly-spoken as a monk, except when his eyes crinkle slightly in concentration or mirth. Bassist Adam Clayton has the louche bearing of a disgraced aristocrat, and a perpetual air of mild and mysterious amusement. Drummer Larry Mullen, Jr, tends to lean forward with earnest intensity, punctuating his speech with apologetic grimaces: he is U2's restraining anchor, the equal and opposite force to Bono's grand gestures.

As a result of both temperament and circumstance, U2 could neither play with Clash-style guerrilla chic nor take sides. 'Very early on we played pro-contraception gigs and pro-choice gigs,' says Clayton. 'The Catholic dogma and the Fianna Fáil republicanism was something we didn't feel a part of. People in the South were always revolted by the acts of terrorism and brutality in the North but to express it would have been to sympathise with the British, so it was complicated. We were part of finding a spiritual dimension to it rather than just standing at the barricades.'

'Miserabilism seemed to be very common at the time and we tried to sidestep [that] and be *for* things as opposed to against things,' says The Edge. 'The influence there would have been Bob Marley, who didn't see any distinctions between aspects of his life: sexual, spiritual, religious, political.'

All of U2 except Adam had experienced some degree of Christian upbringing and they would try, with increasing success, to absorb some of the spiritual politics of soul, gospel and reggae, an unfashionable ambition in the post-punk era. At first, the desire manifested itself in a wired, Pentecostal urgency. 'I think we were particularly intense back in those days and you can certainly hear that in the recordings,' says The Edge. 'Some of it's overwrought and way too intense. We wanted to connect and break down the barriers. It made for shows that were really very ramped up on an emotional level – almost a desperation in the performances to make a connection, which didn't help at

times. Our lives seemed to depend on it. There was a sense that it could go all the way or it could go nowhere. Literally, it felt like those were the two options.'

In 1978 they began holding Bible meetings, which The Edge compares to Rasta reasoning sessions 'but without the weed'. This gradually brought them into contact with a radical Christian group called Shalom, who believed in miracles and speaking in tongues. After *Boy* (1980), with its themes of faith and loss, the meetings became more intense and some Shalom members pressured Bono, The Edge and Mullen to abandon U2 and devote themselves to the faith. Mullen left the meetings, while Bono and The Edge announced they were leaving the band. Their formidable manager Paul McGuinness put the counter-argument: 'Do you really think you're going to be more effective by going back to your kind of normal lives? Or do you think taking this opportunity to be in a great rock'n'roll band is, in the long term, going to have more value?' Bono and The Edge decided to distance themselves from Shalom, and reconcile their faith with their music. Hence the overtly religious *October* (1981), which panicked some of the people around them. 'It's OK,' assured Island Records' Chris Blackwell. 'There's Bob Marley and Marvin Gaye, Bob Dylan, it's a tradition. We can get through it.'

October salted post-punk hallelujahs such as 'Gloria' and 'With a Shout (Jerusalem)' with anguished doubt, heavily influenced by Joy Division. It was a bleak, confused record which found a chilly reception. The title refers to the feeling that the Western world was heading into winter: Gil Scott-Heron's *Winter in America* revisited. 'Here I am, aged 22, with a head full of gothic dread,' Bono told writer Neil McCormick, 'looking around at a world where there's millions of unemployed or hungry people, and all we've [done with] the technology we've been blessed with is to build bigger bombs so no one can challenge our empty ideas.'

*

At the same time as U2 were touring *October*, Bobby Sands was wasting into oblivion in Northern Ireland's Maze prison, so U2 found themselves, as Irishmen in America, being embraced by IRA supporters for whom Sands's martyrdom was a fundraising bonanza. Some nights a crowd member would throw the Irish tricolour on stage and, in a deft stroke of symbolism, Bono would slash away the bands of green and orange, leaving just a strip of white: a banner of truce. Paramilitary activity in Ireland, conflict in the Falklands, Israeli forces in Lebanon, revolutions and counter-revolutions in Central America, US–Soviet sabre-rattling: all pointed towards *War* (1983). 'I think that love stands out when set against struggle,' explained Bono. 'The album is about the struggle for love.'

The US tour hardened U2's unspoken opposition to armed struggle in Northern Ireland, whether it be the Irish Republican Army or their loyalist opponents the Ulster Defence Association. 'We decided that it was morally wrong that we weren't coming to terms with it ourselves,' Clayton told *NME*. The Edge began working on a stinging lyric: 'Don't talk to me about the rights of the IRA, the UDA . . .' Bono dropped that line and worked on contrasting the 1972 Bloody Sunday massacre with the promise of Easter Sunday.* 'I don't think we really pulled it off,' he later reflected. 'It was a song whose eloquence lay in its harmonic power rather than its verbal strength.'

'Sunday Bloody Sunday' is militant pacifism, matching a martial drumbeat to a non-violent sentiment: 'I won't heed the battle call.' 'The irony was that a lot of people thought "Sunday Bloody Sunday" was a call to arms, a rebel song for a united Ireland,' Bono told writer Michka Assayas. The first test of the song came when they played Belfast. 'Bono told the audience that if they didn't like it then we'd never play it again,' The Edge told *NME*. 'Out of the 3,000 people in the hall about three walked

* The title had already been used by John Lennon in 1972, and that in turn came from an unlikely source: John Schlesinger's 1971 movie about a bisexual love triangle.

out. I think that says a lot about the audience's trust in us.' One prominent Belfast resident, however, was not won over. Gerry Adams, leader of the IRA's political wing, Sinn Féin, reputedly called Bono a 'little shit' and tore down a U2 poster from his office wall.

On *War*, 'Sunday Bloody Sunday' was followed by two more protest songs: the nuclear paranoia of 'Seconds', and 'New Year's Day', which repeated the trick of linking a symbolic annual holiday to a political event, in this case the struggle of Poland's Solidarity union against the communist dictatorship of General Jaruzelski. Although Bono regrets the sloppy, improvised lyric, the imagery clicks evocatively with the wintry piano melody and the frosted-breath clarity of the production. Oddly, it was only after the song was written that Jaruzelski announced that he would be lifting martial law on New Year's Day 1983.

Although *War* was a success, Bono soon had reservations about its 'strident' and 'finger-pointing' tone. For *The Unforgettable Fire* (1984), U2 approached producer Brian Eno, the Roxy Music alumnus and ambient pioneer who had worked on landmark records with David Bowie and Talking Heads. 'I thought it was a pretty strange idea to tell you the truth,' says Eno. 'I remember having a phone call with Bono and I said, "If I come on board what I'm going to do is change a lot of what you're doing. Is that what you want?" And he said, "That's exactly what we want."'

The album was named after a series of paintings by survivors of Hiroshima and Nagasaki, and 'Pride (In the Name of Love)' was proudly, if uncontroversially, political but the lyrics mostly followed the more oblique path of the music they recorded with Eno, even on the song 'MLK', which needed its title to give its elemental imagery shape. It was a stepping stone to bigger things.

In March 1985 *Rolling Stone* named U2 'Our Choice: Band of the '80s.' 'For a growing number of rock'n'roll fans,' raved Christopher Connelly, 'U2 . . . has become the band that matters most, maybe the *only* band that matters.' The allusion to the Clash's old promotional slogan, 'The Only Band That Matters',

was surely intentional. It was, however, a heavy burden. 'There is a danger of being a spokesman for your generation if you have nothing to say other than help,' Bono admitted to *NME*'s Gavin Martin. 'That's all we say in our music. It's never sort of, yes folks, here we go, here's *the* plan. It's always, where's the plan?'

That discomfort was shared by another spokesman for his generation, a major influence on U2's growth and, in *Rolling Stone* parlance, the only solo rock star who mattered in mid-1980s America.

*

Bruce Springsteen had much in common with the young Bono. Not just origins – they were both working-class, from towns not accustomed to producing rock stars – but mentality: they both privileged instinct over intellect and sincerity over cool. When Springsteen described his show as 'a combination of a circus, a political thing and a spiritual event', he could have been describing what U2 were working towards. But he was a decade, and an entire musical epoch, older. 'U2 had no tradition, we were from outer space,' Bono told Neil McCormick. 'There were no roots to our music, no blues, no gospel, no country – we were post-punk.'

Springsteen's music was all about roots, both musical and geographical: he was an ambassador from the land of truck stops, five-and-dimes and jukeboxes crammed with history. He sang about the working man and he played music like a working man, all sweat and sinew. He is still perhaps the only rock icon you would trust to fix your car or build you a toolshed. With the success of his third album, *Born to Run* (1975), he became rock's noble savage, single-handedly representing an idealised, prelapsarian version of rock'n'roll which combined heroic individual achievement with a sense of community. He sang about escaping his own small town in New Jersey while making his listeners feel that they could do likewise.

If U2's understanding of politics in the early days was

somewhat incomplete, Springsteen's was non-existent. 'There wasn't any kind of political consciousness down in Freehold in the late Sixties,' he told *Rolling Stone*'s Kurt Loder. 'It was a small town and the war seemed very distant.' In 1968, while many young Americans were passionately protesting the war in Vietnam, the nineteen-year-old Springsteen was just relieved to have failed his army physical on account of an old motor-cycling injury. Springsteen didn't think the war was wrong; he just didn't want to die. Similarly, when he sang about blue-collar struggles, he was more interested in the *what* and the *how* than the *why*. Not that 'Born to Run' or 'Thunder Road' would have been improved by a Marxist reading of labour conditions in small-town New Jersey but, without any kind of broader context, Springsteen's narratives suggested a world of victims without victimisers: what Robert Christgau witheringly called 'pseudotragic beautiful-loser fatalism'. His strength was creating persuasive characters, and they would be the foundation for his subsequent protest songs: he built his politics from the ground up.

A switch seemed to trip in his brain on the night of 4 November 1980, as he stayed up late watching Reagan turn the map red. 'I don't know what you thought about what happened last night,' he told an audience at Arizona State University. 'But I thought it was pretty terrifying.' And then he rode 'Badlands' (1978) into suddenly unfamiliar territory. The same night, someone handed him a copy of Joe Klein's *Woody Guthrie: A Life*, and another switch was tripped.

Springsteen grew up in a house with no books and he was a poor student, but his manager Jon Landau, a college graduate and former *Rolling Stone* journalist, fed him a steady stream of books. The information jumped right off the page and into his live set. After reading Klein, he began performing 'This Land Is Your Land' in concert. He even plugged his next big discovery, Henry Steele Commager and Allan Nevins's *History of the United States*, from the stage. 'I started to learn about how things get to be the way they are today, how you end up a victim

without even knowing it,' he told a crowd in Paris in 1981. *Born on the Fourth of July*, by paraplegic Vietnam veteran Ron Kovic, led him to meet with, and play benefits for, the Vietnam Veterans of America. All of this new information had a catalytic effect on his existing material. It was precisely because he believed in the American dream that he reacted with such moral rage to its flaws and betrayals. In this sense, he was Woody Guthrie's heir apparent: a wounded patriot set on reclaiming his country.

His next album was written under the influence of this new scepticism and charted a different America, following different cultural road signs: the Southern gothic tales of Flannery O'Connor; baleful old folk records; *Badlands*, Terrence Malick's haunting movie about the 1958 killing spree of Nebraska couple Charles Starkweather and Caril Ann Fugate; Suicide, the New York art-punk duo whose story of a maddened factory worker, 'Frankie Teardrop' (1977), was basically Springsteen in hell. *Nebraska* (1982) was Springsteen's what-if? album. What if the runaway lovers of 'Born to Run' packed guns instead of guitars and didn't stop driving until the police forced them to? What if by leaving behind their dead-end jobs and small-town blues, they also cut themselves adrift from everything that kept them grounded? What if their poverty was not just financial but emotional and spiritual? What if the highway led nowhere? The most heroic figure in American mythology is the loner, and so is the most frightening. '*Nebraska* was about that American isolation,' he told Kurt Loder. 'What happens to people when they're alienated from their friends and their community and their government and their job. Because those are the things that keep you sane, that give meaning to life in some fashion.'

Springsteen recorded the album with a full band but felt it had lost its stripped-to-the-bone rawness, and so released the unvarnished cassette-tape demos. It is a folk record which combines the boneyard eeriness of Harry Smith's 'old, weird America' with the political consciousness of Woody Guthrie and Pete Seeger, but Seeger and Guthrie never admitted to such loneliness and

despair. The album ends with a cruel trick. 'Reason to Believe', a very Springsteenian title, promises a final candle of hope but delivers nothing but a roster of gothic sorrows and a bleak shrug: 'Struck me kinda funny . . . How at the end of every hard-earned day people find some reason to believe.' Greil Marcus, while noting the complete absence of polemic, called *Nebraska* 'the most complete and probably the most convincing statement of resistance and refusal that Ronald Reagan's USA has yet elicited from any artist or any politician'.

During the *Nebraska* sessions, Springsteen demoed a song called 'Born in the USA', narrated by a maimed and unemployed Vietnam veteran who has 'nowhere to run'. Alone with his guitar, Springsteen sings like a man who has nothing, and reiterates the title like it's a curse rather than a blessing. He is Frankie Teardrop with discharge papers. Landau called the acoustic version 'a dead song' but what would happen to it later would add more layers of irony to the title than it could bear: it would be *murdered* by irony.

When a song is misunderstood, it is traditional to smirk at the knuckleheads who don't get it, but the official version of 'Born in the USA' (1984) was misunderstood so widely that Springsteen has to take some of the blame. A song's meaning does not just reside in its lyrics, but in its melody, its production, its tone of voice. Edwin Starr's 'War' gets away with sounding belligerent because the hook is so forceful and unambiguous, but the words of 'Born in the USA' needed to be handled with more care. On the demo, you feel like you're leaning in to the life story of a broken man; on the single, he's hollering it at you while riding in a tank. When you listen to Roy Bittan's triumphantly martial synthesiser riff, Max Weinberg's heavy-ordnance drums, Springsteen's full-throated roar, the major-key melody, you don't hear bleakness and betrayal: you hear a battle cry. Landau thought the original version was too small, but this one is far too big. It is a Trojan horse with the door jammed shut. The subversive lyric cannot get out.

It's undeniable that Springsteen benefited commercially from the misunderstanding because it suited the mood of the times. As he told Kurt Loder, 'I think what's happening now is people want to forget. There was Vietnam, there was Watergate, there was Iran – we were beaten, we were hustled, and then we were humiliated. And I think people got a need to feel good about the country they live in. But what's happening, I think, is that that need – which is a good thing – is gettin' manipulated and exploited.'

But the song, paired with the stars-and-stripes on the cover of the *Born in the USA* album (1984), let people feel good about America, provided they didn't listen too closely. The album's return to community and hope after the terminal loneliness of *Nebraska* mistranslated as patriotic triumphalism. As the tour rolled on into 1985, unofficial Springsteen T-shirts appeared bearing the legend 'RAMBO OF ROCK', in reference to Sylvester Stallone's musclebound Yankee avenger.* However much Springsteen tried to push a different message from the stage, he was inadvertently riding the Reagan wave. 'The flag is a powerful image, and when you set that stuff loose, you don't know what's gonna be done with it,' he admitted to Kurt Loder.

In September 1984 the conservative columnist George Will demonstrated to Springsteen how badly his song had backfired. 'I have not got a clue about Bruce Springsteen's politics, if any, but flags get waved at his concerts while he sings about hard times,' wrote Will. 'He is no whiner, and the recitation of closed factories and other problems always seem punctuated by a grand, cheerful affirmation: "Born in the USA!"' Will obviously didn't

* Yet another irony: in *First Blood* (1982), Stallone's John Rambo was an embittered Vietnam veteran hounded by redneck cops, but in *First Blood 2: Rambo* (1985), he is kicking communist ass on a mission to rescue American POWs and retrospectively turn defeat into victory. Reagan was allegedly a huge fan of the second movie. 'Put Rambo back inside your pants,' urged Jello Biafra on 'Stars and Stripes of Corruption'.

listen to the verses (or chose to ignore them), and nor did Reagan because a few days later, on a campaign stop in Hammonton, New Jersey, the president announced: 'America's future rests in a thousand dreams inside your hearts. It rests in the message of hope in the songs of a man so many young Americans admire: New Jersey's Bruce Springsteen. And helping you make those dreams come true is what this job of mine is all about.'

This put Springsteen in an invidious position. Not, by nature, a radical, he did not savour a war of words with the president of the United States, but three days after Reagan's speech he said on stage, 'The president was mentioning my name the other day and I kinda got to wondering what his favourite album might have been. I don't think it was the *Nebraska* album.' Diplomatically done. Nor did he support the Democratic nominee, Walter Mondale: he avoided Washington altogether, preferring to support local food banks, unions and community action groups. And throughout 1985 he attempted to take back his song – by mentioning covert US wars in Central America, or the time he was almost drafted, or by preceding it with an explosive version of Starr's 'War'.*

Steve Erickson of the *Village Voice* hit upon a felicitous phrase to describe the Born in the USA tour: 'aggressive doubt'. 'Springsteen's record and tour find doubt and faith locked in protracted negotiations with no settlement in sight,' he wrote, a sentence which could have applied equally to U2, and to that moment in late 1984 when stadium activism was born.

*

One shouldn't underestimate the importance of depression and failure as triggers for political action. Without personal

* Another cover version on the tour was 'Street Fighting Man', with all the irony blasted out of it. In revolutionary 1968, Mick Jagger thought that to 'sing for a rock'n'roll band' was a pretty feeble contribution to the cause; at the apex of Reaganism, it seemed like one of the few remaining options.

turmoil, Jerry Dammers wouldn't have written 'Ghost Town', Marvin Gaye wouldn't have seized upon 'What's Going On', and Boomtown Rats frontman Bob Geldof wouldn't have conceived Band Aid. 'So many conditions needed to exist for this to have worked,' he told *Rolling Stone*'s Rob Tannenbaum years later. 'I had to be in [watching TV]. I had to be depressed, so that my responses were wide open. The Rats had to not be doing well . . . I knew that if *I* wrote a song, it wouldn't sell. So I needed to get people I knew to sing it.'

The Boomtown Rats, who took their name from Guthrie's *Bound for Glory*, were an Irish punk band who had fallen on hard times, forced to tour universities just to raise enough money to record their next album. In late October 1984 Geldof was collapsed on his sofa when the BBC broadcast a shocking report from famine-struck Ethiopia. The image that most haunted him was that of a nurse facing a starving crowd of 10,000 and trying to choose just a few hundred to be fed and saved. 'I felt disgusted, enraged, and outraged,' Geldof wrote in his memoir, 'but more than all those, I felt shame.'

The next day he tentatively suggested to his wife, Paula Yates, that he organise a benefit single featuring singers whose profile was somewhat higher than that of the Boomtown Rats. While Geldof put in calls to singers, managers, publishers and retailers, he and his friend Midge Ure, of portentous synth-pop band Ultravox, passed fragments of the song back and forth, glueing Geldof's basic melody to Ure's ringing synth refrain. Geldof later called it 'not a particularly good song', but although some of the riper lines, like the one which contrasts Christmas bells with 'the clanging chimes of doom', might not have survived a longer editing process, this jerry-built effort did its job as well as could be expected. Ure's solemn, faintly African intro – half Ultravox, half Peter Gabriel's 'Biko' – conveyed something of the gravitas of the situation, while the massed chorus ('I wanted something which sounded like a football chant or "Give Peace a Chance",' wrote Geldof) and the ample use of bells made it something that

people could feel good about playing at Christmas.

Bono got the call while on tour in Germany. 'All I remembered was having rows with Geldof about how he thought pop music and rock'n'roll should stay away from politics and agitprop, be sexy, fun, mischievous,' he told McCormick. 'So it was odd to get a call from Geldof to talk about Africa.' But he was soon convinced and flew to ZTT's west London studio with Adam Clayton to join the other forty-five performers.* Perusing the lyrics before the session, he saw only one line he didn't like: 'Tonight thank God it's them instead of you.' Geldof came over and said that was exactly the line he wanted Bono to sing. Bono said no. 'This is not about what you want, OK?' barked Geldof. 'This is about what these people need.' Reluctantly, Bono agreed. 'I kind of did an impersonation of Bruce Springsteen, that was really what was in my mind.' The line was as controversial as he had feared, but it does give the song an intriguingly discordant note of brutal candour. 'Do They Know It's Christmas?' became the biggest-selling single in British history, raising £8 million for food aid when Geldof had hoped for £100,000 at best.

In America, Harry Belafonte heard the song and called up Ken Kragen, manager of Motown star Lionel Richie. 'Perhaps this is an idea whose time has come,' he said. Using Richie, then at the peak of his success, as bait, Kragen began phoning every pop star in the US, starting from the top of the *Billboard* Top 100 and working his way down. 'The turning point was Bruce Springsteen's commitment,' he told *Rolling Stone*. 'That legitimised the project in the eyes of the rock community.'

On the night of 28 January forty-six singers gathered in the A&M Studios on Hollywood's Sunset Strip, and recorded through the night. Stevie Wonder dispatched aides to translate some lines into Ethiopian – 'It's got to be authentic!' – before Ray Charles gently pointed out that they were having a hard enough time singing in English. Geldof, who had recently visited

* To be entirely accurate, forty-three others were in the studio: the absentee Paul McCartney and David Bowie sent in their parts on tape.

Ethiopia with the charity World Vision, stomped around raging at no-shows like Prince. 'Has he got other things that are more important than trying to save people's lives? Going to a disco? . . . Fuck him. He should have been here. What is he? A creep.'

'We Are the World', written by Richie and Michael Jackson and credited to USA for Africa, was a much less interesting record than 'Do They Know It's Christmas?'* A picture of the Band Aid cast illustrates the oddball nature of Britain's pop aristocracy in 1984, full of strange hairdos, regrettable outfits and awkward grins. USA for Africa, by contrast, looked like a meeting of pop's G20, with careers stretching back to the 1950s. The song is banal, sanctimonious and overlong (only Springsteen and Wonder's climactic duet offers the frisson of genuine commitment), with an unfortunate air of *noblesse oblige*. 'Do They Know It's Christmas?', in its endearingly hamfisted way, established a conscience-pricking contrast between *them* (the famine victims) and *you* (the complacent Westerner). Although 'We Are the World' was meant in a Christian sense, i.e. we are all our brother's keepers, the sweeping *we* erases the starving from the equation. South African singer Miriam Makeba mordantly commented, 'Who is the world? Where are the singers from Africa, Europe, the East, the Third World? They are all Americans singing "We are the world." Oh truly, we say, "America" is the world!'†

Geldof used his visit to the recording to announce a massive transatlantic benefit concert for Ethiopia in July. All-star benefit shows were nothing new – George Harrison's Concert for Bangladesh in 1971, the No Nukes shows and the Concerts for the People of Kampuchea in 1979, Graham Nash's anti-nuclear

* On this issue there is a transatlantic divide. Venerable left-wing critics such as Greil Marcus and Robert Christgau applauded its multiracial line-up and gospel-choir roots, while dismissing the Band Aid record as 'half-assed'.

† * Another avoidable misunderstanding: few listeners realised that USA for Africa actually stood for United Support of Artists for Africa.

Peace Sunday in 1982 – but there had been nothing on this scale before. Never afraid of using the bully pulpit, Geldof hustled and hectored and twisted arms until they snapped.

Live Aid took place on Saturday, 13 July. On a bill of giants, the relatively untested U2 appeared at London's Wembley Stadium in the afternoon. They started with 'Sunday Bloody Sunday'. Then, during 'Bad', Bono clambered down into the crowd, danced with a girl in the crowd, and clambered back up again, all of which took a very long time and left the rest of the band awkwardly extending 'Bad' until his return. The move meant they didn't have time to perform 'Pride', their biggest hit, but it became the making of Bono as a global star: a moment of real, albeit corny, spontaneity and risk.* 'I met Elvis Costello a few months back and he said to me, "I'm ambivalent about U2, I love it and I hate it,"' Bono told NME's Barney Hoskyns. 'He said, "You walk this tightrope that none of your contemporaries will walk – they're afraid to walk it – and when you stay on I bow my head, but you fall off it so many times and . . ." There was no answer to that. We do fall off, a lot, and onstage I'll try for something and it won't work . . . but it might work, that's the point. It *might* work.'

The arithmetic of Live Aid speaks for itself: 400 million TV viewers worldwide, around £40 million raised. Beyond that, its success is up for debate. 'Live Aid is all things to all people,' Geldof told Rob Tannenbaum. 'The Tories could use it as "a shining example of individual action and individual responsibility". The Communists would say, "It's the proletarian rage against the excesses of the First World."'

But British music journalists, weaned on punk and left-wing politics, were divided. While NME's Paul Du Noyer accepted

* If U2 were Live Aid's coming men, Bob Dylan was its clueless old-timer, performing a ragged 'Blowin' in the Wind' and outraging Geldof by suggesting that some of the money go to help American farmers, a comment which led to the establishment of Farm Aid but was hideously tactless on the day.

that saving lives was generally A Good Thing, his colleagues Gavin Martin and Don Watson levelled a series of accusations: the line-up contained too many Anglo-Americans; the aid goals were too short-term and bypassed existing charities; Geldof was too obnoxious and defensive; and, worst of all, it was apolitical. Live Aid implicitly portrayed famine as an act of God rather than the consequence of bad governance, rapacious capitalism and Western apathy. 'Band Aid was a moral issue: whether you were of the right or left was irrelevant,' Geldof writes in his defence.* The only performer to politicise Live Aid was German singer Udo Lindenberg, who blamed 'colonial exploitation' and contrasted the money raised with the billions spent on nuclear weapons. BBC switchboards lit up with complaints. People didn't want to hear *that*.

Musicians outside of the Live Aid line-up joined the dissenting chorus. 'It really pisses me off when I read Midge Ure saying that Band Aid isn't political,' complained Billy Bragg. 'I'm genuinely pleased they did it, but they didn't even admit they are perpetuating a system that makes that happen.' There were even response records. Reacting to the fact that most performers received sales boosts after Live Aid, Leeds-based anarcho-punks Chumbawamba called their debut album *Pictures of Starving Children Sell Records* (1986). Californian funk-metal group Faith No More recorded the wonderfully sarcastic 'We Care a Lot' (1985), claiming to be concerned about 'disasters, fires, floods and killer bees'. Satirical Houston group Culturcide *détourned* 'We Are the World' into 'They Aren't the World' (1986), overlaying the original song with snarky new lyrics.

One thing Live Aid did was to remove the risk from protest. The cause was so uncontroversial that everyone could appease their consciences without the slightest risk of ruffling feathers. Geldof actively encouraged people to buy the Band Aid single as

* On the subject of the predominately white line-up, he snapped: 'There's nothing wrong with Aswad or Steel Pulse, but you just have to face it, they don't sell many records.'

a donation rather than because they liked the record, logic which was good for Ethiopians but bad for pop. Any song should earn its audience with more than goodwill.

It marked the end of strange, subversive statements such as 'Two Tribes' and the beginning of phony protest songs by artists with little grasp of politics who nonetheless felt obliged to make a Big Statement: what Bono later referred to as 'Rock against bad things'. Such trite and irritating social commentaries as Red Box's 'For America', Hollywood Beyond's 'What's the Colour of Money?' and the Culture Club's 'The War Song' made one wonder if greed and bloodshed weren't so bad after all. If you had to isolate one moment as the absolute nadir of the protest song, it would be the Thompson Twins and Madonna blundering through the Beatles' 'Revolution' at Live Aid, so evidently befuddled by references to Chairman Mao and giving money to 'minds that hate' that they pounced upon the opportunity to sing 'We all want to feed the world' as shipwreck victims might pounce on a life raft.*

Meanwhile, Band Aid and USA for Africa sparked a trend for charity singles with videos in which miscellaneous celebrities alternated between goofball backslapping and earnestly clutching their headphones. For the artists who kept cropping up on these singles and concert bills, the individual cause became less important than being seen to care, telegraphing their sincerity with what critic Tom Ewing describes as 'that curious register of human speech that exists only on charity records, the *concerned bellow*'. By the end of the 1980s even Geldof thought the benefit gig was a busted flush. 'The big concert is seriously devalued currency,' he grumbled. Thus the mainstream protest song became

* 'Rock against bad things' found its ultimate visual expression in the video to Michael Jackson's 'Man in the Mirror' (1987), which collaged the century's most emotively iconic images (everything from Vietnam to Ethiopia, Hitler to Gandhi, and, inevitably, some whales) into meaningless moving wallpaper: a hyperbolic display of 'caring' devoid of any remotely cogent political point.

a toothless beast. Of the Live Aid crew, only U2 endeavoured to retain some bite.

*

Shortly after Live Aid, World Vision invited Bono and his wife Ali to Ethiopia to perform volunteer work at a feeding station in the north of the country. 'The thing I came away with was a sense that there was a structural side to this poverty,' Bono told McCormick. 'The story of starvation and poverty in Africa is not always war and natural disaster. A lot of it is corruption . . . and not just theirs but our corrupt relationship with Africa.'

After Ethiopia, he chose an activist path because 'this was how I could justify being in a band in a certain sense'. In 1986 U2 played the Conspiracy of Hope tour for the US branch of Amnesty International, alongside Peter Gabriel, Sting, Jackson Browne, Joan Baez, Fela Kuti and others. Then, through the charity Sanctuary, Bono and Ali spent a week in Nicaragua and El Salvador, visiting peasant farmers and priests, flinching at the sound of mortar shells, questioning the validity of revolutionary violence, and witnessing the effect of Reagan's anti-communist zealotry. Even as he was immersing himself in American music and literature, he was discovering another side of the country. 'I started to see two Americas, the mythic America and the real America,' he told McCormick. 'It was an age of greed, Wall Street, button down, win, win, win, no time for losers . . . So I started working on something which in my own mind was going to be called *The Two Americas*. I wanted to describe this era of prosperity . . . as a spiritual drought.'

The Two Americas became *The Joshua Tree*. For many reasons – the self-serious cover image of U2 squinting solemnly in the Mojave Desert, the anthemic imprecision and gospel rush of the hit singles, the album's sheer commercial success – *The Joshua Tree*'s profound ambivalence towards America was often overlooked. But it was transparent on 'Mothers of the Disappeared'. 'The song was written after visiting with the *madres* in El

Salvador during the revolution there,' says Bono. 'I wrote this gentle little song as an afterthought.' If 'Mothers' was a spooked lament for the victims of US foreign policy, then 'Bullet the Blue Sky' was a rocket directed at the perpetrators.

'Bullet the Blue Sky' is the only song in U2's history into which Bono pours all of his violence and none of his diplomacy: it is the anti-'Pride'. When he came back from Central America he told his bandmates what he had seen and asked The Edge, 'Could you put that through your amplifier?' He even brought in photographs and videos of the atrocities to inform the playing of the song, which he wanted to sound like 'hell on earth'. The man with the face 'red like a rose on a thorn bush', slapping down $100 bills, was Reagan, he later admitted, but Eno had advised him, 'You'll ruin it for people if you give them images.' As the song builds, the brutality of the lyrics possesses the playing. 'I can see those fighter planes,' Bono murmurs like some hallucinating prophet. The guitar writhes and flares. U2 songs like to say: *Yes, we can work things out*. 'Bullet the Blue Sky' is a giant, blazing *No*. 'We were on the other side of the barricade at that stage and that is a much more comfortable place to be,' says Larry Mullen.

The Joshua Tree saddled U2 with an excessively earnest image: 'OK, these are really serious guys from war-torn Ireland and they've got a thing or two to tell you,' as Clayton drily puts it. But it also made them the biggest band of their generation, and at least some listeners got the message in its totality. When *Time* put U2 on the cover in April 1987, its reporter spoke to some fans. One Patty Klipper, from Parsippany, New Jersey, said: 'First they opened my mind to their music. Then their music opened my mind to the world.'

Bono maintains that U2's truest protest song isn't 'Pride' but 1991's 'One', a lustrous plea for compassion, marbled with doubt. 'I'm into difference,' he explains. 'Holding hands and all that stuff isn't really it. "One" has that *rage* at the heart of it. It's a very bitter song. It's about we *get* to carry each other. Not we *got* to carry each other.'

During the long tours that followed *Achtung Baby*, the mothership album of 'One', U2 reworked stadium rock into tongue-in-cheek political theatre, with walls of TV screens, satirical alter-egos and prank calls to right-wing politicians, all with a compelling measure of risk.

'I think by that point we'd figured out that it's sometimes enough to ask the right question,' says The Edge. 'You don't necessarily have to come up with an answer. Just to open yourself up to the possibility of being able to change doesn't necessarily mean you have to live up to some impossible ideal. We just went, "Y'know what? Fuck it. We are a bunch of contradictions and we're fine with that."'

24

'Are you so blind that you cannot see?'

The Special AKA, 'Nelson Mandela', 1984

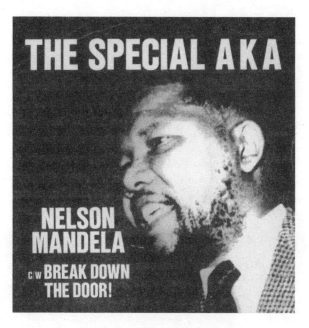

The fight against apartheid

The Special AKA, 'Nelson Mandela' (2 Tone, 1984).

Bizarre though it seems, when Jerry Dammers began writing what became 'Nelson Mandela' he hadn't actually *heard* of Nelson Mandela. He was already toying with the exuberant brass riff and African-influenced melody when he decided to attend the African Sounds festival at Alexandra Palace Pavilion, north London, on 17 July 1983. The twelve-hour event was to mark the imprisoned ANC leader's sixty-fifth birthday the following day, and a giant bust of his head surveyed the dancefloor. 'Free Mandela,' chanted the crowd during South African trumpeter Hugh Masekela's headline set. 'Free Mandela.'

Dammers was no stranger to the anti-apartheid cause. When the Springbok rugby team came to play in England in 1969, he had joined a demonstration and plastered protest stickers around his school in Coventry. But this focus on one man was new to him. Even though Mandela had by then been in prison for twenty years, he was not yet a global icon. The average British music fan would have been more familiar with Steve Biko, the black activist who had died in police custody in 1977. Dammers picked up some leaflets from anti-apartheid stalls at Alexandra Palace and digested Mandela's story. A few days later he came up with a simple three-word chorus for his African-influenced instrumental: 'Free Nelson Mandela'.

If any protest song can be said to have had a tangible effect on its subject matter, it is 'Nelson Mandela'.* It didn't exactly spring Mandela from jail single-handed but it raised awareness of his plight like nothing else and helped to make apartheid one of the defining causes of the 1980s, something the man himself acknowledged after his release in 1990. And Dammers went further by founding the lobby group Artists Against Apartheid. In its broad outline it is an uplifting tale, but the full story is a

* 'Nelson Mandela' is its original title, although it is better known under the name used for its US release, 'Free Nelson Mandela'.

turbulent affair, involving mental illness, creative paralysis, crippling debt and a damaging musical row during which Dammers found himself on the opposing side to two black South African musicians who had been fighting apartheid decades before he paid that life-changing visit to Alexandra Palace: Hugh Masekela and Miriam Makeba.

<p style="text-align:center">*</p>

Hugh Masekela was nine in 1948, when South African voters narrowly elected the Afrikaner National Party (ANP), who set about instituting apartheid with a series of acts which divided the country on racial lines and forced races and tribes to relocate accordingly. The ANP exploited the Manichaean mindset of the Cold War: by tarring their opponents as Reds, they ensured the West's tacit consent.

In his teens, Masekela had the good fortune to attend the progressive St Peter's school in Johannesburg, whose staff included future African National Congress (ANC) leader Oliver Tambo and the activist British cleric Reverend Trevor Huddleston, who nurtured his new student's interest in the trumpet. Huddleston returned to Britain in 1955, where he was the first to call for a cultural boycott of South Africa, while Masekela became increasingly radicalised, joining the strikes and bus boycotts organised by the ANC along the lines of civil rights activism in the US. He first encountered Mandela, at that point the ANC's star orator, while playing at fundraisers and attending rallies. Joining the cast of hit all-black musical *King Kong*, he met and fell in love with singer Miriam Makeba. The couple talked of escaping to America, the home of jazz and, so it seemed to them, a beacon of freedom. While Makeba was in London promoting the 1959 anti-apartheid documentary *Come Back Africa*, the South African government revoked her citizenship and Huddleston introduced her to Harry Belafonte, who became her mentor – her 'big brother,' she said – helping her to build a new life in the US.

The situation at home hit a new low on 21 March 1960. When

thousands of protesters from the Pan-Africanist Congress of Azania (PAC) demonstrated against the controversial passbook laws outside a police station in Sharpeville, a township in the Southern Transvaal, police opened fire. In the ensuing bloodbath 69 died and over 180 were wounded, igniting a powder trail of strikes, protests and riots across the country. The government declared a state of emergency and banned both the PAC and the ANC under the Suppression of Communism Act. Most of the leadership was jailed, with the prominent exception of Mandela, who, for the next seventeen months, would be 'the black pimpernel', an elusive underground resistance leader fomenting armed revolt. Masekela, who narrowly escaped arrest himself for breaking passbook laws, fled to join Makeba in the US.

The chorus of international outrage over Sharpeville was unanimous: not a single country came to South Africa's defence and at home even the Afrikaner press urged restraint. But Prime Minister Hendrik Verwoerd, like many demagogues, revelled in pariahdom: in 1961, South Africa became a republic and left the Commonwealth. Verwoerd's hardline approach paid off. With the arrest of Mandela in August 1962, domestic opposition was crushed – Mandela called the decade the 'silent Sixties' – and because international disgust did not translate into economic sanctions, the economy was booming. Britain introduced an arms embargo in 1964, but became too distracted by deadlock with the white minority government of Rhodesia to prioritise South Africa; America, likewise, had its foreign-policy plate full with Vietnam.

Sharpeville did at least provoke a lasting cultural backlash. In 1961 the British Musicians Union ruled that its members should not perform in South Africa, under threat of expulsion, while Belafonte became apartheid's most prominent US opponent.* Makeba became an international icon, aligning herself with

* Veteran agitator Ewan MacColl had the distinction of recording the first British anti-apartheid protest song, 'The Ballad of Sharpeville' (1960), a swingeing account of the massacre in the topical broadside tradition.

US civil rights while spreading the word about South African injustice, and she and Belafonte included several Zulu and Xhosa songs on *An Evening With Belafonte/Makeba* (1965).*
Masekela, too, built a considerable, if troublesome, reputation, befriending key figures in the Black Power and anti-war movements. 'I was always on the TV talking about South Africa, and they hated me for it,' he told writer Robin Denselow. When the State Department approached him to tour Africa, including South Africa, he responded, 'You've got a fucking nerve to come to ask me to see my country under your auspices.'

By 1968, many bands had struck South Africa off their tour schedules, but Makeba suggested to Roger McGuinn of the Byrds that he visit the country to witness the situation and publicly voice his opposition. The Byrds' sympathies were in no doubt – they had recently recorded 'So You Want to Be a Rock'n'Roll Star' with Masekela – but it was still a risky gambit and McGuinn's bandmate Gram Parsons quit the band in protest. It turned out to be a smart decision. McGuinn lectured white audiences and was rewarded with heckles and boos. The band ended up fleeing the country, without being paid, to avoid phony drug charges, decried by the press as enemies of South Africa. The idea that a foreign band could change minds by engaging with South African audiences was in tatters. Makeba had certainly changed her mind by 1971, when she persuaded Aretha Franklin to pull out of a South African date, pungently arguing, 'You can't roll around with pigs and not end up covered with mud.'

Towards the end of the 'silent Sixties', Steve Biko's Black Consciousness Movement (BCM) filled the vacuum left by the ANC and PAC, taking inspiration from Frantz Fanon and the Black Panthers in order to champion black pride. It staged protests and strikes throughout the early 1970s and, inspired by the

* One song on the album, 'Ndodemnyama Verwoerd! (Beware, Verwoerd!)' was written by Vuyisile Mini, an ANC activist and composer of protest songs who was executed for alleged political crimes in 1964. He went to the gallows singing freedom songs.

liberation struggles being waged by the MPLA in Angola and FRELIMO in Mozambique, caught fire on 16 June when a student demonstration against new education laws flowered into a full-blown uprising in the townships of Soweto. Police fired on a peaceful rally, killing twenty-three people and triggering months of unrest across the country. Angry students flocked to the BCM and the resurgent ANC, and the apartheid regime was never again able to restore full control. 'It is not as it was after Sharpeville,' wrote Makeba. 'Now, the people do not rest. They get shot at, but they still go out. This is new and surprising for the authorities, and from this moment they will have to sleep with one eye open.'

The following year the rebels found a potent martyr in thirty-year-old BCM leader Steve Biko. He was arrested at a police roadblock on 21 August 1977 and badly beaten. Shortly after his arrival at a prison in Pretoria three weeks later, he died from his injuries. No police officers were ever prosecuted for his murder. Biko's funeral was attended by 10,000 people, including many Western diplomats, and he quickly became the subject of documentaries, plays, books and songs, most famously Peter Gabriel's 'Biko' (1980).* Like Neil Young's 'Ohio', the song was born out of a visceral jolt of shock and grief upon reading the news, and was the first anti-apartheid statement by a major artist since Gil Scott-Heron's 'Johannesburg' five years earlier. The use of South African field recordings shrank the distance between the white Westerner and his subject, while the sustained drone granted the song the solemn gravitas of a funeral procession. For millions of listeners, it was an introduction to Biko's story as tactful as it was powerful.

That year was a pivotal one. Firstly, the UN passed a resolution calling for a sweeping cultural and academic boycott of South Africa. Secondly, ANC leader-in-exile Oliver Tambo conceived

* Gabriel was far from the first musician to reference Biko. During 1978 alone he was mentioned by Tom Paxton ('The Death of Stephen Biko'), Peter Hammill ('A Motor Bike in Afrika'), Tappa Zukie ('Tribute to Steve Biko') and Steel Pulse ('Biko's Kindred Lament').

a campaign that would put a face to the victims of apartheid and create an international hero: 'Free Mandela'. As the man himself later reflected, it was the first time most people outside South Africa had heard of him. 'I am told,' he wrote, 'that when "Free Mandela" posters went up in London, most young people thought my Christian name was "Free".'

*

By the time he wrote 'Nelson Mandela', Jerry Dammers was in a parlous frame of mind. Shaken by the premature demise of the Specials, he had hastily assembled a new line-up under the name the Special AKA, and started work on a new record. It was a bad idea. 'The problem was that I went straight into the studio rather than taking time out to write the songs,' he says, frowning. 'It's completely the wrong way to do it.'

Upon the belated release of *In the Studio* in 1984, Dammers told *NME*: 'Working on this album was like painting the Forth Bridge. We kept going round from one track to the other.' Ex-Specials bassist Horace Panter, who lasted about a fortnight in the new group, writes in his memoir: 'It was like attending a funeral every day of the week . . . Jerry's determination to continue had turned into tunnel vision.' 'Horace left with his sanity intact,' vocalist Rhoda Dakar told *Mojo*. 'I left in the back of a cab after collapsing on the studio floor in tears. I had to be carried to the car.' Having driven his bandmates to distraction with his perfectionism during the day, Dammers would spend long nights alone, endlessly finessing the mixes, as the studio bills continued to mount.

The material that Dammers was producing was often uncompromisingly grim. 'Pop is giving people what they want to hear,' he told *NME*'s Neil Spencer. 'We're giving people what they don't want to hear.' The Special AKA's Dakar-narrated first single, 'The Boiler' (1982), was a first-person account of a rape which culminated in a series of harrowing screams that made 'Ghost Town' sound like 'Club Tropicana'. 'War Crimes' was sinister-sounding

Middle Eastern dub which rather tactlessly compared the Israeli occupation of Lebanon to genocide at Belsen. 'Racist Friend' solemnly urged zero tolerance towards bigoted acquaintances. Dammers admits that he hates writing lyrics, and the expansive, internationalist music on *In the Studio* was often more persuasive than the words. 'I was very down because of the break-up of the Specials and the break-up of a long-term relationship and the album was about that,' Dammers explains. 'What I try to do in all my songs is put my personal life in a bigger political context.'

'Nelson Mandela' was the last song recorded and was meant to be the album's 'happy ending'. There was just the small matter of holding the band together long enough to put it on tape. Most problematic of all was the singer Stan Campbell, who, Dammers belatedly discovered, had serious mental health problems and was fast realising that the Special AKA would not, after all, be his fast track to pop stardom. During the band's terminal stages he was leaving and rejoining every few days. In desperation, Dammers called Elvis Costello, who had produced the first Specials album, and said, 'Elvis, I've got a good song but everything is chaos. Can you come and sort it out?'

'I was desperate to get that one song recorded before it all broke up because it felt like something important,' he says. 'It was a bit like "Ghost Town".' There was another point of comparison between the two swansongs. 'Terry [Hall] and Stan aren't virtuoso singers,' says Dammers, 'so that forces you into writing fairly easy-to-sing stuff, which is good. "Nelson Mandela" couldn't be a more simple tune. That's probably part of its strength because anyone can sing it.' Where the two records drastically part company is mood. While 'Ghost Town' evoked the night before a riot, 'Nelson Mandela' sounds like a street party. By alchemising anger into joy, it is a victory celebration before the fact.

Costello restored a degree of sanity to the process and recorded the song in a relatively lightning-fast four days. Dammers invited a number of former 2 Tone stars, including Lynval Golding from

the Specials and Dave Wakeling and Ranking Roger from the Beat, to join in on the chorus. 'The idea came from "Let's Clean Up the Ghetto", which was one of the very few records where different stars all appeared on the same record for a political cause. I like to think the seeds of that idea went on to Band Aid.' At the end of the song, Dammers indulged himself in an extended piano solo, eyes closed, lost in the music. When he finally opened his eyes, he saw that Costello had stopped the tape. 'Hey, I was getting something going there,' he protested. 'Why did you turn the tape off?' Costello just glared. 'Elvis, that's *jazz*!' said Dammers. 'It's bollocks,' retorted Costello.

'If "Nelson Mandela" hadn't got in the charts I would have felt it had failed,' said Dammers afterwards. In March 1984 it cracked the UK Top 10, but that was the least of its achievements. As its fame spread internationally, Dammers received letters of praise from the United Nations and the ANC. And although the South African arm of Chrysalis Records asked not to be sent copies for fear of prosecution, the song did manage to reach black South Africans, as Dammers discovered while watching the news one day. 'One of the ways the ANC would organise people at football matches and sporting events [was to] take over the tannoy system. Suddenly over the speakers would come someone hidden in the crowd making political speeches and then this music!' He later learned that Mandela objected to just one element of the song: the line about his being forced to wear ill-fitting shoes. Although that petty cruelty was a staple of anti-apartheid publicity, it had been enforced for only a few weeks. 'That's the mark of him,' says Dammers. 'He didn't want anything exaggerated. But that's irrelevant, really. It's all part of a campaign.'

Dammers soon found himself being drawn into hands-on activism. The Special AKA were dead anyway. Campbell had left the day he finished recording the song, only returning under duress to film the video and a *Top of the Pops* performance, and the band never recorded another note. Instead, Dammers produced

'The Wind of Change', a benefit single with Robert Wyatt and the SWAPO (South West Africa People's Organisation) Singers, to raise awareness of Namibia's armed struggle for independence from South Africa. He also marshalled a cast of ska and reggae bands, including Madness and UB40, to record 'Starvation', a multiracial response to Band Aid. But his most important and challenging work was to take place outside the studio.

<div align="center">*</div>

Dammers' US equivalent in the anti-apartheid campaign was Bruce Springsteen's guitarist, 'Little' Steven Van Zandt. Since the UN's imposition of a cultural boycott in 1980, the lavish casino resort of Sun City had become a focus of anti-apartheid sentiment. In 1984 Van Zandt, who had learned about apartheid after hearing 'Biko', twice visited South Africa, and was particularly disturbed by the way the resort, situated in the impoverished black homeland of Bophuthatswana, exploited the Pretoria government's ban on casinos to the benefit of the white elite rather than the black locals. Citizens of black homelands, or Bantustans, suffered poverty, malnutrition, unemployment and neglect. Families were fragmented as fathers were forced to find work far from home. 'To forcibly relocate people is bad enough, but to erect a $90-million showplace to celebrate their imprisonment is beyond all conscience,' Van Zandt protested. Queen, in particular, were condemned for giving succour to the regime by playing there.*

Danny Schechter, a journalist for ABC News, suggested that Van Zandt write an all-star song in the vein of 'We Are the World', but 'a song about change not charity, freedom not famine'. At Schechter's suggestion, the original demo savaged individual boycott-breakers ('Queen and the O'Jays, what you got to say?') but Van Zandt decided he would rather avoid 'value

* The list of boycott-breakers also included Black Sabbath, Elton John, Rod Stewart, Linda Ronstadt and, surprisingly, black artists such as Ray Charles.

judgments' and reserve his ire for politicians. Credited to Artists United Against Apartheid, 'Sun City' featured a staggering array of talent, including such proven voices of protest as Dylan, Springsteen, Gabriel, Bono, Jackson Browne, Jimmy Cliff, Miles Davis, Melle Mel, Run-D.M.C., Linton Kwesi Johnson and Sonny Okosuns, all of whom pledged not to play the resort.* The baldly declamatory lyrics were as oblivious to subtlety as the electro-rock overproduction and showpiece vocal theatrics but its jubilant ire and integrated cast made for a bracing contrast with 'We Are the World'.† The video climaxed potently with crowds of demonstrators singing the banned Xhosa national anthem 'Nkosi Sikelel' iAfrika'. The song also spawned a forty-five-minute documentary, book and teaching pack. Naturally, it was banned in South Africa, but it was also blacklisted by many US radio stations, who objected to its critique of President Reagan's policy of 'constructive engagement'.

'There is a new phrase in the air and it hurts my ear like a sour note: "constructive engagement,"' wrote Miriam Makeba. 'This is Washington's way of saying, "Speak softly and do not even carry a stick, and maybe everything will get better."' Whereas President Carter had supported majority rule, Reagan was a firm ally of the apartheid regime during his first term, offering economic and military support while gently encouraging reform behind closed doors. With Cuban troops fighting in neighbouring Angola, Reagan's fear of a Soviet-backed revolution far out-weighed his reservations about apartheid. Archbishop Desmond Tutu, the South African cleric who had recently been awarded the Nobel Peace Prize, called the US policy 'immoral, evil and totally un-Christian'.

* Van Zandt also wanted Fela Kuti, but he had recently been sentenced to ten years for currency trafficking. Named an Amnesty prisoner of conscience, he was released after eighteen months and recorded the anti-apartheid album, *Beasts of No Nation* (1989).
† The B-side, 'Revolutionary Situation', was an audio collage assembled by Schechter and Keith LeBlanc.

In Britain, however, Margaret Thatcher was a fellow believer. In June 1984, shortly after 'Nelson Mandela' left the charts, Thatcher entertained South African prime minister P. W. Botha at Chequers. She did, in fact, try to persuade him to release Mandela and grant Namibia independence, but she refused to publicly condemn the regime. While the rest of the world lionised Mandela, she considered the ANC terrorists and possibly communists and favoured the Zulu leader Chief Buthelezi (who, it later emerged, was being armed and trained by Botha to fight the ANC). And she adamantly opposed economic sanctions, which ran contrary to her faith in free-market solutions, not to mention British jobs: Britain was South Africa's biggest foreign investor.

Eventually, though, international opinion overtook both leaders. On New Year's Day 1985, Oliver Tambo issued an edict calling on blacks to 'render South Africa ungovernable'. Amid mounting violence on both sides, and fears of a full-blown civil war, TV footage of township bloodshed stoked international outcry to the point where punitive measures became inevitable. Although Thatcher initially vetoed sanctions packages by both the European Community and the Commonwealth, she was first isolated and then overruled. Reagan's presidential veto on US sanctions was also overridden by Congress, with even his own party turning against him. Amid much acrimony and embarrassment, by the end of 1986 'constructive engagement' was dead.

Following the rash of songs about Biko, Western musicians had been relatively quiet on apartheid, with the exception of Randy Newman's bitterly satirical 'Christmas in Cape Town' (1983). But thanks to 'Nelson Mandela' and the sanctions debate it was suddenly fashionable, with notable contributions from Stevie Wonder ('It's Wrong (Apartheid)'), British reggae singer Eddy Grant ('Gimme Hope Jo'anna') and rappers Stetsasonic ('Free South Africa'). Wonder was even arrested for protesting outside the South African embassy in Washington DC, and dedicated his Best Song Oscar for 'I Just Called to Say I Love You' to Mandela,

prompting Pretoria to ban all of his music from the country: a singular honour. More pointedly, the British satirical sketch show *Spitting Image* featured 'I've Never Met a Nice South African' on the B-side of its number one novelty hit 'The Chicken Song', turning it into an improbable playground chant.*

In South Africa itself, where all these records were predictably blacklisted, white group Bright Blue managed to bypass the censors by interpolating 'Nkosi Sikelel' iAfrika' on their song 'Weeping' (1987). In a spectacularly misguided move, Botha's Bureau of Information spent $1.8 million on its own Band Aid-style unity anthem, 'Together We Can Build a Brighter Future' (1986), which the anti-apartheid Azanian People's Organisation condemned as 'a thundering flop, a ridiculous anti-climax'. Several black musicians who consented to appear were punished with attacks on their houses.

As economic sanctions slowly made their way past Thatcher and Reagan, Dali Tambo, son of the ANC leader Oliver Tambo, approached Jerry Dammers to front a new UK pressure group, Artists Against Apartheid. It launched on 15 April 1986, with Belafonte as the star guest and a number of prominent left-wing musicians, including Billy Bragg, Bob Geldof and the Pogues, in attendance. Dammers drew up a draft contract for bands to show their record labels, demanding the insertion of a clause ensuring that their records could not be exported to South Africa. Somewhat optimistically he declared: 'If there was no music, no films, and no TV from the West, apartheid wouldn't last more than a few months.'

AAA staged its first concert on London's Clapham Common in June, a joyous event featuring talent from Britain (Bragg, Costello, the Style Council), the US (Gil Scott-Heron) and South Africa (Masekela), climaxing with a multi-artist rendition of

* The award for the most vituperative attack on Botha's regime, however, goes to Ireland's Microdisney, who featured 'Pretoria Quickstep' on their album *We Hate You South African Bastards!* (1984).

'Nelson Mandela', the movement's undisputed anthem. Trevor Huddleston, now seventy-three, addressed the crowd, marvelling at the strength of a boycott which he had first called for three decades earlier. The transatlantic cultural assault was already having an effect – the likes of Queen and Elton John recanted and joined the boycott – but the biggest battle over the embargo would be with a thoroughly well-intentioned liberal: Paul Simon.

*

In the summer of 1984 Simon had been passed a bootleg cassette of township music, *Gumboots: Accordion Jive Hits, Vol. II*, which inspired him to travel to South Africa the following February and work with black musicians, including Zulu vocalists Ladysmith Black Mambazo. Simon thus obeyed the letter of the UN boycott, which governed live performances but not recording sessions, and, he believed, the spirit, because he was bringing money and publicity to black musicians. Certainly nobody believed he *supported* apartheid, and his desire for black South Africans to hear the record explained the absence of any ban-inviting explicit politics on 1986's *Graceland*, but he foolishly pretended that politics didn't exist, or at least were less important than the sacred principle of artistic freedom.

Responding to a press-conference question from the *Guardian*'s Robin Denselow about why he snubbed Belafonte's advice to meet with the ANC during his visit, his language betrayed a weaselly moral equivalence. 'I didn't ask the permission of the ANC, I didn't ask the permission of Chief Buthelezi, or Desmond Tutu, or the Pretoria government.' The man who had campaigned for George McGovern, and recorded '7 O'Clock News/Silent Night', now insisted: 'Pop music is not the forum to discuss political issues . . . I am not a politician. I did not set out to make a political statement.' Inevitably, such equivocation enraged Dammers, who began to drum up a campaign against the album. A worried Simon turned to a South African icon whose own views on the boycott were rather complicated.

Hugh Masekela later explained to Simon's biographer, Patrick Humphries: 'There's a kind of misdirected energy in the helping of South Africa. Even our revolution has been hijacked, because agencies overseas don't feel that they have to consult with South Africans while they're helping them. Like the cultural boycott – nobody approached *us*, nobody asked *us*!' So his enthusiasm for Simon's promotion of South African music – a feeling shared by many black South Africans who embraced *Graceland* – easily outweighed his concerns about the boycott and he suggested that Simon assemble a touring revue which would include himself, Makeba and other South African artists.

Simon's explanation of his motives appeased the UN but not the AAA, and there was confusion over whether or not Oliver Tambo had retracted the ANC's original condemnation: Simon claimed he did; Dali Tambo angrily refuted this. So when the *Graceland* revue, having passed peacefully through the US, Europe and Zimbabwe, reached London, it met with a hot blast of indignation. In an open letter handed to Simon before he went on stage at the Royal Albert Hall, Dammers and his fellow musicians called on the singer to apologise for thinking he was 'above politics' and vow to adhere to the boycott in future. It was an acrimonious and self-destructive affair. Ticket-holders arriving at the Albert Hall experienced the bizarre sensation of passing noisy AAA picket lines (which included the writer of 'Nelson Mandela') in order to hear Hugh Masekela perform the pro-Mandela 'Bring Him Back Home'. 'If Paul Simon had come to us first and discussed this, none of this shit would have happened,' grumbled Dali Tambo.*

Dammers found the whole experience hugely stressful. 'There's a liberal argument that says that music is more important than anything, but some things actually *are* more important than

* At the same time, the logic of the boycott was muddied by the Musicians Union's attempts to block visits by Black Sowetans the Malapoets and the multiracial South African group Savuka, whose tribute to Mandela and Biko, 'Asimbonaga' (1987) had been banned at home.

music,' he says. 'It's just seeing the bigger picture. No matter how much you love South African music, the people who make that music are going to be better off when apartheid is abolished, so the message is solidarity.' He admits now that his work with AAA 'took a toll'. 'It's fair to say I lost the thread of my career. I didn't spend any time making music.'

Dammers gradually phased himself out of the organisation during preparations for Mandela's massive seventieth-birthday concert at Wembley Arena in June 1988. It fell to impresario Tony Hollingsworth to hack his way through a jungle of celebrity egos, tactical disagreements and logistical tangles in order to make it happen. Twenty-four Conservative MPs tabled a shameful motion criticising the BBC for giving 'publicity to a movement that encourages the African National Congress in its terrorist activities', while the US Fox network bowdlerised all of the explicitly political moments (including 'Sun City') from its coverage. Masekela later complained that it was 'more of a showcase for top British groups than it had to do with Nelson Mandela's birthday'. Nonetheless, the concert was a gigantic success, with a bill including Stevie Wonder, Simple Minds, UB40 and Senegalese star Youssou N'Dour performing to 600 million viewers worldwide. Naturally, two of the highlights were 'Biko' and 'Nelson Mandela'.*

Mandela finally walked free on 11 February 1990 and made it a priority to attend Hollingsworth's celebration concert at Wembley on 16 April, where two former Manhattan Brothers, heroes of 1950s South Africa, joined Dammers for 'Nelson Mandela'. Dammers met the subject of the song for the first time

* Simple Minds, who had mutated from icy post-punk outsiders into bombastic stadium rockers, deserve enormous credit for making the event a success – their presence on the bill helped attract other big names and they doubled as backing band on several key performances – but their own ponderous contribution, 'Mandela Day', only sharpens one's appreciation for the light-footed grace of 'Nelson Mandela'.

at the concert. 'I think he spent every minute shaking hands so he was just shell-shocked,' he says. He remembers Mandela saying just four words to him, four words which might just have been a social nicety but suited the moment nonetheless: 'Ah yes, very good.'

25

'Bring up the banners from the days gone by'

Billy Bragg, 'Between the Wars', 1985

· Billy Bragg's history lesson

Three striking miners occupy the first floor offices of the National Coal Board HQ in Grosvenor Square to protest pit closures, 1984.

If you ask someone to name a British protest singer, there is invariably only one response: Billy Bragg. During the second half of the 1980s, his tersely struck acoustic guitar and 'Essex fog-horn' voice became synonymous with left-wing activism, from the miners' strike to the anti-apartheid movement to the ill-fated attempt to help elect a Labour government, Red Wedge. To this day he regularly leaves his home in the south of England to play benefit gigs, attend rallies, meet with politicians and talk with curious writers. He makes it his business to know what he is talking about; few musicians are better informed about the nuts and bolts of politics or as sceptical of rebel glamour.

As he talks over a bowl of chips in a bookshop café, what seems unusual is not so much his unfussy eloquence as his unquashable optimism. Unlike many political songwriters, he does not sigh or wince at the memory of compromises and setbacks. He long ago accepted that political progress is won by inches, not leaps and bounds. But when he first shouldered his guitar to play for striking miners in Newport, Wales, in September 1984, he was, by his own admission, a political naif. 'The miners' gigs began a process of politicisation which I had previously not undergone,' he says.

Stephen Bragg (he became Billy in his teens) was born five days before Christmas 1957 in Barking, Essex, a working-class town which merged with London's expanding East End a few years later but still retained a certain apartness. There was no political discussion in the house, though Barking was staunchly Labour and his father brought the left-wing *Daily Mirror* home from work every day. Most of Bragg's political education came from Bob Dylan and Motown: 'It was impossible to listen to Stevie Wonder or Marvin Gaye without some of Dr King's beliefs filtering through.' He also borrowed from Barking Library a series of themed folk samplers which had been compiled by

Topic Records, a label established in 1939 by the Communist Party-affiliated Workers' Music Association. But his burgeoning interest in folk was cut short by the arrival of punk. Seeing the Clash on the White Riot tour convinced him he could form a band; attending the Rock Against Racism carnival in Victoria Park the following year taught him that the music could mean something greater. 'It was the moment when my generation took sides,' he later reflected.

After the dissolution of his punk band, Riff Raff, in 1980, he took the surprising step of joining the army, convinced that war with Russia was imminent. During his three months, he learned a lot about Northern Ireland, nuclear weapons, how easily patriotism tilts into racism, and, most of all, class. Back on civvy street, he turned himself into a 'one-man Clash', and wrote his first protest song, 1983's class-conscious 'To Have or Have Not'. 'The politics I had were personal,' he says. 'You lean towards the side of fairness and equality.' Most of his compositions, however, were love songs and 'A New England' wryly acknowledged his limitations: 'I don't want to change the world / I'm not looking for a new England / I'm just looking for another girl.'

By the time he started playing for the miners, however, he *did* want to change the world. Two of his newest songs critiqued the right-wing tabloids ('It Says Here') and Falklands War jingoism ('Island of No Return') and now he felt compelled to address the strike. 'I had to learn how to speak to people who were deeply involved in politics with a capital *P* in a manner that reassured them that I wasn't just a pop star from London who was exploiting this to further my career.'

During the year-long strike, musicians showed their support in various ways. Former Sugar Hill bassist Keith LeBlanc cut up Arthur Scargill speeches over electro beats on The Enemy Within's 'Strike!'; the pointedly named a cappella group the Flying Pickets (whose recent hit 'Only You' ironically included among its fans Margaret Thatcher) joined the picket lines at a Yorkshire power station; and an eclectic roster of artists, ranging

from Crass to permatanned boy band Wham!, played fundraising shows.* More mobile performers, like Bragg, sometimes played the coalfields themselves. The heart of the musical campaign, however, resided with veteran folksingers whose names were obscure: Jewish satirical songwriter Leon Rosselson, Scotland's Dick Gaughan (who performed an updated version of Florence Reece's 1930s classic 'Which Side Are You On?'), and former miner Jock Purdon.

'The folk musicians got there before me and they were more radical than me,' admits Bragg. 'Punk rock was Year Zero: "Forget it, it's over, give away all your records, cut your hair." So when I went up to the coalfields for the first time and saw Jock Purdon singing his songs I suddenly remembered that there *is* something beyond Year Zero.'

*

The songs Bragg heard in the coalfields sent him spinning back into the past: to Joe Hill and the Wobblies; to Florence Reece and the Harlan County miners; to the tales of endurance and woe on those Topic samplers from Barking Library, tales whose significance he only now understood. One sent him back further than most. Leon Rosselson liked to perform his 1975 song 'The World Turned Upside Down', which took its name from an anti-Cromwellian broadside ballad from the English Civil War. Bragg sought out a copy of Marxist historian Christopher Hill's book of the same name and read up on the Levellers, a progressive nonconformist sect, and the Diggers, or True Levellers, whose self-reliant rural communes constituted a kind of proto-socialism.

Rosselson's song, says Bragg, 'suddenly opened a door to an entire radical history that I had absolutely no knowledge of. By

* As teen-pop pin-ups, Wham! were an unlikely presence but they voted Labour throughout the 1980s. 'To call us Thatcherite was so simplistic, basically saying that if you've got a deep enough tan and you've made a bit of money than you've got to be a Thatcherite!' singer George Michael said in 2004.

going to do gigs for the miners and by standing next to Jock and Leon I was now part of a tradition that stretched back to the Diggers and that historical perspective opened up in front of me. There then came a moment when I felt I should recognise that by showing that I do have a knowledge of folk music and "Between the Wars" was a manifestation of that.'

Although the US had enjoyed a major folk revival in the early 1960s, British folk had never really been fashionable, dismissed by John Lennon as 'people with fruity voices trying to keep alive something old and dead . . . Today's folk song is Rock and Roll.' More recently, RAR's Dave Widgery had been similarly scornful: 'If socialism is transmitted in a deliberately doleful, pre-electronic idiom . . . it will simply bounce off people who have grown up this side of the sixties watershed.' A furious Rosselson responded by branding rock music 'basically conservative' and calling for music 'more deeply rooted in human experience and history'. 'Between the Wars' was a vivid example of Bragg's bridge-building mentality: a musical peace treaty; a folk song wearing punk boots.

He remembers writing it during the winter of the strike. He was staying with a friend who was housesitting in Wimbledon but couldn't afford the fuel bills. 'The only really warm place in the house was the bathroom where the boiler was, so I was in the bathroom at the table writing the song. I was halfway through and there was a bang on the door and she wanted to use the bathroom. So I finished the last verse on a bench on Wimbledon Common.'

The title, he explains, stemmed from the geopolitical uncertainty which had led him to join the army. Also: 'In some ways the miners' strike was a war – a war on the working class. It felt like you were part of an underground resistance movement, trying to get through the police lines to do the gig. It started out as an anti-war song and then became a kind of a hymn to the ideas of the welfare state.' The lyrics are rich in historical resonances. The image of 'skies all dark with bombers' comes from a famous propaganda poster from the Spanish Civil War. The 'land with a wall around it' recalls the 'No Trespassing' verse from 'This

Land Is Your Land'. 'Build me a path from cradle to grave' paraphrases the 1942 Beveridge Report which laid the foundations of the welfare state. And because there are no explicit references to Thatcher or the NUM, the song escapes its historical moment and travels back through the decades to alight on other struggles, other conflicts. The rest of the EP expanded the history lesson, adding Rosselson's 'The World Turned Upside Down' and (with new lyrics by Bragg) Reece's 'Which Side Are You On?'

By the time the EP came out in February 1985, the strike was all but over. It later emerged that the miners had come close to victory the previous autumn, when the tactless Coal Board chairman Ian MacGregor almost provoked a disastrous sympathy strike by another coal industry union, NACODS. But NACODS was appeased at the eleventh hour and no other unions joined the NUM pickets. The miners were isolated and gradually worn down, with increasing numbers going back to work. On 3 March delegates finally voted to call off the strike, and the war was lost. In the aftermath, Bragg rewrote Joe Hill's 'There Is Power in a Union' and poured his gloom into the unusually bleak 'Days Like These': 'The majority by their silence shall pay for days like these . . . Wearing badges is not enough in days like these.'*

*

Bragg was already plotting a different strategy. If Thatcher could not be brought down by the miners, then she would have to be beaten at the ballot box. In 1983 young voters had favoured the Conservatives; if Labour was to stand a chance of winning the next election that trend would have to be reversed. 'The SWP promised us the miners' strike was a revolutionary situation,' says Bragg. 'It didn't fucking happen. That's what Red Wedge was – a response to the failure of there to be a revolution.'

* After the strike, Bruce Springsteen, whose Born in the USA tour had reached the UK, took time to meet with the Durham Miners' Wives Support Group and donate £16,000, a thoughtful gesture of blue-collar solidarity.

Indeed, the line on 'Between the Wars' which most angered left-wing hardliners called not for revolution but 'sweet moderation'. Another inspiration was musical: 'the failure of the Clash to actually connect with mainstream politics. If you don't, then it just becomes a bit of a pose. It hurts me to say that but I learnt from the mistakes of the Clash. That incredible feeling that you get from listening to music – invigorating, empowering – is that just a transient experience or can it be focussed on to reality and actually inspire people? How far can you go?'

To some on the left, Neil Kinnock's Labour Party had betrayed the miners. Unable to endorse the NUM's contravention of its own rules, they focussed instead on criticising the violence of the police, a tactical compromise which stuck in many throats. 'I feel the Labour Party let the miners down. I feel the [Trades Union Congress] let the miners down,' Bragg told *Melody Maker*'s Colin Irwin when the strike ended. 'The fact there wasn't a general strike . . . just shows how demoralised the Labour movement is.' But Bragg was a pragmatist and he liked Kinnock personally. 'Kinnock was the first modern leader of a political party to understand the power of popular music,' he says. 'Not only did he know the songs of Victor Jara, he'd been a junior member of the Gene Vincent fan club! With Kinnock you could talk about Bob Dylan or Joe Hill or Phil Ochs. He knew his shit. That was the sea change that allowed Red Wedge to happen.'

Bragg first met Kinnock in February 1985. It was as awkward as a first date, with Bragg, manager Peter Jenner and Radio 1 DJ Andy Kershaw among those discussing youth issues with the Labour leader over claret and crisps. But Bragg saw a window of opportunity. Kinnock had proved himself in the anti-apartheid movement, the Anti-Nazi League and CND, and he took musicians seriously as a way of engaging with young voters. Two days later Bragg went to Downing Street to deliver a petition against a new scheme to cut the benefits of young people who did not sign up to the Youth Training Scheme (YTS). In a meeting with Labour MPs, including Birmingham Ladywood's Clare

Short, he handed out copies of 'Between the Wars' and invited them along to his Jobs for Youth tour. 'Clare Short was the best,' he says. 'We left a gig in Birmingham and she was still arguing with spiky-topped punks as we left.' Onstage that night he discussed the miners' strike and told the crowd, 'This isn't the end of the fight. It's the *beginning*.'

Bragg's most important ally was Paul Weller, who accompanied him to Downing Street. The bathetic demise of the Clash that year left Weller's new soul-pop outfit, the Style Council as the most successful leftists in pop. Having fudged his politics in the Jam, the singer now set about attacking Thatcher with the zeal of a convert. The newspaper advert for 'Shout to the Top', with its collage of loaded imagery and class-war slogans, looked suspiciously like a Crass record sleeve. During the miners' strike Weller had convened a multiracial line-up called the Council Collective to record a benefit single, 'Soul Deep'. He affirmed his sincerity, to the disappointment of anyone expecting more music, by devoting the B-side of the 12-inch to an extended interview with some striking Nottinghamshire miners. Although 'Soul Deep' suffered from minimal airplay, none of the Style Council's first eight singles peaked lower than number eleven. 'Without Weller, Red Wedge would have been nothing,' says Bragg. 'I couldn't have carried it. He always had doubts but despite that he stood with us. Red Wedge really wasn't a bunch of people who supported the Labour Party – it was a bunch of people who hated Margaret Thatcher.'

In fact, the same could be said of the Labour Party itself. In 1983 five editors of the *Militant* newspaper, the voice of the party's Trotskyist Militant Tendency, had been expelled, the severest measure yet in an acrimonious ideological struggle for the party's future. In early 1985 the 'Millies', as Bragg calls them, had an iron grip on the Labour Party Young Socialists (LPYS), whom he had met through the YTS petition. When he played a gig at their Blackpool conference in April, they called him into a room for a meeting. 'They gave me the line, what they believed in. And I said, "Well, that's great, and if I believed everything you said I'd join the

SWP but I don't, so I'm sorry, I can't be your singer-songwriter."'
For the next two years he would find himself in the middle of
Labour's civil war (Kinnock expelled several key Militants, calling
them 'misplaced, outdated, irrelevant to the real needs'), distrusted
by both sides. 'The Derby party said, "We don't need you to come
to Derby, we don't have any young people here,"' he remembers,
shaking his head. 'The old guard thought we were entryists and
the LPYS thought we were being used by the leadership to water
them down!' He laughs at the memory. 'It was all a bit bonkers.'

*

Pop's new alliance with Labour was launched with an unusual
party political broadcast on 17 July, hosted by Bragg (who played
'Days Like These') and featuring Aswad, Bronski Beat's outspo-
kenly gay Jimmy Somerville and jazz-dance band Working Week.
Six days later the Labour HQ in London's Walworth Road played
host to a selection of musicians, managers, journalists and activists,
invited there to give shape to a loose alliance between the party and
the arts world. Like Rock Against Racism, the idea was to reach
pop fans on their own terms, wrapping a hard kernel of political
information in an inviting package. Bragg appropriated the title of
a work by Russian constructivist artist El Lissitzky (another RAR
touchstone): *Beat the Whites With the Red Wedge*. The commu-
nist associations were a little strong for more moderate voices at
the meeting but in the face of feeble counter-suggestions like Red
Steady Go and Moving Hearts and Minds, Red Wedge prevailed.

The row was a taste of things to come, as Bragg found when
he started trying to sign up pop stars to the cause.* One dis-

* Synth-pop duo the Pet Shop Boys also kept their distance from Red
Wedge's heart-on-sleeve declarations, despite brilliantly satirising
Thatcherite greed on 'Opportunities (Let's Make Lots of Money)'
and 'Shopping' ('songs where you take the character of someone you
hate', explained singer Neil Tennant), and mourned social division
on 'King's Cross', which Tennant compares to 'Ghost Town'. 'In the
1980s there was quite a lot of naff political pop,' he complains.

appointment was Elvis Costello, who said he didn't like what the name signified, but, says Bragg with genuine anger, 'The one that really made me spit pips was a hero of mine: "Let it happen. Let the revolution come. Let them destroy the working class so that people are out on the streets with machine guns."' He pulls a face. 'That's the worst kind of posing. I've got no fucking time for radical chic.'

It was a fertile period, at least in the pages of *NME*, for militantly left-wing bands of limited appeal, including the Three Johns from Leeds, Easterhouse from Stretford and New Model Army from Bradford. 'We're a scourge, if you like, because we stand against both sloppy thinking, all that wishy-washy naff liberal cop-out stuff, and against ignorant peasants,' said New Model Army's frontman, who took the Christopher Hill-inspired stage name Slade the Leveller. But it was the Redskins, a trio of SWP-aligned soul fans from York, who became synonymous with hectoring, hair-shirt protest-pop. 'If people think that we're ramming it down their throats, then that's tough shit,' bassist Martin Hewes told *NME* during the strike. 'If you get too subtle, no one knows what you're on about.' They disparaged Labour's move to the centre, accused CND of 'empty rhetoric' and dismissed Weller, Dammers, Strummer and Costello as 'hit and miss'. 'At the end of the day they might light a spark in people's minds,' said frontman Chris Dean, who also wrote for the *NME* under the pseudonym X Moore. 'The Redskins want to put the whole rotting system to the torch.'

Bragg remembers sharing a bill with them at a venue with a screen which could broadcast slogans. 'All the while I was playing, the Redskins were putting anti-Labour announcements above my head, which I thought was a bit out of order frankly. When the Redskins split up they had to write a *mea culpa* in the *Socialist Worker* about how they'd been deluded to think that pop music and capitalism could work together.' Bragg is not the smirking type but this is as close as he comes.

Red Wedge was officially unveiled on the terrace of the House

of Commons on 21 November 1985. Although the central aim was to get Kinnock into Number 10, Red Wedge had its own agenda, including gay rights, nuclear-free zones, cheap public transport and support for Ken Livingstone's Greater London Council, which was facing abolition. It was around the edges that things got fuzzy. 'It was a great idea but a confused idea, that was the problem,' former *NME* editor and Red Wedge organiser Neil Spencer told writer Andrew Collins. 'No one could quite decide what it was about.'

Jerry Dammers remembers some curious discussions. 'One idea that we came up with was a leaflet explaining to people what they were voting for, what socialism was. And one of Neil Kinnock's apparatchiks snapped at me: "It's not the Labour Party's job to define socialism!" I thought that's exactly what the Labour Party's job was! So that was quite a shock. The trouble was the pop stars were more left-wing than Labour. One of the funniest things was they were going to use for their theme song the Who's "Won't Get Fooled Again". And I told them I didn't think that was a very good idea.' He laughs. 'I think they'd slightly missed the point of the song.'

In January 1986, *Melody Maker* arranged a round-table debate. In the Red Wedge camp: Bragg, Weller, Dammers and Clare Short MP. For the opposition: right-wing Police drummer Stewart Copeland, Tory MP Greg Knight, and Chris Dean of the Redskins.* While Dammers and Bragg focussed on electing Labour, Weller talked optimistically of 'radicalis[ing]' the party

* The American-born Copeland was the socialist-hating son of former CIA agent Miles Axe Copeland, Jr, and the brother of Police manager Miles Copeland III, who called left-wing pop 'destructive' and 'appalling' and spoke at the 1985 Tory conference. His bandmate Sting, meanwhile, had just released the pro-miner song 'We Work the Black Seam', which must have made for some interesting conversations. 'Me and my mate Sting are violently opposed to each other politically,' Copeland said cheerfully. 'Not a single inch of shared ground.'

and Dean stuck to a hard line, joking about forming Redder Wedge. Copeland observed the disagreement with louche amusement: 'What we have here is an argument between the left and the far left. So can you achieve more by being ideologically pure like Chris or by getting "stuck in" like Clare and Billy?' During an increasingly heated row with Dean, Bragg cut to the core of Labour's problem in the mid-1980s: 'The trouble is, Chris, we agree on 90 per cent of things, it's just the last 10 per cent we have to haggle over. It's these gentlemen here that worry me much more. We argue and they sit there grinning.'

*

The same month as the *Melody Maker* debate, the first Red Wedge tour took place. The official bill featured Bragg, the Style Council, Jimmy Somerville's new synth-pop duo the Communards, reggae MC Lorna Gee, soul singer Junior Giscombe, and a Dammers DJ set. By the last date, the likes of Tom Robinson, Madness, the Smiths and even Spandau Ballet's Gary Kemp had also offered their services. The regular finale was a version of Curtis Mayfield's 1970s soul anthem 'Move on Up'. 'In our minds this was the Motown Revue,' says Bragg. 'On a bus, travelling around. The vibe was incredible.'

Another nightly highlight was 'Between the Wars'. Bragg played it at a political song festival in East Berlin in February, where he met Pete Seeger and gave out tapes to Soviet troops. He played it at the GLC's bittersweet farewell party in March, to cries of 'Maggie out!' He played it in Kiev at the stiffly titled Festival of Song in the Struggle for Peace. He played it up and down the country as the general election approached.

When Thatcher named the date, 11 June, Red Wedge sprang into life with its own manifesto, *Move on Up! A Socialist Vision of the Future* and a short tour featuring the usual suspects (Bragg added the Beat's 'Stand Down Margaret' to his set) plus Lloyd Cole and The The's Matt Johnson, who performed his mordant state-of-the-nation address, 'Heartland'. Another

band on the bill, white funk group the Blow Monkeys, targeted a whole album at the prime minister, *She Was Only a Grocer's Daughter* (an unhelpfully snobbish title, Thatcher's proud lower-middle-class roots being one source of her strength), featuring 'How Long Can a Bad Thing Last?' and '(Celebrate) The Day After You', a duet with Curtis Mayfield that was too partisan for Radio 1. At a Labour rally in Islington, Bragg performed Woody Guthrie's 'Deportees' (party officials baulked at 'There Is Power in a Union'), 'We Shall Overcome' and Bob Marley's 'One Love', while outside of the Red Wedge camp U2 made a rare foray into British party politics with a charged rendition of Dylan's 'Maggie's Farm'. The Conservatives, meanwhile, had to make do with Hot Chocolate's Errol Brown performing Lennon's 'Imagine' at a rally that the *Guardian* branded a 'degraded circus'. It may be a deeply flawed song but it didn't deserve *that*.

The Tories had a healthy poll lead but there was cause for optimism in the Labour camp. The campaign, masterminded by modernisers Peter Mandelson and Bryan Gould, was infinitely slicker than in 1983 and hit the government hard on the issues of health, unemployment and the inner cities. The Tories, by contrast, were quarrelsome and divided, combining vague policies with shameless jingoism and scare tactics. 'It's hardly worth bothering, let's give up, it's the end,' a gloomy Thatcher told close advisers after the campaign's faltering start.

The *NME* devoted its election-week cover to Neil Kinnock, who obligingly discussed his love of Little Richard and Gene Vincent as well as the case for Labour. On the following pages the paper canvassed the voting intentions of pop stars. Synth-pop loner Gary Numan chose the Tories; a few opted not to say, or claimed voting was pointless; the vast majority went for Labour. 'I'm sick of writing political songs and I can write love songs when Kinnock gets in,' said ex-Beat member David Steele. But the love songs would have to wait.

On election night, the Red Wedge crew watched the results

come in at the Mean Fiddler venue in London. The youth vote did in fact swing to Labour, and the Tories were knocked back in Scotland and the urban north, but the south of England and the middle classes carried the day, giving Thatcher's government a reduced, though still emphatic, majority. For all that Kinnock had done to rehabilitate the party, voters just didn't trust Labour to handle the economy or defence. At the Mean Fiddler, many campaigners were in tears.

Some musicians responded with rage. At Wembley Stadium Bono inserted a furious, 'Screw the election!' into Eddie Cochran's 'C'mon Everybody', and worked Thatcher's name into an incandescent 'Bullet the Blue Sky'. Others were simply shattered by the experience. Weller repudiated his political activism for good. 'I felt uneasy about getting involved but I did, and did the best I could,' he later reflected to *Q*'s Mat Snow. 'I thought we were exploited by the Labour Party . . . I should have stuck with my original instincts . . . Before the Wedge, the Style Council had done a lot independently, raised a lot of money in benefits. But after the Wedge we were so disillusioned it all stopped. We were totally cynical about all of it.' His response makes one think of comedian George Carlin's melancholy aphorism: 'If you scratch a cynic you find a disappointed idealist.'

Bragg, though bitterly disappointed, was saved by his own pragmatism. Asked, before the election, what he had learned from Red Wedge so far, he replied: 'That there are *no* absolute truths in politics, that *nobody* has the answers, that the word – politics – is another word for compromise. Even within that, it's possible to have shining ideals but, if you're gonna be a dreamer in politics, you *have to be a practical dreamer*.'

Out of the gloom of June 1987 came one of Bragg's best songs. 'Waiting for the Great Leap Forwards' (1989) includes a candid admission of doubt ('Mixing pop and politics he asks me what the use is / I offer him embarrassment and my usual excuses') but ends in a raucous chorus of voices, massed in hope. He says

he learned an important lesson from the tragic example of Phil Ochs. 'Phil took it personally. I learned a lot from what happened to Phil: how not to take the blame, to make sure you reflect it back on the audience. Only the audience can change the world – not performers.'

26
'By jingo, buy America'

R.E.M., 'Exhuming McCarthy', 1987

Dissent in Reagan's America

Campaign poster for Reagan/Bush, 1984.

When R.E.M. guitarist Peter Buck was growing up, he had the opportunity to witness the polarisation of US politics over his own dinner table. His father voted for Nixon three times; his mother certainly did not. 'I remember her pulling me aside once when I was a little kid and telling me why Richard Nixon was evil,' says Buck. Buck formed R.E.M. with singer Michael Stipe, bassist Mike Mills and drummer Bill Berry in the college town of Athens, Georgia, a liberal oasis in the conservative Deep South, at the dawn of the Reagan era. Their personal political allegiances were never in any doubt.

Yet when R.E.M. debuted with *Murmur* in 1983, there was nothing to suggest that these ideas would find their way into the music. The contrast between the governing narrative of Reaganomics and Star Wars and the counter-life of *Murmur* recalls the original title of *The Joshua Tree*: *The Two Americas*. Instead of acknowledging the hard reality of Reagan and Bush, *Murmur* represented a shadow America, full of fog and twilight: not so much an underground as an *undergrowth*, rustling with secrets. Those lyrics that weren't thoroughly inaudible were simply perplexing, splinters of meaning scattered in the soil. Said Buck: 'We wanted people to listen to that record and think, Jesus, what planet are these guys from?'

R.E.M.'s rejection of political reality was not just encoded in their music. 'If you want to talk about politics or your love life or social problems or what it's like to live in 1983, you should do it somewhere other than the stage,' Stipe told *The Record*. Buck, as blunt as Stipe is elliptical, proclaimed: 'I don't like sloganeering, especially when it gets to something like the Clash who don't know what they're talking about. They're fucking boneheads. People think that's revolutionary and it's garbage!'*

* Buck also singled out U2 for criticism in *Melody Maker*: 'My mother *hates* U2. She finds it offensive, all these martial rhythms and songs about victory. It's so easy to latch on to, but what does it mean?' Six months later, R.E.M. were supporting U2 on a European tour.

And yet, inch by inch, R.E.M. would re-enter America's socio-political orbit. By the close of the decade they would be the most celebrated activists in US rock music, reporting from the inside what U2 could only observe through foreign eyes. And you could have witnessed the first green shoots of this process if you had seen R.E.M. play Nottingham's Rock City on 21 November 1984, two weeks after Reagan took forty-nine states out of fifty in a landslide re-election, and heard Stipe tell the crowd: 'We're not proud of our president. We're sorry.'

*

America is a work in progress: its meaning is up for grabs. Any successful US politician has to master this plasticity and mould the country's sense of itself according to his or her own beliefs. With far less grave consequences, artists do something similar. 'This Land Is Your Land', Hendrix's 'The Star-Spangled Banner' and 'Born in the USA' were all attempts to wrest the country's soul from the voices of conservatism, to harness the founding conceits of liberty and justice to progressive ideals, to construct a form of patriotism that ran contrary to flag-waving belligerence.

Reagan owed his electoral victories to his innate ability to make Americans feel good about themselves: 'Morning Again in America,' promised one 1984 campaign ad. He was a sunny optimist in a world of frowning pragmatists. 'We see an America where every day is Independence Day, the Fourth of July,' he promised hyperbolically. This was a feelgood script, and he delivered it like the born actor he was. 'Even when he was gone from Hollywood,' writes his biographer, Lou Cannon, 'Hollywood was never gone from him.'

To his critics, his Tinseltown background was an obvious line of attack. In Gil Scott-Heron's 'B Movie' (1981), Reagan is the self-styled 'man on the white horse' (shades of 'California Uber Alles' there), a hustler peddling phony nostalgia, a substitute John Wayne. The rippling spoken-word track is half biography, half satire, framing Reagan's path from movie star to spokesman

to governor to president in the worn-out horse-opera language of showdowns and sundowns. He makes fun of Reagan but it's no joke: to take down the president you have to take him seriously.*

British songwriters, however, had problems understanding Reagan's popularity. In 'Two Tribes', Elvis Costello's 'Peace in Our Time' and the Damned's 'Bad Time for Bonzo' he is a 'cowboy', which to a European is not a compliment. In the Damned song, he is also mocked for his starring role in the 1951 comedy *Bedtime for Bonzo*. In the movie, Bonzo is a chimp, but, either out of ignorance or mischief, the Damned applied the name to Reagan himself. 'We'd best re-write the script while we can,' sings Dave Vanian, noting the need for a persuasive counter-narrative to Reagan's Hollywood presidency.

R.E.M.'s subject was always America; only by degrees did it become political. 'Little America' (1984) was exquisitely double-edged. On one level it was a vivid, imagistic travelogue of the band's first national tour – Little America was the name of a chain of rural gas stations. On another it was a critique of American small-mindedness and insularity: 'The biggest wagon is the empty wagon is the noisiest.' The two narratives are yoked together in the line 'Jefferson, I think we're lost', which is both a cute reference to the band's manager, Jefferson Holt, and a cry for help to founding father Thomas Jefferson.†

Their third album, *Fables of the Reconstruction* (1985) was steeped in the history of the American South. *Reconstruction* did not refer to the period after the South's defeat in the American Civil War so much as the broader concept of rebirth

* In 1983 Scott-Heron extended the conceit on 'Re-Ron', a hip-hop-flavoured sequel, in which Reagan's B-movie becomes a risible TV repeat.
† During their autumn 1985 tour, Stipe tweaked 'Little America' to explicitly criticise Reagan. When R.E.M. restored it to their live set during the presidency of George W. Bush, the original ambiguity was removed. Since Jefferson Holt had been fired in 1996, the line now went: 'Washington, I think we're lost.'

and engagement with the past. In a strange-sounding album peopled with old men, train drivers and Southern eccentrics, 'Green Grow the Rushes' unravelled a more sinister strand of American life: the exploitation of Hispanic immigrant labourers and, by tenuous association, US intervention in Central America. 'That song brings in pieces of the whole history of guestworking in how our country was settled,' Stipe told writer Harold DeMuir, 'but it wasn't obvious enough and people really never caught on to it.' So R.E.M. were slowly edging towards political comment, from their own oblique angle, when, in late 1985, they invited the far more outspoken Minutemen to support them on tour.

Guitarist D. Boon and bassist Mike Watt both grew up in naval families in the blue-collar port neighbourhood of San Pedro, Los Angeles. 'D. Boon didn't think our dads got a fair shake, and I think he was railing against that ever since,' Watt told writer Michael Azerrad. Their band name was a sharp reclamation job. The Massachusetts Minutemen (ready to respond at a minute's notice) had been the heroes of the War of Independence but their legacy had been hijacked in the 1960s by an anti-communist militia group. Watt and Boon snatched back this byword for vigilance and patriotism for the left. 'We were kind of products of the sixties . . . but not adults in the sixties,' Watt told Simon Reynolds. 'We were all primed with this rebellion-minded worldview but we missed the train.' One 1983 song title made the cross-generational link explicit: 'Bob Dylan Wrote Propaganda Songs'. Their own political songwriting combined the class-consciousness of Creedence Clearwater Revival with the ranting verbosity of the Pop Group, spiked with intriguingly askew slang: 'econo' (low-budget) was good; 'mersh' (commercial) and 'boozh' (bourgeois) were bad.

'Econo' was partly a practical philosophy – when you come from little money and you disdain 'mersh', you're pretty much forced to take the DIY route. But it was also a deeply held principle: class was the cornerstone of the Minutemen's worldview.

Boon ran a fanzine called *Prole*, dressed in flannel work shirts and described himself as an 'average Joe'. The band described an almost archaic ideal of the working man, which seemed to pre-date not just Reagan but the hard-hat riots and the siege of Peekskill. When Watt said, 'The first thing is to give the workers confidence,' you could hear echoes of Guthrie or Seeger. Although their short, urgent songs were intended to make listeners 'challenge [their] own ideas about the world every day', next to the theory-heavy severity of the Pop Group or Gang of Four, they were humane and welcoming. 'I'm not religious about God,' Boon told one interviewer. 'I'm religious about people.'*

Their finest hour, the forty-five-track *Double Nickels on the Dime* (1984), was recorded very econo indeed, costing just $1,100. The title was a joke at the expense of rocker Sammy Hagar's 'I Can't Drive 55', a protest against speed limits which represented a risible new low in rock'n'roll rebellion. Watt's lyrics tended towards well-read abstraction, while Boon's directed short jabs at everything from Cold War brinkmanship ('West Germany') to his racist former boss ('This Ain't No Picnic'). One of Boon's songs focussed on the bloodiest political issue of the Reagan years. It was called 'Untitled Song for Latin America'.

<div align="center">*</div>

Upon taking office in 1981, Reagan appointed as his ambassador to the United Nations one Jeane Kirkpatrick, a hard-line conservative who had hooked his attention with an article called 'Dictatorships and Double Standards', which argued that Washington should stick by tyrants who were 'positively friendly' to the US – our enemy's enemy is our friend. Clearly, his devout anti-communism was going to take a proactive tack.

The anti-communists' primary area of concern was Central

* The Minutemen's frequently didactic lyrics were offset by their quirky brevity and a welcome sense of humour. On 1980's 'Paranoid Chant', Boon hollered, 'I try to talk to girls and I keep thinking of World War III!'

America. A civil war was already raging in El Salvador between the US-backed military junta and the communist-funded FMLN. In 1982, a similar conflict broke out in Guatemala. In Nicaragua, the situation was reversed: here, a Marxist junta, the Sandinistas, had deposed the right-wing Somoza dictatorship and infuriated the US by backing communist rebels in neighbouring countries. The US was officially supporting the El Salvadorean government while unofficially funnelling money and advisers to the anti-Sandinista contras in Nicaragua. 'It was a secret little Vietnam we had going on down there and it's not like we were saving anyone from anything,' says Buck. 'It was wrong. It was just plain wrong.'

But what first horrified the likes of R.E.M. and the Minutemen was the brutality of the Salvadorean death squads. Such armed cadres were effectively terrorists in the service of the state. They flourished in Argentina and Chile during the 1970s, and became notorious in El Salvador when, in 1980, they assassinated Archbishop Oscar Romero, then raped and murdered three American nuns and their lay colleague. Between 1980 and 1983 they killed as many as 35,000 peasants and activists. Many victims were abducted and tortured before being murdered. Their bodies were often never found, hence the name *los desaparecidos*, or 'the disappeared', a term first coined in Argentina.

The Dead Kennedys' 'Bleed for Me' (1982) decried 'charbroiled nuns' and 'electrodes on your balls', while the Minutemen's 'Untitled Song for Latin America' talked of 'mining harbours, creating contras'. Boon pushed the point further on 'The Big Stick' (1985), and sometimes positioned a sign reading 'US Out of Central America' on stage while they performed, but the Minutemen did not, alas, survive to carry on the fight. On 22 December 1985, shortly after the end of their tour with R.E.M., Boon was killed in a van accident in Arizona. He was just twenty-seven.

Michael Stipe's commentary on Central America was, typically,

more indirect than Boon's. In 'Flowers of Guatemala' (1986), he sang of Amanita, a genus of toxic mushroom which 'cover everything', i.e. the disappeared. Buck wondered if the song needed another verse explaining that there were no flowers left because they were all on graves, but they decided that subtlety was the better option. 'Flowers of Guatemala' was just one of many protest songs on R.E.M.'s fourth album, *Life's Rich Pageant*, the point at which anger overtook caution with electrifying results. 'Let's begin again', Stipe sang on 'Begin the Begin'. And then, more explicitly, 'Let's put our heads together and start a new country up,' on 'Cuyahoga'.

Let's was a surprisingly direct way for Stipe to address his audience; rallying cries were not previously his style. It constituted a leap of faith for a band with a clear-eyed awareness of a rock group's limitations. 'The 1960s were a time of political activism,' Mike Mills had only recently written in *Spin*. 'It went from innocence to cynicism really quickly. And now the situation is not so much apathy as realisation that there's not a lot you or anyone else personally can do. Any rock star who thinks he's gonna make a big difference is deluded . . . Nobody's that dissatisfied that they need an icon to lead them into the new age. It just isn't that way any more.' *Life's Rich Pageant* was an attempt to turn cynicism into, if not innocence, then at least defiance. 'On *Life's Rich Pageant* there were some Jefferson Airplane-ish calls to arms,' says Buck. 'And the question is: did Jefferson Airplane ever get anyone to man the barricades? Probably not. On the other hand it's nice to say to my kids, "Y'know, I wrote songs about this crap twenty years ago."'

Stipe's cryptic lyrical style allowed him to play with ideas and associations without boxing them into a single message. For example, the band had long been interested in green issues but, says Buck, 'you can't really write songs that are anything other than smarmy about saving the environment. The idea of protest songs where you're pointing out a particular problem,

that wasn't necessarily what we were going for.' Hence the compact symbolism of 'Cuyahoga'. The Cuyahoga, named after the Iroquois for 'crooked river', is a river in Ohio which became so polluted that from time to time it caught fire; one 1969 blaze led to sweeping environmental legislation. When Stipe cries 'Cuyahoga, gone', as if he's mourning a dead friend, he means not just the river but the Native Americans who named it, and who were subsequently all but wiped out by settlers. Buck called the song 'a metaphor for America and lost promises'. 'Fall on Me', meanwhile, started out as a song about acid rain and became one about resisting oppression, though the original meaning bled through to many listeners, especially given its release in the wake of the Soviet nuclear reactor explosion at Chernobyl. Buck called it 'sometimes misunderstood but generally in the right direction'.

R.E.M. did not sound much like the Minutemen, nor share their solidly working-class roots, but both bands offered their audience a sense of solidarity and communality in an era of devil-take-the-hindmost individualism. A line from 'These Days' sums up the album's mood: 'hope despite the times'.

*

Peter Buck wanted to call R.E.M.'s next album *Last Train to Disneyworld*, about the 'little cheesy tinpot dictatorship' they were living in. 'There's a really bleakly interesting way to write about it,' he says. 'A lot of right-wingers would say, "Our country screwed up in the sixties and we're going to take it back." And they kind of did, and look what happened.'

Reagan's aim had been to rescue America from its late-1970s 'crisis of confidence', and he certainly succeeded in raising national morale, as the orgy of flag-waving at the 1984 Los Angeles Olympics illustrated. He was also fortunate in having Gorbachev to deal with in his second term, thus allowing him to pose as the man who 'won' the Cold War. Nor was he as vicious and alienating as Nixon or Thatcher: the columnist George Will

said he had a 'talent for happiness'. By the time he left office, his approval rating was a healthy 64 per cent.

But for many Americans, it was never 'morning again in America'. 'It's not morning in Pittsburgh,' rumbled Bruce Springsteen. 'It's not morning above 125th Street in New York. It's midnight, and, like, there's a bad moon risin'.' A 1984 study found that the richest fifth of the population had seen their earnings rise by 9 per cent while the poorest fifth had experienced an 8 per cent drop. Black inner-city families suffered the brunt of crime, drug addiction, illiteracy and mal-nutrition. Sceptical about the impact of acid rain, Reagan put environmental issues on the back burner. In hock to the religious right, he dragged his heels on AIDS. Sloppy when it came to governance, he relaxed regulations and appointed a series of self-serving crooks to key positions, leading to a string of scandals, the worst of which was the savings and loan crisis which cost the taxpayer billions of dollars.

On the foreign stage, his every move was governed by his hatred of communism and his belief in American exceptionalism. Hence he was disgracefully soft on apartheid. Hence he defied international opinion in 1985 by visiting the West German military cemetery at Bitburg, where the dead included members of the Waffen SS, an incident described by his former supporter Joey Ramone in the snarling 'Bonzo Goes to Bitburg' (1985): 'You watch the world complain, but you do it anyway.'* Although Reagan denied knowledge of the arrangement, exposed in 1986, by which US officials illegally broached the arms embargo on Iran in order to raise money for the contras, the scandal was his lowest ebb.

It was, therefore, no surprise when Reagan's appearances in song became more sinister and macabre. The Dead Kennedys' 'Gone With My Wind' is a manic narrative in which a White House aide has to knock an insane president unconscious before

* The song was renamed 'My Brain Is Hanging Upside Down' for its US release to placate guitarist and Reagan loyalist Johnny Ramone.

he 'start[s] World War III for fun'. In M.D.C.'s 'Bye Bye Ronnie', the president goes to jail for his role in the Iran-contra affair. In the Violent Femmes' 'Old Mother Reagan', he dies and is turned away from heaven.*

By comparison, the striking thing about *Document* is how full of life it sounds. The contrast between the fretful lyrics and upful music is the source of the album's uncommon power. It was sequenced as two sides of vinyl, with the first side constituting a protest suite. The opener, 'Finest Worksong' conjures memories of the Wobblies, and echoes 'Begin the Begin's call to arms: 'The time to rise has been engaged . . .' The folk-inflected 'Welcome to the Occupation' relates Central America to a USA 'occupied' by hardline conservatives. After the message of 'Green Grow the Rushes' and 'Flowers of Guatemala' failed to get through, Stipe ghostwrote *Document*'s press release, 'so that they would say that "this is a song about American intervention in Central America".' On the subject of politics, at least, this famously confounding lyricist was now gunning for relative clarity. 'I think I got tired of writing a song that had a lot in it and no one could understand,' he complained to *Q*'s Adrian Deevoy.

'Disturbance at the Heron House' contains ominous hints of Orwell's *Animal Farm* and mob rule, and the machine-gun black comedy of 'It's the End of the World As We Know It (And I Feel

* Reagan did, however, find support from unexpected quarters. In the mid-1980s, former McGovernite Neil Young outraged many old fans with rants against Jimmy Carter, welfare recipients and gay AIDS victims. 'Don't you think it's better that Russia and these other countries think that [Reagan is] a trigger-happy cowboy than think it's Jimmy Carter, who wants to give back the Panama Canal?' he asked a reporter in Louisiana. He never really explained how the man who savaged Nixon and, later, George W. Bush, came to be one of Reagan's biggest cheerleaders. The deeply ambiguous 'Rockin' in the Free World' (1989), which could be heard as either celebration or condemnation of Reagan/Bush's America, deliberately did nothing to clarify his views.

Fine)' epitomises the reluctant protest of *Document*. Stipe digests fragments of data like someone watching dozens of TV screens at the same time and rattles them out like shrapnel: *earthquake, hurricane, fight, combat, overflow, vitriolic, patriotic, TV, slash-and-burn, book-burning, blood-letting, incinerate, lies, knives, boom!* The song itself *is* the hurricane, and there, harmonising over the final chorus, is Mills, an inner voice sweetly pleading for silence and calm: 'Time I spent some time alone.' Stipe called it both 'bombastic, vomiting sensory overload' and 'the ultimate ambivalent anthem' and compared its frequent misreading (so much for clarity) to that of 'Born in the USA'.

The contradictions of the Born in the USA tour also informed the song that falls right in the middle of side one of *Document*: 'Exhuming McCarthy'. 'Though I like Bruce Springsteen, sometimes his songs get misinterpreted as "Ya Hoo America" stuff,' Buck told *Sounds*' Roy Wilkinson. 'That's so disgusting to see a crowd of people waving flags and thinking your country is great when in fact we're going through a dangerous period.' As a symbol of this danger, the band latched on to a character already revived by the Minutemen on 'Joe McCarthy's Ghost' (1980).

Buck had learned about McCarthy from his mother and had recently read a biography of the man, while Stipe was photographed with copies of *McCarthy*, by his fellow Red-baiter Roy Cohn, and *A Conspiracy So Immense: The World of Joe McCarthy* by David M. Oshinsky. The band were working on a melody (described by Buck as 'vampire-surf-guitar-funk') so ridiculously peppy that Stipe responded, 'I'm going to have to work really hard to try to make this song not sound really, really jolly.' He turned to McCarthy, drawing connections between the Red Scare and the era of Tipper Gore's Parents Music Resource Center (PMRC), which targeted 'offensive' lyrics, and rapacious, freewheeling capitalism: 'Look who bought the myth, by jingo, buy America.' Midway through the song, a sample of US Army attorney Joseph Welch asking the senator

if he has 'no sense of decency' rises up like a vengeful revenant. Mike Mills added the line, 'It's a sign of the times,' which, says Buck, was a deliberate nod to Prince's recent quasi-protest-song 'Sign o' the Times' (1987).*

Document was the high-water mark of R.E.M. as political songwriters: the sound of a band who honestly wanted to write about personal feelings only to find them infected by the state of the country, and so responded with a compelling stew of anger, despair, defiance and wit. After it, they would enter far more problematic territory. 'Overnight I was this really intelligent environmental activist, and the band was the band to save the planet,' Stipe reflected in 1991, 'and it was really frightening how quickly it happened.'

*

The border between artist and activist is a treacherous one: you cross it at your peril. Dylan caught a glimpse of what was on the other side and turned back. Billy Bragg and Bono, in their different ways, pressed on. As a writer of songs whose meanings were sometimes obscure even to himself, Stipe stood to pay a hefty artistic toll as he tentatively made the transition, but the success of *Document* had given him a new platform to speak from, and he wanted to use it.

R.E.M. had for a long time done more than pay lip service to the issues they cared about. They had invited Greenpeace to set up information stalls at their shows since the mid-1980s, and

* An ominous, electronic talking blues in the laundry-list tradition of 'Ball of Confusion', 'Sign o' the Times' dutifully ticks off poverty, drug addiction, gang violence, AIDS, hurricanes, Star Wars and the explosion of the Challenger space shuttle, without blame or explanation. In the context of his bluntly patriotic 'Free' (1983) and 'America' (1985), and his open support for Reagan, it is hopelessly toothless and non-committal as a protest song, albeit brilliant as a pop record. Coincidentally, it was a Prince song, the sexually explicit 'Darling Nikki', which first spurred the creation of the PMRC.

now did the same for Amnesty International. On a local level, they attended city council meetings, voting on nuts-and-bolts issues such as recycling and the preservation of historic buildings. In 1986 they had thrown their weight behind Democratic candidate Wyche Fowler's successful Senate campaign, allowing him to use 'Fall on Me' in a radio advertisement. They insisted, however, on doing things on their own terms, and opted not to join the likes of Springsteen and Sting on Amnesty's 1988 Human Rights Now! tour. 'I'll support Amnesty but I don't feel like singing "Get Up, Stand Up" with Sting and Peter Gabriel,' was Buck's waspish explanation.

The title of *Green* (1988) was ambiguous but there was definitely an ecological element to the choice. During the ensuing tour, they urged fans to boycott the oil company Exxon over a recent catastrophic oil spill in Alaska, while Greenpeace stalls managed to sign up over 30,000 new members. 'R.E.M. is not just like a dunderhead arena gig, which tends to be the norm,' Stipe told *NME*. 'The contradictions are not lost on me. The idea of being a pop band, which is essentially junk culture, doing something that is ostensibly very positive and hopefully would provoke thought, or the desire to be educated, must be good though . . . I maintain that music and politics do not mix at all, it's like oil and water, but godammit I'm gonna try, even if I am walking a very thin line.'

The album itself expressed this activist spirit through its overall tone rather than through lyrical detail. Punchy pop songs such as 'Stand' and 'Get Up' were calls to action which left the details to each listener's discretion, although 'Orange Crush', written circa *Document*, potently referenced the lethal Vietnam War exfoliant Agent Orange (Stipe's father, who had flown a helicopter in the conflict, assumed it was about him). By coincidence, the release date was 8 November, the day of the presidential election which saw George H. W. Bush, Reagan's cadaverous vice-president and former director of the CIA, battle Democrat Michael Dukakis. Stipe took out a newspaper ad: 'STIPE SAYS / DON'T GET BUSHWHACKED / GET OUT AND VOTE / VOTE SMART

/ DUKAKIS.' Clarke County, where R.E.M. were based, went to Dukakis by four votes. 'We were joking, "Oh, it's the four of us,"' says Buck. The country, however, went for Bush by a considerable margin of forty states to ten. As Guy Picciotto of Fugazi told Michael Azerrad: 'We'd already been through eight years of Reagan and then Bush goes in and he was so creepy, so fucked up. Man, that was terrible.'

Buck winces at the mention of the interview he conducted with *Melody Maker*'s Steve Sutherland a few nights before election day, and understandably so. He was sitting in an Athens bar, discombobulated by alcohol, jet lag and white-hot rage at a result which was a foregone conclusion. 'We're pigs!' he hollered. 'Americans are pigs! You can quote me on that . . . I'm so fucking furious, I feel like shooting people – George Bush first and then the people who vote for him.' 'It was pretty inflammatory,' he concedes now. 'I was kind of drunk and pissed off but there were a lot of people who were feeling that way. It's really weird to see your country hijacked.'

During the Bush administration, R.E.M. accelerated their activism. They donated money to former social worker Gwen O'Looney's 1990 mayoral campaign (which she won) and Wyche Fowler's 1992 re-election bid (which he lost). They championed the voter registration lobby group Rock the Vote and funding for AIDS research, and spoke out against the World Bank and the 1991 Gulf War. At that year's Video Music Awards, Stipe silently removed layer after layer of T-shirts, each with a different slogan, promoting issues from gun control to rainforest preservation.

'I think I've gone too far in the past,' Stipe told me in 2007. 'In the 1980s, I was made to be something that I wasn't . . . and I came dangerously close to being the poster boy of a generation for various social and political ideologies . . . It's a very rocky and dangerous path because you're easily shot down if you come out too strong, or if you're too scattershot, or if you don't know what you're talking about.'

Despite the campaigning, politics swiftly evaporated from Stipe's songwriting. The angriest track on *Out of Time* (1991), 'Radio Song', targeted nothing more pernicious than predictable playlists on commercial radio. Apart from 'Smack, crack, Bushwhacked', the evocative opening line of 'Drive', their sombre masterpiece *Automatic for the People* (1992) proffered only 'Ignoreland'. This furious adieu to three presidential terms in which 'these bastards stole their power from the victims of the us-versus-them years' sounded like the anomaly it was: a manic unburdening of frustration, full of dates and jargon, like a garage sale of old junk, necessary but unlovely. 'Revolution', written around the same time but not released until 1997, was similarly dense and frantic: seemingly a dialogue between a patronising reactionary ('Your revolution is a silly idea') and a depressed protester ('the future never happened'). Otherwise, politics vanished from R.E.M.'s songbook for the rest of the 1990s.

One reason was that there were R.E.M. fans in the White House. During the 1992 election campaign, Bill Clinton's running mate, Al Gore, caused stomachs to clench on the University of Georgia campus when he said, 'George Bush is out of time. Bill Clinton and Al Gore will be automatic for the people.' He was embarrassing but he was right: Bush *was* out of time. At Clinton's inauguration Stipe and Mills performed a version of 'One' with U2's rhythm section, under the name Automatic Baby. Buck, who distrusts all politicians, watched Clinton's inauguration from a distance. 'I was in some small town in Nevada drinking tequila and watching TV and I saw them on there and thought, that's weird.'

So the main cause of the animosity and unease which fuelled the likes of *Document* had gone, but Stipe was also keen to shed the pressures of being a spokesman. That the secretive, arcane mumbler who had crawled out of the fog on *Murmur* was now an international celebrity was strange enough; to be the face of multiple causes was a step too far. While R.E.M. would continue their charitable donations and campaigning in private, in

public Stipe's lips would be sealed. 'I know Michael was a little surprised at how you spend your whole life making music and then you spend twenty minutes talking about something and suddenly that becomes who you are,' says Buck. 'He definitely didn't want every single interview to be about the environment or George Bush. Nobody wants to be known as the guy who writes only these kinds of songs.'

During the 1991 Gulf War, Stipe had a revealing exchange with an anti-war protester. The protester quoted 'Finest Worksong' at him: 'The time to rise has been engaged.' Stipe shot back with a line from 'Talk About the Passion', a song on R.E.M.'s very first album: 'Not everyone can carry the weight of the world.' Then he said, 'I'm going to breakfast. See you later.'

PART FIVE

1989–2008

27

'What we need is awareness, we can't get careless'

Public Enemy, 'Fight the Power', 1989

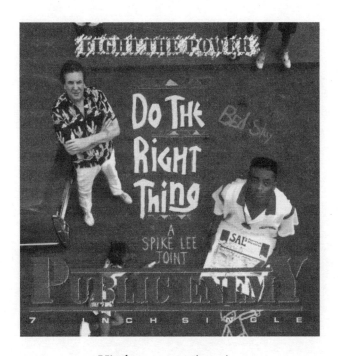

Hip-hop versus America

Public Enemy, 'Fight the Power', (Motown, 1989).

One day in the autumn of 1988, four men sat down to lunch in an Indian restaurant in Greenwich Village. One was the thirty-one-year-old film director Spike Lee. The other three – Carlton 'Chuck D' Ridenhour, Hank 'Shocklee' Boxley and Bill Stephney – were members of Public Enemy, whose *It Takes a Nation of Millions to Hold Us Back* album had just made them the most prominent hip-hop group in the country.

Lee had initiated the meeting to discuss the soundtrack to his next movie, *Do the Right Thing*. The movie's location would be Brooklyn's Bedford-Stuyvesant neighbourhood on the hottest day of the year; the theme, racial unrest. Lee, Chuck D remembers, said he needed 'an anthem to scream out against the hypocrisies and wrongdoings [of] the system'. There was talk of the group working with Lee's regular collaborator, jazz composer Terence Blanchard, perhaps on an update of James Weldon Johnson's 'Lift Ev'ry Voice and Sing', but Public Enemy had other ideas. They argued about it over lunch, and at a subsequent meeting. 'I had a three-hour fight with him,' Hank Shocklee told *Blender*. 'It was heated. I was in his office in Brooklyn saying, "Spike, kids don't listen to 'Lift Ev'ry Voice and Sing'. Open this window, stick your head outside and listen to the sound you hear coming out of cars and boxes."'

In October Public Enemy headed to Europe for a tour with Run-D.M.C. and Chuck wrote the bulk of this new song on planes and buses between shows. 'Usually I would write from the title,' he says, and he borrowed this one from the 1975 Isley Brothers hit, 'Fight the Power', which he remembered because it was the first time he'd heard a curse word on the radio. The flashpoint in the movie is an argument between obstreperous radical Buggin' Out and bullish Italian restaurateur Sal over the absence of black faces on the pizzeria's wall of fame, which led Chuck to chew over the under-representation of black icons in

US culture: 'Most of my heroes don't appear on no stamps.' He remembered an old narrative track, 'Rapp Dirty', by the ribald funk performer Clarence 'Blowfly' Reid, in which a Grand Wizard of the Ku Klux Klan tells a black man, 'Motherfuck you and Muhammad Ali.' 'I was like, wow,' says Chuck. 'So I decided to reverse the charges of the song.' He opted to take down two of white America's Olympian icons with one explosive shot: 'Elvis was a hero to most / But he never meant shit to me, you see / Straight up racist that sucker was simple and plain / Motherfuck him and John Wayne.'

'Whooo! You said that?', Shocklee responded when he heard the lines. 'I'm not sure about that one, Chuck.' Chuck anticipated controversy – that was the whole point – but what he never saw coming was a far greater furore that would cast a toxic cloud over Public Enemy during the spring and summer of 1989, such that by the time the film came out in June critics felt justified in labelling the group 'virulently anti-Semitic' and 'Afro-Fascist race-baiters'.

In an interview with the *Washington Times* on 9 May, Public Enemy's minister of information, Richard 'Professor Griff' Griffin, explained that he refused to wear gold chains because he believed Jews, who dominated the US jewellery industry, were guilty of shoring up apartheid. When the reporter, David Mills, pressed him for clarification, Griff chuckled. 'I'm not saying all of them. The majority of them, the majority of them, yes.'

'Are what?' asked Mills. 'Are responsible for . . .'

'The majority of wickedness that goes on across the globe? Yes. Jews. Yes.'

And all hell broke loose.

*

The first protest song that Chuck D remembers hearing was Stevie Wonder's version of 'Blowin' in the Wind'. Born in 1960, he was older than most of his hip-hop peers, with vivid memories of the Black Power era. He remembers the devastated hush in

his grandparents' house when Malcolm X was shot; his mother wearing black to work the day after Martin Luther King's death; an uncle who never came home from Vietnam. He remembers singing the 'Free Huey' song and 'Say It Loud – I'm Black and I'm Proud'. 'As a youngster in school we sang that record like there was no tomorrow,' he wrote in his memoir, *Fight the Power*.

Born in Queens, Chuck moved to the predominately black Long Island suburb of Roosevelt in 1969: a middle-class area, aspirational and community-conscious. His mother, Judy Ridenhour, was an Afro-wearing radical who sent the eleven-year-old Chuck to join the Afro-American Experience summer programme at Hofstra and Adelphi universities. Among the other children attending lessons in Swahili, African drumming and black history were his future bandmates Hank Boxley and Richard Griffin.

Chuck started writing rhymes in 1977, during hip-hop's infancy. While he was studying graphic design at Adelphi, his commanding baritone caught the attention of Shocklee's DJ crew, Spectrum City, and he became both their regular MC and their flyer designer. He also brought two friends from Adelphi, Bill Stephney and Harold McGregor, into the Spectrum City fold. When Stephney became programme director of campus radio station WBAU, he secured Chuck and Hank their own Saturday-night hip-hop show.

After Spectrum City's Chuck-fronted 1984 single, 'Lies' / 'Check Out the Radio', flopped, the crew were bitterly disillusioned, working go-nowhere jobs at department stores and courier companies. Stephney, however, landed a job at Def Jam, a new hip-hop label set up by Russell 'Rush' Simmons, the brother of Run-D.M.C.'s Joseph 'Run' Simmons, and a long-haired Jewish NYU student called Rick Rubin. Rubin started pestering Chuck in the hope of getting him to rap for Def Jam group Original Source. Chuck, who was now more interested in becoming a sportscaster than a rapper, repeatedly declined. Rubin kept pushing. Eventually, Stephney convinced Chuck and

Hank to bring Rubin a four-track demo tape, which so wowed Rubin that the group left the Def Jam offices with an album deal.

Public Enemy would be a group like no other, modelled more on a football team or the Black Panther party than on a traditional band line-up. Chuck, who is rarely pictured without his New York Yankees cap, talks in terms of sports: offence and defence, teamwork, everyone playing his part. His first signing was an eccentric WBAU DJ, William 'Flavor' Drayton, whom he renamed Flavor Flav. Richard Griffin, who ran Spectrum City's Unity Force security team became Professor Griff, Minister of Information, while Unity Force became the Security of the First World (S1W), Chuck's concept being that 'we're not Third World people, we're First World people, we're the original people'. Hank recruited his brother Keith, Eric 'Vietnam' Sadler and Spectrum City DJ Norman Rogers (reluctantly rechristened Terminator X) to a production team known as the Bomb Squad. Aspiring journalist Harry McGregor was now Harry Allen, 'media assassin'.

At Hank Shocklee's suggestion, the band took its name from the James Brown-inspired demo track 'Public Enemy #1'. To drive home the concept, Chuck designed a logo featuring a silhouette of labelmate LL Cool J's sidekick E Love in a gunsight. Stephney wanted the group to be a hybrid of Run-D.M.C. and the Clash: 'Let's make every track political. Statements, manifestos, the whole nine.' He worried that Flavor's cartoonish antics would dilute the seriousness of the enterprise but, as Chuck explained, that was the whole point. Flavor is 'totally a visual character with audio bonuses', Chuck says with a rumbling chuckle. 'I knew that people were coming to the concert to see rather than hear so I knew we had to come up with an audiovisual experience.' Hence Flav wearing a giant clock around his neck. Hence the S1Ws wearing uniforms and Black Panther berets while executing curiously camp dance moves and brandishing replica Uzis.

The crowd's initial reaction to this paramilitary flamboyance,

Chuck says, was 'WTF?' 'Love and hate is the same emotion,' he says, smiling. 'What we didn't want was somebody being ambivalent to it.'

*

The 'message rap' fad triggered by Grandmaster Flash and the Furious Five had proved flimsy and short-lived, fuelled more by opportunism than conviction. Following the breakthrough success of Run-D.M.C.'s 1986 Aerosmith collaboration 'Walk This Way', hip-hop had its sights set on crossover, not combat. But the messages coming out of Public Enemy's 1987 debut album, *Yo! Bum Rush the Show* were altogether different.

On the album cover, the group members cluster under the harsh glare of a single bulb like menacing basement conspirators, poised for a revolution rather than a party. At the foot of the image runs a ticker-tape message: 'THE GOVERNMENT'S RESPONSIBLE . . . THE GOVERNMENT'S RESPONSIBLE . . .' In truth, Public Enemy's music was not yet up to the standards of their presentation. Recorded in 1986, the album was held back a few months – long enough for hip-hop to take a giant evolutionary leap via new developments in sampling technology (the juicy funk break on MC Shan's 'The Bridge') and vocal delivery (the fluid, jazzy cadences of Long Island rapper Rakim). In a stroke, Public Enemy's stiff rhyming and primitive tape loops sounded outdated. Chuck's lyrical preoccupations included such old standbys as inadequate 'sucker MCs' and the excellence of his automobile. Only one song, 'Rightstarter (Message to a Black Man)', cut to the chase: 'Give you pride that you may not find / If you're blind to your past then I'll point behind.'

Spooked by the new competition, and disappointed by lacklustre sales, the group headed straight back into the studio that April on a mission to raise their game. Opening with the sonorous rhetoric of Jesse Jackson at Wattstax, 'Rebel Without a Pause' instantly redefined Public Enemy with its squealing hook (a saxophone tweaked until it sounded like escaping steam)

and fist-swinging momentum. As Chuck imperiously trashed President Reagan and timid, rap-wary black radio stations, while declaring 'Panther power', Flav cried out in shocked admiration: 'Yo, ya got to slow down, man, you're losin' 'em!' This was the way forward: don't just call for a riot, *sound* like a riot. 'An important message should have its importance embedded into the way it's relayed,' Chuck told the *NME*'s Sean O'Hagan. 'You hear Public Enemy, you hear a tone that says "Look out! This is some serious shit coming!"'

On the following year's *Nation of Millions*, the Bomb Squad's production achieved a thrilling, claustrophobic density. The aim, said Chuck, was to be 'relentless – no escape'. Where other producers went with the flow of their purloined grooves, Shocklee talked of creating a 'hailstorm' of samples, in heavy and constant motion. The music conducted its own dialogue with black history, layering chunks of James Brown and Sly Stone between fragments of speeches by Malcolm X and the Nation of Islam's self-proclaimed 'truth terrorist' Khalid Abdul Muhammad, punctuated with air-raid sirens, jagged bursts of turntable scratching, cries and grunts. Classic protest songs were embedded in the mix: a line from 'Living for the City' here, a refrain from 'Get Up, Stand Up' there. These elements didn't merge so much as collide. In keeping with Chuck's alarm-call analogy, Public Enemy used dissonance and rupture to blast the listener awake and take them, to quote one song title, 'to the edge of panic'.

Chuck's lyrics were equally thick with meaning. Like the Last Poets' street poetry, or even Woody Guthrie's talking blues, hip-hop enabled lyrics to burst their banks and foam in all directions. Any rapper needs to master the art of producing words for words' sake, but Chuck weighted each phrase with significance, creating an information overload that took several exposures to process. 'If you're going to deal with that volume and quantity of words you'd better fill those words up with something,' he says. 'The most difficult thing about a song is not in its expansion but in its condensing.'

Chuck was both preacher and pugilist, promising to 'teach the bourgeois and rock the boulevard'. As a child of the Panther era, he had both the conviction and the platform to deliver a crash course in his updated Black Power philosophy, complete with heroes (Louis Farrakhan, Marcus Garvey, Malcolm X), villains (radio, TV, the FBI, the CIA), and a way forward in the shape of black unity. 'Party For Your Right to Fight' explicitly appointed Public Enemy to finish the job the Panthers started: 'This party started right in '66 / With a pro-Black radical mix.' On the album's opening track, Professor Griff declared: 'Armageddon has been in effect.'

*

Meanwhile, on the west coast, Armageddon was taking a different shape. In the mid-1980s two MCs simultaneously hit upon a new form of rap storytelling: the gang narrative. In Philadelphia, Schoolly D released 'P.S.K. – What Does It Mean?' (1985), a reference to the local Park Side Killers crew, while in Los Angeles Ice-T recorded a brutish picaresque called '6 in the Mornin''. These songs invented gangsta rap, Boogie Down Productions' *Criminal Minded* album cemented it, and a crew from Compton, Los Angeles, blasted it into the American mainstream. If Public Enemy were the Clash, seeking to build something new from the ruins of the old order, then Niggaz With Attitude (N.W.A.) were the Sex Pistols, bent on dancing amid the debris.

Compton was one of several black, working-class suburbs plagued by a crumbling economy, failing infrastructure and soaring crime rates. After the crumbling of the Panthers in the early 1970s, the power vacuum in South Central Los Angeles was filled by a potent new criminal gang known as the Crips, who inspired a wave of rival gangs, some of whom coalesced under the banner of the Bloods. More like networks than single gangs, the Crips wore blue for identification, the Bloods favoured red, and the two groups set about carving up turf throughout black Los Angeles. By the start of the 1980s, with recession ensuring

that the only black business booming was crack cocaine, the city was home to 155 gangs with 30,000 members.

This was the terrain charted by Ice-T: a hard-edged existence in which danger was omnipresent and only the tough and savvy survived. In 1987, it also inspired eighteen-year-old rapper O'Shea 'Ice Cube' Jackson to move from silly sex rhymes to something more documentarian. Local drug dealer and hip-hop scenester Eric 'Eazy-E' Wright wanted to assemble a supergroup of South Central talent, signing up Ice Cube along with DJ/producers Andre 'Dr Dre' Young and Antoine 'DJ Yella' Carraby (Lorenzo 'MC Ren' Patterson joined later). By far the most gifted lyricist of the bunch, Cube brought Eazy-E a song which evinced a perverse form of local pride. 'Boyz-n-the-Hood' was pure South Central, with a cast of carjackers, crackheads, brutal cops and gun-toting girls. Although it ended in a shootout with the law, the heroes were no Eldridge Cleaver and Angela Davis but a hood and his loyal moll.

The single's massive success cleared the way for N.W.A.'s debut album in 1988. *Straight Outta Compton* was a brutal, bewildering mix of hedonism and rage. Powered by Dre's battering-ram drums and ominous horn blasts, the title track was rap's 'Anarchy in the UK': a war cry framed as a hard-nosed statement of local identity. It is shamelessly, gleefully unpleasant, a calculated affront to any liberal ideas of self-improvement. Although 'Express Yourself' counsels focus and integrity over a benign 1970s funk loop, the courtroom drama of 'Fuck tha Police' is the album's only real protest song, aimed squarely at the oppressive tactics of LAPD chief Daryl Gates. Even then, its message is compromised by gangsta posturing. One minute Ice Cube is bemoaning police harassment ('Young nigga got it bad cuz I'm brown'), the next MC Ren and Eazy-E are bragging about their firepower. As protest, *Straight Outta Compton* is blithely uninterested in causes or solutions, only in the reality of 'street knowledge'.

Straight Outta Compton came across like *Nation of Millions*' renegade twin. Public Enemy harked back to the days of black

unity; N.W.A., a few, significant years younger, came of age in a society atomised by neglect. Chuck D described himself as a communist; N.W.A. were red-in-tooth-and-claw libertarians. Public Enemy followed the Panthers; N.W.A. moved amid the Bloods and Crips. Chuck was thoughtful and disciplined; N.W.A. were 'crazy as fuck'. Public Enemy demanded that their listeners read up on their history and take action; N.W.A. asked only that they make the best of what was available. 'N.W.A. said and did things that they knew would strike an attitude with the demographic that they weren't necessarily a part of,' says Chuck. 'They had a sensibility that really hit street cats but they were not those cats.'

In interviews, N.W.A. trotted out the disingenuous line that their lyrics were clear-sighted reportage, but their lurid tales of fucking and fighting were never coloured by the bluesy anguish of 'The Message'. 'We just wanted to do something new and different and talk about what we wanted to talk about,' Eazy-E later explained. 'Like dick-sucking.' Dr Dre was equally blunt: 'Everybody was trying to do this black power and shit, so I was like let's give 'em an alternative.' It was protest only in the sense that it told America it would reap what it had sown: *You treat us like animals? Fine, we're animals.*

Unsurprisingly, it got a reaction. During the summer of 1989, police departments fumed over 'Fuck tha Police'. They refused to provide security at certain N.W.A. shows and, in a case of life mirroring art, busted the tour bus looking for evidence of gang connections. The FBI wrote to the band's label, Priority, arguing that the song was 'both discouraging and degrading to these brave, dedicated officers'. So far, so predictable, but N.W.A. also drew flak from socially conscious hip-hop DJs who believed the group were confirming every possible negative stereotype about young black men. Hip-hop's liberal defenders saw it as the music of the oppressed, but in the violent, misogynistic, homophobic work of N.W.A., the oppressed became the oppressors, so what then?

*

555

Spike Lee shot the video for 'Fight the Power' on the streets of Bedford-Stuyvesant on a cold, wet day in the spring of 1989. It opened with a talismanic image of the civil rights movement – crowds singing 'We Shall Overcome' during the March on Washington – then cut to Chuck D addressing his own audience through a loudhailer and promising, 'We ain't goin' out like that 1963 nonsense.' The sacrilege was calculated. Among other things, *Do the Right Thing* was a referendum on the civil rights movement. After the climactic riot, the movie ended with two competing quotations regarding the validity of violence as a means of dissent, one from Dr King, one from Malcolm X. Each viewer got to decide which one better suited the times.

Few of the Brooklyn residents at the video shoot would have needed telling why the movie was relevant. During the mid-1980s New York became a racial tinderbox, with each year bringing some fresh disaster. In October 1984 NYPD officers shot dead a sixty-six-year-old black woman, Eleanor Bumpurs, while evicting her from her Bronx apartment for non-payment of rent. Two months later white electronics repairman Bernhard Goetz shot four black teenagers on a downtown express train, claiming that they intended to mug him. Five days before Christmas 1986 Trinidadian construction worker Michael Griffith was chased by a white mob on to a highway in Howard Beach, Queens, where he was knocked down and killed by a car. A few days later the activist firebrand Al Sharpton led a 1,200-strong crowd of demonstrators through the streets while white bystanders hurled racial abuse.

These events must have been somewhere in Chuck D's mind when he sat in his aeroplane seat, scribbling the lyrics to 'Fight the Power'. 'I was trying to say something along the lines [of] New York black talk radio,' says Chuck. 'I used to listen to WLIB with Gary Byrd and Mark Riley, and they would be up to the minute on those injustices that were taking place. So I wanted a song which would deal in that manner.' He came up with a call for 'mental self-defensive fitness' and, in one deft line ('swinging while I'm singing'), absorbed Malcolm X's critique

of freedom songs ('It's time to stop singing and start swinging'). One of his targets, however, was a soft one: Bobby McFerrin's indefatigably cheerful a cappella hit 'Don't Worry, Be Happy'. 'I knew Bobby McFerrin was a nice guy,' he says, laughing. 'It had nothing to do with Bobby McFerrin. It had something to do with radio and TV. It's like, "The only way we can have these negros on is that they got to be happy."'

Public Enemy recorded the song in Manhattan's Greene Street studios, starting with a groove that Keith Shocklee had been toying with – one with, in Hank's words, 'a defiant, aggressive, *I'm not gonna take it* feeling.' They worked with the physicality of a rock band, jamming ideas, layering samples, giving the song as much weight as it could bear. This was shortly before the copyright crack-down which forced hip-hop producers to license every sample, and the opening bars alone swarm with so many found sounds that not even the band can now identify them all. They pushed their equip-ment to its limits, snapping the ends off their samples or fraying the edges to create a rough, aggressive, mechanoid sound. 'The key of PE's style was that it was clean and dirty; it was tight and messy,' Hank Shocklee told *Mix* magazine. 'Everybody is pitching in ideas, and the idea that was stronger is what ended up on tape.'

It was just weeks after the video shoot that the trouble started.

*

Viewing Public Enemy as an information portal, Chuck made him-self an enthusiastic and engaging interviewee – he once joked that his interviews were better than some rappers' records. He was push-ing albums, of course, but also ideas. Critics agonised over their conflicted fascination with a group that was at once incalculably thrilling and ideologically troubling, the one quality inseparable from the other. Were they violent? Fascistic? Racist? Anti-Semitic? What did they mean when they said 'two wrongs are gonna have to make a right'? After one long, fractious interview, *Melody Maker* writers the Stud Brothers called the band 'morally abhorrent' and compared them to Leni Riefenstahl. And they were *fans*.

Anybody close to Public Enemy knew that if a storm was going to come it would most likely blow in from Griff's direction. It was Griff who had introduced Chuck to the teachings of Louis Farrakhan back in the Spectrum City days; Griff who told the band's Jewish publicist Bill Adler that he had been reading Henry Ford's notoriously anti-Semitic tract *The International Jew*; Griff who told the Stud Brothers in 1988 that 'if the Palestinians took up arms, went to Israel and killed all the Jews, it'd be all right' (at which point Chuck broke in, 'Listen, Griff, let's not even talk about this').

To an extent, it was Griff's job to be extreme. As Chuck explained to the *NME*, 'I'm like the mediator in all this. Flavor is what America would like to see in a black man – sad to say, but true – whereas Griff is very much what America would not like to see.' But his anti-Semitism was beginning to worry people in the Public Enemy camp. Five years earlier, Jesse Jackson had derailed his White House run by referring to Jews as 'Hymies' and New York as 'Hymietown', and relations between blacks and Jews had been delicate ever since.

So when Griff conducted his calamitous interview with the *Washington Times*' David Mills on 9 May 1989, it was an outburst too far. Mills faxed the article to other media outlets. News programmes pounced on the comments. Movie distributors voiced reservations to Spike Lee. Bill Adler begged Chuck to publicly criticise the stubbornly unrepentant Griff, but Chuck hesitated. There was a principle at stake: his belief that Griff should be able to speak his mind, even if what was on his mind was poisonous nonsense. There was also a practical issue. Exhausted from touring, the band was in ornery spirits, and Chuck, who always saw himself as a team player, was reluctant to appoint himself the disciplinarian leader that the situation required. He was a musician suddenly called upon to make a politician's choice: back Griff or sack him. He did neither.

Eventually, six weeks after the interview, he called a sullen press conference at which he announced Griff's suspension

and insisted, 'We are not anti-Jewish. We are not anti-any-one.' He could have predicted the response: praise from the mainstream media and angry disappointment from black critics who accused him of buckling under pressure. In despair, he promptly announced that Public Enemy was finished, but after what was meant to be their final gig, they received some sage advice from Farrakhan himself: sit tight, keep quiet, ride it out.

In the midst of the meltdown, *Do the Right Thing* reached cinemas. Hank Shocklee was walking down the street when he met some friends who had been to a screening and broke the news: 'Yo, "Fight the Power" is all over it!' Lee, who hadn't even got back to the group to tell him he liked the track, had made it the dissonant heartbeat of the whole movie, from Rosie Perez's opening-credits dance sequence to the final conflagration at the pizzeria.

Predictably, it drew flak from those who had reservations about Lee's message. 'Maybe we should stop emphasizing the negative, maybe we should emphasize the positive,' Bronx judge Burton B. Roberts told the *New York Times*. 'Why can't we fight *for* power, rather than fight *the* power?' But the song instantly caught light. When a riot broke out in Virginia Beach that summer, black students faced ranks of police with cries of 'Fight the power!'

Public Enemy's demise lasted all of six weeks. On 1 August they announced 'The show must go on'. In November they bounced back with 'Welcome to the Terrordome', a single which crunched the events of the summer into a tight ball of frustration. 'I wasn't angry as much as I was perplexed,' says Chuck. 'There was a lot of inside–outside turmoil. I don't know what bothered me more, the inside or the outside, because they combined and created that sort of confusion. People left "Fight the Power" alone and kept their distance. "Welcome to the Terrordome" they looked into.'

There was a lot to look into. In his most personal lyric yet, Chuck began with a line straight from a 1972 record by Joe

Quarterman – 'I got so much trouble on my mind' – and proceeded to defend his behaviour in the Griff case, kick out at his foes (with problematic lines about 'the so-called chosen' who 'got me like Jesus'), and pull back to reference recent upheavals: the murder of Yusuf Hawkins by a white mob in Bensonhurst, the killing of Huey Newton by a drug dealer in Oakland, and the Virginia Beach riots. He rapped what he called his 'Leave Me the Fuck Alone song' like a boxer circling the ring.

The *New York Post*, zeroing in on the most contentious lines, promptly called for a Jewish boycott of the band. Prior to that summer Public Enemy were commentators on the battle for black advancement; now they were on the front line. The Terrordome, Chuck explained, was 'the house of the 1990s'.

*

The Bomb Squad spent the first month of the new decade making Public Enemy's *Fear of a Black Planet* and the second recording *AmeriKKKa's Most Wanted*, the solo debut of N.W.A.'s Ice Cube. These productions vibrated with urgency, enhanced by new sampling techniques. Where Phil Ochs and John Lennon once talked of 'newspaper writing', this might be called 'newscast writing', studded with snatches of radio and TV reports, including those concerning Public Enemy's recent tribulations. Using a kind of musical ju-jitsu, the group were absorbing strength by incorporating criticism. The black history with which they were engaging now included their own.

Fear of a Black Planet, which sold a million copies in its first week, thronged with even more grievances than its predecessor: inadequate emergency services in black neighbourhoods ('911 Is a Joke'), stereotyping in movies ('Burn Hollywood Burn'), police harassment ('Anti-Nigger Machine'), and institutional racism ('Who Stole the Soul?'). 'Fight the Power' was positioned at the end as both a summation and a tentative resolution of everything before it, sublimating all of the record's discord and unease into

one bulletproof battle cry.*

Chuck D may have been in the mood for soul-searching but Ice Cube was ready for war. 'He came from the school of "tell a nigga like it is and not give a fuck" and his "not give a fuck" was so ecstatic, so real, so concentrated that it was like wow!' Hank Shocklee told *Cool'Eh* magazine. On the cover of *AmeriKKKa's Most Wanted*, Cube wore a scowl that could turn milk to yoghurt. Inside, he turned his shrivelling glare on the police, radio stations, treacherous girlfriends, and mainstream black 'sell-outs'. Lacking Chuck's oratorical sweep, Ice Cube had a clenched, pug-nosed delivery, jabbing at each syllable as if it were a punchbag. He was still more bad-tempered gangsta ('The Nigga Ya Love to Hate' to quote one song title) than radical until, while filming John Singleton's movie *Boyz N the Hood* in Los Angeles, Cube met Khalid Abdul Muhammad, who encouraged the rapper to join the Nation of Islam. While N.W.A. prided themselves on looking no further than the next block, Cube now positioned himself as part of a wider black nationalism.

His next album, 1991's *Death Certificate*, was concerned with just one thing: the wellbeing of the black man. When that is threatened by shoddy medical care or gang warfare, his raps have the force of underdog protest. But just as often, black masculinity is undermined here by Jews, homosexuals, bourgeois blacks or insufficiently obedient women. Cube boiled all the compassion out of Public Enemy's template, leaving only unforgiving, strength-in-adversity toughness.

The most shocking song on the record was 'Black Korea', which opened with a tense exchange from *Do the Right Thing* then proceeded to torch the movie's ambivalence in a jawdropping assault on Korean shopkeepers: 'So pay respect to the black fist / Or we'll burn your store right down to a crisp.' *Billboard* called for a boycott of the album, claiming it had crossed the line

* Griff, briefly welcomed back into the fold, stupidly broke his press purdah with a *Spin* interview and agreed to leave Public Enemy for good in February.

separating art from incitement to violence, but Ice Cube only apologised when Korean grocers threatened his endorsement deal with the malt liquor brand St Ides. 'Call him Ice KKKube – a straight-up bigot simple and plain,' decided Robert Christgau in the *Village Voice*. 'Young people who are very upset and angry about things come to rap artists as if they were scholars and have the answers to all these incredible questions,' reflected Michael Franti of Bay Area duo the Disposable Heroes of Hiphoprisy. 'A lot of times they don't and they end up putting their foot in their mouth.'

Sent reeling by Ice Cube's wrecking-ball wrath, liberal defenders of rap were grateful to find a battle worth fighting in the shape of Public Enemy's 1991 single 'By the Time I Get to Arizona'. Martin Luther King, Jr, Day had been signed into law by a reluctant Ronald Reagan in 1983, but by 1991 two states still refused to endorse the holiday: New Hampshire and Arizona. After Arizona voters blocked it yet again, Chuck D wrote a song about marching on the state to assassinate Governor Fife Symington III (who in fact supported the holiday). The video, which climaxed with a car bomb, caused predictable outrage, but this time Chuck was well equipped to defend himself in a panel discussion on ABC's *Nightline*. 'Our whole philosophy is that controversy is good if you can handle it,' he writes in his memoir. 'You can't have controversy take over because controversy can kill your shit.' He elaborates: 'The media is not just this anonymous organism. It's made up of a whole bunch of perpetrators and participators from lots of different angles so you always feel like you're in the middle of a thicket. It's like playing paintball.'

By coincidence, the 'Arizona' video featured two rappers, Sister Souljah and Ice-T, who were about to walk into controversies too big for hip-hop to handle.

*

The events of 1992 put political hip-hop at the centre of the culture even as they killed it as a mainstream proposition. Four

years earlier, *Nation of Millions* and Boogie Down Productions'
By All Means Necessary album had inaugurated a minor boom
in socially alert records: the Nation of Islam rhetoric of X-Clan,
Brand Nubian and the Poor Righteous Teachers; the bracingly
stern sermons of Gang Starr; the Afrocentric optimism of De La
Soul, A Tribe Called Quest and the Jungle Brothers.* Arrested
Development came from Atlanta, Georgia, with a preachy, feel-
good, wholegrain breed of rap, which hoovered up praise from
critics who were tired of defending Ice Cube, but only ended
up proving that hip-hop cleansed of complications was pretty
vanilla. More entertainingly, Philadelphia's the Goats stirred
abortion rights and the genocide of native Americans into the
usual protest-rap brew on their 'hip-hopera', *Tricks of the Shade*.
Better still, the Disposable Heroes of Hiphoprisy updated the
cerebral street poetry of Gil Scott-Heron and the Watts Prophets.
On their sole album, *Hypocrisy Is the Greatest Luxury*, pensive
frontman Michael Franti delivered a damning litany of America's
ills. 'We had CNN on in the studio and I was writing shit straight
off the TV,' he says. 'I was so angry that [the Gulf War] was hap-
pening, and so that record became a reaction to television and
media.' As if sensing the coming storm, he numbered among the
problems a crackdown on freedom of speech.†

On 29 April a jury in LA's Simi Valley acquitted four white
police officers who had been accused of using excessive force
against black motorist Rodney King a year earlier. Because video-
tape of the beating had been on constant rotation for months,

* Eric B and Rakim's 'Casualties of War', about the anguish of a
black Muslim GI in the first Gulf War, is especially memorable for its
spooky premonition of 9/11: 'I look for shelter when a plane is over
me / Remember Pearl Harbor? New York could be over, G.'
† The album included an inspired version of the Dead Kennedys'
'California Uber Alles', its target updated from Jerry Brown to
the Republican governor Pete Wilson. 'Television, the Drug of the
Nation', which U2 used as an introductory theme on the Zoo TV
tour, was hip-hop's sample-heavy answer to 'The Revolution Will Not
Be Televised'.

black Los Angelenos took the verdict as an implicit endorsement of Daryl Gates's racial profiling and heavy-handed policing. Within four hours of the acquittal, crowds at the intersection of Florence and Normandie in South Central Los Angeles were looting and burning the neighbourhood. Within six, Mayor Tom Bradley had declared a state of emergency and Governor Wilson had called in the National Guard. By the time the curfew was lifted on 4 May, fifty-three people were dead, over 9,000 wounded and 12,000 arrested in a disturbance which eclipsed even the Watts riots of 1965.

President George H. W. Bush called it 'purely criminal'. Those sympathetic to the rioters' grievances preferred the term 'uprising'. 'This whole thing is not a reaction to the Rodney King case,' said Michael Franti, 'it's a revolt, an insurrection as a result of twelve years of conservative, militaristic programmes that have sucked money out of the communities.' Although rappers played no part in the violence, this was exactly the kind of conflagration that the likes of Ice Cube had predicted. On the title track of his new album *The Predator* he named the four officers in the King case and declared 'no justice, no peace'. Officer Laurence Powell's notorious comparison, on the day of the assault, of a dispute between black men to something 'right out of *Gorillas in the Mist*' inspired two songs called 'Guerrillas in the Mist': one by Cube confederates Da Lench Mob and another by militant San Francisco rapper Paris.

The most contentious comment on the rampage came from Sister Souljah, a young black activist who had became the first female member of the Public Enemy camp two years earlier. A few days after events in LA she spoke to David Mills, the same journalist who had elicited Professor Griff's peculiar views regarding Jews. Asked about the beating of truck-driver Reginald Denny on 29 April, an incident captured by airborne news crews, Souljah replied: 'If black people kill black people every day, why not have a week and kill white people?'

The full quote made it obvious that she was imagining the

mindset of a frustrated gangbanger rather than advocating violence herself, but that was forgotten once the interview made its way to presidential candidate Bill Clinton, who read out the quote at the convention of Jesse Jackson's Rainbow Coalition in June and asked: 'If you took the words white and black and you reversed them, you might think [Ku Klux Klan politician] David Duke was giving that speech.' The analogy was nonsense but it allowed Clinton to woo moderate voters by distancing himself from black radicalism, a move so blatant and effective that any similar tactic is now dubbed a 'Sister Souljah moment' by Washington pundits.*

Ice-T was another victim of the feverish new mood. In 1990 he had written a deliberately overheated revenge fantasy called 'Cop Killer' for his heavy-metal side-project Body Count. In March 1992 he released the song on the band's debut album, adding topical references to Rodney King and Daryl Gates. Just days before Clinton turned on Souljah, police organisations called for a boycott of Time Warner, which released Body Count's records through its Sire imprint. Tipper Gore, wife of vice-presidential hopeful Al and founder of the PMRC, wrote an editorial disingenuously comparing Ice-T's music to slavery and Nazism. Conservative heavyweights President Bush, Vice-president Dan Quayle, Charlton Heston and Oliver North queued up to damn the song (this was, after all, an election year). Time Warner executives were besieged by death threats and angry shareholders as timid record stores pulled the album from the shelves.

It bore all the hallmarks of a full-blown moral panic, in the teeth of which arguments about First Amendment rights were doomed. Clearly, the target was not one song but the whole

* In 1988, on the subject of New York mayor Ed Koch's criticisms of Jesse Jackson, Chuck D had made a similar point in far more extreme language. 'He needs to be taken out by the same drug dealers, the same brothers who are out there killing themselves,' he told *Melody Maker*. 'They ought to save them bullets for Koch.' His comments had caused not a ripple.

hip-hop industry. After some initial resistance, Ice-T buckled, removing 'Cop Killer' from the album and replacing it with a new protest rap mordantly entitled 'Freedom of Speech'. 'I don't hold anything against them, man, it's business,' he said equably. 'I was costing them money.'

Whether he was being defeatist or just phlegmatic, Ice-T cut to the truth of the matter: free speech comes a poor second to dollars and cents. After losing the battle of 'Cop Killer', hip-hop lost its nerve. Paris, who called himself 'the Black Panther of Hip-Hop', had recorded a thrillingly intemperate song called 'Bush Killa' for his new album *Sleeping With the Enemy*, illustrating it with a mocked-up photograph of himself lurking on the White House lawn with a rifle in his hand. Once the artwork reached the tabloids, Time Warner forced Tommy Boy Records, whose releases it distributed, to drop Paris, who was eventually forced to release *Sleeping With the Enemy* independently. Political rap didn't die but it was forced to either soften its message into generic cries for peace and understanding or move to the fringes and preach to the choir. As a means of mainstream musical revolt, it was cut off at the knees.

'Of course it scared people off,' says Chuck D. 'Because rappers want to be successful and they're given ultimatums – this is what they have to do, and this is what they'd better not to do. If you look at the Sex Pistols, they were art kamikazes. Black artists ain't doing that. They're trying to be loved, they're trying to be successful, and they're trying to be ahead of the battle.'

By the time Public Enemy released their fifth album, 1994's *Muse Sick-n-Hour Mess Age*, they were marginal figures, elbowed aside by the brash swagger of gangsta rap (now reinvigorated and depoliticised by Dr Dre's colossally successful *The Chronic*) and the clammy, noirish storytelling of young New Yorkers such as Nas, the Wu-Tang Clan and Mobb Deep, and their fire dampened by the departure from office of such hate figures as President Bush and Daryl Gates. Younger activist groups such as Dead Prez and the Coup were destined to be niche concerns.

Those who believe that hip-hop has sold its rebel soul have since romanticised Public Enemy's rage, exaggerated their righteousness and simplified their contradictions. But they were powerful *because* of those contradictions. The natural certainty of Chuck's voice was misleading. The truth was in the wild confusion of the noise they made, a noise which offered more questions than answers, and which contained shards of ugliness that could not be wished away. Public Enemy's message was too diffuse, conflicted and sometimes bizarre to withstand the hot glare of media scrutiny indefinitely, but the noise could not be disputed, and it triggered more musical reverberations, awoke more consciences, than that of any band since the Clash.

'You have to be able to do something within the time that you're granted' says Chuck D. 'You can't create the time. You can create the product, you can create the song, but you cannot create the time.'

'Fight the Power' planted political hip-hop in the mainstream of US culture for three eventful years. After 'Cop Killer', that time had passed, never to come again.

28

'This is happening without your permission'

Huggy Bear, 'Her Jazz', 1993

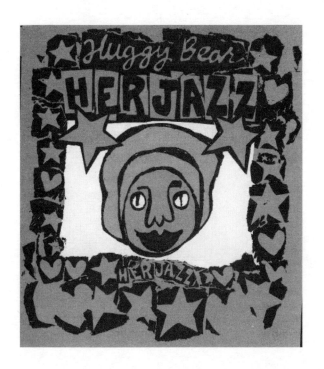

Riot Grrrl

Huggy Bear, 'Her Jazz', (Wiiija, 1993).

There was something different about the crowd gathering outside the London studio of Channel 4's late-night youth programme *The Word* on the night of Valentine's Day 1993. It was to be the TV debut of Huggy Bear, a five-piece band who represented the British wing of the feminist rock movement known as Riot Grrrl. Hosted by the aggravatingly laddish Terry Christian, *The Word* was, for want of anything better at the time, the best possible British showcase for a young alternative rock band, its live recording allowing for attention-grabbing spontaneity. For Huggy Bear, who had thus far released only limited-edition cassettes and seven-inch singles, the booking was a major coup. The queue outside the studio was packed with supporters. Inside, someone from the production crew instructed them as to on-air etiquette: 'Look like you're having fun'; 'Don't make stupid faces at the camera'; 'Look cool.'

During the first half of the show, the Huggy Bear fans were restless. 'You could barely move, they'd let so many kids in,' remembers Gary Walker, whose Wiiija label released the band's first records. 'A group of girls were like, "What do we do? Is there going to be an opportunity for us?"' With a wail of feedback, Huggy Bear introduced themselves to a national audience. The song, 'Her Jazz', was a fractured lurch which exploded into a joyous squall, spraying wonderfully overheated boasts and accusations like a splinter grenade: 'Post-tension realisation / This is happening without your permission / The arrival of a new renegade girl-boy hyper-nation.' 'The performance was so mind-blowing that for me *that* was the statement,' says Walker. 'How could you top that?'

But after the performance the lights went down while the monitors screened a pre-recorded interview with two glossy, plasticised, self-proclaimed bimbos called the Barbi Twins. It seemed like a calculated affront to everything Huggy Bear represented.

In the darkness, several girls manoeuvred themselves into position in front of Christian, so that when the lights came back on at the end of the item, they were ready. 'So, Terry,' guitarist Jo Johnson addressed the host, 'you think all fucking women are shit, do you?' The women beside her struck up a chant of 'Crap! Crap! Crap!' The audience applauded.

The situation turned nasty as security guards waded in, manhandling protesters out of the studio and striking Johnson in the face. Outside in the car park, the band and their friends excitedly debated what had just happened. According to Huggy Bear's Chris Rowley: 'It wasn't our plan. It was one of those star-crossed things. At the time, I felt quite euphoric. We'd caused a ruckus and it seemed to be for a good reason. But obviously in the days that followed it became a huge thing, like we were trying to tarnish the nation's youth with our ugly feminist politics.'

This minor commotion became the event that defined Huggy Bear for the rest of their short existence. A band which had arrived in a tornado of ideas, theories, arguments and contradictions was suddenly reduced to a group of girls shouting at a TV presenter. 'They screech, they spit, they snarl, they swear,' sneered Anne Barrowclough in the right-wing *Daily Mail*. 'Meet the Riot Grrrls, the latest, the nastiest phenomenon to enter the British music scene.'

Less than two years later, Huggy Bear had disintegrated, as had Riot Grrrl. The American Riot Grrrls had experienced their own media mauling only a few months earlier, one from which they never fully recovered. Riot Grrrl thrived only for as long as it inhabited an underground of fanzines, pamphlets, small shows and intimate meetings – as long as those involved maintained control over their own message. As soon as it became fair game for journalists, it collapsed under the weight of its own contradictions. And though Riot Grrrl was an imperfect movement which deserved close scrutiny, there was still something alarming about the viciousness and intensity of the backlash, and what it meant for any future bands who might want to make a political

statement. 'We started off quite ebullient and unbeatable,' says Rowley. 'But three years is quite a long time to maintain that level of "we don't care", because we *did* care. We didn't mind being outsiders, but we didn't want to be hated.'

'The most bizarre aspect of the . . . backlash has been its niggling, nit-picking nature,' argued *NME*'s Steven Wells. '[Huggy Bear] have had their ideology combed over, examined, misinterpreted, rewritten and kicked to death a hundred times. Talk about breaking a butterfly on a wheel. If the Clash or Dylan or Bob bloody Marley had suffered such intense scrutiny they would all have failed the examination.'

*

In the US, Riot Grrrl had two epicentres: the small college town of Olympia, Washington, on the west coast, and Washington DC on the east. Olympia was home to both the liberal Evergreen College and a thriving all-ages, coffeeshop gig scene. In 1982, Calvin Johnson, a charismatic student DJ who loved such off-the-wall, female-dominated British bands as the Slits and the Young Marble Giants, founded K Records and, three years later, his own band, Beat Happening. Instead of codifying punk as hard, fast and aggressive, à la hardcore, Johnson embraced its DIY ethos – the sense that anyone could join in, even if their technical skill left much to be desired – and reclaimed it for geeks, women and others who didn't fancy screaming with their shirt off. Drinking nothing stronger than tea, he favoured vintage cardigans, salaryman haircuts and other cutesy throwbacks to the white-bread 1950s: a previous generation's conformity remade as outsider chic. Johnson, and the acolytes whom Nirvana's Kurt Cobain called 'Calvinists', quickly defined the Olympia scene, creating a nurturing, if somewhat cliquey environment.*

Shortly before establishing K, Johnson had been inspired by

* Some years later, Courtney Love, frontwoman of the grunge band Hole as well as Cobain's wife, recorded 'Olympia' (1994), a satirical dig at a town where 'everyone's the same'.

a trip to Washington DC, where he met Minor Threat's Ian MacKaye. As the decade progressed MacKaye's Arlington, Virginia, HQ, Dischord House, became a hub of punk-rock activism concerning such causes as abortion rights, gun control and the anti-apartheid movement, especially during the 1985 series of events they called 'Revolution Summer'. Dischord's example inspired the Embassy, home to a radical new group called the Nation of Ulysses, who pinched ideas from the Black Panthers and situationists, dispatched tongue-in-cheek revolutionary communiqués about bringing down the adult world, and called their debut album *13-Point Plan to Destroy America* (1991).

Johnson's visit to DC was the start of regular, cross-country traffic between the two scenes, playing gigs and exchanging ideas. Around the turn of the decade, feminist punk fanzines (commonly known as zines) began to spring up, including Sharon Cheslow's *Interrobang?!* in DC and Tobi Vail's *Jigsaw* in Olympia. Vail was so thrilled by a Nation of Ulysses performance in Olympia that she determined to form her own band, an alternative to 'punk rock . . . for and by boys'. With Kathleen Hanna, a singer who was working in a domestic violence shelter at the time, she formed Bikini Kill and released a debut EP with the brilliant, sloganeering title *Revolution Girl Style Now!* (1991).*

Two young women were particularly inspired by *Jigsaw*. Allison Wolfe, the Olympia-raised daughter of a 'super hardcore, seventies-era, second-wave feminist', and Molly Neuman, the daughter of a DC-based publicist for the Democratic Party, became next-door neighbours and fast friends at the University

* Bikini Kill inadvertently inspired the biggest alternative rock song of the era. Vail briefly dated Nirvana's Kurt Cobain during 1990 and, after one discussion of punk rock and politics, Hanna spray-painted the words 'Kurt Smells Like Teen Spirit' on his wall. Cobain took it for a revolutionary slogan and named a new song after it, only realising later that Teen Spirit was Vail's favourite brand of deodorant.

of Oregon in Eugene in the autumn of 1989. Wolfe and Neuman published their own fanzine, *Girl Germs*, while mounting 'guerrilla' a cappella performances at parties. 'We had already named our band Bratmobile and we were going around telling people we were in a band, but we weren't really,' says Wolfe.

Wolfe vaguely knew Hanna from seeing her around Olympia. 'She had a shaved head so she really stood out. I remember being scared of her because she always looked like she was glaring at everyone.' When Wolfe saw Hanna's pre-Bikini Kill band, Viva Knieval, 'she was yelling at the top her lungs: "Boy poison! Boy poison!" And her face was bright red and the veins were popping out on her neck. Most of the bands were more tra-la-la, sweetie-pie and that was the first confrontational girl I'd seen on stage. I was really intrigued by that.' So when Calvin Johnson asked her and Neuman to support Bikini Kill at a show on Valentine's Day 1991, the two women formalised Bratmobile. 'When we formed a band we didn't know how to play,' says Wolfe. 'So for me, expressing and voicing my politics were actually the most important part of being in a band.'

Wolfe and Neuman spent their spring vacation at Nation of Ulysses' Embassy in DC, which was 'much more of a guy town' than the female-dominated Olympia scene. It was a turbulent time in the city. On 23 May the Supreme Court ruled in the case of *Rust* v. *Sullivan* that it was constitutional for the Bush administration to prohibit federally funded clinics from offering advice regarding abortion. The decision stoked fears that the right to abortion itself, as guaranteed by *Roe* v. *Wade*, was under threat. Earlier the same month, three nights of rioting broke out in the city's Mount Pleasant area after a Hispanic man was shot and wounded by a female police officer: the city's worst unrest since 1968.

Though unrelated, the two incidents intensified the sense of urgency and imminent confrontation in the city's punk scene. Zine writer Jen Smith wrote a letter to her friend Wolfe containing a memorable phrase: 'We're going to have a girl riot this summer.'

*

At the time, Wolfe and Neuman were thinking of launching a new weekly zine and needed a catchy title. Working in Neuman's dad's office one night, they combined Smith's language with the playful spelling of *grrrl* in the latest issue of *Jigsaw* (a riff on such 1970s feminist coinages as *womyn*) and printed off the first copies of *Riot Grrrl*. In the third issue, Hanna raised the idea of all-female meetings to discuss issues relevant to the scene. 'She used to have problems relaxing,' says Wolfe. 'She constantly needed to do things and say things. So a lot of the time she was the catalyst.' The first such gathering took place at the DC branch headquarters of punk activists Positive Force in July, where women including Wolfe, Neuman, Hanna, Vail and Cheslow discussed anything from sexual abuse to aggressively macho slam-dancing at rock shows.

The birth of Riot Grrrl coincided with the arrival of a new generation of feminism. In October an attorney called Anita Hill testified to the Senate that Supreme Court nominee Clarence Thomas had made graphic sexual remarks to her when she worked for him during the 1980s. Thomas's nomination was narrowly confirmed but debate over the truth of Hill's allegations boiled for months afterwards. It was in response to the Thomas hearings that writer Rebecca Walker coined the catch-all phrase 'third-wave feminism', referring to a new generation of thinkers who focussed on reproductive rights, language and identity politics.

Whereas second-wave feminism emphasised economic issues such as workplace equality and childcare, Riot Grrrl was more concerned with self-expression. 'Theory didn't always seem to have a place in our lives outside the classroom,' says Wolfe. 'Our goal was to try and make academic feminism more punk, while also making punk rock more feminist.' Riot Grrrls sought to reclaim pejorative terms such as *bitch* and *slut* as well as supposedly un-feminist imagery. 'We can be cutesy and girly and

whatever we want but we should still have rights and we should still be taken seriously,' argued Wolfe. While still exercised by such brass-tack political issues as abortion rights and sexual harassment, Riot Grrrls believed in opening up new cultural spaces for young women. One version of the ever-mutating Riot Grrrl manifesto claimed: 'We seek to create revolution in our own lives every day by envisioning and creating alternatives to the bullshit Christian capitalist way of doing things.'

The joyous apex of Riot Grrrl's own Revolution Summer came in August 1991, at K Records' International Pop Underground Convention in Olympia. Bikini Kill, Bratmobile and the like-minded Heavens to Betsy played on the opening night's all-girl bill. 'I think we all felt like we were in this together and all politicised,' says Wolfe. 'It really felt like a crucial time. That festival was covered in *Rolling Stone* and,' she sighs as a less happy memory pokes through, 'that really felt like the beginning of the onslaught.'

Even before the media attention, Riot Grrrl's attempts to be flexible enough to accommodate different ideas was under strain. There was a utopian quality to the movement. 'There is no editor and there is no concrete vision or expectation,' wrote Molly Neuman in *Riot Grrrl*. 'We Riot Grrrls are not aligning ourselves with any one position or consensus, because in all likelihood we don't agree. One concrete thing we do agree on so far is that it's cool/fun to have a place where we can express ourselves that can't be censored.' But such an open-ended attitude created its own problems. 'There probably were some tensions starting to arise,' admits Wolfe. 'Some of us felt more politicised than others and some people seemed like they just wanted to look cute. There did start to be divisions. Sometimes things got weird.'

*

Gary Walker first learned about Riot Grrrl while working behind the counter at London's Rough Trade record shop, the nexus of the UK independent music scene. He noticed two couples – Jo

Johnson and Jon Slade, and Niki Elliot and Chris Rowley – coming in regularly to ask for releases by Bikini Kill and Bratmobile. Johnson and Slade shared a flat in Brighton with their longtime friend Everett True, an influential *Melody Maker* writer who brought back records and zines from his regular trips to Olympia. Just as the Olympia Riot Grrrls had K Records and Beat Happening, their British counterparts had the so-called C86 scene,* which was similarly bookish, unpolished and sometimes twee. Gary Walker says of bands like Tallulah Gosh, Heavenly and the Pastels: 'They were really influential because of the DIY attitude and making non-macho-sounding music and having girls in the band on an equal footing.'

Huggy Bear began, somewhat ironically, as a male duo comprising Slade and Rowley, but Elliot and Johnson, plus drummer Karen Hill, joined during 1991, the same year they learned about Riot Grrrl and hit upon a tougher, more politicised sound. One day in early 1992 they popped into Rough Trade to give Walker a fuzzy demo cassette, wrapped in a handmade sleeve. Walker ran his own small label named after the shop's postcode, Wiiija, and released a compilation of Huggy Bear's first two cassettes under the title *We Bitched*. A single, 'Rubbing the Impossible to Burst', followed in September, with a polemical fold-out cover laying out the group's ideas. 'I remember the guy at the printers laughing so hard: "What the fuck's all this about?"' Walker laughs himself. 'What seems so natural to you is so alien to everyone else.'

Huggy Bear, says Rowley, were about 'mystery, romance and preciousness'. 'We were all a bit refusenik. We didn't want to do the easy thing. We wanted to be a band you could celebrate being into. We were very aware that people needed to be shaken up.' He was inspired by bands from the Pop Group to Nation of Ulysses: 'Things that seem charged and make you want to run around afterwards and say, "What the hell was that?" or,

* The name was taken from the title of an indie music sampler compiled by the *NME*.

"What were they talking about?"' They had a very clear idea of the music they were against: 'blokey, scruffy, apolitical, border-line misogynistic. We were a bit snooty and snotty but we didn't want to reduce everything to lazy ideas and getting wasted and things being just entertainment. That was *horrible*.' They also cultivated a sexually ambivalent image: their first press photo-graph depicted Rowley kissing Slade, and Johnson kissing Elliot.

Huggy Bear set out to empower fans who felt that the mech-anisms of protest were discredited and second-hand. 'This generation seems to have been convinced that it can't do any-thing for itself, that it's all been done before,' Jo Johnson told *NME*'s Steven Wells. They conceived their own British version of Riot Grrrl, called Huggy Nation, fostering an informal net-work of fanzines, bands and labels. 'Prime movers doesn't imply hierarchy,' emphasised Chris Rowley. 'It's people going out to do stuff and networking and letting us know about it.' In fact, the Leeds-based fanzine writer Karren Ablaze! was just as significant in establishing Riot Grrrl's British identity, via her 1992 newslet-ter *Girlspeak*. Like Tobi Vail, she had been inspired by Nation of Ulysses' provocative approach, though not their poker-faced militia chic. 'They fight the adult world, and we fight the man-world,' Ablaze! wrote.

Because of their friendship with Everett True and Sally Margaret Joy, Huggy Bear were confident that they could make the press work for them. Their first *Melody Maker* feature, in October 1992, was less an interview than a collaborative splurge of ideas. 'You need to rest after talking to Huggy Bear,' wrote Joy. 'It's like you've been out in a thunderstorm.' They discussed the joys of not being proper musicians, the power of zines and home-made cassettes, the idiocy of major labels and, propheti-cally, the perils of negotiating the media. 'The media always tries to pick something from the underground and make it powerless,' said Elliot. 'We're not going to let that happen.'

She must have been thinking about recent upheavals in the American scene. In July, *LA Weekly*'s Emily White had written

the first mainstream story on Riot Grrrl, sparking a feeding frenzy which sucked in the likes of the *New York Times*, *Washington Post*, *Newsweek* and even *Playboy*. In the months since Bikini Kill's old friends Nirvana had found mainstream success as huge as it was sudden and unexpected, punk rock was major news and Riot Grrrl had Next Big Thing appeal. Unfortunately, the coverage was at best simplistic, at worst patronising or hostile. 'Better watch out, boys,' chirruped *USA Today*'s Elizabeth Snead. 'From hundreds of once pink frilly bedrooms comes the young feminist revolution. And it's not pretty. But it doesn't want to be. So there!' Riot Grrrls were variously portrayed as trivial ('feminism with a loud happy face dotting the i'), tiresome ('serious and sombre and self-absorbed') and pampered ('their somewhat privileged lives have given them the time and the freedom to express their rage'). Meanwhile, Kathleen Hanna's confessions of childhood abuse and a spell as a stripper were quickly sculpted into a titillating caricature. 'I do think that people want to stare at my tits, want to see me put my foot in my mouth, to see us fuck up,' Hanna complained. She predicted that someone would soon manufacture 'Riot Barbie'. 'She'll come with a little beat-up guitar, some miniature spray paints that don't work, and a list of dumb revolutionary slogans like "Riot Coke just for the taste of it."'

'It was a total shock,' says Wolfe. 'Even thought [Riot Grrrl] felt like the biggest thing in the world to us, it still just felt like it was our world, and to have that knocked out of our hands . . .' She trails off. 'A lot of what was important about Riot Grrrl was the idea of taking over the means of production: putting out our own media and maintaining control over our images and words. So it was a shock to have other people throw up a mirror that was all distorted. We didn't understand it at all. There was so much disinformation.'

What really twisted the knife was the fact that the harshest coverage came from female writers and musicians. Hole's Courtney Love, despite being an early fan of Bikini Kill, dripped

disdain: 'They're mostly strippers, they all have flat stomachs and they wear hip-huggers. They write their own fanzines, which are kind of like SCUM manifestos for twelve-year-olds . . . It's all about girls, not women.'* 'I felt like the media ended up pitting different girls against each other – "Well, so-and-so *hates* Riot Grrrl,"' says Wolfe. 'Why can't we all coexist?'

Hanna, already wary of the press, responded by imposing a media blackout on Riot Grrrl. If mainstream publications could not be trusted, the message would have to trickle out as it had before, via the fanzines and records. But this new siege mentality exposed further faultlines within both the community and individual bands – Riot Grrrl, after all, wasn't meant to have leaders or rules. 'I agreed with it because I couldn't believe the way our ideas and words were being twisted around, but my bandmates definitely did not agree,' says Wolfe. 'Their idea was: what's best for Riot Grrrl isn't necessarily what's best for our band. So a lot of fights had to do with that. I think all the bands were having those issues.'†

Riot Grrrls saw the movement as an ongoing debate, which in time would resolve, or at least embrace, its discrepancies and explore more fully such neglected areas as race and class, but it was never allowed that time. Just a year after the heady possibilities of Revolution Summer, it was frozen in the media glare: a rough draft dissected as unforgivingly as if it were the finished article. This was the fate that, in October 1992, Huggy Bear were confident they could avoid.

*

* SCUM, aka the Society for Cutting Up Men, was a manifesto written by Valerie Solanas, who famously shot Andy Warhol in 1968, died in 1988 and posthumously became a Riot Grrrl icon.
† Ideological infighting was in no way confined to Riot Grrrl. During punk-rock's post-Nirvana 'sell out' panic, such crucial figures as Fugazi, Jello Biafra and Positive Force co-founder Mark Andersen were also deemed insufficiently pure by hardliners. 'By not giving each other room to move, to grow, we were destroying ourselves,' Andersen later lamented.

Although Riot Grrrl was the first full-fledged feminist rock movement, the bands, like previous generations of politically aware female musicians, expressed themselves more eloquently in their actions than in their songs. Their lyrics were more often personal than polemical, and some of the period's best overtly feminist protest songs came from outside of the scene. New York's Sonic Youth, a good decade older than the Riot Grrrl bands, almost predicted the movement on 1990's 'Kool Thing', on which Kim Gordon (the band's only female member) asked, wryly, 'Are you gonna liberate us girls from male, white, corporate oppression?' and guest Chuck D paraphrased himself to discuss 'fear of a female planet'. In 1992 they struck out at sexual harassment on 'Youth Against Fascism' ('I believe Anita Hill / Judge can rot in hell') and 'Swimsuit Issue'. The same year, Seattle's L7, prime movers behind the Rock for Choice abortion-rights concerts, recorded a crunchingly tuneful attack on political apathy, 'Pretend We're Dead'. But 1993 gave Riot Grrrl two radical anthems to call its own: Bikini Kill's chugging, celebratory 'Rebel Girl' ('When she talks I hear the revolution') and Huggy Bear's 'Her Jazz'.

'Her Jazz' was an article before it was a song. In a 1992 issue of *Huggy Nation*, Huggy Bear talked about 'GIRL-JAZZ SUPREMACY, a state of mind and a way of life that transforms and re-defines itself daily.' The band's prose, like its identity, was in constant flux: declamatory yet opaque, prizing energy over clarity. Their appetite for knowledge was prodigious, their inspirations ranging from Patti Smith to Joan of Arc, the Last Poets to Virginia Woolf, Debbie Harry to Hélène Cixous. 'HER JAZZ is fierce and uncompromising and will not fit into the square world's puzzle,' they promised. Their third single wrangled all of these writhing ambiguities into the most invigorating three minutes of the band's career.

'We wanted a revolution you could dance to. It was like a call-to-arms,' says Rowley, who remembers such diverse influences as rockabilly revivalists Thee Headcoatees, Sonic Youth's

1988 slacker anthem 'Teen Age Riot' and LL Cool J's 'Mama Said Knock You Out'. Rowley's original lyric was about outgrowing a charismatic but manipulative mentor in a blinding flash of realisation ('struck by lightning'), but Johnson turned the last verse on the band's doubters ('This is happening without your permission'), transforming it into a two-fisted declaration of intent which ended up surprising its creators. 'It became the only song that anyone talked about,' Rowley says with a sigh. 'We had a feeling people would love the record, though not to the extent they did. We were quite bad at dealing with compliments. We were quite into being a sour, acquired taste.'

Huggy Bear's mercurial polemic was just one voice in an unusually political period for British music. The ongoing recession, the shock re-election of John Major's Conservative government and the troubling rise of the far-right British National Party (successor to the National Front) contributed to a mood of impatient dissent. The *NME*'s John Harris proposed a track-listing for a cassette he called '1993: THE YEAR THAT MUSIC GOT APOPLECTIC AGAIN'. The artists included Anglo-Asian indie groups Cornershop and Voodoo Queens; anti-fascist dance-punks Blaggers ITA and Senser; radical Islamic rappers Fun-Da-Mental; London MC Credit to the Nation; LA rap-rock outfit Rage Against the Machine; and the fiercely intelligent Welsh rock group the Manic Street Preachers.*

None of this added up to a unified movement as such, but it planted politics firmly in the pages of the music press, via such well-read and inquiring writers as Steven Wells and John Harris at the *NME* and Simon Price and Simon Reynolds at *Melody Maker*. Sometimes, their own combative, analytical prose was more rewarding than anything their interviewees came up with. When former Smiths frontman Morrissey, whose recent lyrics and comments regarding race and British identity had been

* He might also have added socialist rap groups Marxman and the 25th of May, painfully earnest Bay Area rappers Consolidated and punk revivalists S*M*A*S*H.

troublingly ambiguous, swathed himself in a Union flag at a gig in May 1992, *NME* took him to task across five closely argued pages. But not every reader was impressed with the music weeklies' growing interest in issues of race, gender and class. One, calling himself 'Sid the Manager', wrote sarcastically: 'Manager seeks four pro-gay Asian Riot Grrrls to form band. Guaranteed *Melody Maker* blanket coverage. No experience necessary.'

Much though the music weeklies considered themselves the voices of a left-leaning counter-culture, to the Riot Grrrls they were pillars of the establishment. 'NME AND ITS "RIVAL" MELODY MAKER ARE OWNED BY THE SAME COMPANY – IPC,' blared DIY publication *Terrorzine*. 'HATE WOMEN, GIRLS, NON-WHITES. WE EXPOSE!!! THEIR WRITERS AND EDITORS.' Their attitude to the press was summed up in Bikini Kill's 'Don't Need You': 'Don't need you to say we're good / Don't need you to tell us we suck.'

The Riot Grrrls saw engagement with the mainstream media as a zero-sum game: if the weeklies didn't print interviews unedited and without judgement, then they were the enemy. But they could not stop the music papers from writing about them, so the debate carried on without them. No female musician could avoid being asked about Riot Grrrl, and some seemed to attack it only because they were tired of the question. 'It's a load of bollocks,' said Lesley Rankine of Silverfish. 'I'm sick to death of hearing about it.'

'I think everyone was dealing with it on the hoof,' says Gary Walker. 'On one level it was amazing that some teenage girl reading the *Daily Mail* may actually be inspired by this, but it did introduce a lot of paranoia and wanting to retreat back into a world where they felt comfortable.' Chris Rowley remembers: 'We did credit people with intelligence because we were listening to intelligent music. It didn't quite work out like that. You're dealing with political smear tactics that influence everyone that you credited with intelligence in the first place.'

With press attention at its height, Huggy Bear released a split

album with Bikini Kill, *Yeah Yeah Yeah Yeah / Our Troubled Youth*, and the two bands set out on a national tour together. Journalists were not welcome. Before the Manchester show Huggy Bear's Niki Elliot told the *NME*'s Gina Morris to 'fuck off', and a subsequent attempt at an off-the-record conversation ended in a walkout by the group. 'They've fed a political monster and it's grown too big for them to handle,' Morris decided. 'They're scared.' At a notorious concert at Newport TJ's in Wales the band were derailed by male hecklers, many of whom had come along simply to goad the latest media sensations. 'Huggy Bear, being less experienced as a band, would get into arguing with the audience members, and that's where the politics got separated from the art,' says Walker. 'Kathleen [Hanna] was a master of one-liners. She could cut anyone down and move on to the next song.'

'They perceived us to be snotty, southern, pampered friends of the music press who needed a good hiding,' says Rowley. 'Bricks got thrown, people would scream out stuff from the crowd, equipment would be destroyed. There was always ugliness, but there were always amazing shows.'

After a poorly organised summer tour with Bratmobile, Huggy Bear went to play the US, where they could perform with kindred spirits away from the media glare. Back in Britain, the mood was increasingly hostile. Alex James of Blur repeated a joke that was doing the indie-scene rounds: 'How many riot grrrls does it take to change a lightbulb? None, because they're never gonna change anything.' *Melody Maker*'s Sarra Manning rubbished the whole movement, attacking the 'rigid and formulaic' music and 'grubby little fanzine[s]'.

Huggy Bear's decision to break up after 1994's hardcore-influenced *Weaponry Listens to Love* was, says Rowley, always the Crass-style plan. 'Huggy Bear was a three-year project from the beginning. It had to end. Because all the bands we used to like were only three years at their best. There were days prior to the last year when we wanted to give up, and there were days prior to when we *did* give up when we were like, "Oh, we should

carry on doing this." But we kept it like an art project. We had three years to do it and if we didn't we were being lazy.'

Some members quit music altogether for careers in childcare and social work. Other British Riot Grrrl bands – Mambo Taxi, Pussycat Trash, the Voodoo Queens – fell in quick succession. Bratmobile didn't survive either. They had been booked to play a prestigious party hosted by *Sassy* magazine in New York, their first show for six months. 'We hadn't really been talking,' says Allison Wolfe. 'I felt like Riot Grrrl was kind of eating itself. There were a lot of newer girls getting involved. I don't know what their problem was but they were trying as hard as they could to tear people down to make themselves feel better – a contest to see who's more oppressed than who. I was taking it very personally. I felt like the weak link was bound to break under pressure and that's exactly what happened.' In front of such luminaries as Sonic Youth and Joan Jett, Bratmobile 'just completely imploded on stage'. She laughs. '[Sonic Youth's] Thurston Moore did say it was some of the best performance art he had ever seen.'

As an idea, though, Riot Grrrl survived the backlash. Many zines endured, finding a new platform online. Riot Grrrl ideas flowered in the records of Sleater-Kinney (featuring Heavens to Betsy's Corin Tucker) and Le Tigre (featuring Kathleen Hanna), whose 'Hot Topic' (1999) was a joyous roll-call of feminist icons. A generation of young female music fans was introduced to feminism, inspired to learn more and to find new means of creative expression. But the initial optimism and camaraderie of the scene on both sides of the Atlantic was blown apart by the end of 1994, and with it the last significant musical movement to have a political agenda at its core.

'It was never on a firm foundation,' reflects Wolfe. 'I can see what a lot of the flaws were and why it couldn't survive. I just wish it could have run a little longer, or maybe not have ended so negatively, because afterwards there was such a backlash and I felt like the guys especially welcomed that. So much seemed

like it was at stake that I think a lot of people hid under a rock after that.'

With the dissipation of Riot Grrrl and the rise of a potent new scene, Britpop, the music press also became less politically astute and questioning with each passing month. For many disparate reasons, 1994 appeared to represent the protest song's last gasp.

29

'Fuck 'em and their law'

The Prodigy feat. Pop Will Eat Itself,
'Their Law', 1994

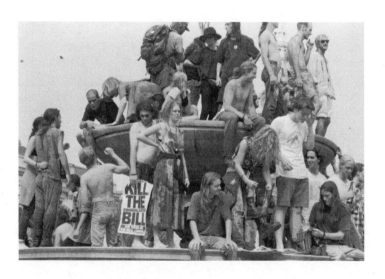

Rave culture's fake revolt

Demonstrators against the Criminal Justice Bill gather on a fountain in Trafalgar Square, July 1994.

Towards the end of 1995 a group of activists protesting the extension of the M11 motorway through east London approached Essex rave band the Prodigy to ask permission to use their year-old track 'Their Law' in a Greenpeace-funded documentary. They had good reason to expect a positive answer. 'Their Law' was a splenetic, anthemic response to the government's controversial Criminal Justice Bill, a cause around which ravers, New Age travellers and eco-activists had all rallied during 1994. Its accompanying album, *Music for the Jilted Generation*, had been a potent soundtrack for the anti-M11 activists.

The campaigners were, however, sorely disappointed. 'Music and politics don't mix,' the Prodigy's Liam Howlett flatly told *Mixmag*. 'We'd like to make clear we're not a political band . . . We're against the Criminal Justice Act, but we're not prepared to get involved in the shit of it.' Neil Goodwin, who directed the documentary, complained, 'We don't believe in hiding behind empty rhetoric.'

The incident revealed just how flimsy dance music's radical stance really was. Cheered on by the music press, the anti-CJB campaign framed itself as a battle against the forces of oppression, and because one of the goals of the bill was to eliminate free parties, it was assumed that ravers would share this sense of counter-cultural rebellion. At its core, however, the dance culture explosion which began in Britain in the late 1980s was purely hedonistic, and no attempt to attach larger political significance stuck for long. In September 1995 Jarvis Cocker of Sheffield indie band Pulp weighed up his own raving days in the single 'Sorted for E's & Wizz', in which a young raver stands in the middle of a huge party 'somewhere in a field in Hampshire' and ventures, hesitantly, 'All this has just got to mean something.'

'It *shouldn't* [mean anything deeper] because that's the simplicity of it,' maintains Howlett. 'I think the New Age groups

brought more complications to it. It's basically freedom to dance.' He gives an apologetic laugh. 'And that sounds totally shit, doesn't it?'

*

Before it crossed the Atlantic and made landfall in Britain, dance music was squarely rooted in the inner cities of the US, and in the outsider sensibility of preceding generations. House music was what happened when disco went underground, acquired a drum machine and blossomed anew in the black gay clubs of Chicago. Some early house records thus inherited disco's politics of pleasure: on his panting, Prince-inspired single 'Baby Wants to Ride' (1986), Jamie Principle posited sex as a response to 'living in a fascist dream'. Others locked into the tradition of gospel optimism: Joe Smooth Inc.'s sublime, Martin Luther King-quoting 'Promised Land' (1987) assured dancers, 'One day we will be free / From fighting, violence, people crying in the streets.' Sterling Void, a minister's son, equated music with God as a means of salvation on 'It's All Right' (1987), which featured perhaps the strangest opening line of any house anthem: 'Dictation being enforced in Afghanistan.'*

Over in Detroit, the architects of techno – Juan Atkins, Derrick May and Kevin Saunderson – were tapping different traditions. Although the trio were middle-class Europhiles from the well-heeled suburb of Belleville, their ambivalent attitude towards technology, as a means of both liberation and control, spoke to Detroit's hollowed-out inner cities, where machines had largely replaced men on the auto factories' assembly lines. 'I'm probably more interested in Ford's robots than Berry Gordy's music,' said Juan Atkins, whose 'Night Drive (Thru-Babylon)' (1985) was a desolate electro travelogue. The enigmatic Underground

* It should, of course, be *dictatorship*, but that has one too many syllables. Another line, 'People in Eurasia on the brink of oppression', is also peculiarly phrased, but the lyrical awkwardness of 'It's All Right' does nothing to dent its life-affirming appeal.

Resistance label, founded in 1990, combined Black Panther-style guerrilla toughness with 'Afronaut' sci-fi fantasies inspired by such black stargazers as George Clinton and Sun Ra: should one take a stand, or flee to a better world? The contrasting titles of their releases – 'The Final Frontier' and *Galaxy 2 Galaxy* on the one hand, 'Attend the Riot' and 'Mind of a Panther' on the other – kept the question open. 'This city is in total devastation,' Derrick May told *The Face*. 'Factories are closing, people are drifting away and kids are killing each other for fun. The whole order has broken down. If our music is a soundtrack to all that, I hope it makes people understand what kind of disintegration we're dealing with.'

These socio-political undercurrents, however, were present in only a handful of records. It was the *sonic* revolution which mattered most, and once the music migrated to Europe, its ties with black and gay culture were, if not severed, then easily ignored. The DJs who brought house and techno to Britain did so via the sun-kissed idyll of Ibiza and, crucially, under the influence of Ecstasy. Introduced to London clubland in the mid-1980s, the drug induced a sense of euphoric togetherness which gelled perfectly with the hypnotic grooves emerging from Chicago and Detroit. The DJs who visited Ibiza in 1987 returned to London in evangelical spirits.

Ecstasy is an essentially utopian drug, in that it can make one feel able to reshape reality rather than merely escape it. What form that reshaping might take depends very much on one's existing matrix of values, ideas and reference points. For many of the new scene's DJs and promoters – working-class suburban-ites hungry for a less mundane existence – the new possibilities were primarily entrepreneurial, hedonistic or both. But some, grasping for some cultural precedent, alighted upon fuzzy, second-hand memories of the 1960s. Of course, the touchstone was the 1967 Summer of Love rather than the revolutionary fervour of 1968, and, what's more, a 1967 whitewashed of such bother-some concerns as Vietnam and civil rights. The so-called Second

Summer of Love (in fact, the twin summers of 1988 and 1989) took the druggy, feelgood optimism of the hippies and left the politics on the shelf. The fact that stringent door policies contradicted this professed one-love spirit didn't detract from the wonder of seeing all sorts of people, including reformed football hooligans and racist thugs, embracing beneath the lights. DJ Paul Oakenfold ended one night of his influential house club Future with a symbolic massed singalong to the Beatles' 'All You Need Is Love'.*

Imagine, then, how miraculous events on the global stage must have seemed to participants in the Second of Summer of Love. Glasnost was sweeping the Soviet Union. The Eastern Bloc was crumbling. The Berlin Wall fell, symbolically if not yet physically, in November 1989. Nelson Mandela was released from prison in February 1990, as F. W. de Klerk's regime set about dismantling apartheid. In Britain, widespread, sometimes violent opposition to the poll tax helped to oust Margaret Thatcher in November 1990. Indeed, events sometimes overtook the songs. Between the first release of the Pet Shop Boys' version of Sterling Void's 'It's All Right' in 1988 and its emergence as a single in June 1989, the Russian army ended their decade-long occupation of Afghanistan, thus rendering the first line obsolete. These mostly bloodless upheavals seemed to mirror and magnify the promise of dance music's revolution in the head, creating a brief window of extraordinarily high hopes just in time for the new decade. 'I saw the decade in, when it seemed / The world could change at the blink of an eye,' marvelled Jesus Jones's Mike Edwards on 'Right Here, Right Now' (1990), so swept up in the historical moment that he was moved to cultural patricide: 'Bob Dylan didn't have this to sing about.'

For a couple of years the UK charts were overrun by dancefloor

* Anyone looking to get a sense of Britain's Ecstasy honeymoon in under five minutes should try Candy Flip's version of 'Strawberry Fields Forever' (1990), in which John Lennon's identity-crisis angst is softened into gooey, saucer-eyed bliss.

utopianism: Sydney Youngblood's 'If Only I Could', the Beloved's 'It's Alright Now', Sabrina Johnston's gospel rewrite 'Peace', the Shamen's 'Move Any Mountain – Progen 91' and the Farm's well-intentioned yet flatly dreadful 'All Together Now'. Even the England football team's official 1990 World Cup Theme, New Order's 'World in Motion', was as concerned with love as with sporting prowess.

This coincided with the 1960s-influenced positivism of De La Soul's 'D.A.I.S.Y. Age' hip-hop and the Sly and the Family Stone references of Brooklyn's Family Stand. As critic Simon Reynolds writes, 'The anti-social egotism of the eighties . . . was eclipsed by a shift from "I" to "we", from materialism to idealism, from attitude to platitude.'* In the *New Statesman and Society*, Stuart Cosgrove doubted that it amounted to much, arguing that dance music's 'pleasures come not from resistance but from surrender'.

But while most dance music enthusiasts were committed either to the present or some mythical, rose-tinted 1967, a few conducted more challenging dialogues with history. The Stone Roses, a rock band closely affiliated to the dance scene, included references to the student uprisings of Paris '68 in the artwork of their eponymous album and the lyrics of 'Bye Bye Badman' (1989): 'I'm throwing stones at you, man / I want you black and blue.' The multiracial dance-pop trio Soho managed to smuggle furious anti-police sentiments into the Top 10 with 'Hippy Chick' (1990), cocking a snook at Flower Power clichés: 'Got no flowers for your gun, no hippy chick.'

Bobby Gillespie, frontman of Scottish band Primal Scream,

* This chapter concentrates on the most widely popular varieties of dance music, which were predominately white. Acts rooted in black culture and pirate radio took a flintier urban perspective with tracks such as Shut Up and Dance's 'Autobiography of a Crackhead' and the Ragga Twins' 'The Homeless Problem' (both 1991). Later, jungle and drum'n'bass tended to encode urban angst into their agitated rhythms and frowning bass lines rather than spell it out.

came to dance music as the son of a staunchly left-wing Glaswegian trade unionist and peppered his interviews with rants about the 'evil' of Thatcherism and the bogusness of New Age blather. In 1991, noting that the Gulf War had punctured the optimism engendered by the end of the Cold War and apartheid, he told *The Face*: 'I don't hold much hope for young people here. They seem to be more right-wing than their parents, perhaps because they grew up under Thatcher.' Primal Scream were a derivative rock band who reassembled themselves, under the spell of dance music, into an amorphous collective, including dance producer Andrew Weatherall. Though their first dance single, the Weatherall-remixed 'Loaded' (1990) espoused hedonism-as-dissent via its sample from the Peter Fonda B-Movie *The Wild Angels* – 'We wanna be free to do what we wanna do, and we wanna get loaded' – their next, 'Come Together', took its title from the Beatles, its spirit from gospel, its sample from Jesse Jackson at Wattstax and its resigned attitude, claimed Gillespie, from the Rolling Stones. 'I see the song as a modern day "Street Fighting Man",' he told Simon Reynolds. 'It's certainly not a statement of vapid New Age optimism. Rather, I see [Jackson's uplifting rhetoric] as being tragic: like, "if only the world could be as one . . ." but I know it never will be.'

In another interview, Gillespie located political significance in the government's recent crackdown on unlicensed dance events. 'The government hated the idea of large groups of kids, black youth, white youth, whatever, getting together in fields and having a good time and dancing. That took the position that rock used to occupy in youth culture where there was some kind of a threat to society, not in a large way, but in people recognising that other people felt the same way, getting on well and not being isolated. And the government actually did see a danger in that.'

While the first moral panic of the dance-music era was drug-related, following the Ecstasy-related deaths of two clubbers in 1988, the second was about the public nuisance of illegal raves. 'Don't the police care about enforcing the law of the land?' the

Sun frothed after a huge party organised by promoters Sunrise. Chief Superintendent Ken Tappenden, a miners' strike veteran whose new Kentish constituency encompassed rave-friendly territory around the M25 motorway, was made head of the Pay Party Unit, with a mission to track and thwart the covert promoters.

Tempting though it is to see the conflict as a classic showdown between the Man and the Kids (*We wanna be free to do what we wanna do*), the politics were complicated. The man behind Sunrise, Tony Colston-Hayter, was a hard-nosed entrepreneur and his publicity officer, Paul Staines, was a self-described 'anarcho-capitalist' and 'fanatical, zealot anti-communist'. As rumours of a government crackdown gathered steam, the Sunrise duo formed a Freedom to Party campaign, which they launched at the Conservatives' annual conference under the banner of free-market entrepreneurship. 'Maggie should be proud of us, we're a product of enterprise culture,' said Colston-Hayter.

But the government was unconvinced. As Tory MP Graham Bright's Entertainments (Increased Penalties) Bill made its speedy way on to the statute books, the Pay Party Unit increasingly outwitted promoters, while Freedom to Party rallies failed to galvanise mass protest. Small wonder: while partygoers could turn to the growing number of licensed clubs, the chief beneficiaries of the pay-party boom were unapologetic capitalists, right-wingers and drug-dealing cartels who couldn't give a damn about a new Age of Aquarius. After Sunrise's anticlimactic swansong on New Year's Eve 1989 (Bright's bill passed six months later), the *Sun* offered its own version of turn-of-the-decade triumphalism: 'The evil craze belonged to the complacent eighties. We hope and believe that it has died along with the decade. The party is over. And that is great news to start 1990.' In truth, it was far from over. Rave only became politicised when some energetic individuals reasoned that the freedom to party was only a worthy cause if the parties themselves were free.

*

The chief instigators belonged to a collective known as Spiral Tribe. Their charismatic spokesman, Mark Harrison, had attended the Stonehenge festivals of the 1970s and brought to raving a passionate counter-cultural ethos that pre-dated house and techno. The festival had been the work of Wally Hope, friend and mentor to Crass's Penny Rimbaud, and it took a bloody turn on 1 June 1985, when 1,000 police officers turned back a convoy of travellers from the site and attacked them in a nearby bean-field off the A303, arresting around 500.

Having been brutalised at the so-called Battle of the Beanfield, the travellers were then demonised by Home Secretary Douglas Hurd as 'a band of medieval brigands who have no respect for the law or the rights of others', and penalised by the 1986 Public Order Act, which imposed conditions on 'public assemblies'. Unlike suburban clubbers, who could go elsewhere for good times, the travellers were profoundly radicalised by having their entire way of life deemed unacceptable. Crass's distinctive merging of punk and hippie philosophies helped to spawn the 'crusty' subculture, with its devotion to squatting, nuclear disarmament and ecological issues. But while the US was big enough to accommodate hippie enclaves, cheerfully disconnected from mainstream society, anyone pursuing an alternative lifestyle in Britain was destined to clash with the authorities.

Dance music's subterranean, psychedelic ethos was destined to appeal to radicals from earlier eras: those who had been turned on by Allen Ginsberg and Timothy Leary. Scottish hippie veteran Fraser Clark championed the ritual, pagan aspects of mass dancing – 'shamanarchy', he called it – and believed the sky was the limit. 'As the depression in the dominator system deepens into final collapse, the co-operative free festy/rave/squatter/new new age/techno tribal traveller cross-over counter-culture will grow unstoppably into the new dominant goddess-worshipping techno-tipi dwelling eco-culture that will inherit a cleansed planet,' he wrote breathlessly. The Shamen even managed to transport Clark's ideas, and those of American psychedelic philosopher Terence

McKenna, on to Radio 1 with their hit single 'Boss Drum' (1992) and its promise of 'shamanic, anarchistic, archaic revival'.

The raver and traveller tribes first bonded en masse at the Glastonbury Festival in 1990, where sound systems such as DiY, Tonka and Club Dog united hippies old and new. Spiral Tribe formed shortly afterwards in the creatively fertile squats of London and came of age at the 1991 Stonehenge People's Free Festival, held at Longstock, Hampshire, where Harrison had something of an epiphany. 'Up until that point I thought ley lines, solstices and all that mumbo-jumbo was just hot air,' he told journalist Matthew Collin. 'Suddenly that all changed.' Psychedelic drugs encourage the mind to look for connections and patterns, both sinister and benign. Devout drug use, sleep deprivation (Harrison once boasted of staying up for nine days) and justified paranoia about an imminent state crackdown mingled to create fertile soil for many of the millenarian ideas that were gaining currency in the early 1990s: conspiracy theories involving the Masons, the Illuminati, and the alleged mystical significance of the number 23. Such obsessions flourished in the music of British techno duo the Drum Club and Dutch group the Psychick Warriors ov Gaia.* 'We were just trying to make it more interesting,' says the Drum Club's Lol Hammond. 'You want a bit of mystery. I remember reading a review of a Drum Club record that said it wasn't a record, it was a lifestyle. All my favourite bands were like that.'

Uniformly clad in black combat gear, Spiral Tribe kept on

* Similar influences, chiefly Robert Shea and Robert Anton Wilson's 1975 *Illuminatus!* trilogy were simultaneously having a very different effect on US hip-hop acts such as the Wu-Tang Clan, who replaced traditional urban protest sentiments with arcane meditations on the 'New World Order', mind control and the mysterious 'black helicopters'. Knowledge of the genuine dirty tricks of COINTELPRO and the CIA merged with the more general millenarian angst that made TV's *The X-Files* so successful, leading to the strange sight of black rappers clutching copies of *Behold a Pale Horse* (1991), by the right-wing conspiracy theorist M. William Cooper.

playing parties across southern England throughout the summer. They emerged in September buzzing with new ideas about techno as modern folk music; about the evils of money and property; about psychedelic drugs as sacraments; about illegal parties creating 'a public new sense' rather than a public nuisance; about the need for their music to be hard, fast, loud, relentless. It was this latter requirement that was destined to cause problems.

*

In 1992, the Avon Free Festival, a free-floating annual event of no fixed abode, chose to alight on picturesque Castlemorton Common in Worcestershire, and to begin, with typical Spiral Tribe symbolism, on Saturday, 23 May. Until then, no Spiral Tribe party had attracted more than around 5,000 people, but the crowd gathering on the common that Saturday night was at least four times that number. Writer Simon Reynolds describes the scene as 'somewhere between a medieval encampment and a Third World shanty town', a full-scale autonomous community with sound systems, tents and food stalls. When the party wound down after five straight days, West Mercia Police swooped, impounding sound systems and arresting thirteen members of Spiral Tribe. 'It was amazing but you knew it couldn't go on,' says Lol Hammond. 'The authorities definitely made up their minds that it was getting out of control.'

While the police shrewdly averted a Beanfield-style confrontation, Castlemorton was a public-relations catastrophe for the free-party scene. The national press ran daily reports on the outrages inflicted upon Middle England: fences dismantled for firewood, dogs running rampant, faeces everywhere (although travellers were used to burying their waste, the influx of weekend ravers were notably less sanitary), and, above all, the ceaseless pounding of the music, which led some local residents to seek counselling. For all their complicated New Age rhetoric, Spiral Tribe's own 'Breach the Peace' single (1992) advanced a brutishly simple agenda: 'Make some fuckin' noise!'

For many seasoned travellers, whose survival depended on not making unnecessary enemies, this confrontational attitude was a disaster. 'Make some fuckin' noise is one thing but making so much noise that you piss everyone off – including the alternative community – is fuckin' stupid,' fumed counter-culture magazine *Pod*. Castlemorton became, as Hendrik Hertzberg wrote of Weatherman's Day of Rage, 'a huge unearned windfall for the forces of repression'.

After Castlemorton, the police had both the resources and the public support to go after what Home Office minister Lord Ferrers called 'these appalling invasions' with a vengeance. Operation Solstice closed the roads around Stonehenge to travellers and ravers at midsummer. Operation Snapshot compiled a database of names and vehicle registration numbers. Spiral Tribe's attempt to mount a symbolic summer-solstice rave at the foot of Canary Wharf, the east London skyscraper that was Thatcherism's totem pole, ended in bathos, when the police broke it up after just an hour. At the Tory Party conference in October Thatcher's successor, Prime Minister John Major, promised action in Westminster. 'New Age travellers?' he asked mockingly. 'Not in this age. Not in any age.'

Despite being re-elected in 1992, Major's government was plagued by scandal and an ineffectual image, and was eager to appear tough and capable. Travellers, squatters and ravers were convenient enemies against which Major could pit himself, but he went further still. Part V of the Criminal Justice and Public Order Bill, which received its first reading shortly before Christmas 1993, not only empowered police to turn back groups of potential ravers numbering as few as ten under the threat of a three-month jail sentence, speeded up eviction of squatters and travellers, and repealed the requirement for local authorities to provide land for traveller encampments. It also created the offence of 'aggravated trespass', antagonising hunt saboteurs, animal rights activists and eco-warriors protesting the building of new roads alike and thus giving direct-action

protesters and apolitical ravers common cause. Camilla Berens of the Freedom Network, an umbrella organisation for protest groups, told Matthew Collin: 'The CJB actually unified this generation. People were just waiting for a common threat to bring them together, and [Home Secretary] Michael Howard did it for us. It couldn't have been better, really.'

Although its roots went back to Crass and Stop the City, the broad-based protest movement known as 'DIY culture' came of age in 1991 and 1992, during the year-long campaign to stop an extension to the M3 motorway being built through Twyford Down in Hampshire. The most colourful protesters, who called themselves the Donga tribe, threw parties, their flamboyant, media-savvy tactics reminiscent of the Yippies. After Twyford Down, the battle moved to the city, as the government proposed a three-mile link road to the M11, requiring the demolition of 250 houses in east London.* The epicentre of the campaign was Claremont Road in Leytonstone, a vacated street which was taken over by activists, and vividly illustrated both the energy and the contradictions of DIY culture. Activist journal *Aufheben* noted friction between the hardcore barricade-builders and the so-called 'lunch outs', who simply wanted to dance to sound systems or drink beer in the armchairs that had been positioned in the street. Hedonism vs hard work: these were the competing instincts that collided in the case of 'Their Law'.

<p style="text-align:center">*</p>

The Prodigy had emerged from the warehouse parties of east London and Essex at the turn of the decade. Producer Liam Howlett was a hip-hop fanatic before he was a raver, electrified by Public Enemy's sonic barrage, and he had an uncommon ability to program drum patterns for maximum physical impact. The Prodigy's breakneck hooligan zeal was leagues apart from

* Although both the M3 and M11 extensions eventually went ahead, the costly delays and the intensity of the opposition led to a widespread rethink of road-building policy.

New Age positivism but Howlett's philosophy overlapped with Spiral Tribe's on one point: 'make some fuckin' noise'.

In the months following Castlemorton he noticed that noise abatement officers were reducing volume levels at legal raves to ridiculously feeble levels. 'It stems back much further than the CJB,' he says. 'Even driving around in convoys listening to music, people were stopped for looking like they were on their way to a rave. We felt it was our job to fucking stand up for it because we were such an integral part of that whole early scene. We never wanted to write a political record but we were so angered by it.'

During a trip to Los Angeles, Howlett became obsessed with Dr Dre's gangsta rap landmark *The Chronic* and the debut album by rock-rap agitators Rage Against the Machine. The first song he wrote for the next Prodigy album, fuelled by his passion for Rage Against the Machine and his anger over the imminent demise of rave, was 'Their Law'. He phoned his friend Clint Mansell, frontman of Pop Will Eat Itself, who provided the growling, warlike guitar riffs and the line 'crackdown at sundown', while Howlett wrote the song's brutally blunt hook line: 'Fuck 'em and their law.' The track opens with an employee of the band's US record label paraphrasing a line from *Smokey and the Bandit*: 'What we're dealing with here is a total lack of respect for the law.' The record enacts what it seeks to defend: the sheer, cathartic, exhilaration of ludicrously loud music. The sternum-cracking kickdrum is probably more articulate than any of the lyrics.

It's ironic both that the most successful record about the CJB's attack on dance culture should be so indebted to the surly machismo of rock music, and that it should have been made by someone with so little interest in politics. DIY culture activists could be forgiven for being confused. The title of the album on which 'Their Law' appeared, *Music for the Jilted Generation*, was open to several interpretations. 'I guess we were trying to say we'd been totally fucked over,' Howlett says simply. For the album's inner sleeve he sketched an outline for artist Les

Edwards of a raver about to sever a rope bridge, on the other side of which are massed the dark forces of law and order, but Edwards painted him with traveller-style long hair. 'I think the guy cutting the bridge ended up looking more New Age than I would have hoped for,' admits Howlett. 'We're ravers, party boys from London. We weren't into any kind of activist shit and when the tree-huggers got hold of the fact we were attacking the Criminal Justice Bill a lot of people tried to attach themselves to us, and we weren't having it. We were like, "This record is purely about the government stopping us from partying, end of story."'

The misunderstanding over 'Their Law' cut to the heart of the anti-CJB campaign. While some musicians, like Steve Hillage of techno outfit System 7, spoke darkly of 'cultural cleansing', the element of the bill which prompted the most musical comment was Clause 58, which defined a rave as an open-air, night-time gathering of one hundred or more people listening to 'sounds wholly or predominantly characterised by the emission of a succession of repetitive beats'. This promoted overheated talk that the government planned to outlaw the very music itself. Orbital, a fraternal techno duo who had sampled Bay Area punk band Crucifix ('Peace or annihilation!') on the anti-war 'Choice' (1991), passed wry comment with 'Criminal Justice Bill?': four minutes of silence. Similarly, Sheffield's Autechre released the *Anti* EP, whose keystone track 'Flutter' was carefully programmed not to contain repetitive beats. A coalition of groups, including the Drum Club, Andrew Weatherall and Fun-Da-Mental, put out 'Repetitive Beats' under the name Retribution. Primal Scream's 'remix' was in fact an updated version of the Clash's 'Know Your Rights'. 'The idea was to make people aware,' says Lol Hammond. 'I don't think we thought we could stop it. Punk had speed and lager; dance music had Ecstasy. It's hard to start a riot when you're rushing your tits off and you love everybody.'

Although the new anti-CJB lobby group the Advance Party mounted three demonstrations during 1994, the bill passed on to the statute books on 3 November. Under new leader Tony Blair,

who had recently replaced the late John Smith, the Labour Party had chosen to abstain rather than vote against it. 'We knew the CJB would be misused by Conservatives to suggest that we were "soft on crime",' Labour MP Alun Michael admitted to *Melody Maker*.

Before the passing of the Criminal Justice Act, Mark Chadwick of crusty standard-bearers the Levellers had predicted, 'It could lead to anarchy, and probably will . . . If people grasped the concepts behind what is really going on, yes, it could topple the Government.' But it sparked no significant civil disobedience, and the coalition between activists and partygoers turned out to be hopelessly fragile – indeed, almost illusory. Without it, dance music lost all pretence of radicalism, becoming the sound of the high street rather than the underground. The boom in legal clubbing, spearheaded by brand-conscious superclubs, ensured ample opportunities to enjoy repetitive beats, while the New Age rhetoric softened to mush in the escapist Goa trance scene. While some sound systems continued to operate under reduced circumstances (one, Derbyshire's Black Moon was successfully prosecuted under the new act), others, including a fragmented Spiral Tribe, relocated to the continent. DIY culture flourished for a while, garnering its biggest headlines to date with the 1995–6 protest against the Newbury Bypass, while the grass-roots Reclaim the Streets movement anticipated the worldwide anti-globalisation protests of the late 1990s, but with a much reduced role for sound systems.

By May 1997, when Labour celebrated their election victory at the Royal Festival Hall by dancing to their campaign theme, D:Ream's apolitical pop-house pick-me-up 'Things Can Only Get Better', rave appeared to be, as George Melly once said of rock music, 'a fake revolt'. Its suitably ambivalent epitaph was written by Jarvis Cocker on the sleeve of 'Sorted for E's & Wizz', in a line whose deliberately awkward phrasing allowed for two opposing readings: 'It didn't mean nothing.'

30

'Who's responsible? You fucking are!'

Manic Street Preachers, 'Of Walking Abortion', 1994

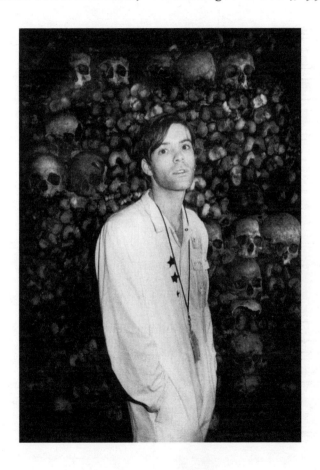

The protest song eats itself

Richey Edwards of the Manic Street Preachers visits the Catacombes de Paris on 22 November 1994, during his last tour with the band.

First comes the voice. It belongs to Hubert Selby, Jr, cult author of *Last Exit to Brooklyn* and *Requiem for a Dream*, and it is crackly and hesitant and laden with woe. The voice says: 'I knew that some day I was going to die. And I knew that before I died two things would happen to me: that, number one, I would regret my entire life and, number two, that I would want to live my life over again.' And then the music begins, metallic and grotesque, like something lurching up from the bowels of some hideous factory. The singer voices the lyrics as if they do not quite fit his mouth – syllables are unnaturally stretched as if on a rack ('cru-ci-i-fied'), and emphasis falls in the wrong places ('mo*ral* su-*i*-cide). The band march stiffly towards a chorus which resembles a sickly, minor-chord inversion of arena-rock anthemicism.

It is a song about the evils of fanaticism – the names of Mussolini and Hitler are rat-a-tatted out – but it *sounds* fanatical. It is like the final report of someone who has been commissioned to investigate the causes of an atrocity and who, instead of producing a series of wise, humanitarian recommendations, concludes that the moral contagion is everywhere and the blame is bottomless. The singer delivers the final verdict in a shrill, distorted howl: 'Who's responsible? You fucking are!'

'Of Walking Abortion' is just one of many alarming moments on *The Holy Bible*, the album the Welsh rock band Manic Street Preachers released on 30 August 1994. Both vast and claustrophobic, gripping and repellent, it remains one of the most extreme albums ever to reach the British Top 10. At the start of 'Mausoleum', J. G. Ballard chillingly states what could be a manifesto for the whole album: 'I wanted to rub the human face in its own vomit . . . to force it to look in the mirror.'

The band's singer was James Dean Bradfield, but the lyricist who did most to shape the album's unforgiving mood was twenty-six-year-old Richey James Edwards. Almost exactly five

months after the album's release, Edwards disappeared. *The Holy Bible*, however, was not just a harrowing expression of personal agonies, like Nirvana's *In Utero*, but a genuinely inquiring moral piece of work. 'Why don't people accept *The Holy Bible* as a tract?' Bradfield protested to me in 2000. 'Nobody really saw there was a political agenda to the album . . . Not all the songs are about Richey sitting in a flat, deciding whether to go for the razor blade or have another beer.' The point of *The Holy Bible* is not Edwards's suffering but what it enabled him to say about human nature. It is the sound of a brilliant mind burning itself out.

As a political record it does not speak the traditional language of bonding together to overcome dark forces, nor does it seek to recruit listeners to its cause. Any successful protest song requires that the songwriter stop asking questions at a certain point and either say, 'Here is something like a solution,' or leave the ambiguities dangling like loose threads, for individual listeners to tug at and unravel in their own way. But on *The Holy Bible*, Edwards is relentless, plunging deep into the moral mulch in order to find some approximation of truth which exists beneath the usual platitudes and assumptions. The album is too confoundingly complex to yield anything as simple as a message, exactly, but the one line that gleams out of the depths with dreadful certainty is the one from 'Of Walking Abortion': 'Who's responsible? You fucking are!' At which point, the protest song's traditional contract with its listener – *you and me, we are on the right side* – is irrevocably shattered. So what then?

*

The Manic Street Preachers grew up in the South Wales mining village of Blackwood, and were all in their teens when Ian MacGregor's pit closures cut a swathe through the area, forcing thousands of miners into retraining or on to the dole. Drummer Sean Moore, Bradfield's cousin, played trumpet on NUM marches. Bassist and co-lyricist Nicky Wire, whose own father

was an ex-miner, read up on Marx and Lenin; his first ever poem was called 'Aftermath 84'.

Even as the four friends aligned themselves with the area's socialist history they were hopelessly estranged from its present. Each was a contradictory misfit: Bradfield, the weightlifting self-described 'nerd' who had briefly entertained dreams of joining the army during the Falklands War; Wire, the lanky, cross-dressing, footballing poet; Moore, the talented but obtuse student who never said more than he had to; and Edwards, the acne-pocked loner who had turned his back on a strict Methodist upbringing but could still recite Bible verses from memory.

None had any enthusiasm for the hard drinking that passed for entertainment in Blackwood. Instead, they hunkered down in their bedrooms, bingeing on knowledge. 'Where we come from in Wales, it's very working class but there is a tradition of bettering yourself,' Wire told *Melody Maker*'s Simon Reynolds in an early interview. 'Self-education is a really big thing.' The Manics' lyrics often resemble a smart teenager's bedroom wall, collaging disparate fragments of inspiration. Their enthusiasms in the second half of the 1980s added up to a primer in outsider culture: political philosophy (Marx, Debord), literature (Camus, Burroughs, Orwell, Plath), art (Munch, Bacon, Warhol), poetry (Ginsberg, Rimbaud, Larkin) and movies (*Rumblefish*, *Apocalypse Now*, *Kes*).* Outside their walls, Blackwood's social life carried on without them. 'We'd be sitting on the bed on a Friday night discussing politics and music,' Bradfield told the band's biographer Simon Price, 'and we'd hear the clip-clop of high heels on the street outside and think, "This *isn't* healthy."'

Like many young bands, the Manics sought escape, but not the benign, apolitical variety of the late-1980s' dominant music scenes: the Summer-of-Love rainbow grooves of Manchester (also known, in one of Edwards's unpunctuated communiqués to the press, as 'the baggy loose attitude scum fuck retard zerodom

* At university, Edwards studied Political History and Wire Politics.

of Madchester') and the acquiescent neo-psychedelic blur of so-called 'shoegazing' bands such as Ride. Their name, chosen by Bradfield, spoke of furious energy (Manic), urban urgency (Street) and commanding rhetoric (Preachers). They weaponised intelligence. 'All we wanted when we were young was a band who spoke about political issues and we've never had one in our lifetime,' Edwards later told *NME*. 'It was all just entertainment, love songs, which never changed anything.'

Though their earliest demos combined the Sex Pistols and the Clash with the jangle-pop of C86, they soon embraced Public Enemy and rock provocateurs Guns N' Roses, both of whom generated excitement and outrage in equal measure; they even rehearsed a version of 'Fight the Power'. 'It was a bit naff for four white indie kids from Blackwood to try to write like Chuck D,' Wire admits. 'But the rage they had! We had this big thing about working-class rage – if you mix real intensity with intelligence, there is something perfect and distilled about it. [And] Chuck D was such a man of integrity. If there was a musical equivalent of Aneurin Bevan then I thought it was Chuck D. I think he was prepared for the contradictions for the sake of the whole organisation. It did interest us, those contradictions, because the whole Red Wedge thing was the most tedious way of getting politics across. Public Enemy and Guns N' Roses are Technicolor. Everything about them is glamorous and larger than life.'

Public Enemy's sports-inspired separation of roles also opened up a space for Edwards, a man with no conspicuous musical gifts. Like Public Enemy's 'media assassin' Harry Allen, he crafted the Manics' bellicose press releases and defined their rhetoric. 'Richey prepared for his interviews like you'd prepare for an exam,' says Bradfield. For the sake of having something to do on stage, he played rhythm guitar. The Manics' unorthodox songwriting process – Wire and Edwards would write dense, prolix lyrics which Bradfield and Moore would then wrestle and crunch into songs – owed a great deal to McCarthy, a Marxist indie band who wrote beguilingly tuneful songs with titles like 'The

Procession of Popular Capitalism'. 'In a lot of ways McCarthy were the biggest influence because they were unbelievably intelligent and literate,' says Wire. 'I think they were liberating for us – write what we want and James can cram them in.'

The Manic Street Preachers played their first London show on 20 September 1989, in the upstairs function room of a Victorian pub. They hurtled through their nine-song set while wearing white shirts with slogans stencilled on them, Clash-style. One read: 'ENGLAND NEEDS REVOLUTION NOW'.

*

The Manics were not looking for allies; enemies were much more fun. They proudly told Steve Lamacq about one gig during which they were pelted with bottles for the full thirty-five minutes. 'After that, I just don't see the joy in it,' said an incredulous Lamacq. 'Oh, I do!' replied Edwards. The more people objected to their provocations, the stronger they became. 'We seemed to become contemptuous of everything,' says Wire. 'We felt uncommonness with the universe.'

Released on 21 January 1991, four days after coalition forces launched Operation Desert Storm to remove Iraqi forces from Kuwait, their 'Motown Junk' single arrived like a letter-bomb. Heralded by a sample from Public Enemy, the verses attacked the diluted soul banalities of bands like Wet Wet Wet, and the experience of being 'numbed out in piss towns'. The almost comically offensive chorus claimed: 'I laughed when Lennon got shot.' It was an inspired stroke of kill-your-parents iconoclasm, putting the 1960s saint to the torch.

There was a helter-skelter quality to the Manics' pronouncements. Among their giddying claims: they would never write a love song; they would immolate themselves on *Top of the Pops*; they would release one album, sell sixteen million copies, and then split up. 'We've always had a total lack of proportion,' confessed Edwards. Journalists lapping up their confrontational rhetoric found them to be, in person, sweet, charming, conscientious

young men driven by real moral purpose. 'We just want to clear everything away,' Edwards told Simon Reynolds. 'Maybe after us, music won't seem as important as actually changing the world.'

What the Manics, like Public Enemy and the Clash, understood was that you had to fight spectacle with spectacle, amplifying all the cultural white noise, then projecting it back in a scree of sounds, slogans, images and high-wire rhetoric. Their records were tangled with meaning, which listeners were invited to unpick. 'You Love Us' (1992) sampled both Penderecki's 'Threnody for the Victims of Hiroshima' and Iggy Pop's 'Lust for Life'; their iconography was Warholesque in its obviousness, from Marilyn to Mao. 'We want to be the biggest cliché at the end of rock,' declared Wire.

During the Manics' initial media blitz, the combination of sincere intent and stylised presentation confounded some journalists. One was Steve Lamacq, a self-deprecating man who liked self-deprecating rock stars and thought all the 'attention-seeking' was obscuring the message. Dispatched to interview them for *NME* in May 1991, he came back with the grisliest of scoops. After a combative interview, Edwards pulled Lamacq aside and, talking calmly all the while, proceeded to carve the words '4 REAL' into his left arm. 'Believe me,' he told Lamacq as blood began to pool at his feet, 'we are for real.' Unfortunately, the stunt was less, not more, likely to convince their detractors that the Manics were '4 REAL'. By the end of 1991 the Manic Street Preachers were the most hated band in Britain – 'They look like someone doing the Clash in a school play,' sniffed Steve Hanley of the Fall – and also, perhaps, the most passionately loved.

They signed a £250,000 deal with Sony's Columbia Records just days after the 4 REAL incident and released their debut album, *Generation Terrorists* (working title: *Culture, Alienation, Boredom and Despair*), in February 1992. It was overlong, patchy, diffuse and, occasionally, thrilling beyond words. One thing it demonstrated was that Wire and Edwards were not especially adept at single-issue protest songs. The record's finest

moment was the *Rumblefish*-inspired existentialist power ballad 'Motorcycle Emptiness', a poetic critique of consumerism's 'orthodox dreams and symbolic myths' with an intoxicating air of doomed romance. More direct songs such as the anti-bank 'NatWest – Barclays – Midlands – Lloyds' were painfully gauche. 'It's just naïveté,' Wire says fondly. 'I look back on it with an odd sense of admiration because you could see the band learning. You could see that we were young and we were expected to do so much and we weren't capable but at least we had the ambition to try.'

For a band with so much to say, the Manics seemed blithely unconcerned with clarity. The lyrics, especially Richey's, were dense with allusion and elision, diverse ideas scrunched together like cut-out letters on a ransom note. 'We took the abortion language of the *Sun* and turned it to our own means,' explained Edwards. Handed these unmusical screeds, Bradfield intensified the strangeness by contorting the syllables to fit his melodies, almost as if he were singing an unfamiliar language. 'I wanted our message to be so powerful but quite unintelligible, in such a way that people would want to find out more, find out what would drive us to create music that sounded like that,' he told Simon Price. In interviews, their scattershot antagonism (Wire told *NME* that New Age travellers 'deserve total hatred and contempt') seemed like less a tactic than an addiction. 'We always open our mouths before we think,' admitted Edwards.

In June 1993 they released their too-glossy second album, *Gold Against the Soul*. Although they invited the outspoken Credit to the Nation, Blaggers ITA and Fun-Da-Mental along on the ensuing tour, the album itself was too saturated in melancholy and confusion to leave much room for politics. Edwards was by now ending each day drinking vodka alone in front of the TV; at the end of the recording sessions his bandmates secretly checked him into a private health farm. 'Roses in the Hospital' advertised his new obsession with images of torn and burned skin; 'Life Becoming a Landslide' and 'From Despair to Where',

if you probed beneath the guitar solos, writhed with self-hatred.

Well-read purchasers of *Gold Against the Soul* would have noticed a cover image inspired by Japanese writer Yukio Mishima (who killed himself), a poem by Auschwitz survivor Primo Levi (who killed himself) and a song title, 'La Tristesse Durera (Scream to a Sigh)', taken from the last letter of Vincent Van Gogh (who killed himself). 'We've reached some sort of conclusion in our career, and the question is, what next?' Wire told *Melody Maker*'s David Bennun in January 1994. 'And what we want to do next is very dark and very depressing.' Edwards, of course, had a quote to hand: 'Henry Miller said: "At the edge of eternity is torture, in our mind's never-ending ambition to damage itself." That's what we would like to write about.'

*

The moral disgust which would wriggle like tapeworm through *The Holy Bible* hatched in the soil of Belsen and Dachau. 'On our days off in Germany after *Gold Against the Soul* we went to the death camps,' says Wire. (They also visited the Peace Museum in Hiroshima, the site of that other totemic mid-century horror.) 'Which is a pretty weird thing to do, let's be honest – a band dressed like Guns N' Roses going to Dachau and Belsen. Obviously we'd read about it but to actually go there and experience the silence and the deathliness and the abject horror, it affected us all. I think that was the final piece in the jigsaw for Richey. There's an overriding philosophy behind the whole album: evil is an essential part of the human condition and the only way to get over it is recognising all hypocrisies, all evils – recognising it's in us all – which I guess is not a liberal view.' Writing *The Holy Bible*, Edwards reconciled the morally engaged Political History graduate with the self-mutilating alcoholic. It was both their most political record and their most personal, because it collapsed the distinction, looking inwards and outwards with equal intensity.

While on tour in Germany, Edwards's depression and drinking

both deepened and he began stubbing out cigarettes on his arms. That December the Manics' beloved manager, Philip Hall, died of cancer. Yet, Wire insists, *The Holy Bible* was 'really joyful to make. We felt great to be cocooned in this neverland. We used this word *important* all the time. We thought that music is important, lyrics are important, ideas are important, *we* were important.'

The neverland in question was a small, shabby studio in Cardiff's red-light district, and they began working there in February 1994. Usually Wire and Edwards passed lyrics back and forth – they had written 'Motorcycle Emptiness' sitting at the same desk – but this time Wire was happy to take a back-seat. 'You could just tell the boy was on fire, that his brain had reached that point where he felt really in control. For four or five months he was really confident about what he was writing – this crystallised vision of what he wanted to say.'

Edwards' knotty arguments were often antithetical to the tenets of mainstream liberalism. Inspired by Michel Foucault's *Discipline and Punish*, 'Archives of Pain' spelled out the logic of the death penalty: 'If hospitals cure then prisons must give their pain.' The last line of 'ifwhiteamericatoldthetruthforonedayit's worldwouldfallapart' (that stray apostrophe the one blot on their record as the most literate band of their generation) attacked the US Congress's gun-control Brady Bill on the grounds that it victimised black people. But no song challenged liberal ideals as forcefully as 'Of Walking Abortion'.

Wire wrote the original lyric and called it 'Walking Abortions', after the description of men coined by SCUM's Valerie Solanas (typical of the Manics to venerate both Warhol and the woman who shot him). Edwards then rewrote all but a few lines. 'I think mine was more inspired by the trips to Belsen and Dachau and it was more literal. Richey made it more about how those visits related to our overall view of humanity. It's just a million times better. I don't think there's many people brave enough to say that we're all responsible. The last lines, the way James sings them, they're kind of accusing everyone and everything.'

The underlying principle of almost every protest song is that people are essentially good and only need to be liberated from a few malign individuals. But 'Of Walking Abortion' contends that people are weak and selfish and create these monsters themselves: a scourging view more in line with the most extreme pronouncements of Crass or the Pop Group. The key image is 'Hitler reprised in the worm of your soul', the human weakness that allows fascism to thrive. 'If your target becomes humanity then it is really difficult,' says Wire. 'I think that is the overriding philosophical quandary of *The Holy Bible* – it's not individuals, it's the worm in your soul.'

Wire describes the workrate as 'Teutonic'; the band practically kept office hours. Guided by the intensity of the lyrics, Bradfield and Moore reached back to the wintry, oppressive sound of post-punk bands such as Public Image Limited and Joy Division, who had espoused a similarly unsparing view of human nature.* Edwards had been recording useful vocal snippets off the television on to a tiny tape recorder and hoarding images to illustrate each song on the album sleeve. 'I considered myself a good reader but sometimes Richey would confront me with things I hadn't heard of before and I had to research it,' says Bradfield. 'I'm really proud that I managed to edit some of those things down and still get that big morass of beautiful words into a tune, but I can't tell you how much it was a strange symbiosis between us all. We were so connected, almost in a fatal sense. We could really all have just sunk together. I think it was a product of the environment we created rather than our individual talents.' Wire agrees: 'We felt so unified in everything we stood for. It was just so easy. It was telepathic.'

The Holy Bible is a tremendous, uncompromising work of art, which at times threatens to crush the air from the listener's lungs, but Edwards found it impossible to detach himself from

* According to Deborah Curtis, the widow of Joy Division frontman Ian Curtis (who killed himself), 'all Ian's spare time was spent reading and thinking about human suffering.'

the record's harrowing subject matter after the work was done. 'Kierkegaard writes about when you realise that all [mundane] things are utterly pointless – he thinks it's a precursor to suicide. When you think all the normalities of day-to-day life mean absolutely nothing then you're fucked. That had gone for Richey. I think that allowed him to examine the real heart of the matter. But Richey had taken it to the point where he was so fucking self-aware that he'd almost become a shell of intelligence and nothing else.'

*

As 1994 wore on, the political awakening trumpeted by the music press only a year earlier quickly evaporated. As press coverage and airplay dried up, bands such as Senser and Blaggers ITA either dissolved or saw follow-up albums flop; most of them, it must be admitted, just weren't good enough. All the cultural momentum was now with the groups who had been corralled under the umbrella of Britpop, chiefly Blur, Oasis, Pulp, Elastica and Suede. Britpop was predominately straight and white, and almost proudly disengaged. 'For me, punk rock was about the Sex Pistols, and they were big-time fun,' claimed Noel Gallagher of Oasis. 'The Pistols were a fucking laugh, and that's what it's all about.'

Such an oversimplification – in what sense was 'Bodies' a 'fucking laugh'? – was typical of the era. Although Blur's albums *Modern Life Is Rubbish* (1993) and *Parklife* (1994) were thoroughly ambivalent about British culture ('They were political records,' frontman Damon Albarn later insisted), Albarn's combative soundbites and fetishisation of such traditions as music-hall and dog-racing, tended to obscure that fact. By the time of the following summer's symbolic chart showdown between Blur and Oasis, ebullient cultural jingoism was rife. In addition, much of the fury which had greeted John Major's re-election in 1992 had dissipated. Labour seemed guaranteed to oust the imploding Tories at the next election, and Britpop felt like one long premature

celebration of this sea-change in British politics. A sea-change in indie-rock, too: thrilled by the novelty of genuine mainstream success, the Britpop bands had no interest in confrontation, no lingering punk reservations about selling out.

This was the climate in which the Manic Street Preachers trailered *The Holy Bible* with 'Faster', a single distinguished by its rigid, survivalist discipline. 'I am an architect, they call me a butcher,' spat Bradfield. On *Top of the Pops* in June they all wore motley army-surplus gear, like members of a terrorist cell who couldn't agree on a uniform. Bradfield's balaclava, misread as a salute to the IRA, attracted the most complaints in the programme's history. Richey sported a Soviet army medal as an apt symbol of corrupted idealism.

It was when they left the shelter of their Cardiff bunker that the full horror of Edwards's mental condition became apparent. Touring Thailand in April, he slashed his chest with a set of carving knives he had received from an obsessive fan. In Portugal at the end of June he regularly burst into uncontrollable crying jags. The following month, after a two-day binge of drinking and cutting, he checked into rehab. His anorexia had shrivelled him to six stone; in *The Holy Bible*'s '4st 7lbs' he had written 'I want to walk in the snow / And not leave a footprint.'

The band continued without him until September, when he checked out of rehab and played some European dates. No longer drinking, but fuelled by insane volumes of coffee and cigarettes, he was a fragile, reclusive presence. The morning after the final date, in Hamburg, Wire found his bandmate smashing his bloodied head against the hotel wall, repeatedly chanting, 'I want to go home.' A week later, the Manics played three visibly fraught yet exhilarating Christmas shows at the London Astoria, at the end of which they cathartically destroyed £8,000 worth of equipment. 'When we smashed everything up, we knew something was ending right there,' Wire later recalled. 'We knew that, whatever happened next, something had finished . . . And we'll never be that good again.'

*

On the morning of 1 February 1995 Richey Edwards checked out of the Embassy Hotel in west London, took the M4, crossed the Severn Bridge and drove to his flat in Cardiff. His car was later found abandoned at the Severn View service station. In his hotel room he left behind a suitcase filled with clothes and a gift-wrapped box containing books and videos for his girlfriend, Jo. When the police, along with Wire and Edwards's father, entered his flat, they found his passport, credit card and Prozac. Despite a police manhunt, heated media speculation and several false sightings, neither his family nor his bandmates have seen him since; in 2008 his family decided to have him officially declared dead.

Shortly before his disappearance Edwards had presented his bandmates with a folder of lyrics and prose, some of which eventually made its way on to the band's 2009 album, *Journal for Plague Lovers*. The songs they recorded demonstrate Richey's obsession with bodily mutilation – whips, crucifixion, sickness, ruptured skin – and his macabre wit, but stop short of *The Holy Bible*'s choking doom. However, says Wire, 'Some of the stuff he left for us crossed the line. It's just too fucking dark. You're not quite sure if he's mentally intact, to be honest with you. He's not mad but if he is planning to go it's just too brutal. Unsettling and upsetting,' he says, growing quiet.

Wire turned to the firmer ground of Aneurin Bevan, old-fashioned socialism and working-class identity for the Manics' first post-Richey single, 'A Design for Life' (1996). Bradfield and Moore set the lyric to music both stirring and elegiac; Wire wanted 'a sense of melancholic victory'. After the asphyxiating intensity of *The Holy Bible*, it was like throwing open the windows of a long-shuttered room.* An equally grand and graceful

* It's ironic that such an apolitical epoch in British music should have produced two of the country's greatest ever songs about the class system: 'A Design for Life' and Pulp's viciously witty 'Common People'.

achievement was 'If You Tolerate This Your Children Will Be Next,' (1998) a memorial to the Welsh socialists who had joined the fight against Franco's forces in the Spanish Civil War: possibly the first left-wing pro-war song released in half a century and certainly the only one to get to number one.

'We could never have made *The Holy Bible* without Richey but we could probably never have done "A Design for Life" *with* him,' says Wire. 'It would have been infected – in a good way but . . .' He tails off, sighs. 'It would have been convoluted and esoteric. I wrestle with that dilemma quite a lot because it's sort of sad, really. It *is* a rejection.'

Five songs on the *Everything Must Go* album used Edwards's lyrics, but the album's anthemic melancholy marked a complete departure from its predecessor. *The Holy Bible* was, on every level, unrepeatable. 'I'm just happy for him because I don't think it's a record that could be made today,' reflects Wire. 'I don't think that anyone's capable of making it. I don't think that anyone would be interested.'

31

'It's the end of history'

Rage Against the Machine, 'Sleep Now in
the Fire', 1999

Rage, Radiohead and the challenge of the 90s

A protester demonstrates against the World Trade Organisation in downtown Seattle, 1 December 1999.

On the morning of 26 January 2000, Wall Street played host to an unusual performance. Confused traders watched hundreds of people gather outside the Federal Hall to see the Los Angeles rock band Rage Against the Machine film the video for their next single, 'Sleep Now in the Fire'. The director, agitprop film-maker Michael Moore, had a permit to film on the steps of the hall but not in the streets. 'Michael basically gave us one director-ial instruction: "No matter what happens don't stop playing,"' remembers Rage's guitarist, Tom Morello.

When the band strayed off the steps and refused to stop mim-ing to the backing track, exasperated NYPD officers arrested Moore. 'Michael's last challenge to the band as he was being dragged away was, "Take the New York Stock Exchange!"' says Morello, laughing. 'So we're like, OK.' Morello and bass-ist Tim Commerford got through the first set of double doors before security guards brought steel gates clanging down in front of the second. Although trading continued inside, from the street it seemed very much as if a rock band had closed Wall Street.

By the end of the year Rage Against the Machine would no longer exist, but their last twelve months together were a period of extraordinary synchronicity. On 2 November 1999 they released their third album, *The Battle of Los Angeles*. The title was meant to refer to everyday tensions in their racially and economically divided home city, rather than literal street fighting. Exactly four weeks later, however, around 40,000 demonstrators converged on Seattle to protest against the latest meeting of the World Trade Organization, effectively shutting down a portion of the city in the biggest street protest on US soil since the Vietnam War. The event became known as 'the Battle in Seattle'; *Time* tellingly headlined its coverage 'Rage Against the Machine'. Many pundits responded with ridicule,

labelling the protesters 'Luddites' and 'flat-earth advocates', but also surprise. Who were these people thronging the streets at a time of such peace and prosperity, and why were they so angry?

*

Until then, the decade had been an enfeebling period for the left. In 1989 philosopher Francis Fukuyama had argued that the fall of the Berlin Wall signified the 'end of history': 'an una-bashed victory of economic and political liberalism'. Fukuyama hedged his bets, conceding that China remained a rather large exception, and expressed sadness that 'the worldwide struggle that called forth daring, courage, imagination, and idealism, will be replaced by economic calculation . . . and the satis-faction of sophisticated consumer demands', but commentators tended to put a triumphalist spin on his phrase, contending that the American way was now the only game in town.* At least under George Bush, Snr, a president so creepy that his buzz-phrase for the post-Cold War era was the ludicrously sinister 'New World Order', there were still battles to fight: over the Gulf War, Clarence Thomas and Rodney King. Under saxophone-playing baby boomer Bill Clinton, America enjoyed an absence of controversial wars and the longest economic expansion in its history.

This put the left in a quandary. Those who did not join Clinton and Tony Blair in the race for the middle ground found themselves nibbling away at the margins, fighting over semantics, identity politics and local issues rather than the socio-economic big picture. Naomi Klein, the Canadian author whose *No Logo* later became 'the *Das Kapital* of the growing anti-corporate movement', characterised left-wing

* Fukuyama's idea soon found its way into the pop charts via Jesus Jones's 'Right Here, Right Now', in which Mike Edwards (paraphrasing James Joyce) is 'watching the world wake up from history'.

voices in the early 1990s as: '"Stop the world we want to get off." It was very negative and regressive, it wasn't imaginative, it didn't have a sense of itself in any way.' At the same time, she noticed the co-option of progressive ideas by major corporations: 'turning rebellion into money', as Joe Strummer once sang. 'So, on the one hand, you're politically totally disempowered,' she told the *Guardian*, 'and on the other all the imagery is pseudo-feminist, Benetton is an anti-racism organisation, Starbucks does this third-world-chic thing. I watched my own politics become commercialised.'

This commodification of dissent also affected protest music. The formerly outspoken rapper KRS-One updated 'The Revolution Will Not Be Televised' (which actively *mocked* advertising) to shill for Nike, changing the refrain to 'The revolution is basketball.' Dead Kennedy Jello Biafra had to veto his ex-bandmates' decision to lease 'Holiday in Cambodia' to Levi's.* Across the musical spectrum, underground movements became declawed by success: punk rock was neutered into mainstream grunge; British indie music softened into Britpop; illegal raves were superseded by superclubs; Public Enemy's guerrilla iconography gave way to Puff Daddy's fashion line. Musical rebels suffered the same fate as Che Guevara, reduced to a face on a T-shirt, an nth-generation reproduction of radicalism. Chilean author Ariel Dorfman asked if Guevara's face had become 'the perfect postmodern conduit to the nonconformist, seditious 60s, that disruptive past confined to gesture and fashion . . . comfortably transmogrified into a symbol of rebellion precisely because he is no longer dangerous?' The same could be asked of a once-vital protest song, now forced to sell running shoes. 'We saw this trend approaching a million

* The process continues unabated. In 2004 British Airways used Thunderclap Newman's 'Something in the Air' to accompany a voiceover by proudly Republican writer P. J. O'Rourke. A year later, Nike lifted an image from the cover of Minor Threat's debut EP and added the slogan 'MAJOR THREAT'.

consumer-miles away,' said marketing consultant Faith Popcorn in 1991. 'It was inevitable: the Protest Generation comes of age as the Generation of Super-Consumers.'*

During the 1990s, Rage Against the Machine and Britain's Radiohead wrestled, in very different ways, with the conundrum of dissent in such comfortable times, eventually converging on the ideas which blossomed in Seattle. One band advocated old-fashioned action; the other explored paralysis and defeat. One harked back to a golden age of resistance; the other moulded a distinctly modern vocabulary. One recorded 'Take the Power Back'; the other gave voice to powerlessness. Different answers to the same question: was it still possible for a politically engaged rock band to be subversive? In conversation with left-wing historian Howard Zinn, Radiohead's Thom Yorke expressed his admiration for Lennon's 'War Is Over' campaign and suggested, 'I think the media is far more heavily controlled now . . . If he had done that today they would have basically bound him up somewhere.' Perhaps. Or perhaps, instead of being hounded by the FBI, Lennon would have been signed up by Nike.

*

'We were always a band that was on the edge of not being a band any more,' Rage Against the Machine drummer Brad Wilk told me in 2002. 'Some people say that's what gives you fire, and I sort of agree with that, but I tend to believe that it was also just a real fucking pain in the ass.'

An unusual number of factors had to align for Rage to exist in the first place. Morello was born in 1964 to an Irish-Italian

* In his 1992 satirical docudrama *Bob Roberts*, Tim Robbins went further by imagining the whole vocabulary of protest songs being co-opted by the right. Roberts, an ambitious Republican congressional candidate and folksinger, played conservative propaganda songs with such titles as 'Times Are Changing Back' and 'My Land'. Wary of these parodies being misused, Robbins refused to release a soundtrack to the movie.

mother who campaigned for civil rights and a father who was a fighter in the Mau Mau uprising and Kenya's first ambassador to the UN. The couple divorced when Morello was one, and he was raised by his mother, Mary, in the overwhelmingly white Chicago suburb of Libertyville. 'The radical politics in my home were in sharp juxtaposition to anyone in any band I ever heard of,' says Morello. 'The pictures that were hanging on Mary Morello's wall were not John Lennon; they were Vladimir Ilyich Lenin.' By the time he left high school, he had worked through the canon of radical literature. 'There was a small group of us who fancied ourselves anarchists and we were certain that we would have fomented revolution by the middle of our junior year in high school! It seemed very much like anything and everything was possible.'

After studying political science at Harvard, where he wrote his thesis on South African student movements under apartheid, he worked for Democratic Californian senator Alan Cranston, and became disenchanted witnessing 'how the underlying principles are lost in the wash of sucking up to power'. Morello is something of a politician himself, having honed his talents for diplomacy and spin through years of explaining Rage's politics and, at least at the time, whitewashing their internal divisions.

Six years younger than Morello, Zack de la Rocha also grew up in a mostly white neighbourhood, in Irvine County, California. His Mexican father, Beto, painted politicised scenes from Mexican history and worked closely with the United Farm Workers union, before suffering a bizarre nervous breakdown and forcing Zack to help him destroy his artwork.

Morello was in a funk-rock group, the Lock Up; de la Rocha in a hardcore punk band, Inside Out, one of whose songs was called 'Rage Against the Machine'. Within a month of getting together in Los Angeles in 1991, the new band had written their first album, thus becoming the first band to move rock-rap cross-pollination out of the realm of thrilling one-offs and make it the cornerstone of their sound. Morello combined the

bombastic riffs of 'Midwestern 7–11 parking-lot rock' with the alien textures of Gang of Four's Andy Gill and the sonic free-for-all of hip-hop, turning his guitar into an air-raid siren or a buzz saw. But their awareness-raising mission plugged into a tradition which pre-dated punk and hip-hop – their very name harked back to the 1960s anti-'machine' rhetoric of Mario Savio and Jerry Rubin.

While Morello processed political issues with the cool reserve of a think-tank wonk, de la Rocha, half rapper, half hardcore screamer, wrestled them to the floor in an apoplectic frenzy. Listening to the best songs on *Rage Against the Machine* (1992) is like watching a flame creep along a fuse. On 'Killing in the Name' or 'Bullet in the Head', de la Rocha broods on his theme with the caged intensity of a political prisoner pacing his cell, while his bandmates lay their plans around him, before the song finally detonates in a kind of sonic jailbreak. Critics enjoyed poking fun at the adolescent petulance of the climactic refrain of 'Killing in the Name' – 'Fuck you, I won't do what you tell me' – but it is the perfect gateway-drug protest song, channelling the boiling frustration of a thwarted teenager in a socio-political direction. Thus political dissent, rather than being an intellectual effort, seems thrillingly physical and natural. 'Nobody will ever write a line in a protest pop song as perfect as "Fuck you, I won't do what you tell me!"' applauded *NME*'s Steven Wells.

Signing to a major label raised ethical dilemmas that some band members never resolved: Wasn't Sony Records part of the 'machine'? As de la Rocha later reflected, 'Our words had to be backed up by our actions because we're dealing with this huge, monstrous pop culture that has a tendency to suck everything that is culturally resistant into it in order to commodify it, pacify it and make it non-threatening.' But the pragmatic Morello relished the opportunities it granted them to make bold statements. 'The band's initial plan was to write and record an album on cassette and sell it for five dollars,' he says. 'Then when it started to take off, it was like, "Oh my goodness, what do we do now

we have the potential to speak to a global audience?" Then we tried through trial and error to find ways to balance being a rock band and also an activist force. If your priority is changing the world, you have to figure out how to do that best.'

Hence Rage Against the Machine played benefits shows for the Anti-Nazi League, Rock for Choice, the Anti-Police Brutality Defense Fund and the United Farm Workers. At the Philadelphia date of the Lollapalooza tour in 1993, they appeared naked with duct tape over their mouths and the letters P-M-R-C daubed on their chests, to protest against censorship, and didn't play a note, even when irritated crowd members began pelting them with coins. And they were selling enough records to get away with it. 'One of the questions I'd get asked is why we were the only protest band,' Morello later wrote. 'We weren't the only band like that – but we were probably the only one having hits.'

*

At this point in time Radiohead's grievances were rather more personal. 'Radiohead very much came out of the culture of complaint,' Thom Yorke told Channel 4 in 1998. 'The X-Generation as they liked to call it for a while. But . . . we've all grown up and it's slowly dawned on us that our problems are utterly, utterly irrelevant.'

Yorke always conveyed the impression that something was terribly wrong. The first song he wrote, as an eleven-year-old in 1979, was called 'Mushroom Cloud'. Like two of his songwriting heroes, Elvis Costello and Magazine's Howard Devoto, he came across in his early twenties as a misanthropic refusenik for whom the world was a minefield of deceit and shattered expectations. His lyrical gripes on Radiohead's first album, *Pablo Honey* (1993), were decidedly parochial: rock-star clichés, the music industry, being ignored by a girl he liked, et cetera. But during the dispiriting US promotional circus which surrounded Radiohead's breakthrough single 'Creep', he found comfort in the theories of Noam Chomsky, which anchored his personal unease with

America in something weightier than complaints about idiotic TV show hosts. 'I think he's wonderful because he made me interested in stuff that could've just passed me by,' he told *NME*.

Books, more than news headlines or even personal observations, would be the catalyst for most of Yorke's political lyrics. 'The Bends' (1995) is a sardonic take on Douglas Coupland's much-discussed 1991 novel *Generation X: Tales for an Accelerated Culture*, which slapped a label on overeducated, understimulated twenty-somethings and their feelings of post-boomer anomie and drift. 'I wish it was the Sixties . . . I wish, I wish that something would happen,' sings Yorke, poking fun at nostalgia for an era of transformation and hope yet also asking, with apparent sincerity, 'Where do we go from here?'*

The Generation X phenomenon was widely interpreted as middle-class narcissism, but Coupland's characters were actively wrestling with their own jaded disillusionment, their protective scab of irony, their crippling tendency to put air quotes around life, their failure to give their era shape. Richard Linklater, director of the quintessential Generation X movie *Slacker*, once said, 'Withdrawal in disgust is not the same as apathy,' a line which Michael Stipe incorporated into R.E.M.'s 'What's the Frequency Kenneth?'. You can hear the protagonists of *Slacker* and *Generation X* speaking through Yorke on 'My Iron Lung': 'We're too young to fall asleep / Too cynical to speak.'

Yorke was clever enough to realise that his palpable discomfort with celebrity was not terribly interesting in itself but might be mapped on to the wider world, just as Jerry Dammers had mapped the bitterness and decay of the Specials' last months on to the state of Britain in 1981. This is what gives the self-pity of 'The Bends' and 'My Iron Lung' a kind of moral ballast.

* The perils of irony: 'I really do wish we'd never written that fucking song,' Yorke told *Melody Maker*'s Caitlin Moran. 'It's become the bane of my life. Hundreds of journalists asking – every *single fucking interview*, asking – "Do you wish it was the Sixties?" No! I don't wish it was the fucking Sixties!'

Throughout Radiohead's second album, *The Bends*, Yorke's evocative imagery and his bandmates' savage grace raise adolescent emotions – petulance on 'Just', Holden Caulfield-like phonyphobia on 'Fake Plastic Trees' – to a higher plane. 'I've been trying to write something political but it's hard not to come up with 80s Live Aid bollocks,' Yorke told *NME*'s Ted Kessler. 'I'm going to keep trying because I think it's a shame that music is purely entertainment now.'

The next step might have been a bona fide protest song but Yorke proved congenitally incapable of writing one, which made him far more a voice of the times than Zack de la Rocha. Certainty did not become him. When he tried to write political lyrics for 'Lucky', Radiohead's contribution to the 1995 *Help!* album in aid of Bosnian children, he decided they were 'bollocks' and junked all of them except an enigmatic reference to the 'head of state'. Like most of Yorke's lyrics, it seems half-shrouded on the page. It needs Jonny Greenwood's guitar solo, shooting skyward like a distress flare, to illuminate its face. 'Lucky' reappeared two years later on *OK Computer*, probably the key text of 1990s rock.

On 1 May 1997, Labour supporters toasted their landslide victory to the sound of 'Things Can Only Get Better'. A few weeks later, *OK Computer* appeared like Banquo's ghost to warn: *No, things can only get worse.* For Yorke, and many of his peers, the question of who was in office was somewhat moot. While writing *OK Computer*, he read texts by left-wing economist Will Hutton, Marxist historian Eric Hobsbawm and crusading reporter John Pilger, and seemed to conclude that modern society itself was sick. 'There's been a lot of looking at headlines and feeling wildly impotent,' he told *Select*'s Caitlin Moran. 'A lot of the album's about that.'

Having supported Rock the Vote while touring with new friends R.E.M. in 1995, Yorke now described elections as 'choosing between one unworkable, outdated system and another. We need to go beyond that – because at the moment, it's just cowboys and Indians.' In this light, the fact that 'No Surprises' ('Bring down

the government / They don't speak for us') was recorded in the dog days of John Major's premiership and released in the hopeful dawn of Tony Blair's makes no difference. The brilliant, and profoundly Yorkeish, thing about those lines is that they are sung in a defeated sigh by a beaten-down narrator who is contemplating suicide. Sentiments that would have sounded insurrectionary in the mouth of Zack de la Rocha become instead a mockery of rebellion – words without the hope of action to match.

Yorke later described *OK Computer* as 'like flicking channels on the TV'. He became a master of the resonant non sequitur. 'The head of state' and 'bring down the government' are lyrical shrapnel: shards snapped off never-completed protest songs. At one point during the writing process, Yorke found himself unable to complete lyrics and began churning out lists. One of them, typed in the middle of the night during a bout of insomnia, became 'Fitter Happier', a catalogue-cum-confession of conformist stability ('pragmatism not idealism'), impassively recited by an electronic voice. The jarring final image, 'a pig in a cage on antibiotics', comes straight from Jonathan Coe's anti-Thatcherite satire *What a Carve-Up*. Here, the 'right' way to live in the modern world becomes a living death.

A noisier kind of list-making animates 'Electioneering', a song frankly indebted to Elvis Costello's logorrhoeic 'Tokyo Storm Warning' (1986), which Yorke approvingly compared to 'the way human brains think'. 'Electioneering' talks of 'riot shields' (Yorke's memories of the 1990 poll tax riots), 'voodoo economics . . . business, cattle prods and the IMF', like a twenty-four-hour news feed with the links missing. In 'Paranoid Android' even the music becomes a composite of fragments. 'It's about the fall of the Roman Empire,' Yorke told Moran. 'There's a friend of mine, in a band in America, who says that America is at the point now where the Roman Empire was, just before it collapsed.* And I haven't been able to see it the same way since.'

* The friend, one imagines, must have been Michael Stipe.

OK Computer made everyday life seem poisonous: out-of-town supermarkets are prisons; your job 'slowly kills you'; cars crash; planes plunge, burning, from the sky.

In the US, Radiohead released a mini-album, *Airbag / How Am I Driving?*, whose sleeve featured a scolding quotation from Noam Chomsky: 'Since we don't participate, we don't control and we don't even think about questions of vital importance. We hope someone is paying attention, who has some competence. Let's hope the ship has a captain, since we're not taking part in what's going on.'

*

On 16 May 1998 the Birmingham International Convention Centre played host to an unsettling collision of music and politics. Delegates witnessed Blair, Clinton and the other leaders of the world's eight most powerful economies dancing to 'All You Need Is Love' at the annual G8 summit. The historical irony was obvious. When the Beatles composed the song for the first ever worldwide satellite link-up, globalisation seemed like a noble ideal: disparate nations united by miraculous airborne technology. By 1998 the word had come to signify something more sinister: a world in which power rests with multinational companies, trade agreements heavily weighted in favour of the West, and the IMF imposing punishing levels of debt on the developing world. Outside the conference hall, thousands of anti-globalisation protesters joined a Global Street Party organised by groups including Reclaim the Streets and Jubilee 2000, one of several actions across the Western world. Anti-globalisation was the cause the 1990s had been waiting for.

It was also, in a sense, just what Rage needed. Their 1996 album, *Evil Empire* (the evil empire in this case, of course, being the United States) had been a rudderless follow-up. Their activism was well targeted: they campaigned to free the Native American Leonard Peltier and the Black Panther Mumia Abu-Jamal, both convicted of murder on dubious evidence, while de la Rocha

spent a great deal of time with the Zapatista Army of National Liberation, a guerrilla cadre fighting the Mexican government in the impoverished Chiapas region.* Their songwriting, however, kept flashing back to Vietnam, Nicaragua and that old chestnut the military-industrial complex, or relying on vague sloganeering. Even the exhaustive reading list on the record sleeve drew heavily on a previous era: Cleaver, Guevara, Fanon, Marcuse.

In 1997, however, Rage fastened on the issue of sweatshops, specifically those used by Guess? jeans. The band paid for billboards reading 'Rage Against Sweatshops: We Don't Wear Guess?' and Morello was arrested in 1997 during a protest in a Santa Monica shopping mall. Asked to write a song for the blockbuster *Godzilla*, they responded with 'No Shelter', a wonderfully impertinent attack on branded ersatz revolt, Hollywood, and the movie itself: 'Godzilla, pure motherfuckin' filler.' The video neatly twisted the movie's bombastic tagline, 'Size Does Matter', into a series of billboard slogans – 'Justice does matter'; 'Inequality does matter'; 'Imperialism does matter' – and images of boardrooms and factories rather than a rampaging giant lizard.

Meanwhile, Radiohead were moving in a similar direction. At the Tibetan Freedom Concert in New York in June 1997, where Radiohead played alongside Michael Stipe and U2, Thom Yorke railed against multinationals who tacitly endorsed the Chinese occupation of Tibet. 'All the governments have their hands tied by the fucking corporations,' Yorke told *Bikini*'s Rob Hill. 'But musicians . . . we can give these corporations the big "Fuck you!"'

* Director W.I.Z.'s video to the Chemical Brothers' 'Out of Control' (1999) uses the Zapatistas to pass wry comment on the commodification of dissent. The glossy portrayal of a scantily clad Latin American guerrilla confronting riot police is revealed to be a commercial for cola. A real rioter then smashes the TV screen and the video concludes with genuine footage of Zapatista street-fighting. The final shot is a spray-painted graffito reading: 'Give me some substance.'

In June 1999 Yorke made his first, uncomfortable foray into hands-on activism when he joined a handful of musicians at the G8 summit in Cologne to deliver a petition on behalf of Jubilee 2000, calling for the cancellation of Third World debt. There is a revealing picture of Bono cheerfully greeting German chancellor Gerhard Schröder while Yorke hovers behind them, in partial eclipse, looking as if he has been artificially inserted into the photograph. 'He was bloody good,' Yorke said of Bono. 'He'd just walk into a room and start talking to some guy and I'd be saying, "You can't talk to him, he's evil, man!" But Bono's quite prepared to deal with whoever, whenever. I just couldn't do it. I was the angry young man.'

Yorke came away from Cologne with renewed disgust for cynical politicians ('[Blair] hijacked it because he'd failed on all his other issues he was trying to deal with that weekend') and the mainstream media, who concentrated on outbreaks of violence at the simultaneous street protest. 'It was a completely peaceful protest and they were calling us trouble-makers,' he complained to *Uncut*'s Stephen Dalton. 'Jubilee 2000! It's a bunch of Christian women in cardigans!'*

On 2 November, Rage Against the Machine released *The Battle of Los Angeles*, which had the energy, focus and flexibility that *Evil Empire* lacked. The standout song was 'Sleep Now in the Fire', which darted between tense, scampering funk and Morello's devastating, Stooges-like guitar riff. De la Rocha is no longer the furious accuser but the incarnation of all he despises, a human anthology of American brutality: 'The *Nina*, the *Pinta*, the *Santa Maria* / The noose and the rapist / The field's overseer.' De la Rocha's claim, à la Fukuyama, that 'it's the end of history'

* The Global Carnival Against Capital pulled together myriad threads of protest: the dance music and DIY activism of Reclaim the Streets; the direct action of the Crass-related Stop the City demonstrations; the mischief of the Yippies; the idealism of the Diggers; the phrasemaking of the situationists. In its language, methods and iconography, the anti-globalisation movement was omnivorous.

can only be read as ironic because this, like so many Rage songs, is an act of aggressive remembrance, yoking past struggles to present ones. 'No Shelter' summed up the American worldview thus: 'Bury the past, rob us blind.'

The tour was eventful even by Rage's standards. Furious at the band's support for Mumia Abu-Jamal, the Fraternal Order of Police orchestrated picket lines outside concerts and called for a boycott. Of course, Rage thrived on such organised opposition. 'It certainly vindicated us,' says Morello. 'The fact that the Man was pushing back encouraged us in our efforts to push back harder.'

Despite their album title, Rage certainly didn't expect real street-fighting to break out in a US city within weeks of its release. Nor did Primal Scream, who were about to release their *Exterminator* album (known as *XTRMNTR* due to its brutalist, vowel-obliterating typography), a thunderously intense assault on the perceived apathy of the late 1990s: 'No civil disobedience,' complained Bobby Gillespie on the title track. And yet here, suddenly, was civil disobedience on a startling scale. 'Seattle surprised me with its militancy,' said Naomi Klein. 'It surprised the organisers. It surprised everyone.'

*

'In this moment of triumphant capitalism, of planetary cash flows and a priapic Dow,' *Time* later wrote, 'all the second thoughts and outright furies about the global economy collected on the streets of downtown Seattle and crashed through the windows of Nike Town.' Months before the World Trade Organization summit in the city, it was obvious that 30 November would be a red-letter day for anti-globalisation. The WTO had unwisely chosen to meet in a region famed for its activism. Labour unions, students, environmentalists, NGOs and a tiny but significant clique of anarchists from Eugene, Oregon, were among the estimated 700 groups making plans to protest. '[This is] the most important event that any of us in this room will have in our lifetimes,'

labour leader Ron Judd told protest organisers in March. 'We are going to shut down Seattle.'

To them, the WTO, founded in 1995, represented the ugly side of globalisation, and not just practical issues like environmental damage, the suppression of workers' rights or pandering to dictators, but a profound sense that something about the whole global labyrinth of dollars and cents stank. Indeed, the practical demands were not always reconcilable: struggling Third World economies did not want their hands tied by strong unions and green legislation, for example. Some of the disparate protesters wanted to reform the WTO, others to abolish it. Some wanted anarchism or socialism, others a more ethical capitalism. Some were new to protest, others seasoned veterans. 'In the '60s, I marched for peace and justice,' one told *Time*. 'Now I'm back.'

On the night of 29 November the Seattle Centre's Key Arena hosted a 'People's Gala', with performances by Jello Biafra's ad hoc No WTO Combo and Michael Franti's Spearhead, and speeches from the likes of Michael Moore and SDS veteran Tom Hayden. At the Denny Street warehouse, activists steeled themselves for the blockades by playing Rage records. The next morning, 30,000 trade unionists convened at Seattle's Memorial Stadium while thousands of protesters began gathering downtown. Most did nothing more dramatic than block traffic with sit-ins, and shouted 'Shame!' or 'No violence!' when a few dozen anarchists, masked with hoods and handkerchiefs, began smashing the windows of stores such as Nike Town and the Gap. By that evening, Mayor Paul Schell had called in the National Guard, imposed a curfew and banned protesters from a fifty-square-block area of downtown. The arrests began the next day as direct-action protesters began blocking routes into central Seattle. The narrative should be familiar by now: the rubber bullets and tear gas, the bricks and broken glass, the claims and counter-claims. One wag blasted out Hendrix's 'The Star-Spangled Banner' from a balcony over tear-gas-filled Pike Street. Elsewhere in the melee, activist Andrew Boyd realised 'that the

wild yet focussed energies in the streets could never be resolved into a folk song – we were now part of Hip-Hop Nation. The rhythms of the chants were more percussive. The energy was fierce and playful.'

Rage, who were playing a show in Worcester, Massachusetts, picketed by 300 policemen, watched it on TV. 'It's hard to extricate the political turmoil of the time from the internal band turmoil,' sighs Morello. 'Outside the bubble of the band there's this music that's having an effect on the world and there's kids in Seattle trying to change history, and we're trying to approve T-shirt designs and decide what the next single should be without breaking up. It always felt like if only we could focus a few more hours on matters in the world rather than in the rehearsal room we might have been able to achieve more.'

Zack de la Rocha's howl and the crash of a brick through Nike Town's window were two sonic expressions of the same urge. The violence in Seattle was naturally decried by most protesters as an ugly, reductive distraction but it was also a large part of what seized the world's attention and made anti-globalisation the issue of the day, and it generated a thrill of illicit electricity. Rage Against the Machine was who you wanted to hear when you were facing a phalanx of riot police or laying siege to Starbucks. Radiohead provided the soundtrack for the morning after, leafing through Chomsky or Klein and wondering what to do next.

*

'My personal influence on Radiohead has been greatly exaggerated,' Klein told *Uncut*'s Stephen Dalton. 'The band had these political ideas long before reading my book, but until a couple of years ago there was less going on politically to tap into. That's the way movements work – they are contagious.'

Klein came from radical stock: she was born in Canada only because her parents, a paediatrician and a feminist film-maker, left the US to protest the Vietnam War. On childhood road trips the Kleins played songs by the Weavers and the Freedom Singers.

Naomi's form of teenage rebellion was 'full-on consumerism', so when she came to write about branding, it was not from the perspective of an ascetic purist.

In *No Logo*, Klein refocussed the left on a new set of villains: Gap, Starbucks, Nike, Guess? – the friendly faces of transnational capitalism. This was not the 1960s redux but a persuasive new language of protest in which the shoes on your feet and the coffee in your cup became political battlegrounds. Klein's book celebrated the opponents of the brand-as-lifestyle creed, including anti-sweatshop campaigners, Reclaim the Streets, and 'culture jammers' who *détourned* billboards so that they mocked the products they used to advertise.*

Radiohead apparently toyed with calling their next album *No Logo*, which would have been a terrible idea. Instead, they acted on its principles, eschewing branded mainstream venues for outdoor tented shows on their next tour. But if, as guitarist Ed O'Brien said, *No Logo* 'gave one real hope', then it did not translate into the songs on *Kid A* (2000) and *Amnesiac* (2001).

On these two albums, Yorke moved from pessimist to catastrophist, one all the more unsettling for his opacity. On 'In Limbo' he sings about 'a message I can't read', and Kid A is a message *we* can't read. The listener feels like someone eavesdropping on a somniloquist, or a spy with faulty recording equipment, desperately trying to parse the fragments: 'Everyone has got the fear'; 'the shadows at the edge of my bed'; 'fireworks and hurricanes'. Something is terribly wrong but you can't tell

* The phrase 'culture jamming' was coined in 1984 by San Francisco band Negativland, who used audio collage to alter the meaning of familiar songs. When U2's record label took Negativland to court for copyright infringement, the band's Mark Hosler used an interesting justification: 'They're like Coca-Cola. As a commodity, as a corporately manufactured and distributed entertainment commodity, they – to me – become totally legitimate targets.' Ironically, U2 employed Negativland-style video collages by the Emergency Broadcast Network on their Zoo TV tour.

what. Over 'Idioteque's freeze-dried electro beat Yorke jabbers premonitions of doom and assures us: 'We're not scaremongering / This is really happening.' A message on the sleeve suggests the vengeful self-satisfaction of a diligent Jeremiah who finally discovers that the end of the world *is* nigh: 'You have no one to blame but yourselves and you know it.' Both albums are paralysed by dread. They represent the opposite of *No Logo*'s can-doism. Yorke cannot move forward; he cannot *act*.

Amnesiac does contain the closest Radiohead come to a straight protest song, 'You and Whose Army', but it's really not that close. First debuted in summer 2000, with a caustic dedication to Tony Blair, it channels Yorke's distaste for the prime minister's opportunism in Cologne into muted pugilism. Singing through microphones muffled with egg boxes, he issues his fighting words ('Come on if you think you can take us all') with such muzzy enervation that you doubt he could raise a fist. His pulse quickens only when he imagines leading a troop of 'ghost horses' against his enemies, but it is short-lived and he wearily descends a ladder of piano chords into silence. Yorke explained the mood of the albums to Simon Reynolds as 'the feeling of being a spectator and not being able to take part'.

*

On 18 October, just a couple of weeks after *Kid A* became the biggest-selling album in the US, Zack de la Rocha announced he was leaving Rage Against the Machine. The band's stuttering lines of communication had finally broken down and *Renegades*, a covers album featuring classic protest songs by the likes of Bob Dylan, Bruce Springsteen, the Rolling Stones, Minor Threat and the MC5, would appear posthumously. 'We fell well short,' sighs Morello. 'I was confident that, given the right dice throw of historical circumstance, that rock band could have started a social revolution in the United States of America that would have changed the country irrevocably. I put no ceiling on what the potential impact a cultural force like that could have. I thought

the sky was absolutely the limit. My friends are surprised I say that because Rage Against the Machine was considered the most commercially successful political band, which is great and all, but my hopes were higher.'

Whether or not one shares Morello's belief in the band's potential, the timing of the split seemed rather cruel. Having soldiered through the most politically somnolent period in decades, Rage fizzled out on the brink of a widespread awakening. There was the anti-globalisation movement, of course, which would reach a violent peak with running battles on the streets of Genoa during the G8 summit in July 2001. But there were transformations they could not have predicted. Just twenty days after de la Rocha's announcement, Americans went to the polls to elect a new president.

Nobody considered it a change election. Vice-president Al Gore was a drab and cautious policy wonk, eventually losing almost three million left-wing votes to the Green Party's Ralph Nader. Republican candidate George W. Bush pitched himself as a 'compassionate conservative', looking to build cross-party consensus and avoid overseas conflicts. Nader called them 'Tweedledum and Tweedledee'; pundits joked about 'Gush and Bore'. In his video for Rage's 'Testify' single, Michael Moore digitally morphed the two candidates' faces, compared their eerily similar rhetoric, and used a flashcard from an old sci-fi movie: 'He appears as two but speaks as one!'*

The closely fought contest came down to the wire in Florida, where the battle for the state's decisive 25 electoral college votes led to over a month of recounts and legal challenges before the Supreme Court, by a 5–4 vote, cut short the recounting, thus awarding the election to Bush. Few suspected that the new

* One of Rage's last performances was outside the Democratic National Convention in Los Angeles, where, in tribute to Chicago '68, their set included MC5's 'Kick Out the Jams'. After most of the concert-goers dispersed, the police charged a hardcore of protesters in a real-life battle of Los Angeles.

president would pursue a hardline conservative agenda, and nobody could have predicted the sudden, shocking event that would encourage him to lead the country into two long and disastrous wars. But how remarkable, how retrospectively ominous, that a month before the election, the biggest-selling album in the country featured Thom Yorke babbling this dire premonition: 'Ice age coming, ice age coming . . .'

32

'I'm just an American boy'

Steve Earle, 'John Walker's Blues', 2002

Saying the unsayable after 9/11

Undated photo of 19-year-old John Walker Lindh attending a religious school in Bannu, Pakistan, 2000.

In the weeks before 11 September 2001 country-rock singer Steve Earle was thinking about putting together an album of protest songs. He already had one in the bag: 'Amerika v 6.0 (The Best We Can Do)', an attack on the US healthcare system he had written for the Nick Cassavetes movie, *John Q*. But when two hijacked jets brought down the World Trade Center in New York, another crashed into the Pentagon and a fourth, thought to be en route to the White House, came down in a field in Pennsylvania, there was suddenly no room in America for dissent.*

On 14 September several media outlets reprinted an email which had been circulated by the giant radio conglomerate Clear Channel; it listed over 150 'lyrically questionable' songs to be avoided by DJs, including 'War', 'Imagine', 'Eve of Destruction' and the entire back catalogue of Rage Against the Machine. Clear Channel were quick to insist that it was merely for guidance, rather than an official blacklist, but in the feverish post-9/11 climate, self-censorship was such a powerful instinct that most DJs obeyed the list anyway in the name of 'sensitivity'. As Rage's Tom Morello commented, 'If our songs are "questionable" in any way, it is that they encourage people to question the kind of ignorance that breeds intolerance. Intolerance which can lead to censorship and the extinguishing of civil liberties, or at its extremes can lead to the kind of violence we witnessed.'

Morello, was right to observe that the human tragedy of 9/11 was, like a dust cloud, obliterating any public discussion of the political context of the attacks, and, as journalist L. A. Kaufman noted, 'definitively interrupt[ing] the unfolding logic of the movements for global justice'. Politics itself became 'insensitive'. Steve Earle soon found that Cassavetes was no longer returning

* By chance, the number one album in the US on 9/11 was *Toxicity* by politically minded Armenian-American art-metal band System of a Down and its mood of accelerating chaos seemed uncannily apt.

647

his calls regarding 'Amerika v 6.0' – apparently, even healthcare was no longer up for debate.

Predictably, Americans turned en masse to songs they could wear like armour. Lee Greenwood's flag-waving evergreen, 'God Bless the U.S.A.', returned to the airwaves with a vengeance, while a Harris poll in late September found that 70 per cent of respondents had sung 'God Bless America' at some point during the past weeks. What chance did a protest song have in such an environment? Not since Pearl Harbor had forced the Almanacs to drop their pro-union songs had a single event so abruptly stunned usually radical voices into silence. R.E.M.'s Michael Stipe referred to the period as 'the Great Quiet'. It was clear that whoever broke the silence would have hell to pay.

*

Steve Earle had never been a conventional country singer. The year that he started performing in coffeehouses in San Antonio, Texas, as a naive fourteen-year-old, was 1968, and his mind was blown open: by LSD, by the anti-war cause and by *The Communist Manifesto*. Marx, he told his biographer Lauren St John, gave him 'the idea that songs should be about something – that there were more things to write about than girls – although I still write about girls.'

Earle's debut album, *Guitar Town* (1986), evinced a tough, blue-collar humanism transparently inspired by Springsteen: the *New York Times* named him one of 'Bruce's Children'. He sifted the legacy of Vietnam on *Copperhead Road* (1988) and became a fierce opponent of capital punishment after striking up a friendship with Jonathan Wayne Nobles, a convicted double murderer awaiting execution at Ellis Unit One in Texas. But his activism, among other things, was muted by a snowballing enthusiasm for heroin and crack which looked set to send him to an early grave. After he detoxed in 1994 he reignited his political zeal with the anti-death-penalty 'Ellis Unit One' and a lament for lost ideals, 'Christmas in Washington': 'Come back Woody Guthrie / Come

back to us now.' Asked if he identified with the working-class Guthrie, Earle demurred: 'Me, I can more easily identify with Bob Dylan – to be middle-class but feel guilty about it, and be a radical only for that reason.'

Earle was on tour in Europe in December 2001 when he first heard the name John Walker Lindh. Lindh was a twenty-year-old American who had been named after John Lennon and raised in Maryland and California. He had first become interested in Islam via rappers such as Ice Cube and Public Enemy, and converted in 1997. He studied Arabic in Yemen, then continued his studies at a radical madrassa in Pakistan. In May 2001 he broke off contact with his family and moved to Afghanistan to join the fundamentalist Taliban regime in the fight against Northern Alliance rebels. And then 9/11 happened.

Before the dust around ground zero had even cleared, the US invasion of Afghanistan was a foregone conclusion. The Taliban were proudly sheltering Osama Bin Laden and Al-Qaeda, the prime suspects in the 9/11 attacks, and rejected a US ultimatum to hand over all Al-Qaeda leaders and close terrorist training camps in the country. With Bush's approval rating at a priapic 90 per cent, and a similar number of Americans in favour of military action, there was never any real prospect of averting conflict. The first air strikes hit Afghanistan on 7 October.

When the invasion began, and the Alliance became US allies, Lindh continued to fight for the Taliban. He was apprehended by the Alliance on 25 November, promptly escaped during a major Taliban uprising at the ad hoc prison in which he was held, and was recaptured on 1 December, which is when this stick-thin, cracked-lipped, dust-throated, virtually delirious figure was introduced to the rest of the world via an interview on CNN.

Earle was struck by the fact that Lindh was the same age as his own son, Justin. 'I became acutely aware that what happened to him could have happened to my son, and your son, and anybody's son,' he told the *Guardian*'s John Harris. 'Nobody in my

country wanted to admit that. It's one of the most American stor-
ies I've ever heard: he came to Islam by way of hip-hop, which I
find fascinating. He was already looking outside his culture, like
a lot of American kids are.'

Earle began writing a song from Lindh's perspective: 'just an
American boy, raised on MTV'. Singing in a parched croak mod-
elled on Lindh's voice in the CNN clip, the narrator of 'John
Walker's Blues' is an alienated teenager groping towards a cul-
tural identity to call his own. In Afghanistan, he 'fight[s] for what
he believes' and is taken back 'to the land of the infidel'. The
chorus is a line from the Koran ('*Asshadu an la illaha il Allah /
There is no God but God*') and the song closes with a sample of
a Koranic prayer. Setting aside the politically loaded context, it's
a classic first-person character song about an outlaw underdog,
with Lindh a successor to the Death Row inmate in 'Billy Austin'
and the desperate Vietnam veteran of 'Copperhead Road'.

'It became increasingly obvious to me that John Walker was
being set up as a warning to any American that got out of line
while this war against the new bogeyman was being pursued,'
explained Earle. 'I was trying to humanise him, because every-
body else was trying to vilify him.' In the jingoistic hothouse of
America in 2002, however, this kind of empathy was a tough
sell. When he told his friend Elvis Costello about planning to
release the song, Costello replied that he was 'fucking crazy'.

Earle included the song on his next album, *Jerusalem*, where
it sat alongside the reclaimed 'Amerika v 6.0 (The Best We Can
Do)', the all-things-must-pass message of 'Ashes to Ashes', the
anti-war 'Conspiracy Theory', and the title track, about the
ongoing deadlock in the Middle East. The disc was due for
release in September 2002 but advance copies went out to crit-
ics two months early, which is when the storm broke. 'Twisted
Ballad Honors the Tali-Rat,' barked the *New York Post* on 21
July. 'Do you think an American would have written a paean to
Hitler during World War Two?' a commentator on CNN asked
absurdly.

At the exact same time, country radio was hammering another Nashville song: the red-blooded war holler of Toby Keith's 'Courtesy of the Red, White and Blue (The Angry American)'. Keith left no patriotic stone unturned: 'Old Glory' flying proud, freedom's bell ringing out, a soaring eagle, a fist-shaking Statue of Liberty, Afghanistan 'lit up like the 4th of July', and so on, like a pick-up truck plastered with bumper-stickers. 'That record embarrasses me,' complained Earle. 'It's pandering to an audience. But doing that in this atmosphere is dangerous. I have a fear that someone with dark skin and clothing different to what people wear in Tennessee might get hurt because of that song. It scares me.' While Keith's song was flying high, Earle wrote in the sleevenotes to *Jerusalem*: 'Lately, I feel like the loneliest man in America.'

*

Earle was not quite the only dissenting voice in American music, but you really had to look hard for the other ones. Hip-hop, for example, had been paralysed by the 9/11 attacks, muting its already dwindling anti-establishment voice. Rappers whose territorial pride didn't previously extend beyond their own backyards suddenly transformed into chest-thumping patriots. 'We're supporting the USA,' rap mogul Suge Knight told the *Washington Post*. 'At this moment, there's no such thing as ghetto, middle class or rich. There's only the United States.'

So the Wu-Tang Clan poked out from their usual labyrinth of Islamic mathematics and arcane conspiracy theories to proclaim, 'America, together we stand, divided we fall,' on 'Rules'; New Orleans MC Mystikal, a veteran of the first Gulf War, recorded the defiant 'Bouncin' Back (Bumpin' Me Against the Wall)'; MC Hammer persuaded a handful of US congressmen to dance in the video for his boosterish new single 'No Stoppin' Us (USA)'; and Canibus went further than anyone on his loopily belligerent 'Draft Me!': 'I wanna fight for my country / Jump in a Humvee and murder those monkeys!' Not that such lyrics were

commonplace, but it was surprising to hear this kind of senti-
ment at all. 'Before 9/11 motherfuckers couldn't stand [Bush's]
name,' rapped Paris on 'What Would You Do'. 'Now even nig-
gas waving flags like they lost their mind.'

How did this happen? Certainly, there was a financial dis-
incentive to rock the boat: the risk of lost airplay, sales and
sponsorship deals, of hysterical denunciations by tabloids and
talk-radio hosts. Easier to stay quiet. But in many cases the
desire to speak up wasn't there in the first place – the muscles of
protest had grown flabby. 'During the Clinton years there wasn't
a common enemy to feed off so hip-hop reverted to a more
relaxed atmosphere,' suggests Damien Randle of Houston duo
the Legendary K.O. 'By the time Bush Junior came into office the
industry believed that consumers didn't want to go back to the
socio-political thing and wanted to stay in escapist mode.'

To criticise the war required a modicum of geopolitical knowl-
edge. To respond to a blatant atrocity in the heart of America
(and New York was also the epicentre of hip-hop) you only
had to go with your gut. So what dissent there was came from
battle-hardened veterans like Public Enemy ('Son of a Bush'),
Paris (*Sonic Jihad*), Nas ('Rule'), and Michael Franti ('Bomb the
World'), with little or nothing to lose in terms of mainstream
exposure.*

Rock was, if anything, even quieter. While Earle was undergo-
ing trial by tabloid, another long-standing liberal voice, Bruce
Springsteen, navigated a cautious path on his album about 9/11,
The Rising. Neither waving the flag nor tearing it down, he homed
in on the rescue workers and victims and crafted a consoling nar-
rative about endurance and rebirth. 'All people have is hope,'
he explained. 'You can't be uncritical, but just a hope grounded
in the real world of living, friendship, work, family, Saturday
night. And that's where it resides.' These were old Springsteenian

* Clearly unafraid of charges of insensitivity, Paris adorned *Sonic
Jihad* with a doctored image of a hijacked passenger jet flying low
over the White House lawn.

themes, dusted down and applied to the new situation.

By the time the media storm hit Steve Earle, however, the world's attention was turning from the existing operation in Afghanistan to a more contentious imminent one in Iraq. 'It's been a long, weird year and, take my word for it, there's an even longer, weirder one coming,' Earle told an audience in Philadelphia that autumn. 'Just remember that no matter what you hear it's never, ever unpatriotic or un-American to question any fucking thing in a democracy.'

*

In March 2003 a group of congressmen meeting with National Security Adviser Condoleezza Rice received a surprise visit from President Bush. 'Fuck Saddam,' said the commander-in-chief. 'We're taking him out.' Bush's administration was stacked with neoconservative foreign-policy hawks, such as Donald Rumsfeld and Paul Wolfowitz, who believed that the US should remove potentially dangerous regimes with pre-emptive strikes rather than merely 'containing' them with sanctions and inspections. They believed the world was a minefield and only the US had the power and the moral authority to clear it. Top of their hit list was Saddam Hussein's Iraq, and 9/11 gifted them a golden opportunity. Once Tony Blair, who had already practised what he called humanitarian intervention in Kosovo and Sierra Leone, realised that Bush had Iraq in his gunsights, he decided that Britain had no choice but to stand squarely by America's side.

However, pre-emption was not an easy doctrine to sell to the public in either country, so the official *casus belli* proved remarkably flexible. At first, the Bush administration tried to demonstrate links between Iraq and the 9/11 hijackers. When those proved non-existent, they gathered evidence pointing towards Saddam having weapons of mass destruction (WMD), ignoring any findings to the contrary. The case was liberally dusted with talk of Saddam's human rights abuses, his flouting of UN resolutions and his potential threat to the stability of the region.

'Bush wanted to remove Saddam, through military action, justified by the conjunction of terrorism and WMD,' recorded a secret Downing Street memo in July 2002. 'But the intelligence and facts were being fixed around the policy.'

Spurious though many of the professed motives turned out to be, they succeeded in subduing opposition: if those in the know claimed Saddam was a serious threat, well, then maybe he was. Uncertainty bred apathy, as Guy Garvey, frontman of Manchester band Elbow, discovered when his band played the V festival in August 2002. 'I said, "I know you're all going to have a great afternoon." And they all cheered. "I know you're all going to get really drunk." And they all cheered. "I know you're going to tell your elected leaders that they're not killing anybody in your name." And there was stony silence among 17,000 people. It completely stunned me.'

A few months later, Elbow essayed a deliberately enervated version of Thunderclap Newman's "Something in the Air" by way of satirical comment. 'The original's quite a rabble-rouser,' Garvey said. 'We wanted to give it a lethargic, almost comical air because there is a general spirit of lethargy among the youth. It's always been in the hands of young people to speak out and nobody gives a fuck. That's scarier than the threat itself. It's not cool to express your opinion or challenge authority any more. If you're seen to be waving your fist on a soapbox, it's almost too '69.' Garvey would later channel his disappointment into 2005's bristling 'Leaders of the Free World': 'I think we dropped the baton / Like the sixties never happened.'

At the end of 2002, Garvey's was one of only six names from popular music on the Stop the War website, a feeble tally compared to dozens of writers, actors and film-makers. The others were Billy Bragg, Brian Eno, Kevin Rowland (formerly of Dexy's Midnight Runners), Damon Albarn of Blur and Robert '3D' Del Naja of Bristol duo Massive Attack. Albarn, a committed pacifist, had worn a CND T-shirt to the MTV Europe awards in November 2001 and announced, 'Bombing one of the poorest

countries in the world is wrong. You've got the voice, use it.' 'I just felt really stupid,' he said a few months later. 'I felt like I was pretty much on my own but I'm glad I did it.'

Del Naja was 'slightly unsure' about the war in Afghanistan, but was adamantly opposed to any action in Iraq. He and Albarn began talking regularly about the situation and forging links with the newly founded Stop the War movement and the venerable CND with a view to mobilising music fans to join demonstrations. Del Naja is a rare and endearing combination of intellectual curiosity, principled concern and modesty. He came to politics late, during the second Palestinian intifada in 2000, and decided to approach other musicians via their managers rather than directly, so as not to be accused of exerting moral blackmail. Again and again, to his and Albarn's bemusement, the answer came back: no.

There were a few reasons. Some people were genuinely persuaded by the case for war; a few even asked Del Naja if he supported Saddam. Some were frightened of controversy. Some were tired of being attacked for their politics. 'It feels untenable for me to say anything,' Nicky Wire of the Manic Street Preachers said at the time. 'I just think it would be completely misinterpreted.' Some doubted their involvement would have any effect. 'Perhaps those of us who still believe there's some point in being involved in political action are being old-fashioned,' said a beleaguered Brian Eno. 'Perhaps [other musicians] think the whole conversation isn't going to achieve anything. And sometimes I have to agree.' Or, as Oasis frontman Liam Gallagher put it, 'Nobody's gonna listen to knobhead out of Blur . . . No one even listens to Bono.'

But many declined for the same reason that some Labour-voting musicians snubbed Red Wedge: they didn't want to sign up to someone else's campaign. 'I think the problem is vanity,' reflected Del Naja. 'Bands like to attach themselves to pet causes. What me and Damon tried to do was rise above all that but, as it went on, we gave up thinking about the bands and thought

about the people.' Del Naja and Albarn joined an estimated 400,000 protesters in London for the first major march against the war in September 2002, signed petitions, wrote impassioned blogs and placed awareness-raising adverts in the music weeklies. What they did not do, however, was write songs about it. 'It takes a particular kind of genius, which I don't think I've been blessed with, to write a song which draws you in without being too black-and-white in its message,' says Del Naja.

One person the pair did not approach, and probably should have, was the man who had recorded the first significant British protest song about Bush and Blair's wars: the former boy-band pin-up turned blue-eyed soul star, George Michael. It was unfortunate that August 2002's 'Shoot the Dog' had an anodyne dance-pop groove, incoherent lyrics and a crassly satirical animated video, but there was no gainsaying its bravery. Michael was ridiculed in the tabloids on both sides of the Atlantic. 'I was hugely depressed by the lack of support from any quarter,' he grumbled afterwards. 'What kind of snobs would not have asked me at that point to be something to do with it? I'd already stuck my neck right out. I'd actually *made a record* to be pilloried. I read the interviews with Damon Albarn and he was horribly simplistic and uninformed. And you know at the time they thought they were too good to give me a ring.'

Meanwhile, a major figure who might have been expected to join the anti-war camp, given his fury over Central America in the 1980s, maintained a diplomatic silence. Bono had recently made himself a spokesman for Third World development issues and felt that any comment on Iraq would alienate the politicians whose fingers were on the foreign aid purse strings. 'You're asking, "Don't you speak up? Don't you get out on the streets?"' he says. 'And I gave up that right once I was in a genuine position of voicing the aspirations of millions of people who had no voice. I did say to Condi [Rice], "Really think about what happened in Ireland. The British army arrived in Ireland to protect the Catholic minority but when you're standing on street corners

in hard hats and khaki carrying that kind of hardware you very quickly become the enemy." But I wasn't there for that.'

Whatever the reasons, a pattern of disunity was being set for the rest of the Bush years: several disparate musicians voicing their dissent, yet feeling that they were the only ones. The protests came piecemeal, often in the form of songs posted online. Some, such as R.E.M.'s solemnly acoustic 'Final Straw', Zack de la Rocha's broiling hip-hop track 'March of Death' and Billy Bragg's sardonic 'The Price of Oil', were quite powerful. Others, like the Beastie Boys' 'In a World Gone Mad' and Lenny Kravitz's appallingly smug and fuzzy-minded 'We Want Peace', were not. None, to be honest, nailed their constituency as effectively as Toby Keith nailed his. In the event, the music world's defining political statement of the period – in fact, its most significant in *years* – wasn't a song at all, but a spontaneous comment made on a London stage.

*

Prior to 10 March 2003, nobody would have fingered the Dixie Chicks as potential troublemakers. Natalie Maines, Emily Robison and her sister Martie Maguire all hailed from Lubbock, Texas, a quintessential red-state heartland. When they sang the national anthem at Texas Rangers games in the 1990s, Governor George W. Bush and his wife sat in the front-row box seats and chatted with the band. In January 2003 they performed the national anthem at the prestigious Superbowl half-time show. A few weeks later, on 1 March, they set a single-day record for ticket sales, pulling in $49 million for their forthcoming US tour. Their album *Home* was enjoying its sixth week on top of the country charts, with the single 'Travelin' Soldier' about to follow suit. They were, unquestionably, country music's sweethearts.

By then, the US and its allies were days away from war with Iraq. For months Blair had been driving efforts to secure a new UN resolution to authorise the invasion, but that day French president Jacques Chirac declared that he would veto the resolution and a White House spokesman made it clear that if the UN

did not act then the US would. The back story that later emerged, namely that the US and UK had long been committed to war, was already dawning on many of the war's opponents. On 15 February anti-war protesters had marched in around 600 cities across the world, images from which Michael Moore edited into the video for System of a Down's 'Boom!'. Among over a million gathering in London were Del Naja, Albarn and Bragg. 'There was a sense of jubilant naivety in the thought that it might change something,' says Del Naja. 'That, apparently, was never going to happen.'

The headlines on 10 March were full of WMD, ultimatums and last-minute diplomatic scrambles. That evening, the Dixie Chicks' Top of the World tour kicked off at the Shepherd's Bush Empire in London. After 'Travelin' Soldier', an apolitical character song about a GI in Vietnam, Maines told the crowd: 'Just so you know, we're on the good side with y'all. We do not want this war, this violence.' She paused, smiled, fiddled with the tuning heads on her guitar. 'And we're ashamed that the President of the United States is from Texas.' As the venue filled with warm applause, she shot her bandmates a broad grin. 'I got hot from my head to my toes,' Robison later told *Time*. 'Just kind of this rush of "Ohhh, shit." It wasn't that I didn't agree with her 100%; it was just, "Oh, this is going to stir something up."'

If it hadn't been for the *Guardian*'s reviewer, Betty Clarke, the incident might have gone unreported, but here was a Middle American superstar explicitly condemning Bush's rush to war; it was surely worth a mention. An influential conservative website, FreeRepublic.com, picked up the story and began mobilising a grassroots boycott campaign. 'Travelin' Soldier' was yanked from playlists, and began free-falling down the charts, while sales of *Home* virtually halved within a week.* Lipton Iced Tea

* One beneficiary of the premature demise of 'Travelin' Soldier' was Darryl Worley's pro-war record 'Have You Forgotten?', which topped the country chart throughout April and May. By crudely conflating 9/11 with Iraq, and dissent with naivety, it merited a place on the Oval Office iPod.

withdrew its lucrative sponsorship of the tour. Some radio stations set up trash bins in which outraged fans could deposit their Dixie Chicks CDs. 'They should send Natalie over to Iraq, strap her to a bomb and just drop her over Baghdad,' opined one caller to WDAF-AM 61 Country. Americans with long memories thought back to the frenzy surrounding John Lennon when he said the Beatles were more popular than Jesus, or to Pete Seeger and the HUAC. Merle Haggard, one-time scourge of the hippies, looked back further still, saying that the furore 'reminded me of things I'd read about in Berlin in 1938. It pissed me off.'

The Dixie Chicks' perceived sin was threefold: they had personally insulted the president; they had done so on foreign soil; and they had flown in the face of country music's red-state constituency. 'It had to be some group that seemed like all-American girls,' Maguire later reflected. 'It had to be the unlikely voice from what looks like the conservative heart of America saying it. That was perfect.' By virtue of their genre, the trio became flak-catchers for Middle America's patriotic fury; the uproar that greeted Seattle alt-rock band Pearl Jam when they sang the satirical 'Bu$hleaguer' with a mask of the president hanging from singer Eddie Vedder's microphone stand was dwarfed by the hurricane engulfing the Dixie Chicks.

On 14 March, two days after the *Guardian* review appeared, Maines offered a guarded apology for her 'disrespectful' remark while still insisting on a diplomatic solution to the Iraq situation. As she later clarified to interviewer Diane Sawyer, she felt she'd chosen 'the wrong wording': 'Am I sorry I said that? Yes. Am I sorry I spoke out? No.'

Maines was no radical firebrand. She had not called for Bush's assassination. She had not raged against AmeriKKKa. She had simply dared to express an opinion shared, as poll after poll revealed, by the majority of the world's population. If her apology had been accepted, she might have left the matter there. But anonymous opponents dumped trash outside Robison's home and sent letters to Robison and Maguire's father, calling him

a traitor. Former Nixon and Reagan aide Pat Buchanan called them the 'Dixie Twits'. Fox News attack dog Bill O'Reilly said they were 'callow, foolish women who deserve to be slapped around'. Even the president passed comment. 'The Dixie Chicks are free to speak their mind,' he mused. 'They shouldn't have their feelings hurt just because some people don't want to buy their records . . . Y'know, freedom is a two-way street.'

The trio, Maines especially, took on a reckless energy. They posed for the cover of *Entertainment Weekly*, their naked bodies stencilled with some of the epithets thrown their way in recent weeks, both positive ('Patriot', 'Brave') and howlingly negative ('Dixie Sluts', 'Saddam's Angel'). In one scene from *Shut Up and Sing*, a documentary about the controversy, the band are discussing whether their career will ever recover from their air-play purdah. 'Now that we've fucked ourselves anyway,' reflects Maines, 'I think that we have a responsibility . . .' She pauses, grins. 'To continue to fuck ourselves!'

The US leg of the Top of the World tour opened in Greenville, South Carolina, on 1 May, the same day that President Bush stood on the flight-deck of the USS *Abraham Lincoln* and declared victory in front of a banner reading 'Mission Accomplished'. Unfortunately for the Dixie Chicks, Bush appeared vindicated. The invasion had begun at dawn on 20 March and Baghdad had fallen on 9 April. The stage-managed toppling of a statue of Saddam by crowds of cheering Iraqis was shown around the world. Outside the Greenville show, Bush-boosters brandished placards such as 'Try the Chics [sic] for Treason'. Inside, Maines wittily invited her detractors to boo, 'because we welcome freedom of speech'. When Toby Keith mocked up a picture of Maines cuddling Saddam, the singer retaliated with a home-made T-shirt reading 'FUTK', which, she deadpanned, stood for 'Friends United Together in Kindness.' But some of their opponents were more dangerous: in Dallas, they were escorted to the stage by policemen after receiving an anonymous letter saying that Maines would be shot dead during the concert. At each step

they toughed it out, and even managed to joke about it. At a press conference, Martie Maguire said: 'We heard they've turned what happened to us into a verb – you can get Dixie Chicked.' She smiled. 'And if we had to be the example that's fine.'

*

After the Dixie Chicks affair, the ground moved. Maines, Robison and Maguire had been hounded, barracked, boycotted and threatened, and they had not just survived; they had put the anti-war cause centre stage like no other musicians. And they did so at the peak of the war's popularity. At the time of the Mission Accomplished speech, Bush's approval rating hovered around 70 per cent, from which perch it began a steady descent.

Something was clearly not right in Iraq. The victorious coalition forces didn't appear to have any clear vision for building a safe, democratic nation. The weeks following Saddam's defeat had seen rampant looting and chaos on the streets, to which Donald Rumsfeld blithely responded, 'Stuff happens! . . . Freedom's untidy.' In May the newly appointed head of the Coalition Provisional Authority, diplomat Paul Bremer, made the catastrophic decision to dissolve the Iraqi army, turfing 40,000 disgruntled, penniless soldiers on to the street. The process of de-Ba'athification removed thousands of government employees who belonged to Saddam's Ba'ath party from their posts, thus creating a skills vacuum and driving a wedge through the middle of Iraqi society. In August the UN headquarters in Baghdad was ripped apart by a terrorist bomb. Was this what victory looked like?

Just as the conduct of the operation was looking shaky, the bottom was falling out of the original moral case for war. The all-important stockpiles of WMD had yet to materialise; indeed, there were growing doubts that they had ever existed. In the UK, the BBC reported that the government's crucial September 2002 dossier, setting out Saddam's WMD capability, had been deliberately 'sexed up' to exaggerate the threat. The rumoured source

of the story, a Ministry of Defence scientific adviser called Dr David Kelly, was called before the Foreign Affairs Committee, where he seemed flustered and confused. On 18 July his body was found on Harrowdown Hill, near his Oxfordshire home, an apparent suicide (his death inspired Thom Yorke's eerie, accusatory 'Harrowdown Hill'). Many Britons who had supported the war were beginning to feel duped; those who had opposed it felt too queasy for Schadenfreude.

The big international song of the summer was 'Where Is the Love?' by Los Angeles rap group Black Eyed Peas. A pacifist anthem seemingly modelled on 'What's Going On', it included an eyebrow-raising line which called the CIA 'terrorists' and another which said flatly, 'A war is going on but the reason's undercover.' Band leader will.i.am had begun writing it after 9/11 and recorded it during the lead-up to war in Iraq. 'I never thought that song was going to be played on the radio,' he confessed. 'If I did I would never have said that. Honestly.'

A very different kind of summer soundtrack was Radiohead's *Hail to the Thief*. The title phrase had been used by critics of Bush's disputed election in 2000, which made it seem too bluntly political. The working title, much better, had been *The Gloaming*, an old-fashioned word for twilight. 'The gloaming,' Thom Yorke explained, was 'the imminent sense of moving into the Dark Ages again. The rise of all this right-wing bigotry, stupidity, fear and ignorance.' Another possible title was *The Lukewarm*, referring to Dante's word for 'the people who don't give a fuck . . . The lukewarm are on the edge of the Inferno, cruising around near the gates but they can't actually get out. They're like, "What are we doing here? We didn't do anything at all." And in Dante's eyes it's, "That's exactly why you're here. You did fuck all. You just let it happen."'

Yorke had become a father in 2001 and was spending a lot of time at home with his son, listening to multiple news programmes on Radio 4 every day. When a phrase leapt out of the radio and snagged his attention, he jotted it down. The lyrics

became jumbles of second-hand language, ripped out of context but still trailing tendrils of ominous meaning, and threaded together with the haunted, half-lit language of fairy tales. 'This was the noise going round my house, and so it was the noise that ended up in the songs,' he told *NME*'s John Robinson. 'Everything felt wrong.'

Of course, Yorke had been saying everything felt wrong for his entire career, but since Radiohead's last album world events had rushed to meet his fearful imaginings. The attacks of 9/11, Afghanistan, Iraq: *ice age coming*. Radiohead's music spoke to people's fear; 'Where Is the Love?' expressed a vague, comforting pacifism; Steve Earle and the Dixie Chicks brought compassion and courage to the issue. Every variety of concern was now, at last, finding a voice.

On 5 June, Michael Stipe went with some friends to see Radiohead play a small show at New York's Beacon Theatre. During 'No Surprises', he noticed something remarkable. When Yorke sighed the lines, 'Bring down the government / They don't speak for us,' the crowd roared the words with an almost desperate force. The reawakening of dissent that had begun with Steve Earle had finally found its voice. 'I felt that the tipping point had occurred,' Stipe told the *Independent*'s Craig McLean. 'Having felt what I call The Great Quiet . . . where people couldn't raise their voices – at that moment, that changed for me. I realised it was shifting rapidly.'

33

'Sing along in the age of paranoia'

Green Day, 'American Idiot', 2004

The protest song revival that never was

President George W. Bush speaking to supporters inside the Evesham Recreation Center in Marlton, New Jersey on 18 October, 2004.

In May 2006, Neil Young released *Living With War*, a hastily recorded blast of ire at President Bush which constituted the singer's most direct political statement since 'Ohio'. 'I was hoping some young person would come along and say this and sing some songs about it, but I didn't see anybody, so I'm doing it myself,' Young later explained, casting himself as an ornery old gunslinger saddling up one more time to do the job that the younger generation was too lily-livered to take on. It was a catchy narrative, but it wasn't true. Plainly, younger artists *were* singing some songs about it, if Young cared to listen. By the time of *Living With War*, President Bush's approval rating had hit a new low of 31 per cent and musicians were queuing up to lob coconuts at the commander-in-chief's head.

But that doesn't mean Young was deliberately lying. He probably *felt* that what he was saying was true, because most people did. 'Are today's artists just apathetic, or is the audience unreceptive to weighty words?' asked Florida's *St Petersburg Times* in an August article entitled 'The Dying Protest Song'. During the Vietnam War, a handful of anti-war songs gained such cultural traction that it seemed as if everybody was making them. During the war in Iraq, the opposite happened: many people wrote them, yet it seemed like nobody was. Instead of snowballing into a movement, myriad individual protest songs lay on the ground like flakes in a mild spring snowfall: frail, scattered, quick to melt away.

Bush was, by some reckonings, the worst president the country had ever had: the architect of two interminable, unpopular wars, the man who allowed 2005's Hurricane Katrina to become not just a tragedy but a national disgrace, and a divisive ideological bully. If ever the ground were ripe for a protest-song revival, surely it was during his benighted administration. And yet even when the songs emerged, the general perception was otherwise.

667

So the right question is not, 'Where have all the protest songs gone?' but, 'Is anybody listening?'

*

As the US presidential election season swung into life at the beginning of 2004, the stakes seemed incalculably higher than they had four years prior. The situation in Iraq was looking increasingly dire. In January, CIA officers in Baghdad warned that the country may be facing civil war, as bombings and kidnappings became commonplace. Weapons inspectors were close to concluding that whatever WMD Saddam might have possessed had been destroyed long before the invasion. In April the coalition's fragile moral authority was shaken to pieces by photographs of the torture and humiliation of Iraqi detainees at Abu Ghraib prison. In August the US death toll hit 1,000. The time was ripe for a genuinely huge anti-Bush song.*

One day in 2003, Billie Joe Armstrong, frontman of Bay Area punk group Green Day, had been driving to his studio in Oakland when a jingoistic Lynyrd Skynyrd song came on the radio. 'It was like, "I'm proud to be a redneck," and I was like, "Oh my God, why would you be proud of something like that? That's exactly what I'm *against*,"' he remembers. When he got to the studio, he wrote his retort in one furious burst: a taut jab to the ribs called 'American Idiot'. 'I looked at the guys like, "Do you mind I'm saying this?" And they were like, "No, we agree with you." And it started the ball rolling.'†

*Among the best recent efforts were Le Tigre's 'New Kicks', a vibrant disco-punk collage of news reports and interviews from the global protests of February 2003, and Tom Waits's gruffly humane letter home from a twenty-one-year-old soldier, 'The Day After Tomorrow'.
† Armstrong can't remember the name of the song but Lynyrd Skynyrd's recent *Vicious Cycle* album included two anthems to Middle American pride, 'That's How I Like It', and 'Red White & Blue (Love It or Leave It)', which fit the bill. Ironically, given that Skynyrd's biggest hit, 'Sweet Home Alabama', was an answer to two less well-known Neil Young songs, 'American Idiot' was an answer to a Skynyrd song that most people have never heard.

Armstrong perches on a sofa in the hangar-like live room of Green Day's studio. On the wall behind him hangs a giant US flag, in front of which dozens of guitars are racked like soldiers on parade. He has wide, panda eyes, a slight frame and the jittery energy of an adolescent. He and the 'guys', bassist Mike Dirnt and drummer Tre Cool, had emerged from Berkeley's Gilman Street scene as teenagers, and incurred Tim Yohannan's wrath when they signed to a major label in 1993. 'It's good that you have this conscience about what's going on, but every step that you took had to be politically correct,' sighs Armstrong, still smarting from his expulsion from the *Maximum Rocknroll* bubble. 'You couldn't enjoy what was happening. It was preying on your conscience so much: Am I doing the right thing? At the time it *sucked*.' Having written his first political lyrics on 2000's *Warning* album, Armstrong felt that he was gravitating back towards some of the ideals, if not the censoriousness, of Gilman Street.

Armstrong does not like to pretend he knows more than he does. He writes songs from the perspective of an anxious spectator, swamped by dismaying information and wondering where to go from here. 'There was something apocalyptic about the whole thing: "Oh my God, the country is *unravelling*!"', he says of the war in Iraq. 'And it was shocking. I never thought I'd see a war brought to you on TV, twenty-four hours a day, and it became like entertainment.' Hurtling along like a stadium-rock Clash, 'American Idiot' is in the 'This Land is Your Land' tradition of alternative patriotism, tartly contrasting the 'subliminal mind fuck America' with 'the faggot [i.e. liberal] America'. But it is also from the school of anti-television songs, buzzing with references to TV news, propaganda and 'information age of hysteria': a 'Trouble Every Day' or 'The Revolution Will Not Be Televised' for the Fox News era.

The making of the *American Idiot* album, a hugely ambitious, politically inclined rock opera which also featured the even angrier 'Holiday', took several months, and it wasn't ready for

release until 21 September 2004, just weeks before the presidential election. After a few warm-up dates, Green Day began their tour, quixotically, in the belly of red-meat America, so there they were in Fort Worth, Texas, Bush's home state, singing, 'Sieg heil to the President gasman,' a line from 'Holiday' that might have been penned by Jello Biafra. Armstrong remembers, 'It's one thing when you're in California and you're saying "Fuck George Bush," but when you're in Texas . . .' He winces. 'It was a mixed response. That's a weird noise, man: half the crowd cheering and half the crowd booing.'

By the time they finished touring in December 2005, they would be doing so to nothing but cheers, and *American Idiot* would have sold thirteen million copies, but those first weeks were strange. Armstrong remembers being accosted while getting off a plane in Orange Country, California, by a woman who told him, 'I just want you to know that I am *proud* to be an American idiot.' He also had a somewhat awkward encounter with the Democratic presidential candidate, John Kerry, when they both appeared on *The Late Show with David Letterman* on 20 September. 'There was a sense of him going, "I don't want to run with this. I got people to impress,"' says Armstrong.

*

Kerry was a decorated former Swift boat captain who had become a charismatic spokesman for Vietnam Veterans Against the War before entering the Senate in 1985. He had voted for the war in Iraq on the understanding that Saddam had WMD, and now expressed a widely shared sense of betrayal. A stiff, cerebral, patrician figure, he was not the most inspiring candidate imaginable, but, as Lou Reed told *Rolling Stone*: 'We must all unite and work for whomever opposes Bush, regardless of whatever differences we may have. Our motto: Anything but Bush.'

Thus, several artists swung into action behind the Democratic challenger. Fat Mike of Bay Area punk band NOFX established the Punkvoter coalition to drum up turnout. Steve Earle

returned with the bluntly angry *The Revolution Starts Now*. 'We are preaching to the choir,' he told *Rolling Stone*, 'but we want to make sure that the choir sings really loud.' Maynard James Keenan of prog-metal band Tool chose election day to release an album of anti-war cover versions under the name A Perfect Circle, including 'Imagine' and 'What's Going On'. Willy Mason, a nineteen-year-old neophyte from New York, attracted so much attention with the plaintive 'Oxygen' ('Do you remember the forgotten America?') that excitable critics held him up as the new Bob Dylan. 'That's what scares me with what's going on now, if people start taking me too seriously,' Mason fretted. 'I'm saying the same shit that everyone's saying.'

Even the hip-hop star Eminem, who tended to reserve his considerable bile for his estranged wife and his mother, released an eleventh-hour election single, a glowering battlesong called 'Mosh'. Eminem, a practised character assassin, moved from opposing the war to attacking the man who conceived it. 'Strap [Bush] with an AK-47, let him fight his own war,' he spat. 'Let him impress Daddy that way.' Bush, he concluded, was a 'weapon of mass destruction'.

The president was a gift to songwriters because he provided so many lines of attack. To Public Enemy in 'Son of a Bush' it was his execution-happy record as governor of Texas. To the Beastie Boys in 'In a World Gone Mad' it was his bellicose posturing: 'looking like Zoolander / Trying to play tough for the camera.' To Pearl Jam in 'Bu$hleaguer' he was a 'confidence man' who 'got lucky'. It wasn't just the war in Iraq which enraged people: it was his tax cuts for the rich, his cavalier approach to the environment, his disregard for civil liberties, his pandering to the religious right, and so much more.

'I'd [prefer] almost anyone who isn't a convicted killer,' said R.E.M.'s Peter Buck. 'As much as I disliked Reagan's politics, he seemed like a charming person. George Bush seems like every rich college kid you've ever had the misfortune to meet – uneducated, doesn't care, and has that smirk at all hours of the day

because he knows that money is more important than thought. This is such a weird time. I've never seen the country so polarised since I was thirteen and the Vietnam War was going on.'

R.E.M., along with Springsteen, Pearl Jam and the Dixie Chicks, spearheaded the Vote for Change tour which played thirty-four shows in battleground states in the weeks before the election. 'You can't tell people what to think,' said Springsteen, ever the diplomat. 'You can say, "Let's think about this together."' Predictably, several old protest songs were pressed into service. Springsteen sharpened the attack of the oft-misread 'Born in the USA'. Creedence Clearwater Revival's John Fogerty played 'Fortunate Son', a song that might have been written for the privileged, Vietnam-avoiding commander-in-chief. Neil Young led a ragged, savage version of 'Rocking in the Free World'.

The question of whether any of this would sway undecided voters was moot; some in the crowd even proudly wore Bush T-shirts. Buck remembers sitting backstage with Springsteen's guitarist, Steve Van Zandt. 'We both said, "Y'know, I'm glad we're doing this but it's not going to do anything. [Kerry]'s losing." I was saying Bush is going to get 55 per cent and he said nah, he's going to get 53 per cent.'

They were both a little too pessimistic – it was 50.7 per cent – but the bottom line was the same. Bush managed to centre the debate on security fears, where Kerry was least convincing, while mobilising his core support with more efficiency than the Democrats. On the morning of 3 November the electoral map of the US resembled two nations: a blue one extending along the west and northeast coasts and around the Great Lakes, and a red one blanketing the rest. The closeness of the result – *again* – made it all the more crushing to those on the losing side. 'We had the money, we had a ground operation the likes of which has never been seen, and we had a good candidate,' wailed Democratic fundraiser Harold Ickes. 'We had all that, and we still lost. People are going to ask, "What do we have to do?"'

A few weeks later, the young Nebraskan singer-songwriter Conor Oberst debuted a new song, 'When the President Talks to God', at New York's Town Hall. It is not, to be frank, a great song – it is callow, overstated and clumsy with anger – but that very failure of poise spoke powerfully to Oberst's young, liberal audience. 'I can't think of many occasions when I felt an audience was so engrossed in the drama of a song,' observed critic Rob Tannenbaum, 'and I don't know that I've ever seen a singer project as much sincerity. There was a point when I thought he was going to start crying.'*

Two wars, and a litany of domestic failures, couldn't bring Bush to his knees. That would take a hurricane.

*

Damien Randle and Micah Nickerson, the two rappers who call themselves the Legendary K.O., noticed the first evacuees arriving in Houston during the last week of August 2005, a few days before Hurricane Katrina made landfall on the Gulf Coast. The migrants came from New Orleans in cars stuffed with family members and piled high with possessions, desperate to get out of the path of the oncoming storm.

But around 250,000 New Orleans residents, a fifth of the city's population, either refused to leave their homes or lacked the transport to do so. As a state of emergency was declared in parts of Louisiana, Alabama and Mississippi, the National Hurricane Center raised the dreadful possibility that the storm might overwhelm the levees protecting New Orleans. Some of the citizens remaining in the city began sheltering in designated

* Oberst was, however, reluctant to repeat the feat. When one radio station asked him to play 'When the President Talks to God' during an interview, he declined. 'I just wasn't into it,' he explained to the *Guardian*'s Laura Barton. 'And they really wanted to talk about politics, to carry this torch for them that was obviously their idea of what I was all about. And when I sort of refused, it turned on a dime to almost anger or resentment.'

refuges such as the Louisiana Superdome. On the morning of Monday, 29 August, Katrina, now a Category 3 storm, smashed into New Orleans and levee and after levee collapsed. Broken-hearted Louisiana senator John Breaux described the city, 80 per cent of which was now submerged, as 'Baghdad under water'.

The images on TV seemed incompatible with life in the USA in the twenty-first century. The city was swamped in a thick brown soup of floodwater and sewage, glinting with spilled oil and leaked chemicals, dotted with wreckage and corpses. Babies, old people and victims of exhaustion died in front of the cameras. Survivors perched on the roofs of their drowned houses and sent distress signals to passing helicopters. Rumours circulated of rampant looting and other crimes, involving both the genuinely desperate and the violently opportunistic, because nobody seemed to be in charge any more. Electricity, fresh water and phone services had been snatched away in a stroke. Inside the darkened, overcrowded Superdome and New Orleans Civic Center, tens of thousands of weary refugees broiled in the heat and stink. Not until Friday – four days after the storm hit – did National Guardsmen and supply convoys arrive in the city to begin rescuing survivors.

Randle and Nickerson volunteered, respectively at the convention centre and the Astrodome, as post-flood evacuees began arriving in Houston. 'It reminded me of a shanty town somewhere in Jamaica,' says Randle. 'The news coverage started to get to a lot of people. They weren't degenerates, they weren't casualties of war. They were normal people caught in a very bad situation. A lot of us started to realise that these people who were still stuck in New Orleans had no idea how they were being portrayed. They didn't even have an outlet to tell their side of the story.'

The Chicago rapper Kanye West was just one of a phalanx of celebrities recruited to drum up donations on NBC's telethon that Friday night.* Famous as much for his braggadocio as his

* One guest, Aaron Neville, gave a moving performance of 'Louisiana 1927', Randy Newman's 1974 account of another time the levees broke: a piece of history rendered grimly topical.

talent, he was accustomed to making outlandish statements but only on the pressing subject of Kanye West, and the matchless brilliance thereof. But when you watch a clip of the telethon, you see something else come over him. While comedian Mike Myers diligently reads the autocue, West clears his throat and, in a breathless, uneven voice, begins: 'I hate the way they portray us in the media. If you see a black family, it says they're looting; if you see a white family, it says they're looking for food.' He rambles on for a while before Myers takes a deep breath and plugs on robotically with the script, and then you can almost see the cogs in West's brain click into place as he blurts out: 'George Bush doesn't care about black people.' It's a remarkable piece of television; Myers's open-mouthed double-take is certainly the funniest thing he has done in years. 'I was just flipping the channels and I turned to the telethon maybe twenty seconds before he said that,' remembers Randle. 'I hadn't even got a chance to digest what I was watching. I was floored for a second because I didn't really think what I was looking at was real! People never really knew him to take a stand on something so heavy.'

NBC edited the outburst from the version that was broadcast three hours later on the west coast, but that February had seen the launch of the revolutionary video-sharing website YouTube, and the clip circulated the globe regardless. As was the case with Natalie Maines two years earlier, West's extemporaneous comment carried more political weight than any song. But whereas Maines had spoken with cheerful confidence, West's moment of truth was shaky, indeed borderline incoherent, with emotion. Those seven words resonated because they expressed a national mood of betrayal and disappointment with the president. In the days and weeks following Katrina, fingers were pointed at New Orleans mayor Ray Nagin, Louisiana governor Mary Landrieu and Michael Brown, hapless director of the Federal Emergency Management Agency, all of whom failed to move quickly or effectively enough, but West captured a growing feeling that the buck should stop at the Oval Office.

It didn't really matter that his focus on race rather than class was inaccurate. 'I would like to say yeah, he was right but he wasn't,' the Black Eyed Peas' will.i.am. said soon afterwards. 'I'm sure George Bush has a lot of black friends. He loves black people with a fuck of a lot of money. He doesn't care about people that don't have money. It just so happens that those people are black.'

The Legendary K.O. talked about the comment over the weekend. On Tuesday, Randle received an email from Nickerson containing the first half of a song, set to the beat of West's recent hit 'Gold Digger' in the same repurposing spirit as a 1960s freedom song. As soon as Randle got home from work he recorded the last verse in less than twenty minutes. 'A lot of what we were saying was stuff we'd already been saying amongst ourselves,' he says. 'It was just a matter of putting it into a song format.' The duo promptly emailed the finished song to friends, one of whom posted it on his hip-hop website. The next morning Randle had 200 complimentary emails in his inbox. By Friday, just a week after West's comments, he was getting calls from major newspapers and TV stations, and hundreds of thousands of people had downloaded the song. It was the first protest song to become a viral internet sensation. 'The immediacy of it was astounding to me,' says Randle. 'This song would not have been possible three or four years before.'

One reason 'George Bush Doesn't Care About Black People' was so effective is that it was as vividly topical as an old folk ballad about a mining disaster. Another is that it's funny. In contrast to the mute, huddled victims portrayed on the news, the song's storm-hit narrator is pithy, pugnacious, resilient, flipping West's chorus about a mercenary girlfriend – 'I ain't saying she's a gold digger / But she ain't messing with no broke niggas' – in George Bush's direction. 'Unfortunately a lot of people don't take to serious songs too easily,' says Randle. 'You almost have to sugar coat it in order to trick people into listening to it. Some people said, "You guys should do a remix of that track with your own beat – make it grittier and darker in order to fit the mood." And

we said, "No, we're going to leave it as it is. That's what caught people's attention the first time."'

The song seemed to spur other rappers into action. New Orleans-born Lil' Wayne, who lost friends in the hurricane, drolly sampled Ray Charles's 'Georgia on My Mind' on 'Georgia . . . Bush'. 'Hurricane Katrina,' drawled Wayne, 'we should've called it Hurricane Georgia Bush.' Brooklyn's Mos Def rushed out 'Katrina Clap'. Other MCs, like the superstar-turned-mogul Jay-Z, took longer to respond. 'I personally felt that Jay-Z's approach was somewhat disingenuous because his ["Minority Report"] came well after the fact,' says Randle. 'Most of the big artists who did speak up still didn't give it the kind of bite they should have. They stand to lose more if they don't calculate their moves.'

But it was soon apparent that Katrina had swept away the last teetering struts of George Bush's authority, and with it any sense of risk that accompanied criticising him. 'After Katrina happened, people in the South saw people starving to death because of ineptitude by the government,' says Michael Franti. 'And Bush came down and made a bunch of bullshit speeches and everybody was like, What the *fuck*? And that really changed the attitude of the country overnight.'

The president's approval rating went south. Opposition to the war in Iraq was growing by the week, as was the US death toll. When Natalie Maines was interviewed by *Time* in May 2006, she felt comfortable retracting her 2003 apology. 'I apologised for disrespecting the office of the President,' she said. 'But I don't feel that way any more. I don't feel he is owed any respect whatsoever.'

*

Neil Young's sustained assault on the president in 2006, *Living With War*, was therefore notable less for its timing than for its ferocity: with one song called 'Let's Impeach the President', he could not be accused of hedging his bets. The McGovern liberal who became a Reagan cheerleader had come full circle,

surpassing even 'Ohio' in the scale of his scalding indignation.*
Young turned his website into a news service about the war, and
invited fans to send in their own protest songs. In a shrewd stroke
of *realpolitik* he decided that the album would have more impact
if he harnessed it to a Crosby, Stills, Nash and Young reunion,
so he issued a take-it-or-leave-it invitation to his quondam band-
mates: tour the album, as a complete body of work, adding only
those old songs which fitted the anti-war theme.

Hence the confrontational 'Freedom of Speech' tour, timed
to precede the midterm elections in November, resurrected old
Vietnam-era songs like 'Ohio', 'Military Madness' and 'For
What It's Worth': what the enduringly cantankerous Stills, who
required the most persuasion, called 'the dated, boring-assed
fucking protest music'. For years, Young had felt unable to sing
'Ohio' because it felt too much like 'a rush of nostalgia . . . But
in this period of time that doesn't apply. What it is now is a his-
tory. We're bringing history back. That's what folk music does.'

Old warhorses like CSNY weren't the only ones reaching for
classic protest songs. Hip-hop act the Roots turned 'Masters
of War' into a funk-rock battlefield, the Flaming Lips and the
Dresden Dolls both covered Black Sabbath's 'War Pigs' (1970),
Bruce Springsteen recorded an album of songs made famous
by Pete Seeger, including 'We Shall Overcome' and 'Bring 'Em
Home', and anti-war demonstrators could still be heard singing
'Give Peace a Chance'.

Newer songs such as Pink's 'Dear Mr President' and Ian Brown's
'Illegal Attacks' did not stand up so well.† More artistically success-

* Like 'Ohio', *Living With War* was spurred by a photograph (a *USA
Today* picture of wounded soldiers on a hospital plane) and written
and recorded quickly, in just nine days.
† Among those who also wrote critical songs during Bush's second
term were the Manic Street Preachers, Rufus Wainwright, Pearl Jam,
Sonic Youth, Pet Shop Boys, System of a Down, Tom Morello, the
Coup, Travis, James McMurtry, Sum 41, Linkin Park, Willie Nelson,
the Rolling Stones, Ministry and the Eagles.

ful were those who translated their disgust with Bush into opaque protest. Arcade Fire's *Neon Bible*, Gorillaz's *Demon Days*, TV on the Radio's *Dear Science* and Erykah Badu's *New Amerykah Part One (4th World War)* all embodied the distemper of the times, while Muse, Nine Inch Nails and the Flaming Lips framed opposition to the president in the language of science-fiction on, respectively, *Black Holes and Revelations*, *Year Zero* and *At War With the Mystics*.* 'We really do love having someone we can all hate,' says the Flaming Lips' Wayne Coyne. 'I liked the idea that we had this one common bond between us. Even if we can't all like the same kind of music we can all hate George Bush.'

Even as he was performing these songs, however, Coyne scented something half-hearted behind the cheers and jeers. 'I thought we'd reach this tipping point where everybody just went, "Oh my God, we have to do something,"' he says. 'But it's not like Vietnam. My brothers knew guys at high school who got drafted, and two weeks later they were dead. That's a powerful experience. When Green Day are singing a song you're like, "Cool song, dude, I got my new iPhone." That's not a powerful experience. The youth aren't dying in the same way. There's no protest, really. They weren't powerless – they just didn't give a shit.'

The singer-songwriter John Mayer examined this feeling on 'Waiting on the World to Change', which took its chord progression from Curtis Mayfield's 'People Get Ready' but replaced Mayfield's call to action with a manifesto for apathy. It was profoundly passive and defeatist, and whereas Radiohead explored the existential agony induced by political impotence, Mayer served up a pablum of glib cynicism. According to Mayer, 'We see everything that's going wrong,' but 'we just feel like we don't have the means to rise above and beat it.' As he told *The Advocate*, 'It's saying, "Well, I'll just watch *American Idol* because I know that if I were engaged in changing anything for the better, or the

* So distracting was all the cosmic hoo-hah that nobody commented, or perhaps even noticed, that the lyrics to Muse's 'Assassin' appeared to advocate shooting world leaders.

better as I see it, it would go unnoticed or be completely ineffective." A lot of people have that feeling.' True enough, but Mayer did nothing to interrogate or challenge that feeling. The song's answer is simply to hang around until this generation gets old enough to govern the country, at which point, for reasons Mayer does not specify, the world will finally become a better place.

Willy Mason's 'Oxygen' was also a young man's lament, both pained and consoling, and, yes, a little jejune, but Mason took some responsibility by calling on his peers to 'speak louder than ignorance'. Mayer, instead, gave his listeners licence to stay quiet, just 'waiting on the world to change'. Fatuous in its assumptions about one generation's moral superiority, delusionally smug in its passivity, dishonest in its pretence that it is part of the solution rather than the problem, this spineless shrug of a record was perhaps the protest song its listeners deserved.

Epilogue

In the epilogue to the first edition, completed in December 2010, I wrote: 'I began this book intending to write a history of a still-vital form of music. I finished it wondering if I had instead composed a eulogy.' It was an unfortunate choice of words, because it was generally read as meaning I *definitely* believed I had composed a eulogy. I am not that pessimistic. Certainly we have to concede that the era of the mainstream protest song, when it was such a natural part of the pop conversation that even the biggest artists in the world felt moved to write one or two, is over. Protest music no longer has a clear and undeniable presence: a narrative that states its case. If we accept that, and stop waiting for a full-blown revival, we can still feel inspired by the numerous exceptions.

Firstly, it is a fallacy to assume that political upheaval automatically triggers an avalanche of protest songs. Certainly political unrest has experienced a remarkable rebirth after a relatively fallow period. *Time* magazine made its Person of the Year for 2011 'The Protester', citing the Arab Spring, Occupy Wall Street and anti-austerity movements in Greece and Spain; *The Guardian* drew comparisons with the similarly seismic 1968 and 1989. But you need groundwork before you can have songs to reflect these struggles. The 1960s protest generation were connected, via folk, to the idealism of the 1930s; the most politicised punks had some kind of bond with the 1960s; the outspoken artists of the 1980s and 90s were the children of punk, or of radical soul music. But for a songwriter coming of age now, the idea that music can, and should, engage with politics seems increasingly distant. There

has been a missing generation, and the long decline in political songwriting that began in the 90s cannot be reversed overnight. It will be interesting to see what musicians who came of age during the economic crisis will do further down the line, and if one of them can have the creatively galvanising force of a Bob Dylan, Clash or Public Enemy.

As for their commercial reach, however, we may have to manage our expectations in an age of atomised media outlets and listening habits. Pop music is no longer a party in which very different people are constantly bumping into each other, but a mansion in which every room is occupied by a different constituency. The biggest room, thanks to increasingly narrow radio playlists, has never been more homogenous, thus shutting out many unorthodox voices, including politically motivated ones. And pop itself plays a less central part in the cultural landscape. The heyday of the mainstream protest song was also an era when music was the most exciting and relevant outlet for dissent. Now, chiefly because of the internet and social media, it is one option among many. As the critic Simon Reynolds writes, 'The realities of how music is made, distributed, consumed and experienced seem to agitate against investing belief in artists as spokespersons/saviours . . . These days, a performer who wanted to have any kind of political effect would most likely not bother writing a song about an issue, but get involved in activism . . . But even this will tend to get mocked as superstar grandstanding or noblesse oblige.'

Therein lies another challenge. *The Simpsons Movie* (2007) contains a revealing and funny scene in which Green Day are performing a concert in the quintessential Middle American town of Springfield. A weary Billie Joe Armstrong says: 'We've been playing for three and a half hours. Now we'd like just a minute of your time to say something about the environment.' There is a pregnant pause, followed by a barrage of rubbish and angry cries of, 'Preaching!'

The scene mocks how absurdly unforgiving the discourse

around politics and pop has become. Take the case of M.I.A., aka Anglo-Sri Lankan singer/rapper Maya Arulpragasam, the daughter of a Tamil activist. Her music is a vivid bustle of styles and ideas which evokes the surging confidence of the developing world in an age of increasingly porous borders. For her, globalisation is an arena of friction as well as fusion. She is from everywhere and nowhere, a globe-trotting hustler with a frisson of both radical chic and gangsta rap recklessness. Her 2007 hit 'Paper Planes' samples the Clash's 'Straight to Hell' (1982) but the Third World citizens who are downtrodden in Joe Strummer's lyric are newly empowered in M.I.A.'s: the chorus resounds to the noise of gunshots and cash tills. M.I.A. has variously suggested that the song is a celebration of immigrant culture and a critique of the arms industry, but the lyric insists on neither interpretation: can it somehow be both? It is, as Greil Marcus said of 'Street Fighting Man', 'a challenging emotional jigsaw puzzle, not congratulations for being on the right side'.

In interviews, however, M.I.A. is prone to hyperbole, conspiracy theory and fatuous sloganeering. Because of the internet, her inconsistencies and missteps have been debated to an extent that earlier political musicians never had to deal with, but the questions extend back to the birth of the modern protest song: What right does a musician have to discuss politics? What place is there for serious political issues in entertainment? And the answer is the same as ever: there comes a point when we have to accept that a musician does not have the same responsibilities as a politician, and that music can contain, and derive energy from, ambiguities that an interview cannot.

M.I.A. is not a policy-maker or pundit, nor does she preach solutions; she does not have to be sophisticated or exhaustively well informed to be interesting and resonant. Her pop music is always two steps ahead of her politics. The same could be said of many who have gone before her.

So the obstacles are obvious and yet, in the two years since I wrote the first edition, wonderful protest songs have flowered

in diverse places. PJ Harvey's *Let England Shake*, the most acclaimed album of 2011, was an eloquent and multivalent song suite about war and national identity, drawing inspiration from poems, paintings, diaries and news reports. Lady Gaga named her gay-rights anthem 'Born This Way' after Carl Bean's song and backed it up by campaigning for gay marriage and against the US military's since-revoked Don't Ask Don't Tell policy. Connecticut musician tUnE-yArDs reflected the motley, communal energy of street protest in 'My Country', which hijacked 'My Country 'Tis of Thee' from a globalist, feminist perspective: 'My country 'tis of thee/Sweet land of liberty/How come I cannot see my future within your arms?' Rapper Plan B addressed both the demonisation of working-class 'chavs' and the riots which flared in Britain's urban centres in August 2011 in the unusually complex (and indecently exciting) 'iLL Manors'. Veterans Bruce Springsteen, Tom Waits and Ry Cooder caustically addressed the economic crisis while young musicians such as Leicester's Grace Petrie began to write protest songs with precision and vigour. And let's not ignore the newly unleashed voices of dissent beyond the west. In Cairo's Tahrir Square, unknown singer-songwriter Ramy Essam echoed the ad-hoc compositions of the civil-rights freedom singers by fashioning the chanted slogans of demonstrators into 'Irhal (Leave)', a powerful song calling for the resignation of President Hosni Mubarak. In Russia, three members of feminist punk agitators Pussy Riot were jailed for two years for illegally performing a 'punk prayer' called 'Mother of God Drive Putin Away' in a Moscow cathedral. Their trial became a cause celebre for dozens of western artists including Madonna, Patti Smith and original Riot Grrrls Bikini Kill.

These artists do not cohere into a movement, it's true, but what they have in common is political conviction and the talent to channel it in ways that seem fresh and vital. If we wax nostalgic about 'Blowin' in the Wind' or 'Ghost Town' – products of specific and unrepeatable historical moments – or long for the larger-than-life 'spokesperson/saviour', then we are doomed to

disappointment. If, however, we accept that we have to look for great protest songs in diverse places, then we will find them.

Do activists and demonstrators need protest songs? Probably not. When I accompanied Tom Morello to Occupy London Stock Exchange, where he performed a surprise acoustic set, he told me: 'The media likes to quantify things: what's the anthem? Occupy is not an advertising agency – it's a social movement. I don't think it needs a Kanye West jam that says "let's occupy y'all" to bring it all together. The movement's not waiting for it. My broader concern is what are we all doing about the problem of gross economic inequality? There aren't enough musicians making songs? Who the fuck cares?' But music, like any serious artform, needs a political dimension, lest it become blithely removed from the world outside. Escapism is fine – I love escapism – but it is not enough.

To create a successful protest song in the twenty-first century may seem to be a daunting challenge, but what I think this book demonstrates is that it has never been easy. To take on politics in music is always a leap of faith, a gesture of hope over experience, because there are always a dozen reasons not to. The fact that artists as diverse as PJ Harvey, Plan B and Lady Gaga have taken that leap since I wrote the first epilogue gives me hope. Back then, nobody would have predicted the extraordinary political events of 2011. Pop music, like history, has a habit of springing surprises.

Appendix 1

A Short History of Protest Songs Before 1900

The history of protest singing at the dawn of the twentieth century was understood rather than studied: a melting pot of topical ballads, labour songs, parodies, spirituals and hymns. Before the advent of recorded sound, songs were popularised by word-of-mouth, so the quickest way to get a topical message to the people was to fasten new lyrics to well-known melodies, much as football chants are created today. As far back as the thirteenth century, renegade clerics known as Goliards adapted Latin hymns in order to lampoon the Catholic church. Medieval ballads such as 'Song of the Husbandman' satirised the ruling classes. The earliest confirmed example of a protest song is the couplet, 'When Adam delved and Eve span / Who was then the gentleman?', which became popular during the 1381 Peasants' Revolt.

In the sixteenth and seventeenth centuries, cheap printing presses allowed the circulation of hundreds of thousands of topical ballads, attached to folk melodies and named after the one-sided sheets that bore them: broadsides. The Thirty Years War inspired the anti-war ballad 'The Maunding Souldier or, The Fruits of Warre is Beggery', while the ferment of the English Civil War produced 'The Diggers' Song', a rallying cry for the eponymous agrarian radicals, and 'The World Turned Upside Down', which critiqued Oliver Cromwell's outlawing of traditional Christmas festivities. In a 1703 letter to the Marquis of Montrose, the Scottish politician Andrew Fletcher wrote: 'I knew a very wise man . . . [who] believed if a man were permitted to make all the ballads, he need not care who should make the laws of a nation, and we find that most of the ancient legislators

thought that they could not well reform the manners of any city without the help of a lyric, and sometimes of a dramatic poet.'

If the broadsides resembled news reports, then nineteenth-century examples could sometimes be more like sermons. English composer Henry Russell wrote over 800 songs, decrying slavery, alcoholism, industrialisation and conditions in madhouses. Later, socialists recognised the morale-boosting value of music, and left-wing songbooks began to appear, full of borrowed tunes. Many industrial folk songs about life in the coal mines ('The Black Leg Miner') and factories ('Poverty Knock') were compiled decades later by song collectors Ewan MacColl and A. L. Lloyd. Reviewing Edward Carpenter's *Chants of Labour* in 1889, Oscar Wilde wrote: 'They are not of any very high literary value, these poems that have been dexterously set to music. They are meant to be sung, not to be read. They are rough, direct and vigorous, and the tunes are stirring and familiar. Indeed, most any mob could warble them with ease . . . It is evident from Mr Carpenter's book that should the Revolution ever break out in England we shall have no inarticulate roar but, rather, pleasant glees and graceful part-songs.'

The tradition simultaneously developed across the Atlantic. A market in broadsides developed in the years leading to the American War of Independence; the anti-British messages of 'American Taxation' and 'Free Americay' were both pointedly set to the melody of 'The British Grenadiers'. Indeed, the US national anthem, 'The Star-Spangled Banner', started life in 1814 as a broadside called 'Defence of Fort McHenry', set to the tune of a British drinking song, 'The Anacreontic Song'. During the 1840s the New Hampshire-based Hutchinson Family Singers toured the country singing songs in favour of abolitionism and women's suffrage and tended to borrow melodies from the church. 'Who can measure the influence of their songs of freedom upon the unformed opinions of the youth of the day?' wrote journalist Frank Carpenter in 1896. Meanwhile, black slaves voiced their dissatisfaction in the coded form of spirituals.

In the late nineteenth century, labour pamphlets published reams of lyrics written by workers about working conditions, politicians and other pressing issues. The Wobblies and Joe Hill were just around the corner.

Appendix 2

Songs Mentioned in the Text

The following is a list of every relevant song and album mentioned in the text. It is not intended to be a discography, complete with label information and catalogue numbers, but rather a chronological reference tool for readers who would like to know when certain songs were first recorded or performed. Dates given are usually the dates of the first commercial release. In the case of unreleased material, I have given the date of the first recording or live performance. Where significant time elapsed between a song's composition or live debut and its commercial release, I have given both dates. Dates and artist credits have been variously derived from the records themselves; *The Guinness Book of Hit Singles and Albums*; specialist websites maintained by artists or fans; and the online resources, allmusic.com and discogs.com: two invaluable treasure troves for the discographically minded.

I. 'STRANGE FRUIT'

Billie Holiday, 'Strange Fruit', 1939
Lead Belly, 'Bourgeois Blues', 1938
Lou Rawls, 'Strange Fruit', 1963
— —, *Black and Blue*, 1962
Ethel Waters, '(What Did I Do to Be So) Black and Blue', 1929
— — 'Supper Time', 1933
Josh White and the Carolinians, *Chain Gang*, 1940
Josh White, *Southern Exposure: An Album of Jim Crow Blues*, 1941
— — 'Strange Fruit', 1942

2. 'THIS LAND IS YOUR LAND'

The Almanac Singers, *Songs for John Doe*, 1941
— — 'Mister Lindbergh', 1941
— — 'Washington Breakdown', 1941
— — 'Reuben James', 1942
— — 'Round and Round Hitler's Grave', 1942
— — 'Dear Mr President', 1942
Marc Blitzstein, *Cradle Will Rock*, 1937
The Carter Family, 'Little Darling, Pal of Mine', 1927
Aaron Copland, *Hear Ye! Hear Ye!*, 1934
Sarah Ogan Gunning, 'I Hate the Capitalist System', 1938
Woody Guthrie, 'So Long, It's Been Good to Know You', 1936/1940
— — 'Talking Dust Bowl Blues', 1936/1940
— — 'Do Re Mi', 1937/1940
— — 'Dust Bowl Refugees', 1938/1940
— — 'Dust Pneumonia Blues', 1938/1940
— — 'Dust Can't Kill Me', 1938/1940
— — 'I Ain't Got No Home in This World Anymore', 1938/1940
— — 'More War News', 1939
— — *Dust Bowl Ballads*, 1940
— — 'Tom Joad', 1940
— — 'This Land Is Your Land', 1940/1944
— — 'Grand Coulee Dam', 1941
— — 'Roll On, Columbia, Roll On', 1941
— — 'Deportee (Plane Wreck at Los Gatos)', 1948
Joe Hill, 'The Preacher and the Slave', 1911
— — 'Casey Jones the Union Scab', 1912
— — 'There Is Power in a Union', 1913
Aunt Molly Jackson, 'Kentucky Miner's Wife', 1931
Florence Reece, 'Which Side Are You On?', 1931
Paul Robeson, 'Ballad for Americans', 1939
Earl Robinson and Alfred Hayes [composers], 'Joe Hill', 1936
Kate Smith, 'God Bless America', 1938
Trad. Arr., 'We Shall Not Be Moved'
— — 'Oh, My Loving Brother'

3. 'WE SHALL OVERCOME'

Ralph Abernathy, 'Ain't Gonna Let Nobody Turn Me Round', 1962
Ray Anderson, 'Stalin Kicked the Bucket', 1953

Songs Mentioned in the Text

Joan Baez, 'We Are Crossing Jordan River' (live), 1959
Ray Charles, 'Hit the Road, Jack', 1961
Laura Duncan, 'We Shall Overcome', 1952
Freedom Riders, 'Get Your Rights, Jack', 1961
Joe Glazer and His Elm City Four, 'We Will Overcome', 1950
Sam Hinton 'Old Man Atom', 1950
Ferlin 'Terry Preston' Husky, 'Let's Keep the Communists Out', 1950
The Kingston Trio, 'Tom Dooley', 1958
Harry Dixon Loes (composer), 'This Little Light of Mine', c. 1920
The Louvin Brothers, 'Weapon of Prayer', 1951
Ewan MacColl, 'The Ballad of Ho Chi Minh', 1954
— — 'The Ballad of Sharpeville', 1960
— — 'That Bomb Has Got to Go!', 1961
Paul Robeson, 'Steal Away', 1925
— — 'Joshua Fit the Battle of Jericho', 1925
— — 'Go Down, Moses', 1930
Pete Seeger, 'If I Had a Hammer (The Hammer Song)', 1949
— — 'Wasn't That a Time', 1949
— — 'Where Have All the Flowers Gone?', 1955/1960
— — 'We Shall Overcome', 1964 [Seeger's first studio version]
Trad. Arr., 'Wade in the Water'
— — 'Gospel Train'
— — 'No More Auction Block for Me'
— — 'Hold On' (aka 'Gospel Plow')
— — 'Everybody Sing Freedom'
— — 'I'm on My Way to the Freedom Land'
The Weavers, 'Goodnight, Irene', 1950
— — 'So Long, It's Been Good to Know You', 1950
— — 'Rock Island Line', 1951
— — 'Wimoweh', 1952
Hank Williams, 'No, No, Joe', 1950
Wallace Willis (composer), 'Swing Low, Sweet Chariot', c. 1870
Alice Wine, 'Keep Your Eyes on the Prize', 1956

4. 'MASTERS OF WAR'

The Animals, 'We've Gotta Get Out of This Place', 1965
The Back Porch Majority, 'A Song of Hope', 1966
Bob Dylan, *Bob Dylan*, 1962
— — 'Blowin' in the Wind', 1962/1963
— — 'The Ballad of Emmett Till', 1962

— — 'Talkin' John Birch Society Blues', 1962
— — 'I'd Hate to Be You on That Dreadful Day', 1962
— — 'Train a-Travelin'', 1962
— — 'I Will Not Go Down Under the Ground' (aka 'Let Me Die in My Footsteps'), 1962
— — *The Freewheelin' Bob Dylan*, 1963
— — 'Oxford Town', 1963
— — 'A Hard Rain's a-Gonna Fall', 1963
— — 'Masters of War', 1963
— — *The Times They Are a-Changin'*, 1964
— — 'The Times They Are a-Changin'', 1964
— — 'With God on Our Side', 1963/1964
— — 'Only a Pawn in Their Game', 1963/1964
— — 'When the Ship Comes In', 1963/1964
— — 'The Lonesome Death of Hattie Carroll', 1964
— — 'Mr Tambourine Man', 1964
— — 'Chimes of Freedom', 1964
— — *Another Side of Bob Dylan*, 1964
— — *Bringing It All Back Home*, 1965
— — 'My Back Pages', 1964
— — 'Subterranean Homesick Blues', 1965
— — 'It's Alright, Ma (I'm Only Bleeding)', 1965
— — 'Desolation Row', 1965
— — 'Like a Rolling Stone', 1965
— — 'Maggie's Farm', 1965
— — 'It's All Over Now, Baby Blue', 1965
— — 'Positively 4th Street', 1965
— — *Highway 61 Revisited*, 1965
Barry McGuire, 'Eve of Destruction', 1965
Phil Ochs, 'Talking Birmingham Jam', 1963/1964
— — 'Too Many Martyrs', 1964
— — 'Power and the Glory', 1964
— — *All the News That's Fit to Sing*, 1964
Peter, Paul and Mary, 'If I Had a Hammer (The Hammer Song)', 1962
— — 'Blowin' in the Wind', 1963
Jean Ritchie / Trad. Arr., 'Nottamun Town', 1957
Sonny and Cher, 'Laugh at Me', 1965
The Spokesmen, 'Dawn of Correction', 1965

Songs Mentioned in the Text

5. 'MISSISSIPPI GODDAM'

John Coltrane, *Africa/Brass*, 1961
— — 'Song of the Underground Railroad', 1961
— — 'Alabama', 1963
Sam Cooke, 'A Change Is Gonna Come', 1964
Duke Ellington, 'King Fit the Battle of Alabam'', 1963
The Impressions, 'Keep on Pushing', 1964
— — 'People Get Ready', 1965
Charles Mingus, 'Fables of Faubus', 1959
— — 'Original Faubus Fables', 1960
Max Roach, *We Insist! Max Roach's Freedom Now Suite*, 1960
Sonny Rollins, *Freedom Suite*, 1958
Nina Simone, 'Mississippi Goddam', 1963/1964
— — 'Pirate Jenny', 1964
— — 'Feeling Good', 1965
— — 'Strange Fruit', 1965
— — 'Four Women', 1966
— — 'I Wish I Knew How It Would Feel to Be Free', 1967
— — 'The Times They Are a-Changin'', 1969
— — 'Turn! Turn! Turn! (to Everything There Is a Season)', 1969
— — 'To Be Young, Gifted and Black', 1970
Trad. Arr., 'This Train Is Bound for Glory'

6. 'I-FEEL-LIKE-I'M-FIXIN'-TO-DIE RAG'

The Association, 'Requiem for the Masses', 1967
Joan Baez, 'Saigon Bride', 1967
The Beach Bums, 'The Ballad of the Yellow Beret', 1966
Jan Berry, 'The Universal Coward', 1965
Pat Boone, 'Wish You Were Here, Buddy', 1966
Buffalo Springfield, 'For What It's Worth', 1967
Eric Burdon and the Animals, 'Sky Pilot', 1968
The Byrds, 'Draft Morning', 1968
Country Joe and the Fish, 'I-Feel-Like-I'm-Fixin'-to-Die Rag',
 1965/1967/1969
— — 'Who Am I?', 1965/1967
— — 'Superbird', 1965
Creedence Clearwater Revival, 'Bad Moon Rising', 1969
— — 'Fortunate Son', 1969
— — 'Have You Ever Seen the Rain?', 1970

—— 'Run Through the Jungle', 1970

John Denver, 'Leaving on a Jet Plane', 1969

The Doors, 'Unknown Soldier', 1968

Dave Dudley, 'What We're Fighting For', 1965

—— 'Viet Nam Blues', 1966

The Fugs, 'Kill for Peace', 1966

The Goldwaters, *The Goldwaters Sing Folk Songs to Bug the Liberals*, 1964

Arlo Guthrie, 'Alice's Restaurant Massacree', 1967

Jimi Hendrix, 'The Star-Spangled Banner', 1969

—— 'Machine Gun', 1970

Stonewall Jackson, 'The Minute Men (Are Turning in Their Graves)', 1966

Jefferson Airplane, 'Crown of Creation', 1968

Loretta Lynn, 'Dear Uncle Sam', 1966

Ewan MacColl / Trad. Arr., 'The Dove', 1950s

The Monkees, 'Last Train to Clarksville', 1966

Phil Ochs, 'Viet Nam', 1962

—— *I Ain't Marching Anymore*, 1965

—— 'I Ain't Marching Anymore', 1965

—— 'Love Me, I'm a Liberal', 1965/1966

—— 'The War Is Over', 1968

—— 'The Harder They Fall', 1968

—— 'When in Rome', 1968

—— *Rehearsals for Retirement*, 1969

Allen Peltier, 'Day of Decision', 1966

The Rolling Stones, 'Paint It, Black', 1966

Staff Sgt Barry Sadler, 'The Ballad of the Green Berets', 1966

Buffy Sainte-Marie, 'The Universal Soldier', 1964

Pete Seeger, 'The Housewife Terrorists', 1966

—— 'Ballad of the Fort Hood Three', 1966/1969

—— 'Bring Them Home', 1965/1971

—— 'Waist Deep in the Big Muddy', 1967

Simon and Garfunkel, 'A Simple Desultory Philippic (Or How I Was Robert McNamara'd Into Submission)', 1966

—— '7 O'Clock News / Silent Night', 1966

Trad. Arr., 'Ain't Gonna Study War No More'

Johnny Wright, 'Hello, Vietnam', 1965

—— 'Keep the Flag Flying', 1965

7. 'SAY IT LOUD – I'M BLACK AND I'M PROUD'

James Brown and the Famous Flames, *Live at the Apollo*, 1963
James Brown, 'Papa's Got a Brand New Bag', 1965
— — 'Don't Be a Drop Out', 1967
— — 'Cold Sweat', 1967
— — 'America Is My Home', 1968
— — 'Say It Loud – I'm Black and I'm Proud', 1968
— — 'Santa Claus Go Straight to the Ghetto', 1968
— — 'I Don't Want Nobody to Give Me Nothing (Open Up the Door,
 I'll Get It Myself)', 1969
Country Joe and the Fish, *Together*, 1968
Bob Dylan, 'Ballad of a Thin Man', 1965
The Impressions, 'Mighty Mighty (Spade and Whitey)', 1969
Curtis Mayfield, 'Miss Black America', 1970
— — 'We the People Who Are Darker than Blue', 1970
Nina Simone, 'Why? (The King of Love Is Dead)', 1968
Sly and the Family Stone, 'Don't Call Me Nigger, Whitey', 1969
The Temptations, 'Message From a Black Man', 1969
The Wailers, 'Black Progress', 1970

8. 'GIVE PEACE A CHANCE'

The Beatles, 'Taxman', 1966
— — 'All You Need Is Love', 1967
— — 'A Day in the Life', 1967
— — 'I Am the Walrus', 1967
— — 'Strawberry Fields Forever', 1967
— — 'Revolution', 1968
— — *The Beatles* (aka *The White Album*), 1968
— — 'Revolution 1', 1968
— — 'Revolution 9', 1968
— — 'Blackbird', 1968
— — *Abbey Road*, 1969
— — 'Come Together', 1969
Elastic Oz Band, 'God Save Us', 1971
— — 'Do the Oz', 1971
John Lennon / Plastic Ono Band, *John Lennon / Plastic Ono Band*, 1970
— — 'God', 1970
— — 'Working Class Hero', 1970
— — 'Power to the People', 1971

John Lennon, *Imagine*, 1971
— — 'Imagine', 1971
— — 'I Don't Wanna Be a Soldier Mama I Don't Wanna Die', 1971
— — 'Gimme Some Truth', 1971
The Plastic Ono Band, 'Give Peace a Chance', 1969
The Rolling Stones, 'Street Fighting Man', 1968
— — *Beggars Banquet*, 1968
— — 'Salt of the Earth', 1968
— — 'Sympathy for the Devil', 1968
— — *Let It Bleed*, 1969
— — 'Gimme Shelter', 1969
— — 'You Can't Always Get What You Want', 1969
Nina Simone, 'Revolution (Pts 1 & 2)', 1969
P. F. Sloan, 'Sins of a Family', 1965
The Who, 'My Generation', 1965

9. 'WAR'

Abdullah, 'I Comma Zimba Zio (Here I Stand the Mighty One)', 1968
— — 'Why Them, Why Me', 1968
William Bell, 'Marching Off to War', 1966
The Chambers Brothers, 'Time Has Come Today', 1966
The Chi-Lites, '(For God's Sake) Give More Power to the People', 1971
— — 'We Are Neighbours', 1971
Aretha Franklin, 'Respect', 1967
— — 'People Get Ready', 1968
— — 'Think', 1968
Marvin Gaye, 'I Heard It Through the Grapevine', 1968
— — 'What's Going On', 1971
— — *What's Going On*, 1971
— — 'Inner City Blues (Make Me Wanna Holler)', 1971
— — 'What's Happening Brother', 1971
— — 'God Is Love', 1971
Gladys Knight and the Pips, 'I Heard It Through the Grapevine', 1967
J. B. Lenoir, 'Vietnam Blues', 1966
Les McCann, 'Compared to What', 1969
Elvis Presley, 'In the Ghetto', 1969
Otis Redding, '(I Can't Get No) Satisfaction', 1965
Martha Reeves and the Vandellas, 'Dancing in the Street', 1964

— — 'Jimmy Mack', 1967
— — 'I Should Be Proud', 1970
Smokey Robinson and the Miracles, 'I Care About Detroit', 1968
Diana Ross and the Supremes, 'Love Child', 1968
Sam and Dave, 'Soul Man', 1967
Nina Simone, 'Backlash Blues', 1967
Sly and the Family Stone, *A Whole New Thing*, 1967
— — 'Dance to the Music', 1967
— — *Dance to the Music*, 1968
— — 'Dance to the Medley', 1968
— — 'Don't Burn Baby', 1968
— — 'Color Me True', 1968
— — 'I Want to Take You Higher', 1969
— — 'Everybody Is a Star', 1969
— — 'Stand!', 1969
Edwin Starr, 'War', 1970
— — 'Stop the War Now', 1970
The Temptations, 'Cloud Nine', 1968
— — 'Ball of Confusion (That's What the World Is Today)', 1970
— — 'You Make Your Own Heaven and Hell Right Here on Earth', 1970
— — 'Psychedelic Shack', 1970
— — 'War', 1970
— — 'Ungena Za Ulimwengu (Unite the World)', 1971
Stevie Wonder, 'Blowin' in the Wind', 1966

10. 'OHIO'

Bill Anderson, 'Where Have All Our Heroes Gone', 1969
The Beach Boys, 'Student Demonstration Time', 1971
C Company feat. Terry Nelson, 'The Battle Hymn of Lt. Calley', 1971
Johnny Cash, 'What Is Truth?', 1970
Chicago Women's Liberation Rock Band, 'Ain't Gonna Marry', 1972
David Crosby, 'What Are Their Names', 1971
Crosby, Stills and Nash, 'Wooden Ships', 1969
— — 'Long Time Gone', 1969
— — 'Almost Cut My Hair', 1970
— — 'Teach Your Children', 1970
— — 'Ohio', 1970
— — 'Find the Cost of Freedom', 1970
Devo, 'Ohio', 2002

Guy Drake, 'Welfare Cadillac', 1970

Bob Dylan, 'Hurricane', 1975

Allen Ginsberg, 'Going to San Diego', 1971

Merle Haggard, 'Okie From Muskogee', 1969

— — 'The Fightin' Side of Me', 1970

John Lee Hooker, 'The Motor City Is Burning', 1967

Harlan Howard, *To the Silent Majority with Love*, 1971

— — 'Better Get Your Pride Back Boy', 1971

— — 'Uncle Sam I'm a Patriot', 1971

Jefferson Airplane, 'Volunteers', 1969

John and Yoko / Plastic Ono Band, *Some Time in New York City*, 1972

— — 'John Sinclair', 1972

— — 'Attica State', 1972

— — 'Sisters, O Sisters', 1972

— — 'The Luck of the Irish', 1972

John Lennon, 'Bring on the Lucie (Freda People)', 1973

Victor Lundberg, 'An Open Letter to My Teenage Son', 1967

Lynyrd Skynyrd, 'Sweet Home Alabama', 1974

MC5, 'Kick Out the Jams', 1968/1969

— — 'Motor City Is Burning', 1969

Graham Nash, 'Chicago', 1971

— — 'Military Madness', 1971

New Haven Women's Liberation Rock Band, 'Abortion Song', 1972

Randy Newman, 'Political Science', 1972

— — 'Rednecks', 1974

Phil Ochs, 'No More Songs', 1970

— — 'Here's to the State of Richard Nixon', 1971

Helen Reddy, 'I Am Woman', 1972

The Stooges, '1969', 1969

Thunderclap Newman, 'Something in the Air', 1969

The Who, 'Won't Get Fooled Again', 1971

Wings, 'Give Ireland Back to the Irish', 1972

Stevie Wonder, 'Heaven Help Us All', 1970

Neil Young, 'Don't Let It Bring You Down', 1970

— — 'After the Goldrush', 1970

— — 'Southern Man', 1970

— — 'Alabama', 1972

Neil Young and Graham Nash, 'War Song', 1972

11. 'THE REVOLUTION WILL NOT BE TELEVISED'

Bob Dylan, 'George Jackson', 1971
Nikki Giovanni, *Truth Is On Its Way*, 1971
Amde Hamilton, 'The Meek Ain't Gonna', 1969
John and Yoko / Plastic Ono Band, 'Angela', 1972
The Last Poets, *The Last Poets*, 1970
— — 'Run, Nigger', 1970
— — 'Niggers Are Scared of Revolution', 1970
— — 'Wake Up, Niggers', 1970
— — 'When the Revolution Comes', 1970
— — *This Is Madness*, 1971
Curtis Mayfield, '(Don't Worry) If There's a Hell Below We're All
 Gonna Go', 1970
Sunny Murray with Amiri Baraka, 'Black Art', 1965
The Rolling Stones, 'Sweet Black Angel', 1972
Gil Scott-Heron, *Small Talk at 125th and Lenox*, 1970
— — 'Brother', 1970
— — 'Comment #1', 1970
— — 'Whitey on the Moon', 1970
— — 'The Revolution Will Not Be Televised', 1970/1971
— — *Pieces of a Man*, 1971
— — 'Home Is Where the Hatred Is', 1971
— — 'Lady Day and John Coltrane', 1971
Gil Scott-Heron and Brian Jackson, 'H2Ogate Blues', 1974
— — *Winter in America*, 1974
— — 'Johannesburg', 1976
— — 'We Almost Lost Detroit', 1977
Archie Shepp, 'Attica Blues', 1972
— — 'Blues for Brother George Jackson', 1972
The Temptations, 'Run Charlie Run', 1972
Various Artists, *The Black Voices: On the Streets of Watts*, 1969
The Watts Prophets, *Rappin' Black in a White World*, 1971

12. 'LIVING FOR THE CITY'

The Alexander Review, 'A Change Had Better Come', 1975
James Brown, 'Talkin' Loud and Sayin' Nothing', 1970/1972
— — *There It Is*, 1972
— — *The Payback*, 1973
— — *Hell*, 1974

– – 'Hell', 1974
– – *Reality*, 1974
– – 'Funky President (People It's Bad)', 1974
Lamont Dozier, 'Fish Ain't Bitin'', 1973
Marvin Gaye, 'You're the Man', 1972
– – *Trouble Man*, 1972
Donny Hathaway, 'The Ghetto', 1970
– – 'Little Ghetto Boy', 1972
Isaac Hayes, *Shaft*, 1971
– – *Truck Turner*, 1974
The Honey Drippers, 'Impeach the President', 1973
Willie Hutch, *The Mack*, 1973
– – 'Life's No Fun Living in the Ghetto', 1974
Leroy Hutson, 'The Ghetto 1974', 1974
Weldon Irvine, 'Watergate', 1973
The Isley Brothers, 'Fight the Power', 1975
The JBs, 'You Can Have Watergate Just Gimme Some Bucks and I'll
 Be Straight', 1973
Paul Kelly, 'Stealing in the Name of the Lord', 1970
Eddie Kendricks, 'My People – Hold On', 1972
Curtis Mayfield, *Super Fly*, 1972
– – 'Back to the World', 1973
The O'Jays, *Back Stabbers*, 1972
– – 'Back Stabbers', 1972
– – 'Shiftless, Shady, Jealous Kind of People', 1972
– – *Ship Ahoy*, 1973
– – 'Ship Ahoy', 1973
– – 'For the Love of Money', 1973
– – 'Love Train', 1972
– – 'Don't Call Me Brother', 1973
– – *Family Reunion*, 1975
– – *Survival*, 1975
– – 'Rich Get Richer', 1975
– – *Message in the Music*, 1976
Bobby Patterson, 'This Whole Funky World Is a Ghetto', 1972
Billy Paul, 'Am I Black Enough For You?', 1972
– – 'War of the Gods', 1973
– – 'Black Wonders of the World', 1975
– – *When Love Is New*, 1975
– – 'Let the Dollar Circulate', 1975

The Rance Allen Group, 'Lying on the Truth', 1972
Smokey Robinson, 'Just My Soul Responding', 1973
Gil Scott-Heron, 'The Get Out of the Ghetto Blues', 1972
—— 'Pardon Our Analysis (We Beg Your Pardon)', 1975
—— 'South Carolina (Barnwell)', 1976
Marlena Shaw, 'Woman of the Ghetto', 1969
Sly and the Family Stone, *There's a Riot Goin' On*, 1971
—— 'Family Affair', 1971
—— 'Africa Talks to You (The Asphalt Jungle)', 1971
S.O.U.L., 'Down in the Ghetto', 1971
The Soul Children, 'I Don't Know What This World Is Coming To', 1972
The Spinners, 'Ghetto Child', 1973
The Staple Singers, 'Respect Yourself', 1971
—— 'I'll Take You There', 1972
Swamp Dogg, 'God Bless America For What?', 1971
The Temptations, 'Papa Was a Rolling Stone', 1972
—— *Masterpiece*, 1973
—— 'Law of the Land', 1973
—— 'Masterpiece', 1973
—— *1990*, 1973
Tonto's Expanding Head Band, *Zero Time*, 1971
The Undisputed Truth, 'Smiling Faces (Sometimes)', 1971
War, 'Slippin' into Darkness', 1971
—— 'The World Is a Ghetto', 1972
Kim Weston, 'Lift Ev'ry Voice and Sing', 1972
Stanley Winston, 'No More Ghettos in America', 1970
Bill Withers, 'I Can't Write Left-Handed', 1973
Bobby Womack, 'Across 110th Street', 1972
Stevie Wonder, *Where I'm Coming From*, 1971
—— *Music of My Mind*, 1972
—— *Talking Book*, 1972
—— 'Superstition', 1972
—— 'Big Brother', 1972
—— *Innervisions*, 1973
—— 'Too High', 1973
—— 'Jesus Children of America', 1973
—— 'He's Misstra Know-It-All', 1973
—— 'Higher Ground', 1973
—— 'Visions', 1973
—— 'Living for the City', 1973

— — *Fulfillingness' First Finale*, 1974
— — 'You Haven't Done Nothin'', 1974
— — *Songs in the Key of Life*, 1976
— — *Journey Through the Secret Life of Plants*, 1979

13. 'MANIFIESTO'

The Clash, 'Washington Bullets', 1980
Drugstore feat. Thom Yorke, 'El President', 1998
Arlo Guthrie, 'Victor Jara', 1974/1976
Inti-Illimani, 'Venceremos', 1970
Victor Jara, 'El aparecido', 1967
— — 'Movil Oil Special', 1969
— — 'Preguntas por Puerto Montt', 1969
— — 'Plegaria a un labrador', 1969
— — 'El alma llena de banderas', 1971
— — *La Población*, 1972
— — 'Las casitas del barrio alto', 1972
— — 'El hombre es un creador', 1972
— — *Canto por travesura*, 1973
— — 'Vientos del pueblo', 1973
— — *Manifiesto*, 1973
— — 'Manifiesto', 1973
Quilapayún, 'El soldado', 1969
— — 'Venceremos', 1971
— — 'El pueblo unido jamás será vencido', 1973
Pete Seeger, 'Estadio Chile', 1974
U2, 'One Tree Hill', 1987
Working Week, 'Venceremos (We Will Win)', 1984

14. 'ZOMBIE'

Lord Kitchener, 'Birth of Ghana', 1959
Fela Kuti and Afrika 70, 'Black Man's Cry', 1971
— — 'Why Black Man Dey Suffer', 1971
— — 'Go Slow', 1972
— — 'Alagbon Close', 1974
— — 'Expensive Shit', 1975
— — 'Zombie', 1976
— — 'Sorrow, Tears and Blood', 1977
— — 'Shuffering and Shmiling', 1978

—— 'Unknown Soldier', 1979
—— 'I.T.T. (International Thief Thief)', 1979
—— 'Coffin for Head of State', 1981
Fela Kuti and Nigeria 70, 'Viva Nigeria', 1969
Bob Marley and the Wailers, 'Zimbabwe', 1979
—— 'Africa Unite', 1979
Dorothy Masuka, 'Ghana', date unknown

15. 'WAR INA BABYLON'

The Abyssinians, 'Satta Massagana', 1969/1971
Burning Spear, *Marcus Garvey*, 1975
Junior Byles, 'Beat Down Babylon', 1971
—— 'King of Babylon', 1972
—— 'Pharaoh Hiding', 1972
—— 'A Place Called Africa', 1972
—— 'When Will Better Come', 1973
The Chosen Few, 'Am I Black Enough For You?', 1972
Jimmy Cliff, 'Many Rivers to Cross', 1969
The Congos, *Heart of the Congos*, 1977
Culture, 'Two Sevens Clash', 1977
Desmond Dekker, 'Israelites', 1968
Clancy Eccles, 'River Jordan', 1960
—— 'Freedom', 1960
—— 'Power to the People', 1971
—— 'Rod of Correction', 1971
The Ethiopians, 'Everything Crash', 1968
Leo Graham, 'News Flash', 1973
The Heptones, 'Message From a Black Man', 1970
—— *Party Time*, 1977
—— 'Sufferer's Time', 1977
John Holt, 'Up Park Camp', 1976
David Isaacs, 'A Place in the Sun', 1968
Gregory Isaacs, 'Mr Cop', 1977
Al T. Joe 'Rise Jamaica (Independence Time Is Here)', 1962
Frankie Jones, 'The War Is Over', 1978
Fred Locks, 'Black Star Liner', 1975
Bob Marley and the Wailers, *Natty Dread*, 1974
—— *Rastaman Vibration*, 1976
—— *Exodus*, 1977
—— 'One Love / People Get Ready', 1977

—— *Survival*, 1979
—— 'Redemption Song', 1980
The Meditations, 'Running from Jamaica', 1978
The Melodians, 'Rivers of Babylon', 1972
The Mighty Diamonds, 'Right Time', 1976
—— *Stand Up to Your Judgment*, 1978
Jacob Miller, 'The Peace Treaty Special', 1978
Pablo Moses, 'We Should Be in Angola', 1977
Junior Murvin, 'Police and Thieves', 1976
—— *Police and Thieves*, 1977
—— 'Rasta Get Ready', 1977
Niney the Observer, 'Blood and Fire', 1970
Kentrick Patrick, 'Independent Jamaica', 1962
Lee 'Scratch' Perry, 'People Funny Boy', 1968
—— 'Blowin' in the Wind', 1968
—— (as King Koba), 'Station Underground News', 1973
—— 'Justice to the People', 1973
—— 'Dreadlocks in Moonlight', 1977
The Pioneers, 'Rudies Are the Greatest', 1967
Prince Buster, 'Judge Dread', 1967
—— 'Give Peace a Chance', 1970
Prince Far-I, 'Heavy Manners', 1977
The Professionals, *State of Emergency*, 1976
Max Romeo, 'Wet Dream', 1970
—— 'Labor Wrong', 1970
—— 'Let the Power Fall', 1971
—— 'Ginalship', 1971
—— 'No Joshua No', 1973
—— *Revelation Time*, 1975
—— 'War Ina Babylon', 1976
—— *War Ina Babylon*, 1976
—— 'One Step Forward', 1976
—— 'Uptown Babies Don't Cry', 1976
—— 'Chase the Devil', 1976
Toots and the Maytals, 'Pressure Drop', 1968
—— 'Give Peace a Chance', 1970
—— 'Time Tough', 1974
Peter Tosh, 'Equal Rights', 1977
The Upsetters, 'Return of Django', 1969
The Valentines, 'Blam Blam Fever', 1967

Various Artists, *The Harder They Come*, 1972
The Wailers, 'Simmer Down', 1963
— — 'Rude Boy', 1965
— — '400 Years', 1970
— — 'Duppy Conqueror', 1971
— — 'Trenchtown Rock', 1971
— — *Catch a Fire*, 1973
— — *Burnin'*, 1973
— — 'Get Up, Stand Up', 1973
— — 'I Shot the Sheriff', 1973
— — 'Burnin' and Lootin'', 1973
Delroy Wilson, 'Better Must Come', 1971
Winston and Roy with Count Ossie, 'Babylon Gone', 1962
Tappa Zukie, 'M.P.L.A.', 1976
— — 'Green Bay Murder', 1978

16. 'WHITE RIOT'

The Clash, 'White Riot', 1977
— — '1977', 1977
— — *The Clash*, 1977
— — 'Police and Thieves', 1977
— — *Give 'Em Enough Rope*, 1978
— — '(White Man) in Hammersmith Palais', 1978
— — 'Safe European Home', 1978
— — *London Calling*, 1979
— — *Sandinista!*, 1980
— — *Combat Rock*, 1982
The Jam, 'In the City', 1977
— — 'All Around the World', 1977
Bob Marley, 'Punky Reggae Party', 1977
The Mekons, 'Never Been in a Riot', 1978
Scritti Politti, 'Skank Bloc Bologna', 1978
The Sex Pistols, 'Anarchy in the UK', 1976
— — 'God Save the Queen', 1977
— — *Never Mind the Bollocks, Here's the Sex Pistols*, 1977
— — 'Holidays in the Sun', 1977
— — 'Bodies', 1977
Sham 69, 'If the Kids Are United', 1978
Stiff Little Fingers, 'Suspect Device', 1978
— — 'Alternative Ulster', 1978

The Tom Robinson Band, '2-4-6-8 Motorway', 1977
— — 'Glad to Be Gay', 1978
— — *Power in the Darkness*, 1978
— — 'Winter of '79', 1978
— — 'Up Against the Wall', 1978
— — 'You Gotta Survive', 1978
— — 'Better Decide Which Side You're On', 1978

17. 'I WAS BORN THIS WAY'

Milton Ager and Jack Yellen (composers), 'Happy Days Are Here
 Again', 1929
Carl Bean, 'I Was Born This Way', 1977
David Bowie, *Let's Dance*, 1983
Chic, 'Dance, Dance, Dance (Yowsah, Yowsah, Yowsah)', 1977
— — 'Le Freak', 1978
— — 'At Last I Am Free', 1978
— — 'Good Times', 1979
The Dead Kennedys, 'Saturday Night Holocaust', 1978
Rick Dees and His Cast of Idiots, 'Disco Duck', 1976
Gloria Gaynor, 'I Will Survive', 1978
Eddie Kendricks, 'Girl You Need a Change of Mind', 1972
Love Unlimited Orchestra, 'Love's Theme', 1973
Machine, 'There But for the Grace of God Go I', 1979
Madonna, *Like a Virgin*, 1984
McFadden and Whitehead, 'Ain't No Stoppin' Us Now', 1979
MFSB, 'Love Is the Message', 1974
Odyssey, 'Native New Yorker', 1977
Parliament, 'Bop Gun (Endangered Species)', 1977
Pet Shop Boys, 'In the Night', 1985
Philadelphia International All Stars, 'Let's Clean Up the Ghetto', 1977
Al Jolson, 'About a Quarter to Nine', 1935
Sister Sledge, 'We Are Family', 1979
The Slickee Boys, 'Put a Bullet Thru the Jukebox', 1978
Sylvester, 'You Make Me Feel (Mighty Real)', 1978
Donna Summer, 'I Feel Love', 1977
Valentino, 'I Was Born This Way', 1975
Various Artists, *Saturday Night Fever: The Original Movie Sound
 Track*, 1977
The Village People, 'YMCA', 1978
— — 'In the Navy', 1979

— — 'Go West', 1979
Was (Not Was), 'Tell Me That I'm Dreaming', 1981

18. 'SONNY'S LETTAH'

The Angelic Upstarts, 'The Murder of Liddle Towers', 1978
The Clash, *The Cost of Living* EP, 1979
Fun Boy Three, 'The Lunatics Have Taken Over the Asylum', 1981
Linton Kwesi Johnson, *Dread Beat an' Blood*, 1978
— — 'It Dread Inna Inglan (For George Lindo)', 1978
— — 'Man Free (For Darcus Howe)', 1978
— — *Forces of Victory*, 1979
— — 'Sonny's Lettah (Anti-Sus Poem)', 1979
— — 'Reggae fi Peach', 1980
— — *Making History*, 1983
The Nips, 'Ghost Town', 1980
The Pop Group, *Y*, 1979
— — 'We Are All Prostitutes', 1980
— — 'Forces of Oppression', 1980
— — 'There Are no Spectators', 1980
The Ruts, 'Babylon's Burning', 1979
— — 'S.U.S.', 1979
— — 'Jah War', 1979
The Slits, *Cut*, 1978
The Specials, 'Gangsters', 1979
— — *The Specials*, 1979
— — 'Concrete Jungle', 1979
— — 'Doesn't Make It Alright', 1979
— — *More Specials*, 1980
— — 'Ghost Town', 1981
— — 'Why?', 1981
Steel Pulse, 'Jah Pickney – R.A.R.', 1979
The Tom Robinson Band, 'Blue Murder', 1979
UB40, 'Food for Thought', 1979
— — 'Burden of Shame', 1980
— — 'One in Ten', 1981
— — 'Don't Let It Pass You By', 1981

19. 'HOLIDAY IN CAMBODIA'

Bad Brains, 'Big Takeover', 1983

— — 'Destroy Babylon', 1983
Black Flag, *Damaged*, 1981
— — 'Police Story', 1981
— — 'TV Party', 1981
— — 'Rise Above', 1981
The Dead Kennedys, 'California Uber Alles', 1979
— — 'Pull My Strings', 1980/1987
— — 'Holiday in Cambodia', 1980
— — 'Kill the Poor', 1980
— — *Fresh Fruit for Rotting Vegetables*, 1980
— — 'We've Got a Bigger Problem Now', 1981
— — 'Nazi Punks Fuck Off', 1981
— — *Plastic Surgery Disasters*, 1982
— — 'Terminal Preppie', 1982
— — 'Bleed for Me', 1982
— — 'Moon Over Marin', 1982
— — 'Trust Your Mechanic', 1982
— — *Frankenchrist*, 1985
— — 'Stars and Stripes of Corruption', 1985
— — *Bedtime for Democracy*, 1986
— — 'Anarchy for Sale', 1986
— — 'Chickenshit Conformist', 1986
The Dils, 'I Hate the Rich', 1977
— — 'Class War', 1977
Fear, 'Let's Have a War', 1982
— — 'We Got to Get Out of This Place', 1982
M.D.C., 'Corporate Deathburger', 1982
— — 'Multi-Death Corporations', 1983
— — 'Pay to Come Along', 1983
Minor Threat, 'Straight Edge', 1981
— — 'In My Eyes', 1981
— — 'Think Again', 1983
— — 'Betray', 1983
— — 'Salad Days', 1985

20. 'THE MESSAGE'

Afrika Bambaataa and the Soulsonic Force, 'Planet Rock', 1982
Kurtis Blow, 'Christmas Rappin'', 1979
— — 'Hard Times', 1980
Brother D and the Collective Effort, 'How We Gonna Make the Black

Nation Rise?', 1980

The Fearless Four, 'Problems of the World (Today)', 1983

The Geto Boys, 'Mind Playing Tricks on Me', 1991

Grandmaster Flash and the Furious Five, 'Superrappin'', 1979

— — 'The Adventures of Grandmaster Flash on the Wheels of Steel',
1981

Grandmaster Flash and the Furious Five feat. Melle Mel and Duke
Bootee, 'The Message', 1982

Grandmaster and Melle Mel, 'White Lines (Don't Don't Do It)',
1983

Grandmaster Melle Mel, 'Jesse', 1984

— — 'World War III', 1984

Cheryl Lynn, 'Got to Be Real', 1978

Melle Mel and Duke Bootee, 'The Message II (Survival)', 1982

Rock Master Scott and the Dynamic 3, 'It's Life (You Gotta Think
Twice)', 1983

Run-D.M.C., 'Hard Times', 1983

The Sugarhill Gang, 'Rapper's Delight', 1979

2Pac, *Me Against the World*, 1995

21. 'HOW DOES IT FEEL?'

The Beat, 'Stand Down Margaret', 1980

Billy Bragg, 'Island of No Return', 1984

Crass, *The Feeding of the 5000*, 1978

— — 'Do They Owe Us a Living?', 1978

— — 'So What', 1978

— — *Stations of the Crass*, 1979

— — 'White Punks on Hope', 1979

— — 'Bloody Revolutions', 1980

— — *Penis Envy*, 1981

— — [as Creative Recording and Sound Services] 'Our Wedding',
1981

— — *Christ: The Album*, 1982

— — 'Sheep Farming in the Falklands', 1982

— — 'How Does It Feel?', 1982

— — 'Whodunnit?', 1983

— — *Yes Sir, I Will*, 1983

— — 'You're Already Dead', 1984

— — *Acts of Love*, 1984

— — *Ten Notes on a Summer's Day* (EP), 1984

Flux of Pink Indians, *Strive to Survive Causing Least Suffering Possible*, 1982
Hawkwind, 'Urban Guerrilla', 1973
New Model Army, 'Spirit of the Falklands', 1984
Pink Floyd, 'The Fletcher Memorial Home', 1983
The Specials, 'Maggie's Farm', 1980
The Subhumans, *The Day the Country Died*, 1982
Third World War, 'Urban Rock', 1972
— — 'Hammersmith Guerrilla', 1972
Robert Wyatt, 'Strange Fruit', 1980
— — 'Shipbuilding', 1982
Zounds, 'More Trouble Coming Every Day', 1982

22. 'TWO TRIBES'

Art of Noise, *Into Battle with the Art of Noise*, 1983
Lowell Blanchard, 'Jesus Hits Like an Atom Bomb', 1950
Bonzo Goes to Washington [aka Jerry Harrison and Bootsy Collins], 'Five Minutes', 1984
Kate Bush, 'Breathing', 1980
The Clash, 'Stop the World', 1980
Elvis Costello, 'Peace in Our Time', 1984
Doris Day, 'Tic, Tic, Tic', 1949
Depeche Mode, 'Two Minute Warning', 1983
Ian Dury, 'Ban the Bomb', 1984
Frankie Goes to Hollywood, 'Relax', 1984
— — 'Two Tribes', 1984
— — 'Two Tribes (Annihilation)', 1984
— — 'War', 1984
Nena, '99 Luftballoons', 1983
— — '99 Red Balloons', 1984
The Police, 'Walking in Your Footsteps', 1983
Prince, 'Ronnie, Talk to Russia', 1981
— — '1999', 1982
The Specials, 'Man at C&A', 1980
The Style Council, 'Money Go Round', 1983
Timmy Thomas, 'Why Can't We Live Together', 1972
U2, 'Seconds', 1983
Various Artists, *Life in the European Theatre*, 1982
Young Marble Giants, 'Final Day', 1980
Zager and Evans, 'In the Year 2525', 1969

23. 'PRIDE (IN THE NAME OF LOVE)'

Band Aid, 'Do They Know It's Christmas?', 1984
Chumbawamba, *Pictures of Starving Children Sell Records*, 1986
Culturcide, 'They Aren't the World', 1986
Culture Club, 'The War Song', 1984
Faith No More, 'We Care a Lot', 1985
Hollywood Beyond, 'What's the Colour of Money?', 1986
Michael Jackson, 'Man in the Mirror', 1987
Red Box, 'For America', 1986
Bruce Springsteen, *Born to Run*, 1975
— — 'Born to Run', 1975
— — 'Thunder Road', 1975
— — 'Badlands', 1978
— — *Nebraska*, 1982
— — 'Reason to Believe', 1982
— — 'Born in the USA', 1982/1984
— — *Born in the USA*, 1984
Suicide, 'Frankie Teardrop', 1977
Thompson Twins and Madonna, 'Revolution (live at Live Aid)',
 1985
U2, *Boy*, 1980
— — *October*, 1981
— — 'Gloria', 1981
— — 'With a Shout (Jerusalem)', 1981
— — *War*, 1983
— — 'Sunday Bloody Sunday', 1983
— — 'New Year's Day', 1983
— — *The Unforgettable Fire*, 1984
— — 'Pride (In the Name of Love)', 1984
— — 'MLK', 1984
— — 'Bad', 1984
— — *The Joshua Tree*, 1987
— — 'Mothers of the Disappeared', 1987
— — 'Bullet the Blue Sky', 1987
— — *Achtung Baby*, 1991
— — 'One', 1991
USA for Africa, 'We Are the World', 1985

24. 'NELSON MANDELA'

Artists United Against Apartheid, 'Sun City', 1985
Harry Belafonte and Miriam Makeba, *An Evening with Belafonte/
Makeba*, 1965
— — 'Ndodemnyama Verwoerd!', 1965
Bright Blue, 'Weeping', 1987
The Byrds, 'So You Want to Be a Rock'n'Roll Star', 1967
Peter Gabriel, 'Biko', 1980
Peter Hammill, 'A Motor Bike in Afrika', 1978
Fela Kuti and Egypt 80, *Beasts of No Nation*, 1989
Hugh Masekela, 'Bring Him Back Home', 1987
Microdisney, *We Hate You South African Bastards!*, 1984
— — 'Pretoria Quickstep', 1984
Randy Newman, 'Christmas in Cape Town', 1983
Tom Paxton, 'The Death of Stephen Biko', 1978
Savuka, 'Asimbonaga', 1987
Paul Simon, *Graceland*, 1986
Simple Minds, 'Mandela Day', 1988
The Special AKA, 'The Boiler', 1982
— — 'War Crimes', 1982
— — 'Racist Friend', 1983
— — 'Nelson Mandela', 1984
— — *In the Studio*, 1984
Spitting Image, 'I've Never Met a Nice South African', 1986
Starvation, 'Starvation', 1985
Steel Pulse, 'Biko's Kindred Lament', 1978
Various Artists, *Gumboots: Accordion Jive Hits, Vol. II*, 1984
— — 'Together We Can Build a Brighter Future', 1986
Stevie Wonder, 'I Just Called to Say I Love You', 1984
Robert Wyatt and the SWAPO Singers, 'The Wind of Change', 1984
Tappa Zukie, 'Tribute to Steve Biko', 1978

25. 'BETWEEN THE WARS'

Roy Bailey and Leon Rosselson, 'The World Turned Upside Down',
1975
The Blow Monkeys, *She Was Only a Grocer's Daughter*, 1987
— — 'How Long Can a Bad Thing Last?', 1987
— — '(Celebrate) The Day After You', 1987
Billy Bragg, 'To Have or Have Not', 1983

— — 'A New England', 1983
— — 'It Says Here', 1984
— — 'Between the Wars', 1985
— — 'The World Turned Upside Down', 1985
— — 'Which Side Are You On?', 1985
— — 'There Is Power in a Union', 1986
— — 'Days Like These', 1985
— — 'Waiting for the Great Leap Forwards', 1989
Council Collective, 'Soul Deep', 1984
The Enemy Within [aka Keith LeBlanc], 'Strike!', 1984
The Flying Pickets, 'Only You', 1983
Dick Gaughan, 'Which Side Are You On?', 1985
Pet Shop Boys, 'Opportunities (Let's Make Lots of Money)', 1985
— — 'Shopping', 1987
— — 'King's Cross', 1987
Sting, 'We Work the Black Seam', 1985
The Style Council, 'Shout to the Top', 1984
The The, 'Heartland', 1986

26. 'EXHUMING MCCARTHY'

The Damned, 'Bad Time for Bonzo', 1982
The Dead Kennedys, 'Gone With My Wind', 1986
Sammy Hagar, 'I Can't Drive 55', 1984
M.D.C., 'Bye Bye Ronnie', 1987
The Minutemen, 'Paranoid Chant', 1980
— — 'Joe McCarthy's Ghost', 1980
— — 'Bob Dylan Wrote Propaganda Songs', 1983
— — *Double Nickels on the Dime*, 1984
— — 'West Germany', 1984
— — 'This Ain't No Picnic', 1984
— — 'Untitled Song for Latin America', 1984
— — 'The Big Stick', 1985
Prince, 'Free', 1983
— — 'Darling Nikki', 1983
— — 'America', 1985
— — 'Sign o' the Times', 1987
The Ramones, 'Bonzo Goes to Bitburg', 1985
R.E.M., *Murmur*, 1983
— — 'Talk About the Passion', 1983
— — 'Little America', 1984

— — *Fables of the Reconstruction*, 1985
— — 'Green Grow the Rushes', 1985
— — *Life's Rich Pageant*, 1986
— — 'Flowers of Guatemala', 1986
— — 'Begin the Begin', 1986
— — 'Cuyahoga', 1986
— — 'Fall on Me', 1986
— — 'These Days', 1986
— — *Document*, 1987
— — 'Finest Worksong', 1987
— — 'Disturbance at the Heron House', 1987
— — 'Welcome to the Occupation', 1987
— — 'It's the End of the World As We Know It (And I Feel Fine)', 1987
— — 'Exhuming McCarthy', 1987
— — *Green*, 1988
— — 'Stand', 1988
— — 'Get Up', 1988
— — 'Orange Crush', 1988
— — *Out of Time*, 1991
— — 'Radio Song', 1991
— — *Automatic for the People*, 1992
— — 'Drive', 1992
— — 'Ignoreland', 1992
— — 'Revolution', 1997
Gil Scott-Heron, 'B Movie', 1981
— — 'Re-Ron', 1983
The Violent Femmes, 'Old Mother Reagan', 1986
Neil Young, 'Rockin' in the Free World', 1989

27. 'FIGHT THE POWER'

Blowfly, 'Rapp Dirty', 1980
Body Count, 'Cop Killer', 1990 / 1992
— — 'Freedom of Speech', 1992
Boogie Down Productions, *By All Means Necessary*, 1988
The Disposable Heroes of Hiphoprisy, *Hypocrisy Is the Greatest Luxury*, 1992
— — 'California Uber Alles', 1992
Dr Dre, *The Chronic*, 1992
Eazy-E, 'Boyz-n-the-Hood', 1987
Eric B and Rakim, 'Casualties of War', 1992

The Goats, *Tricks of the Shade*, 1992

Ice Cube, *AmeriKKKa's Most Wanted*, 1990

— — 'The Nigga Ya Love to Hate', 1990

— — *Death Certificate*, 1991

— — 'Black Korea', 1991

— — *The Predator*, 1992

— — 'The Predator', 1992

Ice-T, '6 in the Mornin'', 1986

Da Lench Mob, 'Guerrillas in tha Mist', 1992

MC Shan, 'The Bridge', 1986

Bobby McFerrin, 'Don't Worry, Be Happy', 1988

N.W.A., *Straight Outta Compton*, 1988

— — 'Straight Outta Compton', 1988

— — 'Express Yourself', 1988

— — 'Fuck tha Police', 1988

Paris, *Sleeping With the Enemy*, 1992

— — 'Guerrillas in the Mist', 1992

— — 'Bush Killa', 1992

Public Enemy, *Yo! Bum Rush the Show*, 1987

— — 'Public Enemy #1', 1987

— — 'Rightstarter (Message to a Black Man)', 1987

— — 'Rebel Without a Pause', 1987

— — *It Takes a Nation of Millions to Hold Us Back*, 1988

— — 'Terminator X to the Edge of Panic', 1988

— — 'Party for Your Right to Fight', 1988

— — 'Countdown to Armageddon', 1988

— — 'Fight the Power', 1989

— — 'Welcome to the Terrordome', 1989

— — *Fear of a Black Planet*, 1990

— — '911 Is a Joke', 1990

— — 'Anti-Nigger Machine', 1990

— — 'Who Stole the Soul?', 1990

— — 'By the Time I Get to Arizona', 1991

— — *Muse Sick-n-Hour Mess Age*, 1994

Public Enemy feat. Ice Cube and Big Daddy Kane, 'Burn Hollywood Burn', 1990

Sir Joe Quarterman and Free Soul, '(I've Got) So Much Trouble on My Mind', 1972

Run-D.M.C. and Aerosmith, 'Walk This Way', 1986

Schoolly D, 'P.S.K. – What Does It Mean?', 1985

Spectrum City, 'Lies,' 1984
— — 'Check Out the Radio', 1984

28. 'HER JAZZ'

Bikini Kill, *Revolution Girl Style Now!* EP, 1991
— — *Yeah Yeah Yeah Yeah*, 1993
— — 'Rebel Girl', 1993
— — 'Don't Need You', 1993
Hole, 'Olympia', 1994
Huggy Bear, *We Bitched*, 1992
— — 'Rubbing the Impossible to Burst', 1992
— — *Our Troubled Youth*, 1993
— — 'Her Jazz', 1993
— — *Weaponry Listens to Love*, 1994
L7, 'Pretend We're Dead', 1992
Le Tigre, 'Hot Topic', 1999
LL Cool J, 'Mama Said Knock You Out', 1991
Nation of Ulysses, *13-Point Plan to Destroy America*, 1991
Nirvana, 'Smells Like Teen Spirit', 1991
Sonic Youth, 'Teen Age Riot', 1988
— — 'Youth Against Fascism', 1992
— — 'Swimsuit Issue', 1992
Sonic Youth feat. Chuck D, 'Kool Thing', 1990
Viva Knieval, 'Boy Poison', 1990

29. 'THEIR LAW'

Autechre, 'Flutter', 1994
The Beloved, 'It's Alright Now', 1990
Candy Flip, 'Strawberry Fields Forever', 1990
D:Ream, 'Things Can Only Get Better', 1997
De La Soul, 'D.A.I.S.Y. Age', 1989
EnglandNewOrder, 'World in Motion', 1990
The Farm, 'All Together Now', 1990
Galaxy 2 Galaxy, *Galaxy 2 Galaxy* EP, 1993
Sabrina Johnston, 'Peace', 1991
Jesus Jones, 'Right Here, Right Now', 1990
Model 500, 'Night Drive (Thru-Babylon)', 1985
Orbital, 'Choice', 1991
— — 'Criminal Justice Bill?', 1994

Songs Mentioned in the Text

Pet Shop Boys, 'It's Alright', 1988
Primal Scream, 'Loaded', 1990
— — 'Come Together (Andrew Weatherall Remix)', 1990
Jamie Principle, 'Baby Wants to Ride', 1986
The Prodigy, *Music for the Jilted Generation*, 1994
The Prodigy feat. Pop Will Eat Itself, 'Their Law', 1994
Psychick Warriors ov Gaia, 'Exit 23', 1990
Pulp, 'Sorted for E's & Wizz', 1995
Retribution, 'Repetitive Beats', 1994
— — 'Repetitive Beats (Know Your Rights – Primal Scream)', 1994
The Ragga Twins, 'The Homeless Problem', 1991
The Shamen, 'Move Any Mountain – Progen 91', 1991
— — 'Boss Drum', 1992
Shut Up and Dance, 'Autobiography of a Crackhead', 1991
Joe Smooth Inc. feat. Anthony Thomas, 'Promised Land', 1987
Soho, 'Hippy Chick', 1990
Spiral Tribe, 'Breach the Peace', 1992
The Stone Roses, *The Stone Roses*, 1989
— — 'Bye Bye Badman', 1989
Suburban Knight, 'Mind of a Panther', 1994
Underground Resistance, 'Attend the Riot', 1991
— — 'The Final Frontier', 1991
Sterling Void, 'It's All Right', 1987
Sydney Youngblood, 'If Only I Could', 1989

30. 'OF WALKING ABORTION'

Blur, *Modern Life Is Rubbish*, 1993
— — *Parklife*, 1994
Manic Street Preachers, 'Motown Junk', 1991
— — 'You Love Us', 1992
— — *Generation Terrorists*, 1992
— — 'Motorcycle Emptiness', 1992
— — 'NatWest – Barclays – Midlands – Lloyds', 1992
— — *Gold Against the Soul*, 1993
— — 'Roses in the Hospital', 1993
— — 'Life Becoming a Landslide', 1993
— — 'From Despair to Where', 1993
— — 'La Tristesse Durera (Scream to a Sigh)', 1993
— — *The Holy Bible*, 1994
— — 'Of Walking Abortion', 1994

— — 'Mausoleum', 1994
— — 'Archives of Pain', 1994
— — 'ifwhiteamericatoldthetruthforonedayit'sworldwouldfallapart', 1994
— — 'Faster', 1994
— — '4st 7lbs', 1994
— — 'A Design for Life', 1996
— — *Everything Must Go*, 1996
— — 'If You Tolerate This Your Children Will Be Next', 1998
— — *Journal for Plague Lovers*, 2009
McCarthy, 'The Procession of Popular Capitalism', 1987
Nirvana, *In Utero*, 1993
Pulp, 'Common People', 1995

31. 'SLEEP NOW IN THE FIRE'

Elvis Costello, 'Tokyo Storm Warning', 1986
Inside Out, 'Rage Against the Machine', unreleased
Primal Scream, *Exterminator* [aka *XTRMNTR*], 2000
— — 'Exterminator', 2000
Radiohead, 'Creep', 1992
— — *The Bends*, 1995
— — 'The Bends', 1995
— — 'My Iron Lung', 1995
— — 'Just', 1995
— — 'Fake Plastic Trees', 1995
— — 'Lucky', 1995
— — *OK Computer*, 1997
— — 'No Surprises', 1997
— — 'Fitter Happier', 1997
— — 'Electioneering', 1997
— — 'Paranoid Android', 1997
— — *Airbag / How Am I Driving?*, 1998
— — *Kid A*, 2000
— — 'In Limbo', 2000
— — 'Idioteque', 2000
— — *Amnesiac*, 2001
— — 'You and Whose Army', 2001
Rage Against the Machine, *Rage Against the Machine*, 1992
— — 'Take the Power Back', 1992
— — 'Killing in the Name', 1992

— — 'Bullet in the Head', 1992
— — *Evil Empire*, 1996
— — 'No Shelter', 1998
— — *The Battle of Los Angeles*, 1999
— — 'Sleep Now in the Fire', 1999
— — 'Testify', 1999
— — *Renegades*, 2000
— — 'Kick Out the Jams', 2000
R.E.M., 'What's the Frequency Kenneth?', 1994
Tim Robbins [aka Bob Roberts], 'Times Are Changing Back', 1992
— — 'My Land', 1992

32. 'JOHN WALKER'S BLUES'

The Beastie Boys, 'In a World Gone Mad', 2003
Black Eyed Peas feat. Justin Timberlake, 'Where Is the Love?', 2003
Billy Bragg, 'The Price of Oil', 2002
Canibus, 'Draft Me!', 2001
Zack de la Rocha and DJ Shadow, 'March of Death', 2003
The Dixie Chicks, *Home*, 2003
— — 'Travelin' Soldier', 2003
Steve Earle, *Guitar Town*, 1986
— — *Copperhead Road*, 1988
— — 'Copperhead Road', 1988
— — 'Billy Austin', 1990
— — 'Ellis Unit One', 1995
— — 'Christmas in Washington', 1997
— — *Jerusalem*, 2002
— — 'Ashes to Ashes', 2002
— — 'Conspiracy Theory', 2002
— — 'Jerusalem', 2002
— — 'Amerika v 6.0 (The Best We Can Do)', 2002
Elbow, 'Something in the Air', 2003
— — 'Leaders of the Free World', 2005
Michael Franti, 'Bomb the World', 2003
Lee Greenwood, 'God Bless the U.S.A.' 1984/2001
Toby Keith, 'Courtesy of the Red, White and Blue (The Angry
 American)', 2002
Lenny Kravitz, 'We Want Peace', 2003
MC Hammer, 'No Stoppin' Us (USA)', 2001
George Michael, 'Shoot the Dog', 2002

Mystikal, 'Bouncin' Back (Bumpin' Me Against the Wall)', 2001
Nas, 'Rule', 2001
Paris, *Sonic Jihad*, 2003
— — 'What Would You Do', 2003
Pearl Jam, 'Bu$hleaguer', 2002
Public Enemy, 'Son of a Bush', 2002
Radiohead, *Hail to the Thief*, 2003
R.E.M., 'Final Straw', 2003
Bruce Springsteen, *The Rising*, 2002
System of a Down, *Toxicity*, 2001
— — 'Boom!', 2002
Darryl Worley, 'Have You Forgotten?', 2003
The Wu-Tang Clan, 'Rules', 2001
Thom Yorke, 'Harrowdown Hill', 2006

33. 'AMERICAN IDIOT'

Arcade Fire, *Neon Bible*, 2007
Erykah Badu, *New Amerykah Part One (4th World War)*, 2008
Black Sabbath, 'War Pigs', 1970
Bright Eyes, 'When the President Talks to God', 2005
Ian Brown feat. Sinead O'Connor, 'Illegal Attacks', 2007
The Dresden Dolls, 'War Pigs' (live), 2004
Steve Earle, *The Revolution Starts Now*, 2004
Eminem, 'Mosh', 2004
The Flaming Lips, *At War With the Mystics*, 2006
— — 'War Pigs' (live), 2006
Gorillaz, *Demon Days*, 2005
Green Day, *American Idiot*, 2004
— — 'American Idiot', 2004
— — 'Holiday', 2004
Jay-Z, 'Minority Report', 2006
The Legendary K.O., 'George Bush Doesn't Care About Black
 People', 2005
Le Tigre, 'New Kicks', 2004
Lil' Wayne, 'Georgia . . . Bush', 2006
Lynyrd Skynyrd, *Vicious Cycle*, 2003
— — 'That's How I Like It', 2003
— — 'Red, White & Blue (Love It or Leave It)', 2003
Willy Mason, 'Oxygen', 2004
John Mayer, 'Waiting on the World to Change', 2006

Mos Def, 'Katrina Clap', 2005
Muse, *Black Holes and Revelations*, 2006
— — 'Assassin', 2006
Aaron Neville, 'Louisiana 1927', 1991
Randy Newman, 'Louisiana 1927', 1974
A Perfect Circle, *Emotive*, 2004
— — 'Imagine', 2004
— — 'What's Going On', 2004
Pink feat. the Indigo Girls, 'Dear Mr President', 2006
The Roots, 'Masters of War' (live), 2006
Bruce Springsteen, *We Shall Overcome: The Seeger Sessions*, 2006
— — 'We Shall Overcome', 2006
— — 'Bring 'Em Home', 2006
TV on the Radio, *Dear Science*, 2008
Tom Waits, 'The Day After Tomorrow', 2004
Kanye West feat. Jamie Foxx, 'Gold Digger', 2005
Neil Young, *Living with War*, 2006
— — 'Let's Impeach the President', 2006

EPILOGUE

M.I.A., 'Paper Planes', 2007
The Clash, 'Straight to Hell', 1982
PJ Harvey, *Let England Shake*, 2011
Lady Gaga, 'Born This Way', 2011
Ramy Essam, 'Irhal (Leave)', 2011
tUnE-yArDs, 'My Country', 2011
Plan B, 'iLL Manors', 2012

Appendix 3

One Hundred Songs not Mentioned in the Text

Even in a book of this size, it is impossible to include every worthwhile protest song. The following is a list of 100 recommended songs that do not appear in the main text. Needless to say, it is by no means exhaustive.

Blind Alfred Reed, 'How Can a Poor Man Stand Such Times and Live?', 1929
Bing Crosby, 'Brother, Can You Spare a Dime?', 1932
Josh White, 'Freedom Road', 1944
Johnny Cash, 'The Ballad of Ira Hayes', 1964
Janis Ian, 'Society's Child (Baby I've Been Thinking)', 1966
Steve Reich, 'Come Out', 1966
The United States of America, 'Love Song for the Dead Che', 1968
The Deviants, 'Let's Loot the Supermarket', 1968
Os Mutantes, 'Panis et Circenses', 1968
Jimmy Cliff, 'Vietnam', 1969
Scott Walker, 'The Old Man's Back Again (Tribute to the Neo-Stalinist Regime)', 1969
Joni Mitchell, 'Big Yellow Taxi', 1970
Parliament, 'Come in Out of the Rain', 1970
The Guess Who, 'American Woman', 1970
Gary Byrd, 'Are You Really Ready for Black Power?', 1970
MC5, 'American Ruse', 1970
Joe South, 'Walk a Mile in My Shoes', 1970
John Prine, 'Sam Stone', 1971
Eric Bogle, 'And the Band Played Waltzing Matilda', 1971
Freda Payne, 'Bring the Boys Home', 1971
The Isley Brothers, 'Ohio/Machine Gun', 1971
Peggy Seeger, 'I'm Gonna Be an Engineer', 1970/1973

One Hundred Songs not Mentioned in the Text

The Action 13, 'More Bread (to the People)', 1973
Aaron Neville, 'Hercules', 1973
Willie Hutch, 'Brothers Gonna Work It Out', 1973
Brinsley Schwarz, '(What's So Funny 'Bout) Peace, Love and
 Understanding', 1974
Labelle, 'What Can I Do for You?', 1974
Harold Melvin and the Blue Notes, 'Wake Up Everybody', 1975
The Congos, 'Children Crying', 1977
X-Ray Spex, 'Oh Bondage Up Yours!', 1977
Elvis Costello, 'Oliver's Army', 1979
The Jam, 'The Eton Rifles', 1979
Gang of Four, 'Ether', 1979
The Slits, 'Typical Girls', 1979
Heaven 17, '(We Don't Need) This Fascist Groove Thang', 1981
Sun Ra, 'Nuclear War', 1982
Conflict, 'Meat Means Murder', 1983
Depeche Mode, 'Everything Counts', 1983
The Wolfe Tones, 'Joe McDonnell', 1983
Malcolm X [aka Keith LeBlanc], 'No Sell Out', 1984
Time Zone feat. John Lydon, 'World Destruction', 1984
Bronski Beat, 'Small Town Boy', 1984
Robert Wyatt, 'The Age of Self', 1984
The Style Council, 'Walls Come Tumbling Down', 1985
The Smiths, 'Meat Is Murder', 1985
New Model Army, '51st State', 1986
Jackson Browne, 'Lives in the Balance', 1986
Midnight Oil, 'Beds Are Burning', 1987
The Housemartins, 'Johannesburg', 1987
The Pogues, 'Streets of Sorrow' / 'Birmingham Six', 1988
Public Enemy, 'Black Steel in the Hour of Chaos', 1988
Miriam Makeba, 'Soweto Blues', 1989
Spacemen 3, 'Revolution', 1989
Don Henley and Bruce Hornsby, 'The End of the Innocence', 1989
Elvis Costello, 'Tramp the Dirt Down', 1989
McCarthy, 'The Home Secretary Briefs the Forces of Law and Order',
 1989
The Levellers, 'Battle of the Beanfield', 1990
Brand Nubian, 'Wake Up', 1990
Fatima Mansions, 'Blues for Ceausescu', 1990
Fugazi, 'Merchandise', 1990

Consolidated, 'This Is Fascism', 1991
Ruthless Rap Assassins, 'Justice (Just Us)', 1991
Leonard Cohen, 'The Future', 1992
Ministry, 'N.W.O.', 1992
Gang Starr, 'Who's Gonna Take the Weight?', 1992
L7, 'Wargasm', 1992
Da Lench Mob, 'Freedom Got an A.K.', 1992
KRS-One, 'Sound of Da Police', 1993
Digable Planets, 'La Femme Fetal', 1993
Stereolab, 'French Disko', 1993
Cornershop, 'England's Dreaming', 1993
Marxman feat. Sinead O'Connor, 'Ship Ahoy', 1993
Fun-Da-Mental, 'Wrath of the Blackman', 1993
Chumbawamba and Credit to the Nation, 'Enough Is Enough',
 1993
Scarface feat. Ice Cube, 'Hand of the Dead Body', 1994
Super Furry Animals, 'The Man Don't Give a Fuck', 1996
Coldcut, 'Timber', 1997
Pulp, 'Cocaine Socialism', 1998
Primal Scream, 'Swastika Eyes', 1999
Asian Dub Foundation, 'Free Satpal Ram', 1999
Bruce Springsteen, 'American Skin (41 Shots)', 2000
DJ Vadim feat. Sarah Jones, 'Your Revolution', 2000
Manic Street Preachers, 'Freedom of Speech Won't Feed My
 Children', 2001
The Coup, '5 Million Ways to Kill a C.E.O.', 2001
Godspeed You! Black Emperor, '09-15-00', 2002
OutKast, 'War', 2003
!!!, 'Me and Giuliani Down By the Schoolyard (A True Story)', 2003
Johnny Boy, 'You Are the Generation That Bought More Shoes and
 You Get What You Deserve', 2004
Rachid Taha, 'Rock el Casbah', 2004
System of a Down, 'BYOB', 2005
Immortal Technique feat. Mos Def and DJ Green Lantern, 'Bin
 Laden', 2005
James McMurtry, 'We Can't Make It Here Anymore', 2005
The Gossip, 'Standing in the Way of Control', 2005
Massive Attack, 'False Flags', 2006
Pet Shop Boys, 'Integral', 2006
Jarvis Cocker, 'Running the World', 2006

One Hundred Songs not Mentioned in the Text

Rufus Wainwright, 'Going to a Town', 2007
Dizzee Rascal, 'Dirtee Cash', 2009
Aloe Blacc, 'I Need a Dollar', 2010
DELS, Joe Goddard and Roots Manuva, 'Capsize', 2011

Notes and Sources

EPIGRAMS

vii 'There are two approaches to music' – John Grissim, Jr, 'Joan
Baez', *Rolling Stone*, 7 December 1968.

vii 'As bad as it may sound' – Karl Dallas, 'Dylan Said It – "I Can't
Keep Up with Phil"', *Melody Maker*, 29 November 1965.

vii 'What Art gains' – Oscar Wilde, 'Poetical Socialists', *Pall Mall
Gazette*, 15 February 1889, reprinted at http://history-is-made-at-
night.blogspot.com/2009/12/oscar-wilde-on-socialist-songs.html.

INTRODUCTION

xi 'It's been a long time coming' – Barack Obama's acceptance
speech, Grant Park, Chicago, 4 November 2008, transcribed at
http://edition.cnn.com/2008/POLITICS/11/04/obama.transcript/.

xii 'I hate protest songs' – Grissim.

xii 'It's not exactly a protest song' – Anne Moses, 'Barry McGuire . . .
Protests About Protests', *NME*, 1 October 1965.

xii 'This here ain't a protest song' – Clinton Heylin, *Revolution
in the Air: The Songs of Bob Dylan*, Vol. 1: *1957–73* (London:
Constable, 2009), p. 78.

xiii 'It's always a double-edged sword' – author interview with Tom
Robinson, 2009.

xiii 'I came to be entertained' – liner notes, Phil Ochs, *All the News
That's Fit to Sing* (Elektra LP, 1964).

xiv 'Remember, it's just maybe' – Woody Guthrie, *Bound for Glory*
(London: Penguin Modern Classics, 2004), p. 295.

1. 'STRANGE FRUIT'

5 Café Society – John White, *Billie Holiday: Her Life and Times*
(Tunbridge Wells: Spellmount, 1987), p. 48 and Elijah Wald, *Josh
White: Society Blues* (Amherst, MA.: University of Massachusetts
Press, 2000), pp. 102–103.

5 'The Wrong Place for the Right People' – *New Yorker* advert, 1939, reprinted in David Margolick, *Strange Fruit: The Biography of a Song* (New York: HarperCollins, 2001).

5 'She does not care enough' – 'Strange Record', *Time*, 12 June 1939.

7 'That is about the ugliest song' – Nina Simone, 'Strange Fruit (Interview)', *Protest Anthology* (Andy Stroud Inc. digital album, 2008).

7 'song of the century' – *Time*, 31 December 1999.

8 'resolutely fractured' – Barry Singer, *Black and Blue: The Life and Lyrics of Andy Razaf* (New York: Schirmer Books, 1992), p. 218.

9 'Bitter Fruit' – Margolick, p. 21.

9 'just about the only place' – Billie Holiday with William Dufty, *Lady Sings the Blues* (London: Penguin, 1984), p. 11.

10 'When she was on stage' – John Chilton, *Billie's Blues: A Survey of Billie Holiday's Career 1933–1959* (London: Quartet, 1975), p. 70.

10 'Some guy's brought me' – Chilton, p. 69.

10 'To be perfectly frank' – Margolick, p. 28.

10 'something or other' – Margolick, p. 32.

10 'She gave a startling' – Lewis Allan, 'The Strange Case of "Strange Fruit"', *Broadside* 122 (First Quarter, 1973).

11 'People had to remember' – White, p. 50.

11 'I don't want to fill my head' – Chilton, p. 67.

11 'La Holiday' – Chilton, p. 88.

11 'Have you heard?' – *New Yorker* advert, 1939, reprinted in Margolick.

12 'a fantastically perfect' – Margolick, p. 56.

13 'It's got too much of an agenda' – Margolick, p. 60.

13 'There comes a time' – Margolick, p. 61.

13 'You don't celebrate' – Margolick, p. 74.

14 'I only do it' – Margolick, p. 90.

14 'all of a sudden' – Margolick, p. 92.

14 'When she wrenched' – Margolick, p. 77.

14 'For a time, she wanted' – Chilton, p. 103.

14 'The audience shouted' – Holiday, p. 85.

15 'Yeah, that song was written by a nigger lover' – Margolick, p. 79.

15 'Music is my weapon' – Ann Seymour, 'Josh White Says: Music Is a Mighty Sword Against Discrimination,' *Daily Worker*, 15 January 1947, quoted in Wald, p. 144.

15 her former producer John Hammond – Margolick, p. 59.

15 'How are you doing?' – Chilton, p. 92.

16 'Lynching to Billie Holiday' – White, p. 55.

16 'By the time I started' – Holiday, p. 145.

16 'throat-tightening' – 'Music: New Life', *Time*, 12 April 1948.

16 'she had grown oddly, sadly' – Margolick, p. 106.

17 'Why are you sticking your neck out?' – Margolick, p. 31.

2. 'THIS LAND IS YOUR LAND'

21 'I ain't a writer' – Alan Lomax (compiler), Woody Guthrie (notes on songs), Pete Seeger (transcriber and editor), *Hard Hitting Songs for Hard-Hit People* (New York: Oak Publications, 1967), p. 16.

21 'a guitar busker, a joint hopper' – Guthrie, p. 258.

21 'He sings the songs' – Lomax, Guthrie and Seeger, p. 9.

22 'attract his own land' – Walt Whitman, *Leaves of Grass: 150th Anniversary Edition* (Oxford: Oxford University Press, 2005), p. xiv.

22 'The proof of a poet' – Whitman, p. xvi.

22 Guthrie's early years – Joe Klein, *Woody Guthrie: A Life* (London: Faber & Faber, 1990).

23 'It was pitch black all the way to the ground' – *This Machine Kills Fascists* (dir: Stephen Gammond, 2005).

24 'His singing voice' – Klein, p. 78.

24 Joe Hill's story – Philip S. Foner, *The Case of Joe Hill* (New York: International Publishers, 1965).

24 'At times we would sing' – Richard Brazier, 'The Industrial Workers of the World's "Little Red Songbook"', reprinted in R. Serge Denisoff and Richard A. Peterson (ed.), *The Sounds of Social Change* (Chicago: Rand McNally, 1972), p. 66.

25 'If a person can put a few cold' – Foner, p. 11.

25 'inflammatory' etc. – Foner, p. 26.

25 'What kind of man is this' – Foner, p. 98.

26 'I think Woody learned socialism' – *This Machine Kills Fascists*.

26 'Cornpone Philosophy' – Klein, p. 97.

27 'Communism is twentieth-century Americanism' – David King Dunaway, *How Can I Keep From Singing?: The Ballad of Pete Seeger* (New York: Villard, 2008), p. 134.

28 'the voice of his people' – Klein, p. 133.

28 'I ain't a Communist necessarily' – Klein, p. 126.

28 'You can date the renaissance' – Dunaway, p. 69.

29 'My father was a big influence' – Alec Wilkinson, 'The Protest Singer', *New Yorker*, 17 April 2006.

29 'to bring music to the poor people of America' – Dunaway, p. 28.

29 Composers' Collective background – Alex Ross, *The Rest Is Noise* (London: Fourth Estate, 2008), p. 271; Ann M. Pescatello, *Charles Seeger: A Life in American Music* (Pittsburgh, PA: University of Pittsburgh Press, 1992), pp. 110–135.

29 'useful' – Ross, p. 271.

30 'A nigger sings about two things' – John Lomax, 'Self-Pity in Negro Folk Songs', *The Nation*, vol. 105, 9 August 1917, quoted in John Greenway, *American Folksongs of Protest* (Philadelphia: University of Pennsylvania Press, 1953), p. 67.

30 'My grandfather' – *Folk America: This Land Is Your Land*, BBC 4, 2009.

31 'I went up to her' – Pescatello, p. 135.

31 'old, weird America' – Greil Marcus, *Invisible Republic: Bob Dylan's Basement Tapes* (London: Picador, 1998), p. 89.

32 'a Communist Joe Hill' and 'Shakespeare in overalls', Klein, p. 145.

33 'too hot' – Lomax, Guthrie and Seeger, p. 12.

33 'Sing it, Woody, sing it' – quoted in Klein, p. 156.

33 'That fuckin' little bastard' – reported by Will Geer, quoted in Ed Cray, *Ramblin' Man: The Life and Times of Woody Guthrie* (New York: W. W. Norton & Company, 2006), p. 181.

34 'I'm sure Victor' – Klein, p. 159.

34 'Whitman cantata' – Martin Bauml Duberman, *Paul Robeson* (London: The Bodley Head, 1989), p. 236.

35 'all slicked up' – Guthrie, p. 297.

35 'America Is in Their Songs' and 'If there were six more teams' – George Lewis, 'America Is in Their Songs', *Daily Worker*, 24 March 1941, reprinted at Peteseeger.net.

36 'I guess we won't be singing' – *This Machine Kills Fascists*.

37 'Singers on New Morale Show' – 'Singers on New Morale Show Also Warbled for Communists', *New York World Telegram*, 17 February 1942, reprinted at Peteseeger.net.

38 'I am out to sing songs' – Cray p. 285.

38 'get America singing' etc. – Dunaway, p. 133.

38 'panty waist crap' – Lomax, Guthrie and Seeger, p. 26.

38 'I confessed it' – 'Archive Hour: Pete Seeger at 90', Radio 4, 2 May 2009.

39 'He keeps testing people' – *This Machine Kills Fascists*.

39 'People tried to explain this' – *This Machine Kills Fascists*.

41 'The times which led the Almanacs to live' – Dunaway, p. 149.

41 'Are you an American?' – Dunaway, p. 147.

3. 'WE SHALL OVERCOME'

45 The melody dated back – Peter S. Scholtes, 'Something About That Song Haunts You', complicatedfun.com, 9 June 2006.

45 'Zilphia was a very warm' – author interview with Guy Carawan, 2009.

45 'It's the genius of simplicity' – Carlyle Murphy, 'The Rise of the Rights Anthem; "We Shall Overcome": The Song, the History', *Washington Post*, 17 January 1988.

46 '"We shall" opens the mouth' – quoted in Scholtes.

46 'Give us Robeson' – Dunaway, p. 6.

47 'Robeson: He Asked For It' – Duberman p. 366.

47 'Communist military raid' – Duberman p. 373.

47 'If that nigger Robeson' – Duberman p. 373.

48 'seditious conspiracy' – Dunaway, p. 180.

49 Leon Josephson – Wald, pp. 146–148.

49 'contrary to the best interests' – Duberman, p. 389.

49 One musical victim – 'Old Man Atom: Sam Hinton (1950)', atomicplatters.com.

49 'it's our family affair' – Wald, p. 191.

50 'To most black folks' – Wald, p. 209.

50 'toad' – Wald, p. 197.

50 'We've never seen anyone sing' – 'Burl Ives Sings a Different Song', *Sing Out!* 3:2 (October 1962), quoted in Ronald D. Cohen, *Rainbow Quest: The Folk Music Revival & American Society 1940–1970* (Amherst, MA: University of Massachusetts Press, 2002), p. 81.

50 'Weavers Named Reds' – Dunaway, p. 187.

50 'Seeger was now' – Dunaway, p. 190.

51 'Have you no sense of decency' – Richard M. Fried, *Nightmare in Red: The McCarthy Era in Perspective* (Oxford: Oxford University Press, 1990), p. 139.

51 'McCarthywasm' – Fried, p. 141.

52 'We, the people, suffer' – Pete Seeger, Jo Metcalf Schwartz (ed.), *The Incompleat Folksinger* (Lincoln: University of Nebraska Press, 1992), p. 157.

52 'almost proved too melodramatic' etc. – Seeger, p. 173.

53 'I'll apologize for a number of things' – quoted in Dunaway, p. 404.

53 'a singing army is a winning army' – Lewis quoted in R. Serge Denisoff, *Great Day Coming: Folk Music and the American Left* (Urbana: University of Illinois Press, 1971), p. 66.

53 'Everything' – Pam McMichael, 'Learning to Act', highlandercenter. org.

54 'the beginning of a flame' – quoted in Pete Seeger and Bob Reiser, *Everybody Says Freedom* (New York: W. W. Norton & Company, 1989), p. 22.

55 'There's something about that song that haunts you' – Murphy.

56 '"We Shall Overcome" is definitely' – author interview with Carawan.

56 'We put more soul in it' – Scholtes.

56 'both exciting and scary' – author interview with Carawan.

56 'It is an oddity' – Guy and Candie Carawan (compilers), *We Shall Overcome! Songs of the Southern Freedom Movement* (New York: Oak Publications, 1963), p. 112.

57 'The people were cold with fear' – Robert Shelton, 'Songs Become a Weapon in Rights Battle', *New York Times*, 20 August 1962.

57 'In a sense the freedom songs' – Martin Luther King, Jr., *Why We Can't Wait* (New York: Signet, 1964), p. 61.

58 'tried to explain' – author interview with Carawan.

59 'the Queen of American folk music' – Garth Cartwright, 'Obituary: Odetta', *Guardian*, 4 December 2008.

59 'as pleasant as an international blend' – 'Night Clubs: The Faculty', *Time*, 16 June 1961.

59 'the living prayer' – Todd Gitlin, *The Sixties: Years of Hope, Days of Rage* (New York: Bantam, 1987), quoted in Cohen, p. 159.

60 'Every 100 yards or so' – Colin Irwin, 'Power to the People', *Observer Music Monthly*, 10 August 2008.

60 'Do I have the right' – Dunaway, p. 252.

60 'unworthy of sympathy' – Dunaway, p. 260.

61 'Albany remains a monument' – Reese Cleghorn, 'Epilogue in Albany: Were the Mass Marches Worthwhile?', *New Republic*, 20 July 1963.

61 'These people got a lot of feeling' – Shelton.

61 'a different sort of folk music' – Shelton.

62 'a singing newspaper' – Brian Ward, *Just My Soul Responding: Rhythm and Blues, Black Consciousness, and Race Relations* (Berkeley: University of California Press, 1998), p. 295.

62 'If your heart is downcast and blue' – Seeger, p. 233.

62 'segregation now' – George Wallace, inaugural address, 14 January 1963, Alabama archive.

62 'One cannot describe the vitality' – Carawan and Carawan, p. 11.

63 'To hundreds of thousands' – Seeger, p. 111.

63 'By 1965' – author interview with Carawan.

63 'glad thunder and gentle strength' – Martin Luther King, *Chaos or Community?* (London: Hodder & Stoughton, 1968), p. 25.

63 'What kind of namby-pamby' – Dunaway, pp. 292–293.

63 'I don't believe we're going to overcome' – John Hope Franklin and August Meier, *Black Leaders of the Twentieth Century* (Urbana: University of Illinois Press, 1982), p. 319.

64 'Now it is over' – Julius Lester, *Look Out Whitey! Black Power's Gon' Get Your Mama* (London: Allison & Busby, 1970), p. 107.

4. 'MASTERS OF WAR'

67 'They tell me that every period' – *The Other Side of the Mirror: Bob Dylan Live at Newport Folk Festival 1963–1965* (dir: Murray Lerner, 2007).

67 'Take him' and 'I wasn't a preacher' – Bob Dylan, *Chronicles Volume One* (London: Simon & Schuster, 2004), p. 115.

68 'Prophet, Messiah, Saviour' – Dylan, p. 124.

68 'People are recognizing me' – Anthony Scaduto, *Bob Dylan* (London: W. H. Allen & Co, 1972), p. 125.

68 'gate-crashers, spooks' – Dylan, p. 117.

68 'Fuck off!' – *Monty Python's Life of Brian* (dir: Terry Jones, 1979).

69 'I been travelin'' – Scaduto, p. 52.

69 'To me Woody Guthrie' – Robert Hilburn, 'Rock's Enigmatic Poet Opens a Long-Private Door', *Los Angeles Times*, 4 April 2004.

70 'outrageous power' – Dylan, p. 276.

70 'He didn't read or clip the papers' – Scaduto, p. 116.

71 'a restless piece of paper' – *Sing Out!* quoted in Heylin, p. 79.

71 'This here ain't a protest song' – Heylin, p. 78.

71 'Protest songs are difficult' – Dylan, p. 54.

71 'a grocery list' – Howard Sounes, *Down the Highway: The Life of Bob Dylan* (London: Black Swan, 2002), p. 145.

71 'puerile' – Robin Denselow, *When the Music's Over: The Story of Political Pop* (London: Faber & Faber, 1990), p. 29.

72 'a bullshit song' – Heylin, p. 72.

73 'It's not an anti-war song' – Edna Gunderson, 'Dylan is positively on top of his game', *USA Today*, 10 September 2001.

73 'finger-pointing songs' – Nat Hentoff, 'The Crackin', Shakin', Breakin' Sounds', *New Yorker*, 24 October 1964, reprinted in *Dylan on Dylan: The Essential Interviews*, ed. Jonathan Cott (London: Hodder & Stoughton, 2007), p. 15.

73 'I've never really written' – Nat Hentoff, liner notes, Bob Dylan, *The Freewheelin' Bob Dylan* (Columbia LP, 1963).

74 'This Machine Surrounds Hate' – photograph printed in Dunaway.

74 'It's the elegance of the melody' – Greil Marcus, 'Stories of a Bad Song', *Threepenny Review*, December 2005, reprinted in *Da Capo Best Music Writing 2006*, ed., Mary Gaitskell and Daphne Carr (Cambridge, MA: Da Capo Press, 2006), p. 8.

74 'Anything called a hootenanny' – 'Sibyl With Guitar', *Time*, 23 November 1962.

75 'I am not a saint, I am a noise' – Joan Baez, *And a Voice to Sing With: A Memoir* (New York: Summit Books, 1987), p. 33.

75 'a voice that drove' – Dylan, p. 254.

75 'a promising young hobo' – 'Sibyl With Guitar'.

75 'Before the days of television' – Phil Ochs, 'The Need for Topical Music', *Broadside* 22 (March 1963).

76 'A protest song is' – quoted in Marc Eliot, *Phil Ochs: Death of a Rebel* (London: Omnibus Press, 1990), p. 93.

76 There seemed no end – Cohen, p. 200.

76 'steer clear of the Protesty people' – quoted in Cohen, p. 182.

76 'sappy and idiotic' – quoted in Cohen, p. 182.

76 'melodramatic and maudlin' – quoted in Cohen, p. 182.

77 'written by the most important' – quoted in Sounes, p. 169.

77 'He was paranoid to start' – Scaduto, p. 149.

77 'My knees were shaking' – David Crosby and David Bender, *Stand and Be Counted: Making Music, Making History: The Dramatic Story of the Artists and Events that Changed America* (San Francisco: HarperSanFrancisco, 2000), p. 15.

78 'Tell them about the dream, Martin!' – Peter Guralnick, *Dream Boogie: The Triumph of Sam Cooke* (London: Little, Brown, 2005), p. 512.

78 'Think they're listening?' – quoted in Scaduto, p. 151.

79 'Something had just gone haywire' – Scaduto, p. 160.

79 'They were supposed to be on my side' etc. – Hentoff, reprinted in Cott, p. 26.

80 'He started using bayonets' – Scaduto, p. 173.

80 'The stuff you're writing' – Michael Schumacher, *There But For Fortune: The Life of Phil Ochs* (New York: Hyperion, 1996), p. 103.

81 'somehow lost contact with people' – Irwin Silber, 'An Open Letter to Bob Dylan', *Sing Out!* 14:5 (November 1964), quoted in Cohen, p. 222.

81 'meaning vs innocuousness' – Paul Wolfe, *Broadside* 53 (20 December 1964).

81 'taking his first faltering steps' – Paul Nelson, 'Newport: Down There on a Visit', *Little Sandy Review* 30 (April 1965), quoted in Cohen, p. 221.

81 'Me, I don't want to write' – Hentoff, *New Yorker*, reprinted in Cott, p.16.

82 'I was playing a lot of songs' – Nat Hentoff, 'The Playboy Interview: Bob Dylan', *Playboy*, March 1966, reprinted in Cott, p. 97.

83 'The truth is' – Scaduto, p. 218.

84 'only college newspaper editors' – Hentoff, *Playboy*, reprinted in Cott, p. 100.

84 One night in the middle of 1964 – P. F. Sloan, 'P. F. Sloan: In His Own Words: The Stories Behind the Songs', www2.gol.com/users/davidr/sloan/aboutsongs.html.

84 'The media frenzy' – Sloan.

84 'a love song – a love song to and for humanity' – Sloan.

84 'How do you think the enemy will feel' – 'Message Time', *Time*, 17 September 1965.

85 'communist fodder' – Cohen, p. 243.

85 'an awful song' – quoted in James Perone, *Songs of the Vietnam Conflict* (Westport, CT: Greenwood Press, 2001), p. 40.

85 'some very good lines' – Sis Cunningham and Gordon Friesen, 'An Interview with Phil Ochs', *Broadside* 63, 15 October 1965.

85 'Suddenly the shaggy ones' – 'Message Time'.

85 'Half of 'em don't understand what they're trying to say' – Derek Johnson, 'Question-time with Bob Dylan', *NME*, 15 October 1965.

86 'Pete get away from here' – Cohen, p. 236.

86 'The old guard hung their heads' – Joe Boyd, *White Bicycles: Making Music in the 1960s* (London: Serpent's Tail, 2007), p. 106.

87 'His voice now tells the true story' – Israel Young, 'Bob Dylantaunt', *East Village Other* 1:1 (October 1965), quoted in Cohen, p. 246.

87 'It was a sad parting of the ways' – Paul Nelson, *Sing Out!* 15:5 (November 1965), reprinted at http://richardandmimi.com/article-singoutnov65.html.

87 'You're not a folksinger' – Schumacher p. 106.

87 'I'm quite sure Dylan despises what I write' etc. – Cunningham and Friesen.

88 'see buried' etc. – Cunningham and Friesen.

5. 'MISSISSIPPI GODDAM'

91 'I'm not beyond killing' – Michael Smith, 'The Other (More Serious) Side of Nina . . .', *Melody Maker*, 7 December 1968.

91 'I went down to the garage' – Nina Simone with Stephen Cleary, *I Put a Spell on You: The Autobiography of Nina Simone* (Cambridge, MA: Da Capo Press, 2003), p. 89.

91 'As the bomb detonated' – Lester, p. 105.

92 'asked what I was doing' – Simone and Cleary, p. 88.

92 'All the truths' – Simone and Cleary, p. 89.

92 'Nina, you don't know' – Simone and Cleary, p. 89.

92 'It erupted' – Simone and Cleary, p. 89.

93 'Nightclubs were dirty' etc. – Simone and Cleary, p. 90.

94 'If someone had walked up' – Simone and Cleary, p. 65.

95 'The way they are treating' – David Margolick, 'The Day Louis Armstrong Made Noise', *New York Times*, 23 September 2007.

95 'upward-springing trend' – Frantz Fanon, *The Wretched of the Earth* (London: Penguin Classics, 2001), p. 196.

95 'How ironic' – liner notes, Sonny Rollins, *Freedom Suite* (Riverside LP, 1958).

95 'Some jazzmen' – Nat Hentoff, liner notes, Max Roach, *We Insist! Max Roach's Freedom Now Suite* (Candid LP, 1960).

96 'Like anyone with half a brain' – Simone and Cleary, p. 86.

96 'I have always detested people' – Sam Cooke, 'Boy Singer Makes Good', *New York Journal-American*, 5 August 1960, quoted in Guralnick, p. 336.

97 'You know, we'll never' – Guralnick, p. 486.

97 'We can get no justice' – Hugh Pearson, *The Shadow of the Panther: Huey Newton and the Price of Black Power in America* (Reading, MA: Addison-Wesley, 1994), p. 28.

97 'Social change in something' – Robert Franklin Williams, *Negroes With Guns* (African American Life Series) (Detroit: Wayne State University Press, 1988), p. 72.

98 'Some of you are local residents' – John Dittmer, *Local People:*
 The Struggle for Civil Rights in Mississippi (Urbana: University
 of Illinois Press, 1995), p. 113.

98 'an idiotic idea' – quoted in Guralnick, p. 490.

98 'no one would want to listen to me' – quoted in Suzanne E. Smith,
 Dancing in the Street: Motown and the Cultural Politics of Detroit
 (Cambridge, MA: Harvard University Press, 2003), p. 152.

98 Dizzy Gillespie ran – Sholto Byrnes, 'Let's Swing the Vote',
 Independent, 20 October 2004.

98 'There is hardly one' – quoted in Guralnick, p. 490.

99 'chickens coming home' – Malcolm X, 'God's Judgement
 of White America (The Chickens Come Home to Roost)', 4
 December 1963, transcribed at Malcolm-x.org/speeches.

99 'We want freedom' – Malcolm X, 'Speech on the Founding of the
 OAAU', 28 June 1964.

100 'Fuck that dream, Martin! – David R. Goldfield, *Black White*
 and Southern: Race Relations and Southern Culture 1940 to the
 Present (Baton Rouge: Louisiana State University Press, 1990),
 p. 143.

100 'The name of this tune' – Nina Simone, 'Mississippi Goddam',
 Nina Simone in Concert [recorded live at Carnegie Hall, 21
 March 1964] (Philips LP, 1964).

101 'A white boy writing a song like that?' – Daniel Wolff, *You Send*
 Me: The Life and Times of Sam Cooke (London: Virgin, 1996),
 p. 251.

102 'It feels like death' – Guralnick, p. 549.

102 'It almost scared the shit' – Guralnick, p. 552.

103 'Burn, baby, burn!' – Douglas Martin, 'William Epton, 70, Is
 Dead; Tested Free Speech Limits', *New York Times*, 3 February
 2002.

103 'I now believe I know how it felt to be a Jew in Hitler's
 Germany' – quoted in Guralnick, p. 588.

103 'This proves the liberal' – Rick Perlstein, *Before the Storm: Barry*
 Goldwater and the Unmaking of the American Consensus (New
 York: Nation Books, 2009), p. 404.

103 'Our purpose is to educate' – quoted in Ward, p. 414.

104 'Lady, you shot me' – Guralnick, p. 619.

104 'No I am not' – Gavin Martin, 'Nina Simone: Diary of a Princess
 Noir', *NME*, 4 February 1984.

105 'the singer of the black revolution' – Phyl Garland, 'Nina Simone

– High Priestess of Soul', *Ebony*, August 1969.

105 'The moment you started' – Simone and Cleary, p. 104.

105 'Instead of singing' – Crosby and Bender, p. 21.

105 'the Year of Fire' – quoted in Peter Doggett, *There's a Riot Going On: Revolutionaries, Rock Stars and the Rise and Fall of '60s Counter-Culture* (Edinburgh: Canongate, 2007), p. 47.

106 'We won' – King, p. 112.

106 'Everything seemed to collapse' – Stephen B. Oates, *Let the Trumpet Sound: A Life of Martin Luther King* (Edinburgh: Payback Press, 1998), p. 377.

6. 'I-FEEL-LIKE-I'M-FIXIN'-TO-DIE RAG'

111 'What's almost unfathomable' – author interview with Country Joe McDonald, 2009.

111 'There have always been a few hold-outs' – Jon Landau, 'Beggars Banquet', *Rolling Stone*, 4 January 1969.

112 'that Dada poetry' – Ed Sanders, 'The History of the Fugs', thefugs.com.

112 'local war' – quoted in Perlstein, *Before the Storm*, p. 265.

113 'When we rolled into Washington' – Christian Appy, *Vietnam: The Definitive Oral History Told From All Sides* (London: Ebury Press, 2006), p. 266.

113 'Security Matter' – Schumacher, p. 118.

113 'Is this the enemy?' – liner notes, Phil Ochs, *Phil Ochs in Concert* (Elektra LP, 1966).

113 'light at the end of the tunnel' – A. J. Langguth, *Our Vietnam: The War 1954–1975* (New York: Simon & Schuster, 2000), p. 354.

114 'I was twelve years old' etc. – author interview with McDonald.

115 'the machine' – Mark Kurlansky, *1968: The Year That Rocked the World* (London: Jonathan Cape, 2004), pp. 92–93.

115 'I had to get it out' – author interview with McDonald.

115 'facetious and sacrilegious' – Appy, p. 198.

116 'The person singing the song' – author interview with McDonald.

116 'revolutionaries move' – Appy, p. 196.

117 'probably the closest-cropped' – 'No Time for Sergeanting', *Time*, 15 April 1966.

117 'The folk-rock of anti-Vietnam-war ballads' – *Life*, 4 March 1966, quoted in J. Hoberman, *The Dream Life: Movies, Media, and the*

Mythology of the Sixties (New York: The New Press, 2003), p. 147.

118 'I think we killed for a lot of Americans' – *Kris Kristofferson: His Life and Work* (dir: Paul Joyce, 1993).

118 'A Molotov cocktail or two' – 'Which One Is the Phoanie?', *Time*, 20 January 1967.

118 Napalm Ladies – Tom Wells, *The War Within: America's Battle Over Vietnam* (Berkeley: University of California Press, 1994), p. 85.

118 'a war of extermination' – Wells, p. 99.

119 'I ain't got no quarrel' – George Plimpton, 'Muhammad Ali – The Greatest', *Time*, 14 June 1999.

119 'a time comes when silence is betrayal' etc. – Martin Luther King, 'Beyond Vietnam: A Time to Break Silence', 4 April 1967, New York City.

119 '1967! Yes' – Sanders, thefugs.com.

119 'The songs are sometimes satiric' – Tom Phillips, 'Vietnam Blues', *New York Times*, 8 October 1967.

120 'We couldn't be too direct' – liner notes, the Monkees, *Music Box* (Rhino CD, 2001).

120 'It was really four different things' – Cecilia Rasmussen, 'LA Then and Now: Closing of Club Ignited the "Sunset Strip" Riots', *Los Angeles Times*, 5 August 2007.

121 'silly' – Schumacher, p. 140.

121 'Phil thought' – Schumacher, p. 147.

122 'Black people are not' – Wells, p. 180.

122 'the demons of the Pentagon' – Norman Mailer, *The Armies of the Night* (London: Weidenfeld & Nicolson, 1968), p. 122.

122 'national politics was theatre' – Lynda Rosen Obst (ed.), *The Sixties: The Decade Remembered Now, By the People Who Lived It Then* (New York: Rolling Stone Press, 1977), p. 162.

123 'an attack of mental disobedience' – Schumacher, p. 171.

123 'to say we are mired in stalemate' – quoted in Kurlansky, p. 61.

124 'Organise one of those electric guitar "musical" groups' – Rick Perlstein, *Nixonland: The Rise of a President and the Fracturing of America* (New York: Scribner, 2008), p. 247.

124 'When Johnson read' – Tom Hayden, *The Whole World Is Watching: The Streets of Chicago: 1968* (Davis, CA: Panorama West, 1996), p. 18.

125 'Radicalisation involves' – Wells, p. 239.

125 'committed to revolutionary destruction' – Hayden, p. 24.

125 'a beautiful shipwreck' etc. – Schumacher, pp. 183–184.

125 'I didn't like them' – author interview with McDonald.

126 'left-over radical politicos' – Jann Wenner, 'Musicians Reject New Political Exploiters', *Rolling Stone*, 11 May 1968.

126 'Festival of Life' plan – Kurlansky, pp. 273–274.

127 'I got into the elevator' – author interview with McDonald.

127 'a holocaust of decibels' – Norman Mailer, *Miami and the Siege of Chicago: An Informal History of the American Political Conventions of 1968* (London: Weidenfeld and Nicolson, 1968), p. 133.

127 'a gnawing, creepy feeling' – Doggett, p. 190.

128 'A candlelight chorus' – Hayden, p. 60.

128 'This is the highlight' – Schumacher, p. 200.

128 'Chicago Is Prague!' – Hayden, p. 64.

128 'Delegates if you are with us!' – David Gargill, 'The Mess We Made: An Oral History of the '68 Convention', *GQ*, August 2008.

128 'From the look on his face' – Gargill.

129 'Let us make sure that if our blood flows' – Hayden, p. 70.

129 'We started singing "We Shall Overcome"' – Gargill.

129 'like a peasants' army' – Hayden, p. 71.

129 'The whole world is watching' – Hayden, p. 71.

130 'the Atlantis of the left' – John Schultz, *No One Was Killed: The Democratic National Convention, August 1968* with a new foreword by Todd Gitlin (Chicago: University of Chicago Press, 1969), p. 161.

130 'I've always tried' – Schumacher, p. 205.

130 'It's an insane song' – Barbara Dane and Irwin Silber (compilers and editors), *The Vietnam Songbook* (New York: The Guardian, 1969), p. 56.

131 'One thing that's missing' – Phillips.

131 'People have their views' – John Cohen and Happy Traum, 'Interview with Bob Dylan', *Sing Out!* 18:4 (October/November 1968), reprinted in Cott, p. 137.

131 'Screaming inside' – Hank Bordowitz, *Bad Moon Rising: The Unauthorized History of Creedence Clearwater Revival* (Chicago: Chicago Review Press, 2007), p. 80.

132 'He said, "Nobody's paying any attention"' – author interview with McDonald.

132 'It would have been number one' – Crosby and Bender, p. 31.

132 'Fuck off my stage!' – Doggett, p. 274.

133 'groups, electronically turned on LOUD' – Ed Badeaux, 'The
 Spectacle Moves On', *Sing Out!* 17:4 (August/September 1967),
 quoted in Cohen, pp. 267–268.

133 'Protest singers in the past' – Landau.

133 setting an M-16 – Tom Dalzell and Terry Victor, *The Concise
 New Partridge Dictionary of Slang and Unconventional English*
 (London: Routledge 2007), p. 544.

134 'In a war where people talk' – Michael Herr, *Dispatches*
 (London: Picador, 1979), p. 148.

134 A typical AFVN playlist – AFVN playlist, week ending 16
 November 1968, reprinted at http://members.fortunecity.com/
 parker4/play.html.

134 'the true American status symbol' – Charles Perry, 'Is This Any Way
 to Run the Army? Stoned?', *Rolling Stone*, 9 November 1968.

134 'We sometimes segregate ourselves' – 'The Great Society – in
 Uniform', *Newsweek*, 22 August 1966.

134 'This was the Vietnam anthem' – Brian Mattmiller, '"We Gotta
 Get Out of this Place:" Music, Memory and the Vietnam War',
 University of Wisconsin-Madison website, 16 February 2006,
 news.wisc.edu/12188.

134 'The songs are laced with cynicism' – Joseph B. Treaster, 'GI
 View of Vietnam', *New York Times Magazine*, 30 October 1966.

135 'the prisoners would smile and hum along' – Appy, p. 198.

135 'Those things are just chilling' – author interview with
 McDonald.

7. 'SAY IT LOUD – I'M BLACK AND I'M PROUD'

139 On the evening – James Brown with Bruce Tucker, *James Brown:
 Godfather of Soul* (London: Sidgwick & Jackson, 1987), p. 199.

139 'To millions of kids' – Thomas Barry, 'The Importance of Being
 Mr. James Brown', *Look*, 18 February 1969.

139 'to sing lies about America' – quoted in Ward, p. 390.

140 'Won't they call you an Uncle Tom' – Brown and Tucker, p. 190.

140 'the Roy Wilkins' – Barry.

140 'I used to shine shoes' etc. – Brown and Tucker, p. 187.

141 'The paths of Negro–white unity' – King, p. 4.

141 'For myself, Sammy's murder' – Pearson, p. 84.

141 'If President Johnson' – Lester, p. 98.

141 'a label the white man' – Charles Eric Lincoln, *The Black Muslims in
 America* (Grand Rapids, MI: Wm B. Eerdmans, 1994), p. 64.

142 'We Shall Overrun' – King, p. 26.

142 'What do we want?' – Pearson, p. 89.

142 'Ricks had everybody primed' – Henry Hampton and Steve Fayer with Sarah Flynn, *Voices of Freedom: An Oral History of the Civil Rights Movement from the 1950s through the 1980s* (New York: Bantam, 1991), p. 291.

142 'unfortunate choice of words' etc. – Michael T. Kaufman, 'Stokely Carmichael, Rights Leader Who Coined "Black Power," Dies at 57', *New York Times*, 16 November 1998.

142 'Black power can mean in the end' – Lester, p. 98.

142 'What had been a dull march' – Lester, p. 97.

143 'We're not ever to be caught up' – Stokely Carmichael, 'Black Power', October 1966, reprinted at americanrhetoric.com/ speeches/stokelycarmichaelblackpower.html.

144 'Stokely said' – Brown and Tucker, p. 169.

145 'The time has come' – Pearson, p. 132.

146 'We're going to try to burn you black' – quoted in Pearson, p. 135.

146 'OK, you got what you wanted' – Brown and Tucker, p. 171.

146 'I cast my vote with ideas' – Brown and Tucker, p. 171.

146 'I think I was providing the Democrats' – Brown and Tucker, p. 172.

146 'My story is a Horatio Alger story' – Gerri Hirshey, 'Funk's Founding Father', *Rolling Stone*, 25 January 2007.

147 'Detroit exploded' – Pearson, p. 139.

147 'Violence is necessary' – Pearson, p. 140.

147 'Rap, I know what you're trying to do' etc. – Brown and Tucker, pp. 174–175.

148 'I know I am black, I always will be black' – Brown and Tucker, p. 181.

148 'our nation is moving' – Perlstein, *Nixonland*, p. 239.

148 'We must serve notice' – Pearson, p. 152.

149 'If the word gets out' – *The Night James Brown Saved Boston* (dir: David Leaf, 2008).

149 'It was rush hour' – Brown and Tucker, p. 185.

149 'I never met anything' – James Sullivan, *The Hardest Working Man* (New York: Gotham Books, 2008), p. 185.

150 'Negro singer Jimmy Brown' – *The Night James Brown Saved Boston*.

150 'swinging cat' – *The Night James Brown Saved Boston*.

150 'Don't terrorise' – Brown and Tucker, p. 189.

150 'If in every major city' – Nelson George, *The Death of Rhythm & Blues* (London: Penguin, 2004), p. 112.

151 'White America has declared war on black people' – Perlstein, *Nixonland*, p. 260.

151 'We find little fundamental difference' – Perlstein, *Nixonland*, p. 257.

151 Account of Vietnam tour – Brown and Tucker, pp. 192–194.

152 'I was talking about the land' – Barry.

152 'Has James Brown Rejected' – quoted in Sullivan, p. 171.

152 'They called him Sold' – *The Night James Brown Saved Boston*.

152 'It seems that some of our people' – Geoff Brown, *The Life of James Brown* (London: Omnibus Press, 2007), p. 126.

152 'You have a white man' – Brown and Tucker, p. 197.

153 'Talk about your Black Power' – Albert Goldman, 'Does He Teach Us the Meaning of "Black Is Beautiful?"', *New York Times*, 9 June 1968.

153 'When we recorded' – Gavin Martin, 'Sex Machine Today', *NME*, 1 September 1984.

153 'We were sitting there' – *The Night James Brown Saved Boston*.

153 'I think I might have been informed' – author interview with Pee Wee Ellis, 2009.

153 'I wanted it to sound' – James Brown, *I Feel Good: A Memoir of a Life of Soul* (New York: New American Library, 2005), p. 162.

154 'They were having fun' – author interview with Ellis.

154 'People call [the song] militant' – Brown and Tucker, p. 200.

154 'James Brown says' – author interview with Ellis.

154 'We know the Negro deejay' – newspaper advert reprinted in CD booklet, James Brown, *Say It Live and Loud: Live in Dallas 08.26.68* (Polydor, 1998).

154 'It was like giving up something for Lent' – quoted in Sullivan, p. 130.

155 'He had a lot of respect for Nixon' – author interview with Ellis.

156 'Thank you' – on-stage banter, *Say It Live and Loud*.

156 'I paid the price' – Brown, p. 165.

157 'He thought he was all-powerful' – author interview with Ellis.

157 'preaching to the choir' – Brown, p. 165.

8. 'GIVE PEACE A CHANCE'

161 'The Beatles were ordering us' – Greil Marcus, 'A Singer and a

Rock and Roll Band', in *Rock and Roll Will Stand*, ed. Marcus (Boston: Beacon Press, 1969), p. 94.

161 'You *know* which one' – quoted in Marcus, *Rock and Roll Will Stand*, p. 95.

162 'a lamentable petty' – quoted in Jon Wiener, *Come Together: John Lennon in His Time* (London: Faber & Faber, 1985), p. 60.

162 'Love which does not pit' – John Hoyland, 'Power to the People', *Guardian*, 15 March 2008.

162 'The rhythm of the Stones" – Tariq Ali, *Street Fighting Years: An Autobiography of the Sixties* (London: Verso, 2005), p. 331.

163 'We were not pushed by any major issues' – Jonathon Green, *Days in the Life: Voices From the English Underground 1961–1971* (London: Pimlico, 1998), p. 61.

163 'Their enjoyment of life' – quoted in Wiener, p. 19.

163 'It's the saga' – 'Message With a Beat', *NME*, 1 October 1965.

163 'We don't like protest songs' – Chris Hutchins, 'Paul Talks to *NME* About His "Yesterday",' *NME*, 22 October 1965.

164 'as relevant as Vietnam' – quoted in Wiener, p. 17.

164 'We don't like war' – quoted in Wiener, p. 17.

164 'We think of it every day' – quoted in Wiener, p. 17.

164 'I hate war' – quoted in Wiener, p. 53.

164 'damn-you-England' – Ian MacDonald, *Revolution in the Head: The Beatles' Records and the Sixties* (London: Pimlico, 1998), p. 234.

165 'The Vietnam War, however' – Green, pp. 61–62.

165 'I am sure that' – Ali, p. 254.

165 'The Cossacks are coming' – Ali, p. 255.

166 'war stems from power-mad' – quoted in Wiener, p. 66.

166 'Oh, what? Own up!' – Chris Welch, 'Oh, What? Own up! Just Groove!', *Melody Maker*, 21 September 1968.

166 'It's stupid to think' – Keith Altham, 'The Banned Stones' LP Cover . . . Jagger Protests Against "Dylan Offensive" Charge', *NME*, 14 September 1968.

166 'In America, the rock'n'roll bands' – TV interview, 28 October 1968, quoted in Mark Paytress, *The Rolling Stones: Off the Record* (London: Omnibus Press, 2003), p. 158.

167 'a challenging emotional jigsaw puzzle' – Marcus, *Rock and Roll Will Stand*, p. 101.

167 'Beggar's Banquet is not' – Landau, 'Beggars Banquet'.

167 'this, you know, "God will save us" feeling' – Jann Wenner,

Lennon Remembers (London: Penguin, 1972), p. 131.

168 'very good' – Wenner, *Lennon Remembers*, p. 123.

168 'The International Communist' – *National Review Bulletin*, 12
November 1968, quoted in Gary Allen, 'That Music, There's
More to It Than Meets the Ear', *American Opinion* 12 (February
1969), reprinted in Denisoff and Peterson, p. 163.

168 'There is freedom and movement' – Marcus, *Rock and Roll Will
Stand*, p. 96.

168 'I put in both' – Robin Blackburn and Tariq Ali, '"Power to the
People!" John Lennon & Yoko Ono talk to Robin Blackburn
and Tariq Ali', *Red Mole*, 22 March 1971, reprinted in Ali,
p. 364.

168 When Rolling Stone's Jonathan Cott – Jonathan Cott, 'The
Rolling Stone Interview: John Lennon', *Rolling Stone*, 28
September 1968.

168 'painting in sound' – Blackburn and Ali, p. 364.

168 'black bird' – Barry Miles, *Paul McCartney: Many Years From
Now* (Vintage: 1998), p. 485.

168 'Look at the society' – quoted in Hoyland.

169 'crazy or a genius' – David Sheff and G. Barry Golson, *The
Playboy Interviews with John Lennon & Yoko Ono* (Sevenoaks:
New English Library, 1982), p. 133.

169 'publishing these attacks' – quoted in Wiener, p. 82.

169 'I don't worry about' – Ali, p. 360.

169 'a classic New Left' – Hoyland.

169 'You simply cannot be completely turned on' – quoted in Wiener,
p. 84.

169 'our protest against all the suffering' – quoted in Wiener, p. 88.

169 'fight[ing] through the jungles of TV' – Perlstein, *Nixonland*,
p. 290.

170 'All we're saying is give peace a chance' – Lennon and Ono press
conference, Vienna, Austria, 31 March 1969, transcribed at
www.beatlesinterviews.org/db1969.0331.beatles.html.

170 'It was hilarious' – Sheff and Golson, p. 91.

170 'a haven for communist sympathisers' – Seth Rosenfeld,
'The Campus Files: Regan, Hoover and the Red Scene: The
Governer's Race', *San Francisco Chronicle*, 9 June 2002.

170 'The monster doesn't care' – quoted in Wiener, p. 93.

171 'Lennon's call' – Robert Christgau, 'Rock'n'Revolution', reprinted
in *Any Old Way You Choose It: Rock and Other Pop Music, 1967–*

1973 (New York: Cooper Square Press, 2000), p. 99.

171 'something else' – Wiener, p. 93.

171 'He gave the impression' – Paul Williams, 'Eyewitness: John & Yoko record "Give Peace a Chance"', *Q*, November 1995.

172 'not just "crazy radicals" but "your sons and daughters"' – Wells, p. 330.

172 'I confess when I first heard it' – Wiener, p. 97.

172 'Are you listening, Nixon?' – *The US vs John Lennon* (dir: David Leaf and John Scheinfeld, 2006).

172 'For those present' – Seeger, p. 205.

173 'I was . . . pleased' – Ali, p. 368.

173 'We might not have a leader' – 'The Peace Anthem', *Newsweek*, 1 December 1969.

173 'Britain's involvement' – quoted in Wiener, p. 106.

174 'apocalypse' – Jann S. Wenner, 'Jagger Remembers', *Rolling Stone*, 14 December 1995.

174 'Vietnam War, violence' – Wenner, 'Jagger Remembers'.

174 'You don't shoulder' – Peter Doggett, 'Children of the Revolution', *Mojo*, April 2008.

174 'This was surely the moment' – George Melly, *Revolt Into Style* (London: Penguin, 1970), pp. 119–120.

174 'Year One' – quoted in Wiener, p. 130.

175 'Mr Lennon's Cry' – 'Clown of the Year', *Daily Mirror*, 18 December 1969, quoted in Wiener, p. 113.

175 'Come together, join the party' – Paul Williams.

176 'a revolutionary song' – Wenner, *Lennon Remembers*, p. 110.

176 'Nothing happened' – Wenner, *Lennon Remembers*, p. 12.

176 'I really thought that love' – Wenner, *Lennon Remembers*, p. 132.

176 'I resent the implication' – Wenner, *Lennon Remembers*, p. 91.

177 'complete oppression' – Ali, p. 367.

177 'If we took over Britain' – Ali, pp. 376–377.

177 'How do you think?' – Ali, p. 380.

177 'Look, I was so excited' – Ali, p. 333.

177 '"Power to the People" isn't expected' – Michael Watts, 'Lennon', *Melody Maker*, 2 October 1971.

177 'written in the state of being asleep' – Sheff and Golson, p. 182.

178 'You wonder' – Wiener, p. 186.

178 'what John is really like' – Chris Charlesworth, 'McCartney', *Melody Maker*, 20 November 1971.

178 '"working class hero" with sugar on it' – John Lennon, 'John's Letter to Paul', *Melody Maker*, 4 December 1971.

179 'For the IRA' – Wiener, p. 159.

179 'But Lenin's dead!' – Sheila Hamilton, 'Fighting Spirit of the Clyde', www.sunnygovan.com/PLACES/Clyde/FightingSpirit.html.

179 'In New York' – Ali, p. 335.

9. 'WAR'

183 'I was told' – author interview with Martha Reeves, 2008.

183 'Can It Happen in Detroit' – 'Citizens and Officials Apprehensive: Can It Happen in Detroit?', *Michigan Chronicle*, 23 July 1966, quoted in Suzanne Smith, p. 177.

183 'They firebombed' – author interview with Dennis Coffey, 2008.

184 'The next morning' – Otis Williams with Patricia Romanowski, *Temptations: Updated Edition* (New York: Cooper Square Press, 2002), p. 123.

184 'It was *definitely* in the air' – author interview with Otis Williams, 2008.

184 'He would tell us' – author interview with Williams.

184 Born in 1929 – Nelson George, *Where Did Our Love Go? The Rise & Fall of the Motown Sound* (London: Omnibus Press, 2003).

185 'At the plant' – Berry Gordy, *To Be Loved: The Music, the Magic, the Memories of Motown* (New York: Warner Books, 1994), p. 140.

186 'for consistent presentation of Afro-American music, without apology' – Suzanne Smith, p. 141.

186 'Motown's music' – author interview with Williams.

186 'It's an awful insult' – Gerri Hirshey, *Nowhere to Run: The Story of Soul Music* (London: Southbank, 2006), p. 151.

187 'the brewing period' – Ed Vulliamy, 'A Funk Inferno', *Observer Music Monthly*, 17 February 2008.

187 ''Retha, Rap and Revolt' – quoted in Craig Werner, *A Change Is Gonna Come: Music, Race and the Soul of America* (Edinburgh: Canongate, 2002), p. 116.

187 'Aretha was the riot' – Nikki Giovanni, 'Poem for Aretha', *Re: Creation* (Detroit: Broadside, 1970).

188 'You'd hear Aretha' – Werner, p. 121.

188 'Soul is getting kicked' – 'Lady Soul Singing It Like It Is', *Time*, 28 June 1968.

188 'All the black businesses' – *Respect Yourself: The Stax Records Story* (dir: Robert Gordon and Morgan Neville, 2007).

188 'I had a physical and mental breakdown' – author interview with Reeves.

189 'commercial product' – Smith, p. 229.

189 Abdullah story – Ben Edmonds, *What's Going On? Marvin Gaye and the Last Days of the Motown Sound* (Edinburgh: MOJO Books, 2002), pp. 237–241.

191 'He kept pushing and pushing' – Edmonds, p. 131.

191 'That ain't nothing' – Williams and Romanowski, p. 139.

191 'That was Norman' – author interview with Williams.

192 'To look at us' – Joel Selvin, *Sly and the Family Stone: An Oral History* (New York: Avon Books, 1998), pp. 38–39.

193 'I want everybody to understand' – Rochelle Larkin, 'The Soul Message', in Denisoff and Peterson, p. 95.

193 'I said "Uh-huh"' – author interview with Williams.

193 'I know Berry' – author interview with Williams.

194 'Norman was a hands-on producer' – author interview with Coffey.

194 'They didn't talk about politics' – author interview with Williams.

194 'What bothers me' – Edmonds, p. 215.

196 'I identified' – author interview with Reeves.

196 'I had a cousin' – Don Waller, 'Earth to Cloud Nine', *LA Weekly*, 21 January 1999.

196 'Edwin I got a song for you!' – liner notes to *The Complete Motown Singles Vol. 10: 1970*, p. 68 (Motown CD, 2008).

196 'When [they] brought the lyrics' – *The Complete Motown Singles*, p. 68.

197 'We had no idea' – author interview with Coffey.

197 'Actually, we were talking' – *The Complete Motown Singles*, p. 68.

197 'Certainly troops in Vietnam' – author interview with Coffey.

197 'totally redundant' – Spencer Leigh, Edwin Starr obituary, *The Independent*, 4 April 2003.

197 'They got Western Union' – Edmonds, p. 211.

197 'I saw this and started wondering' – Edmonds, p. 96.

198 'My partners' – Edmonds, p. 96.

198 'I know this sounds strange' – David Ritz, *Divided Soul: The Life of Marvin Gaye* (London: Omnibus Press, 1995), p. 146.

198 'My stomach got real tight' – Ritz, pp. 106–107.

199 'I felt a strong urge' – *What's Going On: The Life and Death of Marvin Gaye* (dir: Jeremy Marre, 2005).

199 'Protest about what?' – Gordy, p. 302.

199 'added some things' – Edmonds, pp. 97–98.

199 'Well, you goof exquisitely' – Edmonds, p. 121.

199 'the worst thing I've ever heard in my life' – Edmonds, p. 125.

200 'A lot of people ask me' – Ben Fong-Torres, 'A Visit With Marvin Gaye', *Rolling Stone*, 27 April 1972.

200 'national anthems' – Edmonds, p. 156.

10. 'OHIO'

205 'I remember getting nuts' – Jimmy McDonough, *Shakey: Neil Young's Biography* (London: Vintage, 2003), p. 345.

206 'Middle America' – Perlstein, *Nixonland*, p. 366.

206 'The Revolt of the White Lower Middle Class' – Perlstein, *Nixonland*, p. 367.

206 'We were hated' – Appy, p. 267.

206 'an honourable end to the war' – Richard Nixon's acceptance speech at the RNC in Miami, 8 August 1968.

207 'I want you for the Wallace rebellion' – quoted in Hoberman, p. 229.

207 'We ought to turn this country over' – quoted in Hoberman, p. 231.

207 'Dick Nixon is a decent man' – Perlstein, *Nixonland*, p. 342.

207 'Nixon got across his image' – Schumacher, p. 222.

208 'the hardcore dissidents' – Perlstein, *Nixonland*, p. 431.

208 'The Revolt of the Average Man' – 'New York: The Revolt of the Average Man', *Time*, 3 October 1969.

208 'positive polarisation' – Perlstein, *Nixonland*, p. 432.

208 'great, silent majority' – Perlstein, *Nixonland*, p. 435.

208 'aggressive confrontation politics' – Wells, p. 284.

208 'urban adventure' – *Motor City's Burning: Detroit From Motown to the Stooges* (BBC Four, 2008).

209 'Total assault on the culture' – John Sinclair, 'The White Panther State/Meant', 1 November 1968.

209 'You can't approach' – *Motor City's Burning*.

209 'free food, clothes, housing, dope, music' – Sinclair, p. 91.

209 'I'm so useless' – Eric Ehrmann, 'MC5', *Rolling Stone*, 4 January 1969.

209 'You guys wanted to be bigger' – Ben Fong-Torres, 'Shattered

Dreams in Motor City', *Rolling Stone*, 8 June 1972.

209 'We felt like miners – Obst, p. 299.

210 'neon oven' etc. – Perlstein, *Nixonland*, pp. 451–452.

210 'No, no, no, Mr Witness' – Country Joe McDonald's testimony at the Chicago Seven Conspiracy Trial, 19 January 1970, transcript available at countryjoe.com/Chicago.htm.

210 'A nonviolent revolution was impossible' – Perlstein, *Nixonland*, p. 455.

211 'Between Judge Hoffman's courtroom' – Hayden, p. 123.

211 'a huge unearned windfall' – Hendrik Hertzberg, 'Weather Report: White Tornado', *Win Magazine*, 1 February 1970, reprinted in Hertzberg, *Politics: Observations & Arguments* (New York: Penguin, 2004), p. 20.

211 'anarchistic, opportunistic' – Jeremy Varon, *Bringing the War Home: The Weather Underground, the Red Army Faction, and Revolutionary Violence in the Sixties and Seventies* (Berkeley: University of California Press, 2004), p. 81.

211 'I'm dreaming of a white riot' – Varon, p. 159.

211 'The Man Can't Bust Our Music' – Doggett, *There's a Riot Going On*, p. 220.

211 'Join the Tool Revolution!' – Thomas Frank, *The Conquest of Cool: Business Culture, Counterculture, and the Rise of Hip Consumerism* (Chicago: University of Chicago Press, 1997), p. 134.

211 'It took about eighteen months' – Christgau, 'Rock'n'Revolution'.

212 'history's biggest happening' – 'Woodstock – The Message of History's Biggest Happening', *Time*, 29 August 1969.

212 'Congratulations!' – Letters, *Time*, 12 September 1969.

212 'satirical' – Bill Janovitz, 'Okie From Muskogee', Allmusic.com.

212 'Tell it like it is!' – Merle Haggard and the Strangers, *Okie From Muskogee* (Capitol CD, 1969).

213 'wild!' – Varon, p. 160.

213 'answered MAKE LOVE NOT WAR', etc. – 'The Middle Americans', *Time*, 5 January 1970.

214 'Julius, you radicalized more people' – Hayden, p. 172.

214 'The first part of the Yippie program' – Perlstein, *Nixonland*, p. 475.

214 'All we are saying' – Wiener, p. 134.

214 At Kent State – James A Michener, *Kent State: What Happened and Why* (London: Secker & Warburg, 1971).

214 'We aren't no cheap tin soldiers' – Perlstein, *Nixonland*, p. 484.

215 'If the President thinks I'm a bum' – Perlstein, *Nixonland*, p. 486.

216 'Neil surprised everyone', etc. – 'Tin Soldiers and Nixon Coming', unsourced newspaper cutting reproduced on Neil Young, *The Archives Vol. 1 1963–1972* (Reprise DVD, 2009).

216 'It's quite strange that Neil should be seen as a political animal' – Alastair McKay, 'The Never-Ending War', *Uncut*, July 2008.

216 'a move away from rock-as-cultural-offensive' – quoted in Barney Hoskyns, *Hotel California: Singer-Songwriters and Cocaine Cowboys in the LA Canyons, 1967–1976* (London: HarperPerennial, 2006), p. 107.

216 'western sky music' – quoted in Hoskyns, p. 102.

217 'fucking parlor-pink' – quoted in Doggett, *There's a Riot Going On*, p. 285.

217 'Do we change the world' – Hoskyns, p. 102.

217 'we just thought rich hippies' – McDonough, p. 346.

217 'I always felt funny' – McDonough, p. 346.

218 'predictable' – Associated Press, 'Death of Students Seen "Predictable" by Agnew', *The Victoria Advocate*, 4 May 1970.

218 'The score is four' – Michener, p. 447.

218 'the real Kent State martyrs' – Perlstein, *Nixonland*, p. 492.

218 'With Americans like John Lindsay' – photograph reprinted in Perlstein, *Nixonland*.

219 'Kent State marked' – William Shawcross, *Sideshow: Kissinger, Nixon and the Destruction of Cambodia* (London: Andre Deutsch, 1979), pp. 157–158.

219 'That changed me' – Simon Reynolds, *Totally Wired: Post-Punk Interviews and Overviews* (London: Faber & Faber, 2009), p. 42.

219 'The meaning of May' – Wells, p. 425.

219 'Within the next fourteen days' – Bernardine Dohrn, 'Weather Underground Declaration of a State of War', 21 May 1970, reprinted at en.wikisource.org/wiki/Weather_Underground_Declaration_of_a_State_of_War.

220 'It may be that in the decade ahead' – 'The City as a Battlefield: A Global Concern', *Time*, 2 November 1970.

220 'Bring an end' – Perlstein, *Nixonland*, p. 534.

220 'If the Vice-president were slightly roughed up' – Richard Reeves, *President Nixon: Alone in the White House* (New York: Simon & Schuster, 2001), p. 265.

221 'The image of the hermit leader' – Reeves, p. 273.

221 'a real force for anti-American' – memorandum from Egil 'Bud' Krogh, 27 January 1972, reprinted at elvisfbifiles.com/Krogh_Memo.html.

221 'You either do something' – Ritchie Yorke, 'Disc Biz Hit by Trends', *NME*, 4 July 1970.

221 'Events like that don't happen every day' – McDonough, p. 346.

222 'We thought Neil' – Tom Dupree, 'Sweet Home Atlanta', *Rolling Stone*, 24 October 1974.

222 'Allison Whatsername' – audio interview with B. Mitchel Reed, September 1973, reproduced on Neil Young, *The Archives Vol. 1*.

222 'a gray-faced man' – *Journey Through the Past* (dir: Neil Young, 1974).

222 'the tool of the British revolution', etc. – Denselow, pp. 96–97.

223 'the killer-clowns of the revolution' – Doggett, *There's a Riot Going On*, p. 369.

223 'Lennon always said' – Wiener, p. 180.

223 'Somehow the arrival' – Jerry Rubin, 'Ann Arbor', *East Village Other*, 16 December 1971, quoted in Wiener, p. 194.

224 'We'd make musical history' – Wiener, p. 196.

224 'It was done in the tradition' – *SunDance*, August/September 1972.

225 'so embarrassingly puerile' – Stephen Holden, review of *Some Time in New York City*, *Rolling Stone*, 20 July 1972, quoted in Wiener, p. 217.

225 'It almost ruined it' – Pete Hamill, 'Long Night's Journey into Day: A Conversation with John Lennon', *Rolling Stone*, 5 June 1975.

225 'Lennon appears to be radically oriented' – Perlstein, *Nixonland*, p. 714.

225 'A great deal of the leadership' – quoted in Hoberman, p. 347.

226 'The people don't know' – *Washington Post*, 27 April 1972, quoted in Perlstein, *Nixonland*, p. 652.

226 'groovin' on democracy' – 'Flamingo Park Jamboree', *Time*, 24 July 1972.

226 'the streets of '68' – Perlstein, *Nixonland*, p. 694.

227 'This is *it*?' – Wiener, p. 253.

227 'guilt for being rich' – Sheff and Golson, p. 81.

228 'This ain't Frantz Fanon' – quoted in Wiener, p. 263.

228 'sodomized Seventies' – quoted in Schumacher, p. 272.

228 'It was like now that the dragon was slain' – Crosby and Bender, p. 89.

228 'a realistic and self-contained' – Pete Townshend, 'Creators or Capitalists?', *Melody Maker*, 16 October 1971.

228 'I cared mostly' – David Crosby with Carl Gottlieb, *Long Time Gone: The Autobiography of David Crosby* (New York: Doubleday, 1988), p. 186.

11. 'THE REVOLUTION WILL NOT BE TELEVISED'

231 '"What is your thing"' – Abiodun Oyewole and Umar Bin Hassan with Kim Green, *On a Mission: Selected Poems and a History of the Last Poets* (New York: Henry Holt & Company, 1996), p. 3.

231 'I was the baby in the group' – Jason Gross and John Grady, 'The Last Poets', www.furious.com/perfect/lastpoets.html, February 1997.

231 'Are you ready, niggers? – Oyewole and Hassan, p. 4.

232 'There wasn't any question' – Oyewole and Hassan, p. 44.

232 'All art must reflect' – quoted in Sullivan, p. 171.

232 'The only poem you will hear' – K. William Kgositsile, 'Towards a Walk in the Sun', in *Black Fire*, ed. LeRoi Jones and Larry Neal (New York: William Morrow & Company, 1968), p. 228.

232 'Therefore we are the last poets of the world' – Jalal Mansur Nuriddin, 'Birth of a Name', grandfatherofrap.com/first_coming_2.htm.

232 '"poems that kill", assassin poems' – LeRoi Jones, 'Black Art', in *Black Magic Poetry 1961–1967* (Indianapolis: Bobbs-Merrill, 1969), p. 116.

232 'trying to be super-militant' – James Campbell, 'Revolution Song', *Guardian*, 4 August 2007.

232 'He was taking strides outside the boundaries' – Gross and Grady.

233 'It is the progeny of the blacks' – Nat Hentoff, 'The New Jazz – Black, Angry and Hard to Understand', *New York Times Magazine*, 25 December 1966, quoted in Lloyd Miller and James K. Skipper, Jr, 'Sounds of Black Protest in Avant-Garde Jazz', reprinted in Denisoff and Peterson, pp. 35–36.

233 'Suppose James Brown read Fanon' – 'The Social Background of the Black Arts Movement', *Black Scholar* 1, 1987, quoted in

Ward., p. 391.

234 'the first totally black film' – quoted in Hoberman, p. 301.

234 'We wanted to have a collective of men' – Gross and Grady.

234 'That shit blew my mind' – quoted in David Dalton, 'The Last Poets: Progenitors of Rap', *Gadfly*, September 2000.

234 'Smash those jelly white faces' – Oyewole and Hassan, p. 25.

234 'There's a brother here from Ohio' etc. – Oyewole and Hassan, p. 29.

234 'Jalal almost didn't get into the group' – Gross and Grady.

235 'dropped a bomb on black Amerikkka's turntables' – Darius James, *That's Blaxploitation!: Roots of the Baadasssss 'Tude (Rated X by an All-Whyte Jury)* (New York: St Martin's Griffin, 1995), p. 167.

236 'I began to feel that being a poet' – Oyewole and Hassan, p. 6.

236 'Back then, I wanted to see everything burned' – Gross and Grady.

236 'There I was, on the front lines' etc. – Oyewole and Hassan, p. 45.

237 'We hit it off immediately' – James Maycock, 'Gil Scott-Heron and Brian Jackson: Brothers in Arms', *Mojo*, December 2003.

237 'Gil Scott-Heron takes you Inside Black' – liner notes, Gil Scott-Heron, *Small Talk on 125th & Lenox* (Flying Dutchman LP, 1970).

237 'There are 360° of the black experience' – Sheila Weller, 'Survival Kits on Wax', *Rolling Stone*, 2 January 1975.

238 'It seemed practical' – Weller.

238 'She was black before it was fashionable to be black' – liner notes, *Small Talk on 125th and Lenox*.

239 'That was satire' – Rob Fitzpatrick, full transcript of interview with Gil Scott-Heron, February 2010.

239 'The song that people' – Fitzpatrick.

239 'You have to be able to perceive things with clarity' – Cliff White, 'And now, for a fascinating and demanding dialogue . . .', *NME*, 6 March 1976.

239 'survival kits on wax' – Weller.

239 'I sometimes thought he was a little too blunt' – Maycock.

240 'IF YOU'RE WHITE' – 1971 advert for *This Is Madness*, reprinted in CD booklet of the Last Poets, *When the Revolution Comes* (Rev-Ola, 2005).

240 'Watts people were the lowest' – author interview with Amde

Hamilton, 2010.

241 'Anthony would go out there' – Brian Cross, *It's Not About a Salary: Rap, Race and Resistance in Los Angeles* (London: Verso, 1993), p. 116.

241 'What made the Watts Prophets so different' – Cross, p. 110.

241 'The cat in the front' – author interview with Hamilton.

242 'White folks were afraid of us' – Jeff Chang, liner notes, the Watts Prophets, *Things Gonna Get Greater: The Watts Prophets 1969–1971* (Water CD, 2005).

242 'NO COP OUT' – quoted in Hoberman, p. 299.

243 'all the brothers and sisters who had enough of the Man' – *Sweet Sweetback's Baadasssss Song* (dir: Melvin Van Peebles, 1971).

243 'mangled, crippled, white supremacist' – quoted in Hoberman, p. 302.

243 'first truly revolutionary Black film' – quoted in Hoberman, p. 303.

244 'tripping out, pseudo-masochism' – Pearson, pp. 229–230.

245 'Attica is every prison' – 'The Law: A Year Ago at Attica', *Time*, 25 September 1972.

245 'radical chic' – Tom Wolfe, *Radical Chic & Mau-Mauing the Flak Catchers* (New York: Farrar, Straus & Giroux, 1970).

246 'You can take their culture and use it against them' – TV interview with Darthard Perry, posted at www.youtube.com/watch?v=RwYhVzAoisM.

246 'It got to me a great deal' – Perry interview.

246 'Our goal was to open up' – author interview with Hamilton.

246 'First, I started selling cocaine' – Oyewole and Hassan, p. 31.

12. 'LIVING FOR THE CITY'

251 'there was a cloud' – Selvin, *Sly*, p. 81.

251 'Sly had a baboon' – Selvin, *Sly*, p. 111.

251 'They cut the tail off' – Selvin, *Sly*, p. 99.

251 'It was over' – Selvin, *Sly*, p. 95.

252 'in which any political inclination' – Ian Penman, 'Tricknology', in *Vital Signs* (London: Serpent's Tail, 1998).

253 'cocaine informercial' – Craig Werner, *Higher Ground: Stevie Wonder, Aretha Franklin, Curtis Mayfield, and the Rise and Fall of American Soul* (New York: Crown, 2004), p. 161.

253 'I know it's a rotten game' – *Super Fly* (dir: Gordon Parks, Jr, 1971).

253 Merchandise and box office – Novotny Lawrence, *Blaxploitation Films of the 1970s: Blackness and Genre* (New York: Routledge, 2008), p. 67.

253 'The movie tells young people' – Lawrence, p. 66.

254 'part of a conspiracy' – Doggett, *There's a Riot Going On*, p. 506.

254 'the degree of refusal' – Trewhitt quoted in William Safire, *Safire's Political Dictionary* (New York: Oxford University Press, 2008), p. 158.

255 'I wasn't trying to help' – Richie Unterberger, *Unknown Legends of Rock 'n' Roll* (San Francisco: Miller Freeman, 1998), p. 249.

255 'use the available federal machinery' – John Dean, 'Dealing with Our Political Enemies', White House memo, 16 August 1971.

257 'seemed never to come' – John A. Jackson, *A House on Fire* (New York: Oxford University Press, 2004), p. 45.

257 'turn off a lot of people' – Jackson, p.127.

258 'the joy of love' – quoted in Werner, *A Change Is Gonna Come*, p. 197.

258 'He had not played them' – Joel Selvin, 'Stevie Wonder', *Mojo*, March 2003.

258 'I hope for a better tomorrow' – quoted in John Swenson, *Stevie Wonder* (London: Plexus, 1986), p. 150.

258 Malcolm Cecil and his fellow – Howard Sounes, *The Seventies*, p. 123, and Selvin, 'Stevie Wonder'.

259 'I had all the instruments' – Selvin, 'Stevie Wonder'.

259 'This album' – liner notes, Stevie Wonder, *Music of My Mind* (Tamla LP, 1972).

260 Until the 1960s – Walter Thabit, *How East New York Became a Ghetto* (New York: New York University Press, 2003), pp. 37–55.

260 The pace of ghettoisation – Vincent J. Cannato, *The Ungovernable City: John Lindsay's New York and the Crisis of Liberalism* (New York: Basic Books, 2001) pp. 127–129.

261 'The vacant houses' – Richard Rogin, 'This Place Makes Bedford-Stuyvesant Look Beautiful', *New York Times Magazine*, 28 March 1971, quoted in Cannato, p. 128.

261 'a necropolis' – Cannato, p. 528.

262 During Lindsay's tenure – Cannato, pp. 525–553.

263 'It's the last days of life' – Werner, *Higher Ground*, p. 192.

263 'the deepest I really got' – Werner, *Higher Ground*, p. 193.

264 'It was one hell of a way' – Werner, *Higher Ground*, p. 193.

264 'reach people who otherwise' – *Classic Albums: Songs in the Key of Life* (dir: David Heffernan, BBC/Isis Productions/Daniel Television, 1997).

264 'His product does more than sell millions of records' – Swenson, p. 112.

264 'You've got to understand this' – David Walker, Andrew J. Rausch and Chris Watson, *Reflections on Blaxploitation* (Lanham, MD: Scarecrow Press, 2009), p. 139.

265 'James Brown, Nixon's clown' – Sullivan, p. 197.

266 '100,000 brothers and sisters' – Poster, *Wattstax* (dir: Mel Stuart, 1973).

266 'Whose cause was it' – Peter Guralnick, *Sweet Soul Music: Rhythm and Blues and the Southern Dream of Freedom* (London: Virgin, 1986), p. 388.

266 'You are one of my disciples' – Jackson, p. 166.

267 'Evil plan' – quoted in Jackson, p. 182.

267 'Let's keep on making babies' – quoted in Jackson, p. 182.

267 'Stevie became' – Selvin, 'Stevie Wonder'.

268 'Everybody promises you everything' – quoted in Werner, *Higher Ground*, p. 200.

268 'our long national nightmare' – Yanek Mieczkowski, *Gerald Ford and the Challenges of the 1970s* (Lexington: University Press of Kentucky, 2005), p. 18.

269 'Politics has gone from an age of Camelot' – Mieczkowski, p. 3.

269 'We approach winter' – liner notes, Gil Scott-Heron and Brian Jackson, *Winter in America* (Strata-East LP, 1974).

269 'I was taking over the administration' – Coleman Young, *The Hard Stuff: The Autobiography of Mayor Coleman Young* (New York: Viking Adult, 1994), quoted in Suzanne Smith, p. 244.

270 'I read a review' – author interview with Otis Williams.

271 'I don't have to tell you things are bad' – *Network* (dir: Sidney Lumet), 1976.

13. 'MANIFIESTO'

277 'jungles, mines, caves' – Schumacher, p. 239.

278 'I just met the real thing' – Crosby and Bender, p. 73.

278 'taken certain measures' – Joan Jara, *Victor* (London: Jonathan Cape, 1993), p. 121.

279 'the English of Latin America' – Pamela Constable and Arturo

Valenzuela, *A Nation of Enemies: Chile Under Pinochet* (New York: W. W. Norton & Company, 1991), p. 21.

281 'It seems that nobody dares to be themselves' – Jara, p. 114.

282 'Escapism, decadence, superficiality' – Salvador Allende's inaugural address, Santiago, 5 November 1970, reprinted in James D. Cockcroft (ed.), *Salvador Allende Reader: Chile's Voice of Democracy* (Melbourne: Ocean Press, 2000), p. 58.

282 'An artist must be an authentic creator' – Jara, p. 124.

283 'I don't see why we need to stand idly by' – Cockcroft, p. 245.

284 'It is firm and continuing policy' – Cockcroft, p. 246.

285 'You can't have a revolution without songs' – 'Nueva Cancion', allmusic.com.

285 'People believed paradise' – Constable and Valenzuela, p. 25.

286 'Some were funny' – Jara, p. 195.

287 'This coming year is a crucial one' – Jara, p. 208.

287 'We worked to a background' – Jara, p. 215.

288 'The task is great' – Nathaniel Davis, *The Last Two Years of Salvador Allende* (Ithaca, NY: Cornell University Press, 1985), p. 188.

288 'We Chileans are naturally' – Jara, p. 222.

289 'History belongs to us' – Jara, p. 234.

289 'I'll be back as soon as I can' – Jara, p. 235.

289 'that whole pile of pigs' – Constable and Valenzuela, p. 16.

290 'To Salvador' – Constable and Valenzuela, p. 17.

290 'Mamita, I love you' – Jara, p. 236.

290 'You're that fucking singer' – Jara, p. 247.

291 'Sing now, if you can' – Jara, p. 249.

291 In June 2009 – Gideon Long, 'Murdered Chilean Folk Singer Laid to Rest After 36 Years', *Guardian*, 6 December 2009.

292 'It could only have happened' – Constable and Valenzuela, p. 34.

293 'The Allende era' – Constable and Valenzuela, pp. 146–147.

293 'When that happened I said' – Eliot, p. 257.

293 'Phil used to say to me' – Schumacher, p. 289.

14. 'ZOMBIE'

297 'You cannot see two of Fela' – author interview with Tony Allen, 2009.

297 'by far and away' – 'Another Disruption in Egba Politics?', *Daily Service*, 31 January 1946, quoted in Michael Veal, *Fela: The Life & Times of an African Musical Icon* (Philadelphia: Temple

University Press, 2000), p. 23.

297 'What I liked about my father' – Carlos Moore, *Fela, Fela: This Bitch of a Life* (London: Allison & Busby, 1982), p. 37.

298 'Ademola Ojibosho' – Veal, p. 32.

298 'wind of change' – Harold Macmillan, speech to South African parliament, 3 February 1960.

298 'Man, I was so fucking ignorant' – Moore, p. 64.

300 'I said, "This is a man!"' – Moore, p. 85.

300 'I had been using jazz' – John Collins, *Musicmakers of West Africa* (Washington DC: Three Continents Press, 1985), p. 119.

300 'Everything changed after America' – author interview with Allen.

300 'It was just bullshit' – Moore, p. 83.

301 'He was talking about government' – author interview with Odion Iruoje, 2008.

301 'There are no jam sessions' – author interview with Allen.

302 'Many things happening there' – author interview with Allen.

303 'Everywhere he goes' – John Collins, *West African Pop Roots* (Philadelphia, PA: Temple University Press, 1992), p. 69, quoted in Veal, p. 126.

303 'Things started going haywire' – author interview with Allen.

303 '1974!' – Moore, p. 120.

304 'I had nothing to fear' – Moore, p. 120.

304 'clean like a baby's shit' – Moore, p. 127.

304 'You know how people are brought up' – Moore, p. 119.

304 'Our music should not be about love' – Collins, p. 119.

305 'I'm very cool with this government' – Collins, p. 120.

306 'FESTAC!' – Moore, p. 135.

306 'counter-FESTAC' – Moore, p. 137.

307 'against the kind of mind' – Vivien Goldman, 'The Rascal Republic Takes on the World', *NME*, 18 October 1980.

307 'We had to get permission' – author interview with Allen.

307 'You can come with bazookas' – Moore, p. 138.

308 'Oh man, I could *hear* my own bones' – Moore, p. 140.

308 'I saw a disaster' – author interview with Allen.

308 'exasperated and unknown soldier' – Veal, p. 156.

309 'I've rarely been happy in my life' – Moore, p. 239.

309 'Seeing my mother die' – *Sunday Punch*, 25 June 1978, quoted in Veal, p. 167.

310 'We know every time when the lyrics come' – author interview with Allen.

310 'I managed to be inside everything' – author interview with Allen.

310 'Ka-la-ku-ta' – Zee-Tei Debekeme, 'Kalakuta Falls', *Punch*, 30 October 1978, quoted in Veal, p. 165.

312 'technology, industrialisation' – Moore, p. 151.

312 'I say to myself: "How can I cancel my existence?"' – Moore, p. 266.

312 'He says his music is not for pleasure' – Niyi Odutola's letter, *Punch*, 29 May 1982, quoted in Veal, p. 249.

312 'With my music I create a change' – Moore, p. 260.

15. 'WAR INA BABYLON'

315 'It wasn't intended to be a slogan song' – author interview with Max Romeo, 2008.

316 'The paranoid spokesman' – Richard Hofstadter, *The Paranoid Style in American Politics and Other Essays* (New York: Vintage, 2008), p. 30.

316 'the ghetto's newspaper' – quoted in Lloyd Bradley, *Bass Culture: When Reggae Was King* (London: Penguin, 2001), p. 280.

317 'since rum and bananas' – Timothy White, quoted in *Catch a Fire: The Life of Bob Marley: Revised and Enlarged* (London: Omnibus, 1991), p. 198.

317 'Look to Africa' – M. G. Smith, Roy Augier and Rex Nettleford, *Report on the Rastafari Movement in Kingston, Jamaica* (Mona, Jamaica: University of the West Indies, 1978), p. 5.

317 Rasta customs – James A Winders, 'Reggae, Rastafarians and Revolution: Rock Music in the Third World', reprinted in Chris Potash, *Reggae, Rasta, Revolution: Jamaican Music From Ska to Dub* (London: Books With Attitude, 1997).

318 'Because the sound man' – Bradley, p. 190.

321 'Them shouldn't have said "rude boy"' – Vivien Goldman, 'Uptown Ghetto Living: Bob Marley in His Own Backyard', *Melody Maker*, 11 August 1979.

321 'revolutionary soul' – David Katz, *People Funny Boy: The Genius of Lee 'Scratch' Perry* (London: Omnibus, 2006), p. 111.

321 '*This* is how reggae should sound!' – Mick Sleeper, 'Shocks of Mighty', July 1996, reprinted in Potash, p. 159.

322 'A lot of people were surprised' – Bradley, p. 347.

323 'The people started questioning me' – author interview with Romeo.

324 Manley increased spending – David Panton, *Jamaica's Michael Manley: The Great Transformation (1972–92)* (Kingston, Jamaica: Kingston Publishers Ltd, 1993).

324 'When the people hear what I-man do' – Katz, p. 112.

325 'He was a guy who makes sound out of anything' – author interview with Romeo.

325 'Marcus Garvey is from the town where I-man is from' – David Katz, *Solid Foundation: An Oral History of Reggae* (London: Bloomsbury, 2003), p. 243.

325 'There is really no dread in Marley's music' – Linton Kwesi Johnson, 'Roots and Rock', *Race Today*, 7:10 (October 1975) – quoted in Potash, p. 165.

325 'a rough spiritual analogue' – Robert Christgau, 'Bob Marley & the Wailers – Catch a Fire', *Christgau's Record Guide* (Boston: Houghton Mifflin, 1981).

326 'He was on the other side of the fence' – author interview with Romeo.

326 'Yuh cyan't kill God' – Timothy White, quoted in *Catch a Fire*, p. 271.

327 'When they see their back is going up against the wall' – Katz, *Solid Foundation*, p. 251.

328 'I always remember it' – author interview with Romeo.

328 'Everything sipple this morning' – Katz, *People Funny Boy*, p. 235.

328 I said, "Wait we're taking one step forward"' – Katz, *People Funny Boy*, p. 239.

329 'He was a genius' – author interview with Romeo.

329 'Them just shot Bob Marley' etc. – Katz, *People Funny Boy*, p. 257.

330 'we are not for sale' – Panton, p. 52.

331 'Shitstem' and One Love concert – Timothy White, quoted in *Catch a Fire*, p. 301.

332 'I am a batty man' – Katz, *People Funny Boy*, p. 313.

332 'I sensed a method in Scratch's madness' – Katz, *People Funny Boy*, p. 318.

333 One houseful of mourners – Isaac Ferguson, '"So Much Things to Say": The Journey of Bob Marley', reprinted in Potash, p. 60.

16. 'WHITE RIOT'

339 'Over here, it's bright young Americans' – Anthony O'Grady, 'Dictatorship – The Next Step?', *NME*, 23 August 1975.

339 'Goodbye, Great Britain' – *Wall Street Journal*, 29 April 1975, quoted in Andy Beckett, *When the Lights Went Out: Britain in the Seventies* (London: Faber & Faber, 2009), p. 321.

340 'People [forget] what genuine flux' – author interview with Tom Robinson, 2009.

340 'long hair' and 'guitar solos' – author interview with Marco Pirroni and Poly Styrene, conducted for 'Punk Reunion: London, *Spin*, October 2007.

340 'protest songs' – Denselow, p. 148.

340 'I always felt like I was coming' – *Joe Strummer: The Future Is Unwritten* (dir: Julien Temple, 2007).

341 'The Clash was a bit like the Communist Party' – Chris Salewicz, *Redemption Song: The Definitive Biography of Joe Strummer* (London: Harper Collins, 2007), p. 24.

341 'Joe was his own man' – author interview with Don Letts, 2009.

341 'Write about what's important' – Salewicz, p. 167.

341 'The situation is far too serious' – quoted in Pat Gilbert, *Passion Is a Fashion: The Real Story of the Clash* (London: Aurum, 2005), p. 112.

342 'I have the idea of the singer' – quoted in Jon Savage, *England's Dreaming: Sex Pistols and Punk Rock* (London: Faber & Faber, 2005), p. 69.

342 'I learnt hate and resentment' – Savage, p. 116.

342 'It's the repressive class system' – author interview with John Lydon, conducted for '"PiL lets me express proper emotions"', *Guardian*, 6 September 2009.

342 'I suppose Malcolm's idea' – Denselow, p. 145.

343 'There was nihilism' – Savage, p. 133.

343 'I felt that what we had done as a joke' – Legs McNeil, *Please Kill Me* (London: Abacus, 1997), p. 303.

343 'The Pistols had to come in' – *Joe Strummer: The Future Is Unwritten*.

344 'What had begun as an excuse' – Savage, p. 196.

344 'I don't think anyone wanted' – Savage, p. 138.

344 'a reaction against the hippie counterculture' – Lester Bangs, 'The White Noise Supremacists', *Village Voice*, 30 April 1979.

345 'The whole idea of being black and British' – author interview with Letts.

345 'You went there thinking' – author interview with Letts.

345 'Coming down, coming down' – Savage, p. 234.

346 'We were there at the very first throw' – *The Clash: Westway to the World* (dir: Don Letts, 2000).

346 'That was when I realised' – Savage, p. 234.

346 'If you lived in the streets of London' – author interview with Letts.

347 'We did feel like we were on the frontline of Babylon' – Simon Reynolds, *Rip It Up and Start Again: Postpunk 1978–1984* (London: Faber & Faber, 2005), p. 88.

347 'political anarchy' – Jon Savage, *The England's Dreaming Tapes* (London: Faber & Faber, 2009), p. 223.

348 'They didn't know which direction' – Savage, *England's Dreaming Tapes*, p. 443.

348 'When you go to one extreme' – author interview with Lydon.

349 'tough shit', 'you fucking rotter!' – *Today*, Thames Television, 1 December 1976.

349 'All over the country' – Margaret Drabble, *The Ice Age* (Harmondsworth: Penguin, 1979), p. 62.

349 'The Filth and the Fury!' – Stuart Grieg, Michael McCarthy and John Peacock, 'The Filth and the Fury', *Daily Mirror*, 2 December 1976, reprinted in Hanif Kureishi and Jon Savage, *The Faber Book of Pop* (London: Faber and Faber, 1995), pp. 498–499.

349 'Who Are These Punks?' – *Daily Mail* front page reprinted in Savage, *England's Dreaming*, p. 263.

349 Dee Generate – author interview with Dee Generate for *Spin*, 2007.

349 'From that day on, it was different' – Savage, *England's Dreaming*, p. 260.

350 'I've always thought the Clash read books' – author interview with Lydon.

350 'we're anti-fascist' – Barry Miles, 'Eighteen Flight Rock and the Sound of the Westway', *NME*, 11 December 1976.

351 'They chronicle our lives' – Tony Parsons, 'The Clash: War on Inner City Front', *NME*, 16 April 1977.

351 'It was a lot more glitzy' – author interview with Letts.

352 'The soldiers crouching in cubby holes' – Ian Birch, 'Clash Lose Control . . .', *Melody Maker*, 29 October 1977.

352 'Che, Durruti, the Watts Riots' – quoted in Savage, *England's Dreaming*, p. 305.

352 'sounds like an ad for a bank' – Savage, *England's Dreaming*, p. 315.

354 'We love our Queen, you bastard!' – Savage, *England's Dreaming*, p. 365.

354 'It took us about three years' – Savage, *England's Dreaming Tapes*, pp. 468–9.

355 'a silly comment' – Harry Doherty, 'A Mod at 20', *Melody Maker*, 20 January 1979.

355 'I was kind of ready for a road-to-Damascus moment' – author interview with Robinson.

356 'It's make-your-mind-up time' – Ray Coleman, 'Power in the Darkness: Tom Robinson's Greatest Hit', *Melody Maker*, 22 October 1977.

356 'I was a driven, unhappy person' – author interview with Robinson.

357 'The lyrics of Joe Strummer' – *Joe Strummer: The Future Is Unwritten*.

357 'It's hard when you define a period' – Jon Savage, 'The Clash: War'n'Pizza', *Melody Maker*, 11 November 1978.

357 'Strummer's totally facile' – Nick Kent, 'White Punks on Hope', *NME*, 11 November 1978.

357 'We're going for a new direction' – Graham Lock, 'Gabba Gabba Hegel', *NME*, 13 October 1979.

358 'We didn't have any solutions' – *The Clash: Westway to the World* (deleted scene on DVD).

17. 'I WAS BORN THIS WAY'

361 'The epitome of all that's wrong' – John Holmstrom, Editorial, *Punk* Volume 1 Number 1, January 1976.

361 'garbage and pollution' – Werner, *A Change Is Gonna Come*, p. 210.

361 A grimy dive bar – Martin Duberman, *Stonewall* (New York: Penguin, 1993).

362 'It's about time we did something' – Duberman, *Stonewall*, p. 209.

362 'I was on the streets and in the party' – Tim Lawrence, *Love Saves the Day: A History of American Dance Music Culture, 1970–1979* (Durham, NC: Duke University Press, 2003), p. 51.

362 In 1973, a printer of T-shirts – Alix Kates Shulman, 'Dances With Feminists', *Women's Review of Books* 11:3, December 1991.

363 'couldn't tune in and drop out' – Lawrence, *Love Saves the Day*, p. 53.

364 'I began to feel that gays' – Christopher Stone, 'Hollywood', *The Advocate*, 4 June 1975, reproduced at queermusicheritage.us.

364 'You've got a hit record' – Stone.

364 'No major company' – Stone.

365 'When the song came on' – 'Valentino Would Do It Again', *The Advocate*, 7 April 1976, reproduced at queermusicheritage.us.

365 'lead such a crusade' – Peter N. Carroll, *It Seemed Like Nothing Happened: America in the 1970s* (Piscataway, NJ: Rutgers University Press, 1990), p. 290.

365 'Anita's going to create' – Ivan Sharpe, 'Angry Gays March Through SF', *San Francisco Examiner*, 8 June 1977.

365 'The preacher didn't have an answer', – Carol Chastang, 'Good News at Unity For Carl Bean, Rejection by His Boyhood Church Pointed the Way to a New Ministry', *Los Angeles Times*, 5 October 1992.

366 'She is the opposite of Anita Bryant' – Daniel Conlon, 'Carl Bean was "Born This Way"', *The Advocate*, 19 April 1978, reproduced at queermusicheritage.us.

366 'The entire studio was filled with joy' – CD sleevenotes to reissue of 'I Was Born This Way' (West End Records, 2005).

366 'The name of the game' – Conlon.

367 'I am using my voice' – Conlon.

367 Abe Beame – Jonathan Mahler, *Ladies and Gentlemen the Bronx Is Burning* (New York: Picador, 2005), pp. 6–16.

368 'never tell the people' – Mahler, pp. 15–16.

368 'Everyone in the room wept' – Hertzberg, 'A Moral Ideologue', in *Politics*, p. 53.

368 On the hot, sticky evening – Mahler, pp. 175–205.

368 'a night of terror' – 'Night of Terror', *Time*, 25 July 1977.

369 'a Praetorian Guard' – Anthony Haden-Guest, *The Last Party: Studio 54, Disco and the Culture of the Night* (New York: William Morrow & Company, 1997), p. 57.

369 'When the Vietnam War stopped' – Peter Shapiro, *Turn the Beat Around: The Secret History of Disco* (New York: Faber & Faber, 2005), p. 161.

370 'fucking Studio 54', Shapiro, p. 159.

370 'That was the bargain' – Daryl Easlea, *Everybody Dance: Chic and the Politics of Disco* (London: Helter Skelter, 2004), p. 93.

370 'DHM – Deep Hidden Meaning' – Jody Rosen, 'The Greatest Songs Ever: Good Times', *Blender*, July 2005.

371 'genius' – Shapiro, p. 204.

371 'I am sincerely trying to produce' – *Newsweek*, 2 April 1979, quoted in Lawrence, *Love Saves the Day*, p. 333.

372 'Too many products' – Haden-Guest, p. 150.

372 'was hearing "YMCA"' – Shapiro, p. 277.

374 'I've never been an advocate of gay rights' – Paolo Hewitt, 'Sylvester: Return of the Cool Black Aristocrat', *NME*, 1 December 1984.

374 'paralysis and stagnation and drift', etc. – Jimmy Carter, 'A Crisis of Confidence', 15 July 1979, reprinted at americanrhetoric.com.

374 'I remember the journalists' – Rosen.

375 'If Dylan was standing' – Easlea, p. 156.

376 'Obviously, some people dislike disco' – Frank Rose, 'Discophobia: Rock & Roll Fights Back', *Village Voice*, 12 November 1979, quoted in Shapiro, p. 103.

376 'It felt to us like Nazi book-burning' – Easlea, p. 151.

376 'Disco was probably a catalyst' – Lawrence, *Love Saves the Day*, p. 379.

377 'Every time a person of colour' – Easlea, p. 152.

377 'there were a lot of legitimate' – Mark Andersen and Mark Jenkins, *Dance of Days: Two Decades of Punk in the Nation's Capital* (New York: Akashic Books, 2003), p. 17.

18. 'SONNY'S LETTAH'

381 'Do we have any foreigners' quoted in Christopher Sandford, *Clapton: Edge of Darkness* (London: Victor Gollancz, 1995), p. 207.

381 'being a colony' – Niall Cluley, 'Eric's Moonshine: Eric Clapton, Birmingham', *Sounds*, 14 August 1976.

381 'the river Tiber' – Simon Heffer, *Like the Roman: The Life of Enoch Powell* (London: Weidenfeld & Nicolson, 1998), p. 454.

381 'enviable' – Heffer, p. 773.

381 'One down – a million to go' – Sarfraz Manzoor, '1978: The Year Rock Found the Power to Unite', *Observer*, 20 April 2008.

381 'For the first time' – author interview with Robinson.

382 'It is very difficult to explain' – author interview with Linton Kwesi Johnson, 2009.

382 'We want to organise a rank and file movement' – 'Letters', *Sounds*, 28 August 1976.

382 'When 400 letters' – author interview with Red Saunders, 2009.

382 'the only bloke who was telling the truth' – Chris Welch, 'Portrait of the Artist as a Working Man', *Melody Maker*, 9 December 1978.

383 'There was a window of opportunity' – author interview with Saunders.

383 'couldn't hide their contempt' – author interview with Johnson.

385 'We used to make jokes' – author interview with Letts.

386 'It was a raggedy-arsed united front' – author interview with Saunders.

386 'As the police prepared to charge' – David Widgery, *Beating Time* (London: Chatto & Windus, 1986), pp. 46–47.

386 'garage politics' – Widgery, p. 61.

386 'an opportunity' – Widgery, p. 52.

387 'We want Rebel music' – David Widgery, *Temporary Hoarding* 1, July 1977.

387 'This was their Woodstock' – Widgery, *Beating Time*, p. 90.

388 'Initially I was a bit cynical' – author interview with Johnson.

388 'I don't see the point in entertaining' – Max Bell, 'The Pop Group: Idealists in Distress', *NME*, 30 June 1979.

388 'In '76, there were very few' – author interview with Saunders.

389 'It *was* about starting the revolution' – Lois Wilson, 'Original Gangsters', *Mojo*, May 2008.

390 'There were seven people in that band' – author interview with Terry Hall, conducted for 'Fun Boy Free', *Guardian*, 22 July 2003.

390 'Everyone had their fists up in the air' – Reynolds, *Totally Wired*, pp. 101–102.

391 'I haven't got much to say' – The Specials, *Live at the Moonlight Club* (2 Tone CD, 1992).

391 'It was like being on a liner' – Beckett, p. 496.

392 'People are really rather afraid' – Beckett, p. 442.

392 'They've created a lot of mischief' – Angus MacKinnon, 'Forces of Reality', *NME*, 21 April 1979.

392 'We didn't stop racism' – author interview with Saunders.

392 'They lost ground because the Tories' – author interview with Johnson.

392 'frightening near-massacres' – Nick Kent, 'Ulcer Boy', *NME*, 27 October 1979.

393 'system's oppression' – Kent.

393 'Pursey was so brave' – author interview with Saunders.

393 'We don't care' – Deanne Pearson, 'Nice Band, Shame About the Fans', *NME*, 24 November 1979.

393 'Fuck that, I'm from the streets' – Alexis Petridis, 'Please Look After This Band', *Mojo*, January 2002.

393 'Every day someone left' – Petridis.

394 'We found it hard to address' – Dave Thompson, *Wheels Out of Gear: 2 Tone, the Specials and a World in Flame* (London: Helter Skelter, 2004), p. 171.

394 'In Liverpool all the shops were shuttered' – Alexis Petridis, 'Ska For the Madding Crowd', *Guardian*, 8 March 2002.

394 '"Ghost Town" was about my state of mind' – author interview with Jerry Dammers, 2009.

394 'Everybody was stood in different parts' – Petridis, 'Ska for the Madding Crowd'.

394 'No! No!' – Petridis, 'Ska for the Madding Crowd'.

395 'You didn't have to be a prophet' – author interview with Johnson.

396 'Nothing, but nothing, justifies what happened' – John Campbell, *Margaret Thatcher*, Vol. II: *The Iron Lady* (London: Pimlico, 2004), p. 114.

397 'civil war' – Heffer, p. 846.

397 'It was frightening' – Wilson.

397 'complex political, social and economic factors' – Baron Leslie George Scarman, *The Brixton Disorders 10–12 April 1981: Report of an Enquiry by Lord Scarman* (London: HMSO, 1981).

397 'There was a rather nasty little journalist' – author interview with Johnson.

19. 'HOLIDAY IN CAMBODIA'

401 'torpedoed the American dream' – quoted in f-Stop Fitzgerald (ed.) and Marian Kester, *Dead Kennedys: the Unauthorized Version* (San Francisco, Last Gasp of San Francisco, 1990), p. 2.

401 'Yeah, Biafra, you got such a big mouth' – Jello Biafra, 'Running For Mayor', *I Blow Minds for a Living* (Alternative Tentacles CD, 1991).

401 'What's your platform?', Jack Boulware and Silke Tudor, *Gimme Something Better: The Profound, Progressive and Occasionally Pointless History of Bay Area Punk from Dead Kennedys to Green Day* (New York: Penguin, 2009), p. 76.

401 'would be a joke except he's too smart' – CBS 5 (KPIX-TV)

newscast, 1979, quoted in Boulware and Tudor, p. 77.

402 'a city with more sadness and despair' – 'A Mourning City Asks Why', *San Francisco Examiner*, 28 November 1978.

402 'Free Dan White' – Randy Shilts, *The Mayor of Castro Street: The Life & Times of Harvey Milk* (New York: St Martin's Press, 1982), p. 302.

402 'She was a mean, hateful witch' – Boulware and Tudor, p. 78.

402 'I never voted for Jello to be mayor' – Boulware and Tudor, p. 82.

403 'It had no political agenda' – McNeil, p. 371.

404 'The rebels in the sixties' – author interview with Jello Biafra, 2009.

404 'Both Tim and I wanted to create' – Boulware and Tudor, p. 61.

404 'We were very close friends' – author interview with Biafra.

404 'Hey kids, this is a real Air Force pilot' – Jodi Vander Molen, 'Jello Biafra Interview', *The Progressive*, February 2002.

404 'There were one or two cartoon shows' – author interview with Biafra.

406 'People will tear each other apart' – J. D. Lorenz, *Jerry Brown: The Man on the White Horse* (Boston: Houghton Mifflin, 1978), p. 142.

406 'I thought, "Oh my God"' – author interview with Biafra.

407 'The 1970s turned out to be so stale' – Vander Molen.

407 'Anybody who doesn't use art as a weapon' – quoted in Fitzgerald and Kester, p. 30.

407 'It broke my heart' – author interview with Biafra.

408 'more of a Ramones-style chainsaw punk song' – Alex Ogg, unpublished interview with Jello Biafra.

408 'He thought it would probe deeper' – author interview with Biafra.

409 'Awright! Kill the poor!' – Ogg, unpublished interview.

409 'East Bay Ray' – author interview with Biafra.

409 'We don't say "fuck the world"' – Kathleen Ennis, 'Punks: Admittedly Bored to Distraction, Clearly Looking for Reaction', The District Weekly, *Washington Post*, 22 January 1981.

411 'It was like a vision' – Andersen and Jenkins, p. 80.

411 'I came from the Sixties, I grew up in the Sixties' – Michael Azerrad, *Our Band Could Be Your Life: Scenes From the American Underground 1981–1991* (Boston, MA: Back Bay, 2002), p. 142.

411 'a parade of fucking idiots' – Azerrad, p. 130.

411 'a preaching motherfucker' – Azerrad, p. 135.

411 'It's less music as religion' – quoted in Andersen and Jenkins, p. 147.

412 'Now all you've gotta do is take this kind of attitude' – Andersen and Jenkins, p. 86.

412 'I never knew what was going to happen next' – Boulware and Tudor, p. 83.

413 'Babylon bloodclot faggot' – Andersen and Jenkins, p. 107.

413 'heartbreak' – Andersen and Jenkins, p. 109.

413 'We did find out' – author interview with Biafra.

414 'While I may be ignoring' – quoted in Andersen and Jenkins, p. 139.

414 'In retrospect, *Maximum Rocknroll*' – Boulware and Tudor, p. 199.

414 'Tim became more hardline' – author interview with Biafra.

414 'It was like its own mini-country' – author interview with Billie Joe Armstrong, conducted for 'Viva la Revolution!', *Q*, 2009.

415 'putting the protest back in punk' – Andersen and Jenkins, p. 190.

415 'We wanted to do something we felt good' – Ben Myers, *American Heretics: Rebel Voices in Music* (Hove: Codex, 2002), p. 24.

416 'Any form of underground culture' – author interview with Biafra.

20. 'THE MESSAGE'

419 '15 minutes from Manhattan' – poster, *Fort Apache the Bronx* (dir: Daniel Petrie, 1981).

420 'At that time anybody could have said that' – Alex Ogg with David Upshal, *The Hip Hop Years: A History of Rap* (London: Channel 4 Books, 1999), p. 69.

422 'I just stood and watched this guy in awe' – author interview with Grandmaster Flash, conducted for the *Big Issue*, 2002.

423 'I didn't respect it at first' – JayQuan, 'Get Funky, Make Money & Ya Don't Stop: The Story of Duke Bootee AKA Ed Fletcher', Thafoundation.com, February 2007.

423 'When we first came to this company' – Bob LaBrasca and Larry 'Ratso' Sloman, 'Interview: Grandmaster Flash & the Furious Five', *High Times*, 1983, reproduced at http://hightimes.com/entertainment/ht_admin/351 on 31 March 2003.

424 'Every so often' – JayQuan.

424 'Nobody actually liked the song' – author interview with Melle Mel, conducted for 'The Greatest Song Ever: The Message', *Blender*, November 2004.

424 'There was nothing in rap like that before' – Ian Pye, 'Christmas Rapping', *Melody Maker*, 18 December 1982.

424 'Like you listening to music' – LaBrasca and Sloman.

424 'A track might be cut already' – JayQuan.

425 'She owned the company' – author interview with Mel.

425 '"The Message" wasn't one of my favourites' – author interview with Flash.

426 'beyond rebuilding' – Jeff Chang, *Can't Stop Won't Stop: A History of the Hip-Hop Generation* (London: Ebury Press, 2005), p. 18.

426 'It was like Christmas for black people' – Jody Rosen, 'A Rolling Shout-Out to Hip-Hop History', *New York Times*, 12 February 2006.

427 'Like, I've been to jail' – LaBrasca and Sloman.

428 'I remember one person scared the daylights' – LaBrasca and Sloman.

428 'We could turn the dial' – Chuck Miller, 'Grandmaster Cuts Faster: The Story of Grandmaster Flash and the Furious Five', www.mvanakkeren.nl/home/contents/flash4ever/2005/html/pages/history/boardwalk/boardwalk_contents.htm.

428 'When they played a record like that' – author interview with Melle Mel.

429 'After the discovery' – author interview with Flash.

429 'Everybody was high' – author interview with Melle Mel.

430 'culturally' – 'National Recording Registry Criterion', www.loc.gov/rr/record/nrpb/nrpb.nrr.html

21. 'HOW DOES IT FEEL?'

433 'Will she take time off today', etc. – recording of Prime Minister's Question Time, 1982, Penny Rimbaud's private collection.

433 'the most vicious, scurrilous and obscene', etc. – radio debate between Tim Eggar MP, Andy Palmer and Pete Wright, 1982, Penny Rimbaud's private collection.

433 'I'm an absolute elitist' – author interview with Penny Rimbaud, 2009.

434 'In many ways yeah' – author interview with Steve Ignorant, 2009.

435 *'Fun?'* – author interview with Rimbaud.

435 'I didn't meet my dad' – author interview with Rimbaud.

435 'For the best part of five years' – Penny Rimbaud aka J. J. Ratter, *Shibboleth: My Revolting Life* (Edinburgh: AK Press, 1998), p. 55.

436 'like World War Three' – George Berger, *The Story of Crass* (London: Omnibus, 2008), p. 62.

436 'For me, Phil's death' – Rimbaud, p. 67.

437 'When I first went there' – Berger, p. 77.

437 'We used each other' – author interview with Rimbaud.

439 'full of shit' – quoted in Berger, p. 124.

439 'a nasty, worthless little record' – quoted in Berger, p. 124.

439 'The sight of crowds of earnest young men' – Rimbaud, p. 106.

439 'The Left, in the guise of middle-class liberals' – Rimbaud, p. 108.

439 'People would ask, "What do you want . . ."' – author interview with Ignorant.

440 'I think Thatcher' – author interview with Rimbaud.

440 'To fuel the aggression that drove her career' – Campbell, p. 351.

440 'If there's one thing that Thatcher taught me' – author interview with Ignorant.

440 'That was what suggested to me' – author interview with Rimbaud.

442 'They never smiled' – author interview with Ignorant.

442 'They're popular but they're not "personalities"' – Paul Du Noyer, 'At Crass Purposes', *NME*, 14 February 1981.

442 'I don't think there's a day when we don't confront ourselves' – Mike Stand, 'The Aesthetics of Anarchy: A Report from the House of Crass', *The Face*, December 1981.

443 'You'd end up with forty bands' – Steven Wells, 'Veg Wedge', *NME*, 23 May 1987.

443 'sick joke'– Berger, p. 190.

443 'BAND OF HATE' – Berger, p. 190.

443 'self-defeating' – Du Noyer.

443 'Artistically, that's where I would have liked to have bowed out' – Berger, p. 209.

444 'Britain underestimated' – Lawrence Freedman and Virginia Gamba-Stonehouse, *Signals of War* (London: Faber & Faber,

1990), p. 99.

445 'I still don't see where it's funny' – author interview with Ignorant.

445 'They're fucking killing machines' – author interview with Rimbaud.

445 The sinking of the *Belgrano* – Salewicz, p. 339.

446 'Pen puts twelve words in a sentence' – author interview with Ignorant.

446 'I suppose it was empowering' – author interview with Rimbaud.

446 'It scared the shit out of me' – author interview with Ignorant.

447 'from a bossy nanny' – Campbell, p. 138.

447 'the longest suicide note in history' – Campbell, p. 185.

447 'Rock'n'roll appears to have increasingly concentrated' – Berger, p. 233.

447 'Even that, which was supposed to be a laugh' – author interview with Ignorant.

448 'Everything we did post-Falklands' – author interview with Rimbaud.

448 'One was: "What can we do"' – author interview with Ignorant.

448 'unrealistic and naive' – Rimbaud, p. 263.

448 'nothing short of all-out global revolution' – Rimbaud, p. 269.

448 'A parody of ourselves' – Rimbaud, p. 276.

448 'if you can't say what you need to say' – author interview with Rimbaud.

449 'the enemy without' . . . 'the enemy within' – Seumas Milne, *The Enemy Within: MI5, Maxwell and the Scargill Affair* (London: Verso, 1994), p. 19.

449 'Mrs Thatcher was fortunate in her enemies' – *Strike: When Britain Went to War* (Channel 4, 2004).

449 'It was one of the saddest things' – author interview with Rimbaud.

450 'There was a general hubbub' – author interview with Ignorant.

22. 'TWO TRIBES'

453 'The deterioration of US–Soviet relations' – 'Men of the Year: Ronald Reagan and Yuri Andropov', *Time*, 2 January 1984.

453 'an evil empire' – Lou Cannon, *President Reagan: The Role of a Lifetime* (New York: Public Affairs, 2000), p. 273.

453 'obscenities alternating' – Gerard DeGroot, *The Bomb: A Life* (London: Jonathan Cape, 2004), p. 315.

453 'Everything is finished!' – 'Men of the Year', *Time*.

453 'Never in my thirty-five years' – DeGroot, p. 315.

454 'I was just writing songs' – author interview with Holly Johnson, 2009.

455 'REMEMBER to listen to your radio' – *Protect and Survive* (London: HMSO, 1980), reprinted at atomica.co.uk.

456 'the true peace movement' – Campbell, p. 190.

456 'the craziest thing I ever heard of' – Ronald E. Powaski, *Return to Armageddon: the United States and the Nuclear Arms Race 1981–1999* (New York: Oxford University Press, 1999), pp. 29–30.

456 'We may be the generation' – Cannon, p. 248.

456 'Reagan was guided' – Cannon, p. 249.

456 Rebecca Johnson – Aida Edemariam, 'Protest and Survive', *Guardian*, 9 October 2006.

457 'He said it was like the story of a Russian peasant' etc. – author interview with Johnson.

458 'For reasons long forgotten' – *Mad Max 2* (dir: George Miller, 1981).

458 'It sounds quite obtuse' – author interview with Johnson.

459 'What I wanted to do was to reconstruct' – Lynden Barber, 'State of the Art', *Melody Maker*, 19 May 1984.

459 'obscene' – Holly Johnson, *A Bone in My Flute* (London: Century, 1994), p. 171.

459 'He was saying' – author interview with Johnson.

461 'I was behind the mixing desk' – Reynolds, *Totally Wired*, p. 347.

461 'the first genuine protest song' – ZTT press release, May 1984.

461 'There was paranoia in the air' – author interview with Johnson.

462 'greatly depressed' – Powaski, p. 39.

462 'My fellow Americans' – Ronald Reagan, soundcheck before Radio Address to the Nation on Congressional Inaction on Proposed Legislation, 11 August 1984.

463 'Apocalypso' – Tom Ewing, 'Frankie Goes to Hollywood – Two Tribes', freakytrigger.co.uk, 13 August 2009.

464 'I don't know exactly what it says' – Adrian Thrills, 'Public Inconveniences', *NME*, 20 October 1984.

464 'I've always been a bit pissed off' – Barney Hoskyns, 'The Morley and Horn Show Present How to Make a Spectacle of Yourself', *NME*, 13 October 1984.

466 'Because they are making an important political message' –
Dylan Jones, 'Once Upon a Time in America', *Record Mirror*,
December 1984.

23. 'PRIDE (IN THE NAME OF LOVE)'

469 'Right, we will reopen this discussion' – recounted in author
interview with Bono, 2009.

469 'I was looking for a balance' – author interview with Bono.

469 'It was originally meant' – Gavin Martin, 'U2: Call Us
Unforgettable', *NME*, 27 October 1984.

470 'In the end this slain preacher' – author interview with Bono.

470 'just a load of vowel sounds' – Bono, The Edge, Adam Clayton,
Larry Mullen, Jr, with Neil McCormick, *U2 by U2* (London:
HarperCollins, 2008), p. 224.

471 'Very early on we played' – author interview with Adam
Clayton, 2009.

471 'Miserabilism seemed to be very common' – author interview
with The Edge, 2009.

472 'but without the weed' – Bono et al., p. 101.

472 'Do you really think you're going to be more effective' – Bono et
al., p. 151.

472 'It's OK' – recounted by Bono in U2's Rock and Roll Hall of
Fame induction speech, 14 March 2005, reprinted at www.
u2station.com/news/archives/2005/03/transcript_u2s.php.

472 'Here I am, aged 22' – Bono et al., p. 153.

473 'I think that love stands out' – Adrian Thrills, 'U2: War &
Peace', *NME*, 26 February 1983.

473 'We decided that it was morally wrong' – Thrills, 'U2: War &
Peace'.

473 'Don't talk to me about the rights of the IRA' – Bono et al.,
p. 164.

473 'The irony was that a lot of people' – Michka Assayas, *Bono on
Bono: Conversations with Michka Assayas* (London: Hodder &
Stoughton, 2005), p. 170.

473 'Bono told the audience' – Thrills, 'U2: War & Peace'.

474 'little shit' – Assayas, p. 172.

474 'I thought it was a pretty strange idea' – author interview with
Brian Eno, conducted for 'Brian Eno', *Q*, November 2007.

474 'Our Choice: Band of the '80s' – Cover, *Rolling Stone*, 14 March
1985.

474 'For a growing number of rock'n'roll fans' – Christopher Connelly, 'Keeping the Faith', *Rolling Stone*, 14 March 1985.

475 'There is a danger of being a spokesman' – Martin, 'U2: Call Us Unforgettable'.

475 'a combination of a circus' – Kurt Loder, 'Bruce!', *Rolling Stone*, 28 February 1985.

475 'U2 had no tradition' – Bono et al., p. 211.

476 'There wasn't any kind of political consciousness' – Kurt Loder, 'The Rolling Stone Interview – Bruce Springsteen', *Rolling Stone*, 6 December 1984.

476 'pseudotragic beautiful-loser fatalism' – Robert Christgau, 'Christgau's Consumer Guide', 22 September 1975, reprinted at robertchristgau.com.

476 'I don't know what you thought about what happened' – Dave Marsh, *Glory Days: Bruce Springsteen in the 1980s* (London: Sidgwick & Jackson, 1987), p. 29.

476 'I started to learn about how things get to be' – Marsh, p. 36.

477 '*Nebraska* was about that American isolation' – Loder, 'The Rolling Stone Interview'.

478 'the most complete and probably the most convincing' – Greil Marcus, 'Born in the USA', *New West*, November 1982, quoted in Marsh, p. 145.

478 'a dead song' – Marsh, p. 116.

479 'I think what's happening now' – Loder, 'The Rolling Stone Interview'.

479 'The flag is a powerful image' – Loder, 'The Rolling Stone Interview', 1984.

479 'I have not got a clue' – George Will, 'A Yankee-Doodle Springsteen', *New York Daily News*, 13 September 1984, quoted in Mikal Gilmore, 'Bruce Springsteen', *Rolling Stone*, 5 November 1990.

480 'America's future rests in a thousand dreams' – quoted in Marsh, p. 260.

480 'The president was mentioning my name' – Marsh, p. 263.

480 'aggressive doubt' – quoted in Marsh, p. 201.

481 'So many conditions needed to exist' – Rob Tannenbaum, 'Bob Geldof', *Rolling Stone*, 5 November 1990.

481 'I felt disgusted, enraged and outraged' – Bob Geldof with Paul Vallely, *Is That It?* (London: Sidgwick & Jackson, 1986), p. 217.

481 'not a particularly good song' – Tannenbaum.

481 'I wanted something which wounded like a football chant' – Geldof and Vallely, p. 223.

482 'All I remembered was having rows with Geldof' – Bono et al., p. 198.

482 'This is not about what you want, OK?' – Bono et al., p. 199.

482 'I kind of did an impersonation of Bruce Springsteen' – Bono et al., p. 199.

482 'Perhaps this is an idea whose time has come' – Michael Goldberg, 'USA for Africa', *Rolling Stone*, 14 March 1985.

482 'The turning point was Bruce Springsteen's' – Goldberg.

482 'It's got to be authentic!' – Goldberg.

483 'Has he got other things that are more important' – Goldberg.

483 'half-assed' – Robert Christgau, 'A Song for You', *Village Voice*, 7 May 1985.

483 'Who is the world?' – Miriam Makeba with James Hall, *Makeba: My Story* (London: Bloomsbury, 1988), p. 233.

484 'I met Elvis Costello few months back' – Barney Hoskyns, 'Flags & Penance', *NME*, 22 June 1985.

484 'Live Aid is all things to all people' – Tannenbaum.

485 'Band Aid was a moral issue' – Geldof and Vallely, p. 229.

485 'There's nothing wrong with Aswad' – Geldof and Vallely, p. 291.

485 'colonial exploitation' – Udo Lindenberg's Live Aid speech, transcribed at liveaid.free.fr/rewind/bbc/pages/udolindenberg. html.

485 'It really pisses me off' – Colin Irwin, 'The Day the World Turned Upside Down . . .', *Melody Maker*, 23 March 1985.

486 'Rock against bad things' – Robert Hilburn, 'Music and His Mission Are One', *Los Angeles Times*, 4 April 2005.

486 'that curious register of human speech' – Tom Ewing, 'USA for Africa – "We Are the World"', freakytrigger.co.uk, 21 September 2009.

486 'The big concert is seriously devalued currency' – Tannenbaum.

487 'The thing I came away with' – Bono et al., p. 210.

487 'this was how I could justify being in a band' – Bono et al., p. 210.

487 'I started to see two Americas' – Bono et al., p. 220.

487 'The song was written' – author interview with Bono.

488 'Could you put that through your amplifier?' – Bono et al., p. 223.

488 'We were on the other side of the barricade' – author interview with Larry Mullen, Jr, 2009.

488 'OK, these are really serious guys' – author interview with Clayton.

488 'First they opened my mind to their music' – 'U2: Band on the Run', *Time*, 27 April 1987.

488 'I'm into difference' – author interview with Bono.

489 'I think by that point we'd figured out' – author interview with The Edge.

24. 'NELSON MANDELA'

495 'silent Sixties' – Anthony Sampson, *Mandela: The Authorised Biography* (London: HarperCollins, 1999), p. 276.

496 'I was always on the TV' – Denselow, p. 56.

496 Makeba suggested to Roger McGuinn – Denselow, pp. 58–59.

496 'You can't roll around with pigs' – Makeba and Hall, p. 180.

497 'It is not as it was after Sharpeville' – Makeba and Hall, p. 200.

498 'I am told that when "Free Mandela" posters went up' – Nelson Mandela, *Long Walk to Freedom*, Vol. II: *1962–1994* (London: Abacus, 2003), p. 257.

498 'The problem was' – author interview with Jerry Dammers, 2009.

498 'Working on this album was like painting the Forth Bridge' – Gavin Martin, '26,732 Hours in the Studio With Jerry Dammers', *NME*, 18 August 1984.

498 'It was like attending a funeral' – Horace Panter, *Ska'd For Life* (London: Sidgwick & Jackson, 2007), p. 289.

498 'Horace left with his sanity intact' – Lois Wilson.

498 'Pop is giving people what they want to hear' – Neil Spencer, 'The Invisible Profile Shapes Up', *NME*, 8 January 1983.

499 'I was very down' – author interview with Dammers.

499 'happy ending' – author interview with Dammers.

499 'Elvis, I've got a good song' – Steve Lake, 'One More Chance in a Black & White World', *Melody Maker*, 2 June 1984.

499 'I was desperate' – author interview with Dammers.

500 'Hey, I was getting something going there' – Lake.

500 'If "Nelson Mandela" hadn't got in the charts' – Gavin Martin, '26,732 Hours in the Studio With Jerry Dammers'.

500 'One of the ways' – author interview with Dammers.

501 'To forcibly relocate people' – Dave Marsh, *Sun City By Artists United Against Apartheid: The Struggle for Freedom in South Africa: The Making of the Record* (New York: Penguin, 1985).

501 'a song about change not charity' – Danny Schechter, *The More*

You Watch, The Less You Know (New York: Seven Stories Press, 1997), p. 281.

502 'There is a new phrase in the air' – Makeba and Hall, p. 233.

502 'immoral, evil and totally un-Christian' – Associated Press, 'US Policy on S. Africa Is Immoral, Tutu Says', *Boston Globe*, 5 December 1984.

503 'render South Africa ungovernable' – Sampson, p. 334.

504 'a thundering flop' – UPI, '1.8-Million "Peace Song" Widens Rift Among S. Africans', *Los Angeles Times*, 30 October 1986.

504 'If there was no music' – Denselow, p. 192.

505 'I didn't ask the permission' – Denselow, p. 194.

505 'Pop music is not the forum' – Patrick Humphries, *The Boy in the Bubble: A Biography of Paul Simon* (London: Hodder & Stoughton, 1990), p. 182.

506 'There's a kind of misdirected energy' – Humphries, p. 181.

506 'above politics' – Humphries, p. 193.

506 'If Paul Simon had come to us first' – Mark Sinker and Terry Staunton, 'The Boy in the Boycott', *NME*, 4 April 1987.

506 'There's a liberal argument' – author interview with Dammers.

507 'publicity to a movement that encourages' – Denselow, p. 279.

507 'more of a showcase for top British groups' – Denselow, p. 284.

507 'I think he spent every minute' – author interview with Dammers.

25. 'BETWEEN THE WARS'

511 'Essex foghorn' – author interview with Billy Bragg, 2009.

512 'It was the moment when my generation took sides' – Billy Bragg, *The Progressive Patriot* (London: Black Swan, 2007), p. 246.

512 'The politics I had were personal' – author interview with Bragg.

513 'To call us Thatcherite' – author interview with George Michael, conducted for *Big Issue*, 'Keeping the Faith', 1–7 March 2004.

514 'people with fruity voices' – Ali, p. 369.

514 'If socialism is transmitted' – quoted in Denselow, p. 210.

514 'basically conservative' – quoted in Denselow, p. 210.

514 'The only really warm place' – author interview with Bragg.

515 After the strike, Bruce Springsteen – Gavin Martin, 'Bruce Digs Deep in Durham', *NME*, 22 June 1985.

515 'The SWP promised us' – author interview with Bragg.

516 'I feel the Labour party' – Irwin, 'The Day the World Turned Upside Down . . .'.

516 'Kinnock was the first modern leader' – author interview with Bragg.

516 Bragg first met Kinnock – Andrew Collins, *Billy Bragg: Still Suitable for Miners* (London: Virgin Books, 2007), pp. 160–161.

517 'Clare Short was the best' – author interview with Bragg.

517 'This isn't the end of the fight' – Irwin, 'The Day the World Turned Upside Down . . .'.

517 'Without Weller' – author interview with Bragg.

518 'misplaced, outdated' – Martin Linton, Peter Hetherington and Alan Travis, 'Kinnock Onslaught on "Tendency tacticians"', *Guardian*, 2 October 1985.

518 'The Derby party said' – author interview with Bragg.

518 Six days later – Denselow, pp. 219–220 and Collins, pp. 167–168.

518 'songs where you take the character' – liner notes, Pet Shop Boys, *Actually/Further Listening 1987–1988* (Parlophone CD, 2001).

518 'In the 1980s' – author interview with Neil Tennant, conducted for 'Jewel in the Crown', *Guardian*, 14 July 2006.

519 'The one that really made me spit pips' – author interview with Bragg.

519 'We're a scourge' – Amrik Rai, 'Come the Revolution . . .', *NME*, 23 March 1985.

519 'If people think that we're ramming it' – Adrian Thrills, 'Can White Boys Sing the Reds?', *NME*, 3 November 1984.

519 'All the while I was playing' – author interview with Bragg.

520 'It was a great idea' – Collins, p. 171.

520 'One idea that we came up with' – author interview with Dammers.

520 'destructive' and 'appalling' – Denselow, p. 223.

520 'Me and my mate Sting' – Mico.

521 'What we have here' – Ted Mico, 'Red Wedge: The Great Debate', *Melody Maker*, 25 January 1986.

521 The official bill – Denselow, pp. 228–229 and Collins, pp. 187–188.

521 'In our minds this was the Motown revue' – author interview with Bragg.

522 'degraded circus' – Terry Coleman, 'A Mum's Army on the Road', *Guardian*, 8 June 1987.

522 'It's hardly worth bothering' – Campbell, p. 516.

522 'I'm sick of writing political songs' – 'Say What?!', *NME*, 13 June 1987.

523 'Screw the election!' – Denselow, p. 232.

523 'I felt uneasy about getting involved' – Mat Snow, 'We All Make Mistakes', *Q*, October 1993.

523 'If you scratch a cynic you find a disappointed idealist' – Charles Taylor, 'Dirty Old Man', *Salon*, 3 April 2004.

523 'That there are *no* absolute truths in politics – Will Smith, 'Practical Dreamers', *Melody Maker*, 7 March 1987.

524 'Phil took it personally' – author interview with Bragg.

26. 'EXHUMING MCCARTHY'

527 'I remember her pulling me aside' – author interview with Peter Buck, 2009.

527 'We wanted people to listen to that record' – quoted in David Buckley, *R.E.M./Fiction: An Alternative Biography* (London: Virgin Books, 2003), p. 92.

527 'If you want to talk about politics' – quoted in Marcus Gray, *It Crawled From the South: An R.E.M. Companion* (Enfield: Guinness, 1992), p. 193.

527 'I don't like sloganeering' – quoted in Gray, p. 194.

527 'My mother *hates* U2' – quoted in Gray, p. 194.

528 'We're not proud of our president' – quoted in Gray, p. 194.

528 'Morning Again in America' – Cannon, p. 451.

528 'We see an America where every day' – Cannon, p. 454.

528 'Even when he was gone from Hollywood' – Cannon, p. 44.

530 'That song brings in pieces' – quoted in Craig Rosen, *R.E.M. Inside Out: The Stories Behind Every Song* (London: Carlton, 2005), p. 53.

530 'D. Boon didn't think our dads' – Azerrad, p. 65.

530 'We were kind of products of the sixties' – Reynolds, *Rip It Up*, p. 462.

531 'average Joe' – quoted in Azerrad, p. 79.

531 'The first thing is to give the workers confidence' – quoted in Azerrad, p. 78.

531 'I'm not religious about God' – quoted in Azerrad, p. 78.

531 'positively friendly' – Cannon, p. 304.

532 'It was a secret little Vietnam' – author interview with Buck.

533 Buck wondered – Craig Rosen, p. 64.

533 'The 1960s were a time of political activism' – Mike Mills, 'Our Town', *Spin*, July 1985.

533 'On *Life's Rich Pageant*' – author interview with Buck.

534 'A metaphor for America' – quoted in Craig Rosen, p. 63.

534 'sometimes misunderstood' – Peter Buck, liner notes, R.E.M., *Eponymous* (I.R.S. CD, 1988).

534 'little cheesy tinpot dictatorship' – author interview with Buck.

535 'talent for happiness' – Cannon, p. 712.

535 'It's not morning in Pittsburgh' – Loder, 'The Rolling Stone Interview – Bruce Springsteen'.

536 'Don't you think it's better' – McDonough, p. 588.

536 'so that they would say' – Adrian Deevoy, 'Welcome to the Funny Farm', *Q*, December 1988.

537 'bombastic, vomiting sensory overload' – Steve Pond, 'In the Real World', *Rolling Stone*, 13 December 1987.

537 'the ultimate ambivalent anthem' – quoted in Craig Rosen, p. 85.

537 'Though I like Bruce Springsteen' – Roy Wilkinson, 'The Secret File of R.E.M.', *Sounds*, 12 September 1987.

537 'vampire-surf-guitar-funk' – quoted in Craig Rosen, p. 82.

537 'I'm going to have to work really hard' – quoted in Craig Rosen, p. 82.

538 'Overnight I was this really intelligent' – quoted in Gray, p. 193.

539 'I'll support Amnesty' – quoted in Gray, p. 202.

539 'R.E.M. is not just like a dunderhead arena gig' – Jack Barron, 'It's the End of the World as We Know It (And We Don't Feel Fine)', *NME*, 5 August 1989.

539 'STIPE SAYS' – 1988 newspaper advertisement reprinted in Gray, p. 200.

540 'We were joking,' – author interview with Buck.

540 'We'd already been through eight years' – Azerrad, pp. 398–399.

540 'We're pigs!' etc. – Steve Sutherland, 'Buckshot and Blues', *Melody Maker*, 5 November 1988.

540 'It was pretty inflammatory' – author interview with Buck.

540 'I think I've gone too far' – author interview with Michael Stipe, conducted for '"The fact that we carried on doesn't make us great – just stubborn"', *Guardian*, 2 November 2007.

541 'George Bush is out of time' – Roberto Suro, 'Democrats Court Youngest Voters', *New York Times*, 30 October 1992.

541 'I was in some small town' – author interview with Buck.

542 'I'm going to breakfast' – quoted in Gray, p. 216.

27. 'FIGHT THE POWER'

547 'an anthem to scream out' – author interview with Chuck D, 2008.

547 'I had a three-hour fight with him' – Johnny Black, 'The Greatest Songs Ever! Fight the Power', *Blender*, August 2002.

547 'Usually I would write' – author interview with Chuck D.

548 'Whooo! You said that?' – Black.

548 'virulently anti-Semitic' – Joe Klein, 'Spiked?', *New York*, 26 June 1989, quoted in Chang, p. 278.

548 'Afro-Fascist race-baiters' – Stanley Crouch, 'Do the Race Thing', *Village Voice*, 20 June 1989, quoted in Chang, p. 278.

548 'I'm not saying all of them', etc. – David Mills, 'Professor Griff: The Jews Are Wicked', *Washington Times*, 22 May 1989, quoted in Chang, p. 285.

549 'As a youngster' – Chuck D with Yusuf Jah, *Fight the Power: Rap, Race and Reality* (Edinburgh: Payback Press, 1999), p. 27.

550 'we're not Third World People' – Chuck D and Jah, p. 82.

550 'Let's make every track political' – Chang, p. 247.

550 'totally a visual character' – author interview with Chuck D.

552 'An important message' – Sean O'Hagan, 'Rebels With a Cause', *NME*, 10 October 1987.

552 'relentless – no escape' – O'Hagan.

552 'hailstorm' – Chang, p. 260.

552 'If you're going to deal' – author interview with Chuck D.

555 'N.W.A. said and did things' – author interview with Chuck D.

555 'We just wanted to do something new' – Cross, p. 201.

555 'Everybody was trying to do this black power' – Cross, p. 197.

555 'both discouraging and degrading' – quoted in Chang, p. 325.

556 'We ain't goin' out like that 1963 nonsense – Public Enemy, 'Fight the Power' video (dir: Spike Lee, 1989).

556 'I was trying to say something' – author interview with Chuck D.

557 'It's time to stop singing' – Malcolm X, 'The Ballot or the Bullet' (speech), April 1964.

557 'I knew Bobby McFerrin was a nice guy' – author interview with Chuck D.

557 'a defiant, aggressive' – Black.

557 'The key of PE's style' – Gaby Alter, 'Classic Tracks: Public Enemy's "Fight the Power"', *MIX*, 1 November 2006.

557 'morally abhorrent' – the Stud Brothers, 'Black Power', *Melody Maker*, 28 May 1988.

558 'if the Palestinians took up arms' – Stud Brothers.

558 'I'm like the mediator' – quoted in Chang, p. 281.

558 'Hymietown' – Larry J. Sabato, 'Media Frenzies in Our Time',

Washington Post, 27 March 1998.

559 'We are not anti-Jewish' – Chuck D press statement, 21 June 1989, quoted in Chang, p. 290.

559 'Yo, "Fight the Power" is all over it!' – Alter.

559 'Why can't we fight *for* power' – '"Do the Right Thing": Issues and Images', *New York Times*, 9 July 1989.

559 'The show must go on' – Public Enemy press release, quoted in Chang, p. 294.

559 'I wasn't angry' – author interview with Chuck D.

560 'the house of the 1990s' – Chuck D and Jah, p. 236.

561 'He came from the school' – Dzana Tsomondo, 'Bum Rush the Show', *Cool'Eh*, web issue no. 3.

562 'Call him Ice KKKube' – Robert Christgau, review of *Death Certificate*, 1991, reprinted at www.robertchristgau.com/get_artist.php?name=Ice+Cube.

562 'Young people who are very upset' – Gavin Martin, 'Pissing on the White House Lawn', *NME*, 6 June 1992.

562 The video, which climaxed with a car bomb – Seth Mydans, 'For Nonviolent Legacy, a Violent Rap Message', *New York Times*, 11 January 1992.

562 'Our whole philosophy' – Chuck D and Jah, p. 195.

562 'The media is not just' – author interview with Chuck D.

563 'We had CNN on in the studio' – author interview with Michael Franti, conducted for '"The troops thought: this guy's got balls"', *Guardian*, 26 July 2006.

564 'purely criminal' – Jack Nelson, 'Bush Denounces Rioting in LA. as "Purely Criminal"', *Los Angeles Times*, 1 May 1992.

564 'This whole thing is not a reaction' – Martin, 'Pissing on the White House Lawn'.

564 'right out of *Gorillas in the Mist*' – Associated Press, 'Judge Says Remarks on "Gorillas" May Be Cited in Trial on Beating', *New York Times*, 12 June 1991.

564 'If black people kill black people' – David Mills, 'Sister Souljah's Call to Arms', *Washington Post*, 13 May 1992.

565 'If you took the words white and black and you reversed them' – Michael Kenney, 'The Rap Flap', *Boston Globe*, 19 June 1992.

565 'He needs to be taken out' – the Stud Brothers, 'Prophets of Rage', *Melody Maker*, 9 July 1988.

566 'I don't hold anything against them' – Cross, p. 189.

566 'Of course it scared people off' – author interview with Chuck D.

567 'You have to be able to do something' – author interview with Chuck D.

28. 'HER JAZZ'

571 'Look like you're having fun' and further background on *The Word* – Sally Margaret Joy, 'The Revolution . . . Will Not Be Televised', *Melody Maker*, 27 February 1993.

571 'You could barely move' – author interview with Gary Walker, 2009.

572 'So, Terry' – Joy.

572 'It wasn't our plan' – author interview with Chris Rowley, 2009.

572 'They screech, they spit, they snarl' – Anne Barrowclough, 'Save the World? Not a Hope Grrrls', *Daily Mail*, 27 March 1993, quoted in Julia Downes, 'Riot Grrrl: The Legacy and Contemporary Landscape of DIY Feminist Cultural Activism', in Nadine Monem (ed.), *Riot Grrrl: Revolution Girl Style Now!* (London: Black Dog Publishing, 2007), p. 39.

573 'We started off quite ebullient' – author interview with Rowley.

573 'The most bizarre aspect' – Steven Wells, 'Ch-Ch-Ch-Change!', *NME*, 1 May 1993.

573 In 1982, Calvin Johnson – Azerrad, p. 458.

574 'punk rock . . . for and by boys' – Tobi Vail, *Jigsaw* 2, 1990, quoted in Downes, p. 19.

574 'super hardcore' – author interview with Allison Wolfe, 2009.

575 'We're going to have a girl riot' – Downes, p. 25.

576 'She used to have problems relaxing' – author interview with Wolfe.

576 'We can be cutesy and girly' – Downes, p. 27.

577 'We seek to create revolution' – quoted in Emily White, '"Revolution Girl-Style Now!" Notes From the Teenage Feminist Rock'n'Roll Underground', *The Chicago Reader*, 25 September 1992.

577 'I think we all felt' – author interview with Wolfe.

577 'There is no editor' – Molly Neuman, *Riot Grrrl* 4, quoted in Red Chidgey, 'Riot Grrrl Writing', in Monem, p. 102.

577 'There probably were some tensions' – author interview with Wolfe.

578 'They were really influential' – author interview with Walker.

578 'mystery, romance and preciousness' – author interview with Rowley.

579 'Prime movers doesn't imply hierarchy' – Sally Margaret Joy and Everett True, 'Fur Powered', *Melody Maker*, 3 October 1992.

579 'They fight the adult world' – Karren Ablaze!, 'Girlspeak', *GirlFrenzy* 3, 1992, quoted in Chidgey, p. 105.

579 'You need to rest' – Joy and True.

579 'The media always tries to pick something' – Joy and True.

580 'Better watch out, boys' – Elizabeth Snead, 'Feminist Riot Grrrls Don't Just Want to Have Fun', *USA Today*, 7 August 1992.

580 'feminism with a loud happy face' – Lauren Spencer, 'Grrrls Only: From the Youngest, Toughest Daughters of Feminism – Self-Respect You Can Rock To', *Washington Post*, 3 January 1993, quoted in Downes, p. 31.

580 'serious and sombre and self-absorbed' – Snead.

580 'their somewhat privileged lives' – Emily White.

580 'I do think that people want to stare at my tits' – Andersen and Jenkins, p. 343.

580 'She'll come with a little beat-up guitar' – Andersen and Jenkins, p. 364.

580 'It was a total shock' – author interview with Wolfe.

581 'They're mostly strippers' – quoted in Liz Evans, 'Rage Against the Man Machine', *NME*, 6 March 1993.

581 'I felt like the media' – author interview with Wolfe.

581 'By not giving each other room to move' – Andersen and Jenkins, p. 364.

582 'GIRL-JAZZ SUPREMACY' – 'Her Jazz', *Huggy Nation* 4, 1992–1993, reprinted in Chidgey, p. 106.

582 'We wanted a revolution' – author interview with Rowley.

583 '1993: THE YEAR' – John Harris, 'The Eclectic Riot Orchestra', *NME*, 10 July 1993.

584 'Manager seeks four pro-gay Asian Riot Grrrls' – 'Backlash', *Melody Maker*, 27 February 1993.

584 'NME AND ITS "RIVAL"' – *Terrorzine*, 1993, reprinted in Chidgey, p. 108.

584 'It's a load of bollocks' – Sian Pattenden, 'Mind Over Batter', *NME*, 6 March 1993.

584 'I think everyone was dealing' – author interview with Walker.

585 'fuck off' – Gina Morris, 'Grrrls Just Wanna Bait Scum . . .', *NME*, 20 March 1993.

585 'Huggy Bear, being less experienced' – author interview with Walker.

585 'They perceived us' – author interview with Rowley.

585 'How many riot grrrls does it take to change a lightbulb?' – the Stud Brothers, 'Our Culture Is Under Siege', *Melody Maker*, 25 September 1993.

585 'rigid and formulaic' – Sarra Manning, 'Viewpoint', *Melody Maker*, 29 January 1994.

585 'Huggy Bear was a three-year project' – author interview with Rowley.

586 'We hadn't really been talking' – author interview with Wolfe.

29. 'THEIR LAW'

591 'Music and politics don't mix' – 'The Prodigy Jilt Protesters', *Mixmag*, November 1995.

591 'It *shouldn't*' – author interview with Liam Howlett, 2009.

592 'I'm probably more interested' – *The Face*, May 1988, quoted in Matthew Collin, *Altered State* (London: Serpent's Tail, 1997), p. 23.

593 'This city is in total devastation' – Stuart Cosgrove, 'Seventh City Techno', *The Face*, May 1988.

595 'The anti-social egotism' – quoted in Simon Reynolds, *Energy Flash* (London: Picador, 1998), p. 83.

595 'pleasures come not from resistance' – quoted in Reynolds, *Energy Flash*, p. 47.

596 'I don't hold much hope for young people here' – Sheryl Garratt, 'Q&A: Ten Minutes in the Mind of Bobby Gillespie', *The Face*, August 1991.

596 'I see the song as a modern day "Street Fighting Man"' – Simon Reynolds, 'Sympathy for the Screamadelicist: Bobby Gillespie's Primal Reinvention', *Observer*, 1991, reprinted at *Rock's Backpages* (rocksbackpages.com).

596 'The government hated the idea of large groups of kids' – Roger Morton, 'High Generation', *NME*, 28 July 1990.

596 'Don't the police care' – *Sun*, 14 August 1989, quoted in Collin, p. 105.

597 'anarcho-capitalist' and 'fanatical, zealot anti-communist' – Collin, p. 100.

597 'Maggie should be proud of us' – quoted in Collin, p. 111.

597 'The evil craze' – *Sun*, 2 January 1990, quoted in Collin, p. 115.

598 'a band of medieval brigands' – Douglas Hurd, 'Hippy Convoy (New Forest)', Hansard, 3 June 1986.

598 'As the depression in the dominator system' – quoted in Collin, p. 191.

599 'Up until that point' – Collin, p. 200.

599 Similar influences – Chang, pp. 437–439.

600 'a public new sense' – Richard Lowe and William Shaw, *Travellers: Voices of the New-Age Nomads* (London: Fourth Estate, 1993), p. 169.

600 'somewhere between a medieval encampment' – Reynolds, *Energy Flash*, p. 137.

600 'It was amazing' – author interview with Lol Hammond, 2009.

601 'Make some fuckin' noise is one thing' – *Pod*, 1994, quoted in Collin, p. 221.

601 'these appalling invasions' – Stuart Bailie, 'Up Against the Law', *NME*, 8 May 1993.

601 'New Age travellers? Not in this age' – John Major, 1992 conference speech, reprinted at www.johnmajor.co.uk/speechconf1992c.html.

602 'The CJB actually unified this generation' – Collin, p. 228.

602 'lunch outs' – '*Aufheben* Magazine' in George McKay (ed.), *DiY Culture: Party & Protest in Nineties Britain* (London: Verso, 1998).

603 'It stems back much further' – author interview with Howlett.

604 'cultural cleansing' – Steve Hillage, speech at Anti-CJB rally, 19 October 1994 – reprinted at www.a-wave.com/system7/pages/archive/views/justice.htm.

604 'sounds wholly or predominantly' – Criminal Justice and Public Order Act 1994 (c.33) V. 63. (1) (b), published at www.opsi.gov.uk/Acts/acts1994/ukpga_19940033_en_8.

604 'The idea was to make people aware' – author interview with Hammond.

605 'We knew the CJB' – Carl Loben and Ngaire-Ruth, 'Road to Nowhere', *Melody Maker*, 30 April 1994.

605 'It could lead to anarchy' – Dele Fadele, 'The New Wave of No Rave', *NME*, 30 April 1994.

605 'It didn't mean nothing' – liner notes, Pulp, 'Sorted for E's & Wizz' (Island CD single, 1995).

30. 'OF WALKING ABORTION'

610 'Why don't people accept' – author interview with James Dean Bradfield, conducted for 'A Redesign for Life', *Q*, March 2001.

610 The Manic Street Preachers grew up – Simon Price, *Everything (A Book About Manic Street Preachers)* (London: Virgin, 1999).

611 'Where we come from in Wales' – Simon Reynolds, 'Rock'n'Roll Suicide', *Melody Maker*, 20 July 1991.

611 'We'd be sitting on the bed' – Price, p. 9.

611 'the baggy loose attitude' – quoted in Price, p. 17.

612 'All we wanted when we were young' – Steve Lamacq, 'Blood on the Tracks', *NME*, 25 May 1991.

612 'It was a bit naff' – author interview with Nicky Wire, 2008.

612 'Richey prepared for his interviews' – author interview with Bradfield, conducted for 'Not So Manic Now,' *Guardian*, 1 October 2004.

613 'In a lot of ways McCarthy' – author interview with Wire.

613 'After that, I just don't see the joy in it' – full transcript of *NME* interview with Steve Lamacq, 15 May 1991, quoted in Price, p. 50.

613 'We seemed to become contemptuous' – author interview with Wire.

613 'We've always had a total lack of proportion ' – David Quantick, 'It Takes an Advance of Millions to Hold Us, Bach', *NME*, 15 February 1992.

614 'We just want to clear everything away' – Reynolds, 'Rock'n'Roll Suicide'.

614 'We want to be the biggest cliché' – quoted in Price, p. 51.

614 'Believe me, we are for real', quoted in Price, p. 51.

614 'They look like someone doing the Clash' – James Brown, 'Indecent Exposure', *NME*, 11 May 1991.

615 'It's just naïveté' – author interview with Wire.

615 'We took the abortion language' – quoted in Price, p. 78.

615 'I wanted our message to be so powerful' – Price, p. 78.

615 'deserve total hatred and contempt' – John Harris, 'From Sneer to Maturity', *NME*, 19 June 1993.

615 'We always open our mouths' – John Harris, 'The Eclectic Riot Orchestra', *NME*, 10 July 1993.

616 'We've reached some sort of conclusion' – David Bennun, 'All That Glitters . . .', *Melody Maker*, 29 January 1994.

616 'On our days off' – author interview with Wire.

618 'all Ian's spare time' – Reynolds, *Rip It Up*, p. 183.

618 'I considered myself a good reader' – author interview with Bradfield, 2004.

618 'We felt so unified' – author interview with Wire.

619 'For me, punk rock' – John Harris, *The Last Party* (London: Fourth Estate, 2003), p. 144.

619 'They were political records' – author interview with Damon Albarn, conducted for 'Boy Meets World', the *Big Issue*, 25–31 March 2002.

620 'I want to go home' – Price, p. 154.

620 'When we smashed everything up' – Taylor Parkes, '"Escape From Our History . . ."', *Melody Maker*, 1 June 1996.

621 'Some of the stuff he left for us' etc. – author interview with Wire.

621 'a sense of melancholic victory' – Stuart Bailie, 'Everything Must Go . . . On', *NME*, 11 May 1996.

622 'We could never have made *The Holy Bible*' – author interview with Wire.

31. 'SLEEP NOW IN THE FIRE'

625 'Michael basically gave us' – author interview with Tom Morello, 2009.

625 'Rage Against the Machine' – 'Rage Against the Machine', *Time*, 13 December 1999.

626 'Luddites' – Charles Krauthammer, 'Return of the Luddites', *Time*, 13 December 1999.

626 'flat-earth advocates' – Thomas Friedman, 'Senseless in Seattle', *New York Times*, 1 December 1999.

626 'end of history' – Francis Fukuyama, 'The End of History?', *The National Interest*, Summer 1989.

626 'New World Order' – George H. W. Bush, Address Before a Joint Session of the Congress on the Persian Gulf Crisis and the Federal Budget Deficit, 11 September 1990.

626 'the *Das Kapital* of the growing anti-corporate movement' – Nick Cohen, 'Corporate Hostility', *Observer*, 23 April 2000.

627 '"Stop the world we want to get off"' – Katharine Viner, 'Hand-to-Brand Combat', *Guardian*, 23 September 2000.

627 'The revolution is basketball' – quoted in 'Paid in Full: Madison Avenue Cashes in with Hip Hop', *Vibe*, September 1996.

627 'the perfect postmodern conduit' – Ariel Dorfman, 'Che Guevara', *Time*, 14 June 1999.

628 'It was inevitable' – Frank, p. 225.

628 'I think the media is far more heavily controlled now' – Sarah Burton, 'Duty of Expression', *Resonance*, 2003.

628 'We were always a band that was on the edge' – author interview with Brad Wilk, conducted for 'Big Audio Dynamite', *Blender*, March 2003.

629 'The radical politics in my home' – author interview with Morello.

629 'how the underlying principles are lost in the wash' – R. J. Smith, 'The World's Most Dangerous Band', *Spin*, October 1996.

630 'Midwestern 7–11 parking-lot rock' – author interview with Morello.

630 'Nobody will ever write a line' – Steven Wells, 'Marx Out of Tension', *NME*, 18 June 1994.

630 'Our words had to be backed up' – Myers, p. 40.

630 'The band's initial plan' – author interview with Morello.

631 'One of the questions I'd get asked' – Tom Morello, 'What Rock'n'Roll Has Taught Me', NME.com, 23 October 2009.

631 'Radiohead very much came out of the culture of complaint' – *Channel 4 News* interview, 1999, transcribed at www.indyrock. es/paris2.html.

632 'I think he's wonderful because he made me interested' – 'Thom Yorke's Heroes and Villains', *NME*, 4 December 1993.

632 'I really do wish we'd never written that fucking song' – Caitlin Moran, 'Head Cases', *Melody Maker*, 10 June 1995.

633 'I've been trying to write something political' – Ted Kessler, 'Radio Daze', *NME*, 27 May 1995.

633 'There's been a lot of looking at headlines' – Caitlin Moran, 'Everything Was Just Fear', *Select*, July 1997.

635 'Since we don't participate' – CD booklet, Radiohead, *Airbag / How Am I Driving?* (Capitol CD, 1998).

636 'Give me some substance' – the Chemical Brothers, 'Out of Control' video (dir: W.I.Z., 1999).

636 'Justice does matter' – Rage Against the Machine, 'No Shelter' video, 1998.

636 'All the governments have their hands tied' – Rob Hill, Radiohead interview, *Bikini* 25, reprinted at www.greenplastic. com/coldstorage/articles/bikini.html.

637 'He was bloody good' – Yoichiro Yamazaki, Erica Yamashita and Phil Sutcliffe, 'Thom Yorke', *Q Radiohead Special Edition* (London: EMAP Metro, Ltd, 2003), p. 136.

637 'Blair hijacked it because he'd failed on all his other issues' – Stephen Dalton, 'Radiohead and Whose Army', *Uncut*, August 2001.

638 'It certainly vindicated us' – author interview with Morello.

638 'Seattle surprised me' – Viner.

638 'In this moment' – *Time*, 'Rage Against the Machine'.

638 '[This is] the most important event that any of us' – Janet Thomas, *The Battle in Seattle: The Story Behind and Beyond the WTO Demonstrations* (Golden, CO: Fulcrum, 2000), p. 123.

639 'In the '60s, I marched for peace and justice' – Krauthammer, 'Return of the Luddites'.

639 'Shame!' – 'How Organized Anarchists Led Seattle into Chaos', *Time*, 13 December 1999.

639 One wag blasted out – T. V. Reed, *The Art of Protest* (Minneapolis: University of Minnesota Press, 2005), p. 268.

640 'that the wild yet focussed energies' – Reed, p. 257.

640 'It's hard to extricate' – author interview with Morello.

640 'My personal influence on Radiohead' – Dalton, 'Radiohead and Whose Army'.

641 'full-on consumerism' – Viner.

641 'They're like Coca-Cola' – Deuce of Clubs, 'Suits, Lawsuits, and Art: Negativland Takes on the Man', *Planet Magazine*, 4 July 1995.

641 'gave one real hope' – Ed O'Brien, diary posting, Radiohead.com, 2000.

642 'You have no-one to blame but yourselves and you know it' – liner notes, Radiohead, *Kid A* (Parlophone CD, 2000).

642 'the feeling of being a spectator' – Simon Reynolds, 'Walking on Thin Ice', *The Wire*, July 2001.

642 'We fell well short' – author interview with Morello.

643 'Tweedledum and Tweedledee' – William Safire, 'The Protest Vote', *New York Times*, 30 October 2000.

643 'Gush and Bore' – Max Garrone, 'The Gush and Bore Show!', Salon.com, 21 January 2000.

643 'He appears as two but speaks as one!' – Rage Against the Machine, 'Testify' video (dir: Michael Moore, 2000).

32. 'JOHN WALKER'S BLUES'

647 'If our songs are "questionable"' – quoted in Eric Nuzum, *Singing in the Echo Chamber: Music Censorship in the US after September 11th* (Copenhagen: Freemuse, 2005), p. 28.

647 'definitively interrupt[ing]' – quoted in Reed, p. 281.

648 a Harris poll in late September – this and presidential approval

ratings recorded in 'America and the War of Terrorism', AEI Studies in Public Opinion, updated 24 July 2008, published at www.aei.org/publicopinion3.

648 'the Great Quiet' – Craig McLean, 'R.E.M.: Angels in America', *Independent*, 14 November 2004.

648 'the idea that songs' – Lauren St John, *Hardcore Troubadour: The Life & Near Death of Steve Earle* (New York: Fourth Estate, 2004), p. 35.

648 'Bruce's Children' – Jon Pareles, 'Heartland Rock: Bruce's Children', *New York Times*, 30 August 1987.

649 'Me, I can more easily' – St John, p. 343.

649 'I became acutely aware' – John Harris, '"My Country Is Sleepwalking"', *Guardian*, 23 September 2002.

650 'fucking crazy' – Robert Chalmers, 'Is Steve Earle America's Greatest Living Songwriter?', *Independent*, 22 July 2007.

650 'Twisted Ballad' – quoted in Harris, '"My Country Is Sleepwalking"'.

650 'Do you think an American' – *Just an American Boy* (dir: Amos Poe, 2003).

651 'That record embarrasses me' – Harris, '"My Country Is Sleepwalking"'.

651 'Lately, I feel like the loneliest man in America' – liner notes, Steve Earle, *Jerusalem* (Artemis CD, 2002).

651 'We're supporting the USA' – 'Paper Tigers: Double Standards, Celebs and Gary Condit', *San Francisco Chronicle*, 30 September 2001.

652 'During the Clinton years' – author interview with Damien Randle, 2009.

652 'All people have is hope' – Jon Pareles, 'His Kind of Heroes, His Kind of Songs', *New York Times*, 14 July 2002.

653 'It's been a long, weird year' – Earle onstage at TLA, Philadelphia, autumn 2002, documented in *Just an American Boy*.

653 'Fuck Saddam' – Daniel Eisenberg, 'We're Taking Him Out', *Time*, 5 May 2002.

654 'Bush wanted to remove Saddam' – memo from Matthew Rycroft to David Manning, Downing Street, 23 July 2002.

654 'I said, "I know you're all . . ."' – author interview with Guy Garvey, conducted for 'No More Heroes', *Guardian*, 18 October 2002.

654 'Bombing one of the poorest countries' – 'Gorillaz Storm MTV Awards', BBC News website, 8 November 2001.

655 'I just felt really stupid' – author interview with Albarn, 2002.

655 'slightly unsure' – author interview with Robert Del Naja, 2009.

655 'It feels untenable' – author interview with Nicky Wire, 'Not So Manic Now,' *Guardian*, 1 October 2004.

655 'Perhaps those of us' – author interview with Brian Eno, conducted for 'No More Heroes'.

655 'Nobody's gonna listen to knobhead' – quoted in Dorian Lynskey, 'No More Heroes'.

655 'I think the problem is vanity' – author interview with Del Naja, conducted for 'No More Heroes'.

656 'I was hugely depressed' – author interview with George Michael, 2004.

656 'You're asking, "Don't you speak up?"' – author interview with Bono.

658 'There was a sense of jubilant naivety' – author interview with Del Naja.

658 'Just so you know' – Maines onstage at Shepherd's Bush Empire, London, 10 March 2003, documented in *Shut Up and Sing* (dir: Barbara Kopple and Cecilia Peck, 2006).

658 'I got hot from my head to my toes' – Andrea Sachs, 'Chicks in the Line of Fire', *Time*, 21 May 2006.

659 'They should send Natalie' – *Shut Up and Sing*.

659 'reminded me of things' – Damien Cave, 'Rockers Unite to Oust Bush', *Rolling Stone*, 11 December 2003.

659 'It had to be some group' – *Shut Up and Sing*.

659 'disrespectful' – official statement, 12 March 2003, quoted in 'Dixie Chicks: anti-American?', guardian.co.uk, 19 March 2003.

659 'Am I sorry I said that?' – *Shut Up and Sing*.

660 'Dixie Twits', etc. – *Shut Up and Sing*.

660 'Patriot' – *Entertainment Weekly*, 2 May 2003.

660 'Now that we've fucked ourselves' – *Shut Up and Sing*.

660 'because we welcome freedom of speech' – *Shut Up and Sing*.

661 'Stuff happens!' – Thomas E. Ricks, *Fiasco: The American Military Adventure in Iraq* (London: Penguin, 2006), p. 136.

661 'sexed up' – *Today*, BBC Radio 4, 29 May 2003.

662 'I never thought that song' – author interview with will.i.am, conducted for 'Give Peas a Chance', *Blender*, 2005.

662 'The gloaming' – Yamazaki, Yamashita and Sutcliffe.

662 'the people who don't give a fuck' – Yamazaki, Yamashita and
Sutcliffe.
663 'This was the noise' – John Robinson, 'It's Clear and Pretty – But
I Think People Won't Get It', *NME*, 3 May 2003.
663 'I felt that the tipping point' – McLean.

33. 'AMERICAN IDIOT'

667 'I was hoping some young person' – Richard Waters, 'The
Gentler Side of Anger', *Financial Times*, 4 July 2008.
667 'Are today's artists just apathetic' – Eric Deggans, 'The Dying
Protest Song', *St Petersburg Times*, 13 August 2006.
668 'It was like, "I'm proud to be a redneck"' etc. – author interview
with Billie Joe Armstrong, 2009.
670 'We must all unite' – Cave.
671 'That's what scares me' – Adam Sweeting, 'The Freewheelin'
Willy Mason', *Guardian*, 15 February 2005.
671 'I'd [prefer] almost anyone' – author interview with Peter Buck,
conducted for 'The Great Divide', *The Word*, October 2004.
672 'You can't tell people what to think' – Adam Sweeting, 'Battle of
the Bands', *Guardian*, 8 October 2004.
672 'We both said' – author interview with Peter Buck, 2009.
672 'We had the money' – James Carney, 'What Happens to the
Losing Team?', *Time*, 3 November 2004.
673 'I can't think of many occasions' – author interview with Rob
Tannenbaum, 2009.
673 'I just wasn't into it' – Laura Barton, '"I'm Not Gonna Be a Tool
for Anyone"', *Guardian*, 26 March 2007.
674 'Baghdad under water' – Nancy Gibbs, 'The Nightmare After
Katrina', *Time*, 4 September 2005.
674 'It reminded me' – author interview with Damien Randle.
675 'I hate the way they portray us' – Lisa de Moraes, 'Kanye
West's Torrent of Criticism, Live on NBC', *Washington Post*, 3
September 2005.
675 'I was just flipping the channels' – author interview with Randle.
676 'I would like to say' – author interview with will.i.am, 2005.
676 'A lot of what we were saying' etc. – author interview with
Randle.
677 'After Katrina happened' – author interview with Michael Franti,
2006.
677 'I apologised for disrespecting' – Sachs.

678 'the dated, boring-assed fucking' – Alastair McKay, 'The Never-Ending War', *Uncut*, July 2008.

678 'a rush of nostalgia' – *CSNY/Déjà Vu* (dir: Neil Young and Benjamin Johnson, 2008).

679 'We really do love' – author interview with Wayne Coyne, 2009.

680 'It's saying, "Well . . ."' – John Wirt, 'John Mayer Finding Unexpected Deeper Connection with Fans Through "Continuum"', *The Advocate*, 26 January 2007.

EPILOGUE

681 '*Time* magazine made its Person of the Year' – *Time*, 26 December 2011

681 'The *Guardian* drew comparisons' – John Harris, 'Global protests: is 2011 a year that will change the world?', The *Guardian*, 16 November 2011

682 'We've been playing for three and a half hours' – *The Simpsons Movie* (dir: David Silverman, 2007).

682 'The realities of how music is made' – Simon Reynolds, 'Notes on the Noughties: Is M.I.A. Artist of the Decade?', guardian.co.uk, 16 December 2009.

685 'The media likes to quantify things' – author interview with Tom Morello, November 2011.

Acknowledgements

Writing a book about the origins of classic songs is a useful reminder that nothing is created in a vacuum. Even the song-writers who possessed real genius needed the right influences, the right opportunities, and the right people to bring it to fruition. A book of this nature may only have one name on the cover but it owes its existence to dozens more.

The late Pat Kavanagh believed in me even before I had the idea for this book, and gave me the confidence to keep going. Her friend and colleague Sarah Ballard was involved in the project from the start and I am happy to have her as my agent. My New York agent, Zoe Pagnamenta, ensured that I found a US audience. Lee Brackstone, Angus Cargill, Lucie Ewin and the team at Faber gave me their energy and expertise.

Certain friends were indispensable throughout this project, whether by reading rough drafts, offering useful insights, or just keeping my morale high with their interest and enthusiasm: Joshua Blackburn, Sarah Donaldson, Tom Doyle, Dan Jolin, Lucy Jolin, Steve Lowe, Caitlin Moran, John Mullen, Pete Paphides, Alexis Petridis, Jude Rogers, Bob Stanley, and Matt Weiner.

Some fellow journalists helped out with advice, contacts and useful information: Ian Aitch, Daryl Easlea, Dave Everley, Rob Fitzpatrick, Barney Hoskyns, Ian McPherson, Alex Ogg, and Simon Reynolds. Thanks also to all the writers who gave me their blessing to quote from their work, to Fred Courtright for obtaining other permissions, to Miriam Rosenbloom and Miles Donovan for designing the book jacket, to Simon Leigh for the

author photograph, to Trevor Horwood, for his eagle-eyed copy-editing and to the staff of the British Library, where most of the writing and research took place.

Some of the interviews in this book were conducted in the context of features for magazines and newspapers, but other interviewees were generous with their time and their memories just because they found the project interesting (in a couple of cases it was a bit of both): Tony Allen, Jello Biafra, Bono, Billy Bragg, Peter Buck, Guy Carawan, Adam Clayton, Dennis Coffey, Chuck D, Jerry Dammers, Robert Del Naja, The Edge, Pee Wee Ellis, Amde Hamilton, Lol Hammond, Liam Howlett, Steve Ignorant, Holly Johnson, Linton Kwesi Johnson, Don Letts, Country Joe McDonald, Tom Morello, Larry Mullen, Jr, Damien Randle, Martha Reeves, Penny Rimbaud, Tom Robinson, Max Romeo, Chris Rowley, Red Saunders, Gary Walker, Otis Williams, Nicky Wire, and Allison Wolfe.

Many of these interviews could not have taken place without the kind efforts of publicists and managers: Billy Bannister, Joolz Bosson, Brady Brock, Mike Champion, Barbara Charone, George Chen, Nadja Coyne, Charlotte Crofton-Sleigh, Ruth Drake, Sarah J. Edwards, Heather Finlay, Liz Gould, Terri Hall, Dundee Holt, Claire Horton, Tony Linkin, Frances McCahon, Kevin O'Neil, Andy Prevezer, Sally Reeves, Chris Stone, and Jo Wiser.

Writing this book also made me aware of the debt I owe to the various editors whose encouragement and advice have made me a better writer over the last fifteen years, in particular: John Aizlewood, Matthew Collin, Maddy Costa, Paul Du Noyer, Danny Eccleston, Mark Ellen, Charlie English, Gareth Grundy, Claude Grunitzky, Michael Hann, John Harris, Andrew Harrison, Tina Jackson, Ted Kessler, Andrew Male, Craig Marks, Merope Mills, Kate Mossman, Andy Pemberton, Dom Phillips, Rob Tannenbaum and Frank Tope.

Finally, I'd like to thank my mother Tola, my sister Tammy, and my late father Dave, who nurtured my love of music and patiently endured my angry political monologues when I was a

teenager. I like to think Dave would have enjoyed this book. And love and gratitude without end to my wife Lucy and my daughters Eleanor and Rosa for all the things that make this book, and my life, possible.

Picture Acknowledgements

Index

Songs are indexed under their artist. Those without artists are indexed under themselves. Page references in italics are illustrations.

Index

Index

Chambliss, Robert Edward, 91

Chandler, Len, 70, 94

Chang, Jeff, 242

Changeover (play), 115

Charles, Ray, 482, 501, 677; 'Hit the Road, Jack', 57

Chase, James 'Jiggs', 423–4

Chayefsky, Paddy, 271

The Chemical Brothers, 636

Chernenko, Konstantin, 460, 462, 465

Cheslow, Sharon, 574, 576

The Chi-Lites: '(For God's Sake) Give More Power to the People', 195, 324; 'We Are Neighbours', 195

Chic, 369–71, 374, 377, 423; 'At Last I Am Free', 370–1; 'Dance, Dance, Dance (Yowsah, Yowsah, Yowsah)', 367, 370; 'Good Times', 374–5; 'Le Freak', 370; *see also* Rodgers, Nile

Chicago Seven trial (1969), 209–10, 214

Chicago White Sox, 375–6

Chicago Women's Liberation Rock Band, 'Ain't Gonna Marry', 225

Chile, 277–94, 311, 532

Chilton, John, 10, 11

Chirac, Jacques, 657

Chomsky, Noam, 631–2, 635

The Chosen Few, 'Am I Black Enough For You?', 324

Christgau, Robert, 171, 211, 325, 476, 483, 562

Christian, Terry, 571, 572

Chuck D: on 1960s soul music, 187; background, 548–9; on Koch, 565; and Manic Street Preachers, 612; political views, 555; and Public Enemy, 547–8, 549–53, 556–61, 562, 566–7; and Sonic Youth, 582; *see also* Public Enemy; Sonic Youth feat. Chuck D

Chumbawamba, 442; *Pictures of Starving Children Sell Records*, 485

CIA, 553, 599

CIO *see* Congress of Industrial Organizations

Civil Rights Act (1964), 103

civil rights movement: 1950s, 53–8; 1960s and 1970s, 61–4, 77–8, 89–106, 139–57, 229–47; films about,

556; and Motown, 183–4, 186–95

Clapton, Eric, 381, 382

Clark, Fraser, 598

Clark, Petula, 171

Clark, Ramsey, 106

Clarke, Betty, 658

The Clash, 337; bands challenging them, 355; Buck on, 527; and the Falklands, 445; and hip-hop, 421, 423; influence, 437, 438, 512, 516; and nuclear weapons, 455, 457; origins, 340–1, 343; protest songs and tours, 344–7, 350–2, 357–8; and RAR, 387; and the Specials, 389; style, 350; and Thatcher, 392 SONGS AND ALBUMS: '1977', 347; *Combat Rock*, 357; *The Cost of Living* EP, 392; *Give 'Em Enough Rope*, 357; 'Know Your Rights', 604; *London Calling*, 357–8; 'Police and Thieves', 351; 'Safe European Home', 352; *Sandinista!*, 357; 'Stop the World', 455; 'Straight to Hell', 683; 'Washington Bullets', 293; '(White Man) in Hammersmith Palais', 351; 'White Riot', 344–7, 350, 388, 441

Clay, Cassius *see* Ali, Muhammad

Clayton, Adam, 471, 473, 482, 488; *see also* U2

Clayton, Merry, 222

Clear Channel, 647

Cleary, John, 203

Cleaver, Eldridge: and Black Panther civil war, 244–5; and Black Panthers, 145, 147, 148, 151; exile, 155; and Rage Against the Machine, 636; Weatherman on, 219

Cleveland, Al, 198

Cliff, Jimmy, 316, 502; 'Many Rivers to Cross', 323

Clinton, Bill, 541, 565, 626, 635

Clinton, George, 194, 377, 593

A Clockwork Orange (novel and film), 340

Club Dog, 599

CND *see* Campaign for Nuclear Disarmament

Cobain, Kurt, 573, 574

Cobb, Ron, 121

807

Index

Index

Index

Adventures of Grandmaster Flash on the Wheels of Steel', 423; 'Superrappin'', 423, 425, 427

Grandmaster Flash and the Furious Five feat. Melle Mel and Duke Bootee, 'The Message', 420, 423–9, 430

Grandmaster Melle Mel: 'Jesse', 429; 'World War III', 429; see also Mel, Melle

Grant, Eddy, 'Gimme Hope Jo'anna', 503

The Grateful Dead, 225

Green Day, 668–70, 682; 'American Idiot', 668–9; American Idiot, 669–70; 'Holiday', 669, 670; see also Armstrong, Billie Joe

Greenham Common, 456

Greenpeace, 538, 539, 591

Greenway, John, 407

Greenwich Village, 69–70, 75, 94, 96

Greenwood, Jonny, 633; see also Radiohead

Greenwood, Lee, 'God Bless the U.S.A.', 648

Gregory, Dick, 94, 171, 188

Griff, Professor (Richard Griffin): anti-Semitism, 548, 558–9; background, 549, 550; in Public Enemy, 553; leaves Public Enemy, 561; see also Public Enemy

Griffin, Junius, 253

Griffith, Michael, 556

Grossman, Albert, 59, 70, 75, 78

Grosvenor Square demonstration (1967), 165–6, 340–1

Grundy, Bill, 348

Grunwick strike, 349

Guatemala, 532, 533

Guess?, 641

Guevara, Che, 280, 282, 627, 636

Guinea, 298

Gumboots: Accordion Jive Hits, Vol. II (various artists), 505

Gunning, Sarah Ogan, 'I Hate the Capitalist System', 32

Guns N' Roses, 612

Guthrie, Arlo, 40, 60, 210; 'Alice's Restaurant Massacree', 120; 'Victor Jara', 293

Guthrie, Carolyn, 34

Guthrie, Cathy, 40

Guthrie, Charley, 22–3

Guthrie, Gwendolyn Gail, 23, 24, 34

Guthrie, Joady, 40

Guthrie, Marjorie, 40

Guthrie, Mary Jennings, 23, 24, 34

Guthrie, Mary Jo, 23

Guthrie, Nora (Woody's daughter), 26, 39–40

Guthrie, Nora (Woody's mother), 22–3

Guthrie, Woody, 19; ambition for his songs, xiv–xv; benefit concert, 52–3; character and persona, 21–2; cover versions of his songs, 48, 476, 477, 522; Earle on, 648–9; influence, 69, 70, 114, 341, 476, 481; life, 2–4, 26–8, 32–5, 36–40, 51; musical tributes, 76
SONGS AND ALBUMS: 'Deportee (Plane Wreck at Los Gatos)', 40, 522; 'Do Re Mi', 34; Dust Bowl Ballads, 33–4, 35; 'Dust Bowl Refugees', 27; 'Dust Can't Kill Me', 27; 'Dust Pneumonia Blues', 27; 'Grand Coulee Dam', 35; 'I Ain't Got No Home in This World Anymore', 27, 34; 'More War News', 28; 'Roll On, Columbia, Roll On', 35; 'So Long, It's Been Good to Know You', 33–4; 'Talking Dust Bowl Blues', 26; 'This Land Is Your Land', xi, 34, 37–9, 476, 514–15; 'Tom Joad', 33; see also the Almanac Singers

Guyana, 401

Gwinn, Walton W., 47

H.R., 411, 413

Haden-Guest, Anthony, 369, 372

Hagar, Sammy, 'I Can't Drive 55', 531

Haggard, Merle, 659; 'The Fightin' Side of Me', 212; 'Okie From Muskogee', 212, 219

Haile Selassie, 315, 317, 319, 326

Haldeman, H. R., 219

Haley, Alex, 254

Haley, Judge Harold J., 244

Hall, Philip, 617

Hall, René, 102

Hall, Terry, 390, 391, 395, 397, 455;

Index

Major, John, 583, 601

Makeba, Miriam: and apartheid, 495–6, 497, 502, 506; background, 494–5; on Live Aid, 483; plans to move to Ghana, 156; and Simone, 105; *see also* Belafonte, Harry and Miriam Makeba

Makota, Leo, 205

The Malapoets, 506

Malcolm X: activism style, 63, 93, 100; advocation of word 'black', 141; death, 105; documentary about, 97; and Fela, 299–300, 302; in films, 556; growing influence, 99; influence in Jamaica, 319; posthumous tributes, 231; on protest songs, 63, 556–7; and Public Enemy, 552, 553

Malick, Terrence, 477

Mambo Taxi, 586

Mancuso, David, 362

Mandela, Nelson, 374, *491*, 493–508

Mandelson, Peter, 522

The Manhattan Brothers, 507

The Manic Street Preachers, 358, 583, 609–19, 620–2, 678; '4st 7lbs', 620; 'Archives of Pain', 617; 'A Design for Life', 621, 622; *Everything Must Go*, 622; 'Faster', 620; 'From Despair to Where', 615–16; *Generation Terrorists*, 614–15; *Gold Against the Soul*, 615–16; *The Holy Bible*, 609–10, 616–19, 620; 'If You Tolerate This Your Children Will Be Next', 622; 'ifwhiteamericatoldthet ruthforonedayit'sworldwouldfallap art', 617; *Journal for Plague Lovers*, 621; 'Life Becoming a Landslide', 615–16; 'Mausoleum', 609; 'Motorcycle Emptiness', 615, 617; 'Motown Junk', 613; 'Natwest – Barclays – Midlands – Lloyds', 615; 'Of Walking Abortion', 609, 610, 617–18; 'Roses in the Hospital', 615; 'La Tristesse Durera (Scream to a Sigh)', 616; 'You Love Us', 614

Manley, Michael: election campaigns, 315–16; in government, 323–4, 326–7; loss of power, 332; and Marley, 315, 329–30, 331, 333; and

reggae, 315–16, 322, 328

Mann, Barry, 134

Manning, Bernard, 382

Manning, Judson, 82

Manning, Sarra, 585

Mansell, Clint, 603

Manson, Charles, 212–13

Mao Tse-tung, 47, 116, 144, 145, 176

Mapfumo, Thomas, 311

March Against Fear (1966), 141–2

March on Washington (1963), 77–8, 100

Marcus, Greil: and Band Aid, 483; on Beatles vs Rolling Stones protest songs, 161, 167, 168; on 'Masters of War', 74; on *Nebraska*, 478; on original American folk music, 31

Marcuse, Herbert, 168, 178, 636

Margolick, David, 13, 14, 16

Margouleff, Robert, 258–9

Marinetti, Filippo, 459

Marley, Bob: assassination attempt on, 329–30; background, 321; death, 332–3; influence, 471; and Manley, 315, 329–30, 331, 333; One Love benefit show, 331; output, 321–2, 325–6; 'Punky Reggae Party', 352

Marley, Bob and the Wailers: 'Africa Unite', 311; *Exodus*, 330; *Natty Dread*, 325; 'One Love/People Get Ready', 330, 522; *Rastaman Vibration*, 325; 'Redemption Song', 333; *Survival*, 332, 333; 'Zimbabwe', 311; *see also* the Wailers

Marley, Rita, 321

Márquez, José Adolfo Paredes, 291

Marsh, Dave, 264

Marshall, Bucky, 331

Martin, Gavin, 104, 153, 470, 475, 485

Martin, Luci, 375

Martini, Jerry, 192, 251

Marx, Karl, 648

Marxist Black Guerrilla Family, 243

Marxman, 583

Masekela, Hugh: and apartheid, 493, 496, 504, 506; background, 494–5; 'Bring Him Back Home', 506; and Fela, 302; and Mandela's birthday concert, 507

Index

Truth', 266
Rand, Jess, 96
Randle, Damien, 652, 673, 674, 675, 676–7; *see also* the Legendary K.O.
Rankin, John, 47
Rankine, Lesley, 584
Ranking Roger, 500
Ransome-Kuti, Funmilayo, 197–8, 308, 309, 311
Ransome-Kuti, Israel Oludotun, 297
rap, 419–30, 545–67; gangsta rap, 553–5, 566
RAR *see* Rock Against Racism
Rasta Love, 384
Rastafarianism, 315, 316, 317–18, 319, 326
raves, 591–605
Rawls, Lou, 187, 373; *Black and Blue*, 17; 'Strange Fruit', 17
Ray, James Earl, 49
Ray, Nicholas, 35
Razaf, Andy, 7–8
Read, Mike, 459
Reagan, Ronald, 525; 1984 presidential election, 528; and apartheid, 502, 503; as California's governor, 145, 170, 175; and Central America, 487, 488; Crass hoax, 446; dissent, 527–39; European attitude to, 529; and Frankie Goes to Hollywood, 458, 460; holidays, 469; and Latin America, 487, 488, 531–3, 536; and Middle America, 213; and nuclear weapons, 453, 456, 461–2, 465; political overview, 535; punk on, 409, 411, 415; and Rambo films, 479; reasons for popularity, 528, 534–5; and Springsteen, 480; and U2, 470, 488
Reagon, Cordell, 62
Rebours, Bernhardt, 436
Reclaim the Streets, 605, 635, 637, 641
Rector, James, 170
Red Box, 'For America', 486
Red Brigades, 350
Red Channels (report), 48
Red Mole (newspaper), 177
The Red Song Book, 32
Red Wedge, 515–24, 612

Redding, Otis, '(I Can't Get No) Satisfaction', 187
Reddy, Helen, 'I Am Woman', 225
Redgrave, Vanessa, 165
The Redskins, 519
Reece, Florence, 'Which Side Are You On?', 32, 57, 513, 515
Reed, Lou, 670
Reedy, George, 124
Reeves, Martha, 183, 186, 188–9
Reeves, Martha and the Vandellas: 'Dancing in the Street', 183, 187, 188; 'I Should Be Proud', 195–6; 'Jimmy Mack', 183, 189
reggae, 315–33, 347, 387–8
Reid, Clarence 'Blowfly', 'Blowfly's Rapp', 548; *see also* Blowfly
Reid, Jamie, 347, 348, 352, 353
R.E.M., 527–8, 529–30, 532–42, 633, 672; *Automatic for the People*, 541; 'Begin the Begin', 533; 'Cuyahoga', 533, 534; 'Disturbance at the Heron House', 536; *Document*, 536–8; 'Drive', 541; 'Exhuming McCarthy', 537–8; *Fables of the Reconstruction*, 529–30; 'Fall on Me', 534, 539; 'Final Straw', 657; 'Finest Worksong', 536, 542; 'Flowers of Guatemala', 533; 'Get Up', 539; *Green*, 539; 'Green Grow the Rushes', 530; 'Ignoreland', 541; 'It's the End of the World As We Know It (And I Feel Fine)', 536–7; *Life's Rich Pageant*, 533–4; 'Little America', 529; *Murmur*, 527; 'Orange Crush', 539; *Out of Time*, 541; 'Radio Song', 541; 'Revolution', 541; 'Stand', 539; 'Talk About the Passion', 542; 'These Days', 534; 'Welcome to the Occupation', 536; 'What's the Frequency Kenneth?', 632
Republic of New Afrika, 245
Retribution: 'Repetitive Beats', 604; 'Repetitive Beats (Know Your Rights – Primal Scream)', 604
Reynolds, Malvina, 81, 286
Reynolds, Simon: and Casale, 219; on current state of music, 682–3; and dance music, 595, 596, 600;

Index

Index

Index